W9-BAZ-643

NATIONAL PORTRAIT GALLERY
Permanent Collection Illustrated Checklist

NATIONAL PORTRAIT GALLERY

SMITHSONIAN INSTITUTION

PERMANENT COLLECTION ILLUSTRATED CHECKLIST

NPG
TWENTY-FIFTH
ANNIVERSARY
1962-1987

TWENTY-FIFTH ANNIVERSARY EDITION

Acquisitions through December 31, 1985

Published by the National Portrait Gallery
in association with
the Smithsonian Institution Press
City of Washington, 1987

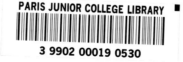

The publication of this *Checklist* has been made possible in part by a generous grant from The T. M. Evans Foundation, Inc.

National Portrait Gallery
Alan Fern, Director
Carolyn Kinder Carr, Assistant Director for Collections
Marc Pachter, Assistant Director for History and Public
 Programs
Frances Kellogg Stevenson, Publications Officer

Compiled by Dru Dowdy
Photographs by Eugene Mantie and Rolland White

Design and production by Polly Sexton and Sally Tiller
Composed by Harlowe Typography, Inc.
Printed by Collins Lithographing & Printing Company, Inc.

Library of Congress Catalog Card Number 86-63389
ISBN 0-87474-373-7

Cover: Stained-glass dome in the Great Hall of the National Portrait Gallery. *Photograph by Carol M. Highsmith*

Once the largest room in America, the Great Hall was originally conceived to display miniature models required of inventors when the building housed the United States Patent Office. The space also served as the first national museum, and it was here that the Declaration of Independence was publicly displayed between 1841 and 1871. During the Civil War the hall served as a makeshift hospital; Walt Whitman tended to sick soldiers here. In March 1865 guests at Abraham Lincoln's second inaugural ball passed through this room to join the receiving line in what is now called the Lincoln Gallery.

In 1877 a massive fire swept through the third floor, destroying the interior of the west and north wings of the building. Repairs and remodeling—which included the undamaged south wing as well—were completed eight years later in the American Victorian Renaissance style. The decor, exuberantly rich in color and texture, combines stone, marbleized or painted plaster, tile, colored glass, and painted wood, all intended as a backdrop for the relief panels and medallion portraits in the rotunda.

CONTENTS

FOREWORD

This book commemorates twenty-five years of collecting activity on the part of a museum unique in America. In celebrating our silver anniversary, we also celebrate the remarkable growth of the Gallery's collections, and this catalogue stands as a tribute to all those who have contributed to our holdings. With the support of an understanding Congress, which made appropriated funds available from the start to assist in acquiring portraits, with the sympathetic support of the Regents and the administration of the Smithsonian Institution, and through the generosity of many individuals, foundations, and corporations who have donated portraits and funds, the staff of the Gallery has succeeded beyond anyone's fondest hopes in 1962—when Congress established the museum as a bureau of the Smithsonian Institution—in assembling a collection of notable range and quality.

Nonetheless, much more remains to be done. At the same time that this *Checklist* serves to record what we have acquired, it reminds us of the many other portraits we ought to have. As we pass this milestone in the history of the Gallery, we must dedicate ourselves to future acquisitions with the same vigor we have devoted to the growth of the collections in the past. My colleagues and I call upon those who use this book to help in this effort, and assist the National Portrait Gallery in fulfilling its purpose, as stated by Congress, to record the "men and women who have made significant contributions to the history, development, and culture of the people of the United States, and of the artists who created such portraiture and statuary."

ALAN FERN
Director

ACKNOWLEDGMENTS

Compiling all of the entries—and ensuring their accuracy—for a collection of nearly four thousand portraits is a massive endeavor, and has necessarily involved the cooperation of many people on the National Portrait Gallery's staff.

All of the entries were supplied by the curatorial offices. Special thanks must be given to the various curators for providing the information: Robert G. Stewart and Monroe Fabian, Office of Painting and Sculpture; Wendy Wick Reaves, Office of Prints; William F. Stapp, Office of Photographs; and Frederick S. Voss, *TIME* Collection. Thanks for help in answering biographical questions must go to historians Marc Pachter, James G. Barber, and Amy Henderson. The visual data—the photographs of each and every portrait—are the work, over some years, of Gallery photographers Eugene Mantie and Rolland White.

Particular recognition must also go to: Bridget M. Barber of the Office of Prints and Ann M. Shumard of the Office of Photographs, who answered numerous curatorial questions; publications intern Jenifer Browning, who cheerfully worked on various editorial and production assignments; Ginger Haydon of the Office of Rights and Reproductions, who helped obtain many of the photographs; and Annetta McRae of the Office of the Historian, who typed the massive number of entries.

Finally, guidance at critical stages was provided by both of the National Portrait Gallery's Assistant Directors, Carolyn Kinder Carr and Marc Pachter; without their efforts, neither the form nor the content of this *Checklist* could ever have been achieved.

FRANCES KELLOGG STEVENSON
DRU DOWDY

THE NATIONAL PORTRAIT GALLERY

Many of the portraits in this *Checklist* are gifts; others have been purchased with funds donated by individuals, foundations, or corporations, or with funds appropriated by Congress specifically for Gallery acquisitions. Portraits listed herein with no information about other sources of acquisition have been purchased with congressionally appropriated funds.

With the exception of Presidents of the United States, portraits are not normally admitted into the Permanent Collection of the Gallery until ten years after the death of the subject. Under certain circumstances, the Commissioners of the Gallery—the group legally empowered to accept works into the collections—may recommend the acquisition of a portrait not yet meeting this qualification, but until it enters the Permanent Collection, such a portrait will only be displayed in special exhibitions. Whenever possible, likenesses must be taken from life.

A reference facility for the study of American portraiture is the Gallery's own Catalog of American Portraits, which has records on more than seventy thousand portraits in public and private collections around the nation. Research may be conducted at the CAP during business hours, preferably by appointment.

The Library, also open for researchers during business hours, specializes in American art, history, and biography. In addition to more than fifty thousand catalogued volumes, it has auction catalogues, serials, scrapbooks, microforms, and an extensive collection of uncatalogued ephemera.

Portraits may be brought in to the National Portrait Gallery on Thursdays, by prior arrangement, for the curators or the conservator to examine, although advice cannot be given about monetary value. General questions about Gallery holdings not on view should be addressed to the Registrar. Access to the museum's vast Study Collection can be arranged through the Registrar.

Biographical files on individuals in the Permanent Collection are kept by the Office of the Historian. The *Selected Papers of Charles Willson Peale and His Family*, a projected seven-volume series, is being edited at the Gallery and published by Yale University Press. The Peale Family Papers Office's files may be consulted by prior arrangement.

USING THE *CHECKLIST*

Entries are in four sections: individual sitters, group portraits, the *TIME* Collection, and the Meserve Collection. They are arranged alphabetically by the sitter's surname in all sections except group portraits, where they are arranged by the title of the work. Each individual subject has a brief biographical designation.

All dimensions are given in centimeters and inches, height preceding width; for freestanding sculpture only the height is given. Print measurements indicate the surface of the image, including any engraved frame or background but excluding any inscription outside that frame.

Every object is given an accession number when it is accepted for the collection. Portraits currently ineligible for public display in the Permanent Collection are identified with an asterisk (*) following the subject's name and a "T" prefix to the accession number.

An Index of Artists is located in the back of this volume; it includes lifedates or working dates of the artists and studios found in this *Checklist*. New to this edition is a comprehensive Index of Sitters, which replaces the cross-references within the text and provides a means of locating sitters by page number, regardless of the section in which they are located.

In March 1974, Mr. and Mrs. Paul Mellon presented the National Portrait Gallery with a collection of 761 portrait engravings by Charles Balthazar Julien Févret de Saint-Mémin (1770-1852), which originally belonged to the artist himself. Those subjects eligible for the Permanent Collection are listed herein; the others have been assigned to the Gallery's Study Collection. These prints will be completely catalogued in a forthcoming Gallery publication, but in the interim, information may be obtained from the curatorial department.

In May 1978, Time, Inc. gave the Gallery the first installment of original works that had served as *TIME* magazine covers from the magazine's inception. A selection of those objects—including later additions from Time, Inc.—is catalogued separately beginning on page 403.

In 1981, with the assistance of Congress, the Gallery purchased some 5,400 objects from the Frederick Hill Meserve Collection of mid-nineteenth-century photographs. Further information, plus a selection of those photographs, may be found on page 425.

Obtaining Reproductions of Checklist Photographs
Photographs of objects (with the exception of *TIME* Collection material)—8-by-10-inch black-and-white glossy prints, 35-millimeter color slides, and 4-by-5-inch color transparencies—may be obtained by writing to the Office of Rights and Reproductions, National Portrait Gallery, Smithsonian Institution, Washington, D.C. 20560. The National Portrait Gallery can supply photographic reproductions of *TIME* Collection objects only after written permission has been provided to the Gallery by the requestor from the Office of Rights and Reproductions, Time, Inc., Time and Life Building, New York, New York 10020.

PORTRAITS OF INDIVIDUALS

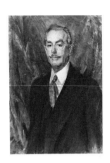

Acheson, Dean Gooderham,
1893-1971
Statesman
Gardner Cox, 1906-
Oil on canvas, 88.9 x 63.5 cm. (35 x
25 in.), 1974
NPG.74.37
Gift of Covington and Burling

Adams, Abigail Smith, 1744-1818
First lady
Attributed to Raphaelle Peale,
1774-1825
Silhouette on paper, 10.4 x 8.6 cm.
(4³⁄₁₆ x 3³⁄₈ in.), c. 1804
NPG.78.282

Adams, Alvin, 1804-1877
Businessman
Leopold Grozelier, 1830-1865, after
daguerreotype by Marcus Ormsbee
S. W. Chandler and Brother
lithography company
Lithograph, 26.7 x 25.2 cm. (10½ x
9¹⁵⁄₁₆ in.), 1854
Published in Charles H. Brainard's
*Portrait Gallery of Distinguished
Americans*, Boston, 1855
NPG.77.64

Adams, Charles Francis, 1807-1886
Diplomat
Mathew Brady, 1823-1896
Photograph, albumen silver print,
48.1 x 40 cm. (18¹⁵⁄₁₆ x 15¾ in.),
c. 1860
NPG.76.64

Adams, Franklin Pierce, 1881-1960
Journalist
Soss Melik, 1914-
Charcoal on paper, 58.1 x 47.3 cm.
(22⅞ x 18⅝ in.), 1933
NPG.68.23

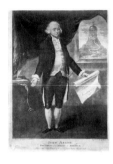

Adams, John, 1735-1826
Second President of the United States
George Graham, active c. 1796-c.
1813
Mezzotint, 44.1 x 33.5 cm. (17⁵⁄₁₆ x
13³⁄₁₆ in.), c. 1798
NPG.84.164

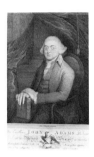

Adams, John, 1735-1826
Second President of the United States
H. H. Houston, active 1796-1798,
after William Joseph Williams
Stipple engraving, 28.4 x 22 cm.
(11³⁄₁₆ x 8⅝ in.), c. 1797
NPG.77.65

Adams, John, 1735-1826
Second President of the United States
James Barton Longacre, 1794-1869,
after Bass Otis, after Gilbert Stuart
Ink on paper, 24.9 x 16.8 cm. (9¹³⁄₁₆ x
6⅝ in.), c. 1825
NPG.77.298

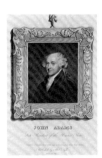

Adams, John, 1735-1826
Second President of the United States
James Barton Longacre, 1794-1869,
after Bass Otis, after Gilbert Stuart
Stipple engraving, 15.5 x 12 cm. (6 x
4¾ in.), 1827
Published in *Casket*, January 1827
NPG.79.236

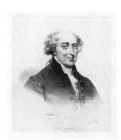

Adams, John, 1735-1826
Second President of the United States
Jean-Baptiste Mauzaisse, 1784-1844,
after Gilbert Stuart
Charles Etiénne Pierre Motte,
lithographer
Lithograph, 29.8 x 25.7 cm. (11¹¹⁄₁₆ x
10⅛ in.), 1827
NPG.85.164

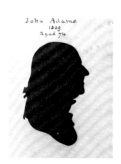

Adams, John, 1735-1826
Second President of the United States
Attributed to Raphaelle Peale,
 1774-1825
Silhouette on paper, 10.7 x 8.8 cm.
 (4⁷⁄₁₆ x 3⁷⁄₁₆ in.), c. 1804
NPG.78.283

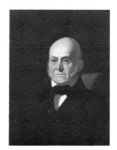

Adams, John Quincy, 1767-1848
Sixth President of the United States
George Caleb Bingham, 1811-1879
Oil on canvas, 76.2 x 63.5 cm. (30 x
 25 in.), c. 1844
NPG.69.20

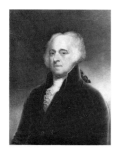

Adams, John, 1735-1826
Second President of the United States
Believed to have been begun in 1798
 by Gilbert Stuart, 1755-1828, and
 finished after 1828 by Jane Stuart,
 1812-1888
Oil on canvas, 76.2 x 61 cm. (30 x
 24 in.)
NPG.71.4

Adams, John Quincy, 1767-1848
Sixth President of the United States
Bishop and Gray studio, active 1843
Daguerreotype, 8.3 x 7 cm. (3¼ x
 2¾ in.), 1843
NPG.70.78
*Gift of John D. Duncan and an
 anonymous donor*

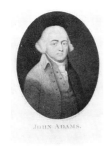

Adams, John, 1735-1826
Second President of the United States
Cornelius Tiebout, c. 1773-1832,
 after William Joseph Williams
Stipple engraving, 21.9 x 17.2 cm.
 (8⅝ x 6¾ in.), c. 1800
NPG.72.9

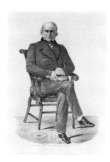

Adams, John Quincy, 1767-1848
Sixth President of the United States
Benjamin F. Butler, active 1841-1859,
 after Philip Haas
Hand-colored lithograph with
 tintstone, 38.1 x 27.5 cm. (15 x
 10¹³⁄₁₆ in.), 1848
NPG.80.60

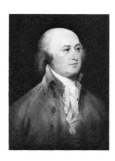

Adams, John, 1735-1826
Second President of the United States
John Trumbull, 1756-1843
Oil on canvas, 65.1 x 54.6 cm. (25⅝ x
 21½ in.), 1793
NPG.75.52

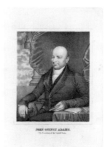

Adams, John Quincy, 1767-1848
Sixth President of the United States
Nathaniel Currier, 1813-1888, after
 Gilbert Stuart
Lithograph, 30.2 x 25.3 cm. (11⅞ x
 9¹⁵⁄₁₆ in.), 1840
Published in *The Eight Presidents of
 the United States of America,*
 Hartford, 1840
NPG.84.221.f

Adams, John, 1735-1826
Second President of the United States
Unidentified artist, after William
 Joseph Williams
Stipple engraving, 5.5 x 5.3 cm. (2³⁄₁₆
 x 2⅛ in.), c. 1820
NPG.79.7

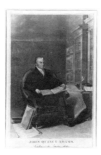

Adams, John Quincy, 1767-1848
Sixth President of the United States
Asher Brown Durand, 1796-1886,
 after Thomas Sully
Engraving, 51.3 x 35.1 cm. (20³⁄₁₆ x
 13¹³⁄₁₆ in.), 1826
NPG.69.88
Gift of Hirschl and Adler Galleries

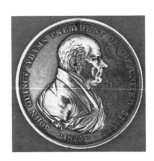

Adams, John Quincy, 1767-1848
Sixth President of the United States
Moritz Furst, 1782-?
Silver medal, 7.5 cm. (3 in.)
 diameter, 1825
NPG.69.79
Gift of Andrew Oliver

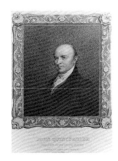

Adams, John Quincy, 1767-1848
Sixth President of the United States
James Barton Longacre, 1794-1869,
 after Gilbert Stuart
Stipple engraving, 17.8 x 15.6 cm.
 (7 x 6³⁄₁₆ in.), c. 1825-1826
NPG.79.241

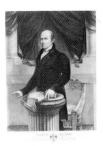

Adams, John Quincy, 1767-1848
Sixth President of the United States
Thomas Gimbrede, 1781-1832, after
 Gilbert Stuart and own life
 drawings
Stipple and line engraving, 38.4 x
 29.7 cm. (15⅝ x 11¹³⁄₁₆ in.), 1826
NPG.76.41

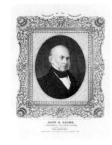

Adams, John Quincy, 1767-1848
Sixth President of the United States
Albert Newsam, 1809-1864, after
 Asher Brown Durand
P. S. Duval lithography company
Hand-colored lithograph, 26 x 22.9
 cm. (10¼ x 9 in.), 1846
NPG.84.1

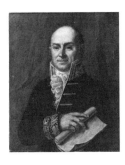

Adams, John Quincy, 1767-1848
Sixth President of the United States
Pieter van Huffel, 1769-1844
Oil on canvas, 63.5 x 52.5 cm. (25 x
 20¾ in.), 1815
NPG.70.12
*Transfer from the National Museum
 of American Art, the Adams-
 Clements Collection; gift of Miss
 Mary Louisa Adams Clement,
 1950*

Adams, John Quincy, 1767-1848
Sixth President of the United States
Attributed to Napoleon Sarony,
 1821-1896, after Arthur J.
 Stansbury
Sarony and Major lithography
 company
Nathaniel Currier, print seller
Lithograph with tintstone, 19.7 x 31
 cm. (7¾ x 12³⁄₁₆ in.), 1848
NPG.77.66

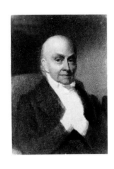

Adams, John Quincy, 1767-1848
Sixth President of the United States
Eastman Johnson, 1824-1906
Crayon on paper, 54.6 x 39.4 cm.
 (21½ x 15½ in.), 1846
NPG.74.55

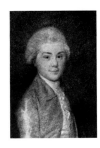

Adams, John Quincy, 1767-1848
Sixth President of the United States
Sidney Lawton Smith, 1845-1929,
 after Izaak Schmidt
Engraving and etching, 23.8 x 16.7
 cm. (9⅜ x 6⅝ in.), 1887
Published in *The Studio*, March 1887
NPG.72.6

Adams, John Quincy, 1767-1848
Sixth President of the United States
E. B. and E. C. Kellogg lithography
 company, active c. 1842-1867, after
 William Henry Brown
Lithographed silhouette, 34.1 x 25.2
 cm. (11⅞ X 9¹⁵⁄₁₆ in.), 1844-1845
Published in William H. Brown's
 *Portrait Gallery of Distinguished
 American Citizens,* Hartford, 1846
NPG.70.60

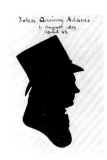

Adams, John Quincy, 1767-1848
Sixth President of the United States
Henry Williams, 1787-1830
Silhouette on paper, 10 x 7.5 cm.
 (3¹⁵⁄₁₆ x 2¹⁵⁄₁₆ in.), 1809
NPG.78.284

Adams, John Quincy, 1767-1848
Sixth President of the United States
Unidentified artist, after
 daguerreotype by John Plumbe, Jr.
Hand-colored lithograph, 33 x 26 cm.
 (13 x 10¼ in.), 1846
Contained in *The National
 Plumbeotype Gallery*,
 Philadelphia, 1847
NPG.78.84.h

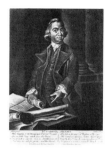

Adams, Samuel, 1722-1803
Revolutionary statesman
Samuel Okey, active 1765-1780, after
 J. Mitchell, after John Singleton
 Copley
Mezzotint, 31.6 x 24.9 cm. (12⁷⁄₁₆ x
 9¹³⁄₁₆ in.), 1775
NPG.76.9

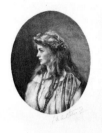

Adams, Maude, 1872-1953
Actress
Samuel Arlent Edwards, 1861-1938
Color mezzotint with watercolor
 on tissue, 13.4 x 10.6 cm. (5¼ x
 4³⁄₁₆ in.), 1904
NPG.83.247
Gift of S. Arlent Edwards, Jr.

Adams, Samuel, 1722-1803
Revolutionary statesman
Paul Revere, 1735-1818, after John
 Singleton Copley
Engraving, 10.5 x 9.4 cm. (4¼ x
 3¾ in.), 1774
Published in *The Royal American
 Magazine, or Universal Repository
 of Instruction and Amusement*,
 Boston, April 1774
NPG.80.108

Adams, Maude, 1872-1953
Actress
Rudulph Evans, 1878-1960
Bronze, 15.2 cm. (6 in.), not dated
NPG.81.102
Gift of Frank A. Vanderlip, Jr.

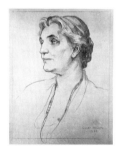

Addams, Jane, 1860-1935
Reformer
George deForest Brush, 1855-1941
Oil on canvas, 63.2 x 45.1 cm. (24⅞ x
 17¾ in.), c. 1920s
NPG.78.48
*Gallery purchase and gift of Mrs.
 Nancy Pierce York and Mrs. Grace
 Pierce Forbes*

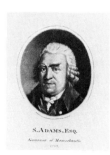

Adams, Maude, 1872-1953
Actress
Alfred J. Frueh, 1880-1968
Linocut, 29.2 x 8.5 cm. (11½ x
 3⁵⁄₁₆ in.), 1922
Published in Alfred J. Frueh's *Stage
 Folk*, New York, 1922
NPG.84.229.p

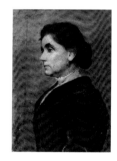

Addams, Jane, 1860-1935
Reformer
Violet Oakley, 1874-1961
Charcoal on paper, 77.5 x 61.5 cm.
 (30½ x 24¼ in.), 1934
NPG.83.13
*Gift of the Violet Oakley Memorial
 Foundation*

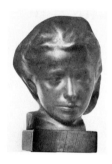

Adams, Samuel, 1722-1803
Revolutionary statesman
Attributed to George Graham, active
 c. 1796-c. 1813, after John Johnston
Mezzotint, 10 x 8.8 cm. (3¹⁵⁄₁₆ x
 3⁷⁄₁₆ in.), 1801
NPG.76.10

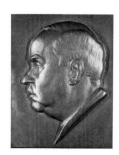

Adler, Alfred, 1870-1937
Psychologist
Slavko Bril, 1900-1943
Bronze mounted on wooden plaque,
 31.7 x 24.1 cm. (12½ x 9½ in.), 1932
NPG.85.7
Gift of Dr. Kurt A. Adler

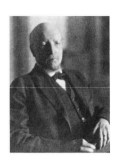

Adler, Felix, 1851-1933
Philosopher
Clara E. Sipprell, 1885-1975
Photograph, gelatin silver print, 20.2
　x 14.9 cm. (8 x 5⅞ in.), 1920
NPG.77.45

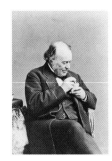

Agassiz, Jean Louis Rodolphe,
　1807-1873
Scientist
Carleton E. Watkins, 1829-1916
Photograph, albumen silver print,
　15 x 10.2 cm. (5⅞ x 4 in.), c. 1870
NPG.77.156

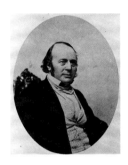

Agassiz, Jean Louis Rodolphe,
　1807-1873
Scientist
James Wallace Black, 1825-1896, and
　Perez M. Batchelder, ?-?; studio
　active 1860-1861
Photograph, albumen silver print,
　6.3 x 5 cm. (2½ x 1¹⁵⁄₁₆ in.), c. 1860
NPG.79.51

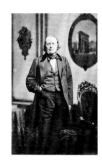

Agassiz, Jean Louis Rodolphe,
　1807-1873
Scientist
John Adams Whipple, 1822-1891
Photograph, albumen silver print,
　9.4 x 5.8 cm. (3¹¹⁄₁₆ x 2⁵⁄₁₆ in.),
　c. 1860
NPG.79.50

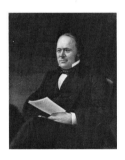

Agassiz, Jean Louis Rodolphe,
　1807-1873
Scientist
Walter Ingalls, 1805-1874
Oil on canvas, 91.7 x 76.5 cm. (36⅛ x
　30⅛ in.), c. 1870
NPG.66.28
*Transfer from the National Museum
　of American Art*

Agassiz, Jean Louis Rodolphe,
　1807-1873
Scientist
Unidentified photographer
Photograph, salt print, 15.5 x 12.2
　cm. (6⅛ x 4¹⁵⁄₁₆ in.), 1861
NPG.77.151

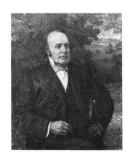

Agassiz, Jean Louis Rodolphe,
　1807-1873
Scientist
Louis Mayer, 1869-1969
Oil on canvas, 88.9 x 76.2 cm. (35 x
　30 in.), 1913
NPG.66.15
*Transfer from the National Museum
　of Natural History*

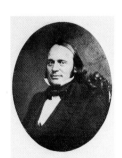

Agassiz, Jean Louis Rodolphe,
　1807-1873
Scientist
Unidentified photographer
Photograph, albumenized salt print,
　10.2 x 8 cm. (4¹⁄₁₆ x 3⅛ in.), c. 1857
NPG.80.239

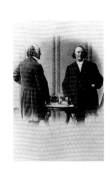

Agassiz, Jean Louis Rodolphe,
　1807-1873
Scientist
Antoine Sonrel, ?-1879
Photograph, albumen silver print,
　9 x 5.3 cm. (3½ x 2⅛ in.), c. 1863
NPG.79.52

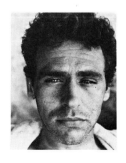

Agee, James, 1909-1955
Author
Walker Evans, 1903-1975
Photograph, gelatin silver print, 22.1
　x 17.4 cm. (8¹¹⁄₁₆ x 6¹³⁄₁₆ in.), 1974
　from 1937 negative
NPG.76.65

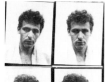

Agee, James, 1909-1955
Author
Walker Evans, 1903-1975
Photograph, gelatin silver print, 25.4
 x 20.1 cm. (10 x 7¹⁵/₁₆ in.), 1937
NPG.84.263

Aldridge, Ira Frederick (as Othello),
 c. 1805-1867
Actor
Henry Perronet Briggs, 1791/93-1844
Oil on canvas, 121.9 x 101.6 cm. (48 x
 40 in.), c. 1830
NPG.72.73

Albright, Ivan Le Lorraine*,
 1897-1983
Artist
Self-portrait
Lithograph, 36.1 x 25.9 cm. (14³/₁₆ x
 10³/₁₆ in.), c. 1947
T/NPG.72.103.93

Alexander, John White, 1856-1916
Artist
Arthur G. Learned, 1872-1959
Etching and drypoint, 18.5 x 12.9 cm.
 (7⁵/₁₆ x 5¹/₁₆ in.), c. 1905-1910
NPG.83.187

Albright, Ivan Le Lorraine*,
 1897-1983
Artist
Gordon Coster, 1906-
Photograph, gelatin silver print, 33.8
 x 26.7 cm. (13¹⁵/₁₆ x 10½ in.), 1941
T/NPG.83.126.93

Allen, Fred, 1894-1956
Humorist
Philippe Halsman, 1906-1979
Photograph, gelatin silver print, 34.9
 x 27.5 cm. (13¾ x 10¹³/₁₆ in.), 1950
NPG.83.70
Gift of George R. Rinhart

Alcott, Louisa May, 1832-1888
Author
Frank Edwin Elwell, 1858-1922
Bronze, 73.3 cm. (28⅞ in.), cast after
 1891 plaster
NPG.68.5
*Gift in memory of Alcott Farrar
 Elwell (1886-1962) by his wife,
 Helen Chaffee Elwell*

Allen, Richard, 1760-1831
Clergyman
P. S. Duval lithography company,
 active 1837-1869, after
 unidentified artist
Lithograph, 12.7 x 10.5 cm. (5 x
 4¼ in.), c. 1840
NPG.79.93

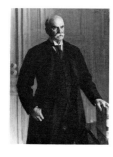

Aldrich, Nelson Wilmarth,
 1841-1915
Statesman
Anders Zorn, 1860-1920
Oil on canvas, 130.8 x 97.7 cm. (51½
 x 38½ in.), 1913
NPG.69.85
*Gift of Stephanie Edgell in memory
 of Elsie Aldrich Campbell*

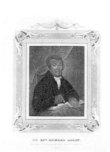

Allen, Richard, 1760-1831
Clergyman
Unidentified artist
Stipple engraving, 20.5 x 15.9 cm.
 (8¹/₁₆ x 6¼ in.), c. 1831
NPG.85.52

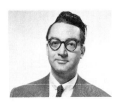

Allen, Stephen Valentine Patrick William*, 1921-
Entertainer
Philippe Halsman, 1906-1979
Photograph, gelatin silver print, 27.4 x 29.8 cm. (10¾ x 11¹¹⁄₁₆ in.), 1954
T/NPG.83.71
Gift of George R. Rinhart

Allston, Washington, 1779-1843
Artist
Paul Peter Duggan, ?-1861
Bronze, 6.3 cm. (2½ in.) diameter, 1847
NPG.84.76
Gift of Colonel Merl M. Moore

Allston, Washington, 1779-1843
Artist
David Claypoole Johnston, 1799-1865, after Shobal Vail Clevenger
Stipple and line engraving, 16.2 x 13 cm. (6⅜ x 5³⁄₁₆ in.), 1843
Published in *The New Mirror*, vol. 2, no. 2, New York, October 14, 1843
NPG.80.112

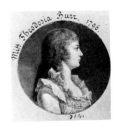

Alston, Theodosia Burr, 1783-1813
Daughter of Aaron Burr
Charles Balthazar Julien Févret de Saint-Mémin, 1770-1852
Engraving, 5.6 cm. (2¼ in.) diameter, 1796
NPG.74.39.714
Gift of Mr. and Mrs. Paul Mellon

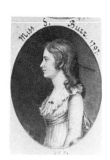

Alston, Theodosia Burr, 1783-1813
Daughter of Aaron Burr
Charles Balthazar Julien Févret de Saint-Mémin, 1770-1852
Engraving, 7.3 x 5.9 cm. (2⅞ x 2⁵⁄₁₆ in.) oval, 1797
NPG.74.39.757
Gift of Mr. and Mrs. Paul Mellon

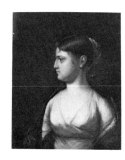

Alston, Theodosia Burr, 1783-1813
Daughter of Aaron Burr
Unidentified artist, after John Vanderlyn
Oil on canvas, 68.2 x 55.8 cm. (26⅞ x 22 in.), probably late nineteenth century
NPG.76.29

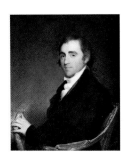

Ames, Fisher, 1758-1808
Statesman
Gilbert Stuart, 1755-1828
Oil on canvas, 76.2 x 63.5 cm. (30 x 25 in.), c. 1807
NPG.79.215
Gift of George Cabot Lodge

Anderson, Herbert Lawrence*, 1914-
Scientist
Peter Strongwater, 1941-
Photograph, gelatin silver print, 35.8 x 35.8 cm. (14⅛ x 14⅛ in.), 1982
T/NPG.84.240
Gift of Christopher Murray

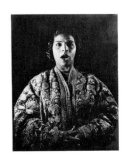

Anderson, Marian*, 1902-
Singer
Philippe Halsman, 1906-1979
Photograph, gelatin silver print, 34.7 x 27.3 cm. (13¹¹⁄₁₆ x 10¾ in.), 1945
T/NPG.83.72
Gift of George R. Rinhart

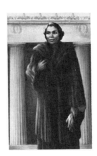

Anderson, Marian*, 1902-
Singer
Betsy Graves Reyneau, 1888-1964
Oil on canvas, 152.3 x 96.5 cm. (60 x 38 in.), 1955
T/NPG.67.76
Gift of the Harmon Foundation

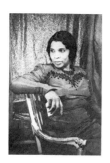

Anderson, Marian*, 1902-
Singer
Carl Van Vechten, 1880-1964
Photogravure, 22.2 x 14.8 cm. (8¾ x
 5⅞ in.), 1983 from 1947 negative
T/NPG.83.188.2

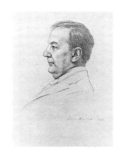

Anderson, Sherwood, 1876-1941
Author
Soss Melik, 1914-
Charcoal on paper, 59.2 x 44.4 cm.
 (23½ x 17½ in.), 1938
NPG.74.26

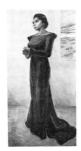

Anderson, Marian*, 1902-
Singer
Laura Wheeler Waring, 1887-1948
Oil on canvas, 193.3 x 101.6 cm.
 (76⅛ x 40 in.), 1944
T/NPG.67.29
Gift of the Harmon Foundation

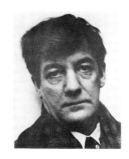

Anderson, Sherwood, 1876-1941
Author
Alfred Stieglitz, 1864-1946
Photograph, gelatin silver print, 22.9
 x 18.4 cm. (9 x 7¼ in.), 1923
NPG.83.189

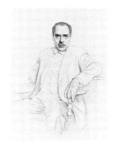

Anderson, Maxwell, 1888-1959
Playwright
Soss Melik, 1914-
Charcoal and pencil on paper, 63.5 x
 48.3 cm. (25 x 19 in.), 1945
NPG.74.25

Andrew, John Albion, 1818-1867
Statesman
Bobbett and Hooper wood-engraving
 company, active 1855-1870, after
 Henry Louis Stephens
Wood engraving, 26.7 x 20 cm. (10½
 x 7⅞ in.), 1862
Published in *Vanity Fair*, New York,
 February 15, 1862
NPG.85.61

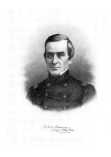

Anderson, Robert, 1805-1871
Union soldier
William G. Jackman, active
 1841-1863, after daguerreotype
Engraving, 21.4 x 19.1 cm. (8⁷⁄₁₆ x
 7½ in.), 1861
NPG.82.39

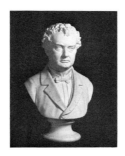

Andrew, John Albion, 1818-1867
Statesman
Jones, McDuffie and Stratton, active
 1872-1900, after Martin Milmore
Parian ware, 25.5 cm. (10⅛ in.), not
 dated
NPG.76.38

Anderson, Sherwood, 1876-1941
Author
Imogen Cunningham, 1883-1976
Photograph, gelatin silver print, 23.9
 x 19.9 cm. (9⅜ x 7⁷⁄₁₆ in.), c. 1970
 from 1927 negative
NPG.81.9

Antheil, George, 1900-1959
Composer
Berenice Abbott, 1898-
Photograph, gelatin silver print, 24.1
 x 19.9 cm. (9½ x 7¹³⁄₁₆ in.), 1927
NPG.82.160

Antheil, George, 1900-1959
Composer
Aline Fruhauf, 1907-1978
India ink over pencil with opaque
 white on paper, 32.2 x 19.8 cm.
 (12⅝ x 7¹³⁄₁₆ in.), c. 1935
NPG.83.50
Gift of Erwin Vollmer

Arliss, George, 1868-1946
Actor
Alfred J. Frueh, 1880-1968
Linocut, 35.7 x 17 cm. (14 x 6¹¹⁄₁₆ in.),
 1922
Published in Alfred J. Frueh's *Stage
 Folk*, New York, 1922
NPG.84.229.b

Anthony, Susan Brownell, 1820-1906
Reformer
Theodore C. Marceau, 1868/69-1922
Photograph, gelatin silver print, 18.5
 x 12.4 cm. (7¼ x 4⅞ in.), 1898
NPG.77.255

Arliss, George, 1868-1946
Actor
Doris Ulmann, 1882-1934
Photograph, platinum print, 20.6 x
 15.8 cm. (8⅛ x 6¼ in.), 1919
NPG.85.22

Anthony, Susan Brownell, 1820-1906
Reformer
Unidentified artist, after Adelaide
 Johnson
Bronze, 59 cm. (23¼ in.), cast after
 1892 marble
NPG.72.116

Armour, Philip Danforth, 1832-1901
Businessman
Unidentified photographer
Photograph, gelatin silver print, 23.3
 x 16.3 cm. (9³⁄₁₆ x 6⅜ in.), c. 1895
NPG.78.178

Arbus, Diane, 1923-1971
Photographer
Stephen Frank, 1947-
Photograph, gelatin silver print, 16 x
 23.2 cm. (6⁵⁄₁₆ x 9³⁄₁₆ in.), 1970
NPG.85.41

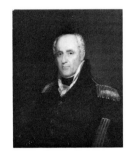

Armstrong, John, 1758-1843
Revolutionary general
Attributed to John Wesley Jarvis,
 1780-1840
Oil on panel, 76.2 x 61.9 cm. (30 x
 24⅜ in.), c. 1812
NPG.72.12

Arbus, Diane, 1923-1971
Photographer
Garry Winogrand, 1928-1984
Photograph, gelatin silver print, 31.2
 x 47.1 cm. (12⁵⁄₁₆ x 18½ in.), 1969
NPG.84.74

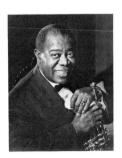

Armstrong, Louis, 1900-1971
Musician
David Lee Iwerks, 1933-
Photograph, gelatin silver print, 24.1
 x 19 cm. (9½ x 7½ in.), 1962
NPG.77.158

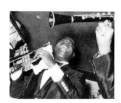

Armstrong, Louis, 1900-1971
Musician
Lisette Model, 1906-1983
Photograph, gelatin silver print, 26.7
x 34.8 cm. (10½ x 13¹¹⁄₁₆ in.),
c. 1950
NPG.82.138

Arthur, Chester Alan, 1830-1886
Twenty-first President of the United
States
Buek and Lindner lithography
company, active 1880s, after
unidentified artist
Lithograph with tintstone, 38.1 x
24.3 cm. (15 x 9⁷⁄₁₆ in.), 1881
Published in *The American Tailor*,
October 1881
NPG.78.91

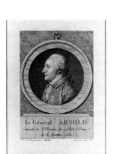

Arnold, Benedict, 1741-1801
Revolutionary general
Benoit Louis Prevost, 1735-1804, after
Pierre Eugène Du Simitière
Engraving, 16.2 x 11.8 cm. (6⅜ x
4⅝ in.), 1780
Published in *Collection des Portraits
des Généraux, Ministres, et
Magistrats . . .* , Paris, 1781
NPG.75.62

Arthur, Chester Alan, 1830-1886
Twenty-first President of the United
States
Rufus Anson, active 1851-1867
Daguerreotype, 8.1 x 6.8 cm. (3¼ x
2¾ in.), c. 1858
NPG.80.19

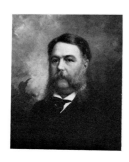

Arthur, Chester Alan, 1830-1886
Twenty-first President of the United
States
Ole Peter Hansen Balling, 1823-1906
Oil on canvas, 61.2 x 51.1 cm. (24⅛ x
20⅛ in.), 1881
NPG.67.62
Gift of Mrs. Harry Newton Blue

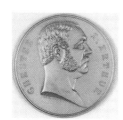

Arthur, Chester Alan, 1830-1886
Twenty-first President of the United
States
Charles E. Barber, 1842-1917
Bronze medal, 7.6 cm. (3 in.)
diameter, 1881
NPG.77.17

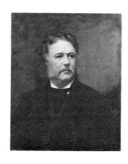

Arthur, Chester Alan, 1830-1886
Twenty-first President of the United
States
Napoleon Sarony, 1821-1896
Photograph, albumen silver print,
14.6 x 10.4 cm. (5¾ x 4⅛ in.), c.
1880
NPG.85.107
Gift of Robert L. Drapkin

Arthur, Chester Alan, 1830-1886
Twenty-first President of the United
States
Matthew Wilson, 1814-1892
Oil on canvas, 76.2 x 63.5 cm. (30 x
25 in.), 1883
NPG.68.37
*Transfer from the Harry S Truman
Library, Independence, Missouri*

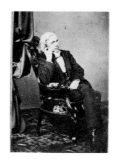

Arthur, Timothy Shay, 1809-1885
Editor, author
Unidentified photographer
Photograph, albumen silver print,
8.1 x 5.6 cm. (3³⁄₁₆ x 2³⁄₁₆ in.),
c. 1861
NPG.80.89

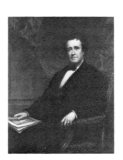

Aspinwall, William Henry,
1807-1875
Businessman
Daniel Huntington, 1816-1906
Oil on canvas, 127 x 101.6 cm. (50 x
40 in.), 1871
NPG.77.18

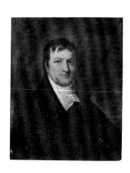

Astor, John Jacob, 1763-1848
Businessman
John Wesley Jarvis, 1789-1840
Oil on canvas, 76.2 x 61.5 cm. (30 x
 24¼ in.), c. 1825
NPG.78.204
Gift of Mrs. Susan Mary Alsop

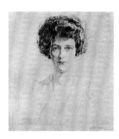

Astor, Nancy Witcher Langhorne,
 Viscountess, 1879-1964
American-born Member of
 Parliament
Walter Tittle, 1883-1968
Drypoint, 28.5 x 19.2 cm. (11¼ x
 7⁹⁄₁₆ in.), 1922
NPG.79.98

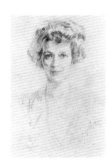

Astor, Nancy Witcher Langhorne,
 Viscountess, 1879-1964
American-born Member of
 Parliament
Walter Tittle, 1883-1968
Pencil on paper, 38.2 x 28 cm. (15¹⁄₁₆
 x 11 in.), 1922
NPG.79.99

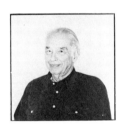

Atanasoff, John Vincent*, 1903-
Scientist
Peter Strongwater, 1941-
Photograph, gelatin silver print, 34.8
 x 34.8 cm. (13¹¹⁄₁₆ x 13¹¹⁄₁₆ in.),
 1983
T/NPG.84.237
Gift of Christopher Murray

Atkinson, Brooks*, 1894-1984
Drama critic
Aline Fruhauf, 1907-1978
India ink and watercolor over pencil
 on paper, 27.4 x 23.4 cm. (10¾ x
 9³⁄₁₆ in.), 1929
Published in *Theatre Magazine,*
 New York, February 1929
T/NPG.83.51.94
Gift of of Erwin Vollmer

Atkinson, Brooks*, 1894-1984
Drama critic
Aline Fruhauf, 1907-1978
Lithograph, 21.2 x 14.9 cm. (8⁵⁄₁₆ x
 5⅞ in.), 1931
T/NPG.83.52.94
Gift of Erwin Vollmer

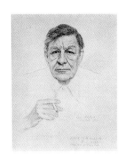

Auden, Wystan Hugh, 1907-1973
Poet
Soss Melik, 1914-
Charcoal on paper, 62.2 x 48.1 cm.
 (24½ x 19 in.), 1972
NPG.80.2

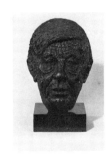

Auden, Wystan Hugh, 1907-1973
Poet
Michael Werner, 1912-
Bronze, 40 cm. (15¾ in.), completed
 1974
NPG.74.50

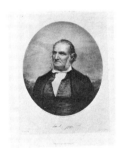

Audubon, John James, 1785-1851
Artist, naturalist
Francis D'Avignon, c. 1814-?, after
 daguerreotype by Mathew Brady
Lithograph, 28 x 24.3 cm. (11 x
 9⁹⁄₁₆ in.), 1850
Published in Mathew Brady's
 Gallery of Illustrious Americans,
 New York, 1850
NPG.69.65

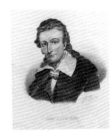

Audubon, John James, 1785-1851
Artist, naturalist
Jules Lion, 1810-1866, after Frederick
 Cruikshank
Lithograph, 15.5 x 16 cm. (6⅛ x
 6⁵⁄₁₆ in.), 1860
NPG.78.208

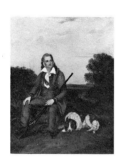

Audubon, John James, 1785-1851
Artist, naturalist
Unidentified artist, after John
 Woodhouse Audubon
Oil on canvas, 71.1 x 55.8 cm. (28 x
 22 in.), c. 1841
NPG.65.67
*Transfer from the National Gallery
 of Art; gift of the Avalon
 Foundation through the generosity
 of Ailsa Mellon Bruce, 1951*

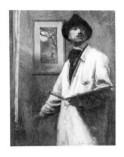

Auerbach-Levy, William, 1889-1962
Artist
Self-portrait
Oil on canvas, 115.5 x 88.9 cm. (45½
 x 35 in.), 1912
NPG.68.60
Gift of Max D. Levy

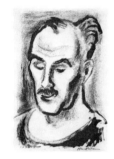

Avery, Milton, 1893-1965
Artist
Herb Kruckman, 1904-
Ink and crayon on paper,
 45.3 x 30.2 cm. (17 13/16 x 11⅞ in.),
 c. 1942
NPG.82.122
Gift of Herb Kruckman

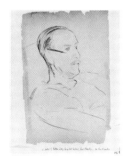

Avery, Milton, 1893-1965
Artist
Louis Wiesenberg, c. 1890-c.1945
Charcoal on paper, 45.2 x 30.1 cm.
 (17 13/16 x 11⅞ in.), c. 1940-1945
NPG.80.250

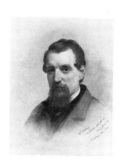

Avery, Samuel Putnam, 1822-1904
Art connoisseur
Charles Loring Elliott, 1812-1868
Oil on canvas, 76.2 x 63.5 cm. (30 x
 25 in.), 1863
NPG.72.88
Gift of Mrs. C. Telford Erickson

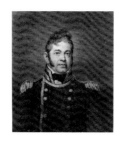

Bainbridge, William, 1774-1833
Early national naval officer
Asher Brown Durand, 1796-1886,
 after John Wesley Jarvis
Line engraving, 22.3 x 19.2 cm. (8¾
 x 7 9/16 in.), c. 1817
NPG.79.4

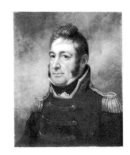

Bainbridge, William, 1774-1833
Early national naval officer
Rembrandt Peale, 1778-1860
Oil on canvas, 60.3 x 48.2 cm. (23¾ x
 19 in.), c. 1814
NPG.79.172

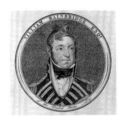

Bainbridge, William, 1774-1833
Early national naval officer
Unidentified artist, after John
 Wesley Jarvis
Stipple and line engraving, 8.1 cm.
 (3 3/16 in.) diameter, c. 1817-1822
NPG.79.15

Baird, Spencer Fullerton, 1823-1887
Scientist
Unidentified photographer
Photograph, albumen silver print,
 14.6 x 7.3 cm. (5¾ x 2⅞ in.), c.
 1880
NPG.77.194

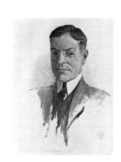

Baker, Newton Diehl, 1871-1937
Statesman
Joseph Cummings Chase, 1878-1965
Oil on academy board, 61.5 x 47 cm.
 (24½ x 18½ in.), c. 1918
NPG.73.43
Gift of Mendel Peterson

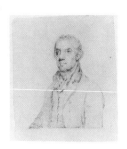

Baldwin, Abraham, 1754-1807
Statesman
Robert Fulton, 1765-1815
Pencil on paper, 17 x 14.1 cm. (6¹¹⁄₁₆
x 5⁹⁄₁₆ in.), not dated
NPG.77.304

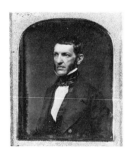

Bancroft, George, 1800-1891
Historian
John Plumbe, Jr., 1809-1857
Daguerreotype, 10.7 x 9.3 cm. (4³⁄₁₆ x
3¹¹⁄₁₆ in.), c. 1844
NPG.77.46

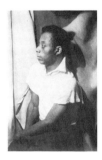

Baldwin, James*, 1924-
Author
Carl Van Vechten, 1880-1964
Photogravure, 22.1 x 14.8 cm. (8¾ x
5⅞ in.), 1983 from 1955 negative
T/NPG.83.188.3

Bancroft, George, 1800-1891
Historian
Unidentified artist, after
daguerreotype by John Plumbe, Jr.
Hand-colored lithograph, 33 x 26 cm.
(13 x 10¼ in.), 1846
Contained in *The National
Plumbeotype Gallery,*
Philadelphia, 1847
NPG.78.84.1

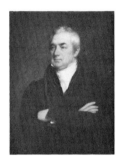

Baldwin, Loammi, 1780-1838
Engineer
Chester Harding, 1792-1866
Oil on canvas mounted on
aluminum, 90.8 x 70.5 cm. (35¾ x
27¾ in.), 1823
NPG.85.6

Bankhead, Tallulah Brockman,
1902-1968
Actress
Augustus John, 1878-1961
Oil on canvas, 121.9 x 62.2 cm. (48 x 24½
in.), 1930
NPG.69.46
*Gift of the Hon. and Mrs. John Hay
Whitney*

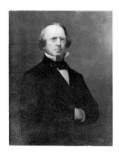

Baldwin, Roger Sherman, 1793-1863
Abolitionist
Charles Noel Flagg, 1848-1916
Oil on canvas, 90.4 x 73.7 cm. (36 x
29 in.), 1874
NPG.72.101
Gift of Bradley B. Gilman

Bankhead, William Brockman,
1874-1940
Statesman
Samuel Johnson Woolf, 1880-1948
Charcoal and white chalk on paper,
65 x 50 cm. (25⁹⁄₁₆ x 19⅝ in.), 1937
NPG.80.251

Bancroft, George, 1800-1891
Historian
John Jabez Edwin Mayall, 1810-1901
Daguerreotype, tinted, 13.9 x 10.9
cm. (5½ x 4¼ in.), c. 1847
NPG.79.214
*Gift of Dr. and Mrs. Lester Tuchman
and Gallery purchase*

Bannister, Edward M., 1833-1901
Artist
Gustine L. Hurd, active 1862-post
1901
Photograph, albumen silver print,
14.5 x 10.2 cm. (5¾ x 4 in.), c. 1875
NPG.76.66
Gift of Dr. and Mrs. Jacob Terner

Banvard, John, 1815-1891
Artist
Charles Baugniet, 1814-1886
M. and N. Hanhart lithography
company
Hand-colored lithograph with
tintstone, 48.8 x 37.2 cm. (19³⁄₁₆ x
14⅝ in.), 1849
NPG.83.178

Barlow, Joel, 1754-1812
Poet
William Dunlap, 1766-1839
Watercolor on ivory, 7.6 x 6.3 cm. (3
x 2½ in.), c. 1805-1811
NPG.76.30
Gift of Joel Barlow, descendant

Bard, John, 1716-1799
Physician
David Claypoole Johnston,
1799-1865, probably after James
Sharples
Pendleton lithography company
Lithograph, 8.6 x 7.5 cm. (3⅜ x 2¹⁵⁄₁₆
in.), 1828
Published in James Thacher's
American Medical Biography,
Boston, 1828
NPG.78.136

Barlow, Joel, 1754-1812
Poet
Robert Fulton, 1765-1815
Oil on panel, 38.7 x 32.3 cm. (15¼ x
12¾ in.), 1805
NPG.83.249

Barkley, Alben William, 1877-1956
Vice-President of the United States
Philippe Halsman, 1906-1979
Photograph, gelatin silver print, 29.4
x 27.4 cm. (11⁹⁄₁₆ x 10¹³⁄₁₆ in.), 1953
NPG.82.177
Gift of George R. Rinhart

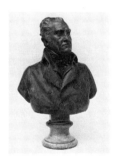

Barlow, Joel, 1754-1812
Poet
Jean-Antoine Houdon, 1741-1828
Plaster, 69.5 cm. (27⅜ in.), 1803
NPG.73.17
*Transfer from the National Museum
of American Art*

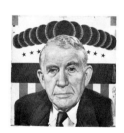

Barkley, Alben William, 1877-1956
Vice-President of the United States
Guy Rowe ("Giro"), 1894-1969
Tempera and crayon on acetate, 25.3
x 25.3 cm. (10 x 10 in.), c. 1948
NPG.83.27
Gift of Charles Rowe

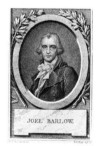

Barlow, Joel, 1754-1812
Poet
Louis Charles Ruotte, 1754-1806,
after Jean Jacques François
Lebarbier
Stipple engraving, 14.7 x 9.5 cm.
(5¹³⁄₁₆ x 3¾ in.), 1793
NPG.76.42
Gift of Joel Barlow, descendant

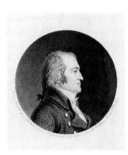

Barlow, Joel, 1754-1812
Poet
Gilles-Louis Chrétien, 1754-1811,
after Jean-Simon Fournier
Engraving, 5.9 cm. (2⁵⁄₁₆ in.)
diameter, c. 1793
NPG.71.54

Barlow, Joel, 1754-1812
Poet
Elkanah Tisdale, 1771-?
Engraving printed on leather, 9.5 x
7.7 cm. (3¾ x 3 in.), 1793
Contained in Joel Barlow's *The
Vision of Columbus*, Paris, 1793
NPG.80.120.b

Barlow, Joel, 1754-1812
Poet
John Vanderlyn, 1775-1852
Charcoal and pencil on paper, 20 x
 15.2 cm. (7⅞ x 6 in.), 1798
NPG.76.31
Gift of Joel Barlow, descendant

Barnes, Djuna*, 1892-1982
Author
Berenice Abbott, 1898-
Photograph, gelatin silver print, 24.3
 x 19.4 cm. (9⁹⁄₁₆ x 7⅝ in.), 1926
T/NPG.82.161.92

Barnum, Phineas Taylor, 1810-1891
Showman
Thomas Ball, 1819-1911
Plaster, bronzed, 65.5 cm. (25¾ in.),
 1883
Bronze, 76.5 cm. (30⅛ in.), cast after
 1883 plaster
NPG.70.24 and NPG.70.24.1
 (illustrated)
*Plaster, a transfer from the National
 Museum of American Art; gift of
 P. T. Barnum, 1884*

Barnum, Phineas Taylor, 1810-1891
Showman
Bobbett and Hooper wood-engraving
 company, active 1855-1870, after
 Henry Louis Stephens
Wood engraving, 16 x 15 cm. (6⁵⁄₁₆ x
 5⅞ in.), 1862
Published in *Vanity Fair*, New York,
 September 13, 1862
NPG.78.227

Barnum, Phineas Taylor, 1810-1891
Showman
Vincent Brooks, Day and Son
 lithography company, active
 1867-c. 1905, after Sir Leslie Ward
 ("Spy")
Chromolithograph, 31.7 x 18.8 cm.
 (12½ x 7⅜ in.), 1889
Published in *Vanity Fair*, London,
 November 16, 1889
NPG.72.51

Barnum, Phineas Taylor, 1810-1891
Showman
Attributed to Max Rosenthal,
 1833-1918, after Henry Louis
 Stephens
Louis Rosenthal lithography
 company
Chromolithograph, 17.5 x 10.4 cm.
 (6⅞ x 4⅛ in.), 1851
Published in Henry L. Stephens's
 The Comic Natural History,
 Philadelphia, 1851
NPG.78.291

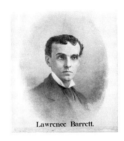

Barrett, Lawrence, 1838-1891
Actor
J. Howard Collier, ?-1900
Lithographic poster, 60 x 48.2 cm.
 (23⅝ x 19 in.), c. 1875-1880
NPG.83.185

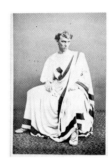

Barrett, Lawrence (as Cassius),
 1838-1891
Actor
Jeremiah Gurney, active 1840-c. 1890
Photograph, albumen silver print,
 9.1 x 6 cm. (3⁹⁄₁₆ x 2½ in.), 1871
NPG.80.190

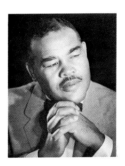

Barrow, Joe Louis*, 1914-1981
Athlete
David Lee Iwerks, 1933-
Photograph, gelatin silver print, 24.1
 x 19 cm. (9½ x 7½ in.), 1962
T/NPG.78.188.91

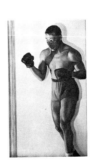

Barrow, Joe Louis*, 1914-1981
Athlete
Betsy Graves Reyneau, 1888-1964
Oil on canvas, 164.3 x 86.3 cm. (64¾
 x 34 in.), 1946
T/NPG.67.42.91
Gift of the Harmon Foundation

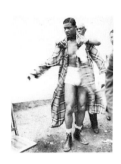

Barrow, Joe Louis*, 1914-1981
Athlete
Underwood and Underwood, active
 1882-c. 1950
Photograph, gelatin silver print, 24.9
 x 19.2 cm. (9¹³⁄₁₆ x 7⁹⁄₁₆ in.), c. 1935
T/NPG.80.326.91

Barrymore, Ethel, 1879-1959
Actress
Alfred J. Frueh, 1880-1968
Linocut, 21.6 x 9.7 cm. (8½ x 3¹³⁄₁₆
 in.), 1922
Published in Alfred J. Frueh's *Stage
 Folk*, New York, 1922
NPG.84.229.1

Barrow, Joe Louis*, 1914-1981
Athlete
Carl Van Vechten, 1880-1964
Photogravure, 22.3 x 14.8 cm. (8¹³⁄₁₆
 x 5⅞ in.), 1983 from 1941 negative
T/NPG.83.188.31

Barrymore, Ethel, 1879-1959
Actress
Paul César François Helleu,
 1859-1927
Drypoint, 34.5 x 32.9 cm. (13⁹⁄₁₆ x
 12¹⁵⁄₁₆ in.), c. 1910
NPG.84.222

Barrymore, Ethel, 1879-1959
Actress
Alfred Bendiner, 1899-1964
India ink over pencil on paper, 25.5
 x 33.7 cm. (10¹⁄₁₆ x 13¼ in.), 1944
NPG.85.207
Gift of Alfred Bendiner Foundation

Barrymore, John, 1882-1942
Actor
Self-portrait caricature
Pencil and watercolor on paper, 53.3
 x 38.1 cm. (21 x 15 in.), 1920
NPG.71.33

Barrymore, Ethel, 1879-1959
Actress
Mabel Conkling, 1871-1966?
Bronze relief, 19.6 x 17.3 cm. (7¾ x
 6⅝ in.), not dated
NPG.73.23
Gift of Mr. and Mrs. Louis Green

Barrymore, John, 1882-1942
Actor
Francis Brugière, 1879-1945
Photograph, gelatin silver print, 34.1
 x 27 cm. (13⁷⁄₁₆ x 10⅝ in.), 1923
NPG.77.306

Barrymore, Ethel, 1879-1959
Actress
Samuel Arlent Edwards, 1861-1938
Hand-colored mezzotint, 37.5 x 30.2
 cm. (14¾ x 11⅞ in.), 1901
NPG.83.244
Gift of S. Arlent Edwards, Jr.

Barrymore, John, 1882-1942
Actor
Clarence Sinclair Bull, 1895-1979
Photograph, gelatin silver print, 31 x
 23.5 cm. (12¼ x 9¼ in.), 1931
NPG.81.73

Barthé, Richmond*, 1901-
Artist
Betsy Graves Reyneau, 1888-1964
Oil on canvas, 158.8 x 87.6 cm. (62½
 x 34½ in.), 1946
T/NPG.67.77
Gift of the Harmon Foundation

Barton, Ralph, 1891-1931
Artist
Self-portrait
Watercolor and pencil on board, 37.4
 x 28.3 cm. (14¹¹⁄₁₆ x 11⅛ in.), c.
 1922
NPG.83.170

Bartholdi, Frédéric Auguste,
 1834-1904
Artist, sculptor of the Statue of
 Liberty
Benjamin J. Falk, 1853-1925
Photograph, albumen silver print,
 14.8 x 10.2 cm. (5¹³⁄₁₆ x 4 in.), 1876
NPG.80.205

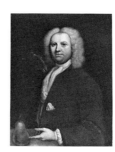

Bartram, John, 1699-1777
Scientist
Attributed to John Wollaston, c.
 1710-c. 1767
Oil on canvas, 90.2 x 69.8 cm. (35½ x
 27½ in.), c. 1758
NPG.66.9

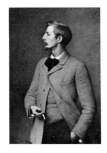

Bartlett, Paul Wayland, 1865-1925
Artist
Charles Sprague Pearce, 1851-1914
Oil on canvas, 108.6 x 76.2 cm. (42¾
 x 30 in.), c. 1890
NPG.65.20
*Transfer from the National Museum
 of American Art; gift of Mrs.
 Armistead Peter III, 1958*

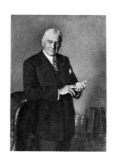

Baruch, Bernard Mannes, 1870-1965
Financier
Douglas Chandor, 1897-1953
Oil on canvas, 127 x 91.5 cm. (50 x
 36 in.), 1948
NPG.66.75
Gift of Bernard Mannes Baruch, 1960

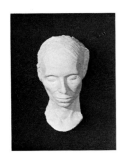

Barton, Clara, 1821-1912
Humanitarian
Ulric Stonewall Jackson Dunbar,
 1862-1927
Plaster death mask, 31 cm. (12¼ in.),
 1912
NPG.75.41
Gift of Anton A. Benson

Baruch, Bernard Mannes, 1870-1965
Financier
Joseph Cummings Chase, 1878-1965
Oil on academy board, 61.5 x 45.1 cm.
 (24⅛ x 17¾ in.), 1918
NPG.72.86
Gift of Mendel Peterson

Barton, Clara, 1821-1912
Humanitarian
Underwood and Underwood, active
 1882-c. 1950
Photograph, gelatin silver print, 7.7
 x 15.2 cm. (3 x 6 in.), c. 1904
NPG.81.83

Baruch, Bernard Mannes, 1870-1965
Financier
Jo Davidson, 1883-1952
Bronze, 63.5 cm. (25 in.), 1917
NPG.78.199
Gift of Dr. Maury Leibovitz

Baruch, Bernard Mannes, 1870-1965
Financier
Philippe Halsman, 1906-1979
Photograph, gelatin silver print, 34.9
 x 27.4 cm. (13¾ x 10¾ in.), 1960
NPG.83.73
Gift of George R. Rinhart

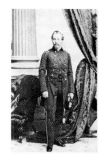

Beauregard, Pierre Gustave Toutant,
 1818-1893
Confederate general
Charles DeForest Fredricks,
 1823-1894
Photograph, albumen silver print,
 9 x 5.3 cm. (3½ x 2⅛ in.), 1862
NPG.80.301

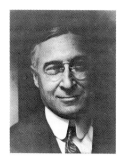

Baruch, Bernard Mannes, 1870-1965
Financier
Helen Warner Johns Kirtland, ?-?, or
 Lucien Swift Kirtland, 1881-1965
Photograph, gelatin silver print, 11.6
 x 8.9 cm. (4⁹⁄₁₆ x 3⁹⁄₁₆ in.), 1919
NPG.80.292

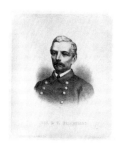

Beauregard, Pierre Gustave Toutant,
 1818-1893
Confederate general
J. L. Giles, active 1861-1881, after
 unidentified photograph
Lithograph with beige tintstone, 30.6
 x 25.3 cm. (12 x 9¹⁵⁄₁₆ in.), c. 1868
NPG.82.20

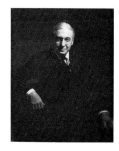

Baruch, Bernard Mannes, 1870-1965
Financier
Edward Steichen, 1879-1973
Photograph, gelatin silver print, 24.6
 x 19.8 cm. (9¹¹⁄₁₆ x 7¹³⁄₁₆ in.), 1932
NPG.82.82
Bequest of Edward Steichen

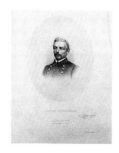

Beauregard, Pierre Gustave Toutant,
 1818-1893
Confederate general
Lemercier lithography company,
 active 1825-1889, after photograph
Lithograph, 10.8 x 9.7 cm. (4¼ x 3³⁄₁₆
 in.), 1864
NPG.84.358

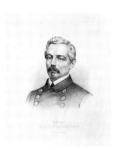

Bearden, Romare*, 1914-
Artist
Carl Van Vechten, 1880-1964
Photogravure, 22.1 x 14.8 cm. (8¾ x
 5¹³⁄₁₆ in.), 1983 from 1944 negative
T/NPG.83.188.4

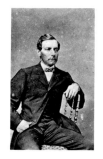

Beauregard, Pierre Gustave Toutant,
 1818-1893
Confederate general
Alphonse J. Liébert, 1827-1914
Photograph, albumen silver print,
 8.7 x 5.3 cm. (3⁷⁄₁₆ x 2⅛ in.), 1866
NPG.79.219

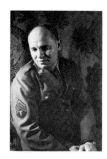

Beauregard, Pierre Gustave Toutant,
 1818-1893
Confederate general
Currier and Ives lithography
 company, active 1857-1907, after
 photograph
Lithograph, 25.9 x 23.8 cm. (10³⁄₁₆ x
 9⅜ in.), c. 1865
NPG.84.357

Beauregard, Pierre Gustave Toutant,
 1818-1893
Confederate general
Jules Lion, 1810-1866, after
 unidentified artist
Lithograph, 14 x 14.8 cm. (5½ x 5¹³⁄₁₆
 in.), 1861
Music sheet title page: "The
 Beauregard Manassas Quick Step"
NPG.78.222

Beauregard, Pierre Gustave Toutant,
 1818-1893
Confederate general
Jules Lion, 1810-1866, after
 photograph
P. P. Werlein and Halsey lithography
 company
Lithograph, 22 x 28 cm. (8⅝ x 11
 in.), c. 1861
NPG.84.359

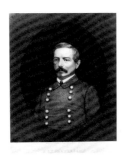

Beauregard, Pierre Gustave Toutant,
 1818-1893
Confederate general
William Sartain, 1843-1924, after
 photograph
Mezzotint, 27.8 x 24 cm. (10¹⁵⁄₁₆ x
 9⁷⁄₁₆ in.), c. 1866
NPG.79.26

Beauregard, Pierre Gustave Toutant,
 1818-1893
Confederate general
Edward Virginius Valentine,
 1838-1930
Bronze, 74.3 cm. (29¼ in.), cast after
 1867 plaster
NPG.78.36

Beaux, Cecilia, 1855-1942
Artist
Self-portrait
Oil on canvas, 45.7 x 35.5 cm. (18 x
 14 in.), c. 1880-1885
NPG.71.34

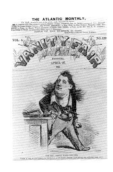

Beecher, Henry Ward, 1813-1887
Clergyman
Bobbett and Hooper wood-engraving
 company, active 1855-1870, after
 Henry Louis Stephens
Wood engraving, 15.5 x 15 cm. (6¼ x
 5⅞ in.), 1862
Published in *Vanity Fair*, New York,
 April 26, 1862
NPG.78.226

Beecher, Henry Ward, 1813-1887
Clergyman
John Chester Buttre, 1821-1893, after
 Augustus H. Morand and William
 Momberger
Engraving, 34.4 x 25.4 cm. (13⁹⁄₁₆ x
 10 in.), 1870
NPG.79.86

Beecher, Henry Ward, 1813-1887
Clergyman
George N. Rockwood, 1833-1911
Photograph, albumen silver print,
 14.7 x 10 cm. (5¹³⁄₁₆ x 4 in.), c. 1883
NPG.82.154
Gift of Paul Katz

Beecher, Henry Ward, 1813-1887
Clergyman
Napoleon Sarony, 1821-1896
Photograph, albumen silver print,
 30.5 x 18.5 cm. (12 x 7¼ in.),
 c. 1880
NPG.76.68

Beecher, Henry Ward, 1813-1887
Clergyman
Unidentified photographer
Photograph, albumen silver print,
 13.7 x 8.9 cm. (5⁷⁄₁₆ x 3½ in.),
 c. 1880
NPG.85.109
Gift of Robert L. Drapkin

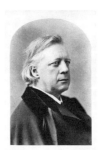

Beecher, Henry Ward, 1813-1887
Clergyman
Unidentified photographer
Photograph, albumen silver print,
 15.3 x 10.1 cm. (6¹⁄₁₆ x 4 in.),
 c. 1880
NPG.85.110
Gift of Robert L. Drapkin

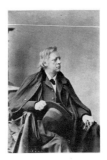

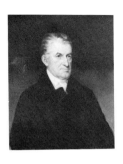

Beecher, Lyman, 1775-1863
Clergyman
James Henry Beard, 1812-1893
Oil on canvas, 76.2 x 63.5 cm. (30 x
 25 in.), 1842
NPG.75.5
Gift of Mrs. Fredson Bowers

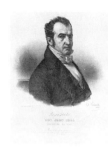

Bell, John, 1797-1869
Statesman
Charles Fenderich, 1805-1887
P. S. Duval lithography company
Lithograph, 25.7 x 26.9 cm. (10⅛ x
 10⁹⁄₁₆ in.), 1841
NPG.66.74
*Transfer from the Library of
 Congress, Prints and Photographs
 Division*

Behrman, Samuel Nathaniel,
 1893-1973
Playwright
Aline Fruhauf, 1907-1978
India ink over pencil with gray wash
 on paper, 38.2 x 28.7 cm. (15 x 11¼
 in.), 1929
Published in *Theatre Magazine,*
 New York, June 1929
NPG.83.53
Gift of Erwin Vollmer

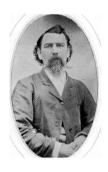

Bellamy, John Haley, 1836-1914
Artist
Unidentified photographer
Tintype, 9.3 x 6.2 cm. (3⅝ x 2⁷⁄₁₆ in.),
 c. 1885
NPG.81.87

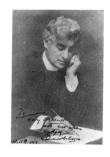

Belasco, David, 1853-1931
Impresario
The Misses Selby (Emily and Lilian),
 active 1899-?
Photograph, platinum print, 24.8 x
 17.4 cm. (9¾ x 6⅞ in.), not dated
NPG.77.139

Bellows, George Wesley, 1882-1925
Artist
Self-portrait
Conté crayon on paper, 30.7 x 20.4
 cm. (12¹⁄₁₆ x 8¹⁄₁₆ in.), c. 1917
NPG.83.160

Bell, Alexander Graham, 1847-1922
Inventor
Moses Wainer Dykaar, 1884-1933
Marble, 64.1 cm. (25¼ in.), 1922
NPG.69.22
*Transfer from the National Museum
 of American Art; gift of David F.
 Dykaar, 1929*

Bellows, George Wesley, 1882-1925
Artist
Self-portrait
Lithograph, 26.7 x 20 cm. (10½ x 7⅞
 in.), 1921
NPG.84.187

Bell, Alexander Graham, 1847-1922
Inventor
John Wycliffe Lowes Forster,
 1850-1938
Oil on canvas, 76.2 x 63.5 cm. (30 x
 25 in.), 1919
NPG.85.74
Gift of Gilbert Grosvenor Coville

Bellows, George Wesley, 1882-1925
Artist
Florence Vandamm, 1882/83-1966
Photograph, gelatin silver print, 23.7
 x 18.5 cm. (9⅜ x 7⁵⁄₁₆ in.), 1924
NPG.85.10

Belmont, August, 1816-1890
Financier
John Quincy Adams Ward,
 1830-1910
Bronze, 60.9 cm. (24 in.), 1892
NPG.78.211

Benton, Thomas Hart, 1782-1858
Statesman
Ferdinand Thomas Lee Boyle,
 1820-1906
Oil on canvas, 91.4 x 73.6 cm. (36 x
 29 in.), c. 1861
NPG.66.1

Benenson, Fira*, 1897/98-1977
Designer
Aline Fruhauf, 1907-1978
Watercolor and pencil with crayon
 and opaque white on paper, 30.2 x
 20 cm. (11⅞ x 7⅞ in.), 1942
T/NPG.83.272.87
Gift of Erwin Vollmer

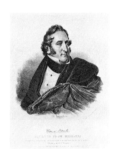

Benton, Thomas Hart, 1782-1858
Statesman
Charles Fenderich, 1805-1887
Lehman and Duval lithography
 company
Lithograph, 26.8 x 26.6 cm. (10⁹⁄₁₆ x
 10½ in.), 1837
NPG.77.274

Benét, Stephen Vincent, 1898-1943
Poet
Soss Melik, 1914-
Charcoal on paper, 62.2 x 41.9 cm.
 (24½ x 16½ in.), 1939
NPG.74.27

Benton, Thomas Hart, 1782-1858
Statesman
E. B. and E. C. Kellogg lithography
 company, active c. 1842-1867, after
 William Henry Brown
Lithographed silhouette, 34 x 25.3
 cm. (13⅜ x 10 in.), 1844
Published in William H. Brown's
 *Portrait Gallery of Distinguished
 American Citizens,* Hartford, 1845
NPG.75.45

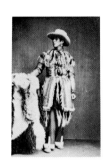

Bennett, Lewis ("Deerfoot"),
 1828-1897
Athlete
George Newbold, ?-?
Photograph, albumen silver print,
 8.9 x 5.7 cm. (3½ x 2¼ in.), c. 1862
NPG.80.203

Benton, Thomas Hart, 1889-1975
Artist
Harry Sternberg, 1904-
Serigraph, 47.2 x 31.2 cm. (18⅝ x
 12⅜ in.), 1944
NPG.80.221

Benson, John Howard, 1901-1956
Artist
John Robinson Frazier, 1889-1966
Oil on canvas, 91.7 x 77.1 in. (36⅛ x
 30⅜ in.), not dated
NPG.70.61
*Gallery purchase and gift of Mrs.
 John H. Benson, Mrs. John R.
 Frazier, and Mr. Robert Schoelkopf*

Berenson, Bernard, 1865-1959
Art historian
Walter Tittle, 1883-1968
Drypoint, 14.6 x 13.3 cm. (5¾ x 5¼
 in.), 1932
NPG.79.88

Berenson, Bernard, 1865-1959
Art historian
Miriam Troop, 1917-
Pencil on paper, 27.5 x 35.5 cm.
(10¹³⁄₁₆ x 14 in.), 1950
NPG.72.38

Berryman, John, 1914-1972
Poet
Louis Safer, ?-
Oil on canvas, 161.9 x 195 cm. (63¾
x 76¾ in.), 1973
NPG.81.1
Gift of Louis Safer

Berle, Milton*, 1908-
Entertainer
Alfred Bendiner, 1899-1964
India ink over pencil on paper, 26 x
24.9 cm. (10¼ x 9¹³⁄₁₆ in.), c. 1945
T/NPG.85.197
Gift of Alfred Bendiner Foundation

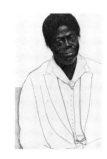

Bethune, Mary McLeod, 1875-1955
Educator
Winold Reiss, 1886-1953
Pastel on artist board, 75.9 x 54.8 cm.
(29⅞ x 21⁹⁄₁₆ in.), c. 1925
NPG.72.75
*Gift of Lawrence A. Fleischman and
Howard Garfinkle with a
matching grant from the National
Endowment for the Arts*

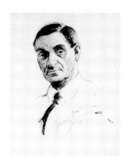

Berlin, Irving*, 1888-
Songwriter
Samuel Johnson Woolf, 1880-1948
Charcoal and white chalk on paper,
53.3 x 42 cm. (21 x 16½ in.), 1944
T/NPG.80.252

Bethune, Mary McLeod, 1875-1955
Educator
Betsy Graves Reyneau, 1888-1964
Oil on canvas, 114.3 x 88.9 cm. (45 x
35 in.), 1943-1944
NPG.67.78
Gift of the Harmon Foundation

Bernstein, Aline, 1880-1955
Stage and costume designer
Aline Fruhauf, 1907-1978
Watercolor and pencil with opaque
white and red chalk on paper, 22 x
20.2 cm. (8⅝ x 7¹⁵⁄₁₆ in.), 1943
NPG.83.54
Gift of Erwin Vollmer

Bethune, Mary McLeod, 1875-1955
Educator
Carl Van Vechten, 1880-1964
Photogravure, 22.5 x 15.1 cm. (8⅞ x
5¹⁵⁄₁₆ in.), 1983 from 1949 negative
NPG.83.188.5

Berryman, James T., 1902-1971
Cartoonist
Aline Fruhauf, 1907-1978
Watercolor and pencil with gouache
on paper, 36.9 x 25.3 cm. (14½ x 10
in.), c. 1949
NPG.83.55
Gift of Erwin Vollmer

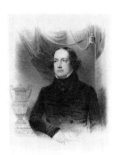

Biddle, Nicholas, 1786-1844
Financier
James Barton Longacre, 1794-1869
Watercolor on paper, 27.6 x 22.5 cm.
(10⅞ x 8⅞ in.), not dated
NPG.76.59

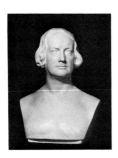

Biddle, Nicholas, 1786-1844
Financier
E. Luigi Persico, 1791-1860
Plaster, 54.2 cm. (21⅜ in.), 1837
NPG.71.32
*Transfer from the National Museum
 of American History; gift of
 Elizabeth Porter Fearing*

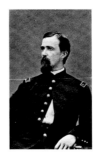

Billings, John Shaw, 1838-1913
Physician, librarian
Unidentified photographer
Photograph, albumen silver print,
 9.1 x 5 cm. (3⁹⁄₁₆ x 2 in.), c. 1862
NPG.77.191

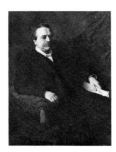

Bien, Julius, 1826-1909
Cartographer
George de Madura Peixotto,
 1858-1937
Oil on canvas, 132 x 101.6 cm. (52 x
 40 in.), 1886
NPG.77.159
*Transfer from the National Museum
 of American Art; gift of Julius
 Bien, Jr., through the Hon. Simon
 Wolf, 1920*

Bingham, George Caleb, 1811-1879
Artist
Self-portrait
Oil on copper, 7.6 x 6.3 cm. (3 x 2½
 in.), 1849/50
NPG.79.46

Bierstadt, Albert, 1830-1902
Artist
Napoleon Sarony, 1821-1896
Photograph, albumen silver print,
 9.1 x 6.1 cm. (3⁹⁄₁₆ x 2⅜ in.), c.
 1870
NPG.76.106

Black, Hugo LaFayette, 1886-1971
Justice of the United States Supreme
 Court
Oscar Berger, 1901-
Ink on paper, 41.9 x 35.7 cm. (16½ x
 14¹⁄₁₆ in.), c. 1968
NPG.69.11
Gift of the artist

Bigelow, John, 1817-1911
Editor, diplomat
Fedor Encke, 1851-?
Oil on canvas, 127 x 101.6 cm. (50 x
 40 in.), 1901
NPG.75.6
Gift of Mrs. Christopher Clarkson

Blaine, James Gillespie, 1830-1893
Statesman
David H. Anderson, active c. 1882-?
Photograph, albumen silver print,
 14.8 x 10 cm. (5¹³⁄₁₆ x 3¹⁵⁄₁₆ in.), c.
 1884
NPG.85.105
Gift of Robert L. Drapkin

Bigelow, John, 1817-1911
Editor, diplomat
Orlando Rouland, 1871-1945
Pencil on cardboard, heightened
 with chalk, 20.3 x 15.2 cm. (8 x 6
 in.), 1910
NPG.78.125

Blaine, James Gillespie, 1830-1893
Statesman
Buek and Lindner lithography
 company, active 1880s, after
 unidentified photographer
Lithograph with tintstone, 46.2 x
 33.5 cm. (18³⁄₁₆ x 13³⁄₁₆ in.), 1884
NPG.77.67

Blaine, James Gillespie, 1830-1893
Statesman
Thomas Nast, 1840-1902
India ink with pencil on board, 55.9
 x 44.3 cm. (22 x 17⁷⁄₁₆ in.), 1888
Illustration for *The Daily Graphic*,
 New York, September 26, 1888
NPG.83.168

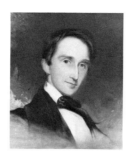

Blair, Montgomery, 1813-1883
Lawyer
Casimir Gregory Stapko, 1913-
 after the 1845 oil by Thomas Sully
Oil on canvas, 52 x 44.4 cm. (20½ x
 17½ in.), 1968
NPG.68.55
Gift of Dr. Montgomery Blair

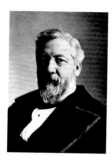

Blaine, James Gillespie, 1830-1893
Statesman
Napoleon Sarony, 1821-1896
Photograph, albumen silver print,
 14.4 x 10.3 cm. (5¹¹⁄₁₆ x 4¹⁄₁₆ in.),
 c. 1880
NPG.77.157

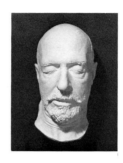

Blake, Francis, 1850-1913
Inventor
Unidentified artist
Plaster death mask, 31 cm. (12¼ in.),
 1913
NPG.69.59
Gift of Ruth Blake Oliver

Blaine, James Gillespie, 1830-1893
Statesman
Thomas Worth, 1834-1917
Lithograph, 33 x 29.4 cm. (13 x 11⁹⁄₁₆
 in.), 1884
NPG.84.199

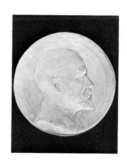

Blake, Francis, 1850-1913
Inventor
Unidentified artist
Plaster relief, 21.5 cm. (8½ in.), 1897
NPG.69.60
Gift of Ruth Blake Oliver

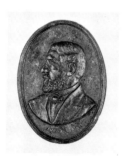

Blaine, James Gillespie, 1830-1893
Statesman
Unidentified artist
Cast metal relief, 14.3 x 10.5 cm. (5⅝
 x 4⅛ in.) oval, not dated
NPG.74.11

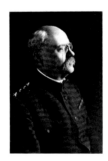

Bliss, Tasker Howard, 1853-1930
World War I general
Barnet M. Clinedinst, Jr., 1874-?
Photograph, gelatin silver print, 22.8
 x 15.3 cm. (9 x 6 in.), c. 1920
NPG.77.190

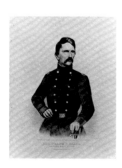

Blair, Francis Preston, 1821-1875
Union general
Currier and Ives lithography
 company, active 1857-1907, after
 unidentified artist
Lithograph, 30.5 x 24 cm. (12 x 9⁷⁄₁₆
 in.), 1861
NPG.78.117

Bliss, Tasker Howard, 1853-1930
World War I general
John Christen Johansen, 1876-1964
Oil on canvas, 76.2 x 76.2 cm. (30 x
 30 in.), 1919
NPG.65.88
*Transfer from the National Museum
 of American Art; gift of
 anonymous donor through Mrs.
 Elizabeth Rogerson, 1926*

**Block, Herbert Lawrence
("Herblock")***, 1909-
Cartoonist
Aline Fruhauf, 1907-1978
Watercolor, chalk, and pencil
 heightened with white on paper,
 50 x 35.9 cm. (19¹¹⁄₁₆ x 14⅛ in.), c.
 1949
T/NPG.83.67
Gift of Erwin Vollmer

Bonfanti, Maria (Marietta),
 1847-1921
Dancer
Jeremiah Gurney and Son, active
 c. 1860-c. 1875
Photograph, albumen silver print,
 9.3 x 5.4 cm. (3⅝ x 2⅛ in.), c. 1866
NPG.80.193

Bloodgood, Joseph Colt, 1867-1935
Physician
Doris Ulmann, 1882-1934
Photograph, platinum print, 20.7 x
 15.7 cm. (8⅛ x 6³⁄₁₆ in.), 1920
NPG.85.24

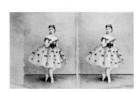

Bonfanti, Maria (Marietta),
 1847-1921
Dancer
Unidentified photographer
Photograph, albumen silver print,
 7.8 x 12 cm. (3¹⁄₁₆ x 4¹¹⁄₁₆ in.),
 c. 1868
NPG.80.81

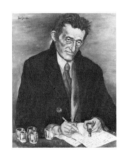

Bodenheim, Maxwell, 1893-1954
Author
Leonard DeGrange, 1890-1959
Oil on panel, 66 x 53.3 cm. (26 x 21
 in.), not dated
NPG.73.6
Gift of Mrs. Tom McClary

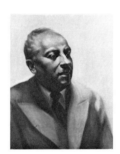

Bontemps, Arna, 1902-1973
Author
Betsy Graves Reyneau, 1888-1964
Oil on canvas, 69.8 x 52 cm. (27½ x
 20½ in.), 1953
NPG.67.79
Gift of the Harmon Foundation

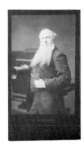

Bogardus, Abraham, 1822-1908
Photographer
Unidentified photographer
Photograph, albumen silver print,
 15.1 x 9.9 cm. (5¹⁵⁄₁₆ x 3⅞ in.),
 c. 1890
NPG.82.151

Bontemps, Arna, 1902-1973
Author
Carl Van Vechten, 1880-1964
Photogravure, 22.3 x 14.9 cm. (8¹³⁄₁₆
 x 5⅞ in.), 1983 from 1939 negative
NPG.83.188.6

Bogart, Humphrey, 1899-1957
Actor
Philippe Halsman, 1906-1979
Photograph, gelatin silver print, 11.3
 x 8.6 cm. (4⁷⁄₁₆ x 3⅜ in.), 1944
NPG.85.11

Boone, Daniel, 1734-1820
Frontiersman
Attributed to Albert Newsam,
 1809-1864, after J. W. Berry, after
 Chester Harding
Childs and Inman lithography
 company
Lithograph, 12.2 x 10.3 cm. (4¹³⁄₁₆ x
 4¹⁄₁₆ in.), c. 1832
NPG.78.235

Booth, Edwin Thomas, 1833-1893
Actor
Bobbett and Hooper wood-engraving
 company, active 1855-1870, after
 Henry Louis Stephens
Wood engraving, 15.5 x 13 cm. (6¼ x
 5⅛ in.), 1862
Published in *Vanity Fair*, New York,
 November 1, 1862
NPG.78.225

Booth, Edwin Thomas (as Iago),
 1833-1893
Actor
Thomas Hicks, 1823-1890
Oil on canvas, 80 x 54.6 cm. (31½ x
 21½ in.), 1863
NPG.70.62
*Transfer from the Cooper-Hewitt
 Museum; gift of Miss Charlotte
 Arnold, 1920*

Booth, Edwin Thomas, 1833-1893
Actor
Mathew Brady, 1823-1896, or his
 studio
Photograph, albumen silver print,
 8.4 x 5.5 cm. (3¼ x 2⅛ in.), c. 1862
NPG.78.289

Booth, Edwin Thomas, 1833-1893
Actor
George N. Rockwood, 1833-1911
Photograph, albumen silver print,
 14.9 x 10 cm. (5¹³⁄₁₆ x 3¹⁵⁄₁₆ in.), c.
 1880
NPG.80.65

Booth, Edwin Thomas, 1833-1893
Actor
Charles H. Crosby lithography
 company, active 1857-c. 1872, after
 Jeremiah Gurney and Son
Lithograph, 19.4 x 15.8 cm. (7⅝ x
 6³⁄₁₆ in.), c. 1872
NPG.82.7

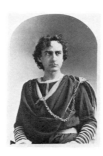

Booth, Edwin Thomas, 1833-1893
Actor
Napoleon Sarony, 1821-1896
Photograph, albumen silver print,
 14.7 x 10.4 cm. (5¹³⁄₁₆ x 4⅛ in.),
 c. 1870
NPG.77.136

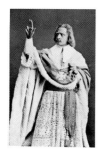

Booth, Edwin Thomas (as Richelieu),
 1833-1893
Actor
Jeremiah Gurney, active 1840-c. 1890
Photograph, albumen silver print,
 9.2 x 5.8 cm. (3⅝ x 2⁵⁄₁₆ in.), 1871
NPG.80.159

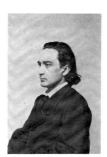

Booth, Edwin Thomas, 1833-1893
Actor
Unidentified photographer
Photograph, albumen silver print,
 8 x 5.5 cm. (3⅛ x 2¼ in.), c. 1862
NPG.79.148

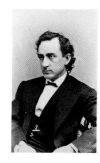

Booth, Edwin Thomas, 1833-1893
Actor
Jeremiah Gurney and Son, active c.
 1860-c. 1875
Photograph, albumen silver print,
 9.6 x 5.6 cm. (3¾ x 2¼ in.), c. 1870
NPG.78.303

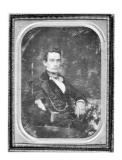

Booth, Edwin Thomas, 1833-1893
Actor
Unidentified photographer
Daguerreotype, 21.6 x 16.4 cm. (8½ x
 6⅜ in.), c. 1857
NPG.80.20

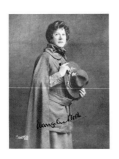

Booth, Evangeline Cory, 1865-1950
Social worker
Ira L. Hill studio, active 1901-?
Photograph, gelatin silver print, 24 x
18.6 cm. (9⁷⁄₁₆ x 7⁵⁄₁₆ in.), c. 1905
NPG.77.195

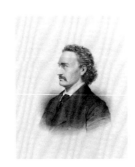

Booth, John Wilkes, 1838-1865
Actor, assassin
F. Sala lithography company, ?-?,
after unidentified artist
Lithograph, 17.4 x 15 cm. (6⅞ x 5⅞
in.), not dated
NPG.78.38

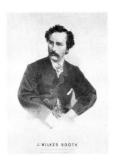

Booth, John Wilkes, 1838-1865
Actor, assassin
J. H. Bufford lithography company,
active 1835-1890, after photograph
by Charles DeForest Fredricks
Lithograph, 24.5 x 18.9 cm. (9⅝ x
7⁷⁄₁₆ in.), 1865
NPG.81.149

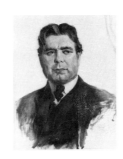

Borah, William Edgar, 1865-1940
Statesman
Joseph Cummings Chase, 1878-1965
Oil on artist board, 61 x 45.7 cm. (24
x 18 in.), 1918
NPG.70.63
Gift of Mendel Peterson

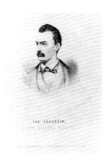

Booth, John Wilkes, 1838-1865
Actor, assassin
C. J. Culliford, ?-?, after photograph
Hand-tinted lithograph, 11.5 x 11
cm. (4½ x 4⁵⁄₁₆ in.), c. 1865
NPG.79.23

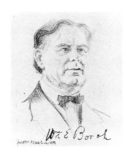

Borah, William Edgar, 1865-1940
Statesman
Joseph Margulies, 1896-
Crayon on paper, 26.3 x 22.1 cm.
(10⅜ x 8¹¹⁄₁₆ in.), 1929/30
NPG.70.49

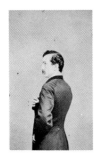

Booth, John Wilkes, 1838-1865
Actor, assassin
Charles DeForest Fredricks,
1823-1894
Photograph, albumen silver print,
9.2 x 5.6 cm. (3⅝ x 2³⁄₁₆ in.), c.
1863
NPG.80.161

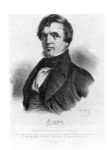

Botts, John Minor, 1802-1869
Southern unionist
Charles Fenderich, 1805-1887
P. S. Duval lithography company
Lithograph, 27.9 x 25.8 cm. (11 x
10³⁄₁₆ in.), 1841
NPG.66.98
*Transfer from the Library of
Congress, Prints and Photographs
Division*

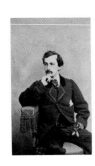

Booth, John Wilkes, 1838-1865
Actor, assassin
Charles DeForest Fredricks,
1823-1894
Photograph, albumen silver print,
9 x 5.4 cm. (3⁹⁄₁₆ x 2⅛ in.), c. 1862
NPG.80.214

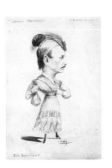

Boucicault, Dion, 1820-1890
Dramatist, actor
Attributed to George Goursat
("SEM"), 1836-1934
Crayon and watercolor on paper, 27
x 18.3 cm. (10⅝ x 7¼ in.), not
dated
NPG.83.204

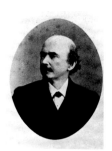

Boucicault, Dion, 1820-1890
Dramatist, actor
José Maria Mora, c. 1847-1926
Photograph, albumen silver print,
 10.8 x 9.2 cm. (4⅝ x 3⅝ in.), c.
 1870
NPG.79.44

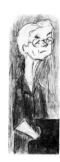

Boulanger, Nadia*, 1887-1979
Musician
Aline Fruhauf, 1907-1978
India ink, pencil, and gray wash
 with blue chalk and opaque white
 on paper mounted on tissue, 20.7
 x 8.7 cm. (8⅛ x 3⅜ in.), 1960
T/NPG.83.256.89
Gift of Erwin Vollmer

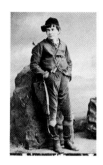

Boucicault, Dion, 1820-1890
Dramatist, actor
Attributed to José Maria Mora, c.
 1847-1926
Photograph, albumen silver print,
 13.6 x 8.8 cm. (5⅜ x 3½ in.),
 c. 1874
NPG.80.66

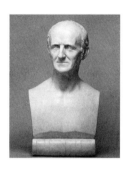

Bowditch, Nathaniel, 1773-1838
Astronomer, mathematician
Robert Ball Hughes, 1806-1868
Painted plaster, 67.3 cm. (26½ in.),
 c. 1838
NPG.84.75

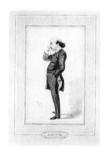

Boucicault, Dion, 1820-1890
Dramatist, actor
Sir Leslie Ward ("Spy"), 1851-1922
Watercolor on paper, 30.7 x 18.2 cm.
 (12⅛ x 7³⁄₁₆ in.), 1882
NPG.83.205

Bowen, Katherine Drinker,
 1897-1973
Author
Violet Oakley, 1874-1961
Charcoal and white chalk on paper,
 43.8 x 29.8 cm. (17¼ x 11¾ in.),
 not dated
NPG.83.20
*Gift of the Violet Oakley Memorial
 Foundation*

Boudinot, Elias, 1740-1821
Revolutionary statesman
Asher Brown Durand, 1796-1886,
 after Samuel Lovett Waldo and
 William Jewett
Engraving, 25.5 x 23.3 cm. (10 x 9³⁄₁₆
 in.), c. 1822-1825
NPG.77.68

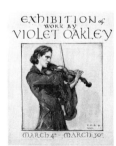

Bowen, Katherine Drinker,
 1897-1973
Author
Violet Oakley, 1874-1961
Charcoal, colored chalks, and india
 ink on paper, 46.2 x 35.4 cm. (18¼
 x 13¹⁵⁄₁₆ in.), not dated
NPG.83.21
*Gift of the Violet Oakley Memorial
 Foundation*

Boudinot, Elias, 1740-1821
Revolutionary statesman
Charles Balthazar Julien Févret de
 Saint-Mémin, 1770-1852
Engraving, 5.6 cm. (2¼ in.) diameter,
 1798
NPG.74.39.450
Gift of Mr. and Mrs. Paul Mellon

Bowles, Samuel, 1826-1878
Editor
Napoleon Sarony, 1821-1896
Photograph, albumen silver print,
 8.9 x 5.9 cm. (3½ x 2⁵⁄₁₆ in.),
 c. 1870
NPG.78.286

Bowles, William Augustus,
1763-1805
Adventurer
Joseph Grozer, c. 1755-1799, after
 Thomas Hardy
Mezzotint, 37.3 x 28.8 cm. (14¹¹⁄₁₆ x
 11⁵⁄₁₆ in.), 1791
NPG.72.52

Boyle, Kay*, 1903-
Author
Berenice Abbott, 1898-
Photograph, gelatin silver print, 23.9
 x 18.8 cm. (9⁷⁄₁₆ x 7⅜ in.), 1935
T/NPG.82.162

Bradley, Omar Nelson*, 1893-1981
World War II general
Guy Rowe ("Giro"), 1894-1969
Crayon on artist board, 21.6 x 19 cm.
 (8½ x 7½ in.), 1950
T/NPG.82.123.91
Gift of Charles Rowe

Bragg, Braxton, 1817-1876
Confederate general
Attributed to George Smith Cook,
 1819-1902
Photograph, albumen silver print,
 9.9 x 6.1 cm. (3⅞ x 2⅜ in.), c. 1863
NPG.77.192

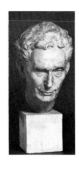

Brandeis, Louis Dembitz, 1865-1941
Jurist, justice of the United States
 Supreme Court
Eleanor Platt, 1910-1974
Plaster, 41.9 cm. (16½ in.), 1942
NPG.81.103
Gift of Mrs. Florence Schaffhausen

Breasted, James Henry, 1865-1935
Scientist
George W. Godfrey, 1818-1888
Photograph, gelatin silver print, 14 x
 9.8 cm. (5½ x 3⅞ in.), c. 1885
NPG.77.193

Brecht, Bertolt Eugen Friedrich,
1898-1956
Playwright, novelist
Grete Stern, 1904-
Photograph, gelatin silver print, 27.5
 x 17.5 cm. (10¹³⁄₁₆ x 6⅞ in.), c. 1935
NPG.85.94
*Gift of Barry Bingham, Sr., W. John
 Kenney, and Mrs. Katie
 Louchheim*

Breckinridge, John Cabell, 1821-1875
Statesman, Confederate general
N. Cozzadi, ?-?, after Mathew Brady
Lithograph, 34.3 x 33.1 cm. (13½ x
 13 in.), c. 1860
NPG.80.52

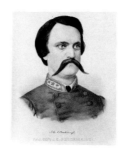

Breckinridge, John Cabell, 1821-1875
Statesman, Confederate general
Currier and Ives lithography
 company, active 1857-1907, after
 photograph
Hand-colored lithograph, 31.1 x 26
 cm. (12¼ x 10¼ in.), c. 1865
NPG.84.331

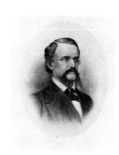

Breckinridge, John Cabell, 1821-1875
Statesman, Confederate general
Strobridge lithography company,
 active 1867-?, after photograph
Lithograph with tintstone, 39.2 x
 30.1 cm. (15⁷⁄₁₆ x 11⅞ in.), not
 dated
NPG.77.69

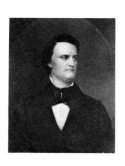

Breckinridge, John Cabell, 1821-1875
Statesman, Confederate general
Unidentified artist, after the 1860 oil
 by Benjamin Franklin Reinhar(d)t
Oil on canvas, 75.9 x 62.8 cm. (29⅞ x
 24¾ in.), after 1860
NPG.70.38
*Gift of Mrs. Marvin Breckinridge
 Patterson*

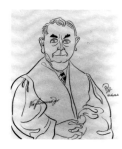

Brennan, William Joseph, Jr.*, 1906-
Justice of the United States Supreme
 Court
Oscar Berger, 1901-
Ink over pencil on paper, 41.9 x 35.7
 cm. (16½ x 14¹/₁₆ in.), c. 1968
T/NPG.69.17
Gift of the artist

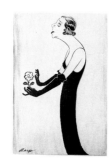

Brice, Fanny, 1891-1951
Singer, comedienne
William Sharp, 1900-1961
India ink on board, 40.6 x 35.5 cm.
 (16 x 13¹⁵/₁₆ in.), c. 1940-1941
NPG.84.111

Brigance, Thomas*, 1913-
Designer
Aline Fruhauf, 1907-1978
Watercolor with pencil, colored
 pencil, crayon, and opaque white
 on paper, 38.5 x 32.5 cm. (15⅛ x
 12¹³/₁₆ in.), 1939
Illustration for *Vogue*, New York,
 October 15, 1940
T/NPG.83.273
Gift of Erwin Vollmer

Bristow, Benjamin Helm, 1832-1896
Statesman
P. Oscar Jenkins, c. 1848-?
Oil on canvas, 76.8 x 63.5 cm. (30¼ x
 25 in.), 1874
NPG.72.104

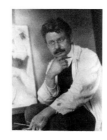

Broedel, Max, 1870-1941
Medical illustrator, anatomist
Doris Ulmann, 1882-1934
Photograph, platinum print, 20.6 x
 15.6 cm. (8⅛ x 6³/₁₆ in.), 1920
NPG.85.23

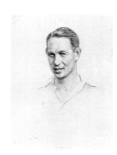

Bromfield, Louis, 1896-1956
Author
Soss Melik, 1914-
Charcoal on paper, 63.5 x 48.5 cm.
 (25 x 19⅛ in.), 1944
NPG.68.29

Brookings, Robert Somers, 1850-1932
Businessman, educational
 philanthropist
Janet Gregg Wallace, 1902-
Plaster, 34.9 cm. (13¾ in.), 1944
Bronze, 33.9 cm. (13⅜ in.), cast after
 1944 plaster
NPG.65.12 and NPG.65.12.1
 (illustrated)
*Plaster, a gift of Mrs. Henry A.
 Schroeder*

Brooks, Van Wyck, 1886-1963
Literary critic, historian
Clara E. Sipprell, 1885-1975
Photograph, gelatin silver print, 21.3
 x 12.3 cm. (8⅜ x 4⅞ in.), c. 1950
NPG.82.180
Bequest of Phyllis Fenner

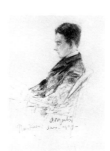

Brooks, Van Wyck, 1886-1963
Literary critic, historian
John Butler Yeats, 1839-1922
Pastel on paper, 51 x 30.5 cm. (20 x
 12 in.), 1909
NPG.76.32

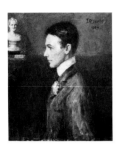

Brooks, Van Wyck, 1886-1963
Literary critic, historian
John Butler Yeats, 1839-1922
Oil on canvas, 76.2 x 63.5 cm. (30 x
 25 in.), 1909
NPG.82.129

Brown, Jacob Jennings, 1775-1828
War of 1812 general
Unidentified artist, after John
 Wesley Jarvis
Charles Bance, publisher, active
 1793-1822
Stipple and line engraving, 8.1 x 8
 cm. (3³⁄₁₆ x 3⅛ in.), c. 1817-1822
NPG.80.61

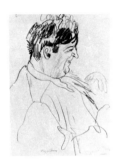

Broun, Heywood Campbell,
 1888-1939
Journalist
Peggy Bacon, 1895-1987
Crayon on paper, 26 x 20 cm. (10¼ x
 7⅞ in.), c. 1934
NPG.74.56

Brown, James, 1800-1855
Publisher
Unidentified photographer
Daguerreotype, 10.7 x 9.2 cm. (4³⁄₁₆ x
 3⅝ in.), c. 1844
NPG.85.214

Broun, Heywood Campbell,
 1888-1939
Journalist
Aline Fruhauf, 1907-1978
India ink over pencil with gray wash
 on paper, 32 x 25.7 cm. (12⁹⁄₁₆ x
 10⅛ in.), 1928
Published in *Theatre Magazine,*
 New York, December 1928
NPG.83.56
Gift of Erwin Vollmer

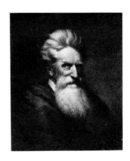

Brown, John, 1800-1859
Abolitionist
Ole Peter Hansen Balling, 1823-1906
Oil on canvas, 76.2 x 63.5 cm. (30 x
 25 in.), c. 1859
NPG.74.2

Brown, Henry Kirke, 1814-1886
Artist
Unidentified photographer
Photograph, albumen silver print,
 18.2 x 13.4 cm. (7³⁄₁₆ x 5¼ in.),
 c. 1860
NPG.77.124

Brown, John, 1800-1859
Abolitionist
James Wallace Black, 1825-1896,
 after daguerreotype attributed to
 Martin M. Lawrence
Photograph, albumen silver print,
 21.6 x 15.2 cm. (8½ x 6 in.), 1859
NPG.74.76

Brown, Jacob Jennings, 1775-1828
War of 1812 general
Mary Estelle Elizabeth Cutts,
 1814-1856
Pencil on paper, 15.8 x 12.4 cm. (6¼
 x 4⅞ in.), not dated
NPG.77.63

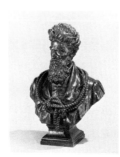

Brown, John, 1800-1859
Abolitionist
Joseph-Charles de Blezer, ?-?
Bronze, 39.3 cm. (15½ in.), 1870
NPG.68.38
*Gift of Mr. Alfred Wolkenberg in
 memory of his wife, Mrs. Janine
 C. Wolkenberg*

Brown, John, 1800-1859
Abolitionist
Currier and Ives lithography
 company, active 1857-1907, after
 photograph
Hand-colored lithograph, 30.1 x 21.7
 cm. (11⅞ x 8⁹⁄₁₆ in.), c. 1859
NPG.84.202

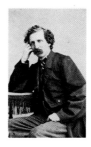

**Browne, Charles Farrar ("Artemus
 Ward"),** 1834-1867
Humorist
Mathew Brady, 1823-1896
Photograph, albumen silver print,
 8.6 x 5.2 cm. (3⅜ x 2¹⁄₁₆ in.),
 c. 1865
NPG.80.105

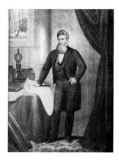

Brown, John, 1800-1859
Abolitionist
Anton Hohenstein, c. 1823-?, after
 daguerreotype attributed to Martin
 M. Lawrence
Lithograph, 58.4 x 44.2 cm. (22¹⁵⁄₁₆ x
 17⅜ in.), 1866
NPG.85.134

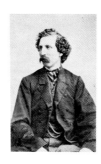

**Browne, Charles Farrar ("Artemus
 Ward"),** 1834-1867
Humorist
Mathew Brady, 1823-1896
Photograph, albumen silver print,
 8.5 x 5.4 cm. (3½ x 2⅛ in.), c. 1862
NPG.80.169

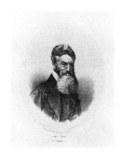

Brown, John, 1800-1859
Abolitionist
Thomas Murphy Johnston,
 1834-1869, probably after
 photograph by James Wallace
 Black, after daguerreotype
 attributed to Martin M. Lawrence
Lithograph, 30.8 x 27 cm. (12⅛ x 10⅝
 in.), 1859
NPG.77.276

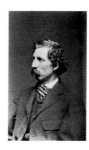

**Browne, Charles Farrar ("Artemus
 Ward"),** 1834-1867
Humorist
Charles DeForest Fredricks,
 1823-1894
Photograph, albumen silver print,
 9.1 x 5.4 cm. (3⁹⁄₁₆ x 2⅛ in.),
 c. 1863
NPG.80.210

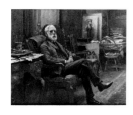

Brown, John George, 1831-1913
Artist
Gilbert Gaul, 1855-1919
Oil on canvas, 51.4 x 64.1 cm. (20¼ x
 25½ in.), 1907
NPG.70.39

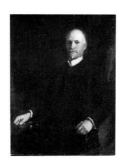

Browning, John Moses, 1855-1926
Inventor
George Henry Taggart, 1865-?
Oil on canvas, 122.5 x 95.2 cm. (48¼
 x 37½ in.), 1902
NPG.82.55
Gift of Val A. Browning

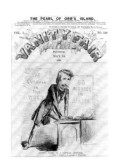

**Browne, Charles Farrar ("Artemus
 Ward"),** 1834-1867
Humorist
Bobbett and Hooper wood-engraving
 company, active 1855-1870, after
 Henry Louis Stephens
Wood engraving, 16.5 x 15.5 cm. (6½
 x 6⅛ in.), 1862
Published in *Vanity Fair*, New York,
 May 24, 1862
NPG.78.233

Brownlow, William Gannaway,
 1805-1877
Editor, politician
Bobbett and Hooper wood-engraving
 company, active 1855-1870, after
 Henry Louis Stephens
Wood engraving, 26.8 x 19.9 cm.
 (10⁹⁄₁₆ x 7¹³⁄₁₆ in.), 1862
Published in *Vanity Fair*, New York,
 May 31, 1862
NPG.85.144

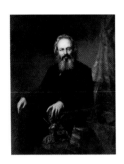

Brownson, Orestes Augustus,
1803-1876
Religious philosopher
George Peter Alexander Healy,
1813-1894
Oil on canvas, 146 x 114.3 cm.
(57½ x 45 in.), 1863
NPG.79.207

Bryant, William Cullen, 1794-1878
Poet, editor
Charles G. Crehen, 1829-?, after
daguerreotype by Philip Haas
Nagel and Weingaertner lithography
company
Lithograph, 34.5 x 27 cm. (13⁹⁄₁₆ x
10⅝ in.), 1850
NPG.77.70

Bryan, William Jennings, 1860-1925
Statesman
Charles DeForest Fredricks,
1823-1894
Photograph, carbon print, 14.2 x 9.8
cm. (5¾ x 3¾ in.), 1889
NPG.80.303

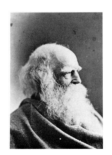

Bryant, William Cullen, 1794-1878
Poet, editor
José Maria Mora, c. 1847-1926
Photograph, albumen silver print,
9.1 x 5.8 cm. (3⁹⁄₁₆ x 2½ in.), c.
1870
NPG.79.20

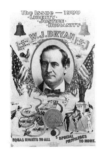

Bryan, William Jennings, 1860-1925
Statesman
Strobridge lithography company,
active 1867-1960, after photograph
Chromolithographic poster, 75.9 x
50.7 cm. (29⅞ x 19¹⁵⁄₁₆ in.), 1900
NPG.83.177

Bryant, William Cullen, 1794-1878
Poet, editor
George N. Rockwood, 1833-1911
Photograph, albumen silver print,
22.1 x 19.3 cm. (8¹¹⁄₁₆ x 7⅝ in.),
1864
NPG.77.125

Bryant, William Cullen, 1794-1878
Poet, editor
Bobbett and Hooper wood-engraving
company, active 1855-1870, after
Henry Louis Stephens
Wood engraving, 14.8 x 16.5 cm.
(5¹³⁄₁₆ x 6½ in.), 1862
Published in *Vanity Fair*, New York,
May 3, 1862
NPG.78.223

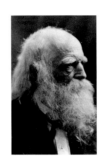

Bryant, William Cullen, 1794-1878
Poet, editor
Napoleon Sarony, 1821-1896
Photograph, albumen silver print,
14.6 x 10.5 cm. (5¾ x 4⅛ in.), 1873
NPG.76.69

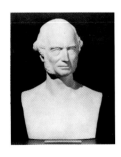

Bryant, William Cullen, 1794-1878
Poet, editor
Henry Kirke Brown, 1814-1886
Marble, 50.1 cm. (19¾ in.), 1846
NPG.66.22
*Transfer from the National Museum
of American Art; gift of H. K.
Bush-Brown, 1926*

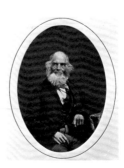

Bryant, William Cullen, 1794-1878
Poet, editor
Unidentified photographer
Photograph, albumen silver print,
18.2 x 13.4 cm. (7³⁄₁₆ x 5¼ in.),
c. 1860
NPG.77.121

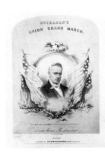

Buchanan, James, 1791-1868
Fifteenth President of the United
 States
J. H. Bufford lithography company,
 active 1835-1890, after unidentified
 daguerreotype
Lithograph with tintstone, 25.8 x
 19.3 cm. (10⅛ x 7⅝ in.), 1856
Music sheet title page: "Buchanan's
 Union Grand March"
NPG.84.13

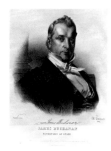

Buchanan, James, 1791-1868
Fifteenth President of the United
 States
Charles Fenderich, 1805-1887
Edward D. Weber lithography
 company
Lithograph, 29.8 x 25.8 cm. (11¾ x
 10⅛ in.), 1847
NPG.66.76
*Transfer from the Library of
 Congress, Prints and Photographs
 Division*

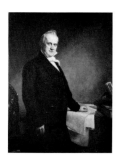

Buchanan, James, 1791-1868
Fifteenth President of the United
 States
George Peter Alexander Healy,
 1813-1894
Oil on canvas, 157.4 x 119.3 cm. (62
 x 47 in.), 1859
NPG.65.48
*Transfer from the National Gallery
 of Art; gift of Andrew W. Mellon,
 1942*

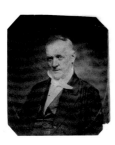

Buchanan, James, 1791-1868
Fifteenth President of the United
 States
Charles Richard Meade, 1827-1858,
 and Henry William Matthew
 Meade, 1823-1865, at the Meade
 Brothers studio, active 1842-1870
Photograph, salt print, 12.5 x 10.8
 cm. (4⅞ x 4¼ in.), c. 1859, after
 c. 1856 daguerreotype
NPG.78.274

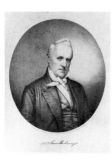

Buchanan, James, 1791-1868
Fifteenth President of the United
 States
John H. Sherwin, 1834-?, after
 daguerreotype
Lithograph, 28.3 x 24.5 cm. (11⅛ x
 9⅝ in.), 1856
NPG.84.201

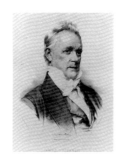

Buchanan, James, 1791-1868
Fifteenth President of the United
 States
Adam Weingaertner, active
 1849-1863, after daguerreotype by
 Mathew Brady
Lithograph with tintstone, 54.3 x
 42.6 cm. (21⅜ x 16¾ in.), c. 1860
NPG.78.75

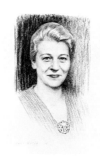

Buck, Pearl S., 1892-1973
Author
Soss Melik, 1914-
Charcoal on paper, 63.5 x 48.2 cm.
 (25 x 19 in.), 1946
NPG.74.28

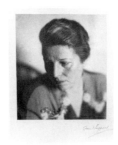

Buck, Pearl S., 1892-1973
Author
Clara E. Sipprell, 1885-1975
Photograph, gelatin silver print, 20.4
 x 17.8 cm. (8¹/₁₆ x 7 in.), c. 1950
NPG.82.181
Bequest of Phyllis Fenner

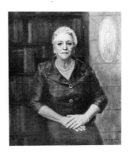

Buck, Pearl S., 1892-1973
Author
Vita Petrosky Solomon, 1916-
Oil on canvas, 106.6 x 91.4 cm. (42 x
 36 in.), 1968
NPG.73.24
Gift of the Pearl S. Buck Foundation

Buck, Pearl S., 1892-1973
Author
Edward Steichen, 1879-1973
Photograph, gelatin silver print, 24.8
 x 19.6 cm. (9¹³/₁₆ x 7¾ in.), 1932
NPG.85.93

Buckley, William Frank, Jr.*, 1925-
Editor, author
Benedict J. Fernandez, 1935-
Photograph, gelatin silver print, 32.5
 x 22.2 cm. (12¾ x 8¾ in.), 1978
T/NPG.80.174
Gift of the artist

Bunche, Ralph Johnson, 1904-1971
Statesman
Carl Van Vechten, 1880-1964
Photogravure, 22.4 x 14.9 cm. (8¹³⁄₁₆
 x 5⅞ in.), 1983 from 1951 negative
NPG.83.188.8

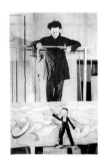

Buckley, William Frank, Jr.*, 1925-
Editor, author
Philippe Halsman, 1906-1979
Photograph, gelatin silver print, 34.9
 x 27.6 cm. (13¾ x 10⅞ in.), 1961
T/NPG.83.74
Gift of George R. Rinhart

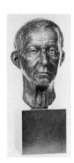

Bunker, Ellsworth*, 1894-1984
Diplomat
Janet Gregg Wallace, 1902-
Bronze, 33 cm. (13 in.), cast after
 1970 plaster
T/NPG.81.89.94
Gift of Mrs. Henry A. Schroeder

Bufano, Remo, 1894-1948
Artist
Prentiss Taylor, 1907-
Photograph, gelatin silver print, 15.8
 x 10 cm. (6¼ x 3¹⁵⁄₁₆ in.), 1932
NPG.84.234
Gift of Prentiss Taylor

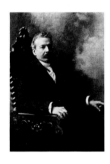

Burbank, Luther, 1849-1926
Horticulturist
Charles Alisky, active 1897-?
Photograph, gelatin silver print, 13.9
 x 9.7 cm. (5½ x 3⁵⁄₁₆ in.), c. 1900
NPG.77.135

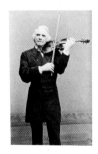

Bull, Ole, 1810-1880
Musician, founder of utopian
 community of Oleana
George K. Warren, c. 1824-1884
Photograph, albumen silver print,
 9.4 x 5.8 cm. (3¹¹⁄₁₆ x 2½ in.),
 c. 1870
NPG.80.188

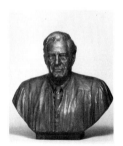

Burger, Warren Earl*, 1907-
Chief Justice of the United States
Walker Hancock, 1901-
Bronze, 63.5 cm. (25 in.), 1983
T/NPG.83.144

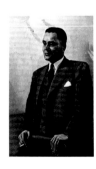

Bunche, Ralph Johnson, 1904-1971
Statesman
Betsy Graves Reyneau, 1888-1964
Oil on canvas, 127 x 84.4 cm. (50 x
 33¼ in.), 1948
NPG.67.30
Gift of the Harmon Foundation

Burger, Warren Earl*, 1907-
Chief Justice of the United States
Rosalind Solomon, 1930-
Photograph, gelatin silver print, 38.6
 x 38.3 cm. (15³⁄₁₆ x 15⅛ in.), 1979
T/NPG.84.139

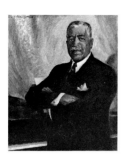

Burleigh, Harry Thacker, 1866-1949
Composer
Laura Wheeler Waring, 1887-1948
Oil on canvas, 101.6 x 86.7 cm. (40 x
34⅛ in.), not dated
NPG.67.80
Gift of the Harmon Foundation

Burnett, Frances Eliza Hodgson,
1849-1924
Author
Herbert Barraud, active c. 1870-1895
Photograph, carbon print, 24.5 x 17.5
cm. (9⅝ x 6⅞ in.), c. 1895
NPG.78.61

Burnside, Ambrose Everett,
1824-1881
Union general
Attributed to Joseph E. Baker,
1835-1914
J. H. Bufford lithography company
Lithograph with beige tintstone, 32.1
x 23.7 cm. (12⅝ x 9⁵⁄₁₆ in.), 1861
NPG.82.17

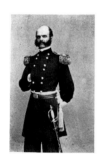

Burnside, Ambrose Everett,
1824-1881
Union general
Mathew Brady, 1823-1896
Photograph, albumen silver print,
8.5 x 5.3 cm. (3⅜ x 2¹⁄₁₆ in.),
c. 1861
NPG.79.42

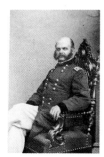

Burnside, Ambrose Everett,
1824-1881
Union general
Mathew Brady, 1823-1896
Photograph, albumen silver print,
8.5 x 5.5 cm. (3¼ x 2⅛ in.), 1864
NPG.80.310
Gift of Dr. Mary M. Juday

Burnside, Ambrose Everett,
1824-1881
Union general
J. H. Bufford lithography company,
active 1835-1890, after photograph
by Mathew Brady
Lithograph, 14.5 x 12.8 cm. (5¾ x
5¹⁄₁₆ in.), 1862
Music sheet title page: "General
Burnside's Victory March"
NPG.77.335

Burnside, Ambrose Everett,
1824-1881
Union general
Manchester and Brother studio,
active c. 1848-1880
Ambrotype, 6.2 x 4.9 cm. (2⁷⁄₁₆ x 2
in.), c. 1861
NPG.78.278

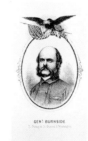

Burnside, Ambrose Everett,
1824-1881
Union general
Louis Prang lithography company,
active 1856-1899, after photograph
Lithograph, 8.3 x 6 cm. (3¼ x 2⅜
in.), 1862
Contained in D. Dudley's *Officers of
Our Union Army and Navy. Their
Lives, Their Portraits,* vol. 1,
Washington, D.C., and Boston,
1862
NPG.80.119.e

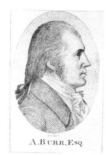

Burr, Aaron, 1756-1836
Vice-President of the United States
Enoch G. Gridley, active 1801-1818,
after John Vanderlyn
Stipple engraving, 10.3 x 7.4 cm. (4 x
2¹⁵⁄₁₆ in.), c. 1801-1802
Published in James Hardie's *The
New Universal Biographical
Dictionary and American
Remembrancer . . . ,* vol. 4, New
York, 1801-1802
NPG.80.184.w

Burroughs, John, 1837-1921
Naturalist
Walter Beck, 1864-1954
Pastel on paper, 83.2 x 109.2 cm.
(32¾ x 43 in.), 1912
NPG.76.24
*Transfer from the National Museum
of American Art; gift of Elizabeth
A. Achelis, 1923*

Burroughs, John, 1837-1921
Naturalist
George Clyde Fisher, 1878-1945
Photograph, gelatin silver print, 8.4
x 10.9 cm. (3⁵/₁₆ x 4⁵/₁₆ in.), 1918
NPG.78.100

Butler, Benjamin Franklin,
1818-1893
Union general
Edward Augustus Brackett,
1818-1908
Marble, 61.5 cm. (24½ in.), 1863
NPG.73.1
*Gift of the children of Oakes and
Blanche Ames*

Burroughs, John, 1837-1921
Naturalist
Harris and Ewing studio, active
1905-1977
Photograph, brown-toned gelatin
silver print, 22.8 x 15.2 cm. (9 x 6
in.), c. 1910
NPG.84.243
Gift of Aileen Conkey

Butler, Benjamin Franklin,
1818-1893
Union general
Currier and Ives lithography
company, active 1857-1907
Lithograph, 20.8 x 33.9 cm. (8³/₁₆ x
13⅜ in.), c. 1862
NPG.84.362

Burt, William Austin, 1792-1858
Inventor, surveyor
Unidentified artist
Oil on canvas, 76.2 x 63.5 cm. (30 x
25 in.), not dated
NPG.79.119
Gift of Mrs. Philip Burt Fisher

Butler, Benjamin Franklin,
1818-1893
Union general
Dominique C. Fabronius, active
1850-1888, after photograph
Louis Prang lithography company
Lithograph with tintstone, 22.1 x
16.5 cm. (8¹¹/₁₆ x 6½ in.), c. 1861
NPG.82.22

Bush, Vannevar, 1890-1974
Engineer
Samuel Johnson Woolf, 1880-1948
Charcoal and chalk on paper, 51.6 x
38.8 cm. (20⁵/₁₆ x 15¼ in.), not
dated
NPG.80.253

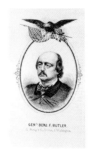

Butler, Benjamin Franklin,
1818-1893
Union general
Louis Prang lithography company,
active 1856-1899, after photograph
Lithograph, 8.3 x 6 cm. (3¼ x 2⅜
in.), 1862
Contained in D. Dudley's *Officers of
Our Union Army and Navy. Their
Lives, Their Portraits*, vol. 1,
Washington, D.C., and Boston,
1862
NPG.80.119.f

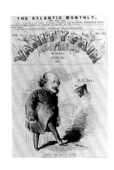

Butler, Benjamin Franklin,
1818-1893
Union general
Bobbett and Hooper wood-engraving
company, active 1855-1870, after
Henry Louis Stephens
Wood engraving, 16 x 14.5 cm. (6⁵/₁₆
x 5¾ in.), 1862
Published in *Vanity Fair*, New York,
June 28, 1862
NPG.78.254

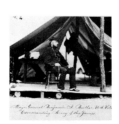

Butler, Benjamin Franklin,
1818-1893
Union general
Unidentified photographer
Photograph, albumen silver print,
11.6 x 14.7 cm. (4⁹/₁₆ x 5¹³/₁₆ in.), c.
1864
NPG.84.151

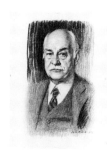

Butler, Nicholas Murray, 1862-1947
Educator
Soss Melik, 1914-
Charcoal on paper, 63.5 x 48 cm. (25
x 19 in.), 1939
NPG.75.22

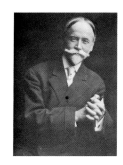

Cable, George Washington,
1844-1925
Author
Hallum (?) B. McClellan, ?-?
Photograph, toned platinum print,
16 x 11.4 cm. (6�5/16 x 4½ in.), 1909
NPG.80.240

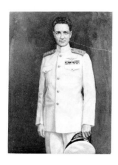

Byrd, Richard Evelyn, 1888-1957
Explorer
Seymour Millais Stone, 1877-?
Oil on canvas, 101.8 x 76.8 cm. (40⅛
x 30¼ in.), 1931
NPG.70.13
*Transfer from the National Museum
of American Art; gift of the artist,
1931*

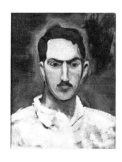

Calder, Alexander, 1898-1976
Artist
Self-portrait
Oil on canvas, 50.8 x 40.6 cm. (20 x
16 in.), c. 1925
NPG.71.35
Gift of the artist

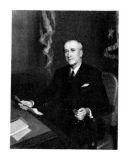

Byrnes, James Francis, 1879-1972
Statesman
Alfred Jonniaux, 1882-1974
Oil on canvas, 127 x 101.6 cm. (50 x
40 cm.), 1946
NPG.66.2
Gift of the artist

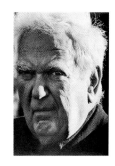

Calder, Alexander, 1898-1976
Artist
Benedict J. Fernandez, 1935-
Photograph, gelatin silver print, 32.5
x 22.1 cm. (12¾ x 8¹¹/16 in.), 1968
NPG.80.175
Gift of the artist

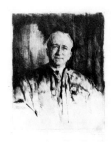

Byrnes, James Francis, 1879-1972
Statesman
Oskar Stoessel, 1879-1964
Etching and drypoint, 34.9 x 29.6 cm.
(13¾ x 11⅝ in.), c. 1941-1943
NPG.64.11
Gift of David E. Finley

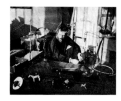

Calder, Alexander, 1898-1976
Artist
André Kertész, 1894-
Photograph, gelatin silver print, 16.7
x 22.6 cm. (6⁹/16 x 8⅞ in.), 1929
NPG.83.212

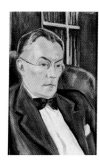

Cabell, James Branch, 1879-1958
Author
Frederick S. Wight, 1902-1986
Oil on canvas, 61 x 38.1 cm. (24 x 15
in.), c. 1934
NPG.81.2
Gift of the artist

Calder, Alexander, 1898-1976
Artist
Miriam Troop, 1917-
Pencil on paper, 35.5 x 27.9 cm. (14 x
11 in.), 1972
NPG.75.23

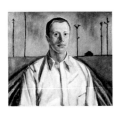

Caldwell, Erskine*, 1903-1987
Author
Frederick S. Wight, 1902-1986
Oil on canvas, 65.4 x 76.2 cm. (25¾ x
 30 in.), 1934
T/NPG.81.96
Gift of Frederick S. Wight

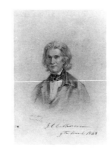

Calhoun, John Caldwell, 1782-1850
Statesman
Miner Kilbourne Kellogg, 1814-1889
Pencil and chalk on paper, 27.6 x
 19.2 cm. (10⅞ x 7⁹∕₁₆ in.), 1848
NPG.71.48

Calhoun, John Caldwell, 1782-1850
Statesman
Charles G. Crehen, 1829-?, after
 daguerreotype by Mathew Brady
Nagel and Weingaertner lithography
 company
Lithograph, 39.2 x 29.8 cm. (15⁷∕₁₆ x
 11¾ in.), 1850
NPG.78.72

Calhoun, John Caldwell, 1782-1850
Statesman
Attributed to Charles Bird King,
 1785-1862
Oil on canvas, 76.2 x 63.5 cm. (30 x
 25 in.), c. 1818-1825
NPG.65.58
*Transfer from the National Gallery
 of Art; gift of Andrew W. Mellon,
 1942*

Calhoun, John Caldwell, 1782-1850
Statesman
Francis D'Avignon, c. 1814-?, after
 daguerreotype by Mathew Brady
Lithograph, 29.1 x 24.5 cm. (11⁷∕₁₆ x
 9⅝ in.), 1850
Published in Mathew Brady's
 Gallery of Illustrious Americans,
 New York, 1850
NPG.72.53

Calhoun, John Caldwell, 1782-1850
Statesman
Peter Kramer, 1823-1907, after
 daguerreotype by Marshall and
 Porter
Thomas Sinclair lithography
 company
Lithograph with tintstone, 43.7 x 35
 cm. (17¼ x 13¾ in.), c. 1850
NPG.78.19

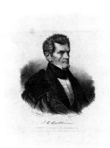

Calhoun, John Caldwell, 1782-1850
Statesman
Charles Fenderich, 1805-1887
Lehman and Duval lithography
 company
Lithograph, 26.4 x 25 cm. (10⅜ x 9⅞
 in.), 1837
NPG.66.77
*Transfer from the Library of
 Congress, Prints and Photographs
 Division*

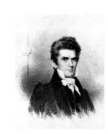

Calhoun, John Caldwell, 1782-1850
Statesman
James Barton Longacre, 1794-1869
Sepia watercolor on artist board, 27.3
 x 22.5 cm. (10¾ x 8⅞ in.), c. 1834
NPG.77.285

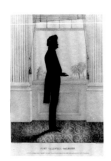

Calhoun, John Caldwell, 1782-1850
Statesman
E. B. and E. C. Kellogg lithography
 company, active c. 1842-1867, after
 William Henry Brown
Lithographed silhouette, 34.2 x 25.4
 cm. (13½ x 10 in.), 1844
Published in William H. Brown's
 *Portrait Gallery of Distinguished
 American Citizens,* Hartford, 1845
NPG.78.78

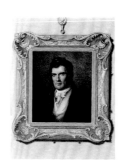

Calhoun, John Caldwell, 1782-1850
Statesman
James Barton Longacre, 1794-1869,
 after Charles Bird King
Stipple engraving, 15.5 x 12.5 cm.
 (6¼ x 4¹⁵∕₁₆ in.), c. 1827
Published in *Casket,* March 1827
NPG.79.237

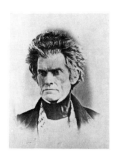

Calhoun, John Caldwell, 1782-1850
Statesman
Unidentified photographer, after
c. 1845 daguerreotype
Photograph, salt print, 14.7 x 11.5
cm. (5¹³⁄₁₆ x 4½ in.), c. 1855
NPG.77.258

Cannon, Joseph Gurney, 1836-1926
Statesman
Jo Davidson, 1883-1952
Bronze, 34.2 cm. (13½ in.), 1917
NPG.67.51

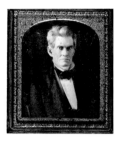

Calhoun, John Caldwell, 1782-1850
Statesman
Unidentified photographer
Daguerreotype, 8.2 x 7 cm. (3³⁄₁₆ x 2¾
in.), c. 1843
NPG.78.64

Cannon, Joseph Gurney, 1836-1926
Statesman
Harris and Ewing studio, active
1905-1977, and Clifford Kennedy
Berryman, 1869-1949
Photograph, brown-toned gelatin
silver print with india ink
drawing, 34.5 x 20.9 cm. (13⁹⁄₁₆ x
8¼ in.), 1905
NPG.84.244
Gift of Aileen Conkey

Calhoun, John Caldwell, 1782-1850
Statesman
Unidentified artist, after
daguerreotype by John Plumbe, Jr.
Hand-colored lithograph, 33 x 26 cm.
(13 x 10¼ in.), 1846
Contained in *The National
Plumbeotype Gallery,*
Philadelphia, 1847
NPG.78.84.g

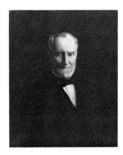

Cannon, Joseph Gurney, 1836-1926
Statesman
Harris and Ewing studio, active
1905-1977
Photograph, brown-toned gelatin
silver print, 22.8 x 15.4 cm. (9 x
6¹⁄₁₆ in.), 1906
NPG.84.245
Gift of Aileen Conkey

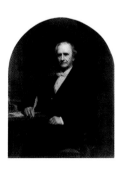

Cameron, Simon, 1799-1889
Statesman
John Dabour, 1837-1905
Oil on canvas, 133.5 x 104 cm. (52½
x 41 in.) elliptical top, 1871
NPG.72.13
Gift of G. H. Chase

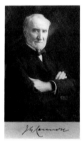

Cannon, Joseph Gurney, 1836-1926
Statesman
Harriet Anderson Stubbs Murphy,
1851-1935
Oil on canvas, 76.2 x 63.5 cm. (30 x
25 in.), 1912
NPG.73.25
Gift of Harriet Murphy Ross

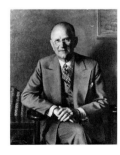

Canaday, Ward Murphey, 1885-1976
Businessman
Douglas Chandor, 1897-1953
Oil on canvas, 91.4 x 76.8 cm. (36 x
30¼ in.), 1950
NPG.77.228
Gift of Doreen Canaday Spitzer

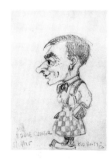

Cantor, Eddie, 1892-1964
Entertainer
Alfred Bendiner, 1899-1964
Pencil and ink on paper, 18.4 x 12.9
cm. (7¼ x 5¹⁄₁₆ in.), 1925
NPG.85.201
Gift of Alfred Bendiner Foundation

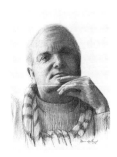

Capote, Truman*, 1924-1984
Author
Barnaby Conrad, 1922-
Charcoal on artist board, 50.8 x 38.1
 cm. (20 x 15 in.), 1974
T/NPG.77.19.94
Gift of the artist

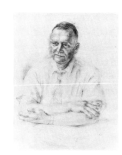

Carmer, Carl, 1893-1976
Author
Barbara Swan, 1922-
Oil on cameo paper, 76 x 56 in. (30 x
 22 in.), 1948
NPG.77.20

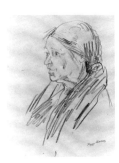

Caraway, Hattie Wyatt, 1878-1959
Stateswoman
Peggy Bacon, 1895-1987
Crayon on paper, 35.4 x 24.7 cm.
 (13¹⁵⁄₁₆ x 9¾ in.), c. 1935
NPG.74.57

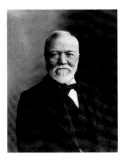

Carnegie, Andrew, 1835-1919
Businessman, philanthropist
Charles H. Davis, ?-?, and E. Starr
 Sanford, c. 1862-1917; studio active
 1892-1933
Photograph, platinum print, 23.2 x
 18.2 cm. (9⅛ x 7³⁄₁₆ in.), c. 1900
NPG.77.199

Cardozo, Benjamin Nathan,
 1870-1938
Justice of the United States Supreme
 Court
Franklin T. Wood, 1887-1945, after
 photograph
Etching, 39 x 29.8 (15¼ x 11⅝ in.), c.
 1932-1938
NPG.81.64

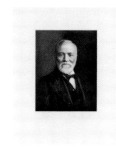

Carnegie, Andrew, 1835-1919
Businessman, philanthropist
Jacques Reich, 1852-1923, after
 photograph by Davis and Sanford
 studio
Etching, 37.8 x 29.1 cm. (14⅞ x 11⁷⁄₁₆
 in.), 1906
NPG.67.75
Gift of Oswald D. Reich

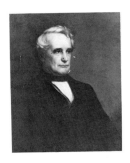

Carey, Henry Charles, 1793-1879
Economist
T. Henry Smith, active second half
 of nineteenth century
Oil on canvas, 76.2 x 63.5 cm. (30 x
 25 in.), 1885
NPG.67.56
Gift of Henry Lea Hudson

Carnegie, Andrew, 1835-1919
Businessman, philanthropist
Orlando Rouland, 1871-1945
Pencil on paper, 13.5 x 14.8 cm. (5⅜
 x 5¹³⁄₁₆ in.), 1911
NPG.78.126

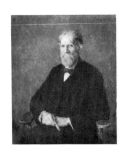

Carlsen, Emil, 1853-1932
Artist
Self-portrait
Oil on canvas, 91.4 x 76.2 cm. (36 x
 30 in.), c. 1920
NPG.82.130

Carnegie, Andrew, 1835-1919
Businessman, philanthropist
Orlando Rouland, 1871-1945
Sanguine chalk on paper, 13.5 x 21.4
 cm. (5⁵⁄₁₆ x 8⁷⁄₁₆ in.), 1911
NPG.78.127

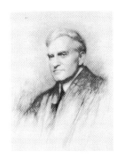

Carnegie, Andrew, 1835-1919
Businessman, philanthropist
Orlando Rouland, 1871-1945
Sanguine chalk on paper, 13.5 x 21.4
 cm. (5⁵⁄₁₆ x 8⁷⁄₁₆ in.), 1911
NPG.78.128

Carroll, Charles, 1737-1832
Revolutionary statesman
Charles Balthazar Julien Févret de
 Saint-Mémin, 1770-1852
Engraving, 5.6 cm. (2¼ in.) diameter,
 1804
NPG.74.39.332
Gift of Mr. and Mrs. Paul Mellon

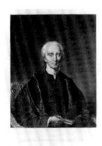

Carnegie, Andrew, 1835-1919
Businessman, philanthropist
Unidentified artist
Oil on canvas, 127.6 x 101.9 cm.
 (50¼ x 40⅛ in.), not dated
NPG.74.44
*Gift of Mrs. Margaret Carnegie
 Miller*

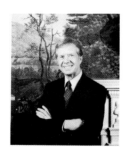

Carroll, John, 1735-1815
Clergyman
William Satchwell Leney, 1769-1831,
 and Benjamin Tanner, 1775-1848,
 after Jeremiah Paul, Jr.
Engraving, 49.5 x 40 cm. (19½ x 15¾
 in.), 1812
NPG.74.58

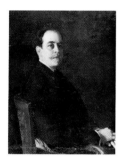

Carrère, John Merven, 1858-1911
Architect
William de Leftwich Dodge,
 1867-1937
Oil on canvas, 102.2 x 76.2 cm. (40¼
 x 30 in.), c. 1905
NPG.81.3
Gift of Joseph Carrère Fox

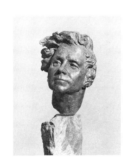

Carson, Rachel Louise, 1907-1964
Environmentalist
Una Hanbury, ?-
Bronze, 29.1 cm. (11½ in.), 1965
NPG.66.19

Carroll, Charles, 1737-1832
Revolutionary statesman
James Barton Longacre, 1794-1869,
 after Chester Harding
Engraving, 25.2 x 19.5 cm. (9¹⁵⁄₁₆ x
 7¹¹⁄₁₆ in.), 1830
NPG.79.238

Carter, Jimmy (James Earl, Jr.), 1924-
Thirty-ninth President of the United
 States
Ansel Adams, 1902-1984
Photograph, polaroid color positive,
 61.2 x 52.1 cm. (24¹⁄₁₆ x 20½ in.),
 1980
NPG.80.305
Gift of James Earl Carter, Jr.

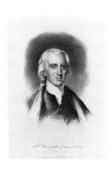

Carroll, Charles, 1737-1832
Revolutionary statesman
Albert Newsam, 1809-1864, after
 Thomas Sully
Childs and Inman lithography
 company
Lithograph, 23.4 x 18.6 cm. (9³⁄₁₆ x
 7⁵⁄₁₆ in.), 1832
NPG.77.331

Carter, Jimmy (James Earl, Jr.), 1924-
Thirty-ninth President of the United
 States
Julian Hoke Harris, 1906-
Gold medal, 7 cm. (2¾ in.) diameter,
 1976
NPG.78.49
Gift of Bardyl Tirana

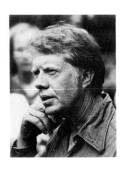

Carter, Jimmy (James Earl, Jr.), 1924-
Thirty-ninth President of the United
 States
Rosalind Solomon, 1930-
Photograph, gelatin silver print, 45.3
 x 34.5 cm. (17¹³/₁₆ x 13⁹/₁₆ in.), 1976
NPG.84.137

Carter, Jimmy (James Earl, Jr.), 1924-
Thirty-ninth President of the United
 States
Robert Templeton, 1929-
Oil on canvas, 235 x 142.2 cm.
 (92½ x 56 in.), 1980
NPG.84.154
*Gift of the 1977 Inaugural
 Committee and Gallery purchase*

Carter, Jimmy (James Earl, Jr.), 1924-
Thirty-ninth President of the United
 States
James Browning Wyeth, 1946-
Pencil on paper, 27.9 x 35.2 cm. (11 x
 13⅞ in.), 1976
NPG.77.21
Gift of Martin Peretz

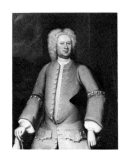

Carter, Robert ("King"), 1663-1732
Colonial statesman
Unidentified artist
Oil on canvas, 125.7 x 100.9 cm.
 (49½ x 39¾ in.), c. 1720
NPG.68.18

Caruso, Enrico, 1873-1921
Singer
Self-portrait caricature
Ink on paper, 15.5 x 10.5 cm. (6⅛ x
 4⅛ in.), 1919
NPG.72.39
Gift of Mrs. Lisette Thompson

Carver, George Washington,
 1864-1943
Scientist
Prentis H. Polk, 1898-
Photograph, gelatin silver print, 19.6
 x 24.5 cm. (7¹¹/₁₆ x 9⅝ in.), c. 1940
NPG.83.190

Carver, George Washington,
 1864-1943
Scientist
Betsy Graves Reyneau, 1888-1964
Oil on canvas, 112.4 x 88.9 cm. (44¼
 x 35 in.), 1942
NPG.65.77
*Transfer from the National Museum
 of American Art; gift of the George
 Washington Carver Memorial
 Committee to the Smithsonian
 Institution, 1944*

Carver, George Washington,
 1864-1943
Scientist
Mary Randolph Witmer, 1892-
Pencil and crayon on paper, 50.5 x
 37.9 cm. (19⅞ x 14¹⁵/₁₆ in.), 1935
NPG.82.63
Gift of Mrs. Katie Louchheim

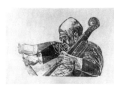

Casals, Pablo, 1876-1973
Musician
Antonio Frasconi, 1919- , after
 photograph
Woodcut, 45 x 72 cm. (17¹¹/₁₆ x 28⁵/₁₆
 in.), 1959
NPG.82.116

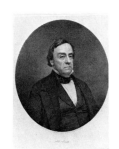

Cass, Lewis, 1782-1866
Statesman
Francis D'Avignon, c. 1814-?, after
 daguerreotype by Mathew Brady
Lithograph, 28.2 x 24.2 cm. (11⅛ x
 9⁹/₁₆ in.), 1850
Published in Mathew Brady's
 Gallery of Illustrious Americans,
 New York, 1850
NPG.72.54

Cass, Lewis, 1782-1866
Statesman
James Barton Longacre, 1794-1869
Sepia watercolor on artist board, 25.7
 x 20.3 cm. (10⅛ x 8 in.), c. 1833
NPG.76.60

Catlin, George, 1796-1872
Artist
William Fisk, 1796-1872
Oil on canvas, 127 x 101.6 cm. (50 x
 40 in.), 1849
NPG.70.14
*Transfer from the National Museum
 of American Art; gift of Miss May
 C. Kinney, Ernest C. Kinney, and
 Bradford Wickes, 1945*

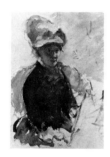

Cass, Lewis, 1782-1866
Statesman
Unidentified artist, after
 daguerreotype by John Plumbe, Jr.
Lithograph, 33 x 26 cm. (13 x 10¼
 in.), 1846
Contained in *The National
 Plumbeotype Gallery,*
 Philadelphia, 1847
NPG.78.84.b

Catron, John, c. 1786-1865
Justice of the United States Supreme
 Court
Charles Fenderich, 1805-1887
Lithograph, 34.2 x 27.5 cm. (13½ x
 10¾ in.), 1839
NPG.66.78
*Gift of the Library of Congress, Prints
 and Photographs Division*

Cassatt, Mary, 1844-1926
Artist
Self-portrait
Watercolor on paper, 33 x 24.4 cm.
 (13 x 9⅝ in.), c. 1880
NPG.76.33

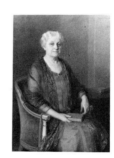

Catt, Carrie Chapman, 1859-1947
Reformer
Mary Foote, 1872-1968
Oil on canvas, 121.9 x 88.9 cm. (48 x
 35 in.), 1927
NPG.71.31
*Transfer from the National Museum
 of American History; gift of the
 National American Woman
 Suffrage Association through Mrs.
 Carrie Chapman Catt, 1939*

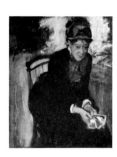

Cassatt, Mary, 1844-1926
Artist
Edgar Degas, 1834-1917
Oil on canvas, 71.4 x 58.7 cm. (28⅛ x
 23⅛ in.), c. 1880-1884
NPG.84.34
*Gift of the Morris and Gwendolyn
 Cafritz Foundation and the
 Regents' Major Acquisitions Fund,
 Smithsonian Institution*

Catt, Carrie Chapman, 1859-1947
Reformer
Theodore C. Marceau, 1868/69-1922
Photograph, gelatin silver print, 18.3
 x 12.5 cm. (7³⁄₁₆ x 4¹⁵⁄₁₆ in.), c. 1901
NPG.82.80
*Gift of University Women's Club,
 Incorporated*

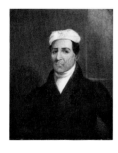

Catahecassa ("Black Hoof"),
 c. 1740-1831
Indian chief
Henry Inman, 1801-1846, after
 Charles Bird King
Oil on canvas, 77.1 x 64.7 cm. (30⅜ x
 25½ in.), 1830-1833
NPG.82.105

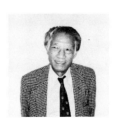

Chang, Min Chueh*, 1908-
Scientist
Peter Strongwater, 1941-
Photograph, gelatin silver print, 36.1
 x 36 cm. (14³⁄₁₆ x 14³⁄₁₆ in.), 1982
T/NPG.84.238
Gift of Christopher Murray

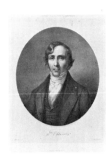

Channing, William Ellery,
 1780-1842
Clergyman
Francis D'Avignon, c. 1814-?, after
 Spiridione Gambardella
Lithograph, 28.1 x 24.5 cm. (11¹¹⁄₁₆ x
 9⅝ in.), 1850
Published in Mathew Brady's
 Gallery of Illustrious Americans,
 New York, 1850
NPG.77.72

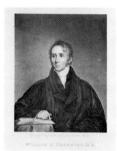

Channing, William Ellery,
 1780-1842
Clergyman
William Hoogland, c. 1795-1832,
 after Chester Harding
Engraving, 26.7 x 21.4 cm. (10½ x
 8⅜ in.), 1829
NPG.80.127

Chaplin, Sir Charles Spencer*,
 1889-1977
Actor, film director, writer
Berkshire Poster Company, active c.
 1915-1916
Color lithographic poster, 197.2 x
 99.3 cm. (77⅝ x 39¹⁄₁₆ in.),
 1915-1916
T/NPG.84.114.87

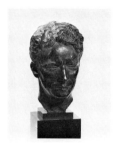

Chaplin, Sir Charles Spencer*,
 1889-1977
Actor, film director, writer
Jo Davidson, 1883-1952
Bronze, 30.5 cm. (12⅛ in.), 1925
T/NPG.72.30.87

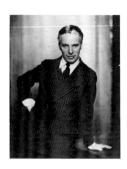

Chaplin, Sir Charles Spencer*,
 1889-1977
Actor, film director, writer
Nickolas Muray, 1892-1965
Photograph, gelatin silver print, 24.4
 x 19.5 cm. (9⅝ x 7¹¹⁄₁₆ in.), 1978
 from 1924 negative
T/NPG.78.190.87

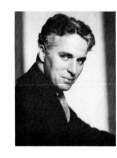

Chaplin, Sir Charles Spencer*,
 1889-1977
Actor, film director, writer
Edward Steichen, 1879-1973
Photograph, gelatin silver print, 24.5
 x 19.3 cm. (9⅝ x 7⁹⁄₁₆ in.), 1925
T/NPG.82.83.87
Bequest of Edward Steichen

Chapman, John Jay, 1862-1933
Essayist
William Collins, ?-?
Oil on canvas, 68.7 x 56.5 cm. (27¹⁄₁₆
 x 22¼ in.), c. 1895
NPG.80.130
Gift of Chanler A. Chapman

Chase, Salmon Portland, 1808-1873
Statesman, Chief Justice of the
 United States
Bobbett and Hooper wood-engraving
 company, active 1855-1870, after
 Henry Louis Stephens
Wood engraving, 26.7 x 20.1 cm.
 (10½ x 7¹⁵⁄₁₆ in.), 1862
Published in *Vanity Fair*, New York,
 January 25, 1862
NPG.85.60

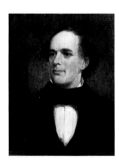

Chase, Salmon Portland, 1808-1873
Statesman, Chief Justice of the
 United States
Francis Bicknell Carpenter,
 1830-1900
Oil on canvas, 30.4 x 25.4 cm. (12 x
 10 in.), 1861
NPG.69.47
Gift of David Rockefeller

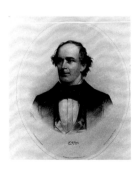

Chase, Salmon Portland, 1808-1873
Statesman, Chief Justice of the
 United States
Leopold Grozelier, 1830-1865, after
 Francis Bicknell Carpenter
S. W. Chandler and Brother
 lithography company
Lithograph, 29 x 27.5 cm. (11⁷⁄₁₆ x
 10⅞ in.), 1855
Published in Charles H. Brainard's
 *Portrait Gallery of Distinguished
 Americans*, Boston, 1855
NPG.77.73

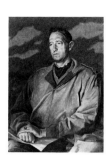

Clark, Mark Wayne*, 1896-1984
World War II general
Pietro Annigoni, 1910-
Oil on canvas, 91.4 x 76.2 cm. (36 x
 30 in.), 1946
T/NPG.71.51.94
Gift of General Mark Wayne Clark

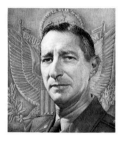

Clark, Mark Wayne*, 1896-1984
World War II general
Guy Rowe ("Giro"), 1894-1969
Crayon on artist board, 23.5 x 21 cm.
 (9¼ x 8¼ in.), 1950
T/NPG.82.107.94
Gift of Charles Rowe

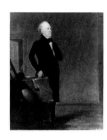

Clark, William, 1770-1838
Explorer
George Catlin, 1796-1872
Oil on canvas, 72.4 x 59.6 cm. (28½ x
 23½ in.), 1832
NPG.71.36

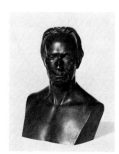

Clay, Cassius Marcellus, 1810-1903
Abolitionist
Unidentified photographer
Photograph, salt print, 27 x 23 cm.
 (10⅝ x 9¹⁄₁₆ in.), 1860
NPG.78.5

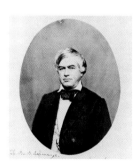

Clay, Henry, 1777-1852
Statesman
Henry Kirke Brown, 1814-1886
Bronze, 32.3 cm. (12¾ in.), 1852
NPG.77.36

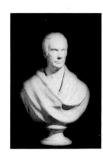

Clay, Henry, 1777-1852
Statesman
Shobal Vail Clevenger, 1812-1843
Plaster, 80 cm. (31½ in.), 1837
NPG.74.51
Gift of Marvin Sadik

Clay, Henry, 1777-1852
Statesman
Charles G. Crehen, 1829-?, after
 Savinien Edmé Dubourjal
Nagel and Weingaertner lithography
 company
Lithograph, 37.5 x 31.1 cm. (14¾ x
 12¼ in.), 1850
NPG.78.71

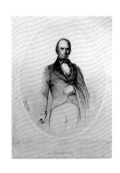

Clay, Henry, 1777-1852
Statesman
Nathaniel Currier, 1813-1888
Hand-colored lithograph, 32.2 x 23.8
 cm. (12¹¹⁄₁₆ x 9⅜ in.), 1844
NPG.85.57

Clay, Henry, 1777-1852
Statesman
Francis D'Avignon, c. 1814-?, after
 daguerreotype by Anthony,
 Edwards and Company
George Endicott lithography
 company
Lithograph, 47.4 x 37.6 cm. (18¹¹⁄₁₆ x
 14¹³⁄₁₆ in.), 1844
NPG.77.332

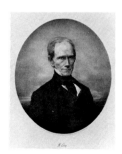

Clay, Henry, 1777-1852
Statesman
Francis D'Avignon, c. 1814-?, after
 daguerreotype by Mathew Brady
Lithograph, 28.5 x 24.6 cm. (11¼ x
 9¹¹⁄₁₆ in.), 1850
Published in Mathew Brady's
 Gallery of Illustrious Americans,
 New York, 1850
NPG.77.4
Gift of Marvin Sadik

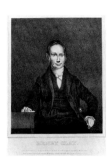

Clay, Henry, 1777-1852
Statesman
Endicott and Swett lithography
 company, active 1830-1834, after
 William James Hubard
Lithograph, 28 x 22.4 cm. (11 x 8¹³⁄₁₆
 in.), 1832
NPG.77.333

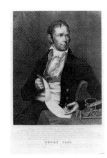

Clay, Henry, 1777-1852
Statesman
Jarvis Griggs Kellogg, 1805-1873,
 after Charles Bird King
Engraving, 26.3 x 22.1 cm. (8¹¹⁄₁₆ x
 10⅜ in.), 1832
NPG.79.158

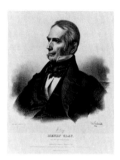

Clay, Henry, 1777-1852
Statesman
Charles Fendrich, 1805-1887
Lehman and Duval lithography
 company
Lithograph, 27.1 x 26.8 cm. (10¹¹⁄₁₆ x
 10⁹⁄₁₆ in.), 1837
NPG.66.79
*Transfer from the Library of
Congress, Prints and Photographs
Division*

Clay, Henry, 1777-1852
Statesman
Frederick C. Key, active 1844-1864
Pressed paper, 6.3 x 4.7 cm. (2½ x 1⅞
 in.) oval, not dated
NPG.72.31

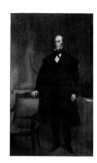

Clay, Henry, 1777-1852
Statesman
Attributed to Chester Harding,
 1792-1866
Oil on canvas, 244.4 x 151.1 cm.
 (96¼ x 59½ in.), not dated
NPG.77.12
*Transfer from the National Museum
of American Art*

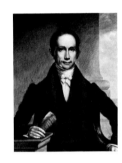

Clay, Henry, 1777-1852
Statesman
James Barton Longacre, 1794-1869,
 after William James Hubard
Ink on artist board, 25.7 x 20.3 cm.
 (10⅛ x 8 in.), c. 1833
NPG.77.288

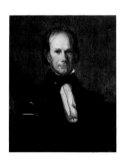

Clay, Henry, 1777-1852
Statesman
George Peter Alexander Healy,
 1813-1894
Oil on canvas, 76.2 x 63.4 cm. (30 x
 25 in.), c. 1845
NPG.65.44
*Transfer from the National Gallery
of Art; gift of Andrew W. Mellon,
1942*

Clay, Henry, 1777-1852
Statesman
John McPherson, active c. 1846-1860,
 after photograph
Pressed paper, 18.1 x 13.1 cm. (7⅛ x
 5³⁄₁₆ in.), c. 1848-1852
NPG.79.183

Clay, Henry, 1777-1852
Statesman
E. B. and E. C. Kellogg lithography
 company, active c. 1842-1867, after
 William Henry Brown
Lithographed silhouette, 34.1 x 25.2
 cm. (13⁷⁄₁₆ x 9⅞ in.), 1844
Published in William H. Brown's
 *Portrait Gallery of Distinguished
 American Citizens*, Hartford, 1845
NPG.79.181

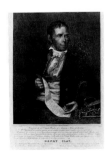

Clay, Henry, 1777-1852
Statesman
Peter Maverick, 1780-1831, after
 Charles Bird King
Engraving, 34 x 27 cm. (13⅜ x 10⅝
 in.), 1822
NPG.72.55

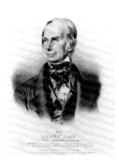

Clay, Henry, 1777-1852
Statesman
Albert Newsam, 1809-1864, after
 John Neagle
Lithograph, 26.2 x 24 cm. (10⁵⁄₁₆ x
 9⁷⁄₁₆ in.), 1844
NPG.79.131

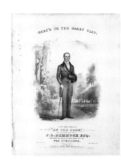

Clay, Henry, 1777-1852
Statesman
Benjamin W. Thayer lithography
 company, active 1840-1851
Lithograph, 19.9 x 17.6 cm. (7¹³⁄₁₆ x
 6¹⁵⁄₁₆ in.), 1844
Music sheet title page: "Here's To
 You Harry Clay"
NPG.84.11

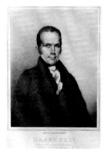

Clay, Henry, 1777-1852
Statesman
Albert Newsam, 1809-1864, after
 Joseph Wood
Cephas G. Childs lithography
 company
Lithograph, 23.6 x 18.2 cm. (9⁵⁄₁₆ x
 7⅛ in.), 1829
NPG.78.39

Clay, Henry, 1777-1852
Statesman
Benjamin W. Thayer lithography
 company, active 1840-1851, after
 William James Hubard
Chromolithograph, 28.3 x 21.5 cm.
 (11⅛ x 8½ in.), 1844
Music sheet title page: "Henry Clay's
 Grand March"
NPG.80.33

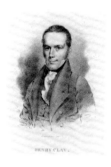

Clay, Henry, 1777-1852
Statesman
Attributed to Albert Newsam,
 1809-1864, after Joseph Wood
Childs and Inman lithography
 company
Lithograph, 11.2 x 9.3 cm. (4¹¹⁄₁₆ x
 3⅝ in.), c. 1831
NPG.78.295

Clay, Henry, 1777-1852
Statesman
William Warner, Jr., c. 1813-1848,
 after John Neagle
Mezzotint, 47.5 x 38.1 cm. (18¹¹⁄₁₆ x
 15 in.), 1844
NPG.79.133

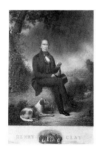

Clay, Henry, 1777-1852
Statesman
Henry S. Sadd, active 1832-1850, after
 John Wood Dodge
Mezzotint, 49.7 x 38.1 cm. (19⁹⁄₁₆ x
 15 in.), 1843
NPG.85.64
*Gift of Gladys M. Whitehead and
 Florence S. Whitehead*

Clay, Henry, 1777-1852
Statesman
Charles Cushing Wright, 1796-1854
Bronze medal, 8.9 cm. (3½ in.)
 diameter, 1851
NPG.77.245
Gift of Marvin Sadik

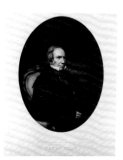

Clay, Henry, 1777-1852
Statesman
Samuel Sartain, 1830-1906, after
 daguerreotype by Marcus Aurelius
 Root
Mezzotint and line engraving, 27.4
 x 20.9 cm. (10¹³⁄₁₆ x 8¼ in.), 1865
NPG.78.43

Clay, Henry, 1777-1852
Statesman
Charles Cushing Wright, 1796-1854
Bronze medal, 7.6 cm. (3 in.)
 diameter, c. 1855
NPG.77.246
Gift of Marvin Sadik

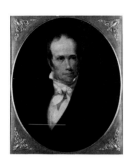

Clay, Henry, 1777-1852
Statesman
Unidentified artist, after the 1838 oil
 by Edward Dalton Marchant
Oil on canvas, 76.8 x 63.4 cm. (30¼ x
 25 in.), 1842-1848
NPG.65.43
*Transfer from the National Gallery
 of Art; gift of Andrew W. Mellon,
 1942*

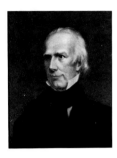

Clay, Henry, 1777-1852
Statesman
Unidentified artist, after Rembrandt
 Peale
Oil on canvas, 61.5 x 50.8 cm. (24¼ x
 20 in.), not dated
NPG.66.27
*Transfer from the National Museum
 of American Art; gift of the
 International Business Machines
 Corporation to the Smithsonian
 Institution, 1962*

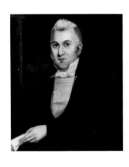

Clay, Henry, 1777-1852
Statesman
Unidentified photographer, after
 1848 daguerreotype attributed to
 Blanchard P. Paige and Beach
Daguerreotype, 10.8 x 8.1 cm. (4¼ x
 3³⁄₁₆ in.), c. 1850
NPG.77.259

Clayton, John Middleton, 1796-1856
Statesman
David Acheson Woodward,
 1823-1909
Oil on canvas, 73.6 x 62.2 cm. (29 x
 24½ in.), 1843
NPG.74.3

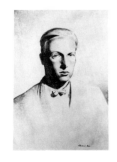

Cleland, Thomas Maitland,
 1880-1964
Graphic designer
Rockwell Kent, 1882-1971
Lithograph, 24.7 x 17.9 cm. (9¹¹⁄₁₆ x 7
 in.), 1929
NPG.83.179

Cleveland, Stephen Grover,
 1837-1908
Twenty-second and twenty-fourth
 President of the United States
Eastman Johnson, 1824-1906
Oil on artist board, 57.7 x 47.6 cm.
 (22¾ x 18¾ in.), 1884
NPG.71.58
Gift of Francis G. Cleveland

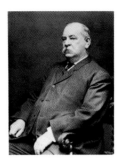

Cleveland, Stephen Grover,
 1837-1908
Twenty-second and twenty-fourth
 President of the United States
Pach Brothers studio, active since
 1867
Photograph, gelatin silver print, 32.2
 x 23.7 cm. (12⅝ x 9⁵⁄₁₆ in.), 1904
NPG.80.24

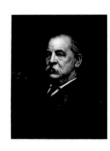

Cleveland, Stephen Grover,
 1837-1908
Twenty-second and twenty-fourth
 President of the United States
Jacques Reich, 1852-1923
Etching, 37.5 x 29.7 cm. (14¾ x 11¹¹⁄₁₆
 in.), 1906
NPG.67.74
Gift of Oswald D. Reich

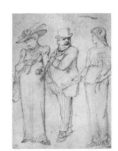

Cleveland, Stephen Grover,
 1837-1908
Twenty-second and twenty-fourth
 President of the United States
Sir John Tenniel, 1820-1914
Pencil on paper, 20.3 x 15.9 cm. (8 x
 6¼ in.), c. 1888
NPG.72.105

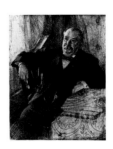

Cleveland, Stephen Grover,
 1837-1908
Twenty-second and twenty-fourth
 President of the United States
Anders Zorn, 1860-1920
Etching and aquatint, 22.4 x 18 cm.
 (8¹³⁄₁₆ x 7¹⁄₁₆ in.), 1899
NPG.71.28

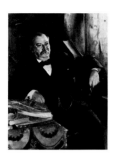

Cleveland, Stephen Grover,
1837-1908
Twenty-second and twenty-fourth
 President of the United States
Anders Zorn, 1860-1920
Oil on canvas, 121.9 x 91.4 cm. (48 x
 36 in.), 1899
NPG.77.229
*Gift of the Reverend Thomas G.
 Cleveland*

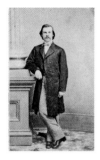

Cleveland, Stephen Grover,
1837-1908
Twenty-second and twenty-fourth
 President of the United States
Unidentified photographer
Photograph, albumen silver print,
 9.1 x 5.4 cm. (3⁹⁄₁₆ x 2⅛ in.), 1862
NPG.80.207

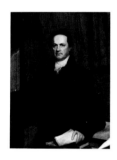

Clinton, DeWitt, 1769-1828
Statesman
John Wesley Jarvis, 1780-1840
Oil on canvas, 122.5 x 92.4 cm. (48¼
 x 36⅜ in.), c. 1816
NPG.65.53
*Transfer from the National Gallery
 of Art; gift of Andrew W. Mellon,
 1942*

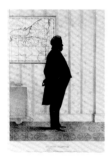

Clinton, DeWitt, 1769-1828
Statesman
E. B. and E. C. Kellogg lithography
 company, active c. 1842-1867, after
 William Henry Brown
Lithographed silhouette, 34.2 x 25
 cm. (13⁷⁄₁₆ x 9⅞ in.), 1844
Published in William H. Brown's
 *Portrait Gallery of Distinguished
 American Citizens,* Hartford, 1845
NPG.79.200

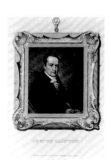

Clinton, DeWitt, 1769-1828
Statesman
James Barton Longacre, 1794-1869,
 after George Catlin
Stipple engraving, 16.3 x 12.9 cm.
 (6⁷⁄₁₆ x 5⅛ in.), 1825
NPG.79.242

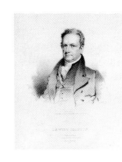

Clinton, DeWitt, 1769-1828
Statesman
Albert Newsam, 1809-1864, after
 Henry Inman
Childs and Inman lithography
 company
Lithograph, 13 x 13.9 cm. (5⅛ x 5⅜
 in.), 1830
NPG.81.62

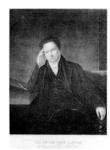

Clinton, DeWitt, 1769-1828
Statesman
John Francis Eugene Prud'homme,
 1800-1892, after Charles Cromwell
 Ingham
Stipple engraving, 42.1 x 34.3 cm.
 (16⁹⁄₁₆ x 13½ in.), 1832
NPG.80.53

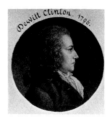

Clinton, DeWitt, 1769-1828
Statesman
Charles Balthazar Julien Févret de
 Saint-Mémin, 1770-1852
Engraving, 5.6 cm. (2¼ in.) diameter,
 1796
NPG.77.39.469
Gift of Mr. and Mrs. Paul Mellon

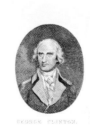

Clinton, George, 1739-1812
Vice-President of the United States
Alexander Anderson, 1775-1870
Engraving and etching, 8.8 x 7 cm.
 (3½ x 2¾ in.), c. 1801
Published in James Hardie's *The
 New Universal Biographical
 Dictionary and American
 Remembrancer . . . ,* vol. 2, New
 York, 1801
NPG.80.184.1

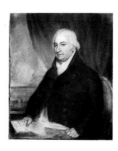

Clinton, George, 1739-1812
Vice-President of the United States
Attributed to James Sharples, c.
 1788-1839, or Felix Sharples, c.
 1786-c. 1824
Pastel on paper, 30.5 x 25.4 cm. (12 x
 10 in.), c. 1806
NPG.84.172
Gift of Charles N. Andreae

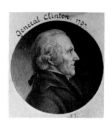

Clinton, James, 1773-1812
Revolutionary general
Charles Balthazar Julien Févret de
 Saint-Mémin, 1770-1852
Engraving, 5.6 cm. (2¼ in.) diameter,
 1796
NPG.77.39.57
Gift of Mr. and Mrs. Paul Mellon

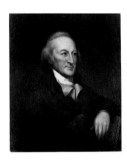

Clymer, George, 1739-1813
Revolutionary statesman
Unidentified artist, after Charles
 Willson Peale
Oil on canvas, 77.4 x 63.4 cm. (30½ x
 25 in.), c. 1807-1810
NPG.72.5
Gift of W. B. Shubrick Clymer

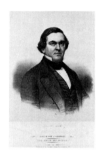

Cobb, Howell, 1815-1868
Statesman
Francis D'Avignon, c. 1814-?
Casimir Bohn, publisher
Lithograph, 27.2 x 26.3 cm. (10¹¹⁄₁₆ x
 10⅜ in.), c. 1851-1854
NPG.74.19

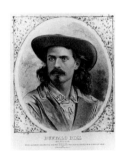

**Cody, William Frederick ("Buffalo
 Bill"),** 1846-1917
Showman
Samuel S. Frizzell, 1843-1895, after
 photograph
J. H. Bufford lithography company
Lithograph, 21.8 x 24.7 cm. (8⅝ x 9¾
 in.), c. 1869-1890
Published in *Folio,* Boston,
 c. 1869-1890
NPG.71.11

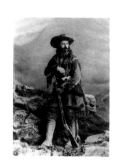

**Cody, William Frederick ("Buffalo
 Bill"),** 1846-1917
Showman
José Maria Mora, c. 1847-1926
Photograph, albumen silver print, 14
 x 10 cm. (5½ x 3¹⁵⁄₁₆ in.), c. 1875
NPG.77.155

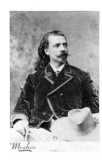

**Cody, William Frederick ("Buffalo
 Bill"),** 1846-1917
Showman
Charles D. Mosher, active 1864-1890
Photograph, albumen silver print,
 15.8 x 10.3 cm. (5¹³⁄₁₆ x 4¹⁄₁₆ in.),
 c. 1877
NPG.77.362

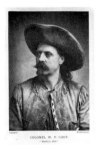

**Cody, William Frederick ("Buffalo
 Bill"),** 1846-1917
Showman
Unidentified photographer
Woodburytype, 14.2 x 9.7 cm. (5⅝ x
 3¹³⁄₁₆ in.), 1887
NPG.83.145

Cohan, George Michael, 1878-1942
Composer, actor, producer
Alfred J. Frueh, 1880-1968
Linocut, 25.7 x 13.8 cm. (10⅛ x 5⁷⁄₁₆
 in.), 1922
Published in Alfred J. Frueh's *Stage
 Folk,* New York, 1922
NPG.84.229.r

Cole, Thomas, 1801-1848
Artist
Attributed to Mathew Brady,
 1823-1896
Daguerreotype, 13.6 x 10.2 cm. (5⅜ x
 4 in.), c. 1845
NPG.76.11
Gift of Edith Cole Silberstein

Cole, Thomas, 1801-1848
Artist
Frederic Edwin Church, 1826-1900
Pencil and ink on paper, 17.8 x 23.6
 cm. (7¹⁄₁₆ x 9⁵⁄₁₆ in.), 1846
NPG.80.3

Coleman, Glenn O., 1887-1932
Artist
Marjorie Organ, 1886-1930
Ink and pencil on paper, 22.9 x
 15 cm. (9 x 5⅞ in.), 1910
NPG.81.143
Gift of Mr. and Mrs. Stuart P. Feld

Coolidge, Calvin, 1872-1933
Thirtieth President of the United
 States
Miguel Covarrubias, 1902-1957
Watercolor and india ink on paper,
 35 x 24.8 cm. (13¾ x 9¾ in.), before
 1925
NPG.79.76

Compton, Arthur Holly, 1892-1962
Scientist
Janet Gregg Wallace, 1902-
Plaster, 41.5 cm. (16⅜ in.), 1950
Bronze, 40.6 cm. (16 in.), cast after
 1950 plaster
NPG.65.11 and NPG.65.11.1

Coolidge, Calvin, 1872-1933
Thirtieth President of the United
 States
Julien Elfenstein, ?-?
Pencil, chalk, and ink on paper, 62.8
 x 52 cm. (24⅞ x 20½ in.), 1924
NPG.83.161

Conkling, Roscoe, 1829-1888
Statesman
John F. Jarvis, ?-?
Photograph, albumen silver print,
 14.8 x 9.9 cm. (5¹³⁄₁₆ x 3¹⁵⁄₁₆ in.),
 c. 1876
NPG.79.213

Coolidge, Calvin, 1872-1933
Thirtieth President of the United
 States
Dwight Case Sturges, 1874-1940
Etching and drypoint, 18.1 x 10 cm.
 (7⅛ x 3¹⁵⁄₁₆ in.), 1925
Published in Coolidge's *Foundation
 of the Republic*, New York, 1926
NPG.78.256

Cookman, Helen Cramp*, 1894-
Designer
Aline Fruhauf, 1907-1978
Watercolor and pencil with crayon
 and opaque white on paper, 41.8 x
 30.1 cm. (16⁷⁄₁₆ x 11⅞ in.), 1939
Illustration for *Vogue*, New York,
 October 15, 1940
T/NPG.83.274
Gift of Erwin Vollmer

Coolidge, Calvin, 1872-1933
Thirtieth President of the United
 States
Doris Ulmann, 1882-1934
Photograph, platinum print, 20.2 x
 15.1 cm. (7¹⁵⁄₁₆ x 5¹⁵⁄₁₆ in.), c. 1924
NPG.85.90

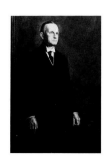

Coolidge, Calvin, 1872-1933
Thirtieth President of the United
 States
Joseph E. Burgess, 1890-1961, after
 the 1929 oil by Ercole Cartotto
Oil on canvas, 143.5 x 97.1 cm. (56½
 x 38¼ in.), 1956
NPG.65.13
*Gift of the Fraternity of Phi Gamma
 Delta*

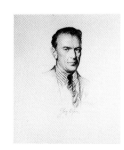

Cooper, Gary, 1901-1961
Actor
Samuel Johnson Woolf, 1880-1948
Charcoal and chalk on paper, 59.8 x
 47.4 cm. (23½ x 18¹¹⁄₁₆ in.), not
 dated
NPG.80.255

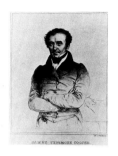

Cooper, James Fenimore, 1789-1851
Author
Julien Leopold Boilly, 1796-1874
Gottfried Engelmann lithography
 company
Lithograph, 24.8 x 14.5 cm. (9¾ x
 5¹¹⁄₁₆ in.), 1831
NPG.77.330

Cooper, James Fenimore, 1789-1851
Author
Cäcilie Brandt, ?-?, after Amalie
 Kautz
Lithograph, 15.7 x 12.9 cm. (6³⁄₁₆ x
 5¹⁄₁₆ in.), c. 1830-1840
NPG.81.44

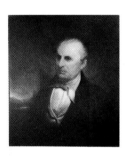

Cooper, James Fenimore, 1789-1851
Author
Attributed to Charles Loring Elliott,
 1812-1868
Oil on canvas, 76.2 x 63.5 cm. (30 x
 25 in.), not dated
NPG.66.97
Gift of Alexis I. duPont deBie

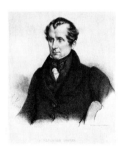

Cooper, James Fenimore, 1789-1851
Author
Amalie Kautz, 1796-1860
Lithograph, 26.3 x 26.6 cm. (10⅜ x
 10½ in.), c. 1827
NPG.81.150

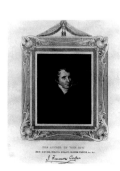

Cooper, James Fenimore, 1789-1851
Author
Oliver Pelton, 1798-1882, after M.
 Mirbel
Engraving, 11 x 8.7 cm. (4⁵⁄₁₆ x 3⁷⁄₁₆
 in.), 1838
NPG.77.74

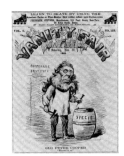

Cooper, Peter, 1791-1883
Manufacturer, inventor,
 philanthropist
Bobbett and Hooper wood-engraving
 company, active 1855-1870, after
 Henry Louis Stephens
Wood engraving, 15.5 x 14.5 cm. (6⅛
 x 5¹¹⁄₁₆ in.), 1862
Published in *Vanity Fair*, New York,
 November 29, 1862
NPG.78.231

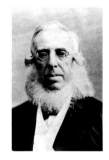

Cooper, Peter, 1791-1883
Manufacturer, inventor,
 philanthropist
Napoleon Sarony, 1821-1896
Photograph, albumen silver print,
 9.4 x 5.9 cm. (3¹¹⁄₁₆ x 2⁵⁄₁₆ in.),
 c. 1868
NPG.79.56

Cooper, Thomas, 1759-1839
Scientist, educator
E. B. and E. C. Kellogg lithography
 company, active c. 1842-1867, after
 William Henry Brown
Lithographed silhouette, 34.3 x 25.3
 cm. (13½ x 10 in.), 1844
Published in William H. Brown's
 *Portrait Gallery of Distinguished
 American Citizens*, Hartford, 1845
NPG.80.276.t
Gift of Wilmarth Sheldon Lewis

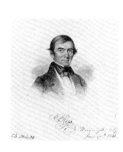

Coowescoowe ("John Ross"),
 1790-1866
Indian chief
John Rubens Smith, 1775-1849
Watercolor and ink on paper, 26 x
 20.3 cm. (10¼ x 8 in.), 1841
NPG.72.74

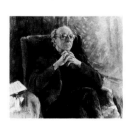

Copland, Aaron*, 1900-
Composer
Marcos Blahove, 1928-
Oil on canvas, 70.8 x 81 cm. (27⅞ x
 31⅞ in.), 1972
T/NPG.73.7
Gift of Felice Copland Marlin

Copland, Aaron*, 1900-
Composer
Aline Fruhauf, 1907-1978
Pencil and blue ink with opaque
 white on paper, 23.4 x 16.3 cm.
 (9³⁄₁₆ x 6⅜ in.), c. 1960
T/NPG.83.57
Gift of Erwin Vollmer

Copland, Aaron*, 1900-
Composer
Aline Fruhauf, 1907-1978
Woodcut, 25.5 x 8 cm. (10¹⁄₁₆ x 3⅛
 in.), 1965
T/NPG.83.257
Gift of Erwin Vollmer

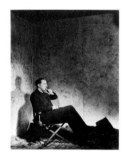

Copland, Aaron*, 1900-
Composer
George Platt Lynes, 1907-1955
Photograph, gelatin silver print, 32.9
 x 26.1 cm. (13 x 10¼ in.), c. 1935
T/NPG.84.264

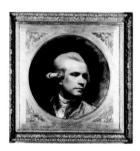

Copley, John Singleton, 1738-1815
Artist
Self-portrait
Oil on canvas, 45.5 cm. (18 in.)
 diameter, 1780-1784
NPG.77.22
*Gift of the Morris and Gwendolyn
 Cafritz Foundation and matching
 funds from the Smithsonian
 Institution*

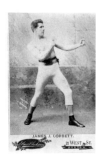

Corbett, James John, 1866-1933
Athlete
Elmer Chickering, ?-1915
Photograph, albumen silver print,
 14.2 x 10 cm. (5⅝ x 3¹⁵⁄₁₆ in.), 1896
NPG.83.148

Corbett, James John, 1866-1933
Athlete
William M. Morrison, active c.
 1875-?
Photograph, albumen silver print,
 13.9 x 10.2 cm. (5½ x 4 in.), c. 1895
NPG.83.147

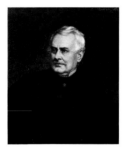

Corcoran, William Wilson,
 1798-1888
Banker, philanthropist
George Peter Alexander Healy,
 1813-1894
Oil on canvas, 76.2 x 63.5 cm. (30 x
 25 in.), 1884
NPG.66.18
*Gift of Mrs. David E. Finley and Mrs.
 Eustis Emmett*

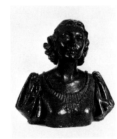

Cornell, Katharine, 1893-1974
Actress
Richmond Barthé, 1901-
Painted plaster, 52 cm. (20½ in.),
 c. 1943
NPG.67.3
*Gift of the artist through the
 Harmon Foundation*

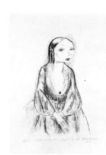

Cornell, Katharine, 1893-1974
Actress
Aline Fruhauf, 1907-1978
Lithograph with pencil, 23.5 x 15.7
 cm. (9¼ x 6⅛ in.), 1931
Published in *The Morning
 Telegraph*, New York, November
 21, 1931
NPG.83.58
Gift of Erwin Vollmer

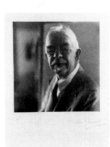

Cortissoz, Royal, 1869-1948
Critic
Clara E. Sipprell, 1885-1975
Photograph, Gevalux print, 17.9 x
 17.6 cm. (7¹⁄₁₆ x 6¹⁵⁄₁₆ in.), c. 1940
NPG.82.198
Bequest of Phyllis Fenner

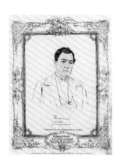

Corwin, Thomas, 1794-1865
Lawyer
Unidentified artist, after
 daguerreotype by John Plumbe, Jr.
Hand-colored lithograph, 33 x 26 cm.
 (13 x 10¼ in.), 1846
Contained in *The National
 Plumbeotype Gallery,*
 Philadelphia, 1847
NPG.78.84.j

Covarrubias, Miguel, 1904-1957
Artist
Al Hirschfeld, 1903-
Pencil on paper, 22.8 x 30.4 cm. (9 x
 11¹⁵⁄₁₆ in.), c. 1924
NPG.84.161
Gift of Al Hirschfeld

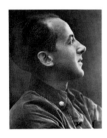

Cowell, Henry Dixon, 1897-1965
Composer
Edward Weston, 1886-1958
Photograph, gelatin silver print, 23.7
 x 18.7 cm. (9⁵⁄₁₆ x 7⅜ in.), c. 1928
NPG.84.117

Cox, Kenyon, 1856-1919
Artist
Augustus Saint-Gaudens, 1848-1907
Bronze bas-relief, 26 x 21.3 cm. (10¼
 x 8⅜ in.), 1889
NPG.83.120
Bequest of Allyn Cox

Cox, Samuel Hanson, 1793-1880
Clergyman
David Octavius Hill, 1802-1870, and
 Robert Adamson, 1821-1848
Photograph, calotype, 21 x 15.4 cm.
 (8⅛ x 6¹⁄₁₆ in.), c. 1843
NPG.84.118

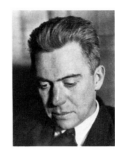

Crane, Harold Hart, 1899-1932
Poet
Walker Evans, 1903-1975
Photograph, gelatin silver print, 12.9
 x 10 cm. (5¹⁄₁₆ x 3¹⁵⁄₁₆ in.), c. 1930
NPG.77.48

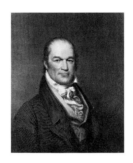

Crawford, William Harris, 1772-1834
Statesman
Asher Brown Durand, 1796-1886,
 after John Wesley Jarvis
Engraving, 24.2 x 19.9 cm. (9½ x
 7¹³⁄₁₆ in.), 1820-1835
NPG.77.75

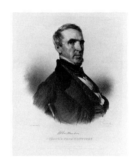

Crittenden, John Jordan, 1787-1863
Statesman
Charles Fenderich, 1805-1887
P. S. Duval lithography company
Lithograph, 26.4 x 25.5 cm. (10½ x
 10 in.), 1841
NPG.66.80
*Transfer from the Library of
 Congress, Prints and Photographs
 Division*

Crittenden, John Jordan, 1787-1863
Statesman
George Peter Alexander Healy,
 1813-1894
Oil on canvas, 74.9 x 62.8 cm. (29½ x
 24¾ in.), 1857
NPG.64.1
*Gift of Mr. and Mrs. Silas B.
 McKinley*

Crockett, David, 1786-1836
Frontiersman
Asher Brown Durand, 1796-1886,
 after Anthony Lewis De Rose
Engraving, 11.2 x 13 cm. (4⅜ x 5⅛
 in.), c. 1835
NPG.79.8

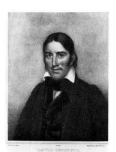

Crockett, David, 1786-1836
Frontiersman
Attributed to Albert Newsam,
 1809-1864, after Samuel Stillman
 Osgood
Childs and Lehman lithography
 company
Lithograph, 22.7 x 18.1 cm. (8¹⁵⁄₁₆ x
 7⅛ in.), 1834
NPG.68.54

Cruger, Henry, 1739-1827
Colonial merchant and statesman
Attributed to Luke Sullivan,
 1705-1771
Watercolor on ivory, 2.8 x 2.5 cm.
 (1⅛ x 1 in.), 1770
NPG.81.117

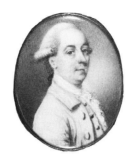

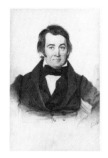

Crockett, David, 1786-1836
Frontiersman
James Hamilton Shegogue, 1806-1872
Watercolor over pencil on paper,
 22.2 x 15.1 cm. (8¾ x 5¹⁵⁄₁₆ in.), 1831
NPG.84.231
Gift of Algernon Sidney Holderness

Cuffe, Paul, 1759-1817
Early black leader
Mason and Maas, active mid-
 nineteenth century, after John Pole
Wood engraving, 16.6 x 12.4 cm.
 (6⁹⁄₁₆ x 4⅞ in.), c. 1830
NPG.77.161

Crockett, David, 1786-1836
Frontiersman
Unidentified artist
Woodcut, 9.4 x 17.2 cm. (3¹¹⁄₁₆ x 6¾
 in.), 1835
Published in *Davy Crockett's
 Almanack for 1835,* Nashville,
 1835
NPG.85.138

Cullen, Countee Porter, 1903-1946
Poet
Winold Reiss, 1886-1953
Pastel on artist board, 76.3 x 54.6 cm.
 (30¹⁄₁₆ x 21½ in.), c. 1925
NPG.72.76
*Gift of Lawrence A. Fleischman and
 Howard Garfinkle with a
 matching grant from the National
 Endowment for the Arts*

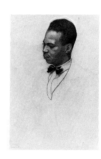

Crockett, David, 1786-1836
Frontiersman
Unidentified artist
Woodcut, 17.2 x 9.4 cm. (6¾ x 3¹¹⁄₁₆
 in.), 1837
Published in *Davy Crockett's
 Almanack for 1837,* Nashville,
 1837
NPG.85.139.a

Cullen, Countee Porter, 1903-1946
Poet
Carl Van Vechten, 1880-1964
Photogravure, 22.3 x 14.9 cm. (8¹³⁄₁₆
 x 5⅞ in.), 1983 from 1941 negative
NPG.83.188.9

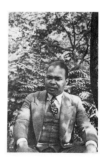

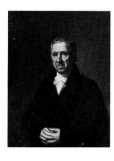

Crosby, Enoch, c. 1750-1835
Revolutionary spy
Samuel Lovett Waldo, 1783-1861,
 and William Jewett, 1789/90-1874
Oil on panel, 83.8 x 64.7 cm. (33 x
 25½ in.), 1830
NPG.77.23

**Cummings, Edward Estlin ("e e
 cummings"),** 1894-1962
Poet
Self-portrait
Oil on canvas, 50.8 x 38.1 cm. (20 x
 15 in.), 1958
NPG.73.26

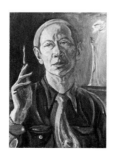

Cunningham, Imogen, 1883-1976
Photographer
Leo Holub, 1916-
Photograph, gelatin silver print, 18.4
 x 20.5 cm. (7¼ x 8¹/₁₆ in.), 1972
NPG.80.307
Gift of Leo Holub

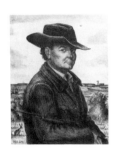

Curry, John Steuart, 1897-1946
Artist
Self-portrait
Lithograph, 32.7 x 24.8 cm. (12⅞ x
 9¾ in.), 1939
NPG.85.33

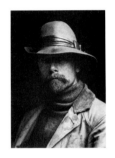

Curtis, Edward Sheriff, 1868-1952
Photographer
Self-portrait
Photograph, gelatin silver print, 25.4
 x 18 cm. (10 x 7⅛ in.), 1899
NPG.77.49

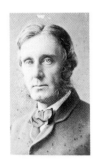

Curtis, George William, 1824-1892
Editor
Abraham Bogardus, 1822-1908
Photograph, albumen silver print,
 9.3 x 5.6 cm. (3¹¹/₁₆ x 2³/₁₆ in.),
 c. 1870
NPG.80.155

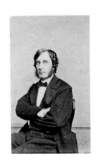

Curtis, George William, 1824-1892
Editor
Charles DeForest Fredricks,
 1823-1894
Photograph, albumen silver print,
 9.1 x 5.3 cm. (3⁹/₁₆ x 2⅛ in.), c.
 1863
NPG.80.209

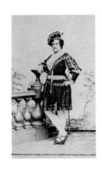

Curtis, George William, 1824-1892
Editor
Jacques Reich, 1852-1923
Etching, 38 x 30.3 cm. (15 x 11¹⁵/₁₆
 in.), 1907
NPG.67.73
Gift of Oswald D. Reich

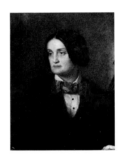

**Cushman, Charlotte Saunders (as
 Romeo),** 1816-1876
Actress
John Case, 1808-1880, and William
 H. Getchell, 1829-1910; studio
 active 1863-1865
Photograph, albumen silver print,
 8.6 x 5.4 cm. (3⅜ x 2⅛ in.), c. 1863
NPG.80.189

Cushman, Charlotte Saunders,
 1816-1876
Actress
William Page, 1811-1885
Oil on canvas, 69.8 x 55.8 cm. (27½ x
 22 in.), 1853
NPG.72.15

Cushman, Charlotte Saunders,
 1816-1876
Actress
Unidentified artist
Oil on canvas, 60.3 x 47 cm. (23¾ x
 18½ in.), c. 1836
NPG.72.106

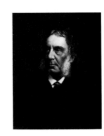

Cushman, Charlotte Saunders,
 1816-1876
Actress
Unidentified photographer
Daguerreotype, 14 x 11.8 cm. (5½ x
 4⅝ in.), c. 1850
NPG.78.60

Cushman, Pauline, 1833-1893
Actress
Charles DeForest Fredricks,
 1823-1894
Photograph, albumen silver print,
 9.2 x 5.4 cm. (3⅝ x 2⅛ in.), c. 1866
NPG.80.218

Custer, George Armstrong, 1839-1876
Union general
Unidentified photographer
Ambrotype, 13.8 x 10.4 cm. (5⅜ x
 4¹/₁₆ in.), c. 1863
NPG.82.53

Cushman, Pauline, 1833-1893
Actress
Charles DeForest Fredricks,
 1823-1894
Photograph, albumen silver print,
 9.1 x 5.4 cm. (3⁹/₁₆ x 2⅛ in.), c.
 1866
NPG.80.219

Daché, Lilly*, ?-
Hat designer
Aline Fruhauf, 1907-1978
Watercolor and pencil with colored
 pencil and opaque white on paper,
 37.8 x 25.6 cm. (14³/₁₆ x 10¹/₁₆ in.),
 1942
T/NPG.83.258
Gift of Erwin Vollmer

Custer, George Armstrong, 1839-1876
Union general
Mathew Brady, 1823-1896
Photograph, albumen silver print,
 7.9 x 16.2 cm. (3⅛ x 6⅜ in.), c. 1890
 from c. 1864 negative
NPG.77.200

Dahlgren, John Adolphus Bernard,
 1809-1870
Naval officer, inventor
Ehrgott, Forbriger lithography
 company, active 1858-1869
Lithograph, 25.1 x 23.9 cm. (9⅞ x 9⅜
 in.), c. 1861
NPG.78.81

Custer, George Armstrong, 1839-1876
Union general
José Maria Mora, c. 1847-1926
Photograph, albumen silver print,
 9.2 x 5.7 cm. (3⅝ x 2¼ in.), c. 1875
NPG.78.277

Dahlgren, John Adolphus Bernard,
 1809-1870
Naval officer, inventor
Jeremiah Gurney and Son, active
 c. 1860-c. 1875
Photograph, albumen silver print,
 5.5 x 3.7 cm. (2¼ x 1½ in.), c. 1863
NPG.80.302

Custer, George Armstrong, 1839-1876
Union general
Unidentified photographer
Ambrotype, 10.8 x 8.3 cm. (4¼ x 3¼
 in.), c. 1859
NPG.81.138

Dale, Chester, 1883-1962
Collector
Miguel Covarrubias, 1902-1957
Watercolor with pencil, 41.7 x 37.7
 cm. (16⅜ x 14¹³/₁₆ in.), c. 1930
NPG.85.39

Daley, Richard Joseph, 1902-1976
Mayor of Chicago
Rosalind Solomon, 1930-
Photograph, gelatin silver print, 33.2
 x 22.4 cm. (13⅛ x 8¹³⁄₁₆ in.), 1976
NPG.84.138

Dana, Richard Henry, 1815-1882
Author
George K. Warren, c. 1824-1884
Photograph, albumen silver print,
 9.5 x 5.8 cm. (3¾ x 2⁵⁄₁₆ in.),
 c. 1870
NPG.79.47

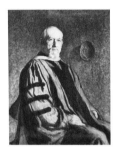

Dall, William Healey, 1845-1927
Naturalist
Wilford Seymour Conrow, 1880-1957
Oil on canvas, 111.7 x 85.1 cm. (44 x
 33½ in.), 1920
NPG.81.97
Gift of Whitney Dall

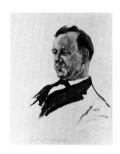

Daniels, Josephus, 1862-1948
Editor, statesman
Joseph Cummings Chase, 1878-1965
Oil on academy board, 62.2 x 47 cm.
 (24½ x 18½ in.), c. 1918
NPG.73.44
Gift of Mendel Peterson

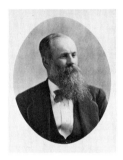

Dana, Charles Anderson, 1819-1897
Journalist
Unidentified photographer
Photograph, albumen silver print,
 11.8 x 9.2 cm. (4⅝ x 3⅝ in.), c.
 1870
NPG.85.104
Gift of Robert L. Drapkin

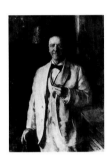

Daniels, Josephus, 1862-1948
Editor, statesman
DeWitt Lockman, 1870-1957
Oil on canvas, 126.6 x 91.4 cm. (49⅞
 x 36 in.), 1918
NPG.75.7
Gift of Mrs. Ann Thornton

Dana, John Cotton, 1856-1929
Librarian
Clara E. Sipprell, 1885-1975
Photograph, gelatin silver print, 25.1
 x 20.1 cm. (9⅞ x 7¹⁵⁄₁₆ in.), c. 1923
NPG.77.50

Darrow, Clarence Seward, 1857-1938
Lawyer
Jo Davidson, 1883-1952
Bronze, 44.7 cm. (17⅝ in.), 1929
NPG.67.50

Dana, Richard Henry, 1815-1882
Author
Asa B. Eaton, active c. 1866-c. 1874
Photograph, salt print, 13.5 x 10 cm.
 (5⁵⁄₁₆ x 3¹⁵⁄₁₆ in.), c. 1868
NPG.81.140

Darrow, Clarence Seward, 1857-1938
Lawyer
Aline Fruhauf, 1907-1978
India ink on paper, 21.6 x 19.1 cm.
 (8½ x 7½ in.), 1929
NPG.83.59
Gift of Erwin Vollmer

Davenport, Edward Loomis,
1815-1877
Actor
Napoleon Sarony, 1821-1896
Photograph, albumen silver print,
9.3 x 5.9 cm. (3¹¹⁄₁₆ x 2⁵⁄₁₆ in.),
c. 1868
NPG.80.152

Davenport, Fanny Lily Gypsy,
1850-1898
Actress
Henry Atwell Thomas, 1834-1904
H. A. Thomas lithography company
Lithographic poster, 59.4 x 49.8 cm.
(23⅜ x 19⅝ in.), c. 1877-1880
NPG.83.285

Davenport, John, 1597-1669/70
Clergyman
Amos Doolittle, 1754-1832, after
painting attributed to John Foster
Etching and engraving, 17 x 9.4 cm.
(6¹¹⁄₁₆ x 3¹¹⁄₁₆ in.), 1797
Published in Benjamin Trumbull's *A
Complete History of Connecticut*,
Hartford, 1797
NPG.77.114

Davidson, Jo, 1883-1952
Artist
Alexander Alland, Sr., 1907-
Photograph, gelatin silver print, 24.5
x 19.5 cm. (9⅝ x 7¹¹⁄₁₆ in.), 1939
NPG.85.48
Gift of the photographer

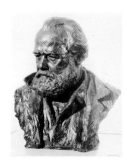

Davidson, Jo, 1883-1952
Artist
Self-portrait
Bronze, 50.8 (20 in.), 1981 cast after
1946 original
NPG.78.198
Gift of Dr. Maury Leibovitz

Davidson, Jo, 1883-1952
Artist
Rockwell Kent, 1882-1971
Pencil on cloth, 48.9 x 39.4 cm. (19¼
x 15½ in.) irregular, 1925
NPG.75.78

Davis, Andrew Jackson, 1826-1910
Spiritualist
Jeremiah Gurney, active 1840-c. 1890
Photograph, albumen silver print,
9.5 x 5.7 cm. (3½ x 2¼ in.), c. 1870
NPG.80.104

Davis, Jefferson, 1808-1889
President, Confederate States of
America
Currier and Ives lithography
company, active 1857-1907, after
photograph by Mathew Brady
Lithograph, 24.5 x 21.2 cm. (9⅞ x 8¼
in.), c. 1860-1864
NPG.81.40

Davis, Jefferson, 1808-1889
President, Confederate States of
America
Ludwig and Hoyer lithography
company, active 1861-1866, after
photograph
Lithograph, 23.4 x 22.4 cm. (9¼ x
8¹³⁄₁₆ in.), c. 1861
NPG.79.118

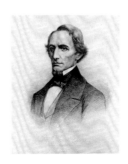

Davis, Jefferson, 1808-1889
President, Confederate States of
America
Pierre Guillaume Metzmacher,
1815-?, after photograph by
Mathew Brady
Engraving, 24.5 x 18.2 cm. (9⅝ x 7⅛
in.), 1862
NPG.78.293

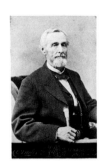

Davis, Jefferson, 1808-1889
President, Confederate States of
America
Columbus W. Motes, 1837-1919
Photograph, albumen silver print,
14.5 x 10.1 cm. (5¹¹⁄₁₆ x 4 in.),
c. 1886
NPG.84.157
Gift of Douglas S. Jordan

Davis, Jefferson, 1808-1889
President, Confederate States of
America
Unidentified photographer
Daguerreotype, 13.4 x 10.2 cm. (5¼ x
4 in.), c. 1858
NPG.77.260

Davis, Jefferson, 1808-1889
President, Confederate States of
America
Edward Sachse and Company
lithography company, active
1851-1874, after photograph by
James McClee
Lithograph with tintstone, 21.4 x 19
cm. (8⅜ x 7½ in.), 1861
Music sheet title page: "Confederacy
March"
NPG.82.11

Davis, Jefferson, 1808-1889
President, Confederate States of
America
Unidentified artist, after photograph
by Mathew Brady
Lithograph, 13.5 x 11.3 cm. (5⁵⁄₁₆ x
4⁷⁄₁₆ in.), 1861
Music sheet title page: "Our First
President Quickstep"
NPG.80.222

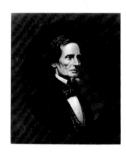

Davis, Jefferson, 1808-1889
President, Confederate States of
America
William Sartain, 1843-1924, after
photograph by Mathew Brady
Mezzotint, 28.2 x 23.7 cm. (11⅛ x 9⅜
in.), c. 1860
NPG.79.36
Gift of John O'Brien

Davis, Jefferson, 1808-1889
President, Confederate States of
America
Unidentified artist
Wood engraving, 23.8 x 34.5 cm. (9⅜
x 13⁹⁄₁₆ in.), 1865
Published in *Illustrated London
News*, July 1, 1865
NPG.84.354

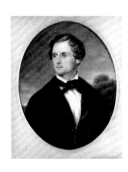

Davis, Jefferson, 1808-1889
President, Confederate States of
America
George Lethbridge Saunders,
1807-1863
Watercolor on ivory, 17 x 14 cm. (6⅝
x 5½ in.) feigned oval, 1849
NPG.79.228
*Gift of Joel A. H. Webb and Mrs.
Varina Webb Stewart*

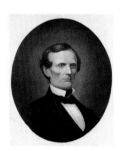

Davis, Jefferson, 1808-1889
President, Confederate States of
America
Unidentified artist, after photograph
Chromolithograph, 42.9 x 35.5 cm.
(16⅞ x 13¹⁵⁄₁₆ in.), c. 1861
NPG.84.355

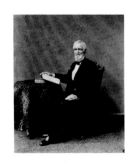

Davis, Jefferson, 1808-1889
President, Confederate States of
America
William W. Washburn, 1827-1903
Photograph, carbon print, 22.9 x 18.7
cm. (9 x 7⅜ in.), 1888
NPG.78.275

Davis, Jefferson, 1808-1889
President, Confederate States of
America
Unidentified artist, after photograph
Wood engraving, 21.6 x 13.2 cm. (8½
x 5³⁄₁₆ in.), 1862
Broadside: *Hark! O'er the Southern
Hills*, Norfolk, 1862
NPG.84.356

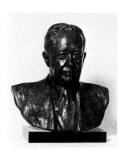

Davis, John William, 1873-1955
Statesman
Eleanor Platt, 1910-
Bronze, 53.9 cm. (21¼ in.), cast after
 1954 original
NPG.72.32
Gift of Davis, Polk, and Wardwell

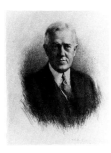

Davis, John William, 1873-1955
Statesman
Franklin T. Wood, 1887-1945
Etching, 33.5 x 26.5 cm. (13³⁄₁₆ x 10½
 in.), c. 1924
NPG.71.55
Gift of Davis, Polk, and Wardwell

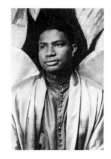

Davis, Ossie*, 1917-
Actor
Carl Van Vechten, 1880-1964
Photogravure, 22.4 x 14.9 cm. (8¹³⁄₁₆
 x 5⅞ in.), 1983 from 1951 negative
T/NPG.83.188.10

Davis, Stuart, 1894-1964
Artist
Self-portrait
Pencil on paper, 46.4 x 33.7 cm. (18¼
 x 13¼ in.), 1922-1924
NPG.82.131

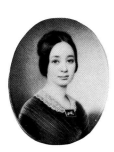

Davis, Varina Howell, 1826-1906
Wife of Jefferson Davis
John Wood Dodge, 1807-1893
Watercolor on ivory, 6.5 x 5.3 cm.
 (2½ x 2 in.), 1849
NPG.80.113
Gift of Varina Webb Stewart

Dawes, Charles Gates, 1865-1951
Vice-President of the United States,
 banker
Aline Fruhauf, 1907-1978
India ink and pencil on paper, 20.4 x
 18.6 cm. (8 x 7⁵⁄₁₆ in.), 1929
Published in *Washingtonian*,
 Washington, D.C., March 1929
NPG.83.60
Gift of Erwin Vollmer

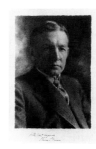

Dawes, Charles Gates, 1865-1951
Vice-President of the United States,
 banker
Harris and Ewing studio, active
 1905-1977
Photograph, gelatin silver print, 33 x
 22.8 cm. (13 x 9 in.), c. 1924
NPG.84.313
Gift of Aileen Conkey

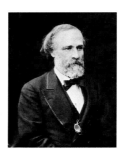

Dawes, Henry Laurens, 1816-1903
Statesman
Attributed to Samuel M. Fassett,
 active 1855-1875
Photograph, albumen silver print, 24
 x 19.6 cm. (9⁷⁄₁₆ x 7¾ in.), c. 1876
NPG.77.173

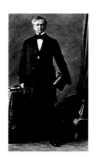

Dayton, William Lewis, 1807-1864
Diplomat
André Ádolphé Eugène Disderi,
 1819-1890
Photograph, albumen silver print,
 8.5 x 5.3 cm. (3⅜ x 2⅛ in.), c. 1861
NPG.77.166

Dean, James, 1931-1955
Actor
Dennis Stock, 1928-
Photograph, gelatin silver print, 17.4
 x 25.3 cm. (6¹³⁄₁₆ x 9¹⁵⁄₁₆ in.), 1955
NPG.83.192

Dean, James, 1931-1955
Actor
Dennis Stock, 1928-
Photograph, gelatin silver print, 21.6
 x 31 cm. (8½ x 12³⁄₁₆ in.), 1955
NPG.85.86

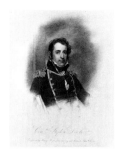

Decatur, Stephen, 1779-1820
Early national naval officer
Bernard Francis Hoppner Meyer,
 1811-?, after John Wesley Jarvis
Engraving, 20.5 x 16.2 cm. (8¹⁄₁₆ x 6⅜
 in.), c. 1830-1840
NPG.77.76

Deane, Silas, 1737-1789
Diplomat
B. B. Ellis, ?-?, after Benoit Louis
 Prevost, after Pierre Eugène Du
 Simitière
Stipple engraving, 11.1 x 9.2 cm. (4⅜
 x 3⅝ in.), 1783
Published in *Portraits of the
 Generals, Ministers, Magistrates,*
 London, 1783
NPG.75.66

Decatur, Stephen, 1779-1820
Early national naval officer
M. Osborn, active c. 1812-c. 1820,
 after Lemuel White
Stipple engraving, 13.9 x 10.4 cm.
 (5½ x 4⅛ in.), c. 1812-1815
NPG.79.11

Deane, Silas, 1737-1789
Diplomat
Benoit Louis Prevost, 1735-1804, after
 Pierre Eugène Du Simitière
Engraving, 16.2 x 11.4 cm. (6⅜ x 4½
 in.), 1780
Published in *Collection des Portraits
 des Généraux, Ministres, et
 Magistrats . . .* , Paris, 1781
NPG.75.60

Decatur, Stephen, 1779-1820
Early national naval officer
Unidentified artist, after David
 Edwin, after Gilbert Stuart
Stipple engraving, 7.6 cm. (3 in.)
 diameter, c. 1815
NPG.79.5

Deane, Silas, 1737-1789
Diplomat
Burnet Reading, active 1780-1820,
 after Benoit Louis Prevost, after
 Pierre Eugène Du Simitière
Stipple engraving, 7.3 x 6 cm. (2⅞ x
 2⅜ in.), 1783
Published in *American Legislators,
 Patriots, Soldiers,* London, 1783
NPG.75.63

Decatur, Stephen, 1779-1820
Early national naval officer
Unidentified artist, after Gilbert
 Stuart
Stipple and line engraving, 8.1 cm.
 (3³⁄₁₆ in.) diameter, c. 1817-1822
NPG.79.125

Debs, Eugene Victor, 1855-1926
Labor leader
Louis Mayer, 1869-1969
Bronze, 65.4 cm. (25¾ in.), 1919
NPG.68.36

Dee, Ruby*, 1924-
Actress
Carl Van Vechten, 1880-1964
Photogravure, 22.3 x 14.8 cm. (8¾ x
 5⅞ in.), 1983 from 1962 negative
T/NPG.83.188.11

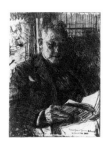

Deering, Charles, 1852-1927
Industrialist
Anders Zorn, 1860-1920
Etching, 20.1 x 15.1 cm. (7¹⁵⁄₁₆ x 5¹⁵⁄₁₆
 in.), 1904
NPG.85.178

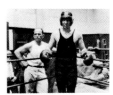

**Dempsey, William Harrison
("Jack")*,** 1895-1983
Athlete
Underwood and Underwood, active
 1882-c. 1950
Photograph, gelatin silver print, 19 x
 23.7 cm. (7½ x 9⁵⁄₁₆ in.), c. 1933
T/NPG.80.229.93

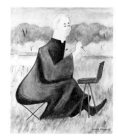

Dehn, Adolf Arthur, 1895-1968
Artist
Aline Fruhauf, 1907-1978
Watercolor with pencil and opaque
 white on paper, 30 x 25.1 cm.
 (11¹³⁄₁₆ x 9⅞ in.), 1937
NPG.83.259
Gift of Erwin Vollmer

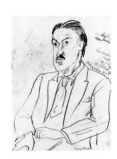

Demuth, Charles, 1883-1935
Artist
Peggy Bacon, 1895-1987
Crayon on paper, 27.6 x 21.3 cm.
 (10⅞ x 8⅜ in.), c. 1935
NPG.73.3

De Kooning, Willem*, 1904-
Artist
Elaine de Kooning, 1920-
Pencil on paper, 60.3 x 47.2 cm. (23¾
 x 18⅝ in.), 1954
T/NPG.81.32
Gift of Frank Stanton

Depew, Chauncey Mitchell,
 1834-1928
Businessman, statesman
Adolph (Adolfo) Müller-Ury,
 1862-1947
Etching, 47.9 x 40.5 cm. (18⅞ x 15¹⁵⁄₁₆
 in.), 1891
NPG.67.60
Gift of Jessica Dragonette

Delany, Martin Robinson, 1812-1885
Union army officer
Unidentified artist
John Smith, publisher
Hand-colored lithograph, 55.2 x 43.8
 cm. (21¾ x 17¼ in.), c. 1865
NPG.76.101

De Valera, Eamon, 1882-1975
President of Ireland
Jo Davidson, 1883-1952
Marble, 34.2 cm. (13½ in.), 1921
NPG.78.18
Gift of Dr. Maury Leibovitz

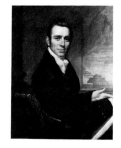

Delaplaine, Joseph, 1777-1824
Publisher
John Wesley Jarvis, 1780-1840
Oil on canvas, 83.8 x 66 cm. (33 x 26
 in.), 1819
NPG.72.16

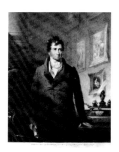

Dewees, William Potts, 1768-1841
Physician
M. E. D. Brown, active 1832-1846,
 after John Neagle
Lithograph, 29.7 x 24.2 cm. (11¹¹⁄₁₆ x
 9½ in.), 1833
NPG.79.141

Dewey, George, 1837-1917
Naval officer, Spanish American
　War
William Harry Warren Bicknell,
　1860-1934, after photograph
Etching, 35.7 x 25.4 cm. (14 1/16 x 10
　in.), 1898
NPG.82.13

Dewey, George, 1837-1917
Naval officer, Spanish American
　War
Unidentified artist, after photograph
Lithograph on silk, 52.4 x 52.7 cm.
　(20 5/8 x 20 3/4 in.), 1898
NPG.85.161

Dewey, George, 1837-1917
Naval officer, Spanish American
　War
Donaldson lithography company,
　active c. 1859-c. 1905, after
　photograph
Chromolithographic poster, 70.9 x
　50.7 cm. (27 7/8 x 19 15/16 in.), c. 1898
NPG.84.66

Dewey, John, 1859-1952
Philosopher
Jacob Epstein, 1880-1959
Bronze, 55.8 cm. (22 in.), 1927
NPG.81.104
Gift of The John Dewey Foundation

Dewey, George, 1837-1917
Naval officer, Spanish American
　War
Ulric Stonewall Jackson Dunbar,
　1862-1927
Plaster death mask, 33.6 cm. (13 1/4
　in.), 1917
NPG.72.33
Gift of Mrs. Lisette Thompson

Dewey, John, 1859-1952
Philosopher
Joseph Margulies, 1896-
Watercolor and pencil on paper, 35.5
　x 28 cm. (14 x 11 in.), 1946
NPG.70.40

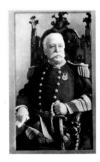

Dewey, George, 1837-1917
Naval officer, Spanish American
　War
Harris and Ewing studio, active
　1905-1977
Photograph, brown-toned gelatin
　silver print, 23.2 x 13.2 cm. (9 3/16 x
　5 3/16 in.), c. 1905
NPG.84.246
Gift of Aileen Conkey

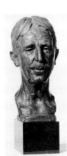

Dewey, John, 1859-1952
Philosopher
Alexander Portnoff, 1887-1949
Bronze, 46.7 cm. (18 3/8 in.), 1930
NPG.70.41
*Transfer from the National Museum
　of American Art; gift of Mrs.
　Alexander Portnoff, 1958*

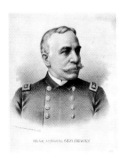

Dewey, George, 1837-1917
Naval officer, Spanish American
　War
Kurz and Allison lithography
　company, active 1880-c. 1899, after
　photograph
Lithograph with hand coloring, 46.4
　x 47 cm. (18 1/8 x 20 9/16 in.), c. 1898
NPG.80.192

Dewey, Thomas Edmund, 1902-1971
Statesman
Alfred Bendiner, 1899-1964
Lithograph, 24.6 x 34.4 cm. (9 11/16 x
　13 9/16 in.), c. 1948
NPG.84.163
Gift of Alfred Bendiner Foundation

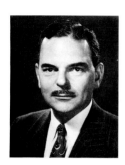

Dewey, Thomas Edmund, 1902-1971
Statesman
Philippe Halsman, 1906-1979
Photograph, gelatin silver print, 34.9
x 27.1 cm. (13¾ x 10¹¹⁄₁₆ in.), 1948
NPG.83.75
Gift of George R. Rinhart

Dickinson, John, 1732-1808
Revolutionary statesman
Attributed to Paul Revere, 1735-1818,
after James Smither, after Charles
Willson Peale
Relief cut, 9.8 x 7 cm. (3⅞ x 2¾ in.),
1771
Published in Nathaniel Ames's *An
Astronomical Diary; or Almanack
for 1772*, Boston, 1771
NPG.79.79

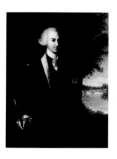

Dickinson, John, 1732-1808
Revolutionary statesman
B. B. Ellis, ?-?, after Benoit Louis
Prevost, after Pierre Eugène Du
Simitière
Stipple engraving, 10.8 x 9.2 cm. (4¼
x 3⅝ in.), 1783
Published in *Portraits of the
Generals, Ministers, Magistrates*,
London, 1783
NPG.75.70

Dickinson, Robert L., 1861-1950
Physician
Abraham Joel Tobias, 1913-
Conté crayon on colored paper, 58.7
x 42.3 cm. (23⅛ x 16⅝ in.), 1947
NPG.85.35
Gift of Abraham Joel Tobias

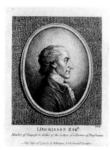

Dickinson, John, 1732-1808
Revolutionary statesman
James Barton Longacre, 1794-1869,
after Charles Willson Peale
Sepia watercolor on artist board, 29.5
x 20 cm. (11⅝ x 8⅞ in.), c. 1835
NPG.77.300

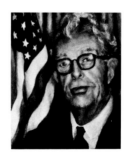

Dillon, Sidney, 1812-1892
Financier
Francis Davis Miller, 1846-1912
Oil on canvas, 132.7 x 107.3 cm.
(52¼ x 42¼ in.), 1889
NPG.74.42

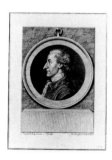

Dickinson, John, 1732-1808
Revolutionary statesman
Benoit Louis Prevost, 1735-1804, after
Pierre Eugène Du Simitière
Engraving, 16.2 x 11.7 cm. (6⅜ x 4⅝
in.), 1780
Published in *Collection des Portraits
des Généraux, Ministres, et
Magistrats . . .* , Paris, 1781
NPG.75.56

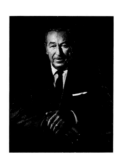

Dirksen, Everett McKinley,
1896-1969
Statesman
Nikki Ryen, 1915-
Oil on canvas, 61 x 76.2 in. (24 x 30
in.), 1967
NPG.69.49
*Gift of Everett McKinley Dirksen
through courtesy of Mr. Glee D.
Gomien*

Dickinson, John, 1732-1808
Revolutionary statesman
Burnet Reading, active 1780-1820,
after Benoit Louis Prevost, after
Pierre Eugène Du Simitière
Stipple engraving, 7.4 x 6 cm. (2¹⁵⁄₁₆
x 2⅜ in.), 1783
Published in *American Legislators,
Patriots, Soldiers*, London, 1783
NPG.76.43

Disney, Walter Elias, 1901-1966
Film producer
David Lee Iwerks, 1933-
Photograph, gelatin silver print, 24.1
x 19.1 cm. (9½ x 7½ in.), 1963
NPG.77.172

Disney, Walter Elias, 1901-1966
Film producer
Edward Steichen, 1879-1973
Photograph, gelatin silver print, 24.5
 x 19.7 cm. (9⅝ x 7¾ in.), 1933
NPG.82.87
Bequest of Edward Steichen

Disney, Walter Elias, 1901-1966
Film producer
Samuel Johnson Woolf, 1880-1948
Charcoal on paper, 59.3 x 43.2 cm.
 (22⅜ x 17 in.), 1938
NPG.80.256

Dix, Dorothea Lynde, 1802-1887
Reformer
Unidentified photographer
Daguerreotype, 14.x 10.8 cm. (5½ x
 4¼ in.), c. 1849
NPG.77.261

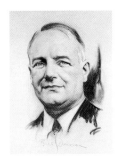

Donovan, William Joseph, 1883-1959
Public official
Casimir Gregory Stapko, 1913-
 after the oil by Thomas Stephens,
 after photograph
Oil on canvas, 101.6 x 76.2 cm. (40 x
 30 in.), 1974
NPG.74.41

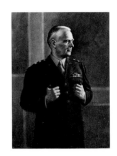

Donovan, William Joseph, 1883-1959
Public official
Samuel Johnson Woolf, 1880-1948
Charcoal and white chalk on paper,
 65 x 50 cm. (23⅝ x 19¾ in.), 1932
NPG.80.257

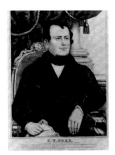

Dorr, Thomas Wilson, 1805-1854
Reformer
James S. Baillie, active 1838-1855,
 after daguerreotype
Hand-colored lithograph, 29.3 x 21.9
 cm. (11⁹⁄₁₆ x 8⅝ in.), c. 1845
NPG.79.87

Dorr, Thomas Wilson, 1805-1854
Reformer
William Warner, Jr., c. 1813-1848,
 after daguerreotype
Mezzotint, 31 x 24.9 cm. (12³⁄₁₆ x
 9¹³⁄₁₆ in.), 1845
NPG.82.27

Dos Passos, John Roderigo, 1896-1970
Author
Philippe Halsman, 1906-1979
Photograph, gelatin silver print, 34.7
 x 27.4 cm. (13⅝ x 10¾ in.), 1948
NPG.82.171
Gift of George R. Rinhart

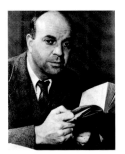

Dos Passos, John Roderigo, 1896-1970
Author
Unidentified photographer
Photograph, gelatin silver print, 15.4
 x 10.2 cm. (6¹⁄₁₆ x 4 in.), c. 1935
NPG.78.250

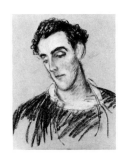

**Dougherty, Walter Hampden (as
 Hamlet),** 1878-1955
Actor
William James Glackens, 1870-1938
Pastel on paper, 41.2 x 33 cm. (16¼ x
 13 in.), c. 1917
NPG.67.55

**Dougherty, Walter Hampden (as
 Hamlet),** 1878-1955
Actor
William James Glackens, 1870-1938
Oil on canvas, 191.8 x 101.6 cm.
 (75½ x 40 in.), 1917
NPG.68.42
Gift of the Sansom Foundation

Douglas, Aaron*, 1899-
Artist
Betsy Graves Reyneau, 1888-1964
Oil on canvas, 116.8 x 76.2 cm. (46 x
 30 in.), 1953
T/NPG.67.81
Gift of the Harmon Foundation

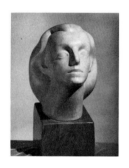

Douglas, Helen Gahagan*, 1900-1980
Actress, political activist
Isamu Noguchi, 1904-
Marble, 39.4 cm. (15½ in.), 1935
T/NPG.82.59.90
Gift of Melvyn Douglas

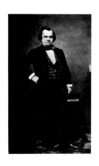

Douglas, Stephen Arnold, 1813-1861
Statesman
Mathew Brady, 1823-1896
Photograph, albumen silver print,
 8.6 x 5.4 cm. (3⅜ x 2⅛ in.), c. 1860
NPG.77.163

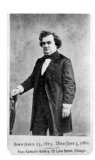

Douglas, Stephen Arnold, 1813-1861
Statesman
John Carbutt, 1832-1905
Photograph, albumen silver print,
 8.7 x 5.8 cm. (3⁷⁄₁₆ x 2⁵⁄₁₆ in.),
 c. 1861
NPG.83.146

Douglas, Stephen Arnold, 1813-1861
Statesman
Currier and Ives lithography
 company, active 1857-1907, after
 photograph
Lithograph with tintstone, 60.9 x
 50.2 cm. (11¹⁵⁄₁₆ x 7¾ in.), 1860
NPG.84.193

Douglas, Stephen Arnold, 1813-1861
Statesman
Leopold Grozelier, 1830-1865, after
 daguerreotype by Julian Vannerson
S. W. Chandler and Brother
 lithography company
Lithograph, 23.5 x 25.7 cm. (9¼ x
 10⅛ in.), 1854
Published in Charles H. Brainard's
 *Portrait Gallery of Distinguished
 Americans*, Boston, 1855
NPG.82.75.d

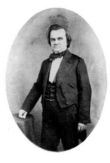

Douglas, Stephen Arnold, 1813-1861
Statesman
James McClees, 1821-1887, and
 Julian Vannerson, c. 1827-?
Photograph, salt print, 18.4 x 13.3
 cm. (7¼ x 5¼ in.), c. 1859
NPG.77.262

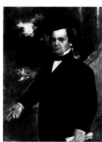

Douglas, Stephen Arnold, 1813-1861
Statesman
Duncan Styles, ?-?
Oil on canvas, 126.3 x 89.5 cm. (49¾
 x 35¼ in.), 1860
NPG.70.42

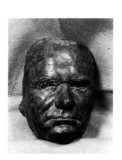

Douglas, Stephen Arnold, 1813-1861
Statesman
Leonard Wells Volk, 1828-1895
Plaster life mask, 21.3 cm. (8⅜ in.),
 1962 cast after original
NPG.69.8
Gift of Joseph Ternbach

Douglas, Stephen Arnold, 1813-1861
Statesman
Unidentified artist
Polychromed wood, 46 cm. (18⅛ in.),
 c. 1858
NPG.71.59
Gift of Richard E. Guggenheim

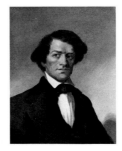

Douglass, Frederick, 1818-1895
Abolitionist, statesman
Attributed to Elisha Hammond,
 1779-1882
Oil on canvas, 69.9 x 57.1 cm. (27½ x
 22½ in.), c. 1844
NPG.74.45

Douglas, William Orville*,
 1898-1980
Justice of the United States Supreme
 Court
Oscar Berger, 1901-
Ink over pencil on paper, 42.1 x 35.2
 cm. (16⁹⁄₁₆ x 13⅞ in.), c. 1968
T/NPG.69.13.90
Gift of the artist

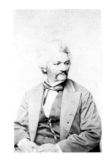

Douglass, Frederick, 1818-1895
Abolitionist, statesman
George Francis Schreiber, 1803-1892
Photograph, albumen silver print,
 9.4 x 5.9 cm. (3¹¹⁄₁₆ x 2⁵⁄₁₆ in.),
 c. 1867
NPG.82.145
Gift of Donald R. Simon

Douglas, William Orville*,
 1898-1980
Justice of the United States Supreme
 Court
Guy Rowe ("Giro"), 1894-1969
Crayon on acetate, 20.3 x 17.8 cm. (8
 x 7 in.), 1943
T/NPG.82.104.90
Gift of Charles Rowe

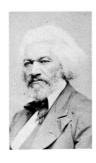

Douglass, Frederick, 1818-1895
Abolitionist, statesman
George K. Warren, c. 1824-1884
Photograph, albumen silver print,
 9.5 x 5.7 cm. (3¾ x 2¼ in.), c. 1879
NPG.80.242

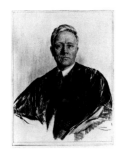

Douglas, William Orville*,
 1898-1980
Justice of the United States Supreme
 Court
Oskar Stoessel, 1879-1964
Etching and drypoint, 32.8 x 28.3 cm.
 (12¹⁵⁄₁₆ x 11⅛ in.), c. 1940
T/NPG.64.12.90
Gift of David E. Finley

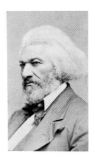

Douglass, Frederick, 1818-1895
Abolitionist, statesman
George K. Warren, c. 1824-1884
Photograph, albumen silver print,
 9.6 x 5.6 cm. (3¾ x 2³⁄₁₆ in.),
 c. 1879
NPG.80.282

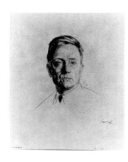

Douglas, William Orville*,
 1898-1980
Justice of the United States Supreme
 Court
Oskar Stoessel, 1879-1964
Pencil on paper, 31 x 27.4 cm. (12¼ x
 10¹³⁄₁₆ in.), not dated
T/NPG.72.40.90

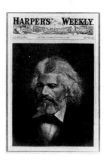

Douglass, Frederick, 1818-1895
Abolitionist, statesman
Unidentified artist, after photograph
Wood engraving, 28.4 x 23 cm. (11³⁄₁₆
 x 9¹⁄₁₆ in.), 1883
Published in *Harper's Weekly*, New
 York, November 24, 1883
NPG.72.7

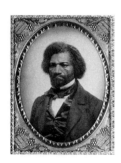

Douglass, Frederick, 1818-1895
Abolitionist, statesman
Unidentified photographer
Ambrotype, 10.6 x 8.6 cm. (4³⁄₁₆ x 3⅜
 in.), 1856
NPG.74.75
Gift of an anonymous donor

Douglass, Frederick, 1818-1895
Abolitionist, statesman
Unidentified photographer
Photograph, salt print, 10.1 x 7.9 cm.
 (4 x 3⅛ in.), c. 1860
NPG.76.111

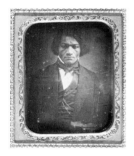

Douglass, Frederick, 1818-1895
Abolitionist, statesman
Unidentified photographer, after
 c. 1847 daguerreotype
Daguerreotype, 8 x 6.9 cm. (3⅛ x 2¾
 in.), c. 1850
NPG.80.21

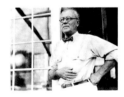

Dove, Arthur Garfield, 1880-1946
Artist
Herbert J. Seligmann, 1891-?
Photograph, gelatin silver print, 7.4
 x 10.1 cm. (2¹⁵⁄₁₆ x 4 in.), c. 1938
NPG.78.247

Draper, Henry, 1837-1882
Scientist
Gilbert K. Harroun, ?-1901, and
 Edward Bierstadt, 1824-1906
Photograph, carbon print, 15.4 x 10.3
 cm. (6¹⁄₁₆ x 4¹⁄₁₆ in.), c. 1880
NPG.77.165

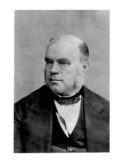

Draper, John William, 1811-1882
Scientist
José Maria Mora, c. 1847-1926
Photograph, albumen silver print, 14
 x 9.8 cm. (5½ x 3⅞ in.), c. 1880
NPG.77.168

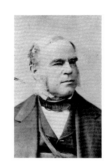

Draper, John William, 1811-1882
Scientist
Napoleon Sarony, 1821-1896
Photograph, albumen silver print,
 9.5 x 6.1 cm. (3¾ x 2⅜ in.), 1878
NPG.77.167

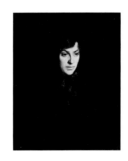

Draper, Ruth, 1884-1956
Actress
Mary Foote, 1872-1968
Oil on canvas, 70.5 x 55.5 cm. (27⅞ x
 21⅞ in.), not dated
NPG.69.3
*Gift of Mr. and Mrs. Franz
 Oppenheimer*

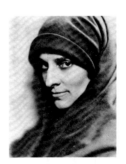

Draper, Ruth, 1884-1956
Actress
Nickolas Muray, 1892-1965
Photograph, gelatin silver print, 23.8
 x 18.9 cm. (9⅜ x 7⁷⁄₁₆ in.), 1978
from c. 1920 negative
NPG.78.146

Draper, William Franklin, 1842-1910
Businessman
M. W. Clark, ?-?
Oil on canvas, 76.2 x 63.5 cm. (30 x
 25 in.), 1890
NPG.75.8
*Gift of William F. Draper,
 descendant*

Drayton, William Henry, 1742-1779
Revolutionary statesman
B. B. Ellis, ?-?, after Benoit Louis
 Prevost, after Pierre Eugène Du
 Simitière
Stipple engraving, 11.1 x 9.2 cm. (4⅜
 x 3⅝ in.), 1783
Published in *Portraits of the
 Generals, Ministers, Magistrates,*
 London, 1783
NPG.75.71

Drayton, William Henry, 1742-1779
Revolutionary statesman
Benoit Louis Prevost, 1735-1804, after
 Pierre Eugène Du Simitière
Engraving, 16.2 x 11.7 cm. (6⅜ x 4⅝
 in.), 1780
Published in *Collection des Portraits
 des Généraux, Ministres, et
 Magistrats . . .* , Paris, 1781
NPG.75.54

Drayton, William Henry, 1742-1779
Revolutionary statesman
Burnet Reading, active 1780-1820,
 after Benoit Louis Prevost, after
 Pierre Eugène Du Simitière
Stipple engraving, 6.6 x 6 cm. (2⅞ x
 2⅜ in.), 1783
Published in *American Legislators,
 Patriots, Soldiers,* London, 1783
NPG.75.64

Dreiser, Theodore, 1871-1945
Author
Lotte Jacobi, 1896-
Photograph, gelatin silver print, 23.5
 x 18.4 cm. (9¼ x 7¼ in.), 1944
NPG.76.72

Dreiser, Theodore, 1871-1945
Author
Lotte Jacobi, 1896-
Photograph, gelatin silver print, 32 x
 23 cm. (12⅝ x 9¹/₁₆ in.), 1944
NPG.85.79

Dreiser, Theodore, 1871-1945
Author
Henry Varnum Poor, 1888-1970
Oil on canvas, 50.4 x 40.6 cm. (19⅞ x
 16 in.), 1933
NPG.73.39

Dreiser, Theodore, 1871-1945
Author
Onorio Ruotolo, 1888-1966
Terra-cotta, 40.9 cm. (16⅛ in.), 1919
NPG.74.12

Dressler, Marie, 1868-1934
Actress
Alfred J. Frueh, 1880-1968
Linocut, 25.5 x 24.2 cm. (10 x 9½
 in.), 1922
Published in Alfred J. Frueh's *Stage
 Folk,* New York, 1922
NPG.84.229.ff

Drew, Charles Richard, 1904-1950
Physician
Betsy Graves Reyneau, 1888-1964
Oil on canvas, 100.9 x 76.8 cm. (39¾
 x 30¼ in.), 1953?
NPG.67.35
Gift of the Harmon Foundation

Drew, John, 1853-1927
Actor
Alfred J. Frueh, 1880-1968
Linocut, 23.8 x 14.6 cm. (9⅜ x 5¾
 in.), 1922
Published in Alfred J. Frueh's *Stage
 Folk,* New York, 1922
NPG.84.229.m

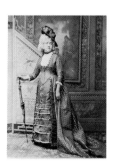

Drew, Louisa Lane, 1820-1897
Actress
Gilbert and Bacon studio, active
 c. 1870-c. 1890
Photograph, albumen silver print,
 14.8 x 10.5 cm. (5¹³⁄₁₆ x 4¼ in.),
 c. 1881
NPG.80.68

Duane, William, 1760-1835
Journalist
Charles Balthazar Julien Févret de
 Saint-Mémin, 1770-1852
Engraving, 5.6 cm. (2¼ in.) diameter,
 1802
NPG.74.39.159
Gift of Mr. and Mrs. Paul Mellon

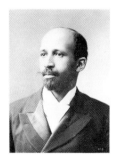

**Du Bois, William Edward
 Burghardt,** 1868-1963
Civil rights statesman
James E. Purdy, 1859-1933
Photograph, gelatin silver print, 14.1
 x 9.9 cm. (5⁹⁄₁₆ x 3⅞ in.), 1907
NPG.80.25

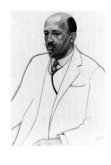

**Du Bois, William Edward
 Burghardt,** 1868-1963
Civil rights statesman
Winold Reiss, 1886-1953
Pastel on artist board, 76.4 x 54.9 cm.
 (30¹⁄₁₆ x 21⅝ in.), c. 1925
NPG.72.79
*Gift of Lawrence A. Fleischman and
 Howard Garfinkle with a
 matching grant from the National
 Endowment for the Arts*

**Du Bois, William Edward
 Burghardt,** 1868-1963
Civil rights statesman
Carl Van Vechten, 1880-1964
Photogravure, 22.5 x 14.9 cm. (8⅞ x
 5⅞ in.), 1983 from 1946 negative
NPG.83.188.12

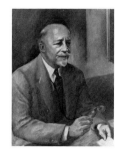

**Du Bois, William Edward
 Burghardt,** 1868-1963
Civil rights statesman
Laura Wheeler Waring, 1887-1948
Oil on canvas, 81.9 x 63.5 cm. (32¼ x
 25 in.), not dated
NPG.67.36
*Gift of Walter Waring in memory of
 his wife, Laura Wheeler Waring,
 through the Harmon Foundation*

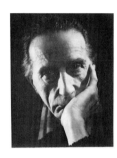

Duchamp, Marcel, 1887-1968
Artist
John D. Schiff, ?-?
Photograph, gelatin silver print, 24.6
 x 19.6 cm. (9¹¹⁄₁₆ x 7¹¹⁄₁₆ in.), 1957
NPG.83.119

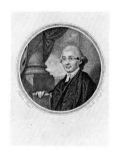

Duché, Jacob, 1737/38-1798
Clergyman
Thomas Clarke, active 1797-1800,
 after Henry Pelham
Stipple engraving, 8.5 cm. (3⅜ in.)
 diameter, 1779
Published in Duché's *Discourses on
 Various Subjects*, London, 1779
NPG.77.207

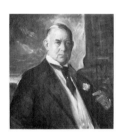

Duke, James Buchanan, 1856-1925
Businessman
John da Costa, 1867-1931
Oil on canvas, 68.5 x 50.8 cm. (27 x
 20 in.), c. 1922
NPG.82.149
Gift of Mr. T. Bragg McLeod

Dulles, Allen Welsh, 1893-1969
Public official
Lotte Jacobi, 1896-
Photograph, Gevalux print, 16.3 x
 12.3 cm. (6⁷⁄₁₆ x 4⅞ in.), c. 1949
NPG.85.80

Dulles, John Foster, 1888-1959
Diplomat
Philippe Halsman, 1906-1979
Photograph, gelatin silver print, 34.7
x 27.3 cm. (13¹¹⁄₁₆ x 10¾ in.), 1948
NPG.83.76
Gift of George R. Rinhart

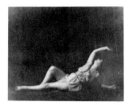

Duncan, Isadora, 1878-1927
Dancer
Arnold Genthe, 1869-1942
Photograph, gelatin silver print, 27.2
x 35.3 cm. (10¹¹⁄₁₆ x 13⅞ in.),
c. 1916
NPG.76.73

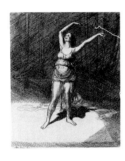

Duncan, Isadora, 1878-1927
Dancer
John Sloan, 1871-1951
Etching, 22 x 18.9 cm. (8⅝ x 7⁷⁄₁₆ in.),
1915
NPG.71.12
Gift of Mrs. Helen Farr Sloan

Duncan, Isadora, 1878-1927
Dancer
Edward Steichen, 1879-1973
Photogravure, 16.7 x 20.5 cm. (6⁹⁄₁₆ x
8¹⁄₁₆ in.), 1913
NPG.83.193

Dunham, Katherine*, 1910-
Dancer, choreographer
Paul Colin, 1892-
Color lithographic poster, 149.6 x 99
cm. (58⅞ x 39 in.), c. 1962
T/NPG.85.140

Dunham, Katherine*, 1910-
Dancer, choreographer
Carl Van Vechten, 1880-1964
Photogravure, 22.3 x 15 cm. (8¹³⁄₁₆ x
5⅞ in.), 1983 from 1940 negative
T/NPG.83.188.13

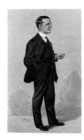

Dunne, Finley Peter, 1867-1936
Humorist
Vincent Brooks, Day and Son
lithography company, active
1867-c. 1905, after Sir Leslie Ward
("Spy")
Chromolithograph, 32.8 x 19.8 cm.
(12¹⁵⁄₁₆ x 7¹³⁄₁₆ in.), 1905
Published in *Vanity Fair,* London,
1905
NPG.74.77

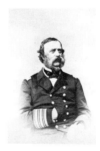

DuPont, Samuel Francis, 1803-1865
Union admiral
Frederick Gutekunst, 1831-1917
Photograph, albumen silver print, 9
x 5.9 cm. (3⁹⁄₁₆ x 2⁵⁄₁₆ in.), c. 1865
NPG.82.93
Gift of Forrest H. Kennedy

DuPont, Samuel Francis, 1803-1865
Union admiral
Daniel Huntington, 1816-1906
Oil on canvas, 148 x 101.6 cm. (58¼
x 40 in.), 1867-1868
NPG.65.22
*Transfer from the National Museum
of American Art; bequest of Mrs.
May DuPont Saulsbury to the
Smithsonian Institution, 1927*

Durand, Asher Brown, 1796-1886
Artist
Unidentified photographer
Photograph, albumen silver print,
18.2 x 13.4 cm. (7³⁄₁₆ x 5¼ in.),
c. 1860
NPG.77.123

Durant, William James*, 1885-1981
Author
Philippe Halsman, 1906-1979
Photograph, gelatin silver print, 35 x
27.3 cm. (13¾ x 10¾ in.), 1953
T/NPG.83.77.91
Gift of George R. Rinhart

Eads, James Buchanan, 1820-1887
Engineer
Napoleon Sarony, 1821-1896
Photograph, albumen silver print,
11.5 x 9 cm. (4½ x 3⁹⁄₁₆ in.), 1871
NPG.77.170

Durrie, George Henry, 1820-1863
Artist
Self-portrait
Oil on canvas, 76.2 x 63.5 cm. (30 x
25 in.), 1843
NPG.71.5

Eakins, Thomas, 1844-1916
Artist
Attributed to Susan Macdowell
Eakins, 1851-1938
Photograph, platinum print, 21.8 x
19.6 cm. (8⁹⁄₁₆ x 7¹¹⁄₁₆ in.), c. 1890
NPG.77.273

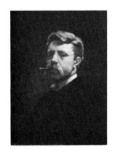

Duveneck, Frank, 1848-1919
Artist
Self-portrait
Oil on canvas, 76.2 x 56.2 cm. (30 x
22⅛ in.), c. 1890
NPG.84.176

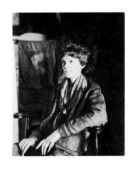

Earhart, Amelia Mary, 1897-1937
Aviator
Peter A. Juley, 1862-1937, or Paul P.
Juley, 1890-1975; studio active
1896-1975
Photograph, gelatin silver print, 24.2
x 19.4 cm. (9⁹⁄₁₆ x 7⅝ in.), c. 1932
NPG.75.82
Gift of Edith A. Scott

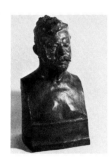

Duveneck, Frank, 1848-1919
Artist
Charles Grafly, 1862-1929
Bronze, 69.2 cm. (27¼ in.), 1915
NPG.70.25
*Transfer from the National Museum
of American Art; gift of Mrs.
Dorothy Grafly Drummond, 1967*

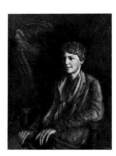

Earhart, Amelia Mary, 1897-1937
Aviator
Edith A. Scott, 1877-1978
Oil on canvas, 96.2 x 70.7 cm. (37⅞ x
27⅞ in.), 1932
NPG.75.33

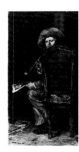

Duveneck, Frank, 1848-1919
Artist
William Unger, 1837-1932, after
William Merritt Chase
Etching, 24.3 x 13 cm. (9⁹⁄₁₆ x 5⅛ in.),
1875
NPG.69.28

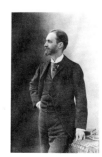

Eastman, George, 1854-1932
Inventor, businessman
Paul Nadar, 1856-1939
Photograph, albumen silver print,
15.2 x 24.1 cm. (6 x 9½ in.), 1890
NPG.68.11
Gift of George Eastman House

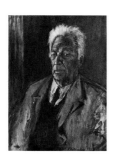

Eastman, Max Forrester, 1883-1969
Author, editor
Kurt Delbanco, 1909-
Oil on canvas, 106.6 x 76.2 cm. (42 x
 30 in.), 1968
NPG.73.28
Gift of the artist

Ederle, Gertrude*, 1906-
Athlete
Underwood and Underwood, active
 1882-c. 1950
Photograph, gelatin silver print, 18.6
 x 23.4 cm. (7¼ x 9¼ in.), 1925
T/NPG.80.230

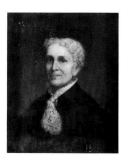

Eddy, Mary Morse Baker, 1821-1910
Founder of Christian Science
Edwin T. Billings, 1824-1893
Oil on artist board, 67.9 x 55.2 cm.
 (26¾ x 21¾ in.), 1889
NPG.72.90
*Gift of Mary D. Johnston in memory
 of her husband, Joseph E. Johnston*

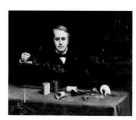

Edison, Thomas Alva, 1847-1931
Inventor
Abraham Archibald Anderson,
 1847-1940
Oil on canvas, 113.6 x 138.4 cm.
 (44¾ x 54½ in.), c. 1890
NPG.65.23
*Transfer from the National Museum
 of American Art; gift of Dr.
 Eleanor A. Campbell to the
 Smithsonian Institution, 1942*

Eddy, Mary Morse Baker, 1821-1910
Founder of Christian Science
Ernest Haskell, 1876-1926
Flick engraving, 7.3 x 5.8 cm. (2⅞ x
 2¼ in.), c. 1912
NPG.83.209

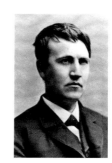

Edison, Thomas Alva, 1847-1931
Inventor
Anderson studio, ?-?
Photograph, albumen silver print,
 9.3 x 6.2 cm. (3¹¹⁄₁₆ x 2⁷⁄₁₆ in.),
 c. 1870
NPG.78.111

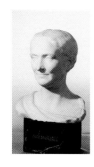

Eddy, Mary Morse Baker, 1821-1910
Founder of Christian Science
Luella Varney Serrao, 1865-post 1935
Marble, 34.9 cm. (13¾ in.), 1889
NPG.66.72
*Gift of Calvin C. Hill and Mrs.
 Frances Thompson Hill*

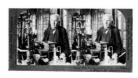

Edison, Thomas Alva, 1847-1931
Inventor
Underwood and Underwood, active
 1882-c. 1950
Photograph, gelatin silver print, 7.7
 x 15.3 cm. (3 x 6 in.), c. 1915
NPG.81.84

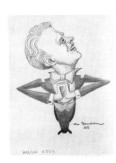

Eddy, Nelson, 1901-1967
Singer
Alfred Bendiner, 1899-1964
Pencil with opaque white on board,
 30.6 x 24 cm. (12¹⁄₁₆ x 9⁷⁄₁₆ in.), 1940
Illustration for *The Evening
 Bulletin,* Philadelphia, April 12,
 1940
NPG.84.39
Gift of Alfred Bendiner Foundation

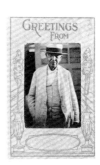

Edison, Thomas Alva, 1847-1931
Inventor
Unidentified photographer
Tintype, 8.8 x 6.2 cm. (3⁷⁄₁₆ x 2⁷⁄₁₆
 in.), 1928
NPG.78.248

Edouart, Auguste, 1788-1861
Silhouettist
Self-portrait
Lithographed silhouette, 6.5 x 4 cm.
 (2⅝ x 1⅝ in.), 1843
NPG.80.140
Gift of Mrs. Tyson Lee

Edwards, Jonathan, 1703-1758
Clergyman
Amos Doolittle, 1754-1832, after
 Joseph Badger •
Stipple and line engraving and
 etching, 15.2 x 7.8 cm. (6 x 3⅟16
 in.), 1793
Published in David Austin's *The
 Milennium; or the Thousand
 Years of Prosperity,* Elizabeth
 Town, 1794
NPG.76.21

Edwards, Samuel Arlent, 1861-1938
Artist
Self-portrait, after Charles Frederick
 Naegele
Color mezzotint, 33 x 25.9 cm. (13 x
 10⅟16 in.), 1900
NPG.83.248
Gift of S. Arlent Edwards, Jr.

Eielson, Carl Ben, 1897-1929
Aviator
Charles Cann, ?-?
Photograph, gelatin silver print, 34.2
 x 23.7 cm. (13⅟16 x 9⅟16 in.), 1982
 from c. 1926 negative
NPG.83.32
Gift of the University of Alaska

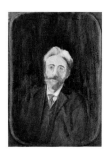

Eilshemius, Louis, 1864-1941
Artist
Self-portrait
Oil on board, 66 x 45.5 cm. (26 x 18
 in.), 1915
NPG.83.132

Eilshemius, Louis, 1864-1941
Artist
Aline Fruhauf, 1907-1978
Pencil and gray and brown wash on
 paper, 23.7 x 20.6 cm. (9⅟16 x 8⅛
 in.), 1933
Published in *Esquire,* New York,
 October 1934
NPG.83.61
Gift of Erwin Vollmer

Einstein, Albert, 1879-1955
Scientist
Lucien Aigner, 1901-
Photograph, gelatin silver print, 34.4
 x 27 cm. (13⅟16 x 10⅝ in.), 1940
NPG.79.251

Einstein, Albert, 1879-1955
Scientist
Jo Davidson, 1883-1952
Terra-cotta, 50.4 cm. (19⅞ in.),
 c. 1937
NPG.78.11
Gift of Dr. Maury Leibovitz

Einstein, Albert, 1879-1955
Scientist
Antonio Frasconi, 1919-
Woodcut, 31.3 x 24.1 cm. (9½ x 12⅟16
 in.), 1952
NPG.80.64

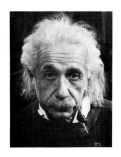

Einstein, Albert, 1879-1955
Scientist
Philippe Halsman, 1906-1979
Photograph, gelatin silver print, 34.2
 x 26.5 cm. (13⅟16 x 10⅜ in.), c. 1979
 from 1947 negative
NPG.79.249
*Transfer from the National Museum
 of American History*

Einstein, Albert, 1879-1955
Scientist
Lotte Jacobi, 1896-
Photograph, gelatin silver print, 34.9
 x 26.1 cm. (13¾ x 10¼ in.), 1938
NPG.77.51

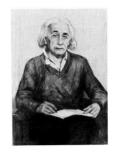

Einstein, Albert, 1879-1955
Scientist
Max Westfield, 1882-1971
Oil on canvas, 104.1 x 78.7 cm. (41 x
 31 in.), 1944
NPG.67.16
Gift of the artist

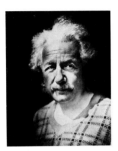

Einstein, Albert, 1879-1955
Scientist
Arthur Johnson, ?-?
Photograph, gelatin silver print, 24.6
 x 19.5 cm. (9¹¹⁄₁₆ x 7¹¹⁄₁₆ in.), 1935
NPG.77.164

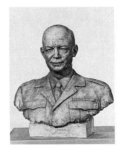

Eisenhower, Dwight David,
 1890-1969
Thirty-fourth President of the United
 States
Jo Davidson, 1883-1952
Plaster, 59.6 cm. (23½ in.), c. 1948
NPG.77.320
Gift of Dr. Maury Leibovitz

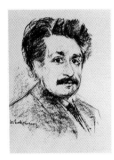

Einstein, Albert, 1879-1955
Scientist
Max Liebermann, 1847-1935
Lithograph, 30 x 24 cm. (12 x 9⅜
 in.), c. 1922-1925
NPG.80.141

Eisenhower, Dwight David,
 1890-1969
Thirty-fourth President of the United
 States
Charles Dunn, 1895-1978
Egg tempera on masonite, 31.8 x 24.8
 cm. (12½ x 9¾ in.), c. 1948
NPG.80.131
*Gift of the Family of Mr. Charles
 Dunn*

Einstein, Albert, 1879-1955
Scientist
Josef Scharl, 1896-1954
Oil on burlap, 81.3 x 63.5 cm. (32 x
 25 in.), 1950
NPG.66.6

Eisenhower, Dwight David,
 1890-1969
Thirty-fourth President of the United
 States
John Groth, 1908-
Sepia ink on paper, 19.8 x 21.5 cm.
 (7¹³⁄₁₆ x 8½ in.), 1955
NPG.65.1
Gift of Arnold Roston

Einstein, Albert, 1879-1955
Scientist
Julius C. Turner, 1881-?
Etching and drypoint, 34.3 x 29.8 cm.
 (13½ x 11¾ in.), 1921
NPG.72.56

Eisenhower, Dwight David,
 1890-1969
Thirty-fourth President of the United
 States
Guy Rowe ("Giro"), 1894-1969
Grease on clear paper, 27.6 x 24.3
 cm. (10⅞ x 9½ in.), 1943
NPG.81.146
Gift of Charles Rowe

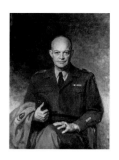

Eisenhower, Dwight David,
1890-1969
Thirty-fourth President of the United
States
Thomas Edgar Stephens, 1886-1966
Oil on canvas, 116.8 x 88.9 cm. (46 x
35 in.), 1947
NPG.65.63
*Transfer from the National Gallery
of Art; gift of Ailsa Mellon Bruce,
1947*

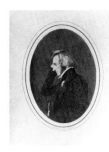

Ellet, Charles, 1810-1862
Civil engineer
Isaac A. Rehn, active 1845-1875, and
John W. Hurn, ?-?; studio active
1861-1863
Photograph, salt print, 18.6 x 13.6
cm. (7⁵⁄₁₆ x 5⁵⁄₁₆ in.), c. 1861
NPG.82.76

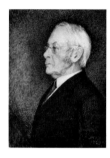

Eliot, Charles William, 1834-1926
Educator
Annie Ware Sabine Siebert,
1864-1947
Watercolor on board, 12.7 x 9.5 cm.
(5 x 3¾ in.), 1923
NPG.67.4
*Gift of Elizabeth L. Howie and John
F. Marshall*

**Ellington, Edward Kennedy
("Duke"),** 1899-1974
Musician, composer
Antonio Frasconi, 1919- , after
photograph
Woodcut, 101.2 x 61.5 cm. (39¹³⁄₁₆ x
24³⁄₁₆ in.), 1976
NPG.82.117

Eliot, Charles William, 1834-1926
Educator
Unidentified photographer
Photograph, salt print, 15.1 x 12.3
cm. (5¹⁵⁄₁₆ x 4⅞ cm.), 1861
NPG.77.201

**Ellington, Edward Kennedy
("Duke"),** 1899-1974
Musician, composer
G. R., ?-?
Base metal medal, 8.7 cm. (3³⁄₁₆ in.)
diameter, 1967
NPG.81.59

Eliot, Thomas Stearns, 1888-1965
Poet
Theresa Garrett Eliot, 1884-1981
Pencil with pastel on paper, 21.5 x
27.8 cm. (8⁷⁄₁₆ x 10¹⁵⁄₁₆ in.), 1955
NPG.79.120
Gift of Mrs. Katie Louchheim

Elliot, Aaron Marshall, 1844-1910
Philologist
Unidentified photographer
Photograph, salt print, 15.1 x 12.1
cm. (5¹⁵⁄₁₆ x 4¾ in.), 1864
NPG.77.53

Eliot, Thomas Stearns, 1888-1965
Poet
Kay Bell Reynal, 1910-1977
Photograph, gelatin silver print, 28.9
x 26.5 cm. (11⅜ x 10⁷⁄₁₆ in.), 1950
NPG.77.52

Elliott, Charles Loring, 1812-1868
Artist
George Augustus Baker, 1821-1880
Oil on canvas, 20.9 x 15.8 cm. (8¼ x
6¼ in.), 1861
NPG.79.121

Elliott, Charles Loring, 1812-1868
Artist
George Kasson Knapp, 1833-1910,
 after photograph
Lithograph, 32.9 x 32.1 cm. (13 x 12⅝
 cm.), 1877
NPG.81.43

Emerson, Ralph Waldo, 1803-1882
Philosopher
Daniel Chester French, 1850-1931
Bronze, 57.4 cm. (22⅝ in.), cast after
 1879 original
NPG.74.13

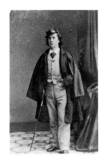

Ellsworth, Elmer Ephraim, 1837-1861
Union soldier
Mathew Brady, 1823-1896
Photograph, albumen silver print,
 8.5 x 5.5 cm. (3⅜ x 2³⁄₁₆ in.), c. 1861
NPG.77.355

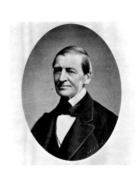

Emerson, Ralph Waldo, 1803-1882
Philosopher
Frederick Gutekunst, 1831-1917
Photograph, albumen silver print,
 11.7 x 7.6 cm. (4⅝ x 3 in.), c. 1875
NPG.77.171

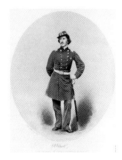

Ellsworth, Elmer Ephraim, 1837-1861
Union soldier
N. Thomas, ?-?, after photograph by
 Mathew Brady
Hand-colored lithograph with
 tintstone, 40.8 x 33.7 cm. (16¹⁄₁₆ x
 13¼ in.), 1861
NPG.78.294

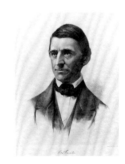

Emerson, Ralph Waldo, 1803-1882
Philosopher
Gerarde A. Klucken, active
 1871-1881, after Southworth and
 Hawes
Armstrong lithography company
Lithograph, 52.5 x 39.6 cm. (20⅝ x
 15⁹⁄₁₆ in.), 1881
NPG.78.86

Elssler, Fanny, 1810-1884
Dancer
James Varick Stout, 1809-1860
Pencil on paper, 26.3 x 20.9 cm. (10⅜
 x 8³⁄₁₆ in.), not dated
NPG.80.277
Gift of Robert S. Pirie

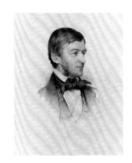

Emerson, Ralph Waldo, 1803-1882
Philosopher
Stephen Alonso Schoff, 1818-1905,
 after Samuel Worcester Rowse
Engraving, 24 x 15.6 cm. (9⅜ x 6¼
 in.), 1878
NPG.79.157

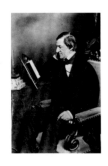

Emerson, Ralph Waldo, 1803-1882
Philosopher
Allen and Rowell studio, active
 1874-1890
Photograph, albumen silver print,
 15.1 x 10 cm. (5¹⁵⁄₁₆ x 3¹⁵⁄₁₆ in.),
 c. 1870
NPG.78.6

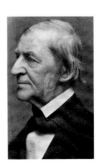

Emerson, Ralph Waldo, 1803-1882
Philosopher
George K. Warren, c. 1824-1884
Photograph, albumen silver print,
 9.4 x 5.8 cm. (3¹¹⁄₁₆ x 2⁵⁄₁₆ in.),
 c. 1870
NPG.79.21

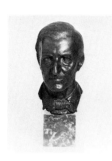

Emerson, Ralph Waldo, 1803-1882
Philosopher
Unidentified artist
Bronze, 36.5 cm. (14⅜ in.), not dated
NPG.68.25

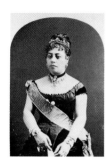

Emma, 1836-1885
Hawaiian ruler
James J. Williams, c. 1853-1926
Photograph, albumen silver print, 13
 x 8.9 cm. (5⅛ x 3⁹/₁₆ in.), c. 1879
NPG.80.316
*Gift of the Bernice Pauahi Bishop
 Museum*

Emmet, Thomas Addis, 1764-1827
Lawyer
John Rubens Smith, 1775-1849, after
 Samuel Finley Breese Morse
Mezzotint, 29.7 x 25.2 cm. (11¾ x
 9¹⁵/₁₆ in.), 1831
NPG.77.358

Enters, Angna*, 1907-
Mime
Aline Fruhauf, 1907-1978
Lithograph, 24.9 x 15.9 cm. (9¹³/₁₆ x
 6¼ in.), 1931
T/NPG.83.62
Gift of Erwin Vollmer

Enters, Angna*, 1907-
Mime
Walt Kuhn, 1877-1949
Etching, 13.5 x 9.8 cm. (5⁵/₁₆ x 3⅞
 in.), c. 1925
T/NPG.72.10

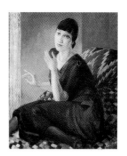

Enters, Angna*, 1907-
Mime
John Sloan, 1871-1951
Oil on canvas, 81.9 x 66.6 cm. (32¼ x
 26⅛ in.), 1925 and 1945
T/NPG.80.132
*Gift of the John Sloan Memorial
 Foundation*

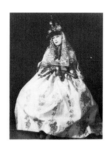

Enters, Angna*, 1907-
Mime
Doris Ulmann, 1882-1934
Photograph, platinum print, 20.3 x
 15.2 cm. (8 x 6 in.), c. 1933
T/NPG.85.92

Epstein, Sir Jacob, 1880-1959
Artist
Alvin Langdon Coburn, 1882-1966
Photograph, collotype print, 30.8 x
 15.7 cm. (8³/₁₆ x 6³/₁₆ in.), 1914
NPG.78.13

Equiano, Olaudah, 1745-1797
Slave, author
Daniel Orme, 1766-1832, after
 W. Denton
Stipple engraving, 10.6 x 8 cm. (4⅛ x
 3⅛ in.), 1789
Published in *The Interesting
 Narrative of . . . Olaudah Equiano,*
 London, 1789
NPG.78.82

Ericsson, John, 1803-1889
Engineer, inventor
Arvid Frederick Nyholm, 1866-1927
Oil on canvas, 123.8 x 92 cm. (48¾ x
 36¼ in.), 1912, after 1862
 photograph by Mathew Brady
NPG.66.54
*Transfer from the National Museum
 of American Art; gift of the
 Swedish American Republican
 League of Illinois to the
 Smithsonian Institution, 1912*

Ericsson, John, 1803-1889
Engineer, inventor
Charles Parsons, 1821-1910, after
 photograph by Mathew Brady
Endicott and Company lithography
 company
Lithograph with tintstones, 34.4 x
 53.1 cm. (13⁹⁄₁₆ x 20⅞ in.), 1862
NPG.84.365

Evans, Robley Dunglison, 1846-1912
Admiral
August Franzen, 1863-1938
Oil on canvas, 151.7 x 102.2 cm.
 (59¾ x 40¼ in.), 1909
NPG.65.81
*Transfer from the National Museum
 of American Art; gift of Col.
 Horatio S. Rubens to the
 Smithsonian Institution, 1926*

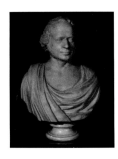

Ericsson, John, 1803-1889
Engineer, inventor
Augustus Saint-Gaudens, 1848-1907,
 after Horace Kneeland
Marble, 62.5 cm. (24⅝ in.), c. 1872
NPG.65.24
*Transfer from the National Museum
 of American Art; bequest of Miss
 Georgiana Welles Sargent, 1947*

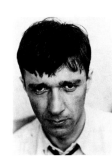

Evans, Walker, 1903-1975
Photographer
Attributed to Paul Grotz, 1902-
Photograph, gelatin silver print, 20.3
 x 15.2 cm. (8 x 6 in.), c. 1934
NPG.77.54

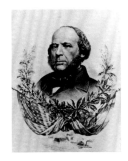

Ericsson, John, 1803-1889
Engineer, inventor
Unidentified artist, after Mathew
 Brady
Lithograph with tintstone, 50 x 47
 cm. (19¹¹⁄₁₆ x 18½ in.), c. 1862
NPG.78.122

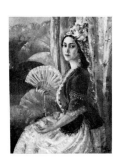

Evanti, Lillian, 1890-1967
Opera singer
Lois Mailou Jones, 1905-
Oil on canvas, 106.6 x 81.3 cm. (42 x
 32 in.), 1940
NPG.82.56
Gift of Max Robinson

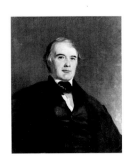

Espy, James Pollard, 1785-1860
Meteorologist
Thomas Sully, 1783-1872
Oil on canvas, 76.2 x 63.5 cm. (30 x
 25 in.), 1849
NPG.66.55
*Transfer from the National Museum
 of American Art; gift of the Espy
 Family to the Smithsonian
 Institution, 1860*

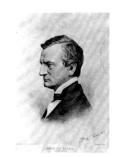

Evarts, William Maxwell, 1818-1901
Statesman
Buek and Lindner lithography
 company, active 1880s, after
 photograph
Root and Tinker, publishers
Lithograph with tintstone, 32.2 x
 23.8 cm. (12¾ x 9⅜ in.), 1884
NPG.78.87

**Etow Oh Koam ("King of the River
 Nation"),** ?-?
Indian chief
John Simon, 1675-1751/55, after John
 Verelst
Mezzotint, 34.4 x 25.7 cm. (13⁹⁄₁₆ x
 10⅛ in.), third state, c. 1760 from
 1710 plate
NPG.74.23

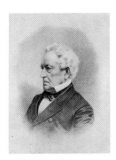

Everett, Edward, 1794-1865
Statesman
Joseph E. Baker, 1835-1914, after
 photograph by Black and Case
J. H. Bufford lithography company
Lithograph with tintstone, 50.3 x
 36.9 cm. (19¾ x 14½ in.), 1865
NPG.80.238

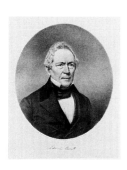

Everett, Edward, 1794-1865
Statesman
Francis D'Avignon, c. 1814-?, after
 daguerreotype by Jesse H.
 Whitehurst
Lithograph, 28.1 x 24.3 cm. (11¹¹⁄₁₆ x
 9⅝ in.), 1854
NPG.72.57

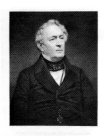

Everett, Edward, 1794-1865
Statesman
John Sartain, 1808-1897, after
 Marcus Aurelius Root
Mezzotint, 15.5 x 20.2 cm. (10¹⁄₁₆ x 8
 in.), 1861
NPG.80.142

Everett, Edward, 1794-1865
Statesman
David Octavius Hill, 1802-1870, and
 Robert Adamson, 1821-1848
Photograph, calotype, 20 x 14.4 cm.
 (7⅞ x 5¹¹⁄₁₆ in.), 1844
NPG.85.13

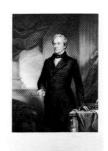

Everett, Edward, 1794-1865
Statesman
Hezekiah Wright Smith, 1823-?, after
 Moses Wright
Engraving and etching, 38.8 x 28.9
 cm. (15¼ x 11⅜ in.), 1858
NPG.78.108

Everett, Edward, 1794-1865
Statesman
David Octavius Hill, 1802-1870, and
 Robert Adamson, 1821-1848
Photograph, calotype, 20.1 x 14.5 cm.
 (7¹⁵⁄₁₆ x 5¾ in.), 1844
NPG.85.14

Everett, Edward, 1794-1865
Statesman
George K. Warren, c. 1824-1884
Photograph, albumen silver print,
 9.7 x 5.8 cm. (3¹³⁄₁₆ x 2¼ in.),
 c. 1860
NPG.77.354

Everett, Edward, 1794-1865
Statesman
Pendleton lithography company,
 active 1825-1836, after Samuel
 Stillman Osgood
Lithograph, 12.5 x 11 cm. (5 x 4⅜
 in.), 1833
Published in *The New-England
 Magazine,* Boston, September 1833
NPG.81.42

Fargo, William George, 1818-1881
Businessman
Unidentified artist
Pastel on paper, 59 x 48 cm. (23¼ x
 19 in.) oval, c. 1840
NPG.75.24

Everett, Edward, 1794-1865
Statesman
Hiram Powers, 1805-1873
Marble, 53.5 cm. (21 in.), c. 1841
NPG.68.53
Gift of Mrs. Charles Glover, Jr.

Farley, James Aloysius, 1888-1976
Public official
Philippe Halsman, 1906-1979
Photograph, gelatin silver print, 27 x
 28 cm. (10⅝ x 11 in.), 1959
NPG.83.80
Gift of George R. Rinhart

Farley, James Aloysius, 1888-1976
Public official
Edward Steichen, 1879-1973
Photograph, gelatin silver print, 24.3
 x 19.3 cm. (9⁹⁄₁₆ x 7⅝ in.), 1934
NPG.85.15

Faulkner, William Cuthbert,
 1897-1962
Author
Soss Melik, 1914-
Charcoal on paper, 45.7 x 32.4 cm.
 (18 x 12¾ in.), 1962
NPG.71.13

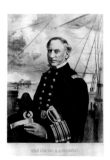

Farragut, David Glasgow, 1801-1870
Union admiral
J. H. Bufford lithography company,
 active 1835-1890, after photograph
 by Mathew Brady
Hand-colored lithograph, 29 x 21.9
 cm. (11⁷⁄₁₆ x 8⅝ in.), c. 1864
NPG.79.30

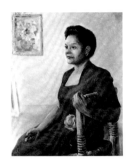

Fauset, Jessie, 1885?-1961
Author
Laura Wheeler Waring, 1887-1948
Oil on canvas, 91.4 x 76.8 cm. (36 x
 30¼ in.), 1945
NPG.67.82
Gift of the Harmon Foundation

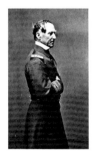

Farragut, David Glasgow, 1801-1870
Union admiral
Charles DeForest Fredricks,
 1823-1894
Photograph, albumen silver print,
 9.1 x 5.4 cm. (3⁹⁄₁₆ x 2⅛ in.), c. 1863
NPG.77.175

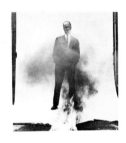

Feiffer, Jules Ralph*, 1929-
Cartoonist
Philippe Halsman, 1906-1979
Photograph, gelatin silver print, 30.5
 x 27.4 cm. (12 x 10¾ in.), 1963
T/NPG.83.81
Gift of George R. Rinhart

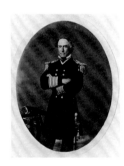

Farragut, David Glasgow, 1801-1870
Union admiral
Edward Jacobs, active c. 1846-?
Photograph, albumen silver print,
 32.4 x 24.5 cm. (12¾ x 9⅝ in.),
 c. 1864
NPG.78.65

Feininger, Lyonel, 1871-1956
Artist
Frederick S. Wight, 1902-1986
Oil on canvas, 54.6 x 41.9 cm. (21½ x
 16½ in.), 1949
NPG.80.5
Gift of Frederick S. Wight

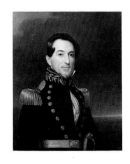

Farragut, David Glasgow, 1801-1870
Union admiral
William Swain, 1803-1847
Oil on canvas, 76.8 x 63.5 cm. (30¼ x
 25 in.), 1838
NPG.69.29
*Transfer from the National Museum
 of American History; gift of the
 estate of Loyall Farragut to the
 United States National Museum,
 1917*

Ferber, Edna, 1887-1968
Author
Philippe Halsman, 1906-1979
Photograph, gelatin silver print, 34.9
 x 27.1 cm. (13¾ x 10¹¹⁄₁₆ in.), 1963
NPG.83.82
Gift of George R. Rinhart

Feuermann, Emanuel, 1902-1942
Musician
August Sander, 1876-1964
Photograph, gelatin silver print, 28.3
 x 21.4 cm. (11⅛ x 8⁷⁄₁₆ in.), c. 1950
 from 1923 negative
NPG.85.96

Field, Stephen Johnson, 1816-1899
Jurist
Unidentified photographer
Photograph, albumen silver print,
 14.2 x 10.1 cm. (5⅝ x 3¹⁵⁄₁₆ in.),
 c. 1877
NPG.85.98
Gift of Robert L. Drapkin

Field, Cyrus West, 1819-1892
Businessman
Attributed to Mathew Brady,
 1823-1896
Photograph, salt print, 44.8 x 35.7
 cm. (17⅝ x 14¹⁄₁₆ in.), c. 1860
NPG.80.294

Fields, James Thomas, 1817-1881
Publisher
Julia Margaret Cameron, 1815-1879
Photograph, albumen silver print,
 32.5 x 26.1 cm. (12¹³⁄₁₆ x 10¼ in.),
 1869
NPG.83.194

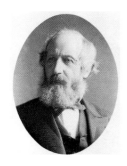

Field, Cyrus West, 1819-1892
Businessman
Benjamin J. Falk, 1853-1925
Photograph, albumen silver print,
 11.8 x 9 cm. (4⅝ x 3½ in.), c. 1875
NPG.77.128

Fields, James Thomas, 1817-1881
Publisher
George K. Warren, c. 1824-1884
Photograph, carbon print, 9.6 x 5.8
 cm. (3¹³⁄₁₆ x 2⁵⁄₁₆ in.), c. 1870
NPG.79.48

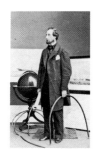

Field, Cyrus West, 1819-1892
Businessman
Charles DeForest Fredricks,
 1823-1894
Photograph, albumen silver print,
 9.1 x 5.3 cm. (3⁹⁄₁₆ x 2⅛ in.), c. 1863
NPG.80.213

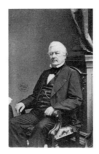

Fillmore, Millard, 1800-1874
Thirteenth President of the United
 States
Mathew Brady, 1823-1896
Photograph, albumen silver print,
 8.3 x 5.3 cm. (3¼ x 2¹⁄₁₆ in.), c. 1860
NPG.77.352

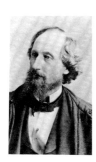

Field, Cyrus West, 1819-1892
Businessman
Unidentified photographer
Photograph, albumen silver print,
 9 x 5.8 cm. (3½ x 2⁵⁄₁₆ in.), c. 1870
NPG.77.356

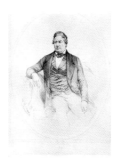

Fillmore, Millard, 1800-1874
Thirteenth President of the United
 States
Charles G. Crehen, 1829-?, after
 daguerreotype by Daniel E. Gavit
Nagel and Weingaertner lithography
 company
Lithograph, 37 x 31.5 cm. (14½ x 12½
 in.), 1850
NPG.80.42

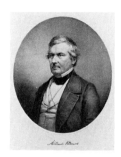

Fillmore, Millard, 1800-1874
Thirteenth President of the United
 States
Francis D'Avignon, c. 1814-?, after
 daguerreotype by Mathew Brady
Lithograph, 28.1 x 24.6 cm. (11¹¹⁄₁₆ x
 9¹¹⁄₁₆ in.), 1850
Published in Mathew Brady's
 Gallery of Illustrious Americans,
 New York, 1850
NPG.72.58

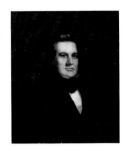

Fillmore, Millard, 1800-1874
Thirteenth President of the United
 States
Unidentified artist
Oil on canvas, 76.2 x 63.5 cm. (30 x
 25 in.), c. 1840
NPG.78.50

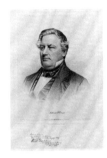

Fillmore, Millard, 1800-1874
Thirteenth President of the United
 States
Leopold Grozelier, 1830-1865, after
 daguerreotype by Whipple and
 Black
J. H. Bufford lithography company
Lithograph, 38.5 x 30.1 cm. (15⅛ x
 11⅞ in.), 1856
NPG.78.121

Finley, David Edward*, 1890-1977
Museum director
Oskar Stoessel, 1879-1964
Etching and drypoint, 18.6 x 10.6 cm.
 (7⁵⁄₁₆ x 4³⁄₁₆ in.), c. 1943
T/NPG.65.2.87
Gift of David E. Finley

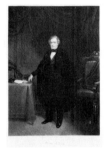

Fillmore, Millard, 1800-1874
Thirteenth President of the United
 States
John Sartain, 1808-1897
Mezzotint, 50.7 x 36.9 cm. (19¹⁵⁄₁₆ x
 14½ in.), c. 1850
NPG.84.99

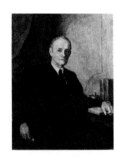

Finley, David Edward*, 1890-1977
Museum director
Augustus Vincent Tack, 1870-1949
Oil on canvas, 121.9 x 91.4 cm. (48 x
 36 in.), not dated
T/NPG.77.231.87
Gift of W. Bedford Moore

Fillmore, Millard, 1800-1874
Thirteenth President of the United
 States
Attributed to Albert Sands
 Southworth, 1811-1894, and Josiah
 Johnson Hawes, 1808-1901; studio
 active 1844-1861
Daguerreotype, 8.2 x 6.9 cm. (3¼ x
 2¹¹⁄₁₆ in.), c. 1850
NPG.77.55

Finley, John Huston, 1863-1940
Editor
Clara E. Sipprell, 1885-1975
Photograph, Gevalux print, 22.7 x
 17.5 cm. (8¹⁵⁄₁₆ x 6⅞ in.), c. 1935
NPG.82.203
Bequest of Phyllis Fenner

Fillmore, Millard, 1800-1874
Thirteenth President of the United
 States
Adam Weingaertner, active
 1849-1863
Lithograph with tintstone, 48 x 34.5
 cm. (18⅞ x 13⅜ in.), c. 1860
NPG.78.25

Firestone, Harvey Samuel, 1868-1938
Businessman
James Earle Fraser, 1876-1953
Bronze, 38.3 cm. (15⅛ in.), not dated
NPG.76.102
*Gift of the Firestone Tire and Rubber
 Company*

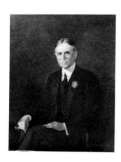

Firestone, Harvey Samuel, 1868-1938
Businessman
Elizabeth Shoumatoff, 1888-1980
Oil on canvas, 118.1 x 92.7 cm. (46½ x
36½ in.), 1962 replica after c. 1938
portrait
NPG.76.3
*Gift of the Firestone Tire and Rubber
Company*

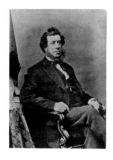

Fish, Hamilton, 1808-1893
Statesman
Mathew Brady, 1823-1896
Photograph, albumen silver print,
14.8 x 10.3 cm. (5¹³⁄₁₆ x 4¹⁄₁₆ in.),
1869
NPG.77.169

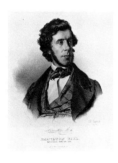

Fish, Hamilton, 1808-1893
Statesman
Charles Fenderich, 1805-1887
Lewis and Brown(e) lithography
company
Lithograph, 28.9 x 25.2 cm. (11⅜ x
9¹⁵⁄₁₆ in.), 1844
NPG.66.81
*Transfer from the Library of
Congress, Prints and Photographs
Division*

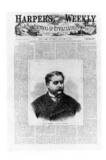

Fisk, James, 1834-1872
Financier
Unidentified artist, after photograph
by Mathew Brady
Wood engraving, 14.4 x 14.9 cm.
(5¹¹⁄₁₆ x 5⅞ in.), 1872
Published in *Harper's Weekly,* New
York, January 20, 1872
NPG.74.20

Fisk, James, 1834-1872
Financier
Unidentified photographer
Photograph, albumen silver print,
8.7 x 5.7 cm. (3⁷⁄₁₆ x 2¼ in.), c. 1870
NPG.76.74

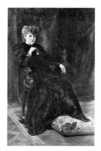

Fiske, Minnie Maddern, 1865-1932
Actress
M. Raphael Colin, c. 1840-?
Oil on canvas, 182.5 x 122.5 cm.
(71⅞ x 48¼ in.), 1893
NPG.67.19
*Gift of Mr. and Mrs. Walter
Schnormeier*

Fiske, Minnie Maddern, 1865-1932
Actress
Alfred J. Frueh, 1880-1968
Linocut, 26.1 x 18 cm. (10¼ x 7¹⁄₁₆
in.), 1922
Published in Alfred J. Frueh's *Stage
Folk,* New York, 1922
NPG.84.229.cc

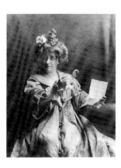

Fiske, Minnie Maddern, 1865-1932
Actress
Arnold Genthe, 1869-1942
Photograph, gelatin silver print, 32.7
x 24.7 cm. (12⅞ x 9¾ in.), c. 1920
NPG.78.241

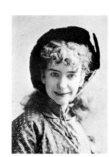

Fiske, Minnie Maddern, 1865-1932
Actress
José Maria Mora, c. 1847-1926
Photograph, albumen silver print,
13.7 x 9.8 cm. (5⅜ x 3⅞ in.),
c. 1880
NPG.80.199

Fitzgerald, Ella*, 1918-
Singer
Carl Van Vechten, 1880-1964
Photogravure, 22.4 x 14.9 cm. (8⅞ x
5⅞ in.), 1983 from 1940 negative
T/NPG.83.188.15

Fitzgerald, Francis Scott Key,
 1896-1940
Author
Harrison Fisher, 1875-1934
Sanguine conté crayon on paper, 57.1
 x 31.4 cm. (22½ x 12⅜ in.), 1927
NPG.73.29
*Gift of his daughter, Mrs. Scottie
 Smith*

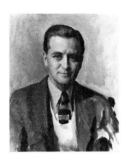

Fitzgerald, Francis Scott Key,
 1896-1940
Author
David Silvette, 1909-
Oil on canvas, 61 x 50.8 cm. (24 x 20
 in.), 1935
NPG.72.107

Fitzgerald, Zelda Sayre, 1900-1947
Wife of Francis Scott Fitzgerald
Harrison Fisher, 1875-1934
Sanguine conté crayon on paper, 58.4
 x 36.2 cm. (23 x 14¼ in.), 1927
NPG.73.46
*Gift of her daughter, Mrs. Scottie
 Smith*

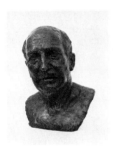

Flaherty, Robert Joseph, 1884-1951
Filmmaker
Jo Davidson, 1883-1952
Bronze, 39.6 cm. (15⅝ in.), 1944
NPG.73.21

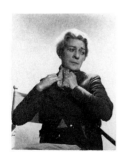

Flanner, Janet*, 1892-1978
Journalist
George Platt Lynes, 1907-1955
Photograph, gelatin silver print, 11.3
 x 8.8 cm. (4⁷⁄₁₆ x 3⁷⁄₁₆ in.), c. 1940
T/NPG.84.316.88

Flanner, Janet*, 1892-1978
Journalist
George Platt Lynes, 1907-1955
Photograph, gelatin silver print, 11.3
 x 8.8 cm. (4⁷⁄₁₆ x 3⁷⁄₁₆ in.), c. 1940
T/NPG.84.317.88

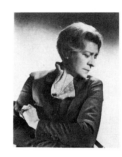

Flanner, Janet*, 1892-1978
Journalist
George Platt Lynes, 1907-1955
Photograph, gelatin silver print, 11.2
 x 8.8 cm. (4⁷⁄₁₆ x 3⁷⁄₁₆ in.), c. 1940
T/NPG.84.318.88

Flanner, Janet*, 1892-1978
Journalist
George Platt Lynes, 1907-1955
Photograph, gelatin silver print, 11.3
 x 8.8 cm. (4⁷⁄₁₆ x 3½ in.), c. 1940
T/NPG.84.319.88

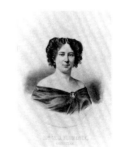

Florence, Malvina Pray, 1830-1906
Actress
Francis D'Avignon, c. 1814-?, after
 daguerreotype by Meade Brothers
Lithograph, 30.5 x 31 cm. (12 x 12³⁄₁₆
 in.), 1857
NPG.78.95

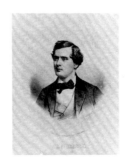

**Florence, William Jermyn (Bernard
 Conlin),** 1831-1891
Actor
Francis D'Avignon, c. 1814-?, after
 daguerreotype by Meade Brothers
Lithograph, 30.5 x 31.2 cm. (12 x 12¼
 in.), 1857
NPG.78.94

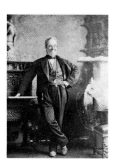

Florence, William Jermyn (Bernard Conlin), 1831-1891
Actor
Napoleon Sarony, 1821-1896
Photograph, albumen silver print, 14.3 x 10.2 cm. (5⅝ x 4 in.), c. 1875
NPG.80.69

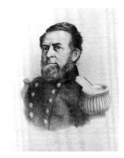

Foote, Andrew Hull, 1806-1863
Union admiral
Caroline Street Leffingwell, 1826-1904, after photograph by James Fitzallan Ryder
Lithograph with tintstone, 51.2 x 43 cm. (20⅛ x 4¹⁵⁄₁₆ in.), c. 1862
NPG.79.1

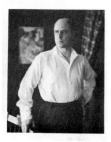

Fokine, Michel, 1880-1942
Choreographer
Clara E. Sipprell, 1885-1975
Photograph, gelatin silver print, 23.7 x 18.9 cm. (9⁵⁄₁₆ x 7⁷⁄₁₆ in.), 1923
NPG.82.157
Bequest of Phyllis Fenner

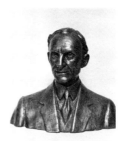

Ford, Henry, 1863-1947
Industrialist
Hans Wollner, c. 1899-c. 1946
Bronze, 42.2 cm. (16⅝ in.), cast after 1937 plaster
NPG.65.3
Gift of the Henry Ford Trade School Alumni Association

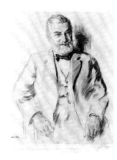

Folger, Henry Clay, 1857-1930
Lawyer, oil magnate, and collector of Shakespeareana
Walter Tittle, 1883-1968
Drypoint, 34.2 x 27.3 cm. (13⁷⁄₁₆ x 10¾ in.), 1924
NPG.79.100

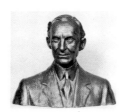

Ford, Henry, 1863-1947
Industrialist
Hans Wollner, c. 1899-c. 1946
Plaster, 42.2 cm. (16⅝ in.), 1937
NPG.80.139
Gift of Raymond H. Schettler

Follen, Charles, 1796-1840
Clergyman, abolitionist
Endicotts lithography company, active 1828-1896, after Spiridione Gambardella
Lithograph, 20 x 16.1 cm. (7⅞ x 6⁵⁄₁₆ in.), c. 1840
NPG.77.336

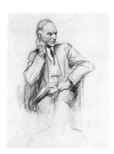

Ford, Henry, 1863-1947
Industrialist
Samuel Johnson Woolf, 1880-1948
Pencil with gouache on paper, 43.2 x 28 cm. (17 x 11 in.), 1938
NPG.80.258.a

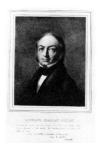

Foote, Andrew Hull, 1806-1863
Union admiral
Ehrgott and Forbriger lithography company, active 1858-1869, after photograph
Lithograph, 25.3 x 23.8 cm. (9¹⁵⁄₁₆ x 9⅜ in.), c. 1861-1862
NPG.81.36

Ford, Henry, 1863-1947
Industrialist
Samuel Johnson Woolf, 1880-1948
Charcoal heightened with chalk on paper, 62.5 x 24.8 cm. (25⅝ x 9¾ in.), 1938
NPG.80.258.b

Ford, Henry, 1863-1947
Industrialist
Samuel Johnson Woolf, 1880-1948
Pencil, charcoal, and gouache on
 paper, 23.6 x 22.7 cm. (9⁵⁄₁₆ x 8¹⁵⁄₁₆
 in.), 1938
NPG.80.258.c

Ford, Henry, 1863-1947
Industrialist
Samuel Johnson Woolf, 1880-1948
Pencil, charcoal, and gouache on
 paper, 37.2 x 28 cm. (14⅝ x 11 in.),
 1938
NPG.80.258.d

Forrest, Edwin (as Metamora),
 1806-1872
Actor
Frederick Styles Agate, 1807-1844
Oil on canvas, 62.2 x 48.9 cm. (24½ x
 19¼ in.), c. 1832
NPG.66.20
*Gift of the Kathryn and Gilbert
 Miller Fund in memory of
 Alexander Ince*

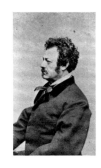

Forrest, Edwin, 1806-1872
Actor
T. R. Burnham, ?-?
Photograph, albumen silver print,
 9.5 x 5.8 cm. (3¾ x 2¼ in.), c. 1860
NPG.78.288

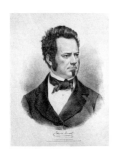

Forrest, Edwin, 1806-1872
Actor
Currier and Ives lithography
 company, active 1857-1907, after
 photograph
Lithograph, 37.3 x 31.1 cm. (14⅝ x
 12¼ in.), 1860
NPG.84.101

Forrest, Edwin, 1806-1872
Actor
Attributed to Max Rosenthal,
 1833-1918, after Henry Louis
 Stephens
Louis Rosenthal lithography
 company
Chromolithograph, 10.6 x 10.8 cm.
 (4⅛ x 4¼ in.), 1851
Published in Henry L. Stephens's
 The Comic Natural History,
 Philadelphia, 1851
NPG.78.292

Forrest, Edwin, 1806-1872
Actor
Napoleon Sarony, 1821-1896
Photograph, albumen silver print,
 9.6 x 6.1 cm. (3¾ x 2⅜ in.), c. 1872
NPG.80.170

Forrest, Edwin, 1806-1872
Actor
Unidentified artist, after James
 Warren Childe
Nathaniel Dearborn, publisher
Lithograph, 20 x 16.5 cm. (7⅞ x 6½
 in.), 1839
NPG.78.118

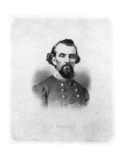

Forrest, Nathaniel Bedford,
 1821-1877
Confederate cavalryman
J. L. Giles lithography company,
 active 1835-1881, after photograph
Lithograph with tintstone, 30.6 x
 25.6 cm. (12¹⁄₁₆ x 10¹⁄₁₆ in.), c. 1868
NPG.84.332

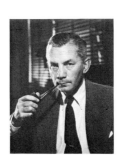

Forrestal, James Vincent, 1892-1949
Statesman
Philippe Halsman, 1906-1979
Photograph, gelatin silver print, 34.9
 x 27.5 cm. (13¾ x 10¹³⁄₁₆ in.), 1947
NPG.82.176
Gift of George R. Rinhart

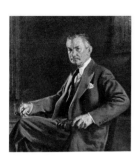

Forrestal, James Vincent, 1892-1949
Statesman
Albert K. Murray, 1906-
Oil on canvas, 100.8 x 80 cm. (39¾ x
 31½ in.), 1949
NPG.65.70
*Transfer from the National Gallery
 of Art; gift of an anonymous
 donor, 1953*

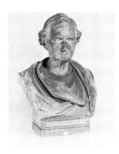

Forsyth, John, 1780-1841
Statesman
Nicola Cantalamessa-Papotti,
 1831-1910
Plaster, 69.2 cm. (27¼ in.), 1853
NPG.70.26
*Transfer from the National Museum
 of American Art*

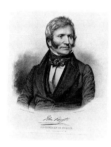

Forsyth, John, 1780-1841
Statesman
Charles Fenderich, 1805-1887
Lithograph, 28.5 x 28.4 cm. (11¼ x
 11³⁄₁₆ in.), 1840
NPG.66.82
*Transfer from the Library of
 Congress, Prints and Photographs
 Division*

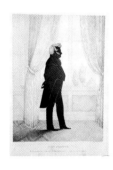

Forsyth, John, 1780-1841
Statesman
E. B. and E. C. Kellogg lithography
 company, active c. 1842-1867, after
 William Henry Brown
Lithographed silhouette, 34.2 x 25.2
 cm. (13⁷⁄₁₆ x 9¹⁵⁄₁₆ in.), 1844
Published in William H. Brown's
 *Portrait Gallery of Distinguished
 American Citizens*, Hartford, 1845
NPG.80.276.f
Gift of Wilmarth Sheldon Lewis

Fortas, Abe*, 1910-1982
Justice of the United States Supreme
 Court
Oscar Berger, 1901-
Ink over pencil on paper, 40 x 30.5
 cm. (15¾ x 12 in.), c. 1968
T/NPG.69.16.92
Gift of the artist

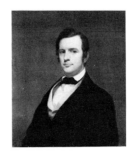

Foster, Stephen Collins, 1826-1864
Composer
Attributed to Thomas Hicks,
 1823-1890
Oil on canvas, 76.2 x 63.5 cm. (30 x
 25 in.), c. 1850
NPG.65.52
*Transfer from the National Gallery
 of Art; gift of Andrew W. Mellon,
 1942*

Foster, Stephen Collins, 1826-1864
Composer
Attributed to Major and Knapp
 lithography company, active
 1864-1871, after photograph
Lithograph with tintstone, 18.8 x
 16.8 cm. (7⅜ x 6⅝ in.), 1888
Music sheet title page: "Old Black
 Joe"
NPG.78.115

Francis, John Wakefield, 1789-1861
Physician
William G. Jackman, active c. 1841-
 c. 1863, after photograph by
 Mathew Brady
Engraving, 22.5 x 19.5 cm. (8⅞ x
 7¹¹⁄₁₆ in.), 1860
NPG.85.175

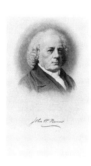

Frankfurter, Felix, 1882-1965
Justice of the United States Supreme
 Court
Oscar Berger, 1901-
Pencil on paper, 42 x 35.2 cm. (16⁹⁄₁₆
 x 13⅞ in.), not dated
NPG.69.10
Gift of the artist

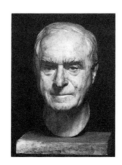

Frankfurter, Felix, 1882-1965
Justice of the United States Supreme
 Court
Eleanor Platt, 1910-1974
Plaster, 45.5 cm. (18 in.), not dated
NPG.81.105
Gift of Mrs. Florence Schaffhausen

Frankfurter, Felix, 1882-1965
Justice of the United States Supreme
 Court
Clara E. Sipprell, 1885-1975
Photograph, gelatin silver print, 22.5
 x 17.4 cm. (8⅞ x 6⅞ in.), c. 1940
NPG.82.156
Bequest of Phyllis Fenner

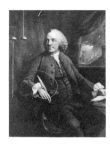

Franklin, Benjamin, 1706-1790
Author, statesman, scientist,
 diplomat
Edward Fisher, 1722-1785, after
 Mason Chamberlin
Mezzotint, 34.9 x 27.7 cm. (13¾ x
 10⅞ in.), 1763
NPG.70.66

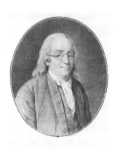

Franklin, Benjamin, 1706-1790
Author, statesman, scientist,
 diplomat
Pierre Michel Alix, 1762-1817, after
 Charles Amédée Philippe van Loo
Color aquatint, 24.1 x 20.3 cm. (9½ x
 8 in.), c. 1790
NPG.70.65

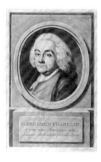

Franklin, Benjamin, 1706-1790
Author, statesman, scientist,
 diplomat
Johann Elias Haid, 1739-1809,
 probably after James MacArdell,
 after Benjamin Wilson
Mezzotint, 20.4 x 13.1 cm. (8 x 5¼
 in.), 1778
NPG.78.114

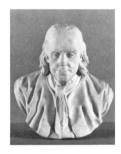

Franklin, Benjamin, 1706-1790
Author, statesman, scientist,
 diplomat
After the 1777 original by Jean
 Jacques Caffieri, 1725-1792
Marble, 56.8 cm. (22⅜ in.), after 1777
NPG.69.61

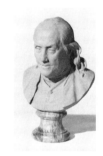

Franklin, Benjamin, 1706-1790
Author, statesman, scientist,
 diplomat
Jean Antoine Houdon, 1741-1828
Terra-cotta, 39 cm. (15⅜ in.), cast
 after 1778 original
NPG.76.40

Franklin, Benjamin, 1706-1790
Author, statesman, scientist,
 diplomat
Louis Carrogis de Carmontelle,
 1717-1806
Ink, crayon, and watercolor on paper,
 30.5 x 19 cm. (12 x 17½ in.), c.
 1780/81
NPG.82.108
*Bequest of Mrs. Herbert Clark
 Hoover*

Franklin, Benjamin, 1706-1790
Author, statesman, scientist,
 diplomat
Jean Antoine Houdon, 1741-1828
Plaster, 28.5 cm. (11¼ in.), cast after
 1778 original
NPG.76.58
Gift of Joseph Hennage

Franklin, Benjamin, 1706-1790
Author, statesman, scientist,
 diplomat
Justus Chevillet, 1729-1790, after
 Joseph Siffred Duplessis
Engraving, 26.6 x 17.9 cm. (10½ x 7¹/₁₆
 in.), c. 1778-1784
NPG.77.219

Franklin, Benjamin, 1706-1790
Author, statesman, scientist,
 diplomat
Jean Charles Le Vasseur, 1734-1805,
 after Antoine Borel
Engraving, 43.2 x 35 cm. (17 x 13¾
 in.), 1778
NPG.78.74

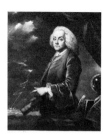

Franklin, Benjamin, 1706-1790
Author, statesman, scientist,
 diplomat
James MacArdell, c. 1728-1765, after
 Benjamin Wilson
Mezzotint, 30.2 x 24.9 cm. (11⅞ x
 9¹³⁄₁₆ in.), 1761
NPG.77.77

Franklin, Benjamin, 1706-1790
Author, statesman, scientist,
 diplomat
John Scoles, active 1793-1844, after
 Jean-Baptiste Nini, after Thomas
 Walpole, Jr.
Engraving printed on leather, 9.4 x
 7.3 cm. (3¾ x 2⅞ in.), 1793
Contained in Joel Barlow's *The
 Vision of Columbus*, Paris, 1793
NPG.80.120.a

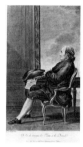

Franklin, Benjamin, 1706-1790
Author, statesman, scientist,
 diplomat
François Denis Née, 1732-1817, after
 Louis Carrogis de Carmontelle
Engraving, 31 x 19.2 cm. (12³⁄₁₆ x 7⁹⁄₁₆
 in.), 1781
NPG.77.218

Franklin, Benjamin, 1706-1790
Author, statesman, scientist,
 diplomat
Johann Martin Will, 1727-1806, after
 Charles Nicolas Cochin
Mezzotint, 30.1 x 23.5 cm. (11⅞ x 9¼
 in.), 1778
NPG.69.30

Franklin, Benjamin, 1706-1790
Author, statesman, scientist,
 diplomat
Jean-Baptiste Nini, 1717-1786
Terra-cotta medallion, 11.1 cm.
 (4⅜ in.) diameter, 1777
NPG.66.12

Frazee, John, 1790-1852
Artist
Self-portrait
Plaster, 58.4 cm. (23 in.), 1827
NPG.82.148

Franklin, Benjamin, 1706-1790
Author, statesman, scientist,
 diplomat
Jean-Baptiste Nini, 1717-1786
Terra-cotta medallion, 9.2 cm.
 (3⅝ in.) diameter, 1777
NPG.66.13

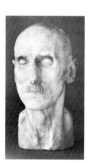

Freer, Charles Lang, 1856-1919
Businessman, collector
H. Walthausen, ?-?
Plaster death mask, 34.2 cm. (13½
 in.), 1919
NPG.80.17
Gift of the Freer Gallery of Art

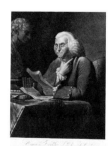

Franklin, Benjamin, 1706-1790
Author, statesman, scientist,
 diplomat
Edward Savage, 1761-1817, after
 Benjamin West, after David
 Martin
Mezzotint, 45.7 x 35.5 cm. (18 x 14
 in.), 1793
NPG.70.9

Frémont, John Charles, 1813-1890
Explorer
Attributed to Joseph E. Baker,
 1835-1914, after photograph
J. H. Bufford lithography company
Lithograph, 31 x 24 cm. (12³⁄₁₆ x 9⁷⁄₁₆
 in.), 1861
NPG.83.3

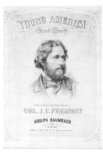

Frémont, John Charles, 1813-1890
Explorer
L. H. Bradford and Company, active
 1854-1859, after photograph by
 Samuel Root
Lithograph with tintstone, 27.9 x
 20.5 cm. (11 x 8 in.), 1856
Music sheet title page: "Young
 America Grand March"
NPG.81.34

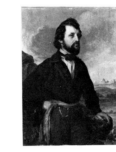

Frémont, John Charles, 1813-1890
Explorer
Leopold Grozelier, 1830-1865, after
 photograph by Samuel Root
J. H. Bufford lithography company
Lithograph, 26.8 x 24 cm. (10⁹⁄₁₆ x
 9⁷⁄₁₆ in.), 1856
NPG.77.80

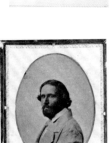

Frémont, John Charles, 1813-1890
Explorer
Mathew Brady, 1823-1896
Ambrotype, 14.1 x 10.9 cm. (5⁹⁄₁₆ x
 3¼ in.), c. 1856
NPG.78.66

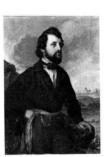

Frémont, John Charles, 1813-1890
Explorer
William S. Jewett, 1812-1873
Oil on panel, 38 x 28 cm. (14⅞ x 11
 in.), not dated
NPG.72.17

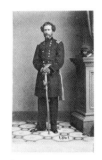

Frémont, John Charles, 1813-1890
Explorer
Mathew Brady, 1823-1896
Photograph, albumen silver print,
 8.5 x 5.4 cm. (3⅜ x 2⅛ in.), 1861
NPG.80.308
Gift of Dr. Mary W. Juday

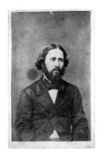

Frémont, John Charles, 1813-1890
Explorer
Charles Richard Meade, 1827-1858,
 and Henry William Matthew
 Meade, 1823-1865, at the Meade
 Brothers studio, active 1842-1870
Photograph, albumenized salt print,
 9.1 x 5.7 cm. (3⅝ x 2¼ in.), c. 1856
NPG.85.190
*Gift of Mr. and Mrs. Dudley
 Emerson Lyons*

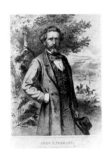

Frémont, John Charles, 1813-1890
Explorer
J. H. Bufford lithography company,
 active 1835-1890, after unidentified
 artist
Lithograph, 29.8 x 22.5 cm. (11¾ x
 8⅞ in.), c. 1864
NPG.77.79

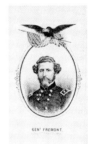

Frémont, John Charles, 1813-1890
Explorer
Louis Prang lithography company,
 active 1856-1899, after photograph
Lithograph, 8.3 x 6 cm. (3¼ x 2⅜
 in.), 1862
Contained in D. Dudley's *Officers of
 Our Union Army and Navy. Their
 Lives, Their Portraits*, vol. 1,
 Washington, D.C., and Boston,
 1862
NPG.80.119.p

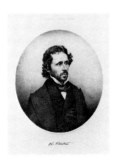

Frémont, John Charles, 1813-1890
Explorer
Francis D'Avignon, c. 1814-?, after
 daguerreotype by Mathew Brady
Lithograph, 28.1 x 24.8 cm. (11¹⁄₁₆ x
 9¾ in.), 1850
Published in Mathew Brady's
 Gallery of Illustrious Americans,
 New York, 1850
NPG.69.68

Frémont, John Charles, 1813-1890
Explorer
Samuel Root, 1819-1889
Photograph, salt print, 18.2 x 13 cm.
 (7¼ x 5¼ in.), c. 1856
NPG.77.119

Frémont, John Charles, 1813-1890
Explorer
Sarony lithography company, active
 1853-1857, after photograph by
 Samuel Root
Lithograph with tintstone, 27.9 x
 19.9 cm. (11 x 7¹³⁄₁₆ in.), 1856
Music sheet title page: "There is the
 White House Yonder"
NPG.82.6

French, Daniel Chester, 1850-1931
Artist
Evelyn Beatrice Longman, 1874-1954
Bronze relief, 127 x 154.9 cm. (50 x
 61 in.), 1926
NPG.70.27
*Transfer from the National Museum
 of American Art; gift of the artist,
 1936*

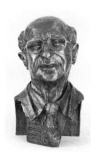

Friedan, Betty Naomi Goldstein*,
 1921-
Author
Garry Winogrand, 1928-1984
Photograph, gelatin silver print, 31.2
 x 46.5 cm. (12⁵⁄₁₆ x 18⁵⁄₁₆ in.), 1969
T/NPG.84.29

Friedman, Milton*, 1912-
Economist
Bonnie Veblen Chancellor, ?-
Bronze, 52 cm. (20½ in.), 1982
T/NPG.83.152
*Gift of the Friends of Milton
 Friedman*

Frohman, Charles, 1860-1915
Impresario
José Maria Mora, c. 1847-1926
Photograph, albumen silver print,
 8.7 x 5.8 cm. (3⁷⁄₁₆ x 2¼ in.), c. 1885
NPG.80.168

Frost, Robert Lee, 1874-1963
Poet
José Buscaglia-Guillermety, 1938-
Bronze, 22.8 cm. (9 in.), 1962
NPG.68.40
*Gift of Banco Credito y Ahorro
 Ponceno, San Juan, Puerto Rico*

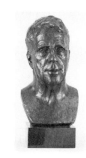

Frost, Robert Lee, 1874-1963
Poet
Walker Hancock, 1901-
Bronze, 40.9 cm. (16⅛ in.), cast after
 1950 clay
NPG.69.31
Gift of the artist

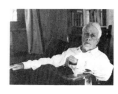

Frost, Robert Lee, 1874-1963
Poet
Lotte Jacobi, 1896-
Photograph, gelatin silver print, 17.5
 x 24.5 cm. (6⅞ x 9¹¹⁄₁₆ in.), c. 1980
 from 1959 negative
NPG.85.82

Frost, Robert Lee, 1874-1963
Poet
Clara E. Sipprell, 1885-1975
Photograph, gelatin silver print, 22.9
 x 17.4 cm. (9¹⁄₁₆ x 6⅞ in.), c. 1955
NPG.82.155
Bequest of Phyllis Fenner

Fruhauf, Aline*, 1907-1978
Caricaturist
Self-portrait
Lithograph with pencil, 32.3 x 22.8
 cm. (12¹¹⁄₁₆ x 8¹⁵⁄₁₆ in.), 1933
T/NPG.83.63.88
Gift of Erwin Vollmer

Fruhauf, Aline*, 1907-1978
Caricaturist
Self-portrait
Lithograph, 26.8 x 18.3 cm. (10⁹⁄₁₆ x
 7³⁄₁₆ in.), 1931
T/NPG.83.260.88
Gift of Erwin Vollmer

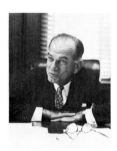

Fulbright, James William*, 1905-
Statesman
Philippe Halsman, 1906-1979
Photograph, gelatin silver print, 35 x
 27.5 cm. (13¾ x 10¹³⁄₁₆ in.), 1961
T/NPG.83.83
Gift of George R. Rinhart

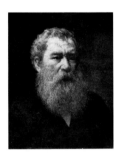

Fuller, George, 1822-1884
Artist
Edwin T. Billings, 1824-1893
Oil on canvas, 45.5 x 38.1 cm. (18 x
 15 in.), not dated
NPG.66.56
*Transfer from the National Museum
 of American Art; gift of Miss
 Catherine McE. Ames to the
 Smithsonian Institution, 1947*

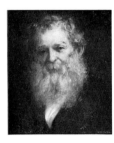

Fuller, George, 1822-1884
Artist
William Baxter Palmer Closson,
 1848-1926
Oil on canvas, 53.3 x 44.4 cm. (21 x
 17½ in.), not dated
NPG.85.5
*Transfer from the National Museum
 of American Art; gift of Mrs. W. B.
 P. Closson*

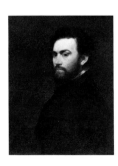

Fuller, George, 1822-1884
Artist
Self-portrait
Oil on canvas, 68.5 x 55.8 cm. (27 x
 22 in.), before 1860
NPG.65.71
*Transfer from the National Gallery
 of Art; gift of Mrs. Augustus
 Vincent Tack, 1954*

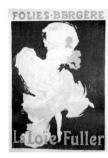

Fuller, Loie, 1862-1928
Dancer
Jules Chéret, 1836-1932
Color lithographic poster, 111.1 x
 82.4 cm. (43¾ x 32⁷⁄₁₆ in.), 1893
NPG.84.109

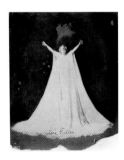

Fuller, Loie, 1862-1928
Dancer
Benjamin J. Falk, 1853-1925
Photograph, albumen silver print, 23
 x 18 cm. (9¹⁄₁₆ x 7⅛ in.), 1901
NPG.81.24

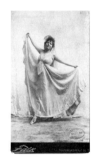

Fuller, Loie, 1862-1928
Dancer
Benjamin J. Falk, 1853-1925
Photograph, albumen silver print, 30
 x 17.9 cm. (11¹³⁄₁₆ x 7¹⁄₁₆ in.), 1892
NPG.82.144

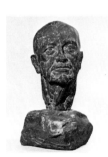

Fuller, Richard Buckminster, Jr.*,
 1895-1983
Inventor, philosopher
Una Hanbury, ?-
Bronze, 34.2 cm. (13½ in.), 1976
T/NPG.77.37.93

**Fuller, Richard Buckminster, Jr. (as
 a thinker)*,** 1895-1983
Inventor, philosopher
Soss Melik, 1914-
Charcoal on paper, 62.5 x 48.1 cm.
 (24⅝ x 19 in.), 1979
T/NPG.80.6.93
Gift of The Barra Foundation

Fuller, Richard Buckminster, Jr. (as an aesthete)*, 1895-1983
Inventor, philosopher
Soss Melik, 1914-
Charcoal with chalk on paper, 63 x 48 cm. (24⅞ x 18⅞ in.), 1979
T/NPG.80.7.93
Gift of The Barra Foundation

Fulton, Robert, 1765-1815
Inventor
Jean-Antoine Houdon, 1741-1828
Bronze, 72.4 cm. (28½ in.), cast after 1803 plaster
NPG.69.2

Furuseth, Andrew, 1854-1938
Labor leader
Jo Davidson, 1883-1952
Bronze, 36.8 cm. (14½ in.), 1929
NPG.85.71

Gable, Clark, 1901-1960
Actor
Clarence Sinclair Bull, 1895-1979
Photograph, gelatin silver print, 34 x 26 cm. (13⅜ x 10¼ in.), c. 1932
NPG.81.72

Galbraith, John Kenneth*, 1908-
Economist
John Erhardy, 1928-
Marble, 39.3 cm. (15½ in.), 1981
T/NPG.83.133

Galbraith, John Kenneth*, 1908-
Economist
Philippe Halsman, 1906-1979
Photograph, gelatin silver print, 34.9 x 27.2 cm. (13¾ x 10¹¹⁄₁₆ in.), 1960
T/NPG.83.84
Gift of George R. Rinhart

Gales, Joseph, 1786-1860
Journalist
Leopold Grozelier, 1830-1865, after George Peter Alexander Healy
S. W. Chandler and Brother lithography company
Lithograph, 26.7 x 24.5 cm. (10½ x 9⅝ in.), 1854
Published in Charles H. Brainard's *Portrait Gallery of Distinguished Americans,* Boston, 1855
NPG.77.81

Gales, Joseph, 1786-1860
Journalist
Thomas Waterman Wood, 1823-1903
Oil on linen, 25.4 x 17.7 cm. (10 x 7 in.), 1856
NPG.74.4

Gallagher, Louise Barnes, ?-?
Designer
Aline Fruhauf, 1907-1978
Watercolor and pencil with colored pencil and opaque white on paper, 37.5 x 24.8 cm. (14¾ x 9¾ in.), 1942
NPG.83.275
Gift of Erwin Vollmer

Gallatin, Albert, 1761-1849
Statesman
Thomas Worthington Whittredge, 1820-1910, after Gilbert Stuart
Oil on artist board, 68.5 x 55.8 cm. (27 x 22 in.), after 1859
NPG.76.34

Gallaudet, Edward Miner, 1837-1917
Educator
Moses P. Rice, c. 1840-1925, and
 Amos I. Rice, c. 1850-?
Photograph, albumen silver print,
 13.2 x 8.8 cm. (5³⁄₁₆ x 3⁷⁄₁₆ in.),
 c. 1875
NPG.81.112

Ganso, Emil, 1895-1941
Artist
Aline Fruhauf, 1907-1978
India ink over pencil on paper, 23.9
 x 17.8 cm. (9⁷⁄₁₆ x 7 in.), 1933
Published in *Creative Art*, New
 York, April 1933
NPG.83.64
Gift of Erwin Vollmer

Galli-Curci, Amelita, 1882-1963
Singer
Violet Oakley, 1874-1961
Pencil on paper, 14.5 x 9 cm. (5¾ x
 3½ in.), not dated
NPG.83.22
*Gift of the Violet Oakley Memorial
 Foundation*

Gardner, Erle Stanley, 1889-1970
Author
Joseph Woodsen ("Pops") Whitesell,
 1875-1958
Photograph, gelatin silver print, 41.8
 x 34.2 cm. (16½ x 13⁷⁄₁₆ in.), c. 1944
NPG.83.195

Galli-Curci, Amelita, 1882-1963
Singer
Violet Oakley, 1874-1961
Pencil on paper, 14.5 x 9 cm. (5¾ x
 3½ in.), not dated
NPG.83.23
*Gift of the Violet Oakley Memorial
 Foundation*

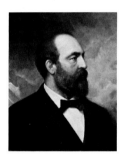

Garfield, James Abram, 1831-1881
Twentieth President of the United
 States
Ole Peter Hansen Balling, 1823-1906
Oil on canvas, 61 x 50.8 cm. (24 x 20
 in.), 1881
NPG.65.25
*Transfer from the National Museum
 of American Art; gift of the
 International Business Machines
 Corporation to the Smithsonian
 Institution, 1962*

Galli-Curci, Amelita, 1882-1963
Singer
Violet Oakley, 1874-1961
Pencil on paper, 14.5 x 9 cm. (5¾ x
 3½ in.), not dated
NPG.83.24
*Gift of the Violet Oakley Memorial
 Foundation*

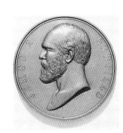

Garfield, James Abram, 1831-1881
Twentieth President of the United
 States
Charles E. Barber, 1842-1917
Bronze medal, 7.6 cm. (3 in.)
 diameter, 1881
NPG.77.16

Galli-Curci, Amelita, 1882-1963
Singer
Violet Oakley, 1874-1961
Pencil on paper, 14.5 x 9 cm. (5¾ x
 3½ in.), not dated
NPG.83.25
*Gift of the Violet Oakley Memorial
 Foundation*

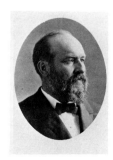

Garfield, James Abram, 1831-1881
Twentieth President of the United
 States
Abraham Bogardus, 1822-1908
Photograph, albumen silver print,
 12.4 x 9.5 cm. (4⅞ x 3¾ in.),
 c. 1881
NPG.77.187

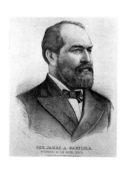

Garfield, James Abram, 1831-1881
Twentieth President of the United
 States
Currier and Ives lithography
 company, active 1857-1907, after
 photograph
Lithograph, 32 x 26.6 cm. (12⁹⁄₁₆ x
 10⁷⁄₁₆ in.), 1880
NPG.85.156

Garfield, James Abram, 1831-1881
Twentieth President of the United
 States
Major and Knapp lithography
 company, active 1864-c. 1880, after
 photograph
Lithograph, 24.9 x 22 cm. (9¹³⁄₁₆ x
 8¹¹⁄₁₆ in.), c. 1880
NPG.81.151

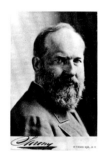

Garfield, James Abram, 1831-1881
Twentieth President of the United
 States
Napoleon Sarony, 1821-1896
Photograph, albumen silver print,
 14.8 x 10.2 cm. (5¹³⁄₁₆ x 4¹⁄₁₆ in.),
 c. 1880
NPG.79.212

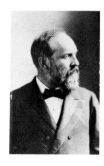

Garfield, James Abram, 1831-1881
Twentieth President of the United
 States
Napoleon Sarony, 1821-1896
Photograph, albumen silver print,
 29.3 x 17.9 cm. (11½ x 7 in.),
 c. 1881
NPG.80.300

Garland, Hamlin, 1860-1940
Author
Doris Ulmann, 1882-1934
Photograph, platinum print, 20.4 x
 15.6 cm. (8 x 6⅛ in.), c. 1925
NPG.85.25

Garland, Judy, 1922-1969
Singer, actress
Ernst Haas, 1921-1986
Photograph, gelatin silver print, 26.1
 x 33.2 cm. (10⁵⁄₁₆ x 13⅛ in.), c. 1955
NPG.85.84

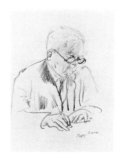

Garner, John Nance, 1868-1967
Vice-President of the United States
Peggy Bacon, 1895-1987
Crayon on paper, 35.2 x 24.7 cm.
 (13⅞ x 9¾ in.), c. 1935
NPG.74.60

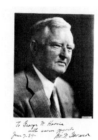

Garner, John Nance, 1868-1967
Vice-President of the United States
Harris and Ewing studio, active
 1905-1977
Photograph, gelatin silver print, 23.6
 x 18.5 cm. (9⁵⁄₁₆ x 7⁵⁄₁₆ in.), 1939
NPG.84.314
Gift of Aileen Conkey

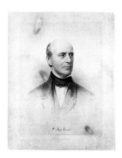

Garrison, William Lloyd, 1805-1879
Abolitionist
Joseph E. Baker, 1835-1914, after
 Thomas Murphy Johnston
J. H. Bufford lithography company
Lithograph with tintstone, 44.6 x
 33.4 cm. (17⁹⁄₁₆ x 13⅛ in.), 1864
NPG.83.2

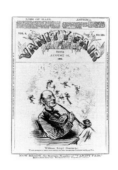

Garrison, William Lloyd, 1805-1879
Abolitionist
Bobbett and Hooper wood-engraving
 company, active 1855-1870, after
 Henry Louis Stephens
Wood engraving, 16.5 x 14.5 cm. (6½
 x 5¹¹⁄₁₆ in.), 1862
Published in *Vanity Fair*, New York,
 August 23, 1862
NPG.78.229

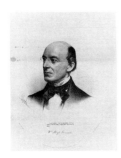

Garrison, William Lloyd, 1805-1879
Abolitionist
Leopold Grozelier, 1830-1865, after
 daguerreotype by Lorenzo G.
 Chase
S. W. Chandler and Brother
 lithography company
Lithograph, 22.1 x 23.6 cm. (8¹¹⁄₁₆ x
 9⁹⁄₁₆ in.), 1854
NPG.77.83

Garrison, William Lloyd, 1805-1879
Abolitionist
Alfred K. Kipps, active 1859-1861,
 after photograph
Louis Prang lithography company
Lithograph with tintstone, 11.1 x 8.8
 cm. (4⅜ x 3⁷⁄₁₆ in.), c. 1860
NPG.78.206

Garrison, William Lloyd, 1805-1879
Abolitionist
Anne Whitney, 1821-1915
Plaster, 62.5 cm. (24⅝ in.), 1878
NPG.74.52
Gift of Lloyd Kirkham Garrison

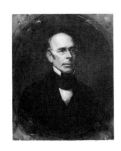

Garrison, William Lloyd, 1805-1879
Abolitionist
Unidentified artist
Oil on canvas, 76.2 x 63.5 cm. (30 x
 25 in.), c. 1855
NPG.84.205
*Gift of Marlies R. and Sylvester G.
 March*

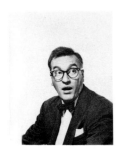

Garroway, David Cunningham*,
 1913-1982
Entertainer
Philippe Halsman, 1906-1979
Photograph, gelatin silver print, 28.3
 x 22.1 cm. (11⅛ x 8¾ in.), 1957
T/NPG.83.85.92
Gift of George R. Rinhart

Gates, Horatio, 1728/29-1806
Revolutionary general
B. B. Ellis, ?-?, after Benoit Louis
 Prevost, after Pierre Eugène Du
 Simitière
Stipple engraving, 11.1 x 9.2 cm. (4⅜
 x 3⅝ in.), 1783
Published in *Portraits of the
 Generals, Ministers, Magistrates,*
 London, 1783
NPG.75.68

Gates, Horatio, 1728/29-1806
Revolutionary general
John Norman, c. 1748-1817
Line engraving, 10.9 x 8.8 cm. (4¼ x
 3⁷⁄₁₆ in.), 1782
Published in *An Impartial History of
 the War in America . . .* , vol. 2,
 Boston, 1782
NPG.82.4

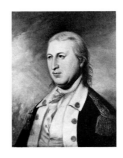

Gates, Horatio, 1728/29-1806
Revolutionary general
James Peale, 1749-1831, after the
 c. 1782 oil by Charles Willson
 Peale
Oil on canvas, 58.4 x 73.6 cm. (23 x
 29 in.), c. 1782
NPG.69.50
*Gallery purchase and gift of
 Lawrence A. Fleischman*

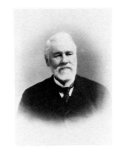

Gatling, Richard Jordan, 1818-1903
Inventor
Moses P. Rice, c. 1840-1925
Photograph, gelatin silver print, 16.4
 x 14.3 cm. (6⁷⁄₁₆ x 5⅝ in.), c. 1890
NPG.77.189

Gatti-Casazza, Giulio, 1869-1940
Opera manager
Samuel Johnson Woolf, 1880-1948
Charcoal and white chalk on paper,
 57.8 x 47.7 cm. (22¾ x 18¾ in.),
 not dated
NPG.80.254

Genthe, Arnold, 1869-1942
Photographer
Self-portrait
Photograph, gelatin silver print, 24.5
x 16.9 cm. (9⅝ x 6⅝ in.), c. 1935
NPG.77.338

Gibbons, James, 1834-1921
Religious leader
George Smith Cook, 1819-1902
Photograph, albumen silver print, 15
x 10 cm. (5⅞ x 3¹⁵⁄₁₆ in.), c. 1872
NPG.84.119

George, Henry, 1839-1897
Reformer
George deForest Brush, 1855-1941
Oil on panel, 22.2 x 19.6 cm. (8¾ x
7¾ in.), c. 1888
NPG.67.53

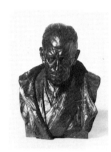

Gibbs, William Francis, 1886-1967
Naval architect
Malvina Hoffman, 1885-1966
Bronze, 49.5 cm. (19½ in.), 1956
NPG.68.2
*Gift of Vera Cravath Gibbs in
memory of her husband, William
Francis Gibbs*

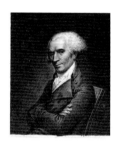

Gerry, Elbridge, 1744-1814
Statesman
James Barton Longacre, 1794-1869,
after John Vanderlyn
Ink on paper, 17.6 x 13 cm. (6⅞ x 5⅛
in.), c. 1825
NPG.77.297

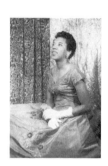

Gibson, Althea*, 1927-
Athlete
Carl Van Vechten, 1880-1964
Photogravure, 22 x 14.9 cm. (8¹¹⁄₁₆ x
5⅞ in.), 1983 from 1958 negative
T/NPG.83.188.16

Gershwin, George, 1898-1937
Composer
Self-portrait
Oil on canvas board, 39.9 x 29.8 cm.
(15¾ x 11¾ in.), 1934
NPG.66.48
Gift of Ira Gershwin

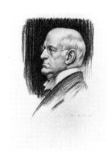

Gibson, Charles Dana, 1867-1944
Artist
Soss Melik, 1914-
Charcoal on paper, 63 x 48.4 cm.
(24¹³⁄₁₆ x 19¹⁄₁₆ in.), 1938
NPG.72.41

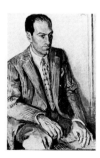

Gershwin, George, 1898-1937
Composer
Arthur Kaufmann, 1888-
Oil on canvas, 91.4 x 61.6 cm. (36 x
24¼ in.), 1936
NPG.73.8

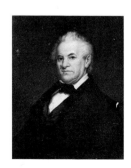

Giddings, Joshua Reed, 1795-1864
Abolitionist
John Cranch, 1807-1891
Oil on canvas, 76.2 x 63.5 cm. (30 x
25 in.), 1855
NPG.75.9

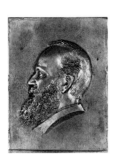

Gildersleeve, Basil Lanneau,
1831-1924
Philologist
Adalbert John Volck ("V. Blada"),
1828-1912
Copper relief, 11.1 x 9.5 cm. (4⅜ x
3¾ in.), c. 1880
NPG.72.91
Gift of Bryden B. Hyde

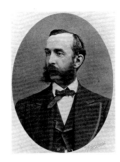

Gilman, Daniel Coit, 1831-1908
Educator
Carleton E. Watkins, 1829-1916
Photograph, albumen silver print,
11.9 x 8.7 cm. (4¹¹⁄₁₆ x 3⁷⁄₁₆ in.),
c. 1872
NPG.77.185

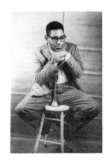

Gillespie, John Birks ("Dizzy")*,
1917-
Musician
Carl Van Vechten, 1880-1964
Photogravure, 22.5 x 14.9 cm. (8⅞ x
5⅞ in.), 1983 from 1955 negative
T/NPG.83.188.17

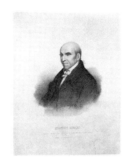

Girard, Stephen, 1750-1831
Financier
M. E. D. Brown, active 1832-1846,
after Bass Otis
Lithograph, 19.2 x 18.6 cm. (7⁹⁄₁₆ x
7⁵⁄₁₆ in.), 1832
NPG.84.103

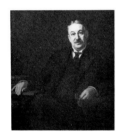

Gillette, King Camp, 1855-1932
Inventor, businessman
Jean Mannheim, 1861-1945
Oil on canvas, 97.1 x 86.4 cm. (38¼ x
34 in.), 1911
NPG.84.16
Gift of the Gillette Company

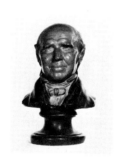

Girard, Stephen, 1750-1831
Financier
Unidentified artist
Polychromed plaster, 47 cm. (18½
in.), c. 1885
NPG.70.6

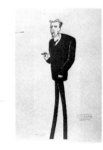

Gillette, William Hooker, 1853-1937
Actor, playwright
Alfred J. Frueh, 1880-1968
Linocut, 38.2 x 11.4 cm. (15 x 4½
in.), 1922
Published in Alfred J. Frueh's *Stage
Folk*, New York, 1922
NPG.84.229.i

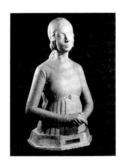

Gish, Lillian*, 1896-
Actress
Gleb W. Derujinsky, 1888-1975
Plaster, 79.4 cm. (31¼ in.), 1923
T/NPG.79.156
Gift of Natalia Derujinsky

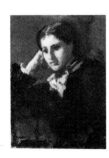

Gilman, Charlotte Perkins,
1860-1935
Reformer
Ellen Day Hale, 1855-1940
Oil on panel, 40.9 x 30.1 cm. (16⅛ x
11⅞ in.), before 1833
NPG.83.162

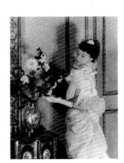

Gish, Lillian*, 1896-
Actress
Laura Gilpin, 1891-1979
Photograph, platinum print, 24.5 x
19.2 cm. (9⅝ x 7⁹⁄₁₆ in.), 1932
T/NPG.79.231
Gift of Mrs. Marka Webb Stewart

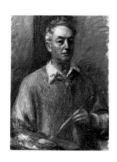

Glackens, William James, 1870-1938
Artist
Self-portrait
Oil on canvas, 72.4 x 53.9 cm. (28½ x
21¼ in.), c. 1935
NPG.72.3
Gift of Ira Glackens

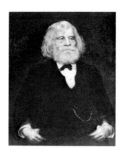

Godwin, Parke, 1816-1904
Editor
Eastman Johnson, 1824-1906
Oil on canvas, 101.6 x 83.8 cm. (40 x
33 in.), c. 1880
NPG.67.45

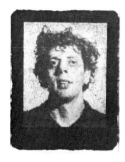

Glass, Philip*, 1937-
Composer
Chuck Close, 1940-
Handmade paper cast on grid, 175.3
x 135.9 x 7.6 cm. (69 x 53½ x 3
in.), 1982
T/NPG.85.38
Partial gift of Martin Peretz

Goldberg, Arthur Joseph*, 1908-
Public official
Philippe Halsman, 1906-1979
Photograph, gelatin silver print, 34.8
x 27.1 cm. (13¹¹⁄₁₆ x 10¹¹⁄₁₆ in.), 1965
T/NPG.83.86
Gift of George R. Rinhart

Gleason, Herbert John ("Jackie")*,
1916-1987
Entertainer
Edward Laning, 1906-1981
Pencil on paper, 31.2 x 23.5 cm. (12¼
x 9¼ in.), c. 1955
T/NPG.84.189
Gift of the estate of Edward Laning

Goldberg, Rube, 1883-1970
Cartoonist
Self-portrait
Bronze, 17.1 cm. (6¾ in.), not dated
NPG.85.75
*Transfer from the National Museum
of American History*

Goddard, Robert Hutchings,
1882-1945
Scientist
Emily Burling Waite, 1887-1980
Oil on canvas, 71.1 x 61 cm. (28 x 24
in.), 1967
NPG.68.3
Gift of an anonymous donor

Goldman, Emma, 1869-1940
Radical reformer
Carl Van Vechten, 1880-1964
Photograph, gelatin silver print, 25.2
x 20.1 cm. (9¹⁵⁄₁₆ x 7¹⁵⁄₁₆ in.), 1934
NPG.85.217
Gift of Virginia M. Zabriskie

Godkin, Edwin Lawrence, 1831-1902
Editor
William M. Hollinger, active 1897-?
Photograph, platinum print, 14.1 x
10.2 cm. (5⁹⁄₁₆ x 4 in.), 1897
NPG.76.105
Gift of Dr. William M. Armstrong

Goldman, Emma, 1869-1940
Radical reformer
Carl Van Vechten, 1880-1964
Photograph, gelatin silver print, 25.2
x 20.2 cm. (9¹⁵⁄₁₆ x 7¹⁵⁄₁₆ in.), 1934
NPG.85.218
Gift of Virginia M. Zabriskie

Goldsmith, Alfred Norton, 1888-1974
Engineer
Edward Field Sanford, 1886-1926
Marble, 41.9 cm. (16½ in.), 1926
NPG.79.122

**Goodman, Benjamin David
("Benny")*,** 1909-1986
Musician
Alfred Bendiner, 1899-1964
Pencil with opaque white on board,
37.2 x 20.5 cm. (14¹¹⁄₁₆ x 8¹⁄₁₆ in.),
c. 1941
T/NPG.85.202.96
Gift of Alfred Bendiner Foundation

Goldwater, Barry Morris*, 1909-
Statesman
John Court, 1948-
Oil on canvas, 61 x 45.5 cm. (24 x 18
in.), 1983
T/NPG.84.71
*Gift of Mr. and Mrs. James Bland
Martin*

Goodyear, Charles, 1800-1860
Inventor
Alexander Gardner, 1821-1882
Photograph, albumen silver print,
8.7 x 5.5 cm. (3⁷⁄₁₆ x 2³⁄₁₆ in.),
c. 1865 from c. 1860 negative
NPG.79.221

Gompers, Samuel, 1850-1924
Labor leader
Moses Wainer Dykaar, 1884-1933
Marble, 59.6 cm. (23½ in.), 1924
NPG.69.78
*Transfer from the National Museum
of American Art; gift of David E.
Dykaar, 1968*

Gordy, Berry, Jr.*, 1929-
Executive
Peter Strongwater, 1941-
Photograph, gelatin silver print, 35.6
x 35.6 cm. (14 x 14 in.), 1982
T/NPG.84.169
Gift of Christopher Murray

Gompers, Samuel, 1850-1924
Labor leader
Hartsook, ?-?
Photograph, brown-toned gelatin
silver print, 23.7 x 17 cm. (9³⁄₈ x
6¹¹⁄₁₆ in.), c. 1920
NPG.76.112

Gorky, Arshile, 1905-1948
Artist
Raphael Soyer, 1899-
Watercolor, chalk, and pencil on
paper, 20.3 x 22.8 cm. (8 x 9 in.),
not dated
NPG.73.13
Gift of the artist

Gompers, Samuel, 1850-1924
Labor leader
Unidentified photographer
Photograph, gelatin silver print, 23.1
x 17.1 cm. (9⅛ x 6¾ in.), 1921
NPG.77.202

Gottschalk, Louis Moreau, 1829-1869
Musician, composer
Bobbett and Hooper wood-engraving
company, active 1855-1870, after
Henry Louis Stephens
Wood engraving, 14.5 x 15 cm. (5¹¹⁄₁₆
x 5⅞ in.), 1862
Published in *Vanity Fair*, New York,
October 11, 1862
NPG.78.228

Gottschalk, Louis Moreau, 1829-1869
Musician, composer
Major and Knapp lithography
 company, active 1864-c. 1871, after
 photograph
Lithograph with tintstone, 30.3 x
 22.4 cm. (11¹⁵⁄₁₆ x 8¹³⁄₁₆ in.), 1870
Music sheet title page: "In
 Memoriam L.M.G."
NPG.84.12

Goudy, Frederic William, 1865-1947
Type designer
Alexander Stern, 1904-
Etching and drypoint, 33 x 25.2 cm.
 (23 x 9½ in.), 1938
NPG.78.143

Gould, Stephen Jay*, 1941-
Scientist
Kelly Wise, 1932-
Photograph, gelatin silver print, 31 x
 26.1 cm. (12³⁄₁₆ x 10¼ in.), 1983
T/NPG.84.242
Gift of Robert Stoller

Goyathlay ("Geronimo"), 1829-1909
Indian chief
Edward Sheriff Curtis, 1868-1952
Photogravure, 39.3 x 26.9 cm. (15½ x
 10⁹⁄₁₆ in.), 1907
NPG.78.67
Gift of Mrs. Katie Louchheim

Goyathlay ("Geronimo"), 1829-1909
Indian chief
Reed and Wallace studio, ?-?
Photograph, albumen silver print,
 14.1 x 10.2 cm. (5½ x 4 in.), 1890
NPG.80.246

Graham, Martha*, 1894-
Dancer
Philippe Halsman, 1906-1979
Photograph, gelatin silver print, 33.8
 x 27.3 cm. (13⁵⁄₁₆ x 10¾ in.), 1946
T/NPG.83.87
Gift of George R. Rinhart

Graham, Martha*, 1894-
Dancer
Paul Meltsner, 1905-1966
Oil on canvas, 106.6 x 81.3 cm. (42 x
 32 in.), c. 1940
T/NPG.73.41

Graham, Martha*, 1894-
Dancer
Nickolas Muray, 1892-1965
Photograph, gelatin silver print, 24.5
 x 19.3 cm. (9⅝ x 7⁹⁄₁₆ in.), 1978
 from 1926 negative
T/NPG.78.191

Graham, Philip Leslie, 1915-1963
Publisher
Philippe Halsman, 1906-1979
Photograph, gelatin silver print, 34.7
 x 27.2 cm. (13⅝ x 10¹¹⁄₁₆ in.), 1961
NPG.83.88
Gift of George R. Rinhart

Grant, Ulysses S., 1822-1885
Eighteenth President of the United
 States
Joseph E. Baker, 1835-1914, after
 photograph
J. H. Bufford lithography company
Hand-painted lithograph with gray
 tintstone, 57.7 x 44.3 cm. (10¹¹⁄₁₆ x
 5⁷⁄₁₆ in.), 1863
NPG.82.44

Grant, Ulysses S., 1822-1885
Eighteenth President of the United
 States
Ole Peter Hansen Balling, 1823-1906
Oil on canvas, 122.5 x 97.1 cm. (48¼
 x 38¼ in.), 1865
NPG.67.34

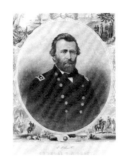

Grant, Ulysses S., 1822-1885
Eighteenth President of the United
 States
John C. McRae, active 1850-1880,
 after photograph by Mathew Brady
Engraving and etching, 32.7 x 27 cm.
 (12⅞ x 10⅝ in.), c. 1865
NPG.78.107

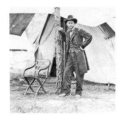

Grant, Ulysses S., 1822-1885
Eighteenth President of the United
 States
Mathew Brady, 1823-1896
Photograph, albumen silver print,
 11.6 x 12.1 cm. (4⁹⁄₁₆ x 4¾ in.), 1864
NPG.77.56

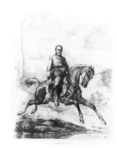

Grant, Ulysses S., 1822-1885
Eighteenth President of the United
 States
L. Mercier, ?-?, after photograph
Etching, 29.1 x 22.7 cm. (11⁷⁄₁₆ x 8¹⁵⁄₁₆
 in.), c. 1865
NPG.83.180

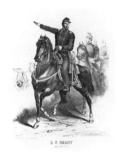

Grant, Ulysses S., 1822-1885
Eighteenth President of the United
 States
Ehrgott and Forbriger lithography
 company, active 1858-1869, after
 photograph
Lithograph, 29.7 x 24.8 cm. (11¹¹⁄₁₆ x
 9¾ in.), c. 1863
NPG.79.31

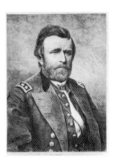

Grant, Ulysses S., 1822-1885
Eighteenth President of the United
 States
John Mooney, active 1853-1902, after
 photograph
Wood engraving, 63 x 46.3 cm. (24¾
 x 18¼ in.), 1867
NPG.80.123

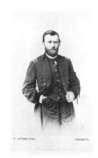

Grant, Ulysses S., 1822-1885
Eighteenth President of the United
 States
Frederick Gutekunst, 1831-1917
Photograph, albumen silver print, 9
 x 5.9 cm. (3⁹⁄₁₆ x 2⁵⁄₁₆ in.), c. 1864
NPG.82.94
Gift of Forrest H. Kennedy

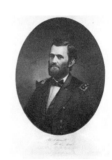

Grant, Ulysses S., 1822-1885
Eighteenth President of the United
 States
John A. O'Neill, active c. 1857-c.
 1890, after photograph by John
 Carbutt
Engraving, 29.8 x 23.1 cm. (11¾ x
 9¹⁄₁₆ in.), c. 1864
NPG.84.131

Grant, Ulysses S., 1822-1885
Eighteenth President of the United
 States
Thomas LeClear, 1818-1882
Oil on canvas, 136.5 x 80.7 cm. (53¾
 x 31¾ in.), c. 1880
NPG.70.16
*Transfer from the National Museum
 of American Art; gift of Mrs.
 Ulysses S. Grant, Jr., 1921*

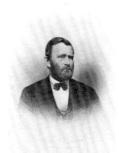

Grant, Ulysses S., 1822-1885
Eighteenth President of the United
 States
Alexander Hay Ritchie, 1822-1895,
 after Charles DeForest Fredricks
Engraving, 26.5 x 25.3 cm. (10½ x 10
 in.), c. 1870-1875
NPG.79.187

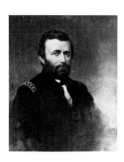

Grant, Ulysses S., 1822-1885
Eighteenth President of the United
 States
Samuel Bell Waugh, 1814-1885
Oil on canvas, 62.2 x 49.5 cm. (24½ x
 19½ in.), 1869
NPG.65.26
*Transfer from the National Museum
 of American Art; gift of the
 International Business Machines
 Corporation to the Smithsonian
 Institution, 1962*

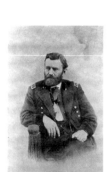

Grant, Ulysses S., 1822-1885
Eighteenth President of the United
 States
Unidentified photographer
Photograph, albumen silver print,
 46.5 x 37.5 cm. (18⅝₁₆ x 14¾ in.),
 c. 1864
NPG.79.92

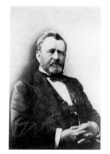

Grant, Ulysses S., 1822-1885
Eighteenth President of the United
 States
Unidentified photographer
Photograph, albumen silver print, 39
 x 25.6 cm. (15⅜ x 10¹⁄₁₆ in.), c. 1876
NPG.80.183

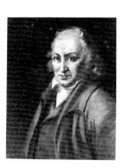

Gratz, Michael, 1740-1811
Businessman
William Edward West, 1788-1857,
 after Thomas Sully
Pastel on paper, 61 x 50.8 cm. (24 x
 20 in.), after 1808
NPG.66.14
Gift of Richard N. Tetlie

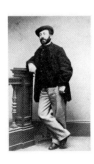

Grau, Maurice, 1849-1907
Impresario
John Case, 1808-1880, and William
 H. Getchell, 1829-1910; studio
 active 1863-1865
Photograph, albumen silver print,
 8.7 x 5.4 cm. (3⁷⁄₁₆ x 2⁷⁄₁₆ in.),
 c. 1863
NPG.80.191

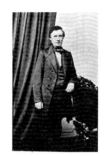

Gray, Asa, 1810-1888
Scientist
John Adams Whipple, 1822-1891
Photograph, albumen silver print, 9
 x 5.8 cm. (3⁹⁄₁₆ x 2⁵⁄₁₆ in.), 1861
NPG.77.174

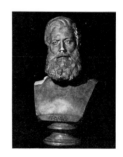

Gray, Asa, 1810-1888
Scientist
Unidentified artist
Plaster, 67.9 cm. (26¾ in.), not dated
NPG.70.28
*Transfer from the National Museum
 of American Art*

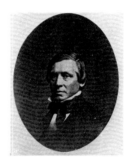

Gray, Asa, 1810-1888
Scientist
Unidentified photographer
Photograph, albumenized salt print,
 10.3 x 8 cm. (4¹⁄₁₆ x 3⅛ in.), c. 1856
NPG.78.302
Gift of an anonymous donor

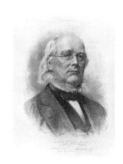

Greeley, Horace, 1811-1872
Editor, statesman
Joseph Edward Baker, 1835-1914
Armstrong and Company
 lithography company
Lithograph with tintstone, 61.2 x
 45.8 cm. (24¹⁄₁₆ x 18¹⁄₁₆ in.), 1872
NPG.85.159

Greeley, Horace, 1811-1872
Editor, statesman
Bobbett and Hooper wood-engraving
 company, active 1855-1870, after
 Henry Louis Stephens
Wood engraving, 27 x 20 cm. (10⅝ x
 7⅞ in.), 1862
Published in *Vanity Fair*, New York,
 March 29, 1862
NPG.85.59

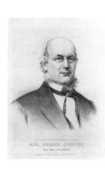

Greeley, Horace, 1811-1872
Editor, statesman
Currier and Ives lithography
 company, active 1857-1907, after
 photograph
Lithograph, 24.5 x 23.8 cm. (9⅝ x 9⅜
 in.), 1872
NPG.85.153

Greeley, Horace, 1811-1872
Editor, statesman
Unidentified photographer
Daguerreotype, 10.7 x 8.2 cm. (4³⁄₁₆ x
 3¼ in.), c. 1850
NPG.77.9

Greeley, Horace, 1811-1872
Editor, statesman
A. L. Edwards, active 1870s, after
 photograph
Wynkoop publishing and
 lithography company
Lithograph with tintstone, 35.8 x
 27.8 cm. (14⅛ x 10¹⁵⁄₁₆ in.), c. 1872
NPG.77.85

Greenberg, Clement*, 1909-
Art critic
Philippe Halsman, 1906-1979
Photograph, gelatin silver print, 34.9
 x 27.3 cm. (13¾ x 10¾ in.), 1959
T/NPG.83.89
Gift of George R. Rinhart

Greeley, Horace, 1811-1872
Editor, statesman
Thomas Nast, 1840-1902
Watercolor with pencil on paper,
 30.7 x 18.5 cm. (12⅛ x 7¼ in.),
 1872
NPG.64.2
*Gift of the Trustees, National
 Portrait Gallery, London*

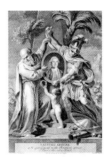

Greene, Nathanael, 1742-1786
Revolutionary general
Justus Chevillet, 1729-1790, after
 Charles Willson Peale
Engraving, 26.4 x 17.8 cm. (10⅜ x 7
 in.), c. 1780
NPG.80.43

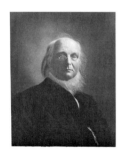

Greeley, Horace, 1811-1872
Editor, statesman
Attributed to Louis Prang
 lithography company, active
 1856-1899, after photograph
Chromolithograph, 43 x 34.9 cm.
 (16⅞ x 13¾ in.), c. 1872
NPG.84.197

Greene, Nathanael, 1742-1786
Revolutionary general
David Edwin, 1776-1841, after
 Charles Willson Peale
Stipple engraving, 9.8 x 8.1 cm. (3⅞
 x 3³⁄₁₆ in.), 1812
NPG.79.127

Greeley, Horace, 1811-1872
Editor, statesman
Napoleon Sarony, 1821-1896
Photograph, albumen silver print,
 13.7 x 10 cm. (5⁷⁄₁₆ x 3¹⁵⁄₁₆ in.), 1869
NPG.85.106
Gift of Robert L. Drapkin

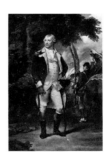

Greene, Nathanael, 1742-1786
Revolutionary general
Valentine Green, 1793-1813, after
 Charles Willson Peale
Mezzotint, 50.1 x 35.2 cm. (19¾ x
 13⅞ in.), 1785
NPG.67.26

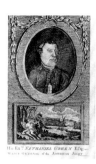

Greene, Nathanael, 1742-1786
Revolutionary general
John Norman, c. 1748-1817, after
 unidentified artist
Line engraving, 14.5 x 9.4 cm. (5¹¹⁄₁₆
 x 3¹¹⁄₁₆ in.), 1781
Published in *An Impartial History of
 the War in America . . .* , vol. 1,
 Boston, 1781
NPG.79.3

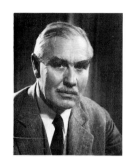

Grew, Joseph Clark, 1880-1965
Diplomat
Philippe Halsman, 1906-1979
Photograph, gelatin silver print, 34.8
 x 27.4 cm. (13¹¹⁄₁₆ x 10¾ in.), 1944
NPG.83.90
Gift of George R. Rinhart

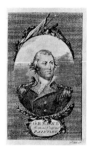

Greene, Nathanael, 1742-1786
Revolutionary general
Elkanah Tisdale, 1771-?, after John
 Trumbull
Line engraving and etching, 14.9 x 9
 cm. (5⅞ x 3⁹⁄₁₆ in.), 1794
Published in *New York Magazine* or
 Literary Repository, New York,
 May 1794
NPG.77.208

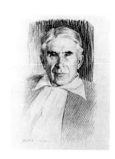

Grey, Zane, 1872-1939
Author
Soss Melik, 1914-
Charcoal on paper, 61 x 45.7 cm. (24
 x 18 in.), 1939
NPG.74.29

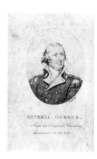

Greene, Nathanael, 1742-1786
Revolutionary general
Elkanah Tisdale, 1771-?, after John
 Trumbull
Stipple engraving, 9.6 x 7.5 cm. (3¾
 x 2¹⁵⁄₁₆ in.), 1797
Frontispiece to *The Monthly Military
 Repository*, New York, 1797
NPG.82.5

Griffith, David Wark, 1875-1948
Motion picture director
Unidentified photographer
Photograph, gelatin silver print, 11.8
 x 17 cm. (4⅝ x 6¾ in.), c. 1923
NPG.80.97

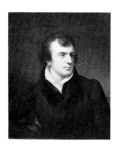

Greenough, Horatio, 1805-1857
Artist
Rembrandt Peale, 1778-1860
Oil on canvas, 76.5 x 59.6 cm. (30⅛ x
 23½ in.), 1829
NPG.82.106

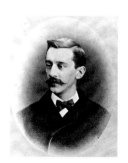

Grinnell, George Bird, 1849-1938
Naturalist
William Notman, 1826-1891
Photograph, gelatin silver print, 11 x
 8.5 cm. (4⁵⁄₁₆ x 3⅜ in.), c. 1875
NPG.77.184

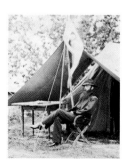

Gregg, David McMurtrie, 1833-1916
Union general
Unidentified photographer
Photograph, albumen silver print,
 14.5 x 11.8 cm. (5¾ x 4⅝ in.),
 c. 1863
NPG.81.26

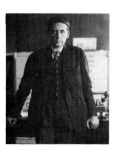

Gropius, Walter, 1883-1969
Architect
Hugo Erfurth, 1874-1948
Photograph, gelatin silver print, 19.5
 x 15.8 cm. (7¹¹⁄₁₆ x 6¼ in.), 1928
NPG.82.139

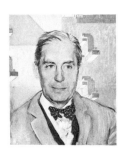

Gropius, Walter, 1883-1969
Architect
Patricia Tate, 1905-
Oil on masonite, 43.2 x 35.5 cm. (17
 x 14 in.), 1949
NPG.83.208

Guggenheim, Marguerite ("Peggy")*,
 1898-1979
Art collector, patron
Man Ray, 1890-1976
Photograph, gelatin silver print, 48.5
 x 33.1 cm. (19⅛ x 13 in.), 1925
T/NPG.84.120.89

Gropper, William*, 1897-1977
Artist
Aline Fruhauf, 1907-1978
Watercolor, pencil, colored pencil,
 ink, and opaque white on paper,
 23 x 21.5 cm. (9¹⁄₁₆ x 8⁷⁄₁₆ in.), 1937
T/NPG.83.261.87
Gift of Erwin Vollmer

Gunther, John, 1901-1972
Travel writer
Philippe Halsman, 1906-1979
Photograph, gelatin silver print, 35.1
 x 27.3 cm. (13¹³⁄₁₆ x 10¾ in.), 1950
NPG.83.91
Gift of George R. Rinhart

Grosman, Tatyana*, 1904-1982
Lithographic publisher
Robert Rauschenberg, 1925-
Color lithograph, 45.4 x 35.3 cm.
 (17⅞ x 13⅞ in.), 1974
T/NPG.85.231.92
Gift of Mr. and Mrs. Daniel Fendrick

Gunther, John, 1901-1972
Travel writer
Philippe Halsman, 1906-1979
Photograph, gelatin silver print, 34.9
 x 27.3 cm. (13¾ x 10¾ in.), 1950
NPG.83.170
Gift of George R. Rinhart

Gross, Chaim*, 1904-
Artist
Harry Sternberg, 1904-
Serigraph, 57.5 x 40.8 cm. (10⅝ x
 16¹⁄₁₆ in.), 1943
T/NPG.84.185

Guthrie, Woody, 1912-1967
Folksinger, composer
Antonio Frasconi, 1919- , after
 photograph
Woodcut, 60.1 x 98 cm. (23¹¹⁄₁₆ x 38⁹⁄₁₆
 in.), 1972
NPG.82.118

Guggenheim, Marguerite ("Peggy")*,
 1898-1979
Art collector, patron
Berenice Abbott, 1898-
Photograph, gelatin silver print, 24.1
 x 17.3 cm. (9½ x 6¹³⁄₁₆ in.), c. 1925
T/NPG.82.163.89

Hale, Edward Everett, 1822-1909
Author, clergyman
James Wallace Black, 1825-1896
Photograph, albumen silver print,
 14.7 x 10.1 cm. (5¹³⁄₁₆ x 4 in.),
 c. 1875
NPG.77.188

Hale, Edward Everett, 1822-1909
Author, clergyman
Philip L. Hale, 1865-1931
Oil on canvas, 99 x 59.7 cm. (39 x
 23½ in.), c. 1905-1909
NPG.75.10
Gift of Mrs. Fredson Bowers

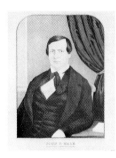

Hale, Edward Everett, 1822-1909
Author, clergyman
Sumner B. Heald, ?-?, at George K.
 Warren studio
Photograph, albumen silver print,
 13.5 x 9.1 cm. (5½ x 3⁹⁄₁₆ in.),
 c. 1870
NPG.78.7

Hale, John Parker, 1806-1873
Lawyer, politician, diplomat
Kelloggs and Comstock lithography
 company, active 1848-1850, after
 daguerreotype by Paige and Beach
Hand-colored lithograph, 30.5 x 22.2
 cm. (12 x 8¹¹⁄₁₆ in.), c. 1848
NPG.81.65

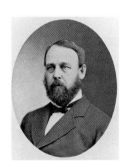

Hall, Asaph, 1829-1907
Astronomer
Mathew Brady, 1823-1896
Photograph, albumen silver print,
 11.7 x 9.2 cm. (4⅝ x 3⅝ in.), 1880
NPG.77.183

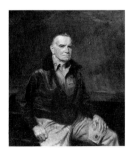

Halsey, William Frederick,
 1882-1959
World War II admiral
Albert K. Murray, 1906-
Oil on canvas, 114 x 102.2 cm. (44⅞
 x 40¼ in.), 1949
NPG.65.27
*Transfer from the National Museum
 of American Art; gift of the
 International Business Machines
 Corporation to the Smithsonian
 Institution, 1962*

Hamblin, Thomas S., 1800-1853
Actor, theatrical manager
David Claypoole Johnston,
 1799-1865, after Henry James
 William Finn
Lithograph, 14.1 x 14.4 cm. (5⁹⁄₁₆ x
 5⅝ in.), 1826
NPG.83.172

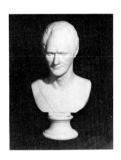

Hamilton, Alexander, 1755/57-1804
Statesman
Giuseppe Ceracchi, 1751-1801/02
Marble, 57.4 cm. (22⅝ in.), replica of
 1794 marble, after 1791 original
NPG.66.30

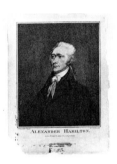

Hamilton, Alexander, 1755/57-1804
Statesman
Robert Field, c. 1769-1819, after John
 Trumbull
Stipple and line engraving, 27.1 x
 22.1 cm. (10¹¹⁄₁₆ x 8¹¹⁄₁₆ in.), 1806
NPG.77.328

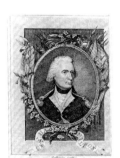

Hamilton, Alexander, 1755/57-1804
Statesman
William Rollinson, 1762-1842, after
 Walter Robertson
Stipple and line engraving and
 etching, 14.4 x 11.3 cm. (5¹¹⁄₁₆ x
 4⁷⁄₁₆ in.), 1802
Published in James Hardie's *The
 New Universal Biographical
 Dictionary and American
 Remembrancer . . .* , vol. 3, New
 York, 1801-1802
NPG.79.9

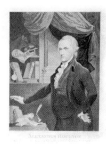

Hamilton, Alexander, 1755/57-1804
Statesman
William Rollinson, 1762-1842, after
 Archibald Robertson
Stipple engraving, 44.8 x 34.8 cm.
 (17⅝ x 13¾ in.), 1804
NPG.80.146

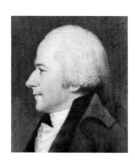

Hamilton, Alexander, 1755/57-1804
Statesman
James Sharples, c. 1751-1811
Pastel on paper, 13 x 12.4 cm. (5⅛ x
4⅞ in.), c. 1796
NPG.70.55

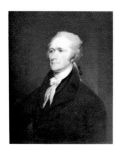

Hamilton, Alexander, 1755/57-1804
Statesman
John Trumbull, 1756-1843
Oil on canvas, 76.2 x 61 cm. (30 x 24
in.), 1806
NPG.79.216
Gift of Henry Cabot Lodge

Hamilton, Edith, 1867-1963
Classicist
Aline Fruhauf, 1907-1978
Woodcut, 25.6 x 10.3 cm. (10¹/₁₆ x 4
in.), 1970
NPG.83.65
Gift of Erwin Vollmer

Hamilton, Edith, 1867-1963
Classicist
Aline Fruhauf, 1907-1978
Lithograph, 34.3 x 23.8 cm. (13½ x
9⅜ in.), 1958
NPG.83.66
Gift of Erwin Vollmer

Hammerstein, Oscar, I, c. 1847-1919
Impresario
P. S. Rogers, ?-?
Photograph, gelatin silver print, 20.6
x 15.5 cm. (8⅛ x 6⅛ in.), c. 1910
NPG.80.98

Hammerstein, Oscar, I, c. 1847-1919
Impresario
P. S. Rogers, ?-?
Photograph, gelatin silver print, 20.5
x 15.8 cm. (8¹/₁₆ x 6¼ in.), c. 1910
NPG.80.99

Hammerstein, Oscar, I, c. 1847-1919
Impresario
P. S. Rogers, ?-?
Photograph, gelatin silver print, 20.2
x 15.2 cm. (7¹⁵/₁₆ x 6 in.), c. 1910
NPG.80.100

Hammerstein, Oscar, I, c. 1847-1919
Impresario
P. S. Rogers, ?-?
Photograph, gelatin silver print, 20.5
x 15.1 cm. (8¹/₁₆ x 6 in.), c. 1910
NPG.80.101

Hammerstein, Oscar, I, c. 1847-1919
Impresario
Unidentified artist
Oil on canvas, 91.4 x 73.6 cm. (36 x
29 in.), not dated
NPG.66.3
*Gift of Mrs. Oscar Hammerstein II
through Mr. Alexander Ince*

Hammerstein, Oscar, II, 1895-1960
Lyricist
Abbey Altson, 1869-?
Oil on canvas, 76.2 x 63.5 cm. (30 x 25
in.), 1943
NPG.66.4
*Gift of Mrs. Oscar Hammerstein II
through Mr. Alexander Ince*

Hammerstein, Oscar, II, 1895-1960
Lyricist
Philippe Halsman, 1906-1979
Photograph, gelatin silver print, 28.1
 x 23.8 cm. (11¹¹⁄₁₆ x 9⅜ in.), 1956
NPG.83.92
Gift of George R. Rinhart

Hammerstein, Oscar, II, 1895-1960
Lyricist
Samuel Johnson Woolf, 1880-1948
Charcoal and chalk on paper, 54.6 x
 43.6 cm. (21⁹⁄₁₆ x 17³⁄₁₆ in.), not
 dated
NPG.80.259

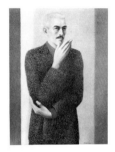

Hammett, Samuel Dashiell,
 1894-1961
Author
Edward Biberman, 1904-1986
Oil on canvas, 101.6 x 76.2 cm. (40 x
 30 in.), 1937
NPG.85.1

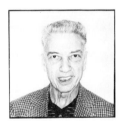

Hammond, John Henry*, 1910-1987
Executive
Peter Strongwater, 1941-
Photograph, gelatin silver print, 34.6
 x 34.6 cm. (13⅝ x 13⅝ in.), 1983
T/NPG.84.236
Gift of Christopher Murray

Hancock, John, 1736-1793
Revolutionary statesman
Attributed to John Coles, Sr.,
 c. 1748/49-1809, after John
 Singleton Copley
Hand-colored etching, 27 x 22.5 cm.
 (10⅝ x 9 in.), c. 1795
NPG.75.47

Hancock, John, 1736-1793
Revolutionary statesman
Joseph H. Seymour, active 1791-1822,
 after John Singleton Copley
Engraving and etching, 25.1 x 21.2
 cm. (9⅞ x 8⅜ in.), 1794
NPG.80.31

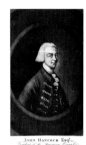

Hancock, John, 1736-1793
Revolutionary statesman
Unidentified artist, after John
 Singleton Copley
Mezzotint, 16.3 x 10.1 cm. (6⁷⁄₁₆ x 4
 in.), 1776
Published in *Monthly Museum,*
 London, 1776
NPG.77.86

Hancock, John, 1736-1793
Revolutionary statesman
Unidentified artist
Relief woodcut, 6.7 x 5.4 cm. (2⅝ x
 2⅛ in.), 1776
Published in *Bickerstaff's Boston
 Almanack for 1777,* Boston, 1776
NPG.77.209

Hancock, John, 1736-1793
Revolutionary statesman
Unidentified artist, after John
 Singleton Copley
Relief cut, 7.5 x 6.2 cm. (2¹⁵⁄₁₆ x 2⁷⁄₁₆
 in.), 1776
Published in *Bickerstaff's Boston
 Almanack for 1777,* Salem, 1776
NPG.79.82

Hancock, Thomas, 1703-1764
Merchant
John Singleton Copley, 1738-1815
Oil on copper, 7.9 x 6.4 cm. (3⅛ x 2½
 in.), c. 1758
NPG.81.17

Hand, Learned, 1872-1961
Jurist
Philippe Halsman, 1906-1979
Photograph, gelatin silver print, 34.8
x 27.2 cm. (13¹¹⁄₁₆ x 10¹¹⁄₁₆ in.), 1957
NPG.84.152

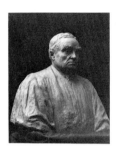

Hand, Learned, 1872-1961
Jurist
Eleanor Platt, 1910-1974
Plaster, 76.2 cm. (30 in.), not dated
NPG.81.106
Gift of Mrs. Florence Schaffhausen

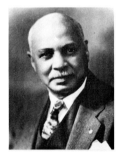

Handy, William Christopher,
1873-1958
Musician, composer
Prentis H. Polk, 1898-
Photograph, gelatin silver print, 24.1
x 19 cm. (9½ x 7½ in.), 1942
NPG.83.196

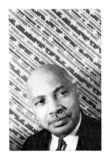

Handy, William Christopher,
1873-1958
Musician, composer
Carl Van Vechten, 1880-1964
Photogravure, 22.3 x 14.9 cm. (8¹³⁄₁₆
x 5⅞ in.), 1983 from 1932 negative
NPG.83.188.18

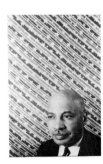

Handy, William Christopher,
1873-1958
Musician, composer
Carl Van Vechten, 1880-1964
Photograph, gelatin silver print, 21.1
x 13.9 cm. (8⁵⁄₁₆ x 5½ in.), 1932
NPG.84.144
Gift of Prentiss Taylor

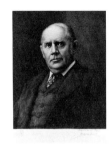

Hanna, Marcus Alonzo, 1837-1904
Political adviser
Jacques Reich, 1852-1923
Etching, 37.2 x 30 cm. (14⅝ x 11¹³⁄₁₆
in.), 1904
NPG.67.72
Gift of Oswald D. Reich

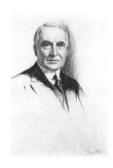

Harding, Warren Gamaliel,
1865-1923
Twenty-ninth President of the
United States
Joseph Pierre Nuyttens, 1880-1960,
after photograph
Drypoint, 33.9 x 24.4 cm. (13⁵⁄₁₆ x 9⅝
in.), 1921
NPG.84.125

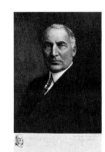

Harding, Warren Gamaliel,
1865-1923
Twenty-ninth President of the
United States
Jacques Reich, 1852-1923
Etching, 37.4 x 28 cm. (14¾ x 11 in.),
1922
NPG.67.71
Gift of Oswald D. Reich

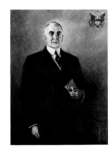

Harding, Warren Gamaliel,
1865-1923
Twenty-ninth President of the
United States
Margaret Lindsay Williams,
1887-1960
Oil on canvas, 135.9 x 99.7 cm. (53½
x 39¼ in.), c. 1923
NPG.66.21

Hare, Robert, 1781-1858
Scientist
Alvan Clark, 1804-1887
Oil on canvas, 76.2 x 63.5 cm. (30 x
25 in.), c. 1856
NPG.66.57
*Transfer from the National Museum
of American Art*

Harlan, John Marshall, 1889-1971
Justice of the United States Supreme
 Court
Oscar Berger, 1901-
Ink over pencil on paper, 41.9 x 35.5
 cm. (16½ x 14 in.), c. 1968
NPG.69.15
Gift of the artist

Harrison, Benjamin, 1833-1901
Twenty-third President of the United
 States
William M. Hollinger, active 1897-?
Photograph, platinum print, 15.5 x
 11.2 cm. (6⅛ x 4⁷⁄₁₆ in.), c. 1900
NPG.77.178

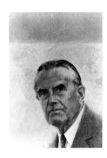

Harriman, William Averell*,
 1891-1986
Statesman
Jo Davidson, 1883-1952
Bronze, 58.4 cm. (23 in.), 1935
T/NPG.78.194.96
Gift of Dr. Maury Leibovitz

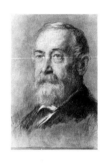

Harrison, Benjamin, 1833-1901
Twenty-third President of the United
 States
Eastman Johnson, 1824-1906
Charcoal and chalk on paper, 45.7 x
 30.5 cm. (18 x 12 in.), c. 1889
NPG.68.4

Harriman, William Averell*,
 1891-1986
Statesman
Gilbert Early, 1936-
Tempera on artist board, 55.2 x 42.5
 cm. (21¾ x 16¾ in.), 1965
T/NPG.65.9.96
Gift of the artist

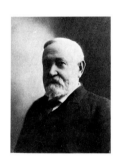

Harrison, Benjamin, 1833-1901
Twenty-third President of the United
 States
Joseph Gray Kitchell, ?-?
Photograph, platinum print, 21.5 x
 16.4 cm. (8½ x 6⁷⁄₁₆ in.), 1897
NPG.77.179

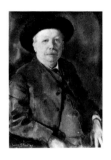

Harris, Joel Chandler, 1848-1908
Author
Lucy May Stanton, 1875-1931
Watercolor on ivory, 17.8 x 12.7 cm.
 (7 x 5 in.), c. 1912
NPG.71.38
Gift of Walter T. Forbes

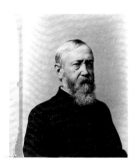

Harrison, Benjamin, 1833-1901
Twenty-third President of the United
 States
W. H. Potter, ?-?
Photograph, gelatin silver print, 36 x
 25.5 cm. (14³⁄₁₆ x 10 in.), 1888
NPG.78.157

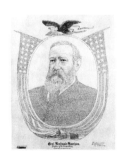

Harrison, Benjamin, 1833-1901
Twenty-third President of the United
 States
Morris Diamond, ?-?, after
 photograph
Lithograph, 42.2 x 34.2 cm. (16⅝ x
 13⁷⁄₁₆ in.), 1892
NPG.84.196

Harrison, Benjamin, 1833-1901
Twenty-third President of the United
 States
Unidentified artist
Woodcarving, 24 cm. (9½ in.), 1888
NPG.77.249

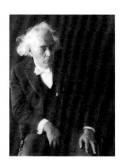

Harrison, Richard Berry, 1864-1935
Actor
Doris Ulmann, 1882-1934
Photograph, gelatin silver print, 20.4
 x 15.5 cm. (8 x 6¹/₁₆ in.), c. 1932
NPG.79.113

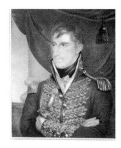

Harrison, William Henry, 1773-1841
Ninth President of the United States
E. B. and E. C. Kellogg lithography
 company, active c. 1842-1867, after
 Rembrandt Peale
Lithograph, 31.1 x 25.6 cm. (12¼ x
 10¹/₁₆ in.), c. 1842-1848
NPG.80.125

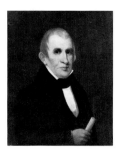

Harrison, William Henry, 1773-1841
Ninth President of the United States
Attributed to James Henry Beard,
 1812-1893
Oil on canvas, 75.6 x 60.3 cm. (29¾ x
 23¾ in.), c. 1840?
NPG.71.6

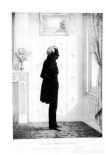

Harrison, William Henry, 1773-1841
Ninth President of the United States
E. B. and E. C. Kellogg lithography
 company, active c. 1842-1867, after
 William Henry Brown
Lithographed silhouette, 34.3 x 25.3
 cm. (13½ x 10 in.), 1844
Published in William H. Brown's
 *Portrait Gallery of Distinguished
 American Citizens*, Hartford, 1845
NPG.80.276.g
Gift of Wilmarth Sheldon Lewis

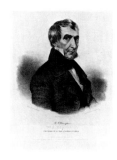

Harrison, William Henry, 1773-1841
Ninth President of the United States
Charles Fenderich, 1805-1887, after
 William Hendrik Franquinet
P. S. Duval lithography company
Lithograph, 27 x 26.5 cm. (10⅝ x 10½
 in.), 1840
NPG.66.83
*Transfer from the Library of
 Congress, Prints and Photographs
 Division*

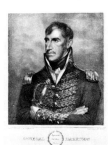

Harrison, William Henry, 1773-1841
Ninth President of the United States
Denison Kimberly, 1814-1863, and
 Oliver Pelton, 1798-1882, after
 Albert Gallatin Hoit
Engraving, 41.9 x 34.8 cm. (16½ x
 13¹¹/₁₆ in.), 1841
NPG.67.6

Harrison, William Henry, 1773-1841
Ninth President of the United States
Alfred M. Hoffy, active 1835-1864,
 after James Reid Lambdin
P. S. Duval lithography company
Lithograph, 20.7 x 20 cm. (8¼ x 7⅞
 in.), 1839
Published in the *U.S. Military
 Magazine*, October 1839
NPG.79.35

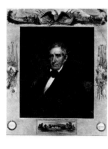

Harrison, William Henry, 1773-1841
Ninth President of the United States
Albert Newsam, 1809-1864, after
 Rembrandt Peale
Lehman and Duval lithography
 company
Lithograph, 31.7 x 26.3 cm. (12½ x
 10⅜ in.), c. 1835-1837
NPG.76.44

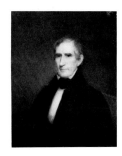

Harrison, William Henry, 1773-1841
Ninth President of the United States
Albert Gallatin Hoit, 1809-1856
Oil on canvas, 76.2 x 63.5 cm. (30 x
 25 in.), 1840
NPG.67.5

Harrison, William Henry, 1773-1841
Ninth President of the United States
Albert Newsam, 1809-1864, after
 daguerreotype by Southworth and
 Hawes
Hand-colored lithograph, 26 x 22.5
 cm. (10¼ x 8⅞ in.), 1846
NPG.79.137

Harrison, William Henry, 1773-1841
Ninth President of the United States
Rembrandt Peale, 1778-1860
Oil on canvas, 72.4 x 58.4 cm. (28½ x
 23 in.), c. 1815
NPG.75.27
Gift of Mrs. Herbert Lee Pratt

Harrison, William Henry, 1773-1841
Ninth President of the United States
Henry R. Robinson, active 1833-1851,
 after James Reid Lambdin
Lithograph, 54.6 x 42.7 cm. (9½ x
 16¹³⁄₁₆ in.), 1840
NPG.85.165

Harrison, William Henry, 1773-1841
Ninth President of the United States
Charles Balthazar Julien Févret de
 Saint-Mémin, 1770-1852
Engraving, 5.6 cm. (2¼ in.) diameter,
 1800
NPG.74.39.447
Gift of Mr. and Mrs. Paul Mellon

Harrison, William Henry, 1773-1841
Ninth President of the United States
John Sartain, 1808-1897, after James
 Reid Lambdin
Mezzotint, 52.2 x 35.4 cm. (20½ x
 13¹⁵⁄₁₆ in.), 1841
NPG.80.54

Hart, George Overbury ("Pop"),
 1868-1933
Artist
Charles Sarka, 1879-1960
Ink and watercolor over pencil on
 paper, 36.3 x 28.7 cm. (14⁵⁄₁₆ x
 11⁵⁄₁₆ in.), c. 1905
NPG.74.61

Hart, Moss, 1904-1961
Playwright
Soss Melik, 1914-
Charcoal on paper, 58.1 x 44.1 cm.
 (22⅞ x 17⅜ in.), 1938
NPG.68.30

Hart, William Surrey, 1870-1946
Actor
Unidentified photographer
Photograph, gelatin silver print, 23.9
 x 18.8 cm. (9⁷⁄₁₆ x 7⅜ in.), c. 1920
NPG.84.127

Harte, Francis Bret, 1836-1902
Author
Jeremiah Gurney, active 1840-c.1890
Photograph, albumen silver print,
 8.2 x 7.3 cm. (3¼ x 2⅞ in.), c. 1870
NPG.76.75

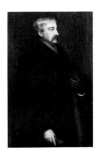

Harte, Francis Bret, 1836-1902
Author
John Pettie, 1839-1893
Oil on canvas, 111.7 x 73.6 cm. (44 x
 29 in.), 1884
NPG.69.52

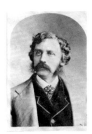

Harte, Francis Bret, 1836-1902
Author
Napoleon Sarony, 1821-1896
Photograph, albumen silver print,
 13.3 x 9.2 cm. (5¼ x 3⅝ in.),
 c. 1870
NPG.79.39

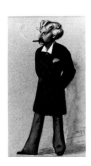

Harte, Francis Bret, 1836-1902
Author
Sir Leslie Ward ("Spy"), 1851-1922
Watercolor on paper, 30.5 x 18.3 cm.
 (12 x 7³⁄₁₆ in.), 1879
NPG.64.8
*Gift of the Trustees, National
 Portrait Gallery, London*

Hartmann, Carl Sadakichi,
 1867?-1944
Author, art critic
Louis Fleckenstein, 1866-1943
Photograph, toned gelatin silver
 print, 19.3 x 12.3 cm. (7⅝ x 4⅞
 in.), c. 1915
NPG.78.130

Hartley, Marsden, 1877-1943
Artist
Emil Otto Hoppé, 1878-1972
Photograph, gelatin silver print, 19.5
 x 16.1 cm. (7¹¹⁄₁₆ x 6⁵⁄₁₆ in.), c. 1926
NPG.78.103

Hassam, Frederick Childe, 1859-1935
Artist
Peggy Bacon, 1895-1987
Crayon on paper, 35.5 x 24.7 cm. (14
 x 9¾ in.), c. 1935
NPG.74.62

Hartley, Marsden, 1877-1943
Artist
Richard Tweedy, 1876-1952
Oil on canvas, 66 x 45.5 cm. (26 x 18
 in.), 1898
NPG.83.135

Hassam, Frederick Childe, 1859-1935
Artist
Arnold Genthe, 1869-1942
Photograph, gelatin silver print, 23.4
 x 18.2 cm. (9¼ x 7⅛ in.), c. 1925
NPG.78.242

Hartmann, Carl Sadakichi,
 1867?-1944
Author, art critic
Marvin Beerbohm, 1909-1981
Oil on canvas, 106.8 x 82 cm. (42 x
 32¼ in.), 1940
NPG.84.124
Gift of Mrs. Marvin Beerbohm

Hassam, Frederick Childe, 1859-1935
Artist
Self-portrait
Etching and drypoint, 17.8 x 12.6 cm.
 (7 x 4¹⁵⁄₁₆ in.), 1915
NPG.81.155

Hartmann, Carl Sadakichi,
 1867?-1944
Author, art critic
John Stevens Coppin, 1904-1986
Oil on canvas, 152.4 x 86.4 cm. (60 x
 34 in.), 1940
NPG.83.207

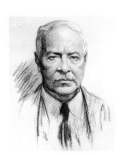

Hassam, Frederick Childe, 1859-1935
Artist
Samuel Johnson Woolf, 1880-1848
Charcoal and chalk on paper, 64.7 x
 50 cm. (25½ x 19¾ in.), 1934
NPG.80.260

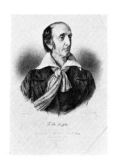

Hassler, Ferdinand Rudolph,
 1770-1843
Scientist
Charles Fenderich, 1805-1887
Lithograph, 26.5 x 26 cm. (10⁷⁄₁₆ x
 10¼ in.), 1841
NPG.66.100
Transfer from the Library of
 Congress, Prints and Photographs
 Division

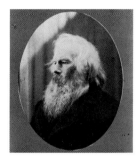

Hastie, William Henry, 1904-1976
Jurist
Betsy Graves Reyneau, 1888-1964
Oil on canvas, 101.6 x 114.3 cm. (40
 x 45 in.), 1943-1944
NPG.67.83
Gift of the Harmon Foundation

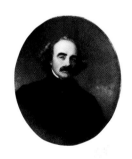

Hawes, Josiah Johnson, 1808-1901
Photographer
Self-portrait
Photograph, albumen silver print,
 9.2 x 7 cm. (3⁹⁄₁₆ x 2¾ in.), c. 1895
NPG.79.117

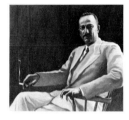

Hawthorne, Nathaniel, 1804-1864
Author
Emanuel Gottlieb Leutze, 1816-1868
Oil on canvas, 63.4 x 50.8 cm. (25 x
 20 in.) oval, 1862
NPG.65.55
Transfer from the National Gallery
 of Art; gift of Andrew W. Mellon,
 1942

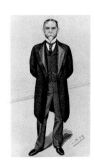

Hay, John Milton, 1838-1905
Author, diplomat
Vincent Brooks, Day and Son
 lithography company, active
 1867-c. 1905, after Sir Leslie Ward
 ("Spy")
Chromolithograph, 32 x 18.6 cm.
 (12⅝ x 7⁵⁄₁₆ in.), 1897
Published in *Vanity Fair*, London,
 June 24, 1897
NPG.77.257

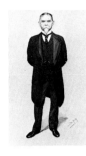

Hay, John Milton, 1838-1905
Author, diplomat
Sir Leslie Ward ("Spy"), 1851-1922
Watercolor on paper, 35.8 x 25.1 cm.
 (14⅛ x 9⅞ in.), 1897
NPG.77.232

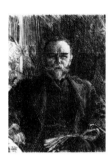

Hay, John Milton, 1838-1905
Author, diplomat
Anders Zorn, 1860-1920
Etching, 20.1 x 15.1 cm. (7¹⁵⁄₁₆ x 5¹⁵⁄₁₆
 in.), 1904
NPG.74.21

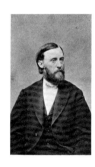

Hayden, Ferdinand Vandiveer,
 1829-1887
Scientist
Unidentified photographer
Photograph, albumen silver print,
 9.1 x 5.5 cm. (3⁹⁄₁₆ x 2³⁄₁₆ in.),
 c. 1875
NPG.77.180

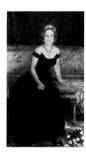

Hayes, Helen*, 1900-
Actress
Furman J. Finck, 1900-
Oil and tempera on canvas, 167.9 x
 101.9 cm. (66⅛ x 40⅛ in.), 1966
T/NPG.75.34
Gift of the artist

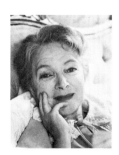

Hayes, Helen*, 1900-
Actress
Philippe Halsman, 1906-1979
Photograph, gelatin silver print, 34.8
 x 27.2 cm. (13¹¹⁄₁₆ x 10¹¹⁄₁₆ in.), 1961
T/NPG.83.93
Gift of George R. Rinhart

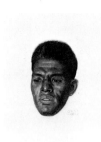

Hayes, Roland, 1887-1976
Singer
Winold Reiss, 1886-1953
Pastel on artist board, 49.4 x 40.6 cm.
 (19⁷/₁₆ x 16 in.), c. 1925
NPG.72.81
*Gift of Lawrence A. Fleischman and
 Howard Garfinkle with a
 matching grant from the National
 Endowment for the Arts*

Hayes, Rutherford Birchard,
 1822-1893
Nineteenth President of the United
 States
? Morgan, ?-?
Bronze medal, 7.6 cm. (3 in.)
 diameter, 1877
NPG.76.108

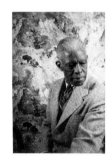

Hayes, Roland, 1887-1976
Singer
Clara E. Sipprell, 1885-1975
Photograph, gelatin silver print, 23.9
 x 18.9 cm. (9⁷/₁₆ x 7½ in.), c. 1960
NPG.82.182
Bequest of Phyllis Fenner

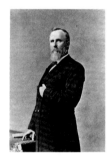

Hayes, Rutherford Birchard,
 1822-1893
Nineteenth President of the United
 States
Olin Levi Warner, 1844-1896
Plaster, 27.6 cm. (10⅞ in.), 1876
NPG.76.27
*Transfer from the National Museum
 of American Art; gift of Mrs.
 Carlyle Jones, 1974*

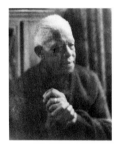

Hayes, Roland, 1887-1976
Singer
Carl Van Vechten, 1880-1964
Photogravure, 22.3 x 14.9 cm. (8¾ x
 5⅞ in.), 1983 from 1954 negative
NPG.83.188.19

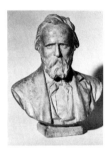

Hayes, Rutherford Birchard,
 1822-1893
Nineteenth President of the United
 States
Unidentified photographer
Photograph, albumen silver print,
 14.9 x 10.3 cm. (5⅞ x 4¹/₁₆ in.),
 c. 1875
NPG.77.181

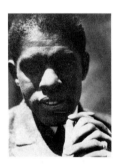

Hayes, Roland, 1887-1976
Singer
Unidentified photographer
Photograph, gelatin silver print, 22.5
 x 16.3 cm. (8¹⁵/₁₆ x 6⁷/₁₆ in.), 1934
NPG.84.17

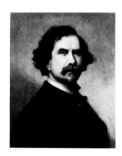

Healy, George Peter Alexander,
 1813-1894
Artist
Self-portrait
Oil on canvas, 61 x 49.5 cm. (24 x
 19½ in.), not dated
NPG.70.17
*Transfer from the National Museum
 of American Art; gift of Ruel P.
 Tolman, 1946*

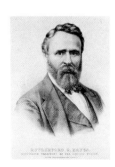

Hayes, Rutherford Birchard,
 1822-1893
Nineteenth President of the United
 States
Currier and Ives lithography
 company, active 1857-1907, after
 photograph
Lithograph, 28.8 x 23.6 cm. (11⅜ x
 9⅜ in.), c. 1877
NPG.80.59

Hecht, Ben, 1894-1964
Author
Philippe Halsman, 1906-1979
Photograph, gelatin silver print, 34.8
 x 27.6 cm. (13¹¹/₁₆ x 10¹³/₁₆ in.), 1953
NPG.83.94
Gift of George R. Rinhart

Heenan, John Carmel, 1835-1873
Athlete
Currier and Ives lithography
 company, active 1857-1907, after
 photograph
Hand-colored lithograph, 30.4 x 21.7
 cm. (12 x 8½ in.), c. 1860
NPG.80.121

Hemingway, Ernest Miller,
 1899-1961
Author
Man Ray, 1890-1976
Photograph, gelatin silver print, 22.6
 x 17.6 cm. (9 x 6¹⁵/₁₆ in.), 1923
NPG.77.130

Heifetz, Jascha*, 1901-
Musician
Aline Fruhauf, 1907-1978
India ink over pencil with opaque
 white on paper, 27.1 x 17.5 cm.
 (10¹¹/₁₆ x 6⅞ in.), 1928
Illustration for *Musical America*,
 New York, January 7, 1928
T/NPG.83.262
Gift of Erwin Vollmer

Hemingway, Ernest Miller,
 1899-1961
Author
Soss Melik, 1914-
Charcoal on paper, 63 x 48 cm. (24⅞
 x 19 in.), 1947
NPG.68.31

Helburn, Theresa, 1887-1959
Impresario
Marion H. Beckett, ?-?
Oil on canvas, 63.8 x 61 cm. (25⅛ x
 24 in.), 1922
NPG.73.30
Gift of Larry Aldrich

Hemingway, Ernest Miller,
 1899-1961
Author
Waldo Peirce, 1884-1970
Ink on paper, 50.8 x 38.1 cm. (20 x 15
 in.), 1928
NPG.81.4
Gift of Jonathan Peirce

Helmuth, Justus Henry Christian,
 1745-1825
Clergyman
John Eckstein, c. 1736-c. 1817
Oil on canvas, 78.8 x 71.1 cm. (31 x
 28 in.), c. 1795
NPG.67.7

Henderson, John Brooks, 1826-1913
Statesman
Jean Joseph Benjamin-Constant,
 1845-1902
Oil on canvas, 85.1 x 59.7 cm. (33½ x
 23½ in.), 1895
NPG.65.28
*Transfer from the National Museum
 of American Art; gift of the heirs
 of the Henderson estate through
 Dr. Charles Moore to the
 Smithsonian Institution, 1935*

Hemingway, Ernest Miller,
 1899-1961
Author
Robert Capa, 1913-1954
Photograph, gelatin silver print, 34.2
 x 23.1 cm. (13⁷/₁₆ x 9⅛ in.), 1941
NPG.85.88

Hendricks, Thomas Andrews,
 1819-1885
Vice-President of the United States
Mathew Brady, 1816-1896
Photograph, albumen silver print, 15
 x 9.5 cm. (5¹⁵/₁₆ x 3¾ in.), c. 1876
NPG.85.99
Gift of Robert L. Drapkin

Hendricks, Thomas Andrews,
 1819-1885
Vice-President of the United States
Mathew Brady, 1816-1896
Photograph, albumen silver print,
 14.2 x 10 cm. (5⅝ x 3¹⁵⁄₁₆ in.),
 c. 1868
NPG.85.100
Gift of Robert L. Drapkin

Henri, Robert, 1865-1929
Artist
Walter Tittle, 1883-1968
Drypoint, 17.3 x 15.3 cm. (6¹³⁄₁₆ x 6¹⁄₁₆
 in.), 1917
NPG.79.89

Henri, Robert, 1865-1929
Artist
Self-portrait
Pencil on paper, 22.5 x 14 cm. (8⅞ x
 5½ in.), 1916
NPG.72.110
Gift of Mr. and Mrs. Stuart P. Feld

Henry, Joseph, 1797-1878
Scientist, first secretary of the
 Smithsonian Institution
Mathew Brady, 1823-1896
Photograph, albumen silver print,
 8.6 x 5.4 cm. (3⅜ x 2⅛ in.), c. 1862
NPG.77.176

Henri, Robert, 1865-1929
Artist
Self-portrait
Crayon on paper, 27.8 x 21.4 cm.
 (10¹⁵⁄₁₆ x 8⁷⁄₁₆ in.), 1904
NPG.84.110

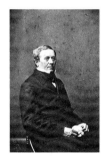

Henry, Joseph, 1797-1878
Scientist, first secretary of the
 Smithsonian Institution
Mathew Brady, 1823-1896
Photograph, albumen silver print,
 8.5 x 5.8 cm. (3⅜ x 2⁵⁄₁₆ in.), c. 1860
NPG.77.177

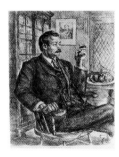

Henri, Robert, 1865-1929
Artist
John Sloan, 1871-1951
Etching, 34.4 x 27.6 cm. (13½ x 10⅞
 in.), 1931
NPG.80.236
*Gift of Mr. and Mrs. Bennard B.
 Perlman*

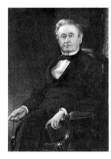

Henry, Joseph, 1797-1878
Scientist, first secretary of the
 Smithsonian Institution
Thomas LeClear, 1818-1882
Oil on canvas, 117.4 x 83.8 cm. (46¼
 x 33 in.), 1877
NPG.64.10
*Transfer from the National Museum
 of American Art*

Henri, Robert, 1865-1929
Artist
Carl Sprinchorn, 1887-1971
Ink on paper, 21.6 x 7.6 cm. (8½ x 3
 in.), 1910
NPG.81.144
Gift of Mr. and Mrs. Stuart P. Feld

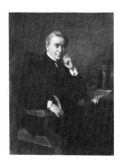

Henry, Joseph, 1797-1878
Scientist, first secretary of the
 Smithsonian Institution
Henry Ulke, 1821-1910
Oil on canvas, 139.7 x 106.6 cm. (55
 x 42 in.), 1875
NPG.79.245
*Transfer from the National Museum
 of American Art*

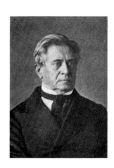

Henry, Joseph, 1797-1878
Scientist, first secretary of the
 Smithsonian Institution
Henry Ulke, 1821-1910
Photograph, albumen silver print,
 11.8 x 8.1 cm. (4¹¹⁄₁₆ x 3³⁄₁₆ in.),
 c. 1870
NPG.81.113
Transfer from the Archives of
 American Art

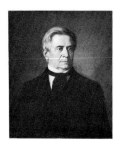

Henry, Joseph, 1797-1878
Scientist, first secretary of the
 Smithsonian Institution
Henry Ulke, 1821-1910
Oil on canvas, 76.8 x 64.1 cm. (30¼ x
 25¼ in.), 1885
NPG.85.49
Transfer from the National Museum
 of American Art

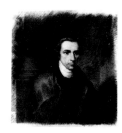

Henry, Patrick, 1736-1799
Revolutionary statesman
James Barton Longacre, 1794-1869,
 after Lawrence Sully
Watercolor on artist board, 16.5 x
 13.3 cm. (6½ x 5¼ in.), c. 1835
NPG.77.291

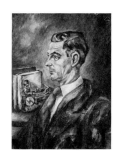

Heyward, DuBose, 1885-1940
Author
George Gershwin, 1898-1937
Oil on canvas, 61 x 45.5 cm. (24 x 18
 in.), 1935
NPG.66.38
Gift of Ira Gershwin

Hicks, Granville*, 1901-1982
Critic
Clara E. Sipprell, 1885-1975
Photograph, gelatin silver print, 23.9
 x 18.8 cm. (9⅜ x 7⁷⁄₁₆ in.), c. 1960
T/NPG.82.199.92
Bequest of Phyllis Fenner

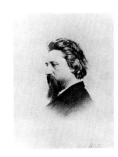

Hicks, Thomas, 1823-1890
Artist
Unidentified photographer
Photograph, albumen silver print,
 17.3 x 13.2 cm. (6¹³⁄₁₆ x 5³⁄₁₆ in.),
 c. 1865
NPG.76.76
Gift of Dr. and Mrs. Jacob Terner

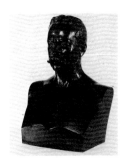

Hill, David Jayne, 1850-1932
Educator
Augustus Saint-Gaudens, 1848-1907
Bronze, 55.3 cm. (23¼ in.), 1901
NPG.74.73
Gift of Mrs. Margaret Garber Blue

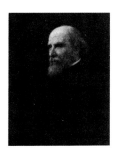

Hill, James Jerome, 1838-1916
Financier
Adolph (Adolfo) Müller-Ury,
 1862-1947
Oil on canvas, 76.2 x 61 cm. (30 x 24
 in.), c. 1916
NPG.68.43
Gift of Jerome J. Hill

Hill, Julian Werner*, 1904-
Scientist
Peter Strongwater, 1941-
Photograph, gelatin silver print, 35.5
 x 35.5 cm. (14 x 14 in.), 1983
T/NPG.84.241
Gift of Christopher Murray

Hillman, Sidney, 1887-1946
Labor leader
Carlos Baca-Flor, 1869-1941
Oil on canvas, 76.2 x 55.2 cm. (30 x
 21¾ in.), 1937
NPG.71.39
Gift of Amalgamated Clothing
 Workers Union of America

Hillman, Sidney, 1887-1946
Labor leader
Jo Davidson, 1883-1952
Bronze, 49.5 cm. (19½ in.), 1939
NPG.78.193
Gift of Dr. Maury Leibovitz

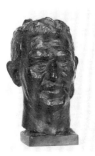

Hillquit, Morris, 1869-1933
Socialist leader
Sergei Timofeevich Konenkov,
 1874-1971
Bronze, 35.5 cm. (14 in.), 1925
NPG.78.212
*Gift of the Estate of Nina Eugenia
 Hillquit, Executrix, Sylvia Kasdan
 Angrist*

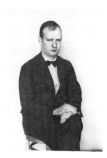

Hindemith, Paul, 1895-1963
Composer
August Sander, 1876-1964
Photograph, gelatin silver print, 25.8
 x 18 cm. (10⅛ x 7¹⁄₁₆ in.), 1980 from
 1926 negative
NPG.85.95

Hine, Lewis Wickes, 1874-1940
Photographer
Berenice Abbott, 1898-
Photograph, gelatin silver print, 11.5
 x 8.7 cm. (4½ x 3⅜ in.), c. 1938
NPG.79.96

Hinmaton-Yalaktit ("Chief Joseph"),
 1840-1904
Indian chief
Edward Sheriff Curtis, 1868-1952
Photogravure, 39.7 x 28.1 cm. (15⅝ x
 11¹¹⁄₁₆ in.), 1903
NPG.78.68

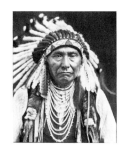

Hinmaton-Yalaktit ("Chief Joseph"),
 1840-1904
Indian chief
Edward Sheriff Curtis, 1868-1952
Orotone, 58.7 x 48 cm. (23 x 19 in.),
 1980 from 1903 negative
NPG.80.325
Gift of Jean-Antony du Lac

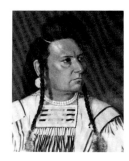

Hinmaton-Yalaktit ("Chief Joseph"),
 1840-1904
Indian chief
Cyrenius Hall, 1830-?
Oil on canvas, 56.5 x 45.5 cm. (22¼ x
 18 in.), 1878
NPG.68.19

Hirshhorn, Joseph Herman*,
 1899-1981
Financier, art patron
Philippe Halsman, 1906-1979
Photograph, gelatin silver print, 35 x
 27.4 cm. (13¹³⁄₁₆ x 10¹³⁄₁₆ in.), 1966
T/NPG.83.95.91
Gift of George R. Rinhart

Hiss, Alger*, 1904-
Public official
Soss Melik, 1914-
Charcoal on paper, 62.5 x 48.4 cm.
 (24⅝ x 19 in.), 1978
T/NPG.79.142
Gift of anonymous donor

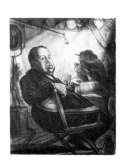

Hitchcock, Alfred*, 1899-1980
Filmmaker
Don Freeman, 1908-1978
Lithograph, 45.8 x 36.1 cm. (18 x
 14³⁄₁₆ in.), c. 1940
T/NPG.83.49.90

Hitchcock, Alfred*, 1899-1980
Filmmaker
Self-portrait
Ink on green paper, 11.2 x 13.5 cm.
(4⅜ x 5⁵⁄₁₆ in.), 1938
T/NPG.84.67.90

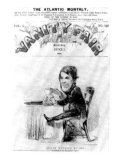

Holmes, Oliver Wendell, 1809-1894
Author
Bobbett and Hooper wood-engraving
 company, active 1855-1870, after
 Henry Louis Stephens
Wood engraving, 14.5 x 14.5 cm.
 (5¹¹⁄₁₆ x 5¹¹⁄₁₆ in.), 1862
Published in *Vanity Fair*, New York,
 June 7, 1862
NPG.78.230

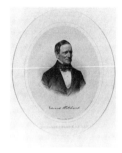

Hitchcock, Edward, 1793-1864
Geologist
Leopold Grozelier, 1830-1865, after
 daguerreotype by John Adams
 Whipple
S. W. Chandler and Brother
 lithography company
Lithograph with tintstone, 35.3 x
 28.4 cm. (13⅞ x 11³⁄₁₆ in.), 1855
NPG.85.176

Holmes, Oliver Wendell, 1809-1894
Author
James Notman, ?-?
Photograph, albumen silver print,
 11.4 x 8.2 cm. (4½ x 3¼ in.),
 c. 1880
NPG.67.32

Hoe, Robert, 1839-1909
Manufacturer, bibliophile
Julian Alden Weir, 1852-1919
Drypoint, 20 x 17.3 cm. (7⅞ x 6¹³⁄₁₆
 in.), 1891
NPG.78.57

Holmes, Oliver Wendell, Jr.,
 1841-1935
Justice of the United States Supreme
 Court
Clara E. Sipprell, 1885-1975
Photograph, gelatin silver print, 21.9
 x 18 cm. (8⅝ x 7¹⁄₁₆ in.), 1935
NPG.82.184
Bequest of Phyllis Fenner

Hoffman, Malvina, 1885-1966
Artist
Clara E. Sipprell, 1885-1975
Photograph, gelatin silver print, 23.2
 x 19 cm. (9⅛ x 7½ in.), c. 1930
NPG.81.12

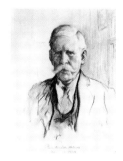

Holmes, Oliver Wendell, Jr.,
 1841-1935
Justice of the United States Supreme
 Court
Samuel Johnson Woolf, 1880-1948
Charcoal on paper, 50.1 x 36.4 cm.
 (19¾ x 14⅜ in.), 1926
NPG.80.261
*Gift of Thomas G. Corcoran and
 Gallery purchase*

Hofmann, Josef, 1876-1957
Musician
Leopold Seyffert, 1887-1956
Charcoal on paper, 63.5 x 48.2 cm.
 (25 x 19 in.), 1916
NPG.69.69

Holmes, Oliver Wendell, Jr.,
 1841-1935
Justice of the United States Supreme
 Court
Unidentified photographer
Photograph, salt print, 15.5 x 12.3
 cm. (6⅛ x 4⅞ in.), 1861
NPG.77.152

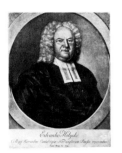

Holyoke, Edward, 1689-1769
Educator
Attributed to John Greenwood,
 1727-1792
Mezzotint, 21 x 18.5 cm. (8¼ x 7⁵⁄₁₆
 in.), 1749
NPG.77.40

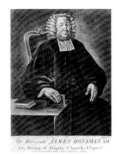

Honyman, James, 1675-1750
Clergyman
Samuel Okey, active 1765-1780, after
 Gains
Mezzotint, 31.1 x 25.2 cm. (12¼ x 9⅞
 in.), 1774
NPG.78.237

Homer, Louise, 1871-1947
Singer
Violet Oakley, 1874-1961
Charcoal and chalk on blue paper,
 40.5 x 30.5 cm. (16 x 12 in.), not
 dated
NPG.83.26
*Gift of the Violet Oakley Memorial
Foundation*

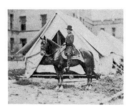

Hooker, Joseph, 1814-1879
Union general
Mathew Brady, 1823-1896
Photograph, albumen silver print,
 15.2 x 18.1 cm. (6 x 7⅛ in.), 1863
NPG.81.15

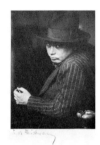

Homolka, Oscar*, 1899-1978
Actor
Trude Fleischmann, 1895-
Photograph, gelatin silver print, 11.3
 x 8.2 cm. (4⁷⁄₁₆ x 3¼ in.), 1930
T/NPG.83.197.88

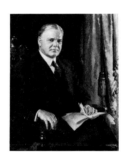

Hoover, Herbert Clark, 1874-1964
Thirty-first President of the United
 States
Douglas Chandor, 1897-1953
Oil on canvas, 114.3 x 96.5 cm. (45 x
 38 in.), 1931
NPG.68.24

Hone, Philip, 1780-1851
Diarist
Asher Brown Durand, 1796-1886,
 after Rembrandt Peale
Engraving, 26 x 13.3 cm. (10¼ x 5¼
 in.), c. 1826
NPG.72.120
Gift of Stuart P. Feld

Hoover, Herbert Clark, 1874-1964
Thirty-first President of the United
 States
Joseph Cummings Chase, 1878-1965
Oil on academy board, 62.8 x 47 cm.
 (24¾ x 18½ in.), 1917
NPG.72.121
Gift of Mendel Peterson

**Ho Nee Yeath Taw No Row ("King of
 the Generethgarich"),** ?-?
Indian chief
John Simon, 1675-1751/55, after John
 Verelst
Mezzotint, 34.4 x 25.5 cm. (13½ x 10
 in.), third state, c. 1760 from 1710
 plate
NPG.74.24

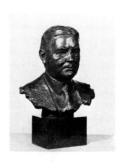

Hoover, Herbert Clark, 1874-1964
Thirty-first President of the United
 States
Jo Davidson, 1883-1952
Bronze, 40.6 cm. (16 in.), 1921
NPG.77.321
Gift of Dr. Maury Leibovitz

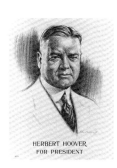

Hoover, Herbert Clark, 1874-1964
Thirty-first President of the United
 States
John Doctoroff, active c. 1918-1938
National lithography company
Lithograph, 48 x 41 cm. (19 x 16 in.),
 1928
NPG.79.227

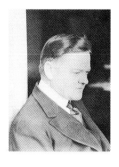

Hoover, Herbert Clark, 1874-1964
Thirty-first President of the United
 States
Helen Warner Johns Kirtland, ?-?, or
 Lucien Swift Kirtland, 1881-1965
Photograph, gelatin silver print, 23.6
 x 17.9 cm. (9⁵⁄₁₆ x 7¹⁄₁₆ in.), 1919
NPG.80.286

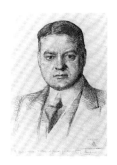

Hoover, Herbert Clark, 1874-1964
Thirty-first President of the United
 States
Leo Mielziner, 1869-1935
Etching, 19.7 x 15.8 cm. (7¾ x 6³⁄₁₆
 in.), 1928
NPG.78.46

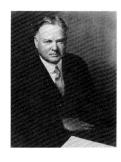

Hoover, Herbert Clark, 1874-1964
Thirty-first President of the United
 States
Edward Steichen, 1879-1973
Photograph, gelatin silver print, 24.2
 x 19.4 cm. (9½ x 7⅝ in.), 1929
NPG.82.86
Bequest of Edward Steichen

Hoover, Herbert Clark, 1874-1964
Thirty-first President of the United
 States
Edmund Charles Tarbell, 1862-1938
Oil on canvas, 116.8 x 91.4 cm. (46 x
 36 in.), 1921
NPG.65.30
*Transfer from the National Museum
 of American Art; gift of the
 National Art Committee to the
 Smithsonian Institution, 1923*

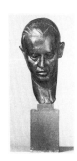

Hope, Leslie Townes ("Bob")*, 1903-
Entertainer
Philippe Halsman, 1906-1979
Photograph, gelatin silver print, 34.6
 x 27.5 cm. (13⅝ x 10¹³⁄₁₆ in.),
 c. 1959
T/NPG.83.96
Gift of George R. Rinhart

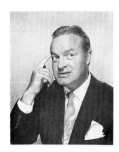

Hopkins, Harry Lloyd, 1890-1946
Public official
Reuben Nakian, 1897-1987
Bronze, 67.3 cm. (26½ in.), 1934
NPG.83.134

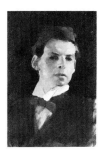

Hopkinson, Charles Sydney,
 1869-1962
Artist
Self-portrait
Oil on canvas, 48.9 x 41.3 cm. (19¼ x
 16¼ in.), c. 1900
NPG.77.24
Gift of the artist's daughters

Hopkinson, Charles Sydney,
 1869-1962
Artist
Self-portrait
Oil on canvas, 43.2 x 45.5 cm. (17 x
 18 in.), c. 1910
NPG.77.25
Gift of the artist's daughters

Hopkinson, Charles Sydney,
 1869-1962
Artist
Self-portrait
Oil on canvas, 33.6 x 23.2 cm. (13¼ x
 9⅛ in.), c. 1918
NPG.77.26
Gift of the artist's daughters

Hopkinson, Charles Sydney,
1869-1962
Artist
Self-portrait
Oil on artist board, 35.5 x 25.7 cm.
(14 x 10⅛ in.), c. 1959
NPG.77.27
Gift of the artist's daughters

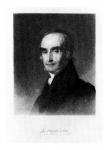

Hopkinson, Joseph, 1770-1842
Jurist
John Sartain, 1808-1897, after
painting by Thomas Sully
Mezzotint, 16.1 x 13.2 cm. (6⁵⁄₁₆ x
5³⁄₁₆ in.), c. 1832-1835
NPG.84.108

Hoppe, William Frederick ("Willie"),
1887-1959
Billiard player
Underwood and Underwood, active
1882-c. 1950
Photograph, gelatin silver print, 23.7
x 18.4 cm. (9⁵⁄₁₆ x 7¼ in.), 1940
NPG.80.231

Hopper, Edward, 1882-1967
Artist
Berenice Abbott, 1898-
Photograph, gelatin silver print, 19.3
x 24.4 cm. (7⅝ x 9⅝ in.), c. 1948
NPG.76.78

Hopper, Edward, 1882-1967
Artist
Self-portrait
Charcoal on paper, 47 x 30.5 cm.
(18½ x 12 in.), 1903
NPG.72.42

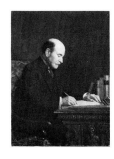

Hornaday, William Temple,
1854-1937
Naturalist
George R. Boynton, 1854-1945
Oil on canvas, 122.5 x 92 cm. (48¼ x
36¼ in.), not dated
NPG.83.251
Gift of William T. Hornaday
Conservation Trust, Inc.

Horne, Lena*, 1917-
Singer, actress
Edward Biberman, 1904-1986
Oil on canvas, 129.5 x 78.8 cm. (51 x
31 in.), 1947
T/NPG.85.2

Horne, Lena*, 1917-
Singer, actress
Carl Van Vechten, 1880-1964
Photogravure, 22.4 x 14.8 cm. (8¹³⁄₁₆
x 5⅞ in.), 1983 from 1941 negative
T/NPG.83.188.22

Horowitz, Vladimir*, 1904-
Musician
Alfred Bendiner, 1899-1964
Crayon on board, 28.5 x 36.5 cm.
(11³⁄₁₆ x 14⅜ in.), 1942
Illustration for *The Evening*
Bulletin, Philadelphia, January 16,
1942
T/NPG.84.56
Gift of Alfred Bendiner Foundation

Horowitz, Vladimir*, 1904-
Musician
Philippe Halsman, 1906-1979
Photograph, gelatin silver print, 31 x
27.5 cm. (12³⁄₁₆ x 10¹³⁄₁₆ in.), 1966
T/NPG.83.97
Gift of George R. Rinhart

Hosmer, Harriet Goodhue, 1830-1908
Artist
James Wallace Black, 1825-1896, and
 John Case, 1808-1880
Photograph, albumen silver print,
 8.8 x 5.4 cm. (3½ x 2⅛ in.), c. 1865
NPG.80.201

Houston, Charles Hamilton,
 1895-1950
Lawyer, civil rights leader
Betsy Graves Reyneau, 1888-1964
Oil on canvas, 91.4 x 71.1 cm. (36 x
 28 in.), 1943-1944
NPG.67.38
Gift of the Harmon Foundation

Hosmer, Harriet Goodhue, 1830-1908
Artist
Jeremiah Gurney and Son, active
 c. 1860-c. 1875
Photograph, albumen silver print,
 9.3 x 5.5 cm. (3¹¹⁄₁₆ x 2⅛ in.),
 c. 1875
NPG.80.202

Houston, Samuel, 1793-1863
Statesman
Henry Dexter, 1806-1876
Bronze, 56.8 cm. (22⅜ in.), cast after
 1859-1860 plaster
NPG.69.82

Hosmer, Harriet Goodhue, 1830-1908
Artist
Unidentified photographer
Photograph, salt print, 15.5 x 11.9
 cm. (6⅛ x 4¹¹⁄₁₆ in.), c. 1855
NPG.84.150

Houston, Samuel, 1793-1863
Statesman
Unidentified photographer
Photograph, salt print, 18.6 x 13.2
 cm. (7⁵⁄₁₆ x 5³⁄₁₆ in.), c. 1858
NPG.77.263

House, Edward Mandell, 1858-1938
Political adviser
Jo Davidson, 1883-1952
Bronze, 42.3 cm. (16⅝ in.), 1919
NPG.77.38

Houston, Samuel, 1793-1863
Statesman
Unidentified artist, after
 daguerreotype by John Plumbe, Jr.
Lithograph, 33 x 26 cm. (13 x 10¼
 in.), 1846
Contained in *The National
 Plumbeotype Gallery,*
 Philadelphia, 1847
NPG.78.84.d

House, Edward Mandell, 1858-1938
Political adviser
Helen Warner Johns Kirtland, ?-?, or
 Lucien Swift Kirtland, 1881-1965
Photograph, gelatin silver print, 23.6
 x 17.9 cm. (9⁵⁄₁₆ x 7¹⁄₁₆ in.), 1919
NPG.80.287

Hoving, Walter, III*, 1897-
Executive
Peter Strongwater, 1941-
Photograph, gelatin silver print, 35.4
 x 35.5 cm. (13¹⁵⁄₁₆ x 14 in.), 1982
T/NPG.84.239
Gift of Christopher Murray

Howe, Julia Ward, 1819-1910
Poet, reformer
Begun by John Elliott, 1858-1925,
 and finished c. 1925 by William
 H. Cotton, 1880-1958
Oil on canvas, 107.9 x 71.8 cm. (42½ x
 28¼ in.), c. 1910 and c. 1925
NPG.65.31
*Transfer from the National Museum
 of American Art; gift of Mrs. John
 Elliott to the Smithsonian
 Institution, 1933*

Howe, Julia Ward, 1819-1910
Poet, reformer
Sarah Choate Sears, 1858-1935
Photogravure, 20.5 x 17.2 cm. (8¹⁄₁₆ x
 6¾ in.), 1907
NPG.77.131

Howells, William Dean, 1837-1920
Author
Zaida Ben-Yusuf, 1871-?
Photograph, platinum print, 21.3 x
 16.3 cm. (8⅜ x 6⅜ in.), c. 1900
NPG.78.179

Howells, William Dean, 1837-1920
Author
Orlando Rouland, 1871-1945
Pencil with crayon on paper, 13.5 x
 21.8 cm. (5⁵⁄₁₆ x 8⁹⁄₁₆ in.), 1890
NPG.78.124

Howells, William Dean, 1837-1920
Author
John Quincy Adams Ward,
 1830-1910
Bronze relief, 33.9 cm. (13⅜ in.)
 diameter, cast after c. 1861 original
NPG.65.72
*Transfer from the National Gallery
 of Art; gift of Miss Mildred
 Howells, 1954*

Hoxie, Vinnie Ream, 1847-1914
Artist
Unidentified photographer
Tintype, 21.3 x 16.5 cm. (8⁷⁄₁₆ x 6½
 in.), c. 1875
NPG.78.112

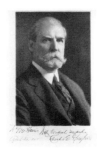

Hughes, Charles Evans, 1862-1948
Statesman
Philip Alexius de Lászlo, 1869-1937
Oil on canvas, 93.9 x 73.7 cm. (37 x
 29 in.), 1921
NPG.84.230
Bequest of Chauncey L. Waddell

Hughes, Charles Evans, 1862-1948
Statesman
Harris and Ewing studio, active
 1905-1977
Photograph, gelatin silver print, 22.8
 x 15.3 cm. (9 x 6¹⁄₁₆ in.), 1921
NPG.84.248
Gift of Aileen Conkey

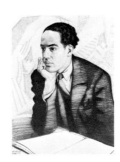

Hughes, Langston, 1902-1967
Poet
Winold Reiss, 1886-1953
Pastel on artist board, 76.3 x 54.9 cm.
 (30¹⁄₁₆ x 21⅝ in.), c. 1925
NPG.72.82
*Gift of W. Tjark Reiss in memory of
 his father, Winold Reiss*

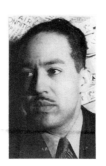

Hughes, Langston, 1902-1967
Poet
Carl Van Vechten, 1880-1964
Photograph, gelatin silver print, 13.8
 x 8.6 cm. (5⁷⁄₁₆ x 3⅜ in.), 1936
NPG.83.150

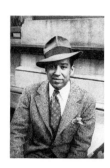

Hughes, Langston, 1902-1967
Poet
Carl Van Vechten, 1880-1964
Photogravure, 22.4 x 15 cm. (8¹³⁄₁₆ x
5¹⁵⁄₁₆ in.), 1983 from 1939 negative
NPG.83.188.23

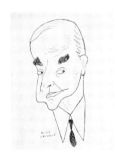

Hughes, Langston, 1902-1967
Poet
Carl Van Vechten, 1880-1964
Photograph, gelatin silver print, 14.1
x 21.4 cm. (5⁹⁄₁₆ x 8⅜ in.), 1932
NPG.84.143
Gift of Prentiss Taylor

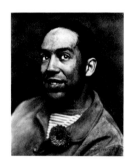

Hughes, Langston, 1902-1967
Poet
Edward Weston, 1886-1958
Photograph, gelatin silver print, 24.3
x 19.4 cm. (9⁹⁄₁₆ x 7⅝ in.), 1932
NPG.77.264

Hull, Cordell, 1871-1955
Statesman
Aline Fruhauf, 1907-1978
India ink over pencil on paper, 38.4
x 28.1 cm. (15¹⁄₁₆ x 11¹⁄₁₆ in.), 1940
Published in *The New Republic*,
Washington, D.C., May 27, 1940
NPG.83.35
Gift of Erwin Vollmer

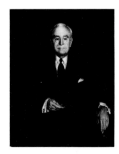

Hull, Cordell, 1871-1955
Statesman
Casimir Gregory Stapko, 1913-
after the oil by Edward Morris
Murray
Oil on canvas, 121.9 x 97.1 cm. (48 x
38¼ in.), c. 1945-1946
NPG.66.58
*Transfer from the National Museum
of American Art; gift of the
International Business Machines
Corporation to the Smithsonian
Institution, 1962*

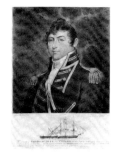

Hull, Isaac, 1773-1843
War of 1812 naval officer
Attributed to George Graham, active
1796-1813, after Gilbert Stuart
Mezzotint and etching, 47.4 x 34.7
cm. (18⅝ x 13¹¹⁄₁₆ in.), 1813
NPG.79.110

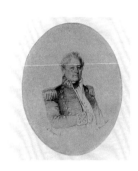

Hull, Isaac, 1773-1843
War of 1812 naval officer
Louis Jean-Baptiste Hyacinthe
Pellegrin, 1808-?
Pencil on paper, 18.6 x 15.2 cm. (7⅜
x 6 in.), 1841
NPG.78.12

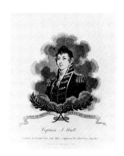

Hull, Isaac, 1773-1843
War of 1812 naval officer
William Strickland, 1788-1854, after
Gilbert Stuart
Aquatint and line etching, 17.5 x 17
cm. (6⅞ x 6¹¹⁄₁₆ in.), c. 1812-1815
NPG.75.49

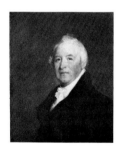

Hull, William, 1753-1825
Soldier
Gilbert Stuart, 1755-1828
Oil on striated panel, 66.7 x 55.3 cm.
(26¼ x 21¾ in.), c. 1823
NPG.84.177

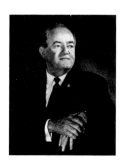

Humphrey, Hubert Horatio*,
1911-1978
Statesman
David Lee Iwerks, 1933-
Photograph, gelatin silver print, 24.1
x 19 cm. (9½ x 7½ in.), 1964
T/NPG.78.185.88

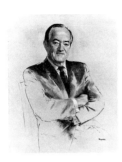

Humphrey, Hubert Horatio*,
1911-1978
Statesman
Robert Templeton, 1929-
Oil on canvas, 93.9 x 76.2 cm. (37 x
 30 in.), 1969
T/NPG.73.9.88
*Gift of Joseph James Akston, Philip
 I. Berman, William R. Biggs,
 Felisa R. DeGautier, S. Harrison
 Dogole, Samuel T. Parelman,
 Marvin Rosenberg, C. Bruce
 Solomonson, Luther L. Terry,
 Edward H. Weiss*

Hunt, Richard Morris, 1827-1895
Architect
Karl Bitter, 1865-1915
Bronze relief, 48.9 cm. (19¼ in.)
 diameter, cast after 1891 original
NPG.67.8

Hunt, William Henry, 1869-1951
Diplomat
Domingos Rebelo, 1891-
Oil on fabric, 105.5 x 91.5 cm. (41½
 x 36 in.), 1951
NPG.72.18
Gift of Mrs. Dorothy B. Porter

Hunt, William Morris, 1824-1879
Artist
Gustav Kruell, 1843-1907, after
 William Morris Hunt
Wood engraving, 17.3 x 21.9 cm.
 (6¹³⁄₁₆ x 8⅝ in.), 1886-1887
Published in *Society of American
 Wood Engraving Portfolio,* 1887
NPG.77.220

Huntington, Collis Potter, 1821-1900
Businessman
William Keith, 1839-1911
Photograph, gelatin silver print, 35 x
 27.2 cm. (13¾ x 10¹¹⁄₁₆ in.), c. 1896
NPG.77.308

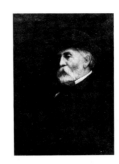

Huntington, Collis Potter, 1821-1900
Businessman
Francis Augustus Lathrop,
 1849-1909, after photograph by
 William Keith
Oil on canvas, 94 x 66 cm. (37 x 26
 in.), 1900
NPG.76.35
Gift of A. Hyatt Mayor

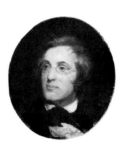

Huntington, Daniel, 1816-1906
Artist
Henry Inman, 1801-1846
Oil on canvas, 40.6 x 35.5 cm. (16 x
 14 in.), 1842
NPG.82.132

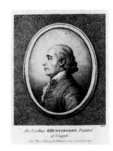

Huntington, Daniel, 1816-1906
Artist
Unidentified photographer
Photograph, albumen silver print,
 8.3 x 5.3 cm. (3¼ x 2⅛ in.), c. 1860
NPG.76.79
Gift of Dr. and Mrs. Jacob Terner

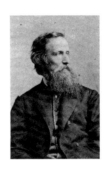

Huntington, Samuel, 1731-1796
Revolutionary statesman
B. B. Ellis, ?-?, after Benoit Louis
 Prevost, after Pierre Eugène Du
 Simitière
Stipple engraving, 11.1 x 9.2 cm. (4⅜
 x 3⅝ in.), 1783
Published in *Portraits of the
 Generals, Ministers, Magistrates,*
 London, 1783
NPG.75.75

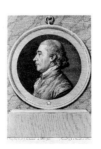

Huntington, Samuel, 1731-1796
Revolutionary statesman
Benoit Louis Prevost, 1735-1804, after
 Pierre Eugène Du Simitière
Engraving, 16.2 x 11.7 cm. (6⅜ x 4⅝
 in.), 1780
Published in *Collection des Portraits
 des Généraux, Ministres, et
 Magistrats . . . ,* Paris, 1781
NPG.75.61

Huntington, Samuel, 1731-1796
Revolutionary statesman
Burnet Reading, active 1780-1820,
 after Pierre Eugène Du Simitière
Stipple engraving, 7.3 x 6.1 cm. (2⅞
 x 2⅜ in.), 1783
NPG.82.3

Huxley, Aldous Leonard, 1894-1963
Author
Aline Fruhauf, 1907-1978
Pencil and colored chalks on blue
 paper, 47.3 x 30.6 cm. (18⅝ x 12
 in.), c. 1960
NPG.83.36
Gift of Erwin Vollmer

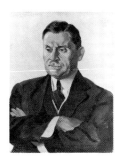

Hurley, Edward Nash, 1864-1933
Industrialist
Joseph Cummings Chase, 1878-1965
Oil on academy board, 68.9 x 46 cm.
 (27⅛ x 18⅛ in.), 1917/18
NPG.72.93
Gift of Mendel Peterson

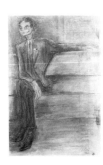

Huxley, Aldous Leonard, 1894-1963
Author
Aline Fruhauf, 1907-1978
Colored chalks with ink and pencil
 on blue paper, 44.2 x 33.1 cm. (17⅜
 x 13 in.), 1960
NPG.83.263
Gift of Erwin Vollmer

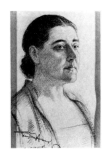

Hurst, Fanny, 1889-1968
Author
Joseph Margulies, 1896-
Lithographic crayon, 48 x 31.7 cm.
 (18⅞ x 12½ in.), 1929
NPG.70.50

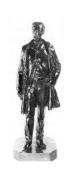

Hyde, Henry Baldwin, 1834-1899
Businessman
John Quincy Adams Ward,
 1830-1910
Bronze, 51.1 cm. (20⅛ in.), 1901
NPG.75.42
*Gift of Equitable Life Assurance
 Society*

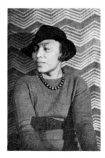

Hurston, Zora Neale, 1903-1960
Author
Carl Van Vechten, 1880-1964
Photogravure, 22.5 x 14.9 cm. (8⅞ x
 5⅞ in.), 1983 from 1935 negative
NPG.83.188.24

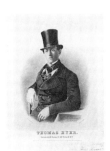

Hyer, Thomas, 1819-1864
Athlete
Eliphalet Brown, Jr., 1816-1886, after
 daguerreotype by Cannon
Lithograph, 33 x 25.7 cm. (13 x 10⅛
 in.), 1849
NPG.85.136

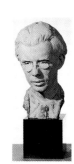

Huxley, Aldous Leonard, 1894-1963
Author
Jo Davidson, 1883-1952
Terra-cotta, 52 cm. (20½ in.), 1930
NPG.77.345
Gift of Dr. Maury Leibovitz

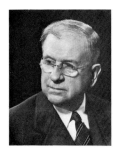

Ickes, Harold, 1874-1952
Public official
Philippe Halsman, 1906-1979
Photograph, gelatin silver print, 35.2
 x 27.2 cm. (13⅞ x 10¾ in.), 1942
NPG.83.98
Gift of George R. Rinhart

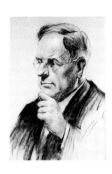

Ickes, Harold, 1874-1952
Public official
Samuel Johnson Woolf, 1880-1948
Charcoal and chalk on paper, 58.1 x
 41.5 cm. (22⅞ x 16⅜ in.), 1933
NPG.80.262

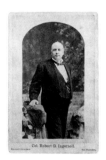

Ingersoll, Robert Green, 1833-1899
Orator
Henry W. Bradley, 1814-1891, and
 William Herman Rulofson,
 1826-1878; studio active 1863-1878
Photograph, albumen silver print,
 13.6 x 7.4 cm. (5⅜ x 2¹⁵⁄₁₆ in.),
 c. 1878
NPG.85.103
Gift of Robert L. Drapkin

Ingraham, Joseph Holt, 1809-1860
Author
Frederick Augustus Wenderoth,
 c. 1814-1884, and William Curtis
 Taylor, active 1863-1890; studio
 active 1863-1864
Photograph, albumenized salt print,
 15.2 x 12.1 cm. (6 x 4¾ in.), c. 1863
 from c. 1860 negative
NPG.82.77

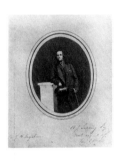

Inman, Henry, 1801-1846
Artist
Self-portrait
Ink on paper, 24.2 x 19.7 cm. (9⅝ x
 7¾ in.), not dated
NPG.82.133

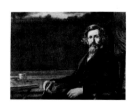

Inness, George, 1825-1894
Artist
Franklin C. Courter, 1854-c. 1935,
 after photograph by E. S. Bennett
Oil on canvas, 80 x 115.5 cm. (31½ x
 45½ in.), after c. 1890
NPG.70.18
*Transfer from the National Museum
 of American Art; gift of August
 Franzen, 1937*

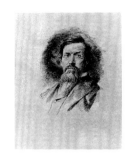

Inness, George, 1825-1894
Artist
Valerian Michaelovich Gribayedoff,
 active c. 1884-c. 1891, after
 photograph by E. S. Bennett
Wood engraving, 8.7 x 6.5 cm. (3⁷⁄₁₆
 x 2⁹⁄₁₆ in.), not dated
NPG.79.33

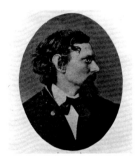

Inness, George, 1825-1894
Artist
Unidentified photographer
Photograph, albumen silver print, 10
 x 7.7 cm. (3¹⁵⁄₁₆ x 3 in.), c. 1860
NPG.78.152

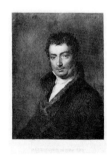

Irving, Washington, 1783-1859
Author
Hatch and Smillie, active
 c. 1831-1832, after Charles Robert
 Leslie
Engraving, 19.3 x 14.2 cm. (7¹¹⁄₁₆ x
 5¹¹⁄₁₆ in.), 1832
NPG.84.132

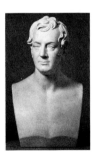

Irving, Washington, 1783-1859
Author
Robert Ball Hughes, 1806-1868
Plaster, 61 cm. (24 in.), c. 1836
NPG.84.168

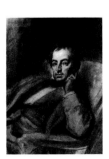

Irving, Washington, 1783-1859
Author
Daniel Huntington, 1816-1906
Oil on canvas, 45.5 x 33 cm. (18 x 13
 in.), not dated
NPG.69.23

Irving, Washington, 1783-1859
Author
Rintoul and Rockwood studio, active
 c. 1860, after c. 1849 daguerreotype
 by John Plumbe, Jr.
Photograph, albumen silver print,
 18.5 x 13.7 cm. (7¼ x 5⅛ in.),
 c. 1860
NPG.77.116

Irving, Washington, 1783-1859
Author
John Sartain, 1808-1897
Mezzotint with line engraving and
 etching, 18.1 x 14 cm. (7⅛ x 5½
 in.), 1856-1858
Published in *Eclectic Magazine of
 Foreign Literature*, New York and
 Philadelphia, vol. 45, October
 1858
NPG.83.68

Irving, Washington, 1783-1859
Author
James David Smillie, 1833-1909, after
 Felix Octavius Carr Darley
Etching, 9 x 9 cm. (3½ x 3½ in.),
 1859
Published in Charles B. Richardson's
 *Irvingiana: A Memorial of
 Washington Irving*, New York,
 1859
NPG.83.69

Irving, Washington, 1783-1859
Author
Unidentified artist, after Daniel
 Maclise ("Alfred Croquis")
Lithograph, 17 x 9.1 cm. (6⁹⁄₁₆ x 3½
 in.), 1831
Published in *Fraser's Magazine for
 Town and Country*, November
 1831
NPG.81.46

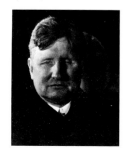

Irwin, Robert, 1883-1951
Humanitarian
Imogen Cunningham, 1883-1976
Photograph, gelatin silver print, 23.4
 x 18.9 cm. (9¼ x 7⁷⁄₁₆ in.), 1933
NPG.76.80

Isherwood, Christopher*, 1904-1986
Author
Don Bachardy, 1934-
Pencil and ink on paper, 61 x 47.9
 cm. (24 x 18⅞ in.), 1976
T/NPG.80.133.96
Gift of the Mildred Andrews Fund

Ito, Michio, 1893-1961
Dancer
Nickolas Muray, 1892-1965
Photograph, gelatin silver print, 24.4
 x 19.5 cm. (9⅝ x 7¹¹⁄₁₆ in.), 1978
 from 1921 negative
NPG.78.148

Ives, Burl*, 1909-
Folksinger
Thomas Hart Benton, 1889-1975
Lithograph, 40.5 x 31 cm. (15¹⁵⁄₁₆ x
 12³⁄₁₆ in.), 1950
T/NPG.85.141

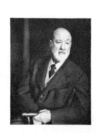

Ives, Charles Edward, 1874-1954
Composer
Clara E. Sipprell, 1885-1975
Photograph, gelatin silver print, 24.1
 x 19 cm. (9½ x 7½ in.), c. 1947
NPG.82.185
Bequest of Phyllis Fenner

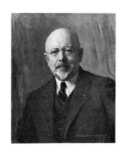

Ives, Herbert E., 1882-1953
Physicist
Chester Warner Slack, ?-?
Oil on canvas, 61 x 50.8 cm. (24 x 20
 in.), 1933
NPG.85.215
*Gift of Kenneth I. Ives and Barbara
 Ives Beyer, the sitter's children*

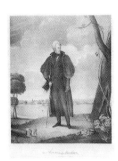

Jackson, Andrew, 1767-1845
Seventh President of the United
 States
John Henry Bufford, 1810-1870, after
 Ralph Eleaser Whiteside Earl
Pendleton lithography company
Lithograph, 53.3 x 43.2 cm. (21 x 17
 in.), 1831
NPG.80.143
Gift of Mrs. Katie Louchheim

Jackson, Andrew, 1767-1845
Seventh President of the United
 States
Edward Williams Clay, 1799-1857
Pencil on paper, 20.4 x 8.2 cm. (8 x
 3¼ in.), 1831
NPG.79.57
Gift of J. William Middendorf II

Jackson, Andrew, 1767-1845
Seventh President of the United
 States
Edward Williams Clay, 1799-1857
Lithograph, 21.4 x 14.8 cm. (8⁷/₁₆ x
 5¹³/₁₆ in.), 1829
NPG.85.66

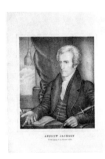

Jackson, Andrew, 1767-1845
Seventh President of the United
 States
Nathaniel Currier, 1813-1888, after
 James Barton Longacre
Lithograph, 30.6 x 25.7 cm. (12¹/₁₆ x
 10⅛ in.), 1840
Published in *The Eight Presidents of
 the United States of America*,
 Hartford, 1840
NPG.84.221.g

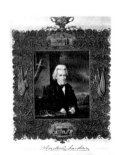

Jackson, Andrew, 1767-1845
Seventh President of the United
 States
Moseley Danforth, 1800-1862, after
 John Wood Dodge
Engraving, 26.4 x 20.6 cm. (10⅜ x
 8⅛ in.), 1843
NPG.79.182

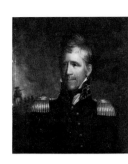

Jackson, Andrew, 1767-1845
Seventh President of the United
 States
Ralph Eleaser Whiteside Earl,
 1788?-1838
Oil on canvas, 76.2 x 64.8 cm. (30 x
 25½ in.), c. 1815
NPG.65.78
*Transfer from the National Gallery
 of Art; gift of Andrew W. Mellon,
 1942*

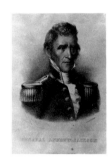

Jackson, Andrew, 1767-1845
Seventh President of the United
 States
Augustus Fay, active c. 1848-1860,
 after unidentified artist
Lithograph, 21.9 x 18 cm. (8⅝ x 7
 in.), 1850
NPG.79.177

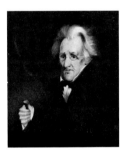

Jackson, Andrew, 1767-1845
Seventh President of the United
 States
Trevor Thomas Fowler, active
 1829-1869
Oil on canvas, 76.8 x 63.4 cm. (30¼ x
 25 in.), c. 1840
NPG.72.19

Jackson, Andrew, 1767-1845
Seventh President of the United
 States
E. B. and E. C. Kellogg lithography
 company, active c. 1842-1867, after
 William Henry Brown
Lithographed silhouette, 34.3 x 25.4
 cm. (13½ x 10 in.), 1844
Published in William H. Brown's
 *Portrait Gallery of Distinguished
 American Citizens*, Hartford, 1845
NPG.80.276.e
Gift of Wilmarth Sheldon Lewis

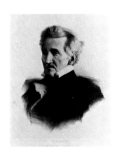

Jackson, Andrew, 1767-1845
Seventh President of the United
 States
(Jean-Baptiste) Adolphe Lafosse,
 c. 1810-1879, after daguerreotype
 by Mathew Brady
Lithograph with tintstone, 54.5 x
 43.5 cm. (21⁷/₁₆ x 17⅛ in.), 1856
NPG.77.113

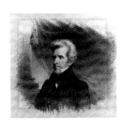

Jackson, Andrew, 1767-1845
Seventh President of the United
 States
James Barton Longacre, 1794-1869
Sepia watercolor on paper, 21.6 x 18.9
 cm. (8½ x 7⁷⁄₁₆ in.), 1828
NPG.69.5
Gift of the Swedish Colonial Society
 through Mrs. William Hacker

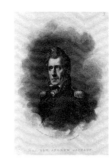

Jackson, Andrew, 1767-1845
Seventh President of the United
 States
Peter Maverick, 1780-1831, after
 Samuel Lovett Waldo
Engraving, 20.9 x 16.3 cm. (8¼ x 6⁷⁄₁₆
 in.), 1819
NPG.79.34

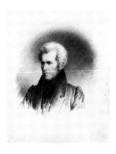

Jackson, Andrew, 1767-1845
Seventh President of the United
 States
James Barton Longacre, 1794-1869
Sepia watercolor on artist board, 25.5
 x 20.1 cm. (10¹⁄₁₆ x 7¹⁵⁄₁₆ in.), not
 dated
NPG.76.61

Jackson, Andrew, 1767-1845
Seventh President of the United
 States
Clark Mills, 1815-1883
Pot metal, 66 cm. (26 in.), 1855-1860
NPG.85.8
Gift of anonymous donor

Jackson, Andrew, 1767-1845
Seventh President of the United
 States
James Barton Longacre, 1794-1869,
 after Joseph Wood
Stipple engraving, 15.4 x 12.2 cm. (6
 x 4¹³⁄₁₆ in.), 1824
Published in *Casket*, January 1828
NPG.79.235

Jackson, Andrew, 1767-1845
Seventh President of the United
 States
Albert Newsam, 1809-1864, after
 William James Hubard
Cephas G. Childs lithography
 company
Lithograph, 49.8 x 35.5 cm. (19⅝ x
 14 in.), 1830
NPG.76.25

Jackson, Andrew, 1767-1845
Seventh President of the United
 States
James Barton Longacre, 1794-1869,
 after Thomas Sully
Stipple engraving, proof before
 letters, 37.4 x 30 cm. (14¼ x 11¹³⁄₁₆
 in.), c. 1820
NPG.79.239

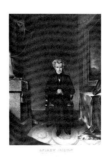

Jackson, Andrew, 1767-1845
Seventh President of the United
 States
Albert Newsam, 1809-1864, after
 William James Hubard
Childs and Lehman lithography
 company
Lithograph, 48.6 x 35 cm. (19⅛ x
 13⁹⁄₁₆ in.), 1834
NPG.79.203

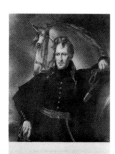

Jackson, Andrew, 1767-1845
Seventh President of the United
 States
James Barton Longacre, 1794-1869,
 after Thomas Sully
Hand-colored stipple engraving, 37.2
 x 30 cm. (14¹¹⁄₁₆ x 11¹³⁄₁₆ in.), 1820
NPG.79.240

Jackson, Andrew, 1767-1845
Seventh President of the United
 States
Charles Risso and William R.
 Browne lithography company,
 active 1832-1838
Lithograph, 31.8 x 26.6 cm. (12½ x
 10½ in.), c. 1833
NPG.79.135

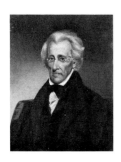

Jackson, Andrew, 1767-1845
Seventh President of the United
 States
James Tooley, Jr., 1816-1844
Watercolor on ivory, 11 x 8.5 cm.
 (4¼ x 3⅜ in.), 1840
NPG.66.43
*Gift of Mr. William H. Lively, Mrs.
 Mary Lively Hoffman, and Dr.
 Charles J. Lively*

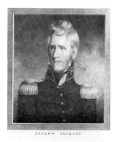

Jackson, Andrew, 1767-1845
Seventh President of the United
 States
Charles Cutler Torrey, 1799-1827,
 after Ralph Eleaser Whiteside Earl
Engraving, 41.6 x 36.2 cm. (16⅜ x
 14¼ in.), 1826
NPG.85.168

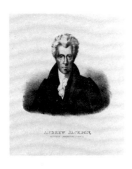

Jackson, Andrew, 1767-1845
Seventh President of the United
 States
Unidentified artist, after William
 James Hubard
Lithograph, 18 x 20.5 cm. (7¹/₁₆ x 8¹/₁₆
 in.), c. 1830
NPG.79.136

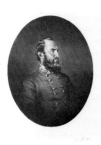

Jackson, Mahalia, 1901-1972
Singer
Carl Van Vechten, 1880-1964
Photogravure, 22.4 x 15 cm. (8⅞ x
 5¹⁵/₁₆ in.), 1983 from 1962 negative
NPG.83.188.25

**Jackson, Thomas Jonathan
 ("Stonewall"),** 1824-1863
Confederate general
A. G. Campbell, active 1860s, after
 ambrotype by Daniel T. Cowell
Mezzotint, 29.8 x 23.5 cm. (11¾ x 9¼
 in.), c. 1863
NPG.84.344

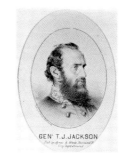

**Jackson, Thomas Jonathan
 ("Stonewall"),** 1824-1863
Confederate general
Ernest Crehen, active c. 1860-c. 1874,
 after ambrotype by Daniel T.
 Cowell
Lithograph with tintstone, 11.6 x 8.9
 cm. (4½ x 3½ in.), 1863
Frontispiece to John E. Cooke's *The
 Life of Stonewall Jackson,*
 Richmond, 1863
NPG.80.124

**Jackson, Thomas Jonathan
 ("Stonewall"),** 1824-1863
Confederate general
Endicott and Company lithography
 company, active 1852-1886, after
 ambrotype by Daniel T. Cowell
Lithograph, 22.5 x 20.8 cm. (8⅞ x
 8³/₁₆ in.), 1865
Music sheet title page: "Gen.
 Stonewall Jackson"
NPG.84.345

**Jackson, Thomas Jonathan
 ("Stonewall"),** 1824-1863
Confederate general
Henry C. Eno, active 1863-1869, after
 ambrotype by Daniel T. Cowell
Hand-colored lithograph with
 tintstone, 27.4 x 21.8 cm. (10¹³/₁₆ x
 8⁹/₁₆ in.), 1864
Music sheet title page: "Stonewall
 Jackson's Prayer"
NPG.82.46

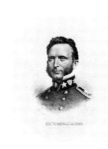

**Jackson, Thomas Jonathan
 ("Stonewall"),** 1824-1863
Confederate general
Dominique C. Fabronius, active
 1850-1888, after unidentified artist
Louis Prang lithography company
Lithograph with tintstone, 22.8 x
 17.3 cm. (9 x 6¹³/₁₆ in.), c. 1863
NPG.76.45

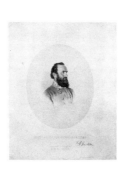

**Jackson, Thomas Jonathan
 ("Stonewall"),** 1824-1863
Confederate general
Goupil lithography company, active
 in America 1840s-1860s, after
 ambrotype by Daniel T. Cowell
Lithograph, 12.1 x 9.5 cm. (4¾ x 3¾
 in.), 1863
NPG.84.346

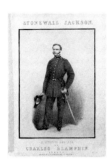

Jackson, Thomas Jonathan
("Stonewall"), 1824-1863
Confederate general
M. and N. Hanhart lithography
company, active c. 1855-c. 1863,
after photograph
Lithograph with tintstone, 26 x 18.6
cm. (10¼ x 7⁵⁄₁₆ in.), c. 1863
Music sheet title page: "Recitative
and Air"
NPG.84.347

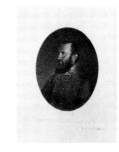

Jackson, Thomas Jonathan
("Stonewall"), 1824-1863
Confederate general
John A. O'Neill, active c. 1857-
c. 1890, after ambrotype by Daniel
T. Cowell
Engraving, 35.2 x 27.1 cm. (13¹³⁄₁₆ x
10¹¹⁄₁₆ in.), 1863
NPG.84.349

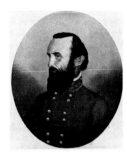

Jackson, Thomas Jonathan
("Stonewall"), 1824-1863
Confederate general
Anton Hohenstein, c. 1823-?, after
photograph by Minnis and Cowell
Hand-colored lithograph, 42.8 x 35.7
cm. (16⅞ x 14¹⁄₁₆ in.), c. 1863
NPG.76.46

Jackson, Thomas Jonathan
("Stonewall"), 1824-1863
Confederate general
T. Stevens, ?-?, after daguerreotype
Woven ribbon, 22.4 x 5.5 cm. (8¹³⁄₁₆ x
2³⁄₁₆ in.), 1863
NPG.84.353

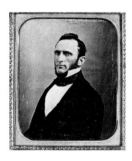

Jackson, Thomas Jonathan
("Stonewall"), 1824-1863
Confederate general
Attributed to H. B. Hull, ?-?
Daguerreotype, 8.4 x 7.2 cm. (3⁵⁄₁₆ x
2¹³⁄₁₆ in.), 1855
NPG.77.57

Jackson, Thomas Jonathan
("Stonewall"), 1824-1863
Confederate general
Adalbert John Volck ("V. Blada"),
1828-1912, after death mask by
Frederick Volck
Etching, 11 x 4.9 cm. (4⁵⁄₁₆ x 1¹⁵⁄₁₆
in.), c. 1863
NPG.78.20

Jackson, Thomas Jonathan
("Stonewall"), 1824-1863
Confederate general
A. Hurdle, active 1863, after
photograph by Daniel T. Cowell
Wood engraving, 38.3 x 26.5 cm.
(15¹⁄₁₆ x 10⁷⁄₁₆ in.), 1863
Published in *Southern Illustrated
News*, Richmond, August 29, 1863
NPG.84.351

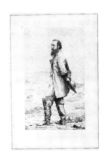

Jackson, Thomas Jonathan
("Stonewall"), 1824-1863
Confederate general
Adalbert John Volck ("V. Blada"),
1828-1912
Etching, 8.9 x 5.4 cm. (3¼ x 2⅛ in.),
1898 printing from 1862 plate
NPG.84.330

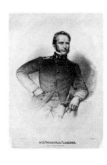

Jackson, Thomas Jonathan
("Stonewall"), 1824-1863
Confederate general
E. B. and E. C. Kellogg lithography
company, active c. 1842-1867
Lithograph with tintstone, 31.2 x
23.8 cm. (12¼ x 9⅜ in.), c. 1861
NPG.84.348

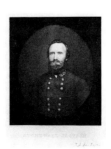

Jackson, Thomas Jonathan
("Stonewall"), 1824-1863
Confederate general
Adam B. Walter, 1820-1875, after
photograph by N. Routzahn
Mezzotint, 26.5 x 22.9 cm. (10⁷⁄₁₆ x 9
in.), c. 1862
NPG.84.352

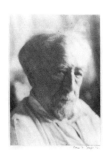

Jacobi, Abraham, 1830-1919
Physician
Doris Ulmann, 1882-1934
Photograph, platinum print, 16.7 x
 11.8 cm. (6⅝ x 4¹¹⁄₁₆ in.), 1916
NPG.85.26

James, William, 1842-1910
Philosopher
Alice Boughton, 1865/66-1943
Photograph, gum print, 20.8 x 15.9
 cm. (8³⁄₁₆ x 6¼ in.), c. 1905
NPG.77.132

James, Henry, 1843-1916
Author
Jacques-Émile Blanche, 1861-1942
Oil on canvas, 99.6 x 81.3 cm. (39¼ x
 32 in.), 1908
NPG.68.13
*Bequest of Mrs. Katherine Dexter
 McCormick*

Jarvis, John Wesley, 1780-1840
Artist
Attributed self-portrait
Oil on canvas, 83.8 x 67.2 cm. (33 x
 26½ in.), c. 1805
NPG.71.7
Gift of Mrs. Gerard B. Lambert

James, Henry, 1843-1916
Author
Alice Boughton, 1865/66-1943
Photograph, gelatin silver print, 20.2
 x 13.2 cm. (7¹⁵⁄₁₆ x 5³⁄₁₆ in.), c. 1906
NPG.72.118
Gift of Allan M. Price

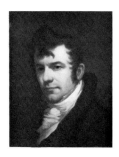

Jarvis, John Wesley, 1780-1840
Artist
Bass Otis, 1784-1861, after
 self-portrait
Oil on panel, 45.8 x 35 cm. (18¹⁄₁₆ x
 13¾ in.), c. 1816
NPG.85.72

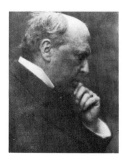

James, Henry, 1843-1916
Author
Alvin Langdon Coburn, 1882-1966
Photogravure, 19.6 x 16.3 cm. (7¾ x
 6⁷⁄₁₆ in.), 1906
NPG.77.309

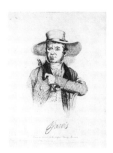

Jarvis, John Wesley, 1780-1840
Artist
Unidentified artist, after Henry
 Inman
Etching, 10.8 x 7.7 cm. (4½ x 3 in.),
 c. 1821
NPG.81.152

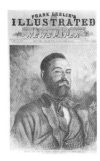

James, Jesse Woodson, 1847-1882
Criminal
Unidentified artist, after photograph
 by Alexander Lozo
Wood engraving, 27.9 x 23.7 cm.
 (10¹⁵⁄₁₆ x 9¼ in.), 1882
Published in *Frank Leslie's
 Illustrated Newspaper*, New York,
 April 22, 1882
NPG.80.196

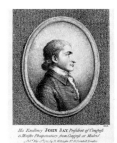

Jay, John, 1745-1829
Statesman
B. B. Ellis, ?-?, after Benoit Louis
 Prevost, after Pierre Eugène Du
 Simitière
Stipple engraving, 11.1 x 9.5 cm. (4⅜
 x 3¾ in.), 1783
Published in *Portraits of the
 Generals, Ministers, Magistrates*,
 London, 1783
NPG.75.69

Jay, John, 1745-1829
Statesman
Benoit Louis Prevost, 1735-1804, after
 Pierre Eugène Du Simitière
Engraving, 16.2 x 11.4 cm. (6⅜ x 4½
 in.), 1780
Published in *Collection des Portraits
 des Généraux, Ministres, et
 Magistrats . . .* , Paris, 1781
NPG.75.58

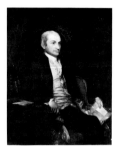

Jay, John, 1745-1829
Statesman
Believed to have been begun c. 1783
 by Gilbert Stuart, 1755-1828, and
 finished c. 1804-1808 by John
 Trumbull, 1756-1843
Oil on canvas, 128.2 x 101.6 cm.
 (50½ x 40 in.)
NPG.74.46

Jay, John, 1745-1829
Statesman
Cornelius Tiebout, c. 1773-1832,
 after Gilbert Stuart
Stipple engraving, 31.3 x 22.2 cm.
 (12⁵⁄₁₆ x 8¾ in.), 1795
NPG.78.238

Jay, John, 1745-1829
Statesman
Unidentified artist
Engraving and etching, 7.8 x 6.5 cm.
 (3¹⁄₁₆ x 2⁹⁄₁₆ in.), not dated
NPG.78.77

Jeffers, Robinson, 1887-1962
Poet
Jo Davidson, 1883-1952
Terra-cotta, 39.7 cm. (15⅝ in.),
 c. 1930
NPG.77.318
Gift of Dr. Maury Leibovitz

Jeffers, Robinson, 1887-1962
Poet
Franz Rederer, 1899-?
Ink over graphite on paper, 45 x
 61 cm. (17¾ x 24 in.), 1945
NPG.84.69
Gift of Elizabeth E. Roth

Jeffers, Robinson, 1887-1962
Poet
Clara E. Sipprell, 1885-1975
Photograph, gelatin silver print, 23.8
 x 18.6 cm. (9⅜ x 7⅜ in.), 1942
NPG.82.186
Bequest of Phyllis Fenner

Jeffers, Robinson, 1887-1962
Poet
Michael Alexander Werboff, 1896-?
Crayon and chalk on paper, 56.2 x
 45.7 cm. (22⅛ x 18 in.), 1939
NPG.71.19
Gift of Mrs. Lila Tyng

Jefferson, Joseph, 1829-1905
Actor
Samuel Arlent Edwards, 1861-1938
Color mezzotint with watercolor,
 11.8 x 9.9 cm. (4⅝ x 3⅞ in.),
 c. 1902
NPG.83.245
Gift of S. Arlent Edwards, Jr.

Jefferson, Joseph, 1829-1905
Actor
Samuel Arlent Edwards, 1861-1938
Color mezzotint with watercolor on
 Japan tissue, 12.4 x 9 cm. (4⅞ x 3½
 in.), c. 1902
NPG.83.246
Gift of S. Arlent Edwards, Jr.

Jefferson, Joseph, 1829-1905
Actor
Leonce Rabillon, 1814-1886
Bronze, 38.1 x 33 cm. (15 x 13 in.),
 1884
NPG.83.6

Jefferson, Thomas, 1743-1826
Third President of the United States
François Jacques Dequevauvillier,
 1783-1848, after Baron Auguste-
 Gaspard-Louis Desnoyers
Engraving, 21.7 x 16.1 cm. (8⁹⁄₁₆ x 6⅜
 in.), c. 1824
NPG.79.184

Jefferson, Joseph, 1829-1905
Actor
Napoleon Sarony, 1821-1896
Photograph, albumen silver print,
 13.7 x 9.9 cm. (5⅜ x 3¹⁵⁄₁₆ in.),
 c. 1871
NPG.80.70

Jefferson, Thomas, 1743-1826
Third President of the United States
David Edwin, 1776-1841, after
 Rembrandt Peale
Stipple engraving, 49.8 x 33.2 cm.
 (19⅝ x 13¹⁄₁₆ in.), c. 1801
NPG.80.45

**Jefferson, Joseph (as Rip Van
 Winkle),** 1829-1905
Actor
Napoleon Sarony, 1821-1896
Photograph, albumen silver print,
 13.7 x 9.9 cm. (5⅜ x 3⅞ in.), 1869
NPG.83.198

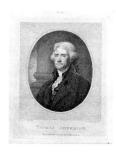

Jefferson, Thomas, 1743-1826
Third President of the United States
Robert Field, c. 1769-1819, after
 Gilbert Stuart
Engraving, 15 x 12.8 cm. (5¹⁵⁄₁₆ x 5
 in.), 1807
NPG.82.179

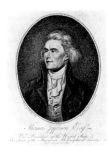

Jefferson, Thomas, 1743-1826
Third President of the United States
James Akin, c. 1773-1846, and
 William Harrison, Jr., active
 1797-1819, after Charles Willson
 Peale
Stipple and line engraving, 13.7 x
 10.8 cm. (5⅜ x 4¼ in.), 1800
NPG.77.162

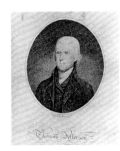

Jefferson, Thomas, 1743-1826
Third President of the United States
William Harrison, Jr., active
 1797-1819, after Rembrandt Peale
Stipple engraving, 11.4 x 9.6 cm. (4½
 x 3⁹⁄₁₆ in.), 1801
Published in Thomas Jefferson's
 Notes on the State of Virginia,
 Philadelphia, 1801
NPG.79.16

Jefferson, Thomas, 1743-1826
Third President of the United States
Pietro Cardelli, ?-1822
Plaster, 57.4 cm. (22⅝ in.), cast after
 1819 original
NPG.72.108

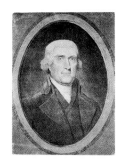

Jefferson, Thomas, 1743-1826
Third President of the United States
Attributed to John Norman,
 c. 1748-1817, after Rembrandt
 Peale
Stipple engraving and etching, 29.5
 x 21.7 cm. (11⅝ x 8⁹⁄₁₆ in.),
 c. 1805-1810
NPG.80.32

Jefferson, Thomas, 1743-1826
Third President of the United States
Attributed to John Norman,
 c. 1748-1817, after Rembrandt
 Peale
Engraving, 38.6 x 44.1 cm. (15³⁄₁₆ x
 7⅜ in.), 1807
NPG.84.116

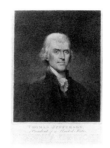

Jefferson, Thomas, 1743-1826
Third President of the United States
Cornelius Tiebout, c. 1773-1832,
 after Rembrandt Peale
Engraving, 28 x 22.2 cm. (11 x 8¾
 in.), 1801
NPG.71.14

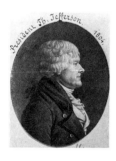

Jefferson, Thomas, 1743-1826
Third President of the United States
Charles Balthazar Julien Févret de
 Saint-Mémin, 1770-1852
Engraving, 7.3 x 5.9 cm. (2⅞ x 2⁵⁄₁₆
 in.) oval, 1804
NPG.74.39.10
Gift of Mr. and Mrs. Paul Mellon

Jefferson, Thomas, 1743-1826
Third President of the United States
Cornelius Tiebout, c. 1773-1832,
 after David Edwin, after
 Rembrandt Peale
Stipple engraving, 14.9 x 12 cm. (5⅞
 x 4¹¹⁄₁₆ in.), c. 1800
NPG.81.60

Jefferson, Thomas, 1743-1826
Third President of the United States
Charles Balthazar Julien Févret de
 Saint-Mémin, 1770-1852
Engraving, 5.6 cm. (2¼ in.) diameter,
 1805
NPG.74.39.441
Gift of Mr. and Mrs. Paul Mellon

Jefferson, Thomas, 1743-1826
Third President of the United States
Unidentified artist, probably after
 John Trumbull
Stipple and line engraving, 8.6 x 7
 cm. (3⅜ x 2¾ in.), 1796
Published in Charles Smith's *The
 Gentleman's Political Pocket
 Almanack for 1797,* New York,
 1796
NPG.77.210

Jefferson, Thomas, 1743-1826
Third President of the United States
Michel Sokolnicki, 1760-1816, after
 Thaddeus Kościuszko
Hand-colored aquatint, 24.7 x 20.6
 cm. (9¾ x 8⅛ in.), 1798-1799
NPG.67.9

Jeffries, John, 1744/45-1819
Scientist, physician
David Claypoole Johnston, 1799-
 1865, after Ethan Allen Greenwood
Pendleton lithography company
Lithograph, 9.5 x 8.5 cm. (3¾ x 3⅜
 in.), 1828
Published in James Thacher's
 American Medical Biography,
 Boston, 1828
NPG.78.137

Jefferson, Thomas, 1743-1826
Third President of the United States
Gilbert Stuart, 1755-1828
Oil on panel, 66.3 x 53.3 cm. (26⅛ x
 21 in.), 1805
NPG.82.97
*Gift of the Regents of the
 Smithsonian Institution, the
 Thomas Jefferson Memorial
 Foundation, and the Enid and
 Crosby Kemper Foundation*
Owned jointly with Monticello

Jenifer, Daniel of St. Thomas,
 1723-1790
Revolutionary statesman
John Hesselius, 1728-1778
Oil on canvas, 125.7 x 100.3 cm.
 (49½ x 39½ in.), c. 1760-1770
NPG.70.43

Johnson, Andrew, 1808-1875
Seventeenth President of the United
States
Bennett, Donaldson, and Elmes
lithography company, active
c. 1866
Hand-colored lithograph, 32.3 x 20.4
cm. (12¹¹/₁₆ x 8¹/₁₆ in.), c. 1866
Music sheet title page: "The Veto
Galop!"
NPG.82.45

Johnson, Andrew, 1808-1875
Seventeenth President of the United
States
Peter Kraemer, 1823-1907, after
photograph
Lithograph with tintstone, 43.2 x
33.3 cm. (17 x 13¹/₁₆ in.), c. 1865
NPG.84.204

Johnson, Andrew, 1808-1875
Seventeenth President of the United
States
J. H. Bufford lithography company,
active 1835-1890
Lithograph, 28.9 x 21.7 cm. (11⅜ x
8⁹/₁₆ in.), c. 1864
NPG.69.70

Johnson, Andrew, 1808-1875
Seventeenth President of the United
States
Thomas Nast, 1840-1902
Pastel cartoon, 131 x 103 cm. (51½ x
40½ in.) irregular, not dated
NPG.69.21

Johnson, Andrew, 1808-1875
Seventeenth President of the United
States
John Chester Buttre, 1821-1893, after
photograph by Samuel Finley
Breese Morse
Engraving, 24.9 x 20 cm. (9¹³/₁₆ x 7¹⁵/₁₆
in.), 1865
NPG.78.297

Johnson, Andrew, 1808-1875
Seventeenth President of the United
States
Louis Nelke, active c. 1865-1879,
after T. Poleni
Lithograph, 21 x 18.8 cm. (8¼ x 7⅜
in.), 1865
Music sheet title page: "President
Johnson's Grand Union March"
NPG.84.82

Johnson, Andrew, 1808-1875
Seventeenth President of the United
States
John Chester Buttre, 1821-1893, and
William Momberger, 1829-?, after
photograph by Morse
Engraving, 33.2 x 25.4 cm. (13¹/₁₆ x
10 in.), 1866
NPG.85.167

Johnson, Andrew, 1808-1875
Seventeenth President of the United
States
Anthony C. Pacquet, 1814-1882
Bronze medal, 7.6 cm. (3 in.)
diameter, 1865
NPG.76.107

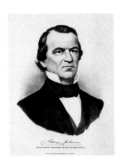

Johnson, Andrew, 1808-1875
Seventeenth President of the United
States
Currier and Ives lithography
company, active 1857-1907, after
photograph
Hand-colored lithograph, 29.1 x 23.6
cm. (11⁷/₁₆ x 9⁵/₁₆ in.), c. 1865
NPG.82.49

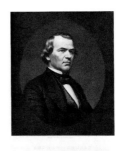

Johnson, Andrew, 1808-1875
Seventeenth President of the United
States
John Sartain, 1808-1897, after
photograph
Mezzotint, 26.7 x 22.5 cm. (10½ x 8⅞
in.), 1865
NPG.85.166

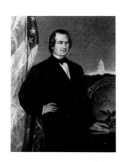

Johnson, Andrew, 1808-1875
Seventeenth President of the United
 States
Arthur Stumpf, 1906- , after the
 1866 oil by Frank Buchser
Oil on canvas, 116.8 x 88.9 cm. (46 x
 35 in.), 1970
NPG.70.77

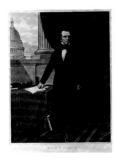

Johnson, Andrew, 1808-1875
Seventeenth President of the United
 States
Edward Valois, active 1840s-1860s,
 after photograph
Hand-colored lithograph, 59 x 45.7
 cm. (23³⁄₁₆ x 18 in.), 1865
NPG.79.132

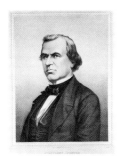

Johnson, Andrew, 1808-1875
Seventeenth President of the United
 States
Zorn lithography company, ?-?, after
 photograph by Mathew Brady
Lithograph with tintstone, 33.8 x
 25.9 cm. (13¼ x 10³⁄₁₆ in.),
 c. 1865-1869
NPG.80.145

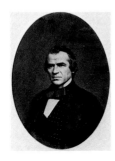

Johnson, Andrew, 1808-1875
Seventeenth President of the United
 States
Unidentified photographer
Photograph, salt print, 20.8 x 15.7
 cm. (8³⁄₁₆ x 6³⁄₁₆ in.), c. 1857
NPG.77.58

Johnson, Charles Spurgeon,
 1893-1956
Sociologist
Winold Reiss, 1886-1953
Pastel on artist board, 76.3 x 54.7 cm.
 (30¹⁄₁₆ x 21⁹⁄₁₆ in.), c. 1925
NPG.72.83
*Gift of Lawrence A. Fleischman and
 Howard Garfinkle with a
 matching grant from the National
 Endowment for the Arts*

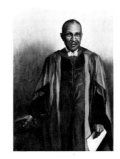

Johnson, Charles Spurgeon,
 1893-1956
Sociologist
Betsy Graves Reyneau, 1888-1964
Oil on canvas, 127 x 87.6 cm. (50 x
 34½ in.), 1955
NPG.67.39
Gift of the Harmon Foundation

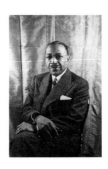

Johnson, Charles Spurgeon,
 1893-1956
Sociologist
Carl Van Vechten, 1880-1964
Photogravure, 22.4 x 14.9 cm. (8¹³⁄₁₆
 x 5⅞ in.), 1983 from 1948 negative
NPG.83.188.26

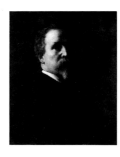

Johnson, Eastman, 1824-1906
Artist
Self-portrait
Oil on artist board, 66 x 55.8 cm.
 (26 x 22 in.), 1887
NPG.71.20
*Transfer from the National Museum
 of American History; gift of Mrs.
 Francis P. Garvan, 1961*

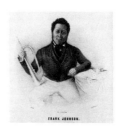

Johnson, Frank, 1792-1844
Music composer and performer
Alfred M. Hoffy, active 1835-1864,
 after daguerreotype by Robert M.
 Douglass, Jr.
Lithograph, 24.2 x 26.5 cm. (9⁹⁄₁₆ x
 10⅞ in.), c. 1842
NPG.84.206

Johnson, Hall, 1888-1970
Musician
Sidney Cowell, ?-?
Photograph, gelatin silver print, 22.3
 x 16.3 cm. (8¹³⁄₁₆ x 6⁷⁄₁₆ in.), 1960
NPG.84.128

Johnson, James Weldon, 1871-1938
Poet, civil rights leader
Winold Reiss, 1886-1953
Pastel on artist board, 76.3 x 54.7 cm.
 (30¹⁄₁₆ x 21⁹⁄₁₆ in.), c. 1925
NPG.72.78
*Gift of Lawrence A. Fleischman and
 Howard Garfinkle with a
 matching grant from the National
 Endowment for the Arts*

Johnson, James Weldon, 1871-1938
Poet, civil rights leader
Doris Ulmann, 1882-1934
Photograph, gelatin silver print, 20.6
 x 16 cm. (8⅛ x 6¼ in.), c. 1925
NPG.79.114

Johnson, James Weldon, 1871-1938
Poet, civil rights leader
Carl Van Vechten, 1880-1964
Photogravure, 22.2 x 14.9 cm. (8¾ x
 5⅞ in.), 1983 from 1932 negative
NPG.83.188.28

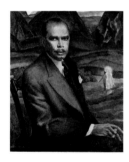

Johnson, James Weldon, 1871-1938
Poet, civil rights leader
Laura Wheeler Waring, 1887-1948
Oil on canvas, 91.4 x 76.2 cm. (36 x
 30 in.), 1943
NPG.67.40
Gift of the Harmon Foundation

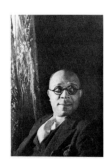

Johnson, J. Rosamond, 1873-1954
Composer
Carl Van Vechten, 1880-1964
Photogravure, 22.3 x 14.9 cm. (8¾ x
 5⅞ in.), 1983 from 1933 negative
NPG.83.188.27

Johnson, Lyndon Baines, 1908-1973
Thirty-sixth President of the United
 States
Philippe Halsman, 1906-1979
Photograph, gelatin silver print, 34.3
 x 27.2 cm. (13½ x 10¾ in.), 1965
NPG.82.172
Gift of George R. Rinhart

Johnson, Lyndon Baines, 1908-1973
Thirty-sixth President of the United
 States
Peter Hurd, 1904-1984
Tempera on panel, 122 x 96.5 cm.
 (48 x 38 in.), 1967
NPG.68.14
Gift of the artist

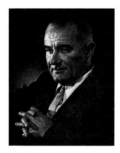

Johnson, Lyndon Baines, 1908-1973
Thirty-sixth President of the United
 States
David Lee Iwerks, 1933-
Photograph, gelatin silver print, 24.1
 x 19.1 cm. (9½ x 7½ in.), 1960
NPG.77.343

Johnson, Lyndon Baines, 1908-1973
Thirty-sixth President of the United
 States
David Levine, 1926-
Ink on paper, 17.8 x 14.5 cm. (7 x 5¾
 in.), 1964
NPG.79.176
Gift of Peter G. Powers

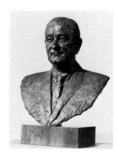

Johnson, Lyndon Baines, 1908-1973
Thirty-sixth President of the United
 States
Jimilu Mason, ?-
Bronze, 49.8 cm. (19⅝ in.), 1959 and
 1963
NPG.72.72
*Gift of the Brown Foundation, Inc.,
 Houston, Texas*

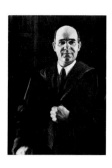

Johnson, Mordecai Wyatt, 1890-1976
Educator
Betsy Graves Reyneau, 1888-1964
Oil on canvas, 101.6 x 76.2 cm. (40 x
30 in.), 1943
NPG.67.84
Gift of the Harmon Foundation

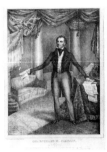

Johnson, Richard Mentor, 1780-1850
Vice-President of the United States
A. A. Hoffay, active 1830s
John Dorival, lithographer
Lithograph, 48.5 x 37.1 cm. (19⅛ x
14⅝ in.), 1833
NPG.85.63

Johnson, Richard Mentor, 1780-1850
Vice-President of the United States
Attributed to Matthew Harris Jouett,
1787/88-1827
Oil on canvas, 55.8 x 61 cm. (22 x 24
in.), c. 1818
NPG.83.11
Gift of Mrs. Henry Lyne, Jr.

Johnson, Richard Mentor, 1780-1850
Vice-President of the United States
Unidentified artist, after
daguerreotype by John Plumbe, Jr.
Hand-colored lithograph, 25.6 x 19.4
cm. (10¹⁄₁₆ x 7⅝ in.), 1846
Contained in *The National
Plumbeotype Gallery,*
Philadelphia, 1847
NPG.78.84.i

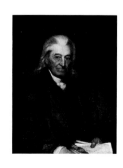

Johnson, William Samuel, 1727-1819
Statesman
John Wesley Jarvis, 1780-1840
Oil on canvas, 87 x 69.2 cm. (34¼ x
27¼ in.), c. 1814
NPG.72.20

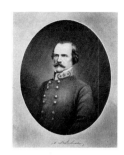

Johnston, Albert Sidney, 1803-1862
Confederate general
George Edward Perine, 1837-1885,
after photograph
Mezzotint, 36 x 29.3 cm. (14⅛ x 11½
in.), 1867
NPG.84.333

Johnston, David Claypoole,
1799-1865
Artist
Self-portrait
Watercolor on paper, 14 x 9.2 cm.
(5½ x 3⅝ in.), c. 1830
NPG.73.4

Johnston, Frances Benjamin,
1864-1952
Photographer
Attributed to Gertrude Käsebier,
1852-1934
Photograph, platinum print, 22.2 x
15.7 cm. (8¾ x 6³⁄₁₆ in.), c. 1906
NPG.83.199

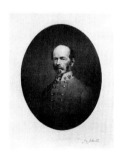

Johnston, Joseph Eggleston,
1807-1891
Confederate general
A. G. Campbell, active 1860s, after
photograph
Mezzotint, 29.7 x 23.2 cm. (11¹¹⁄₁₆ x
9⅛ in.), c. 1865
NPG.84.334

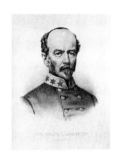

Johnston, Joseph Eggleston,
1807-1891
Confederate general
Currier and Ives lithography
company, active 1857-1907, after
photograph
Hand-colored lithograph, 26.2 x 22.6
cm. (10⁵⁄₁₆ x 8⅞ in.), c. 1865
NPG.84.335

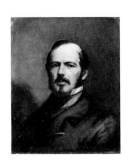

Johnston, Joseph Eggleston,
1807-1891
Confederate general
Benjamin Franklin Reinhar(d)t,
1829-1885
Oil on artist board, 29.8 x 24.7 cm.
(11¾ x 9¾ in.), not dated
NPG.72.21

Jones, John Paul, 1747-1792
Revolutionary naval officer
Carl Guttenberg, 1743-1790, after
Claude Jacques Notté
Engraving, 27.4 x 23.6 cm. (10¾ x
9¼ in.), c. 1781
NPG.79.201

Jolson, Al, 1886-1950
Entertainer
Samuel Johnson Woolf, 1880-1948
Charcoal on paper, 60 x 48.2 cm.
(24¾ x 19 in.), 1942
NPG.80.263

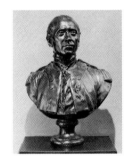

Jones, John Paul, 1747-1792
Revolutionary naval officer
Johann-Elias Haid, 1739-1809, after
unidentified artist
Mezzotint, 30.5 x 24.4 cm. (12 x 9⅝
in.), c. 1779
NPG.67.54

Jones, Absalom, 1746-1818
Clergyman
Unidentified artist
Liverpool ware jug, 21.5 cm. (8½ in.),
1808?
NPG.71.61
Gift of Sidney Kaplan

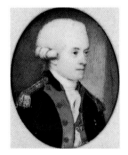

Jones, John Paul, 1747-1792
Revolutionary naval officer
Jean-Antoine Houdon, 1741-1828
Bronze, 69.2 cm. (27¼ in.), cast after
1780 plaster
NPG.71.8

Jones, Jacob, 1768-1850
Early national naval officer
George Delleker, active c. 1805-1824,
after Rembrandt Peale
Engraving and etching, 14.8 x 12.6
cm. (5¹³⁄₁₆ x 4¹⁵⁄₁₆ in.), c. 1813
NPG.79.14

Jones, John Paul, 1747-1792
Revolutionary naval officer
Constance de Lowendal, Comtesse de
Turpin de Crissé, active c. 1780
Watercolor on ivory, 6.3 x 5 cm. (2½
x 2 in.) oval, 1780
NPG.73.10

Jones, Jacob, 1768-1850
Early national naval officer
Unidentified artist, after Rembrandt
Peale
Stipple and line engraving, 8 cm.
(3¼ in.) diameter, c. 1817-1822
NPG.79.18

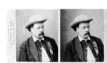

**Judson, Edward Zane Carroll ("Ned
Buntline"),** 1823-1886
Author, activist
Jeremiah Gurney and Son, active
c. 1860-c. 1875
Photograph, albumen silver print,
8.4 x 14.5 cm. (3⅝₁₆ x 5¹¹⁄₁₆ in.),
c. 1872
NPG.84.129

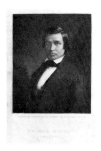

Kah-Ge-Ga-Gah-Bowh ("George Copway"), 1818-1863
Indian statesman
Thomas B. Welch, 1814-1874, after daguerreotype by McClees and German
Mezzotint, 10 x 8 cm. (3¹⁵⁄₁₆ x 3⅛ in.), 1850
Frontispiece to George Copway's *The Ojibway Conquest, a Tale of the Northwest*, New York, 1850
NPG.84.321
Gift of Marvin Sadik and Company

Kahn, Otto Herman, 1867-1934
Financier
Jo Davidson, 1883-1952
Bronze, 38.1 cm. (15 in.), 1924
NPG.68.44
Gift of Mrs. John Barry Ryan

Kahn, Otto Herman, 1867-1934
Financier
Aline Fruhauf, 1907-1978
India ink over pencil and red chalk heightened with white on pale blue paper, 33 x 20.4 cm. (13 x 8 in.), 1929
Published in *Top Notes*, East Stroudsburg, Pennsylvania, December 7, 1929
NPG.83.37
Gift of Erwin Vollmer

Kainen, Jacob*, 1909-
Artist
Aline Fruhauf, 1907-1978
Watercolor and pencil with crayon and opaque white on paper, 44.6 x 32.2 cm. (17⁹⁄₁₆ x 12¹¹⁄₁₆ in.), 1949
T/NPG.83.277
Gift of Erwin Vollmer

Kaiser, Henry John, 1882-1967
Industrialist
David Lee Iwerks, 1933-
Photograph, gelatin silver print, 24 x 19 cm. (9½ x 7½ in.), 1963
NPG.82.68

Kaiser, Henry John, 1882-1967
Industrialist
Samuel Johnson Woolf, 1880-1948
Charcoal and chalk on paper, 47.6 x 41.9 cm. (18¾ x 16½ in.), not dated
NPG.80.264

Kalakaua, David, 1836-1891
Hawaiian ruler
James J. Williams, c. 1853-1926
Photograph, albumen silver print, 14.5 x 10.2 cm. (5¾ x 4 in.), c. 1879
NPG.80.317
Gift of the Bernice Pauahi Bishop Museum

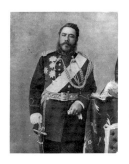

Kalakaua, David, 1836-1891
Hawaiian ruler
Unidentified photographer
Photograph, gelatin dry-plate positive transparency, 24.6 x 19.5 cm. (9¹¹⁄₁₆ x 7¹¹⁄₁₆ in.), from c. 1875 negative
NPG.79.144

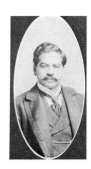

Kalanianaole, Jonah Kuhio, 1871-1922
Hawaiian statesman
James J. Williams, c. 1853-1926
Photograph, gelatin silver print, 13 x 6.4 cm. (5⅛ x 2⁹⁄₁₆ in.), c. 1902
NPG.80.318
Gift of the Bernice Pauahi Bishop Museum

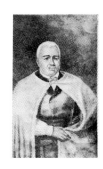

Kamehameha I, c. 1758-1819
Hawaiian ruler
Henry L. Chase, 1831-1901, after unidentified artist
Photograph, albumen silver print, 9 x 5.4 cm. (3⁹⁄₁₆ x 2⅛ in.), c. 1880
NPG.80.311
Gift of the Bernice Pauahi Bishop Museum

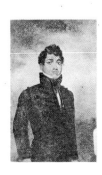

Kamehameha II (Liholiho),
 1797-1824
Hawaiian ruler
Henry L. Chase, 1831-1901, after
 unidentified artist
Photograph, albumen silver print,
 8.7 x 5.4 cm. (3⁷⁄₁₆ x 2⅛ in.), c. 1880
NPG.80.312
*Gift of the Bernice Pauahi Bishop
 Museum*

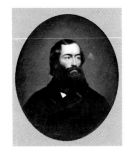

Kane, Elisha Kent, 1820-1857
Naval officer, physician, explorer
Giuseppe Fagnani, 1819-1873
Oil on canvas, 76.2 x 63.5 cm. (30 x
 25 in.), 1857
NPG.68.45

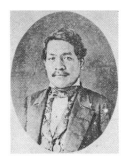

Kamehameha III (Kauikeaouli),
 1814-1854
Hawaiian ruler
Henry L. Chase, 1831-1901, after
 unidentified photographer
Photograph, albumen silver print,
 5.8 x 4.6 cm. (2⁵⁄₁₆ x 1¹³⁄₁₆ in.),
 c. 1870 after c. 1850 original
NPG.80.313
*Gift of the Bernice Pauahi Bishop
 Museum*

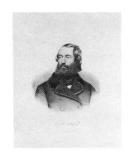

Kane, Elisha Kent, 1820-1857
Naval officer, physician, explorer
C. Kuhn, ?-?, after photograph by
 Mathew Brady
F. F. Oakley lithography company
Lithograph with tintstone, 37.5 x
 30.7 cm. (14¾ x 12⅛ in.), 1857
NPG.80.48

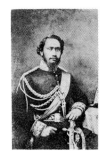

**Kamehameha IV (Alexander
 Liholiho),** 1834-1863
Hawaiian ruler
Henry L. Chase, 1831-1901
Photograph, albumen silver print,
 8.8 x 5.5 cm. (3⁷⁄₁₆ x 2⅛ in.), c. 1862
NPG.80.314
*Gift of the Bernice Pauahi Bishop
 Museum*

Kapiolani, 1834-1899
Hawaiian ruler
James J. Williams, c. 1853-1926
Photograph, albumen silver print,
 14.6 x 10.3 cm. (5¾ x 4⅛ in.), 1883
NPG.80.319
*Gift of the Bernice Pauahi Bishop
 Museum*

**Kamehameha IV (Alexander
 Liholiho),** 1834-1863
Hawaiian ruler
Unidentified photographer
Photograph, wet collodion negative
 on glass, 24.7 x 20.5 cm. (9¹¹⁄₁₆ x 8
 in.), c. 1860
NPG.79.143

Kaufman, George Simon, 1889-1961
Playwright
Soss Melik, 1914-
Charcoal on paper, 57.6 x 42.7 cm.
 (22¹¹⁄₁₆ x 16¹³⁄₁₆ in.), 1938
NPG.68.32

Kamehameha V (Lot Kamehameha),
 1830-1872
Hawaiian ruler
Menzies Dickson, c. 1840-1891
Photograph, albumen silver print,
 6.8 x 4.8 cm. (2¹¹⁄₁₆ x 1⅞ in.),
 c. 1870
NPG.80.315
*Gift of the Bernice Pauahi Bishop
 Museum*

Kaye, Danny*, 1913-1987
Entertainer
Alfred Bendiner, 1899-1964
Crayon on paper, 13.9 x 10.7 cm. (5½
 x 4¼ in.), 1956
T/NPG.85.195
Gift of Alfred Bendiner Foundation

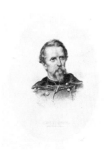

Kearny, Philip, 1814-1862
Union officer
Dominique C. Fabronius, active
 1850-1888, after photograph by
 Mathew Brady
Louis Prang lithography company
Lithograph with tintstone, 22.3 x
 16.7 cm. (8¹³⁄₁₆ x 6⁹⁄₁₆ in.),
 c. 1861-1863
NPG.82.38

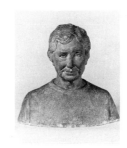

Keller, Helen Adams, 1880-1968
Author, humanitarian
Jo Davidson, 1883-1952
Terra-cotta, 43.8 cm. (17¼ in.), 1942
NPG.67.49

Keaton, Joseph Francis, Jr. ("Buster"),
 1895-1966
Actor
Alfred Bendiner, 1899-1964
Watercolor on paper, 20.9 x 26.8 cm.
 (8³⁄₁₆ x 10⁹⁄₁₆ in.), c. 1960
NPG.85.193
Gift of Alfred Bendiner Foundation

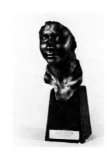

Keller, Helen Adams, 1880-1968
Author, humanitarian
Onorio Ruotolo, 1888-1966
Plaster life mask, 52.7 cm. (20¾ in.),
 1916
NPG.75.16

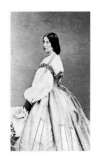

Keene, Laura, 1826-1873
Actress
Charles DeForest Fredricks,
 1823-1894
Photograph, albumen silver print,
 9.2 x 5.4 cm. (3⅝ x 2⅛ in.), c. 1863
NPG.80.220

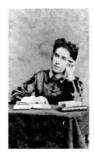

Kellogg, Clara Louise, 1842-1916
Singer
Charles DeForest Fredricks,
 1823-1894
Photograph, albumen silver print,
 9.1 x 5.4 cm. (3⅝ x 2⅛ in.), c. 1863
NPG.78.104

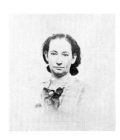

Keene, Laura, 1826-1873
Actress
Moore Brothers, ?-?
Photograph, albumen silver print,
 4.5 x 4.1 cm. (1¾ x 1⅝ in.), c. 1866
NPG.80.71

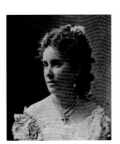

Kellogg, Clara Louise, 1842-1916
Singer
Jeremiah Gurney and Son, active
 c. 1860-c. 1875
Photograph, albumen silver print,
 8.3 x 4.5 cm. (3¼ x 2⅛ in.), c. 1863
NPG.78.105

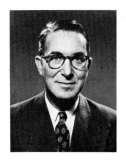

Kefauver, Carey Estes, 1903-1963
Statesman
Philippe Halsman, 1906-1979
Photograph, gelatin silver print, 35 x
 27 cm. (13¾ x 10⅝ in.), 1952
NPG.82.178
Gift of George R. Rinhart

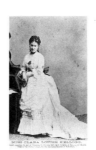

Kellogg, Clara Louise, 1842-1916
Singer
Jeremiah Gurney and Son, active
 c. 1860-c. 1875
Photograph, albumen silver print,
 14.7 x 9.6 cm. (5¹³⁄₁₆ x 3¹³⁄₁₆ in.),
 1867
NPG.83.127

Kellogg, Clara Louise, 1842-1916
Singer
Unidentified artist
Wood medallion, 7.3 cm. (2⅞ in.)
 diameter, c. 1870
NPG.78.55

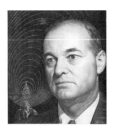

Kennan, George Frost*, 1904-
Diplomat, historian
Guy Rowe ("Giro"), 1894-1969
Tempera on cardboard, 22.6 x 19.7
 cm. (8⅝ x 7¾ in.), c. 1955
T/NPG.83.28
Gift of Charles Rowe

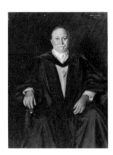

Kellogg, John Harvey, 1852-1943
Nutritionist
Emil Fuchs, 1866-1929
Oil on canvas, 121.9 x 91.4 cm. (48 x
 36 in.), 1927
NPG.66.32
*Transfer from the National Museum
 of American Art; gift of Dr.
 Edward Kellogg, 1963*

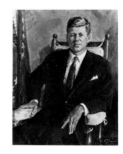

Kennedy, John Fitzgerald, 1917-1963
Thirty-fifth President of the United
 States
William Franklin Draper, 1912-
Oil on canvas, 101.6 x 81.3 cm. (40 x
 32 in.), 1966 from the 1962 life
 sketch
NPG.66.35

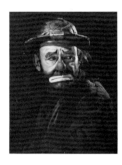

Kelly, Emmett Leo*, 1898-1979
Circus clown
David Lee Iwerks, 1933-
Photograph, gelatin silver print, 24.1
 x 19.1 cm. (9½ x 7½ in.), 1962
T/NPG.78.186.89

Kennedy, John Fitzgerald, 1917-1963
Thirty-fifth President of the United
 States
Robert Frank, 1924-
Photograph, gelatin silver print, 35 x
 23.7 cm. (13¹³⁄₁₆ x 9⁵⁄₁₆ in.), 1956
NPG.84.266

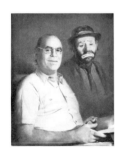

Kelly, Emmett Leo*, 1898-1979
Circus clown
Donald Lee Rust, 1932-
Oil on canvas, 76.2 x 61 cm. (30 x 24
 in.), 1981
T/NPG.81.118.89

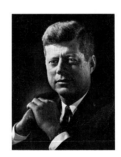

Kennedy, John Fitzgerald, 1917-1963
Thirty-fifth President of the United
 States
David Lee Iwerks, 1933-
Photograph, gelatin silver print, 24 x
 19.1 cm. (9⁷⁄₁₆ x 7½ in.), 1960
NPG.77.344

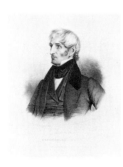

Kendall, Amos, 1789-1869
Journalist, political adviser
Charles Fenderich, 1805-1887
Lehman and Duval lithography
 company
Lithograph, 27.6 x 26 cm. (10⅞ x 10¼
 in.), 1837
NPG.66.86
*Transfer from the Library of
 Congress, Prints and Photographs
 Division*

Kennedy, John Fitzgerald, 1917-1963
Thirty-fifth President of the United
 States
Garry Winogrand, 1928-1984
Photograph, gelatin silver print, 46.9
 x 31.4 cm. (18⁷⁄₁₆ x 12⅜ in.), 1960
NPG.84.18

Kennedy, John Pendleton, 1795-1870
Author, statesman
Felix Octavius Carr Darley, 1822-
1888
Pencil on paper, 11 x 8.5 cm. (4⁵/₁₆ x
3⅜ in.), c. 1863
NPG.78.268
Gift of Mrs. Margaret Garber Blue

Kennedy, John Pendleton, 1795-1870
Author, statesman
Eastman Johnson, 1824-1906
Charcoal on paper, 48.2 x 41.9 cm.
(19 x 16½ in.) oval, not dated
NPG.67.48

Kennedy, John Pendleton, 1795-1870
Author, statesman
Joseph Kayler, ?-?
Pencil on paper, 21 x 18 cm. (8¼ x 7
in.), 1852
NPG.78.267
Gift of Mrs. Margaret Garber Blue

Kennedy, John Pendleton, 1795-1870
Author, statesman
William Shew, active 1841-1903
Daguerreotype, 8.1 x 6.5 cm. (3¼ x
2¾ in.), c. 1845
NPG.78.300
Gift of Mrs. Margaret Garber Blue

Kennedy, John Pendleton, 1795-1870
Author, statesman
Unidentified artist
Black paper on cardboard, 11.8 x 7.9
cm. (4⅝ x 3¹/₁₆ in.), c. 1820
NPG.78.266
Gift of Mrs. Margaret Garber Blue

Kennedy, Robert Francis, 1925-1968
Statesman
Gardner Cox, 1906-
Oil on canvas, 81.3 x 63.5 cm. (32 x
25 in.), 1968
NPG.69.54
Gift of the artist

Kennedy, Robert Francis, 1925-1968
Statesman
Gardner Cox, 1906-
Pencil on paper, 35.4 x 27.9 cm.
(13¹⁵/₁₆ x 11 in.), 1968
NPG.69.54.1
Gift of the artist

Kennedy, Robert Francis, 1925-1968
Statesman
Gardner Cox, 1906-
Pencil on paper, 35.4 x 27.9 cm.
(13¹⁵/₁₆ x 11 in.), 1986
NPG.69.54.2
Gift of the artist

Kennedy, Robert Francis, 1925-1968
Statesman
Gardner Cox, 1906-
Pencil on paper, 35.4 x 27.9 cm.
(13¹⁵/₁₆ x 11 in.), 1986
NPG.69.54.3
Gift of the artist

Kennedy, Robert Francis, 1925-1968
Statesman
Gardner Cox, 1906-
Pencil on paper, 35.4 x 27.9 cm.
(13¹⁵/₁₆ x 11 in.), 1986
NPG.69.54.4
Gift of the artist

Kennedy, Robert Francis, 1925-1968
Statesman
Gardner Cox, 1906-
Pencil on paper, 35.4 x 27.9 cm.
 (13¹⁵⁄₁₆ x 11 in.), 1986
NPG.69.54.5
Gift of the artist

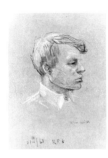

Kennedy, Robert Francis, 1925-1968
Statesman
Gardner Cox, 1906-
Pencil and chalk on paper, 30.3 x
 22.8 cm. (11¹⁵⁄₁₆ x 9 in.), 1968
NPG.69.54.6
Gift of the artist

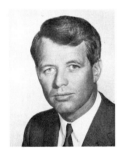

Kennedy, Robert Francis, 1925-1968
Statesman
Philippe Halsman, 1906-1979
Photograph, gelatin silver print, 24.7
 x 19.4 cm. (9¾ x 7⅝ in.), 1961
NPG.83.99
Gift of George R. Rinhart

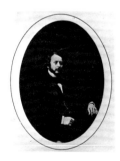

Kensett, John Frederick, 1816-1872
Artist
Unidentified photographer
Photograph, albumen silver print,
 18.2 x 13.4 cm. (7³⁄₁₆ x 5¼ in.),
 c. 1860
NPG.77.122

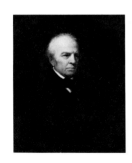

Kent, James, 1763-1847
Jurist
Daniel Huntington, 1816-1906
Oil on canvas, 76.2 x 63.5 cm. (30 x
 25 in.), c. 1840
NPG.67.47

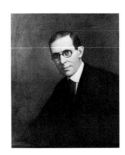

Kettering, Charles Franklin,
 1876-1958
Engineer, inventor
Unidentified artist
Oil on canvas, 76.2 x 63.5 cm. (30 x
 25 in.), not dated
NPG.73.31
*Gift of Mrs. Eugene W. Kettering
 (Mrs. Warren A. Kamph)*

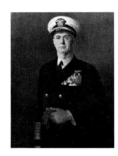

Kiam, Omar, 1894-1954
Fashion designer
Aline Fruhauf, 1907-1978
Watercolor with red pencil, pencil,
 and opaque white on paper, 45.7 x
 39.8 cm. (18 x 15¹¹⁄₁₆ in.), 1942
NPG.83.264
Gift of Erwin Vollmer

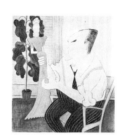

King, Ernest Joseph, 1878-1956
World War II admiral
Albert K. Murray, 1906-
Oil on canvas, 114.3 x 88.9 cm. (45 x
 35 in.) sight, 1947
NPG.65.32
*Transfer from the National Museum
 of American Art; gift of the
 International Business Machines
 Corporation to the Smithsonian
 Institution, 1962*

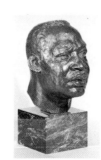

King, Martin Luther, Jr., 1929-1968
Civil rights statesman
Charles Alston, 1907-1977
Bronze, 32 cm. (12⅝ in.), 1970
NPG.74.36

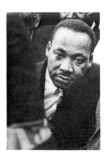

King, Martin Luther, Jr., 1929-1968
Civil rights statesman
Benedict J. Fernandez, 1935-
Photograph, gelatin silver print, 34.2
 x 24.5 cm. (13½ x 9⅝ in.), 1967
NPG.80.173
Gift of the artist

King, Martin Luther, Jr., 1929-1968
Civil rights statesman
Ernst Haas, 1921-
Photograph, gelatin silver print, 34.3
 x 22.4 cm. (13½ x 8⅞ in.), 1963
NPG.85.87

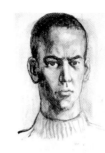

Kirstein, Lincoln*, 1907-
Impresario
Pavel Tchelitchew, 1898-1957
Sepia ink on paper, 45 x 29.5 cm.
 (17¾ x 11⅝ in.), 1937
T/NPG.81.7
Gift of Mrs. R. Kirk Askew

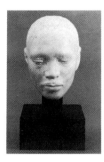

King, Martin Luther, Jr., 1929-1968
Civil rights statesman
Charles Wells, 1935-
Marble, 27.3 cm. (10¾ in.), 1970
NPG.71.52
Gift of an anonymous donor

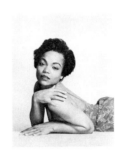

Kitt, Eartha Mae*, 1928-
Singer
Philippe Halsman, 1906-1979
Photograph, gelatin silver print, 24.8
 x 19.7 cm. (9¾ x 8 in.), 1954
T/NPG.83.100
Gift of George R. Rinhart

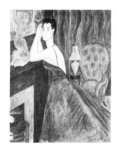

King, Muriel*, 1900/1-1977
Designer
Aline Fruhauf, 1907-1978
Watercolor and pencil with crayon
 and opaque white on paper, 46.1 x
 33.6 cm. (18⅛ x 13¼ in.), 1939
T/NPG.83.278.87
Gift of Erwin Vollmer

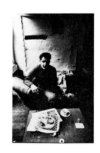

Kline, Franz Joseph, 1919-1962
Artist
Robert Frank, 1924-
Photograph, gelatin silver print, 25.9
 x 17.2 cm. (10⁹⁄₁₆ x 6¾ in.), 1958
NPG.76.81

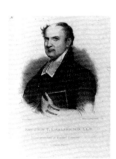

Kinkaid, Thomas Cassin, 1888-1972
World War II admiral
Robert Smullyan Sloan, 1915-
Oil on canvas, 106.6 x 86.4 cm. (42 x
 34 in.), 1947
NPG.65.33
*Transfer from the National Museum
 of American Art; gift of the
 International Business Machines
 Corporation to the Smithsonian
 Institution, 1962*

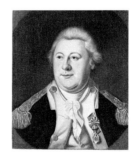

Knowland, William F., 1908-1974
Public official
Guy Rowe ("Giro"), 1894-1969
Tempera and crayon on cardboard,
 27.3 x 27.6 cm. (10¾ x 10⅞ in.),
 1953
NPG.83.29
Gift of Charles Rowe

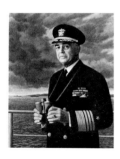

Kirkland, John Thornton, 1770-1840
Clergyman
Attributed to Rembrandt Peale,
 1778-1860, after Gilbert Stuart
Pendleton lithography company
Lithograph, 12.4 x 10.5 cm. (4⅞ x 4⅛
 in.), 1831
Published in *The New-England
 Magazine*, Boston, October 1831
NPG.78.138

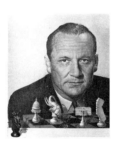

Knox, Henry, 1750-1806
Revolutionary general, statesman
Charles Peale Polk, 1767-1822, after
 the 1783 oil by Charles Willson
 Peale
Oil on canvas, 58.4 x 48.2 cm. (23 x
 19 in.), not dated
NPG.73.11

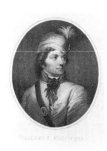

Kościusko, Thaddeus, 1746-1817
Revolutionary general
H. H. Houston, active 1796-1798,
 after Joseph Grassi
Stipple engraving, 20.5 x 17.2 cm.
 (8⅟16 x 6¾ in.), c. 1796
NPG.79.10

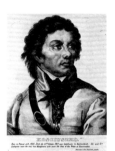

Kościusko, Thaddeus, 1746-1817
Revolutionary general
Paulin Miedzielsky, active 1830s,
 after unidentified artist
Lithograph, 14.1 x 12.2 cm. (5⁹⁄16 x
 4¹³⁄16 in.), 1833
NPG.79.94

Kościusko, Thaddeus, 1746-1817
Revolutionary general
William Sharp, 1749-1824, after
 Catherine Andras
Engraving, 30.9 x 38.3 cm. (12³⁄16 x
 15⅟16 in.), 1800
NPG.70.67

Koussevitsky, Serge Alexandrovich,
 1874-1951
Symphony conductor
Alfred Bendiner, 1899-1964
Lithograph, 23.5 x 25 cm. (9¼ x 9⅞
 in.), 1945
NPG.79.102
Gift of Mrs. Alfred Bendiner

Koussevitsky, Serge Alexandrovich,
 1874-1951
Symphony conductor
Alfred Bendiner, 1899-1964
Lithograph, 19.6 x 20 cm. (7¹¹⁄16 x 7⅞
 in.), 1942
NPG.79.103
Gift of Mrs. Alfred Bendiner

Koussevitsky, Serge Alexandrovich,
 1874-1951
Symphony conductor
Alfred Bendiner, 1899-1964
India ink and pencil on paper, 24.8 x
 24.2 cm. (9¾ x 9½ in.), 1944
Illustration for *The Evening
 Bulletin,* Philadelphia, March 30,
 1944
NPG.84.51
Gift of Alfred Bendiner Foundation

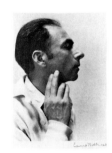

Krasnow, Peter*, 1890-1979
Artist
Edward Weston, 1886-1958
Photograph, gelatin silver print, 24 x
 18.4 cm. (9⁷⁄16 x 7¼ in.), 1928
T/NPG.83.143.89

Kreisler, Fritz, 1875-1962
Musician
Alfred Bendiner, 1899-1964
Lithograph, 18 x 14 cm. (7⅟16 x 5½
 in.), 1942
NPG.79.105
Gift of Mrs. Alfred Bendiner

Kreisler, Fritz, 1875-1962
Musician
Alfred Bendiner, 1899-1964
Lithographic crayon on board, 32.6 x
 27.5 cm. (12¹³⁄16 x 10¹³⁄16 in.), 1939
Illustration for *The Evening
 Bulletin,* Philadelphia, October 21,
 1939
NPG.84.52
Gift of Alfred Bendiner Foundation

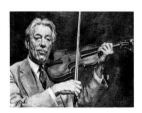

Kreisler, Fritz, 1875-1962
Musician
Boris Chaliapin, 1904-1979
Gouache and colored pencil on artist
 board, 55.8 x 76.2 cm. (22 x 30 in.),
 1943
NPG.72.95
Gift of the artist

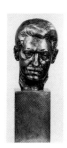

Kreisler, Fritz, 1875-1962
Musician
Jo Davidson, 1883-1952
Bronze, 31.7 cm. (12½ in.), 1978 cast
 from 1919 original
NPG.78.200
Gift of Dr. Maury Leibovitz

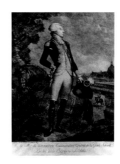

**Lafayette, Marie Joseph Paul Yves
 Roch Gilbert du Motier, Marquis
 de,** 1757-1834
Revolutionary general
Philiber Louis Debucourt, 1755-1832
Color mezzotint, 42.5 x 35.3 cm.
 (16¾ x 13⅞ in.), 1790
NPG.78.44

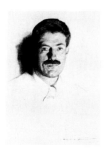

Kreisler, Fritz, 1875-1962
Musician
Leopold Seyffert, 1887-1956
Charcoal on paper, 63.5 x 48.2 cm.
 (25 x 19 in.), 1916
NPG.69.71

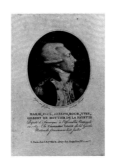

**Lafayette, Marie Joseph Paul Yves
 Roch Gilbert du Motier, Marquis
 de,** 1757-1834
Revolutionary general
Gabriel Fiesinger, 1722-1807, after
 Jean-Urbain Guerin
Stipple engraving and etching, 9 x
 7.8 cm. (3⁹⁄₁₆ x 3¹⁄₁₆ in.), 1790
NPG.79.38

Kuniyoshi, Yasuo, 1889-1953
Artist
Konrad Cramer, 1888-1963
Photograph, gelatin silver print, 25 x
 20 cm. (9⅞ x 7⅞ in.), c. 1948
NPG.83.151

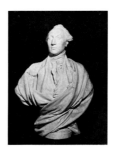

**Lafayette, Marie Joseph Paul Yves
 Roch Gilbert du Motier, Marquis
 de,** 1757-1834
Revolutionary general
Jean-Antoine Houdon, 1741-1828
Marble, 93 cm. (36⅝ in.), after the
 c. 1786 original
NPG.71.41

Kuniyoshi, Yasuo, 1889-1953
Artist
Aline Fruhauf, 1907-1978
India ink over pencil on paper, 33.5
 x 24.6 cm. (13³⁄₁₆ x 9¹¹⁄₁₆ in.), 1932
Published in *Creative Art*, New
 York, February 1932
NPG.83.38
Gift of Erwin Vollmer

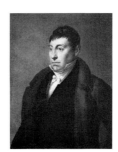

**Lafayette, Marie Joseph Paul Yves
 Roch Gilbert du Motier, Marquis
 de,** 1757-1834
Revolutionary general
Matthew Harris Jouett, 1788-1827
Oil on canvas, 90 x 69.5 cm. (35⁷⁄₁₆ x
 27⅜ in.), c. 1825
NPG.82.150
*Gift of the John Hay Whitney
 Collection*

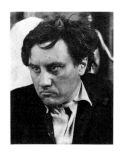

Lachaise, Gaston, 1882-1935
Artist
Paul Strand, 1890-1976
Photograph, gelatin silver print, 24.3
 x 19.3 cm. (9⁹⁄₁₆ x 7⅝ in.), 1927
NPG.85.31

**Lafayette, Marie Joseph Paul Yves
 Roch Gilbert du Motier, Marquis
 de,** 1757-1834
Revolutionary general
Lagardette (Delagardette), ?-?, after
 Edme Quenedey
Etching, 21.3 x 18.2 cm. (8⅜ x 7³⁄₁₆
 in.), c. 1790-1800
NPG.78.113

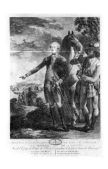

**Lafayette, Marie Joseph Paul Yves
 Roch Gilbert du Motier, Marquis
 de,** 1757-1834
Revolutionary general
Noël LeMire, 1724-1801, after Jean
 Baptiste LePaon
Engraving, 42.3 x 32.1 cm. (16⅝ x
 12⅝ in.), 1781
NPG.84.126

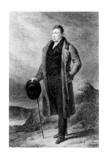

**Lafayette, Marie Joseph Paul Yves
 Roch Gilbert du Motier, Marquis
 de,** 1757-1834
Revolutionary general
Jean Marie Leroux, 1788-1870, after
 Ary Scheffer
Engraving, 55.2 x 37.5 cm. (21¾ x
 14¾ in.), 1824
NPG.69.89
Gift of Stuart P. Feld

**Lafayette, Marie Joseph Paul Yves
 Roch Gilbert du Motier, Marquis
 de,** 1757-1834
Revolutionary general
Charles François Gabriel Levachez
 and Son, active 1760-1820, and
 Jean Duplessi-Bertaux, 1747-1819,
 after Charles François Gabriel
 Levachez
Aquatint and etching, 36.4 x 22.4
 cm. (14⁵⁄₁₆ x 8¹³⁄₁₆ in.), 1790
NPG.78.76

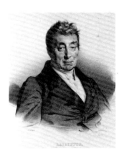

**Lafayette, Marie Joseph Paul Yves
 Roch Gilbert du Motier, Marquis
 de,** 1757-1834
Revolutionary general
Nicholas Eustache Maurin,
 1799-1850, or Antoine Maurin,
 1793-1860
Lithograph, 25 x 24.2 cm. (9¹⁄₁₆ x 9⁹⁄₁₆
 in.), c. 1834
NPG.79.37

**Lafayette, Marie Joseph Paul Yves
 Roch Gilbert du Motier, Marquis
 de,** 1757-1834
Revolutionary general
Joseph Perkins, 1788-1842, after Ary
 Scheffer
Engraving, 46.8 x 40 cm. (18⁷⁄₁₆ x 15¾
 in.), 1825
NPG.84.100

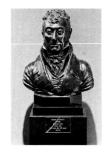

**Lafayette, Marie Joseph Paul Yves
 Roch Gilbert du Motier, Marquis
 de,** 1757-1834
Revolutionary general
William Rush, 1756-1833
Bronze, 59.6 cm. (23½ in.), cast after
 the 1824 plaster
NPG.71.9

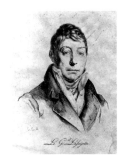

**Lafayette, Marie Joseph Paul Yves
 Roch Gilbert du Motier, Marquis
 de,** 1757-1834
Revolutionary general
C. L. S., ?-?, after Anthelme François
 Lagrenée
Lithograph, 19.6 x 16.5 cm. (7¾ x 6½
 in.), c. 1820-1830
NPG.78.89

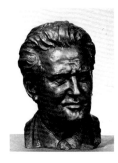

La Follette, Robert Marion, 1855-1925
Statesman
Jo Davidson, 1883-1952
Bronze, 43.5 cm. (17¼ in.), 1977 cast
 after the 1923-1927 original
NPG.78.10

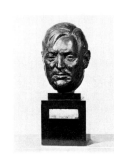

La Guardia, Fiorello Henry,
 1882-1947
Mayor of New York City
Jo Davidson, 1883-1952
Bronze, 26.6 cm. (10½ in.), c. 1933
NPG.77.324
Gift of Dr. Maury Leibovitz

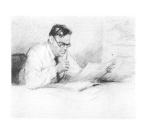

La Guardia, Fiorello Henry,
 1882-1947
Mayor of New York City
Samuel Johnson Woolf, 1880-1948
Charcoal and chalk on paper, 49.8 x
 65.3 cm. (19⅝ x 25⅝ in.), not dated
NPG.80.265

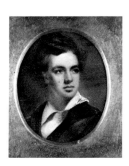

Lambdin, James Reid, 1807-1889
Artist
Self-portrait
Watercolor on ivory, 8.3 x 6.8 cm.
 (3¼ x 2⅝ in.), not dated
NPG.78.213
Gift of Barry Bingham, Sr.

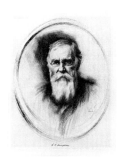

Langdell, Christopher Columbus,
 1826-1906
Lawyer
Otto J. Schneider, 1875-1946
Etching, 25 x 22 cm. (9⅞ x 8¹¹⁄₁₆ in.),
 1906
NPG.77.87

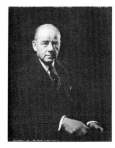

Lamont, Thomas William, 1870-1948
Financier
Edward Steichen, 1879-1973
Photograph, gelatin silver print, 23.9
 x 19.7 cm. (9⅜ x 7¾ in.), 1932
NPG.82.88
Bequest of Edward Steichen

Lange, Dorothea, 1895-1965
Photographer
Lisette Model, 1906-1983
Photograph, gelatin silver print, 34.3
 x 26.8 cm. (13½ x 10⁹⁄₁₆ in.), c. 1948
NPG.82.140

Land, Edwin Herbert*, 1909-
Inventor
Samuel Johnson Woolf, 1880-1948
Charcoal and chalk on paper, 61 x
 48.2 cm. (24 x 19 in.), not dated
T/NPG.80.266

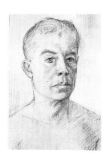

Langley, Samuel Pierpont, 1834-1906
Scientist
Unidentified photographer
Photograph, gelatin silver print, 18 x
 15.1 cm. (7¹⁄₁₆ x 5¹⁵⁄₁₆ in.), c. 1895
NPG.78.180

Land, Emory Scott, 1879-1971
World War II naval planner
Boris Chaliapin, 1904-1979
Watercolor on artist board, 32.4 x
 24.1 cm. (12¾ x 9½ in.), 1948
NPG.78.214
Gift of Miss Bess Udoff

Laning, Edward*, 1906-1981
Artist
Self-portrait
Pencil on paper, 31.2 x 23.4 cm.
 (12⁵⁄₁₆ x 9¼ in.), c. 1940-1950
T/NPG.84.190.91
Gift of the estate of Edward Laning

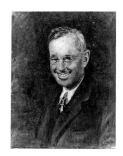

Landon, Alfred Mossman*, 1887-1987
Businessman, statesman
Vera Dvornikoff, 1875-1965
Oil on canvas, 60.6 x 48.5 cm. (23⅞ x
 19⅛ in.), 1936
T/NPG.69.86
Gift of Tassia Peters

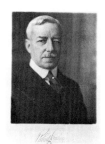

Lansing, Robert, 1864-1928
Statesman
Harris and Ewing studio, active
 1905-1977
Photograph, gelatin silver print, 23.5
 x 18.4 cm. (9⁵⁄₁₆ x 7¼ in.), c. 1915
NPG.84.249
Gift of Aileen Conkey

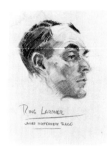

Lardner, Ringgold Wilmer,
1885-1933
Author
James Montgomery Flagg, 1877-1960
Pencil on paper, 33 x 25.4 cm. (13 x
10 in.), not dated
NPG.76.26
Gift of Ring Lardner, Jr.

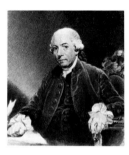

Laurens, Henry, 1724-1792
Revolutionary statesman
William G. Armstrong, 1823-1890,
after John Singleton Copley
Ink on paper, 11.8 x 10.5 cm. (4¹¹/₁₆ x
4⅛ in.), c. 1835
NPG.77.289

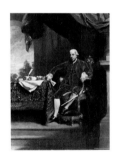

Laurens, Henry, 1724-1792
Revolutionary statesman
John Singleton Copley, 1738-1815
Oil on canvas, 137.4 x 103.1 cm.
(54⅛ x 40⅝ in.), 1782
NPG.65.45
*Transfer from the National Gallery
of Art; gift of Andrew W. Mellon,
1942*

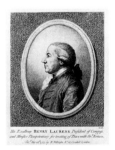

Laurens, Henry, 1724-1792
Revolutionary statesman
B. B. Ellis, ?-?, after Benoit Louis
Prevost, after Pierre Eugène Du
Simitière
Stipple engraving, 11.1 x 9.2 cm. (4⅜
x 3⅝ in.), 1783
Published in *Portraits of the
Generals, Ministers, Magistrates,*
London, 1783
NPG.75.73

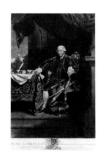

Laurens, Henry, 1724-1792
Revolutionary statesman
Valentine Green, 1739-1813, after
John Singleton Copley
Mezzotint, 58.5 x 40.5 cm. (23 x
15¹⁵/₁₆ in.), 1782
NPG.65.46
*Transfer from the National Gallery
of Art; gift of Andrew W. Mellon,
1942*

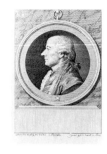

Laurens, Henry, 1724-1792
Revolutionary statesman
Benoit Louis Prevost, 1735-1804, after
Pierre Eugène Du Simitière
Engraving, 16.2 x 11.7 cm. (6⅜ x 4⅝
in.), 1780
Published in *Collection des Portraits
des Généraux, Ministres, et
Magistrats . . .*, Paris, 1781
NPG.75.59

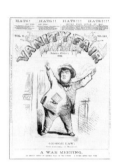

Law, George, 1806-1881
Contractor, financier
Bobbett and Hooper wood-engraving
company, active 1855-1870, after
Henry Louis Stephens
Wood engraving, 26.9 x 19.7 cm.
(10⅝ x 7¹³/₁₆ in.), 1862
Published in *Vanity Fair*, New York,
October 4, 1862
NPG.85.58

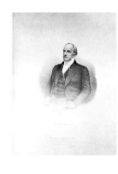

Lawrence, Abbott, 1792-1855
Businessman
J. H. Bufford lithography company,
active 1835-1890, after Marcus
Ormsbee
Lithograph, 29.5 x 24.8 cm. (11½ x
9¾ in.), c. 1855
NPG.80.148

Lawrence, Abbott, 1792-1855
Businessman
Charles Fenderich, 1805-1887
P. S. Duval lithography company
Lithograph, 26 x 26 cm. (10¼ x 10¼
in.), 1842
NPG.66.88
*Transfer from the Library of
Congress, Prints and Photographs
Division*

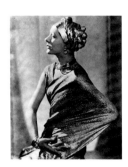

Lawrence, Gertrude, 1898-1952
Actress
Nickolas Muray, 1892-1965
Photograph, gelatin silver print, 24.2
x 19.5 cm. (9½ x 7⅝ in.), 1977 from
c. 1925 negative
NPG.78.149

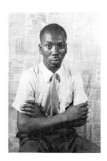

Lawrence, Jacob A.*, 1917-
Artist
Carl Van Vechten, 1880-1964
Photogravure, 22.1 x 14.9 cm. (8¾ x
 5⅞ in.), 1983 from 1941 negative
T/NPG.83.188.29

Lebrun, Federico, 1900-1964
Artist
Leonard Baskin, 1922-
Ink on paper, 53.3 x 76.2 cm. (21 x 30
 in.), 1968
NPG.77.233

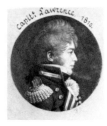

Lawrence, James, 1781-1813
War of 1812 naval officer
Charles Balthazar Julien Févret de
 Saint-Mémin, 1770-1852
Engraving, 5.6 cm. (2¼ in.) diameter,
 1810
NPG.74.39.35
Gift of Mr. and Mrs. Paul Mellon

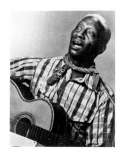

Ledbetter, Huddie ("Leadbelly"),
 1885-1949
Musician
Berenice Abbott, 1898-
Photograph, gelatin silver print, 24.2
 x 18.9 cm. (9½ x 7⁷⁄₁₆ in.), c. 1946
NPG.76.82

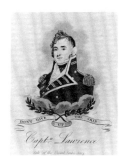

Lawrence, James, 1781-1813
War of 1812 naval officer
William Strickland, 1788-1854, after
 Gilbert Stuart
Aquatint and etching, 14.7 x 11.5
 cm. (5¹³⁄₁₆ x 4½ in.), c. 1814
NPG.79.12

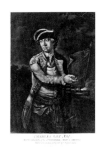

Lee, Charles, 1731-1782
Revolutionary general
Unidentified artist
C. Shepard, publisher
Mezzotint, 32.4 x 23.3 cm. (12¾ x
 9³⁄₁₆ in.), 1775
NPG.69.72

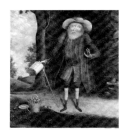

Lay, Benjamin, 1677-1759
Reformer
William Williams, 1727-1791
Oil on red walnut panel, 39 x 36.4
 cm. (15⅜ x 14⅜ in.), 1750
NPG.79.171
Gift of James Smithson Society

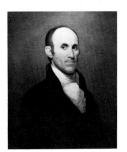

Lee, Charles, 1758-1815
Jurist
Cephas Thompson, 1775-1856
Oil on canvas, 69.8 x 57.1 cm. (27½ x
 22½ in.), c. 1810-1811
NPG.64.4
Gift of Mrs. A. D. Pollock Gilmour

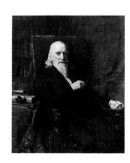

Lea, Isaac, 1792-1886
Naturalist
Bernard Uhle, 1847-1930
Oil on canvas, 128.2 x 107.7 cm.
 (50½ x 42¾ in.), c. 1884-1885
NPG.66.60
*Transfer from the National Museum
 of American Art; gift of Marjorie
 Lea Hudson, 1961*

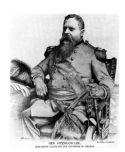

Lee, Fitzhugh, 1835-1905
Confederate officer
William E. Hyde, ?-?
Bell Brothers lithography company
Lithograph, 50.6 x 47.3 cm. (19¹⁵⁄₁₆ x
 18⅝ in.), c. 1884-1885
NPG.72.59

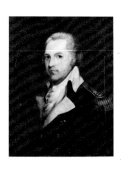

Lee, Henry ("Lighthorse Harry"),
 1756-1818
Revolutionary officer, statesman
Attributed to James Herring,
 1794-1867, after Gilbert Stuart
Oil on canvas, 76.2 x 63.5 cm. (30 x
 25 in.), c. 1834
NPG.78.51

Lee, Robert Edward, 1807-1870
Confederate general
Charles G. Crehen, 1829-?, after
 photograph by Mathew Brady
Lithograph with tintstone, 28.2 x
 21.3 cm. (11 1/16 x 8 3/8 in.), c. 1861
NPG.84.83

Lee, Richard Henry, 1732-1794
Revolutionary statesman
Charles Willson Peale, 1741-1827
Oil on canvas, 76.2 x 63.5 cm. (30 x
 25 in.), replica after 1784 original,
 c. 1795/1805
NPG.74.5
Gift of Duncan Lee and his son,
 Gavin Dunbar Lee

Lee, Robert Edward, 1807-1870
Confederate general
Ernest Crehen, active c. 1860-c. 1874,
 after photograph by Minnis and
 Cowell
A. Hoen and Company lithography
 company
Lithograph, 6 x 14.3 cm. (2 5/16 x 5 5/8
 in.), 1866
NPG.84.96

Lee, Robert Edward, 1807-1870
Confederate general
Mathew Brady, 1823-1896
Photograph, albumen silver print,
 9.1 x 5.5 cm. (3 9/16 x 2 3/16 in.), 1869
NPG.77.310

Lee, Robert Edward, 1807-1870
Confederate general
Currier and Ives lithography
 company, active 1857-1907, after
 photograph by Mathew Brady
Hand-colored lithograph, 20.4 x 31.7
 cm. (8 x 12 7/16 in.), 1870
NPG.84.85

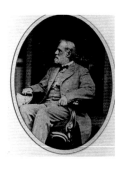

Lee, Robert Edward, 1807-1870
Confederate general
Mathew Brady, 1823-1896
Photograph, albumen silver print,
 20.8 x 15.3 cm. (8 x 6 in.), 1865
NPG.78.243

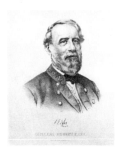

Lee, Robert Edward, 1807-1870
Confederate general
Currier and Ives lithography
 company, active 1857-1907, after
 photograph by Minnis and Cowell
Lithograph, 24.3 x 21.9 cm. (9 9/16 x
 8 5/8 in.), c. 1863
NPG.84.86

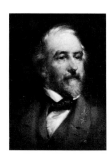

Lee, Robert Edward, 1807-1870
Confederate general
Edward Caledon Bruce, 1825-1901
Oil on canvas, 52 x 39.5 cm. (20 3/8 x
 15 1/2 in.), 1864-1865
NPG.76.4

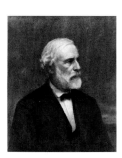

Lee, Robert Edward, 1807-1870
Confederate general
Attributed to John Dabour,
 1837-1905
Pastel on paper, 76 x 63.5 cm. (30 x
 25 in.), 1871
NPG.71.29

Lee, Robert Edward, 1807-1870
Confederate general
John W. Davies, ?-?
Photograph, albumen silver print,
 6.1 x 4.2 cm. (2⅜ x 1¹¹⁄₁₆ in.), 1864
NPG.78.244

Lee, Robert Edward, 1807-1870
Confederate general
D. Murphy, ?-?, after photograph by
 Minnis and Cowell
Engraving, 9.9 x 5.9 cm. (3⅞ x 2⁵⁄₁₆
 in.), c. 1865
NPG.84.121

Lee, Robert Edward, 1807-1870
Confederate general
Frédéric François Dubois-Tesselin,
 1832-?, after Louis Mathieu Didier
 Guillaume
Goupil lithography company
Mezzotint, 64.9 x 53.5 cm. (25⁹⁄₁₆ x
 9¹⁄₁₆ in.), c. 1865
NPG.84.92

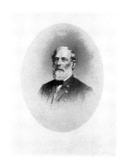

Lee, Robert Edward, 1807-1870
Confederate general
John A. O'Neill, active c. 1857-c.
 1890, after photograph by Minnis
 and Cowell
Engraving, 31.1 x 24.4 cm. (12¼ x
 9⅝ in.), c. 1865
NPG.84.88

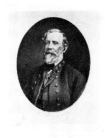

Lee, Robert Edward, 1807-1870
Confederate general
J. L. Giles, active 1861-1881, after
 photograph by Minnis and Cowell
Lithograph with tintstone, 30.6 x
 25.2 cm. (12 x 9⅞ in.), c. 1868
NPG.84.91

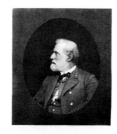

Lee, Robert Edward, 1807-1870
Confederate general
William Sartain, 1843-1924, after
 photograph by Mathew Brady
Mezzotint, 27.8 x 24.2 cm. (10¹⁵⁄₁₆ x
 9½ in.), c. 1865
NPG.84.122

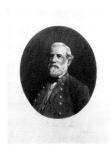

Lee, Robert Edward, 1807-1870
Confederate general
Paul Giradet, 1821-1893, after
 photograph by Minnis and Cowell
Engraving, 23.4 x 19.6 cm. (9³⁄₁₆ x
 7¹¹⁄₁₆ in.), c. 1865
NPG.84.93

Lee, Robert Edward, 1807-1870
Confederate general
John W. Torsch, active 1858-1867,
 after photograph by Minnis and
 Cowell
Wood engraving, 38.3 x 26.5 cm.
 (15¹⁄₁₆ x 10⁷⁄₁₆ in.), 1863
Published in *Southern Illustrated
 News*, Richmond, October 17, 1863
NPG.84.123

Lee, Robert Edward, 1807-1870
Confederate general
A. Hoen and Company lithography
 company, active 1848-1981
Lithograph with tintstones, 40.3 x
 49.7 cm. (15¹³⁄₁₆ x 19⁹⁄₁₆ in.), 1876
NPG.84.97

Lee, Robert Edward, 1807-1870
Confederate general
Edward Virginius Valentine,
 1838-1930
Bronze, 58.4 cm. (23 in.), cast after
 1870 plaster
NPG.78.35

Lee, Robert Edward, 1807-1870
Confederate general
Unidentified artist, after photograph
 by Mathew Brady
Wood engraving, 14.8 x 10 cm. (5¹³⁄₁₆
 x 3¹⁵⁄₁₆ in.), 1862
Published in *Frank Leslie's
 Illustrated Newspaper*, New York,
 October 4, 1862
NPG.84.90

Lee, Robert Edward, 1807-1870
Confederate general
Unidentified artist, after photograph
 by Mathew Brady
Wood engraving, 11.4 x 8.9 cm. (4½
 x 3½ in.), 1861
Published in *Harper's Weekly*, New
 York, August 24, 1861
NPG.84.94

Lee, Robert Edward, 1807-1870
Confederate general
Unidentified artist, after photograph
 by Minnis and Cowell
Wood engraving, 23.3 x 16.2 cm.
 (9³⁄₁₆ x 6⅜ in.), 1864
Published in *Harper's Weekly*, New
 York, July 2, 1864
NPG.84.95

Lee, Robert Edward, 1807-1870
Confederate general
Unidentified artist, after photograph
 by Minnis and Cowell
Wood engraving, 23.6 x 16.4 cm. (9¼
 x 6⁷⁄₁₆ in.), 1864
Published in *Illustrated London
 News*, London, June 4, 1864
NPG.84.98

Leidy, Joseph, 1823-1891
Naturalist
Frederick Gutekunst, 1831-1917
Photograph, albumen silver print,
 14.4 x 10.3 cm. (5¹¹⁄₁₆ x 4¹⁄₁₆ in.),
 c. 1875
NPG.82.67

Leinsdorf, Erich*, 1912-
Symphony conductor
Alfred Bendiner, 1899-1964
India ink over pencil on paper, 34.8
 x 28 cm. (13¹¹⁄₁₆ x 11 in.), c. 1945
T/NPG.84.38
Gift of Alfred Bendiner Foundation

LeMay, Curtis Emerson*, 1906-
Air Force general
David Lee Iwerks, 1933-
Photograph, gelatin silver print, 24 x
 19 cm. (9⁷⁄₁₆ x 7½ in.), 1966
T/NPG.78.189

Lenya, Lotte*, 1900-1981
Actress
Saul Bolasni, ?-?
Oil on canvas, 80 x 54.6 cm. (31½ x
 21½ in.), 1954
T/NPG.78.123.91
Gift of Lee Boltin

Levant, Oscar, 1906-1972
Entertainer
Alfred Bendiner, 1899-1964
Crayon on paper, 23.2 x 33.2 cm. (9⅛
 x 13¹⁄₁₆ in.), c. 1943
NPG.84.42
Gift of Alfred Bendiner Foundation

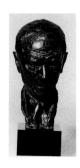

Lewis, Harry Sinclair, 1885-1951
Author
Jo Davidson, 1883-1952
Bronze, 36.1 cm. (14¾ in.), 1937
NPG.68.9

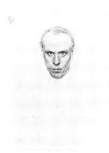

Lewis, Harry Sinclair, 1885-1951
Author
Soss Melik, 1914-
Charcoal on paper, 63.2 x 48.2 cm.
(24⅞ x 19 in.), 1942
NPG.68.33

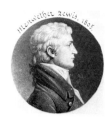

Lewis, Meriwether, 1774-1809
Explorer
Charles Balthazar Julien Févret de
Saint-Mémin, 1770-1852
Engraving, 5.6 cm. (2¼ in.) diameter,
1803/7
NPG.74.39.420
Gift of Mr. and Mrs. Paul Mellon

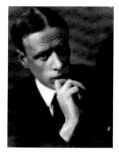

Lewis, Harry Sinclair, 1885-1951
Author
Nickolas Muray, 1892-1965
Photograph, silver bromide print,
24.1 x 19 cm. (9½ x 7½ in.), 1926
NPG.78.8

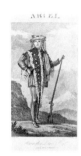

Lewis, Meriwether, 1774-1809
Explorer
William Strickland, 1788-1854, after
Charles Balthazar Julien Févret de
Saint-Mémin
Aquatint, 15.5 x 9.4 cm. (6⅛ x 3¹¹⁄₁₆
in.), 1816
Published in *Analectic Magazine
and Naval Chronicle*, vol. 7, 1816
NPG.76.22

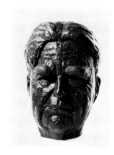

Lewis, John Llewellyn, 1880-1969
Labor leader
Ben Goodkin, 1908-
Bronze, 45.5 cm. (18 in.), 1968
NPG.70.68
*Gift of the artist and the Industrial
Union Department, AFL-CIO*

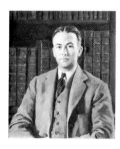

Lewis, Wilmarth Sheldon*,
1895-1979
Editor
Ellen Emmet Rand, 1876-1941
Oil on canvas, 76.2 x 66 cm. (30 x 26
in.), 1931
T/NPG.80.8.89
Bequest of Wilmarth Sheldon Lewis

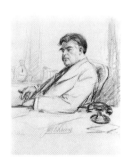

Lewis, John Llewellyn, 1880-1969
Labor leader
Samuel Johnson Woolf, 1880-1948
Charcoal and chalk on paper, 55.6 x
44.9 cm. (21⅞ x 17¹¹⁄₁₆ in.), 1937
NPG.80.267

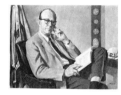

Libby, Willard F.*, 1908-1980
Scientist
Alvin L. Gittins, 1922-1981
Oil on canvas, 91.4 x 121.8 cm. (36 x
48 in.), 1968
T/NPG.82.57.90
Gift of Mrs. Willard F. Libby

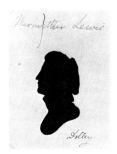

Lewis, Meriwether, 1774-1809
Explorer
Dolley Madison, 1768-1849
Silhouette, 9.8 x 8.2 cm. (3⅞ x 3¼
in.), not dated
NPG.77.28

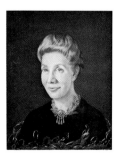

Liebes, Dorothy Wright, 1899-1972
Artist
Brian Connelly, 1926-1965
Oil on masonite, 45.4 x 35.5 cm.
(17⅞ x 14 in.), 1956
NPG.80.134
Gift of Daren Pierce

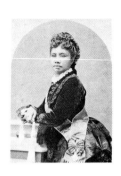

Liliuokalani, 1838-1917
Hawaiian ruler
Menzies Dickson, c. 1840-1891
Photograph, albumen silver print,
 12.7 x 9.1 cm. (5¹⁄₁₆ x 3⁹⁄₁₆ in.),
 c. 1891
NPG.80.320
*Gift of the Bernice Pauahi Bishop
 Museum*

Liliuokalani, 1838-1917
Hawaiian ruler
Harris and Ewing studio, active
 1905-1977
Photograph, gelatin silver print, 37.5
 x 28.6 cm. (14¾ x 11¼ in.), c. 1908
NPG.84.250
Gift of Aileen Conkey

Limón, José, 1908-1972
Dancer
Philip Grausman, 1935-
Bronze, 33.9 cm. (13⅜ in.), 1969
NPG.75.31
Gift of an anonymous donor

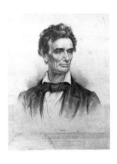

Lincoln, Abraham, 1809-1865
Sixteenth President of the United
 States
Joseph Edward Baker, 1835-1914,
 after Charles A. Barry
J. H. Bufford lithography company
Lithograph on rice paper, 57.7 x 50.1
 cm. (22¾ x 19¾ in.), 1860
NPG.83.182

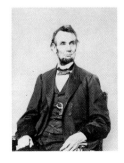

Lincoln, Abraham, 1809-1865
Sixteenth President of the United
 States
Anthony Berger, ?-?
Photograph, albumen silver print,
 32.8 x 24.1 cm. (12⅞ x 9½ in.),
 1864
NPG.80.22

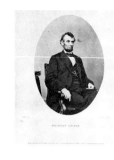

Lincoln, Abraham, 1809-1865
Sixteenth President of the United
 States
Anthony Berger, ?-?, at the Mathew
 Brady studio
Photograph, albumen silver print,
 18.9 x 13.5 cm. (7⁷⁄₁₆ x 5⁵⁄₁₆ in.),
 1864
NPG.83.142

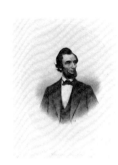

Lincoln, Abraham, 1809-1865
Sixteenth President of the United
 States
C. Bornemann, ?-?, after photograph
 by Mathew Brady
Lemercier lithography company
Hand-colored lithograph with
 tintstone, 25.9 x 21 cm. (10⅛ x 8¼
 in.), not dated
NPG.78.296

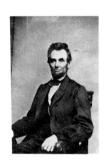

Lincoln, Abraham, 1809-1865
Sixteenth President of the United
 States
Mathew Brady, 1823-1896
Photograph, albumen silver print,
 8.3 x 5.3 cm. (3¼ x 2⅛ in.), 1864
NPG.79.149

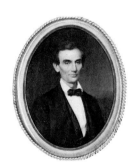

Lincoln, Abraham, 1809-1865
Sixteenth President of the United
 States
John Henry Brown, 1819-1891
Watercolor on ivory, 14 x 11.4 cm.
 (5½ x 4½ in.), 1860
NPG.75.11

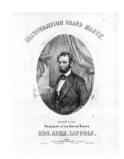

Lincoln, Abraham, 1809-1865
Sixteenth President of the United
 States
J. H. Bufford lithography company,
 active 1835-1890, after photograph
 attributed to Christopher S.
 German
Lithograph, 20.7 x 15.7 cm. (8⅛ x
 6³⁄₁₆ in.), 1860
Music sheet title page: "Inauguration
 Grand March"
NPG.84.81

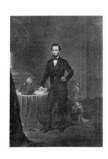

Lincoln, Abraham, 1809-1865
Sixteenth President of the United
 States
John Chester Buttre, 1821-1893, after
 photograph
Engraving, 65.3 x 47.4 cm. (18⅝ x
 25¹¹⁄₁₆ in.), c. 1860-1861
NPG.79.160

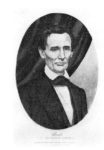

Lincoln, Abraham, 1809-1865
Sixteenth President of the United
 States
Currier and Ives lithography
 company, active 1857-1907, after
 photograph by Mathew Brady
Hand-colored lithograph, 31.1 x 22.8
 cm. (12³⁄₁₆ x 9 in.), 1860
NPG.83.219

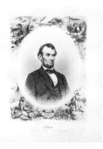

Lincoln, Abraham, 1809-1865
Sixteenth President of the United
 States
John Chester Buttre, 1821-1893, and
 William Momberger, 1829-?, after
 photograph by Anthony Berger
Engraving, 33.6 x 25.1 cm. (13³⁄₁₆ x
 9⅞ in.), c. 1865
NPG.83.243

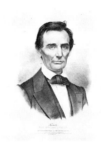

Lincoln, Abraham, 1809-1865
Sixteenth President of the United
 States
Currier and Ives lithography
 company, active 1857-1907, after
 photograph by Mathew Brady
Lithograph, 37.4 x 30 cm. (14¹¹⁄₁₆ x
 11¹³⁄₁₆ in.), 1860
NPG.83.220

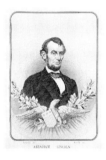

Lincoln, Abraham, 1809-1865
Sixteenth President of the United
 States
Carquillat, 1802/3-1884, after
 Allardet, after photograph by
 Anthony Berger
Silk, 20 x 14 cm. (7⅞ x 5½ in.), 1876
NPG.83.228

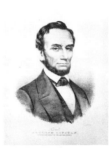

Lincoln, Abraham, 1809-1865
Sixteenth President of the United
 States
Currier and Ives lithography
 company, active 1857-1907, after
 photograph by Samuel M. Fassett
Lithograph, 29.5 x 24 cm. (11⅝ x 9⁷⁄₁₆
 in.), 1860-1861
NPG.83.222

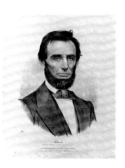

Lincoln, Abraham, 1809-1865
Sixteenth President of the United
 States
Currier and Ives lithography
 company, active 1857-1907, after
 Brady studio
Lithograph, 38 x 29 cm. (24⅞ x 11½
 in.), c. 1860-1861
NPG.79.186

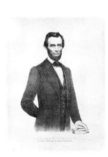

Lincoln, Abraham, 1809-1865
Sixteenth President of the United
 States
Currier and Ives lithography
 company, active 1857-1907, after
 photograph by Mathew Brady
Lithograph, 30.3 x 21.2 cm. (11¹⁵⁄₁₆ x
 8¹⁵⁄₁₆ in.), 1860-1861
NPG.83.223

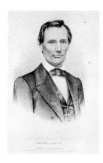

Lincoln, Abraham, 1809-1865
Sixteenth President of the United
 States
Currier and Ives lithography
 company, active 1857-1907, after
 photograph by Mathew Brady
Lithograph, 24.2 x 18.5 cm. (9½ x 7¼
 in.), 1860
NPG.80.51

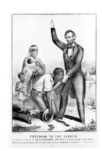

Lincoln, Abraham, 1809-1865
Sixteenth President of the United
 States
Currier and Ives lithography
 company, active 1857-1907, after
 photograph by Anthony Berger
Lithograph, 30.1 x 22.3 cm. (11⅞ x
 8¹³⁄₁₆ in.), c. 1864-1865
NPG.83.224

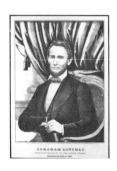

Lincoln, Abraham, 1809-1865
Sixteenth President of the United
 States
Currier and Ives lithography
 company, active 1857-1907, after
 photograph
Lithograph, 34.5 x 24.4 cm. (13⁹⁄₁₆ x
 9⁹⁄₁₆ in.), 1865
NPG.83.226

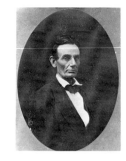

Lincoln, Abraham, 1809-1865
Sixteenth President of the United
 States
Samuel M. Fassett, active 1855-1875
Photograph, salt print, 18.4 x 13.3
 cm. (7¼ x 5¼ in.), 1859
NPG.77.265

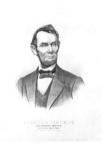

Lincoln, Abraham, 1809-1865
Sixteenth President of the United
 States
Currier and Ives lithography
 company, active 1857-1907, after
 photograph by Anthony Berger
Lithograph, 25.9 x 22.7 cm. (10³⁄₁₆ x
 8¹⁵⁄₁₆ in.), c. 1865
NPG.83.227

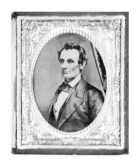

Lincoln, Abraham, 1809-1865
Sixteenth President of the United
 States
Fetter's picture gallery, ?-?, after
 c. 1858 photograph attributed to
 Christopher S. German
Ambrotype, 6.3 x 5.1 cm. (2½ x 2
 in.), c. 1860
NPG.81.25

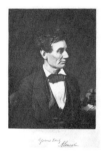

Lincoln, Abraham, 1809-1865
Sixteenth President of the United
 States
Thomas Doney, active c. 1844-1870s,
 after photograph by Alexander
 Hesler
Mezzotint, 20.3 x 15.1 cm. (8 x 5¹⁵⁄₁₆
 in.), 1860
NPG.83.215

Lincoln, Abraham, 1809-1865
Sixteenth President of the United
 States
Alexander Gardner, 1821-1882
Photograph, albumen silver print,
 8.6 x 5.3 cm. (3⅜ x 2⅛ in.), 1861
NPG.79.150

Lincoln, Abraham, 1809-1865
Sixteenth President of the United
 States
Ehrgott and Forbriger lithography
 company, active 1858-1869, after
 Christopher S. German
Hand-colored lithograph, 34.2 x 23.8
 cm. (13½ x 9⅜ in.), c. 1861-1862
NPG.81.35

Lincoln, Abraham, 1809-1865
Sixteenth President of the United
 States
Alexander Gardner, 1821-1882
Wet-collodion photographic
 negative, 59 x 42.2 cm. (20 x 17
 in.), 1863
NPG.83.129
*Gift of the James Smithson Society,
 CBS Television Network, and
 James Macatee*

Lincoln, Abraham, 1809-1865
Sixteenth President of the United
 States
Ensign, Bridgman, and Fanning,
 active 1854-1868, after Mathew
 Brady
Hand-colored wood engraving, 35.8
 x 22.8 cm. (14¹⁄₁₆ x 8¹⁵⁄₁₆ in.),
 c. 1860
NPG.81.50
Gift of Dr. Frank Stanton

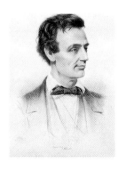

Lincoln, Abraham, 1809-1865
Sixteenth President of the United
 States
Leopold Grozelier, 1830-1865, after
 Thomas Hicks
J. H. Bufford lithography company
Lithograph, 55.5 x 40.5 cm. (21 x 16
 in.), 1860
NPG.80.44

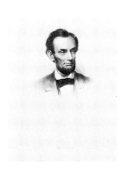

Lincoln, Abraham, 1809-1865
Sixteenth President of the United
 States
Frederick W. Halpin, 1805-1880, after
 Francis Bicknell Carpenter
Stipple and line engraving, 42.8 x
 32.5 cm. (16⅞ x 12¹³⁄₁₆ in.), 1866
NPG.72.96
Gift of Mrs. Robert R. McCormick

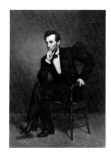

Lincoln, Abraham, 1809-1865
Sixteenth President of the United
 States
George Peter Alexander Healy,
 1813-1894
Oil on canvas, 188 x 137.1 cm. (74 x
 54 in.), 1887
NPG.65.50
*Transfer from the National Gallery
 of Art; gift of Andrew W. Mellon,
 1942*

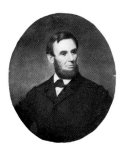

Lincoln, Abraham, 1809-1865
Sixteenth President of the United
 States
Charles Wesley Jarvis, 1812-1868
Oil on canvas, 76.1 x 67.9 cm. (29¹⁵⁄₁₆ x
 26¾ in.), 1861
NPG.78.272
Gift of Mr. and Mrs. Michael Arpad

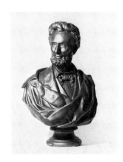

Lincoln, Abraham, 1809-1865
Sixteenth President of the United
 States
Thomas Dow Jones, 1811-1881
Plaster, 83.5 cm. (32⅞ in.), 1861
NPG.74.53

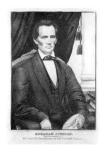

Lincoln, Abraham, 1809-1865
Sixteenth President of the United
 States
E. B. and E. C. Kellogg lithography
 company, active c. 1842-1867, after
 photograph by Mathew Brady
Hand-colored lithograph, 28.4 x 20.9
 cm. (11³⁄₁₆ x 8¼ in.), 1860
NPG.83.216

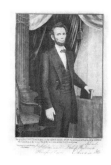

Lincoln, Abraham, 1809-1865
Sixteenth President of the United
 States
E. B. and E. C. Kellogg lithography
 company, active c. 1842-1867, after
 ambrotype attributed to William
 Marsh
Hand-colored lithograph, 30.2 x 21.9
 cm. (11⅞ x 8⅝ in.), 1860-1861
NPG.83.217

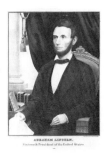

Lincoln, Abraham, 1809-1865
Sixteenth President of the United
 States
E. B. and E. C. Kellogg lithography
 company, active c. 1842-1867, after
 photograph by Alexander Hesler
Hand-colored lithograph, 28.6 x 21.7
 cm. (11¼ x 8½ in.), 1860-1861
NPG.83.218

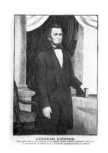

Lincoln, Abraham, 1809-1865
Sixteenth President of the United
 States
E. B. and E. C. Kellogg lithography
 company, active c. 1842-1867, after
 photograph by Alexander Gardner
Hand-colored lithograph, 30.2 x 21.8
 cm. (11⅞ x 8⁹⁄₁₆ in.), c. 1861-1862
NPG.83.221

Lincoln, Abraham, 1809-1865
Sixteenth President of the United
 States
Albert Kidder, active 1863-1869, after
 Mathew Brady
Charles Shober lithography
 company
Lithograph, 8.3 x 7.7 cm. (3¼ x 3
 in.), 1864
NPG.81.47
Gift of Marvin Sadik

Lincoln, Abraham, 1809-1865
Sixteenth President of the United
 States
Kimmel and Forster engraving and
 lithography company, active
 1865-1866, after photograph by
 Mathew Brady
Hand-colored lithograph, 20.8 x 16.2
 cm. (8³⁄₁₆ x 6⁷⁄₁₆ in.), c. 1865
NPG.80.40

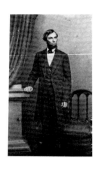

Lincoln, Abraham, 1809-1865
Sixteenth President of the United
States
Thomas Le Mere, ?-?, at the Mathew
Brady studio
Photograph, albumen silver print,
8.1 x 5.3 cm. (3⅜ x 2⅛ in.), 1863
NPG.79.151

Lincoln, Abraham, 1809-1865
Sixteenth President of the United
States
William Roberts, c. 1829-?, after
photograph by Mathew Brady
Wood engraving with one tint, 50.1
x 38.2 cm. (19¹¹⁄₁₆ x 15 in.), 1864
NPG.83.229

Lincoln, Abraham, 1809-1865
Sixteenth President of the United
States
William Edgar Marshall, 1837-1906,
after painting by William Edgar
Marshall, after photograph
Engraving, 52.9 x 40.6 cm. (20¹³⁄₁₆ x
16¹⁵⁄₁₆ in.), 1866
NPG.79.204

Lincoln, Abraham, 1809-1865
Sixteenth President of the United
States
John Sartain, 1808-1897, after
photograph by Wenderoth and
Taylor
Mezzotint, second state of Martin
Van Buren plate (NPG.79.75), 51.4
x 35.2 cm. (20¼ x 13⅞ in.),
1864-1865
NPG.79.73

Lincoln, Abraham, 1809-1865
Sixteenth President of the United
States
Pierre Guillaume Metzmacher,
1815-?, after photograph by
Mathew Brady
Engraving, 20 x 19.8 cm. (7⅞ x 7¹³⁄₁₆
in.), 1862
NPG.80.47

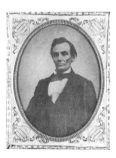

Lincoln, Abraham, 1809-1865
Sixteenth President of the United
States
William Judkins Thomson, ?-?
Ambrotype, 13.8 x 10.7 cm. (5¹⁵⁄₁₆ x
4³⁄₁₆ in.), 1858
NPG.82.52

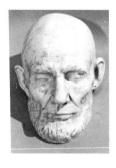

Lincoln, Abraham, 1809-1865
Sixteenth President of the United
States
Clark Mills, 1815-1883
Plaster life mask, 29.2 cm. (11½ in.),
cast after 1865 original
NPG.71.26
*Transfer from the National Museum
of American History*

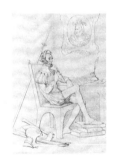

Lincoln, Abraham, 1809-1865
Sixteenth President of the United
States
Adalbert John Volck ("V. Blada"),
1828-1912, after John Roy
Robertson
Etching, 17 x 11.8 cm. (6¹¹⁄₁₆ x 4⅝
in.), 1861
From the series "Great American
Tragedians, Comedians, Clowns
and Rope Dancers in Their
Favorite Characters"
NPG.78.31

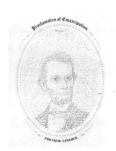

Lincoln, Abraham, 1809-1865
Sixteenth President of the United
States
William H. Pratt, active c. 1858-
c. 1888, after photograph by
Anthony Berger
A. Hageboeck lithography company
Lithograph, 31.3 x 22.9 cm. (12⁵⁄₁₆ x 9
in.), 1865
NPG.84.203

Lincoln, Abraham, 1809-1865
Sixteenth President of the United
States
Leonard Wells Volk, 1828-1895
Plaster life mask, 22.2 cm. (8¾ in.),
cast after 1860 bronze original
NPG.71.24
*Transfer from the National Museum
of American History*

Lincoln, Abraham, 1809-1865
Sixteenth President of the United
 States
Leonard Wells Volk, 1828-1895
Plaster, 66 cm. (26 in.), 1860
NPG.78.215

Lincoln, Abraham, 1809-1865
Sixteenth President of the United
 States
Unidentified photographer, after 1857
 photograph by Alexander Hesler
Photograph, albumen silver print,
 2.8 x 2 cm. (1⅛ x1³⁄₁₆ in.), c. 1860
NPG.80.249

Lincoln, Abraham, 1809-1865
Sixteenth President of the United
 States
Henry F. Warren, ?-?
Photograph, albumen silver print,
 33.8 x 25.8 cm. (13¹⁵⁄₁₆ x 10¹³⁄₁₆ in.),
 1865
NPG.82.141

Lincoln, Abraham, 1809-1865
Sixteenth President of the United
 States
Unidentified artist, after photograph
 by Anthony Berger
Woodcut, 32 x 23.2 cm. (12⁹⁄₁₆ x 9⅛
 in.), 1865
NPG.83.236

Lincoln, Abraham, 1809-1865
Sixteenth President of the United
 States
Frederick A. Wenderoth, c. 1814-
 1884, and William Curtis Taylor,
 active 1863-1890; studio active
 1863-1864
Photograph, albumen silver print,
 6.5 x 5.3 cm. (2⁹⁄₁₆ x 2¹⁄₁₆ in.), 1864
NPG.80.296

Lincoln, Benjamin, 1733-1810
Revolutionary general
John Rubens Smith, 1775-1849, after
 Henry Sargent
Mezzotint, 45 x 35 cm. (17¾ x 13¾
 in.), 1811
NPG.77.41

Lincoln, Abraham, 1809-1865
Sixteenth President of the United
 States
Henry Whateley, active c. 1859-1861,
 after photograph by Samuel M.
 Fassett
Thomas Sinclair lithography
 company
Lithograph with tintstone, 31.6 x
 24.5 cm. (12⁷⁄₁₆ x 9⅝ in.), c.
 1859-1860
Music sheet title page: "Lincoln
 Quick Step"
NPG.80.46

Lind, Jenny, 1820-1887
Singer
Napoleon Sarony, 1821-1896, after
 daguerreotype by Marcus Aurelius
 Root and Samuel Root
Lithograph with tintstone, 26.9 x
 20.4 cm. (10⁹⁄₁₆ x 8 in.), 1850
NPG.81.95

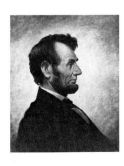

Lincoln, Abraham, 1809-1865
Sixteenth President of the United
 States
William Willard, 1819-1904
Oil on canvas, 61 x 45.5 cm. (24 x 18
 in.), 1864
NPG.76.36
Gift of Mr. and Mrs. David A. Morse

Lindbergh, Charles Augustus,
 1902-1974
Aviator
Jo Davidson, 1883-1952
Bronze, 38.1 cm. (15 in.), 1939
NPG.68.10

Lindbergh, Charles Augustus,
 1902-1974
Aviator
G. L. Manuel Frères, ?-?
Photograph, gelatin silver print, 18.3
 x 12.9 cm. (7³⁄₁₆ x 5¹⁄₁₆ in.), c. 1927
NPG.77.350

Lindbergh, Charles Augustus,
 1902-1974
Aviator
Harris and Ewing studio, active
 1905-1977
Photograph, gelatin silver print, 23 x
 15.4 cm. (9¹⁄₁₆ x 6¹⁄₁₆ in.), 1927
NPG.84.251
Gift of Aileen Conkey

Lindbergh, Charles Augustus,
 1902-1974
Aviator
Kenneth Stubbs, 1907-1967
Charcoal on paper, 62.5 x 47.9 cm.
 (24⅝ x 18⅞ in.), 1927
NPG.69.33
Gift of George O'Connor

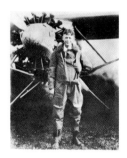

Lindbergh, Charles Augustus,
 1902-1974
Aviator
Unidentified photographer
Photograph, gelatin silver print, 23.3
 x 18.5 cm. (9⅛ x 7¼ in.), 1927
NPG.80.243

Lindsey, Benjamin B., 1869-1943
Jurist
Mary Frances Schreiber, ?-?
Oil on canvas, 55.8 x 45.5 cm. (22 x
 18 in.), 1940
NPG.83.153
Gift of David Mellinkoff

Lipchitz, Jacques, 1891-1973
Artist
Frederick S. Wight, 1902-1986
Oil on canvas, 72.4 x 55.8 cm. (28½ x
 22 in.), 1961
NPG.76.5
Gift of the artist

**Lippincott, Sara Jane Clarke
 ("Grace Greenwood"),** 1823-1904
Author
Napoleon Sarony, 1821-1896
Photograph, albumen silver print,
 14.8 x 10.5 cm. (5¾ x 4⅛ in.),
 c. 1872
NPG.80.297

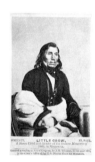

Little Crow the Younger, c.
 1803-1863
Indian chief
Joel Emmons Whitney, 1822-1886
Photograph, albumen silver print,
 8.5 x 5.7 cm. (3⅜ x 2⁷⁄₁₆ in.), 1862
NPG.83.123

Livermore, Mary Ashton Rice,
 1820-1905
Reformer
A. N. Hardy, active c. 1876
Photograph, albumen silver print, 10
 x 5.9 cm. (3¹⁵⁄₁₆ x 2⁵⁄₁₆ in.), c. 1876
NPG.81.71

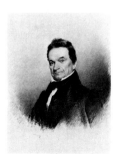

Livingston, Edward, 1764-1836
Statesman
James Barton Longacre, 1794-1869
Sepia watercolor on artist board, 26.1
 x 20.5 cm. (10¼ x 8¹⁄₁₆ in.), c. 1833
NPG.76.62

Livingston, Robert R., 1746-1813
Statesman, diplomat
Charles Balthazar Julien Févret de
 Saint-Mémin, 1770-1852, after
 Thomas Bluget de Valdenuit
Engraving, 5.6 cm. (2¼ in.) diameter,
 1796
NPG.74.39.104
Gift of Mr. and Mrs. Paul Mellon

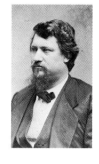

**Locke, David Ross ("Petroleum V.
 Nasby"),** 1833-1888
Journalist, humorist
Sumner B. Heald, ?-?, at George K.
 Warren studio
Photograph, albumen silver print,
 9.5 x 5.5 cm. (3¾ x 2³⁄₁₆ in.), c. 1875
NPG.80.92

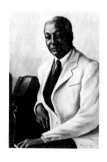

Lloyd, James, 1728-1810
Physician
Attributed to Rembrandt Peale,
 1778-1860, after Gilbert Stuart
Pendleton lithography company
Lithograph, 12.5 x 9 cm. (4⅞ x 3½
 in.), 1828
Published in James Thacher's
 American Medical Biography,
 Boston, 1828
NPG.78.132

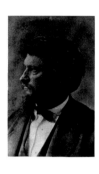

**Locke, David Ross ("Petroleum V.
 Nasby"),** 1833-1888
Journalist, humorist
Unidentified photographer
Photograph, albumen silver print,
 8.9 x 5.7 cm. (3½ x 2¼ in.), c. 1866
NPG.78.285

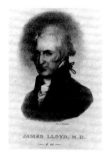

Locke, Alain LeRoy, 1886-1954
Author
Winold Reiss, 1886-1953
Pastel on artist board, 75.9 x 54.9 cm.
 (29⅞ x 21⅝ in.), c. 1925
NPG.72.84
*Gift of Lawrence A. Fleischman and
 Howard Garfinkle with a
 matching grant from the National
 Endowment for the Arts*

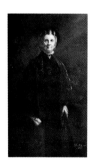

Lockwood, Belva Ann Bennett,
 1830-1917
Reformer
Benjamin J. Falk, 1853-1925
Photograph, albumen silver print,
 14.7 x 9.8 cm. (5¾ x 3⅞ in.),
 c. 1880
NPG.80.298

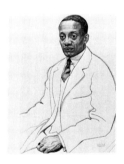

Locke, Alain LeRoy, 1886-1954
Author
Betsy Graves Reyneau, 1888-1964
Oil on canvas, 91.4 x 63.5 cm. (36 x
 25 in.), 1943-1944
NPG.67.85
Gift of the Harmon Foundation

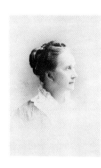

Lockwood, Belva Ann Bennett,
 1830-1917
Reformer
Nellie Mathes Horne, 1870-?
Oil on canvas, 177.1 x 101.6 cm.
 (69¾ x 40 in.), 1913
NPG.66.61
*Transfer from the National Museum
 of American Art; gift of the
 Committee on Tribute to Mrs.
 Belva Ann Lockwood through
 Mrs. Anna Kelton Wiley, 1917*

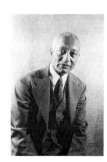

Locke, Alain LeRoy, 1886-1954
Author
Carl Van Vechten, 1880-1964
Photogravure, 22.4 x 15.1 cm. (8¹³⁄₁₆
 x 5¹⁵⁄₁₆ in.), 1983 from 1941
 negative
NPG.83.188.30

Lodge, Henry Cabot, 1850-1924
Statesman
Edward Penfield, 1886-1925, after
 photograph by Charles Milton Bell
Color lithographic poster, 45.2 x 21.5
 cm. (17¾ x 8⁷⁄₁₆ in.), 1899
NPG.83.174

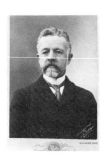

Lodge, Henry Cabot, 1850-1924
Statesman
James E. Purdy, 1859-1933
Photograph, gelatin silver print, 13.9
 x 10 cm. (5½ x 3¹⁵⁄₁₆ in.), 1902
NPG.82.60

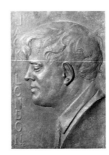

London, Jack, 1876-1916
Author
Finn Haakon Frölich, 1868-1947
Plaster relief, 42.5 x 30.4 cm. (16¾ x
 12 in.), 1915
Bronze relief, 50 x 29.5 cm. (16½ x
 11⅝ in.), cast after 1915 plaster
NPG.68.16 (illustrated) and
 NPG.68.16.1
Plaster, a gift of Irving Shephard

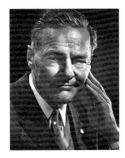

Lodge, Henry Cabot, 1850-1924
Statesman
John Singer Sargent, 1856-1925
Oil on canvas, 127 x 86.4 cm. (50 x
 34 in.), 1890
NPG.67.58
Gift of the Hon. Henry Cabot Lodge

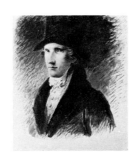

Longacre, James Barton, 1794-1869
Artist
Self-portrait
Watercolor on paper, 12.7 x 11.4 cm.
 (5 x 4½ in.), c. 1820
NPG.67.14

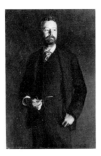

Lodge, Henry Cabot, Jr.*, 1902-1985
Statesman
David Lee Iwerks, 1933-
Photograph, gelatin silver print, 24 x
 19 cm. (9⁷⁄₁₆ x 7½ in.), 1960
T/NPG.78.187.95

Longacre, James Barton, 1794-1869
Artist
Self-portrait
Watercolor on paper, 12 x 12.7 cm.
 (4¾ x 5 in.), c. 1807
NPG.77.301

Logan, John Alexander, 1826-1886
Union general
Currier and Ives lithography
 company, active 1857-1907, after
 photograph by Abraham Bogardus
Lithograph, 33 x 28 cm. (13 x 11 in.),
 1884
NPG.85.151

Longacre, James Barton, 1794-1869
Artist
Self-portrait
Watercolor on artist board, 26 x 20.2
 cm. (10¼ x 8 in.), c. 1845
NPG.78.52

Logan, John Alexander, 1826-1886
Union general
Unidentified artist, after photograph
Hand-colored lithograph, 26 x 22.4
 cm. (10¼ x 8¹³⁄₁₆ in.), c. 1865
NPG.85.56

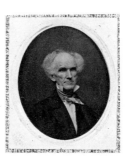

Longacre, James Barton, 1794-1869
Artist
Isaac Rehn, active 1845-1875
Ambrotype, 8.2 x 6.8 cm. (3¼ x 2¹¹⁄₁₆
 in.), c. 1855
NPG.77.305

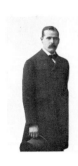

Longbaugh, Harry ("The Sundance Kid"), c. 1862-1909
Criminal
Attributed to DeYoung studio, active 1885-?
Photograph, gelatin silver print, 8.9 x 5.6 cm. (3½ x 2³⁄₁₆ in.), c. 1901
NPG.82.64
Gift of Pinkerton's, Incorporated

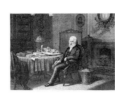

Longfellow, Henry Wadsworth, 1807-1882
Poet
Samuel Hollyer, 1826-1919, after photograph
Engraving, 35.5 x 50.6 cm. (13¹⁵⁄₁₆ x 19⅞ in.), 1881
NPG.85.169

Longfellow, Henry Wadsworth, 1807-1882
Poet
Julia Margaret Cameron, 1815-1879
Photograph, albumen silver print, 34.2 x 26.8 cm. (13½ x 10½ in.), 1868
NPG.82.61

Longfellow, Henry Wadsworth, 1807-1882
Poet
Alphonse Legros, 1837-1911, after Napoleon Sarony
Lithograph, 29 x 22.7 cm. (11⅝ x 8¹⁵⁄₁₆ in.), 1875
NPG.78.260

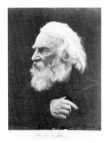

Longfellow, Henry Wadsworth, 1807-1882
Poet
William Merritt Chase, 1849-1916, after photograph by Julia Margaret Cameron
Etching and drypoint, 20.7 x 16.2 cm. (8⅛ x 6⅜ in.), 1882
NPG.83.166

Longfellow, Henry Wadsworth, 1807-1882
Poet
William Edgar Marshall, 1837-1906
Etching and line engraving, 64.5 x 50.5 cm. (25⅜ x 19⅞ in.), 1881
NPG.70.69

Longfellow, Henry Wadsworth, 1807-1882
Poet
Francis D'Avignon, c. 1814-?, after daguerreotype by Whipple and Black studio
Lithograph, 39.8 x 29.4 cm. (15¹¹⁄₁₆ x 11⁹⁄₁₆ in.), 1859
NPG.72.60

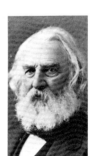

Longfellow, Henry Wadsworth, 1807-1882
Poet
George K. Warren, c. 1824-1884
Photograph, albumen silver print, 9.6 x 5.8 cm. (3¾ x 2⁵⁄₁₆ in.), c. 1870
NPG.79.19

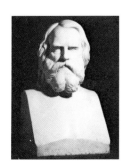

Longfellow, Henry Wadsworth, 1807-1882
Poet
James Henry Haseltine, 1833-1907
Marble, 59 cm. (23¼ in.), 1871
NPG.67.27

Longfellow, Henry Wadsworth, 1807-1882
Poet
Theodore Wust, active c. 1860-c. 1901
Watercolor on ivory, 8.9 x 7 cm. (3½ x 2¾ in.) oval, 1871
NPG.70.70
Gift of Gary J. Polinsky in memory of his mother, Lily Esther Rose

Longfellow, Henry Wadsworth,
 1807-1882
Poet
Unidentified photographer
Photograph, albumen silver print, 6
 x 4.3 cm. (2⁵⁄₁₆ x 1¹¹⁄₁₆ in.), c. 1863
NPG.82.95
Gift of Forrest H. Kennedy

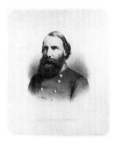

Longstreet, James, 1821-1904
Confederate general
J. L. Giles lithography company,
 active 1835-1881, after photograph
Lithograph with tintstone, 30.6 x
 25.2 cm. (12¹⁄₁₆ x 9¹⁵⁄₁₆ in.), c. 1868
NPG.84.337

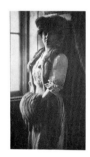

Longworth, Alice Roosevelt*,
 1884-1980
Socialite
Edward Sheriff Curtis, 1868-1952
Photograph, brown-toned platinum
 print, 40 x 22.2 cm. (15¾ x 8¾ in.),
 1906
T/NPG.81.129.90
Gift of Joanna Sturm

Longworth, Alice Roosevelt*,
 1884-1980
Socialite
Aline Fruhauf, 1907-1978
Woodcut, 25.1 x 8.3 cm. (9⅞ x 3¼
 in.), 1971
T/NPG.83.265.90
Gift of Erwin Vollmer

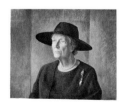

Longworth, Alice Roosevelt*,
 1884-1980
Socialite
Peter Hurd, 1904-1984
Tempera on masonite, 61 x 72.2 cm.
 (24 x 30 in.), 1965
T/NPG.81.115.90
Gift of Joanna Sturm

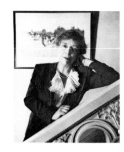

Longworth, Alice Roosevelt*,
 1884-1980
Socialite
Arnold Newman, 1918-
Photograph, gelatin silver print, 24.8
 x 20.7 cm. (9¹³⁄₁₆ x 8⅛ in.), 1948
T/NPG.81.154.90
Gift of Joanna Sturm

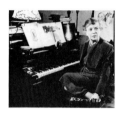

Longworth, Alice Roosevelt*,
 1884-1980
Socialite
Arnold Newman, 1918-
Photograph, gelatin silver print, 20.7
 x 23.5 cm. (8³⁄₁₆ x 9¼ in.), 1948
T/NPG.81.166.90
Gift of Joanna Sturm

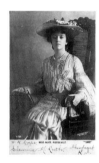

Longworth, Alice Roosevelt*,
 1884-1980
Socialite
Pach Brothers studio, active since
 1867
Photograph, gelatin silver print, 12.6
 x 8.5 cm. (4¹⁵⁄₁₆ x 3⁵⁄₁₆ in.), 1904
T/NPG.81.156.90
Gift of Joanna Sturm

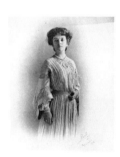

Longworth, Alice Roosevelt*,
 1884-1980
Socialite
Pach Brothers studio, active since
 1867
Photograph, platinum print, 23.3 x
 16.4 cm. (9³⁄₁₆ x 6⁷⁄₁₆ in.), 1906
T/NPG.81.159.90
Gift of Joanna Sturm

Longworth, Alice Roosevelt*,
 1884-1980
Socialite
H. H. Pierce, ?-?
Photograph, platinum print, 23.3 x
 16.9 cm. (9³⁄₁₆ x 6¹¹⁄₁₆ in.), 1905
T/NPG.81.167.90
Gift of Joanna Sturm

Longworth, Nicholas, 1869-1931
Public official
Samuel Johnson Woolf, 1880-1948
Charcoal and gouache on paper, 50.8
 x 38.1 cm. (20 x 15 in.), 1928
NPG.80.268

Louchheim, Katie*, ?-
Author, public official
Harry Rosin, 1899-1973
Bronze, 27.9 cm. (11 in.), 1947
T/NPG.83.121
Gift of Mrs. Katie Louchheim

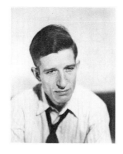

Louis, Morris ("Louis Bernstein"),
 1912-1962
Artist
Unidentified photographer
Photograph, gelatin silver print, 23.5
 x 18.4 cm. (9¼ x 7¼ in.), c. 1940
NPG.83.33
Gift of Marcella Brenner

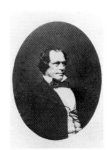

Lovejoy, Owen, 1811-1864
Abolitionist
Unidentified photographer
Photograph, albumen silver print,
 7.5 x 5.7 cm. (2¹⁵⁄₁₆ x 2¼ in.),
 c. 1860
NPG.79.49

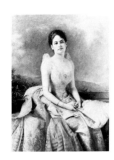

Low, Juliette Gordon, 1860-1927
Founder of Girl Scouts in America
Edward Hughes, 1832-1908
Oil on canvas, 132.3 x 97.1 cm. (52⅛
 x 38¼ in.), 1887
NPG.73.5
*Gift of the Girl Scouts of the United
 States of America*

Lowell, James Russell, 1819-1891
Poet, diplomat
Gustav Kruell, 1843-1907, after
 photographs
Wood engraving, 23.7 x 17.1 cm.
 (9⁵⁄₁₆ x 6¾ in.), 1891
Published in Gustav Kruell's
 Portfolio of National Portraits,
 New York, 1899
NPG.81.45

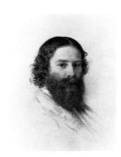

Lowell, James Russell, 1819-1891
Poet, diplomat
Samuel Worcester Rowse, 1822-1901
Crayon on paper, 63.5 x 51 cm. (25 x
 20 in.), not dated
NPG.76.12
Gift of Susan Norton

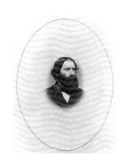

Lowell, James Russell, 1819-1891
Poet, diplomat
Unidentified photographer
Photograph, salt print, 15.5 x 12 cm.
 (6⅛ x 4¾ in.), 1861
NPG.77.203

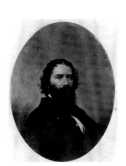

Lowell, James Russell, 1819-1891
Poet, diplomat
Unidentified photographer
Photograph, albumenized salt print,
 14.2 x 10.9 cm. (5⁹⁄₁₆ x 4⁵⁄₁₆ in.),
 1857
NPG.78.153

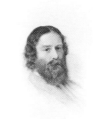

Lowell, James Russell, 1819-1891
Poet, diplomat
Unidentified artist, after Samuel
 Worcester Rowse
Engraving, 16 x 12.5 cm. (6½ x 5 in.),
 c. 1894
NPG.80.223
Gift of Marvin Sadik

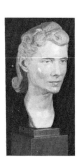

Luce, Clare Boothe*, 1903-1987
Author, stateswoman
Jo Davidson, 1883-1952
Polychromed plaster, 36.8 cm. (14½
　in.), 1937
T/NPG.82.124
Gift of Clare Boothe Luce

Luce, Clare Boothe*, 1903-1987
Author, stateswoman
Philippe Halsman, 1906-1979
Photograph, gelatin silver print, 34.4
　x 27.3 cm. (13½ x 10¾ in.), 1953
T/NPG.83.101
Gift of George R. Rinhart

Luce, Henry Robinson, 1898-1967
Publisher
Jo Davidson, 1883-1952
Plaster, 42.5 cm. (16¾ in.), 1937
NPG.82.125
Gift of Clare Boothe Luce

Luce, Henry Robinson, 1898-1967
Publisher
Edward Steichen, 1879-1973
Photograph, gelatin silver print, 19.4
　x 24.2 cm. (7⅝ x 9½ in.), 1935
NPG.82.84
Bequest of Edward Steichen

Luce, Henry Robinson, 1898-1967
Publisher
Miriam Troop, 1917-
Pencil on paper, 27.8 x 29.1 cm.
　(10¹⁵⁄₁₆ x 11½ in.), 1955
NPG.72.43

Luks, George Benjamin, 1867-1933
Artist
Jo Davidson, 1883-1952
Bronze, 21.6 cm. (8½ in.), 1909
NPG.77.325
Gift of Dr. Maury Leibovitz

Luks, George Benjamin, 1867-1933
Artist
William James Glackens, 1870-1938
Oil on canvas, 76.2 x 63.5 cm. (30 x
　25 in.), 1899
NPG.78.53
Gift of Ira Glackens

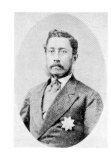

Lunalilo, William Charles,
　1835-1874
Hawaiian ruler
Menzies Dickson, c. 1840-1891
Photograph, albumen silver print,
　6.7 x 4.8 cm. (2¹¹⁄₁₆ x 1⅞ in.),
　c. 1873
NPG.80.321
*Gift of the Bernice Pauahi Bishop
　Museum*

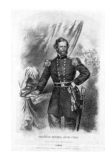

Lyon, Nathaniel, 1818-1861
Union officer
Joseph E. Baker, 1835-1914, after
　photograph by W. L. Troxel
J. H. Bufford lithography company
Lithograph with tintstone, 33.3 x
　23.2 cm. (13⅛ x 9⅛ in.), 1861
NPG.82.9

MacArthur, Douglas, 1880-1964
World War II and Korean War
　general
Howard Chandler Christy, 1873-1952
Oil on canvas, 139.7 x 101.6 cm. (55
　x 40 in.), 1952
NPG.78.271
Gift of Henry Ostrow

MacArthur, Douglas, 1880-1964
World War II and Korean War
 general
Rodolphe Kiss, 1889-1953
Oil on canvas, 8.9 x 63.5 cm. (35 x 25
 in.), 1947
NPG.66.24
*Gift of Mrs. Elisha Gee, Jr., in
 memory of the artist*

MacArthur, Douglas, 1880-1964
World War II and Korean War
 general
Unidentified photographer
Photograph, gelatin silver print, 24.5
 x 19.5 cm. (9⅝ x 7⅝ in.), 1930
NPG.80.241

McBride, Henry, 1867-1962
Art critic
Peggy Bacon, 1895-1987
Crayon on paper, 26 x 19 cm. (10¼ x
 7½ in.), c. 1935
NPG.74.64

McBride, Henry, 1867-1962
Art critic
Aline Fruhauf, 1907-1978
India ink over pencil on paper, 38.2
 x 28 cm. (15 x 11 in.), 1932
Published in *Creative Art,* New
 York, February 1932
NPG.83.40
Gift of Erwin Vollmer

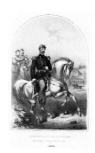

McClellan, George Brinton,
 1826-1885
Union general
Joseph E. Baker, 1835-1914, after
 photograph
J. H. Bufford lithography company
Lithograph with tintstone, 29.3 x
 20.2 cm. (11⁹⁄₁₆ x 7¹⁵⁄₁₆ in.), 1861
NPG.82.18

McClellan, George Brinton,
 1826-1885
Union general
Currier and Ives lithography
 company, active 1857-1907, after
 photograph
Hand-colored lithograph, 37.1 x 34.1
 cm. (14⅝ x 13⅜ in.), c. 1861-1865
NPG.79.178

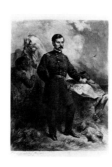

McClellan, George Brinton,
 1826-1885
Union general
Felix Octavius Carr Darley,
 1822-1888
Ink over pencil on paper, 33.4 x 25.6
 cm. (13⅛ x 10¹⁄₁₆ in.), not dated
NPG.76.13

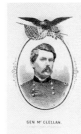

McClellan, George Brinton,
 1826-1885
Union general
Louis Prang lithography company,
 active 1856-1899, after photograph
Lithograph, 8.3 x 6 cm. (3¼ x 2⅜
 in.), 1862
Contained in D. Dudley's *Officers of
 Our Union Army and Navy. Their
 Lives, Their Portraits,* vol. 1,
 Washington, D.C., and Boston,
 1862
NPG.80.119.u

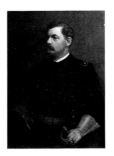

McClellan, George Brinton,
 1826-1885
Union general
Julian Scott, 1846-1901
Oil on canvas, 101.6 x 76.2 cm. (40 x
 30 in.), not dated
NPG.65.35
*Transfer from the National Museum
 of American Art; bequest of
 Georgiana L. McClellan, 1953*

McClellan, George Brinton,
 1826-1885
Union general
Adam B. Walter, 1820-1875, after
 Christian Schussele, after
 photograph
Mezzotint and engraving, 60.7 x 47.5
 cm. (23⅞ x 18¹¹⁄₁₆ in.), 1863
NPG.79.226

McClellan, George Brinton,
1826-1885
Union general
Unidentified artist
Wood carving, 58.4 x 63.5 x 14.6 cm.
(23 x 25 x 5¾ in.), c. 1862
NPG.78.216

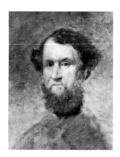

McCormick, Cyrus Hall, 1809-1884
Inventor
Charles Loring Elliott, 1812-1868
Oil on canvas, 50.8 x 41.2 cm. (20 x
16¼ in.), after 1846
NPG.75.2
*Gift of Chauncey and Marion
Deering McCormick Foundation
and Mrs. Gilbert Harrison*

McClendon, Rose, 1884-1936
Actress
Carl Van Vechten, 1880-1964
Photogravure, 22.4 x 15 cm. (8¹³⁄₁₆ x
5⅞ in.), 1983 from 1932 negative
NPG.83.188.32

MacDonald-Wright, Stanton,
1890-1973
Artist
Self-portrait
Oil on plywood, 60.5 x 76 cm. (24⅞ x
30 in.), 1951
NPG.81.119

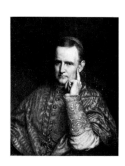

McCloskey, John, 1810-1885
Clergyman
George Peter Alexander Healy,
1813-1894
Oil on canvas, 75.6 x 63.5 cm. (29¾ x
25 in.), 1875
NPG.65.68
*Transfer from the National Gallery
of Art; gift of Miss Elizabeth
McCloskey Cleary, 1951*

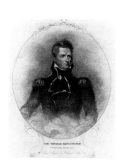

MacDonough, Thomas, 1783-1825
War of 1812 naval officer
Thomas Gimbrede, 1781-1832, after
John Wesley Jarvis
Stipple engraving, 30.6 x 20.8 cm.
(12¹⁄₁₆ x 8¹³⁄₁₆ in.), c. 1815
NPG.76.48

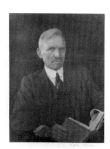

McClure, Samuel Sidney, 1857-1949
Editor
Doris Ulmann, 1882-1934
Photograph, platinum print, 20.4 x
15.4 cm. (8¹⁄₁₆ x 6¹⁄₁₆ in.), c. 1925
NPG.85.27

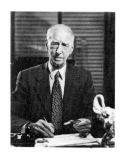

**McGillicuddy, Cornelius ("Connie
Mack"),** 1862-1956
Athlete, baseball manager
Philippe Halsman, 1906-1979
Photograph, gelatin silver print, 34.8
x 27.3 cm. (13¾ x 10¾ in.), 1948
NPG.82.166
Gift of George R. Rinhart

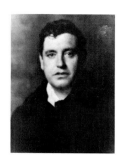

McCormack, John Francis, 1884-1945
Singer
Arnold Genthe, 1869-1942
Photograph, gelatin silver print, 24.1
x 18.7 cm. (9½ x 7⅜ in.), c. 1920
NPG.77.339

McGovern, George Stanley*, 1922-
Statesman
Larry Rivers, 1923- , after
photograph by Malcolm Varon
Color halftone poster, 75.7 x 58.5 cm.
(29¹³⁄₁₆ x 23 in.), 1972
T/NPG.84.322
Gift of Virginia Zabriskie

McGuffey, William Holmes,
1800-1873
Educator
Ernest Bruce Haswell, 1889-
Plaster, 53 cm. (20⅞ in.), cast after
c. 1940 original
Bronze, 51.1 cm. (20⅛ in.), cast after
1968 plaster
NPG.68.46 and NPG.68.46.1
*Plaster, a gift of Miami University,
Oxford, Ohio*

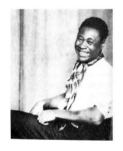

McKay, Claude, 1889-1948
Author
Berenice Abbott, 1898-
Photograph, gelatin silver print, 16.5
x 12.3 cm. (6½ x 4⅞ in.), 1926
NPG.77.266

McKay, Claude, 1889-1948
Author
Berenice Abbott, 1898-
Photograph, gelatin silver print, 24.2
x 19.4 cm. (9 9/16 x 7⅝ in.), 1926
NPG.82.167

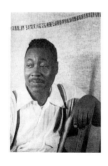

McKay, Claude, 1889-1948
Author
Carl Van Vechten, 1880-1964
Photogravure, 22.4 x 14.9 cm. (8 13/16
x 5⅞ in.), 1983 from 1941 negative
NPG.83.188.33

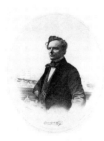

McKay, Donald, 1818-1880
Shipbuilder
Leopold Grozelier, 1830-1865, after
daguerreotype by Southworth and
Hawes studio
S. W. Chandler and Brother
lithography company
Lithograph, 46.4 x 38.5 cm. (18¼ x
15⅛ in.), 1854
NPG.85.174

MacKay, John William, 1831-1902
Miner, financier
Achille Jacquet, 1846-1908, after
Alexander Cabanel
Engraving, 26.3 x 20 cm. (10⅜ x 7⅞
in.), c. 1878
NPG.68.59
Gift of Mrs. Robert C. Hawkins

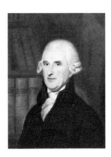

McKean, Thomas, 1734-1817
Revolutionary statesman
Attributed to Charles Willson Peale,
1741-1827
Oil on canvas, 69.2 x 55.8 cm. (27¼ x
22 in.), 1785?
NPG.66.63
*Transfer from the National Museum
of American Art; gift of the
Collection of George Buchanan
Coale, 1926*

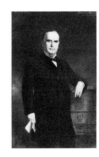

McKinley, William, 1843-1901
Twenty-fifth President of the United
States
August Benziger, 1867-1955
Oil on canvas, 149.2 x 99 cm. (58¾ x
39 in.), 1897
NPG.69.34
Gift of Miss Marieli Benziger

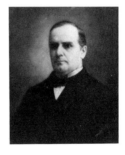

McKinley, William, 1843-1901
Twenty-fifth President of the United
States
Marion (Foote?), ?-?
Pastel on paper, 63.5 x 52 cm. (25 x
20½ in.), 1892
NPG.68.56
*Gift of Mrs. John K. Waters in
memory of Colonel William
Dawes McKinley*

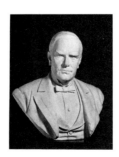

McKinley, William, 1843-1901
Twenty-fifth President of the United
States
A. Frilli, ?-?
Marble, 58.1 cm. (22⅞ in.), not dated
NPG.69.81
Gift of Victor D. Spark

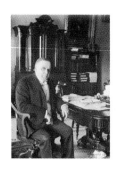

McKinley, William, 1843-1901
Twenty-fifth President of the United
States
Frances Benjamin Johnston,
1864-1952
Photograph, platinum print, 20.8 x
14.9 cm. (8³⁄₁₆ x 5⅞ in.), c. 1899
NPG.80.204

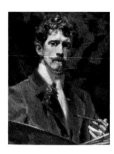

MacMonnies, Frederick William,
1863-1937
Artist
Self-portrait
Oil on canvas, 73.6 x 48.2 cm. (29 x
19 in.), not dated
NPG.70.44

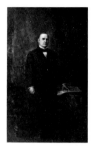

McKinley, William, 1843-1901
Twenty-fifth President of the United
States
Charles Ayer Whipple, 1859-1928
Oil on canvas, 251.4 x 154.9 cm.
(99 x 61 in.), 1899
NPG.66.11
Gift of Mrs. Mary E. Krieg

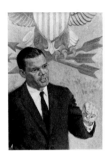

McNamara, Robert Strange*, 1916-
Statesman
Gilbert Early, 1936-
Oil on artist board, 49.5 x 35.5 cm.
(19½ x 14 in.), 1965
T/NPG.65.8
Gift of the artist

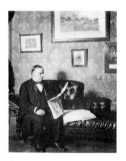

McKinley, William, 1843-1901
Twenty-fifth President of the United
States
Unidentified photographer
Photograph, platinum print, 25.5 x
19.4 cm. (9⅝ x 7⅝ in.), 1896
NPG.80.247

Macomb, Alexander, 1782-1841
War of 1812 army officer
E. B. and E. C. Kellogg lithography
company, active c. 1842-1867, after
William Henry Brown
Lithographed silhouette, 34 x 25.2
cm. (13⅜ x 9¹⁵⁄₁₆ in.), 1844
Published in William H. Brown's
*Portrait Gallery of Distinguished
American Citizens,* Hartford, 1845
NPG.80.276.l
Gift of Wilmarth Sheldon Lewis

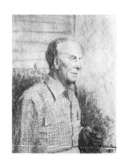

MacLeish, Archibald*, 1892-1982
Poet, public official
Ellen Barry, ?-
Conté crayon over graphite on paper,
30.5 x 22.8 cm. (12 x 9 in.), 1981
T/NPG.82.134.92
Gift of Barry Bingham, Sr.

MacVeagh, Isaac Wayne, 1833-1917
Public official
Augustus Saint-Gaudens, 1848-1907
Bronze medallion, 7.9 cm. (3³⁄₁₆ in.)
diameter, 1902
NPG.65.64
Gift of Eames MacVeagh

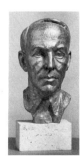

MacLeish, Archibald*, 1892-1982
Poet, public official
Milton Hebald, 1917-
Bronze, 38.1 cm. (15 in.), 1984 cast of
1957 original
T/NPG.84.173.92

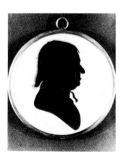

MacWhorter, Alexander, 1734-1807
Clergyman
Isaac Todd, ?-1811?
Silhouette, 9.5 cm. (3¾ in.) diameter,
not dated
NPG.69.73
Gift of Marvin Sadik

Macy, Anne Sullivan, 1866-1936
Teacher
Onorio Ruotolo, 1888-1966
Plaster life mask, 52 cm. (20½ in.),
 1916
NPG.75.17

Madison, Dolley Payne, 1768-1849
First lady
Mary Estelle Elizabeth Cutts,
 1814-1856
Watercolor and pencil on paper, 12.4
 x 10.8 cm. (4⅞ x 4¼ in.),
 c. 1840-1845
NPG.77.29

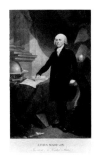

Madison, Dolley Payne, 1768-1849
First lady
William S. Elwell, 1810-1881
Oil on canvas, 76.2 x 63.5 cm. (30 x
 25 in.) feigned oval, 1848
NPG.74.6

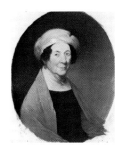

Madison, James, 1751-1836
Fourth President of the United States
David Edwin, 1776-1841, after
 Thomas Sully, after Gilbert Stuart
Stipple engraving, 50.3 x 33.3 cm.
 (19¹³⁄₁₆ x 13⅛ in.), 1810
NPG.77.252
Gift of Mrs. Katie Louchheim

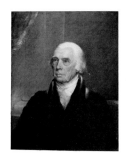

Madison, James, 1751-1836
Fourth President of the United States
Chester Harding, 1792-1866
Oil on canvas, 76.2 x 63.5 cm. (30 x
 25 in.), c. 1825-1830
NPG.68.50

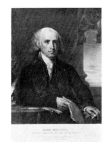

Madison, James, 1751-1836
Fourth President of the United States
Attributed to Nicolas Eustache
 Maurin, 1799-1850, after Gilbert
 Stuart
Pendleton lithography company
Lithograph, 30.2 x 24.5 cm. (11¾ x
 9⅝ in.), c. 1825-1828
NPG.77.89

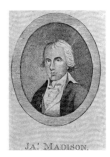

Madison, James, 1751-1836
Fourth President of the United States
Unidentified artist, probably after
 Charles Willson Peale
Stipple and line engraving, 8.6 x 7
 cm. (3⅜ x 2¾ in.), 1796
Published in Charles Smith's *The
 Gentleman's Political Pocket
 Almanack for 1797*, New York,
 1796
NPG.77.211

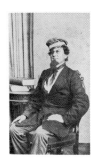

Maffitt, John Newland, 1819-1886
Naval officer
Unidentified photographer
Photograph, albumen silver print,
 9.2 x 5.4 cm. (3⅝ x 2⅛ in.), c. 1865
NPG.80.180

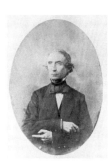

Mahan, Dennis Hart, 1802-1871
Military strategist
Unidentified photographer
Photograph, salt print, 18.5 x 13 cm.
 (7⁵⁄₁₆ x 5⅛ in.), c. 1856
NPG.84.130

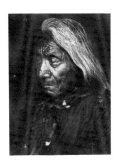

Mahpina Luta ("Red Cloud"),
 1822-1909
Indian chief
Edward Sheriff Curtis, 1868-1952
Photograph, photogravure print, 40
 x 30 cm. (15¾ x 11¹³⁄₁₆ in.), 1905
NPG.78.69

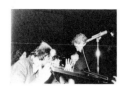

Mailer, Norman*, 1923-
Author
Garry Winogrand, 1928-1984
Photograph, gelatin silver print, 31.5
 x 47 cm. (12⅜ x 18½ in.), 1973
T/NPG.84.24

**Makataimeshekiakiak ("Black
 Hawk")**, 1767-1838
Indian chief
John Cameron, active 1848-1862,
 after James Otto Lewis
Charles Currier, printer
Hand-colored lithograph, 19 x 18 cm.
 (7½ x 7⅛ in.), 1836
Published in James Otto Lewis's *The
 Aboriginal Port-folio*, New York,
 1853
NPG.79.90

Malamud, Bernard*, 1914-1986
Author
Karl Schrag, 1912-
Color aquatint, 60.6 x 45.3 cm. (23⅞
 x 17¹³⁄₁₆ in.), 1970
T/NPG.84.188.96

Mallory, Stephen Russell, c.
 1813-1873
Statesman
Unidentified photographer
Daguerreotype, 14 x 10.8 cm. (5½ x
 4¼ in.), c. 1852
NPG.79.115

Mann, Horace, 1796-1859
Educator
Joseph E. Baker, 1835-1914, after
 daguerreotype
Lithograph, 44.3 x 36.8 cm. (17⁷⁄₁₆ x
 14½ in.), c. 1860
NPG.78.131

Mann, Horace, 1796-1859
Educator
Thomas A. Carew, active 1843-1860
Plaster, 73.6 cm. (29 in.), 1852
NPG.78.33

Mann, Horace, 1796-1859
Educator
Francis D'Avignon, c. 1814-?, after
 daguerreotype
Lithograph with tintstone, 42.1 x
 33.9 cm. (16⁹⁄₁₆ x 13⅜ in.), 1859
NPG.77.224

Mann, James Robert, 1856-1922
Statesman
Gari Melchers, 1860-1932
Oil on canvas, 154.9 x 96.5 cm. (61 x
 38 in.), not dated
NPG.66.62
*Transfer from the National Museum
 of American Art; gift of Mrs. James
 R. Mann, 1924*

Man Ray, 1890-1976
Photographer
David Hockney, 1937- , after
 crayon drawing
Lithograph, 58.5 x 42.3 cm. (23 x 16⅝
 in.), 1976
NPG.84.191

Man Ray, 1890-1976
Photographer
Self-portrait
Photograph, gelatin silver print, 20.8
 x 16.2 cm. (8³⁄₁₆ x 6⅜ in.), 1924
NPG.82.142

Mansfield, Richard, 1854-1907
Actor
Orlando Rouland, 1871-1945
Oil on canvas, 211.4 x 101.6 cm.
 (83¼ x 40 in.), 1907
NPG.65.34
*Transfer from the National Museum
 of American Art; gift of Henry
 Harkness Flagler to the
 Smithsonian Institution, 1932*

Marcy, William Learned, 1786-1857
Public official
Unidentified artist
Oil on canvas, 87.3 x 73.6 cm. (34⅜ x
 29 in.), not dated
NPG.81.98
Gift of Joseph Collector

Marin, John, 1870-1953
Artist
Self-portrait
Pencil on paper, 22.8 x 17.8 cm. (9 x
 7 in.), not dated
NPG.83.136

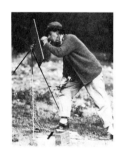

Marin, John, 1870-1953
Artist
Paul Strand, 1890-1976
Photograph, gelatin silver print, 12 x
 9.3 cm. (4¹¹⁄₁₆ x 3⅝ in.), 1930
NPG.82.99

Marion, Francis, c. 1732-1795
Revolutionary general
James Barton Longacre, 1794-1869,
 after Thomas Stothard
Sepia watercolor on paper, 19 x 14.8
 cm. (7½ x 5¹³⁄₁₆ in.), c. 1835
NPG.77.292

Markham, Edwin, 1852-1940
Poet
Harris and Ewing studio, active
 1905-1977
Photograph, brown-toned gelatin
 silver print, 33.2 x 25.4 cm. (13¹⁄₁₆
 x 10¹⁄₁₆ in.), c. 1922
NPG.84.252
Gift of Aileen Conkey

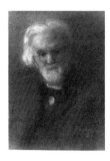

Markham, Edwin, 1852-1940
Poet
Glen Cooper Henshaw, 1881-1969
Pastel on paper, 76 x 56 cm. (30 x 22
 in.), 1925
NPG.70.51
Gift of the Bobbs-Merrill Company

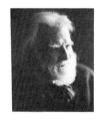

Markham, Edwin, 1852-1940
Poet
Clara E. Sipprell, 1885-1975
Photograph, gelatin silver print, 22.6
 x 18.9 cm. (8¹⁵⁄₁₆ x 7⁷⁄₁₆ in.), c. 1930
NPG.82.187
Bequest of Phyllis Fenner

Marlowe, Julia, 1866-1950
Actress
Benjamin J. Falk, 1853-1925
Photograph, albumen silver print, 30
 x 18.3 cm. (11¹³⁄₁₆ x 7¼ in.), 1890
NPG.84.320
Gift of Fred Bell

Marlowe, Julia, 1866-1950
Actress
Alfred J. Frueh, 1880-1968
Linocut, 27.6 x 23.3 cm. (10⅞ x 9⅛
 in.), 1922
Published in Alfred J. Frueh's *Stage
 Folk*, New York, 1922
NPG.84.229.d

Marlowe, Julia, 1866-1950
Actress
Arnold Genthe, 1869-1942
Photograph, gelatin silver print, 22.5
 x 18.2 cm. (8¹³⁄₁₆ x 7³⁄₁₆ in.), c. 1911
NPG.83.200

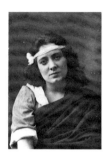

Marlowe, Julia, 1866-1950
Actress
Rose studio, active 1886-?
Photograph, carbon print, 14.1 x 9.9
 cm. (5⁹⁄₁₆ x 3⅞ in.), 1897
NPG.78.287

Marsh, Reginald, 1898-1954
Artist
Aline Fruhauf, 1907-1978
Black and brown wash with pencil
 and opaque white on paper, 29.5 x
 23.8 cm. (11⅝ x 9⅜ in.), 1933
NPG.83.266
Gift of Erwin Vollmer

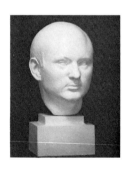

Marsh, Reginald, 1898-1954
Artist
Mary Tarleton Knollenberg, 1904-
Plaster, 29.8 cm. (11¾ in.), 1931
NPG.85.76
Gift of Mary Tarleton Knollenberg

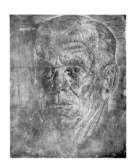

Marshall, George Catlett, 1880-1959
World War II general, statesman
Elias Kanarek, 1901-1969
Woodblock, 24.7 x 20 cm. (9¾ x 7⅞
 in.), c. 1950
NPG.67.90
Gift of the artist

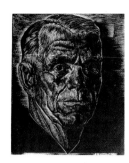

Marshall, George Catlett, 1880-1959
World War II general, statesman
Elias Kanarek, 1901-1969
Wood engraving, 24.2 x 19.9 cm.
 (9⁹⁄₁₆ x 7¹³⁄₁₆ in.), c. 1950
NPG.67.91
Gift of the artist

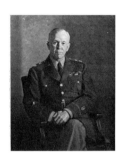

Marshall, George Catlett, 1880-1959
World War II general, statesman
Thomas Edgar Stephens, 1886-1966
Oil on canvas, 127 x 101.6 cm. (50 x
 40 in.), c. 1949
NPG.65.66
*Transfer from the National Gallery
 of Art; gift of Ailsa Mellon Bruce,
 1951*

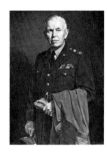

Marshall, George Catlett, 1880-1959
World War II general, statesman
James Anthony Wills, 1912-
Oil on canvas, 107.9 x 79.1 cm.
 (42½ x 31⅛ in.), 1949
NPG.66.64
*Transfer from the National Museum
 of American Art; gift of the
 International Business Machines
 Corporation to the Smithsonian
 Institution, 1962*

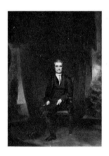

Marshall, John, 1755-1835
Chief Justice of the United States
William James Hubard, 1807-1862
Oil on canvas, 61.6 x 38.9 cm. (24¼ x
 15⅛ in.), c. 1832
NPG.74.71

Marshall, John, 1755-1835
Chief Justice of the United States
E. B. and E. C. Kellogg lithography
 company, active c. 1842-1867, after
 William Henry Brown
Lithographed silhouette, 34.3 x 25.2
 cm. (13⁷⁄₁₆ x 9¹⁵⁄₁₆ in.), 1844
Published in William H. Brown's
 *Portrait Gallery of Distinguished
 American Citizens,* Hartford, 1845
NPG.80.224

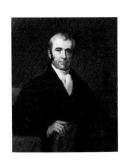

Marshall, John, 1755-1835
Chief Justice of the United States
James Reid Lambdin, 1807-1889,
 after the 1831 oil by Henry Inman
Oil on canvas, 90.2 x 73.6 cm. (35½ x
 29 in.), after 1831
NPG.65.54
*Transfer from the National Gallery
 of Art; gift of Andrew W. Mellon,
 1942*

Marshall, John, 1755-1835
Chief Justice of the United States
Waterman Lilly Ormsby, 1809-1883,
 after model by Robert Eberhard
 Launitz, after marble bust by John
 Frazee
Engraving, 29.7 x 24.4 cm. (11¹¹⁄₁₆ x
 9⁹⁄₁₆ in.), c. 1835
NPG.84.33

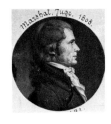

Marshall, John, 1755-1835
Chief Justice of the United States
Charles Balthazar Julien Févret de
 Saint-Mémin, 1770-1852
Engraving, 5.6 cm. (2¼ in.) diameter,
 1808
NPG.74.39.592
Gift of Mr. and Mrs. Paul Mellon

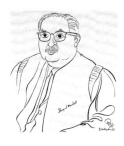

Marshall, Thurgood*, 1908-
Justice of the United States Supreme
 Court
Oscar Berger, 1901-
Ink over pencil on paper, 42.2 x 35.7
 cm. (16⅝ x 14¹⁄₁₆ in.), c. 1968
T/NPG.69.18
Gift of the artist

Marshall, Thurgood*, 1908-
Justice of the United States Supreme
 Court
Betsy Graves Reyneau, 1888-1964
Oil on canvas, 127 x 81.3 cm. (50 x
 32 in.), 1956
T/NPG.67.43
Gift of the Harmon Foundation

Martin, Joseph William, Jr.,
 1884-1968
Public official
Samuel Johnson Woolf, 1880-1948
Charcoal on paper, 64.8 x 50.2 cm.
 (25½ x 19¾ in.), 1940
NPG.80.269

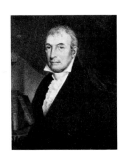

Martin, Luther, c. 1748-1826
Lawyer
Bernard Francis Hoppner Meyer,
 1811-?
Oil on paper, 26.1 x 20.7 cm. (10⁵⁄₁₆ x
 8³⁄₁₆ in.), c. 1835
NPG.77.303

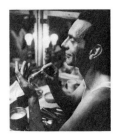

Massey, Raymond*, 1896-1983
Actor
Trude Fleischmann, 1895-
Photograph, gelatin silver print, 31.7
 x 27.1 cm. (12⁷⁄₁₆ x 10¹¹⁄₁₆ in.), 1939
T/NPG.85.16.93

Masters, Edgar Lee, 1869-1950
Poet
Francis J. Quirk, 1907-1974
Oil on canvas, 76.2 x 63.5 cm. (30 x
 25 in.), 1946
NPG.67.11
Gift of the artist

Mathewson, Christopher ("Christy"),
 1880-1925
Athlete
Underwood and Underwood, active
 1882-c. 1950
Photograph, gelatin silver print, 17.9
 x 9 cm. (7 x 3¾ in.), c. 1915
NPG.80.232

Maury, Matthew Fontaine,
 1806-1873
Naval officer, oceanographer
Mathew Brady, 1823-1896
Photograph, albumen silver print,
 8.5 x 5.3 cm. (3³⁄₁₆ x 2¹⁄₁₆ in.),
 c. 1860
NPG.80.122

Maynard, Edward, 1813-1891
Dental surgeon, inventor
Alexander Gardner, 1821-1882
Photograph, albumen silver print,
 8.6 x 5.5 cm. (3³⁄₈ x 2³⁄₁₆ in.), c. 1864
NPG.84.255

Maury, Matthew Fontaine,
 1806-1873
Naval officer, oceanographer
Smith, ?-?
Photograph, salt print, 18.7 x 13.2
 cm. (7³⁄₈ x 5¼ in.), c. 1856
NPG.80.164

Maynard, Edward, 1813-1891
Dental surgeon, inventor
George Willoughby Maynard,
 1843-1923
Oil on canvas, 77.4 x 63.5 cm. (30½ x
 25 in.), 1881
NPG.71.3
*Transfer from the National Museum
 of American Art; gift of the artist,
 1910*

Maury, Matthew Fontaine,
 1806-1873
Naval officer, oceanographer
Edward Virginius Valentine,
 1838-1930
Bronze, 62.8 cm. (24¾ in.), 1978 cast
 after 1869 plaster
NPG.78.34

Maynor, Dorothy*, 1910-
Singer
Alfred Bendiner, 1899-1964
India ink and pencil on board, 28.8 x
 21.2 cm. (11⁵⁄₁₆ x 8³⁄₈ in.), 1940
Illustration for *The Evening
 Bulletin*, Philadelphia, November
 7, 1940
T/NPG.84.43
Gift of Alfred Bendiner Foundation

Maverick, Maury, 1895-1954
Public official
Aline Fruhauf, 1907-1978
India ink over pencil on paper, 38.2
 x 28 cm. (15 x 11 in.), 1940
Published in *The New Republic*,
 Washington, D.C., March 25, 1940
NPG.83.39
Gift of Erwin Vollmer

Meade, Charles Richard, 1827-1858
Daguerreotypist
Charles Richard Meade, 1827-1858,
 and Henry William Matthew
 Meade, 1823-1865, at the Meade
 Brothers studio, active 1842-1870
Daguerreotype, 13.2 x 9.8 cm. (5¼ x
 3¹⁵⁄₁₆ in.), c. 1850
NPG.85.183
*Gift of Mr. and Mrs. Dudley
 Emerson Lyons*

Mayhew, Jonathan, 1720-1766
Clergyman
Richard Jennys, active c. 1766-c. 1799
Nathaniel Hurd, printer
Mezzotint, 30.4 x 24.5 cm. (11¹⁵⁄₁₆ x
 9⅝ in.), 1766
NPG.74.63

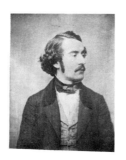

Meade, Charles Richard, 1827-1858
Daguerreotypist
Charles Richard Meade, 1827-1858,
 and Henry William Matthew
 Meade, 1823-1865, at the Meade
 Brothers studio, active 1842-1870
Daguerreotype, 7.6 x 6.3 cm. (3 x 2½
 in.), c. 1855
NPG.85.187
*Gift of Mr. and Mrs. Dudley
 Emerson Lyons*

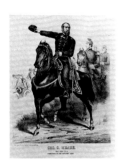

Meade, George Gordon, 1815-1872
Union general
Ehrgott and Forbriger lithography
 company, active 1858-1869, after
 photograph by Mathew Brady
Lithograph, 29.1 x 24.7 cm. (11⁷⁄₁₆ x
 9¾ in.), c. 1863
NPG.79.32

Meade, Henry William Matthew,
 1823-1865
Daguerreotypist
Unidentified photographer
Tintype, 8.4 x 6 cm. (3⁵⁄₁₆ x 2⅜ in.),
 c. 1865
NPG.85.185
*Gift of Mr. and Mrs. Dudley
 Emerson Lyons*

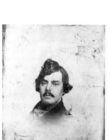

Meade, Henry William Matthew,
 1823-1865
Daguerreotypist
Charles Richard Meade, 1827-1858,
 and Henry William Matthew
 Meade, 1823-1865, at the Meade
 Brothers studio, active 1842-1870
Daguerreotype, 13.6 x 10.3 cm. (5⅜ x
 4¹⁄₁₆ in.), c. 1850
NPG.85.182
*Gift of Mr. and Mrs. Dudley
 Emerson Lyons*

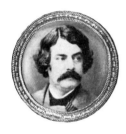

Meade, Henry William Matthew,
 1823-1865
Daguerreotypist
Charles Richard Meade, 1827-1858,
 and Henry William Matthew
 Meade, 1823-1865, at the Meade
 Brothers studio, active 1842-1870
Photograph, hand-colored albumen
 silver print, 3.2 x 3.2 cm. (1¼ x 1¼
 in.), c. 1865
NPG.85.186.a
*Gift of Mr. and Mrs. Dudley
 Emerson Lyons*

Meade, Henry William Matthew,
 1823-1865
Daguerreotypist
Charles Richard Meade, 1827-1858,
 and Henry William Matthew
 Meade, 1823-1865, at the Meade
 Brothers studio, active 1842-1870
Daguerreotype, 9.7 x 7.2 cm. (3¹³⁄₁₆
 in. x 2¹³⁄₁₆ in.) sight, c. 1850
NPG.85.233
*Gift of Mr. and Mrs. Dudley
 Emerson Lyons*

Meade, Henry William Matthew,
 1823-1865
Daguerreotypist
Charles Richard Meade, 1827-1858,
 and Henry William Matthew
 Meade, 1823-1865, at the Meade
 Brothers studio, active 1842-1870
Daguerreotype, 10.2 x 6.3 cm. (4¹⁄₁₆ x
 2½ in.) sight, c. 1845
NPG.85.234
*Gift of Mr. and Mrs. Dudley
 Emerson Lyons*

Meeker, Ezra, 1830-1928
Pioneer
Kathleen Houlahan, 1884-1964
Oil on canvas, 61 x 50.8 cm. (24 x 20
 in.), not dated
NPG.73.12

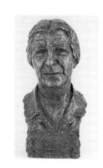

Meir, Golda*, 1898-1978
Israeli prime minister
Jo Davidson, 1883-1952
Bronze, 47 cm. (18½ in.), illegibly
 dated
T/NPG.78.201.88
Gift of Dr. Maury Leibovitz

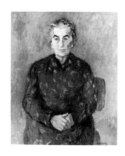

Meir, Golda*, 1898-1978
Israeli prime minister
Raphael Soyer, 1899-
Oil on canvas, 81.3 x 66 cm. (32 x 26
 in.), 1975
T/NPG.75.81.88
*Gift of Mr. and Mrs. Nathan
 Cummings, Mr. and Mrs. Meyer
 P. Potamkin, and the Charles E.
 Smith Family Foundation*

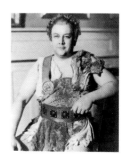

Melchior, Lauritz, 1890-1973
Singer
Unidentified photographer
Photograph, gelatin silver print, 30.7
 x 25.1 cm. (12⅛ x 9⅞ in.), c. 1940
NPG.77.346
Gift of Ib J. Melchior

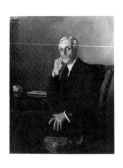

Mellon, Andrew William, 1855-1937
Financier, statesman, art patron
Sir Oswald Hornby Joseph Birley,
 1880-1952
Oil on canvas, 127 x 101.6 cm. (50 x
 40 in.), 1923
NPG.73.32
Gift of Paul Mellon

Menuhin, Yehudi*, 1916-
Musician
Alfred Bendiner, 1899-1964
India ink over pencil on paper, 35.9
 x 28.7 cm. (14⅛ x 11⁵⁄₁₆ in.), c. 1945
T/NPG.84.59
Gift of Alfred Bendiner Foundation

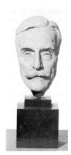

Mellon, Andrew William, 1855-1937
Financier, statesman, art patron
Jo Davidson, 1883-1952
Terra-cotta life mask, 39.3 cm. (15½
 in.), c. 1927
NPG.77.322
Gift of Dr. Maury Leibovitz

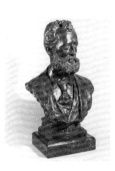

Mergenthaler, Ottmar, 1854-1899
Inventor
Hans Schuler, 1874-1951
Bronze, 62.2 cm. (24½ in.), 1908
NPG.79.77
Gift of Mrs. Pauline R. Mergenthaler

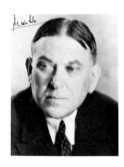

Mencken, Henry Louis, 1880-1956
Editor, critic
Aubrey Bodine, 1907-1970
Photograph, gelatin silver print, 23.3
 x 17.9 cm. (9³⁄₁₆ x 7¹⁄₁₆ in.), 1940
NPG.77.340

Merman, Ethel*, 1909-1984
Singer
Rosemarie Sloat, 1929-
Oil and acrylic on canvas, 214.6 x
 127 cm. (84½ x 50 in.), 1971
T/NPG.71.50.94
Gift of Ethel Merman

Menken, Adah Isaacs, c. 1835-1868
Actress, poet
Napoleon Sarony, 1821-1896
Photograph, albumen silver print, 9
 x 5.6 cm. (3⁹⁄₁₆ x 2³⁄₁₆ in.), 1866
NPG.80.154

Merrick, David*, 1912-
Theatrical producer
Philippe Halsman, 1906-1979
Photograph, gelatin silver print, 31.9
 x 25.4 cm. (12⁹⁄₁₆ x 10 in.), 1968
T/NPG.83.102
Gift of George R. Rinhart

Menken, Adah Isaacs, c. 1835-1868
Actress, poet
Napoleon Sarony, 1821-1896
Photograph, albumen silver print,
 9.2 x 5.5 cm. (3⅝ x 2³⁄₁₆ in.), c. 1866
NPG.82.1

Meyer, Adolph, 1866-1950
Psychiatrist
Hildegard Woodward, 1898-
Oil on canvas, 59.7 x 50.8 cm. (23½ x
 20 in.), c. 1947
NPG.69.6
Gift of Mrs. Julia L. Asher

Meyer, George von Lengerke,
 1858-1918
Diplomat
Julian Russell Story, 1857-1919
Oil on canvas, 55.2 x 46.3 cm. (21¾ x
 18¼ in.), 1894
NPG.66.25
Gift of Donna Julia Brambilla and
 Mrs. Phillip O. Coffin

Millay, Edna St. Vincent, 1892-1950
Poet
Soss Melik, 1914-
Charcoal on paper, 59.5 x 48 cm.
 (23½ x 19 in.), 1945
NPG.74.30

Mies van der Rohe, Ludwig,
 1886-1969
Architect
Yousuf Karsh, 1908-
Photograph, gelatin silver print, 49.6
 x 59.7 cm. (19½ x 23½ in.), 1962
NPG.83.254

Millay, Edna St. Vincent, 1892-1950
Poet
Carl Van Vechten, 1880-1964
Photograph, gelatin silver print, 14.4
 x 8.9 cm. (5¹¹⁄₁₆ x 3½ in.), 1933
NPG.84.140
Gift of Prentiss Taylor

Mies van der Rohe, Ludwig,
 1886-1969
Architect
Hugo Weber, 1918-1971
Ink and oil on paper, 60.9 x 48.1 cm.
 (24 x 18¹⁵⁄₁₆ in.), 1961
NPG.84.10
Gift of Mrs. Thomas Knoll Bassett

Millay, Edna St. Vincent, 1892-1950
Poet
Carl Van Vechten, 1880-1964
Photograph, gelatin silver print, 22.9
 x 16.9 cm. (9 x 6⅝ in.), 1933
NPG.84.141
Gift of Prentiss Taylor

Millay, Edna St. Vincent, 1892-1950
Poet
Berenice Abbott, 1898-
Photograph, gelatin silver print, 24.2
 x 19 cm. (9½ x 7½ in.), c. 1929
NPG.76.83

Millay, Edna St. Vincent, 1892-1950
Poet
Unidentified photographer
Photograph, gelatin silver print, 19.5
 x 24.8 cm. (7⅝ x 9¾ in.), c. 1930
NPG.78.259

Millay, Edna St. Vincent, 1892-1950
Poet
Charles Ellis, 1892-1976
Oil on canvas, 76.2 x 63.5 cm. (30 x
 25 in.), 1934
NPG.68.15
Gift of the artist and Mrs. Norma
 Millay Ellis

Miller, Cincinnatus Hiner
 ("Joaquin"), 1839-1913
Poet
Henry W. Bradley, 1814-1891, and
 William Herman Rulofson,
 1826-1878; studio active 1863-1878
Photograph, albumen silver print, 15
 x 10 cm. (5⅞ x 3¹⁵⁄₁₆ in.), c. 1875
NPG.80.72

**Miller, Cincinnatus Hiner
("Joaquin"),** 1839-1913
Poet
Sumner B. Heald, ?-?, at George K.
 Warren studio
Photograph, albumen silver print,
 9.6 x 5.7 cm. (3¾ x 2¼ in.), c. 1875
NPG.79.152

Millet, Francis Davis, 1846-1912
Artist
George Willoughby Maynard,
 1843-1923
Oil on canvas, 151.1 x 97.1 cm. (59½
 x 38¼ in.), 1878
NPG.78.205
Bequest of Dr. John A. P. Millet

Miller, George C., 1894-1965
Lithographer, printer
Ellison Hoover, 1888-1955
Lithograph, 28.3 x 22.4 cm. (11⅛ x
 8¹³⁄₁₆ in.), 1949
NPG.84.184

Mingus, Charles, 1922-1971
Musician
Antonio Frasconi, 1919- , after
 photograph
Woodcut, 64.4 x 85.1 cm. (25⅝ x 33½
 in.), 1973
NPG.82.119

Miller, Henry*, 1891-1980
Author
Marino Marini, 1901-1980
Bronze, 61.5 cm. (24¼ in.), 1961
T/NPG.69.62.90

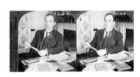

Mitchell, John, 1870-1919
Labor leader
Underwood and Underwood, active
 1882-c. 1950
Photograph, gelatin silver print, 7.8
 x 15.1 cm. (3¹⁄₁₆ x 5¹⁵⁄₁₆ in.), c. 1902
NPG.81.86

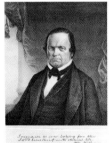

Miller, William, 1782-1849
Religious leader
J. H. Bufford lithography company,
 active 1835-1890, after photograph
Lithograph, 26.4 x 22.7 cm. (10⅜ x
 8⅞ in.), c. 1851
NPG.80.107

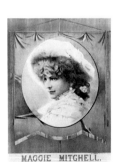

Mitchell, Margaret Julia ("Maggie"),
 1837-1918
Actress
Henry Atwell Thomas, 1834-1904
H. A. Thomas lithography company
Chromolithographic poster, 63.3 x
 46.8 cm. (24⅞ x 18⁷⁄₁₆ in.),
 c. 1880-1883
NPG.83.286

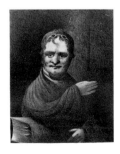

Miller, William, 1782-1849
Religious leader
Attributed to John Landis, active
 1830-1851, after William Matthew
 Prior
Lithograph, 26.5 x 21.3 cm. (10⁷⁄₁₆ x
 8⅜ in.), c. 1840-c. 1845
NPG.79.91

Mitropoulos, Dimitri, 1896-1960
Symphony conductor
Alfred Bendiner, 1899-1964
India ink over pencil on paper, 33.3
 x 26.5 cm. (13⅛ x 10⁷⁄₁₆ in.), c. 1945
NPG.84.54
Gift of Alfred Bendiner Foundation

Mitropoulos, Dimitri, 1896-1960
Symphony conductor
Violet Oakley, 1874-1961
Charcoal and chalk on paper, 52.3 x
33.2 cm. (20½ x 13⅟₁₆ in.), not
dated
NPG.83.14
*Gift of the Violet Oakley Memorial
Foundation*

Mitropoulos, Dimitri, 1896-1960
Symphony conductor
Violet Oakley, 1874-1961
Charcoal and chalk on paper, 51.5 x
33.5 cm. (20¼ x 13⅛ in.), not dated
NPG.83.15
*Gift of the Violet Oakley Memorial
Foundation*

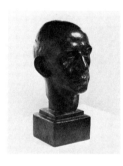

Mitropoulos, Dimitri, 1896-1960
Symphony conductor
Louise Belden Prugh, 1907-
Bronze, 40.9 cm. (16⅛ in.), cast after
the 1942 original
NPG.76.2
*Gift of the artist, Louise Belden
Prugh*

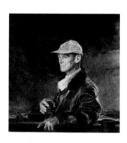

Mitscher, Marc Andrew, 1887-1947
World War II admiral
Albert K. Murray, 1906-
Oil on canvas, 91.4 x 63.5 cm. (36 x
25 in.) sight, not dated
NPG.66.65
*Transfer from the National Museum
of American Art; gift of the
International Business Machines
Corporation to the Smithsonian
Institution, 1962*

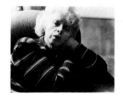

Model, Lisette*, 1906-1983
Photographer
Nata Piaskowski, 1912-
Photograph, gelatin silver print, 18.1
x 23.1 cm. (7⅛ x 9⅛ in.), 1984 from
1949 negative
T/NPG.84.233.93

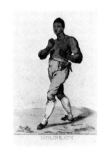

Molineaux, Tom, 1784-1818
Athlete
Robert D. Dighton, c. 1752-1814
Hand-colored etching, 28.7 x 21.7
cm. (11⁵⁄₁₆ x 8⁹⁄₁₆ in.), 1812
NPG.73.33

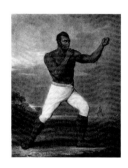

Molineaux, Tom, 1784-1818
Athlete
John Young, 1755-1825, after
Thomas Douglas Guest
Mezzotint with some etching, 53.2 x
42.4 cm. (20⅞ x 16¹¹⁄₁₆ in.), c. 1810
NPG.79.111

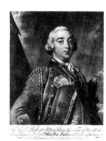

Monckton, Robert, 1726-1782
Colonial statesman
Unidentified artist, after Thomas
Hudson
Mezzotint, 13.3 x 11.2 cm. (5¼ x 4⅜
in.), c. 1760-1762
NPG.77.90

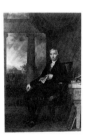

Monroe, James, 1758-1831
Fifth President of the United States
Charles Goodman, 1796-1835, and
Robert Piggot, 1795-1887, after
Charles Bird King
Stipple engraving, 49.2 x 33.2 cm.
(19⅜ x 13⅟₁₆ in.), 1817
NPG.79.72

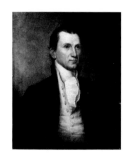

Monroe, James, 1758-1831
Fifth President of the United States
Attributed to James Herring,
1794-1867, after the oil by John
Vanderlyn
Oil on canvas, 76.2 x 63.5 cm. (30 x
25 in.), c. 1835
NPG.65.62
*Transfer from the National Gallery
of Art; gift of Andrew W. Mellon,
1942*

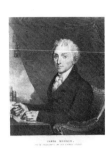

Monroe, James, 1758-1831
Fifth President of the United States
Attributed to Nicolas Eustache
 Maurin, 1799-1850, after Gilbert
 Stuart
Lithograph, 29 x 24.4 cm. (11⁷⁄₁₆ x 9¾
 in.), c. 1825-1828
NPG.79.130

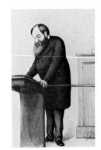

Moody, Dwight Lyman, 1837-1899
Evangelist
Carlo Pellegrini ("Ape"), 1838-1889
Watercolor over pencil on paper, 29.8
 x 18.1 cm. (11¾ x 7⅛ in.), 1875
NPG.64.7
*Gift of the Trustees, National
 Portrait Gallery, London*

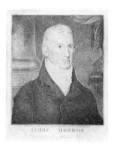

Monroe, James, 1758-1831
Fifth President of the United States
M. M. Peabody, active c. 1817-
 c. 1835, after John Vanderlyn
Stipple engraving, 18.7 x 16.1 cm.
 (7⅜ x 6⁵⁄₁₆ in.), c. 1817
NPG.85.135

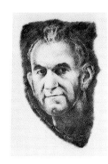

Mooney, Thomas Joseph, 1882-1942
Labor radical
George Biddle, 1885-1973
Lithograph, 34 x 12.3 cm. (13⅜ x 9
 in.), 1933
Published in the Contemporary Print
 Group's *The American Scene No.
 1*, New York, 1933
NPG.81.78

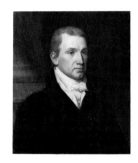

Monroe, James, 1758-1831
Fifth President of the United States
John Vanderlyn, 1775-1852
Oil on canvas, 67.3 x 56.8 cm. (26½ x
 22⅜ in.), 1816
NPG.70.59

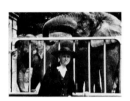

Moore, Marianne, 1887-1972
Poet
Esther Bubley, 1922-
Photograph, gelatin silver print, 24.9
 x 34 cm. (9¹³⁄₁₆ x 13⅜ in.), 1953
NPG.77.137

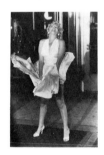

Monroe, Marilyn, 1926-1962
Actress
Garry Winogrand, 1928-1984
Photograph, gelatin silver print, 46.9
 x 31.4 cm. (18⁷⁄₁₆ x 12⅜ in.), 1955
NPG.84.73

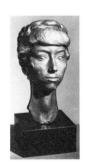

Moore, Marianne, 1887-1972
Poet
Gaston Lachaise, 1882-1935
Bronze, 36.1 cm. (14¼ in.), cast after
 1924 plaster
NPG.74.40

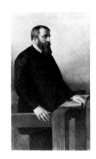

Moody, Dwight Lyman, 1837-1899
Evangelist
Edward Clifford, c. 1844-1907
Watercolor on paper, 132 x 78.7 cm.
 (52 x 31 in.), 1884
NPG.74.7

Moore, Marianne, 1887-1972
Poet
Soss Melik, 1914-
Charcoal and pastel on paper, 48.2 x
 40.6 cm. (19 x 16 in.), 1952
NPG.74.31

Moore, Marianne, 1887-1972
Poet
Michael Alexander Werboff, 1896-?
Oil on canvas, 101.6 x 76.5 cm. (40 x
 30⅛ in.), 1968
NPG.77.234
Gift of The Lu Shan Foundation Inc.

Morgan, John Pierpont, 1837-1913
Financier
Adrian Lamb, 1901- , after the 1888
 oil by Frank Holl
Oil on canvas, 127 x 102.2 cm. (50 x
 40¼ in.), 1966
NPG.66.26
Gift of H. S. Morgan

Moran, Thomas, 1837-1926
Artist
Howard Russell Butler, 1856-1935
Oil on canvas, 99.7 x 91.4 cm. (39¼ x
 36 in.), c. 1922
NPG.70.19
*Transfer from the National Museum
 of American Art; bequest of Ruth
 B. Moran, 1948*

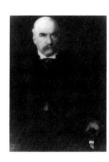

Morgan, John Pierpont, 1837-1913
Financier
Edward Steichen, 1879-1973
Photogravure, 20.6 x 15.7 cm. (8⅛ x
 6³⁄₁₆ in.), 1903
NPG.76.84

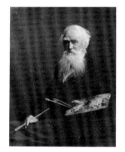

Moran, Thomas, 1837-1926
Artist
William Edwin Gledhill, 1888-1976
Photograph, gelatin silver print, 28.9
 x 23.2 cm. (11⁵⁄₁₆ x 9¹⁄₁₆ in.), c. 1922
NPG.79.210

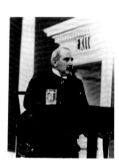

Morgan, John Pierpont, Jr.,
 1867-1943
Financier
Unidentified photographer
Photograph, gelatin silver print, 25.5
 x 20.3 cm. (10 x 8 in.), c. 1910
NPG.78.159

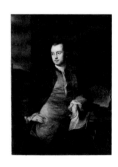

Morgan, John, 1735-1789
Physician
Angelica Kauffmann, 1741-1807
Oil on canvas, 134.6 x 99 cm. (53 x
 39 in.), 1764
NPG.78.221
*Gift of the James Smithson Society
 and Gallery purchase*

Morgenthau, Henry, 1856-1946
Financier, diplomat
Joseph Cummings Chase, 1878-1965
Oil on academy board, 62.2 x 47 cm.
 (24½ x 18½ in.), c. 1918
NPG.73.45
Gift of Mendel Peterson

Morgan, John Hunt, 1825-1864
Confederate officer
J. L. Giles lithography company,
 active 1835-1881, after photograph
 by George Smith Cook
Lithograph, 17 x 16.4 cm. (6¾ x 6½
 in.), c. 1866-1868
NPG.80.117

Morgenthau, Henry, Jr., 1891-1967
Financier, diplomat
Jo Davidson, 1883-1952
Bronze, 53.3 cm. (21 in.), 1939
NPG.78.195
Gift of Dr. Maury Leibovitz

Morgenthau, Henry, Jr., 1891-1967
Financier, diplomat
Joseph Margulies, 1896-
Pastel on paper, 55.8 x 40.6 cm. (22 x
 16 in.), 1938
NPG.70.52

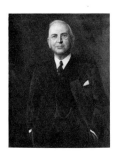

Morris, Arthur J., 1882-1973
Banker
David Berney, ?-?
Oil on canvas, 91.4 x 71.1 cm. (36 x
 28 in.), 1982
NPG.84.68
Gift of Mrs. Virginia Kincaid

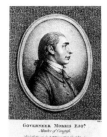

Morris, Gouverneur, 1752-1816
Statesman, diplomat
B. B. Ellis, ?-?, after Benoit Louis
 Prevost, after Pierre Eugène Du
 Simitière
Stipple engraving, 11.1 x 9.5 cm. (4⅜
 x 3¾ in.), 1783
Published in *Portraits of the
 Generals, Ministers, Magistrates,*
 London, 1783
NPG.75.67

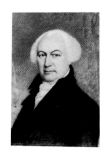

Morris, Gouverneur, 1752-1816
Statesman, diplomat
James Sharples, c. 1751-1811
Pastel on paper, 25.4 x 20.9 cm. (10 x
 8¼ in.) elliptical top, 1810
NPG.74.47
*Gift of Miss Ethel Turnbull in
 memory of her brothers, John
 Turnbull and Gouverneur Morris
 Wilkins Turnbull*

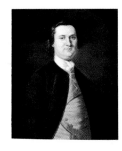

Morris, Lewis, 1726-1798
Revolutionary statesman
John Wollaston, c. 1710-c. 1767
Oil on canvas, 76.2 x 63.5 cm. (30 x
 25 in.), c. 1750
NPG.78.217

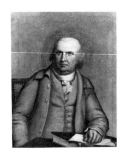

Morris, Robert, 1734-1806
Financier
Robert Edge Pine, c. 1720s-1788
Oil on fabric, 91.4 x 73.6 cm. (36 x 29
 in.), c. 1785
NPG.73.20

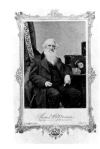

Morse, Samuel Finley Breese,
 1791-1872
Artist, inventor
Abraham Bogardus, 1822-1908
Photograph, albumen silver print,
 13.9 x 10 cm. (5½ x 3¹⁵⁄₁₆ in.), 1871
NPG.76.85

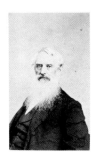

Morse, Samuel Finley Breese,
 1791-1872
Artist, inventor
Charles DeForest Fredricks,
 1823-1894
Photograph, albumen silver print,
 9.2 x 5.3 cm. (3⅝ x 2⅛ in.), c. 1864
NPG.80.212

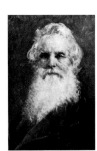

Morse, Samuel Finley Breese,
 1791-1872
Artist, inventor
Edward Lind Morse, 1857-1923
Oil on canvas, 35.5 x 28.5 cm. (14 x
 11¼ in.), 1895
NPG.71.23
*Transfer from the National Museum
 of American History*

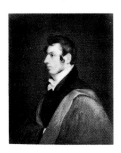

Morse, Samuel Finley Breese,
 1791-1872
Artist, inventor
Self-portrait
Oil on millboard, 27 x 22.5 cm. (10⅝
 x 8⅞ in.), 1812
NPG.80.208
Gift of the James Smithson Society

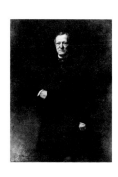

Morton, Levi Parsons, 1824-1920
Vice-President of the United States
Leon-Joseph Florentin Bonnat,
 1833/34-1922
Oil on canvas, 144.7 x 105.7 cm.
 (57 x 41⅝ in.), 1883
NPG.66.45
*Gift of Mrs. Eustis Emmet and Mrs.
 David E. Finley*

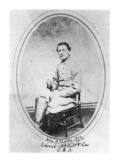

Mosby, John Singleton, 1833-1916
Confederate ranger
Daniel Bendann, 1835-1914, and
 David Bendann, 1841-1915
Photograph, albumen silver print,
 17.4 x 12 cm. (6⅞ x 4¾ in.), c. 1864
NPG.81.30

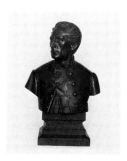

Mosby, John Singleton, 1833-1916
Confederate ranger
Edward Virginius Valentine,
 1838-1930
Bronze, 73 cm. (28¾ in.), 1972 cast
 after 1866 plaster
NPG.72.117

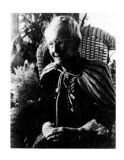

**Moses, Anna Mary Robertson
 ("Grandma Moses"),** 1860-1961
Artist
Alexander Bender, ?-?
Photograph, gelatin silver print, 35.1
 x 27.5 cm. (13¹³⁄₁₆ x 10¹³⁄₁₆ in.),
 c. 1950
NPG.77.148

**Moses, Anna Mary Robertson
 ("Grandma Moses"),** 1860-1961
Artist
Clara E. Sipprell, 1885-1975
Photograph, gelatin silver print, 22.7
 x 19 cm. (8¹⁵⁄₁₆ x 7½ in.), c. 1950
NPG.81.8
Gift of Mrs. Katie Louchheim

**Moses, Anna Mary Robertson
 ("Grandma Moses"),** 1860-1961
Artist
Clara E. Sipprell, 1885-1975
Photograph, gelatin silver print, 22.6
 x 17.5 cm. (8¹⁵⁄₁₆ x 6¹⁵⁄₁₆ in.), c. 1950
NPG.82.188
Bequest of Phyllis Fenner

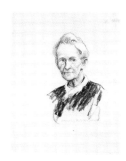

**Moses, Anna Mary Robertson
 ("Grandma Moses"),** 1860-1961
Artist
Samuel Johnson Woolf, 1880-1948
Charcoal and chalk on paper, 55.2 x
 41.9 cm. (21¾ x 16½ in.), not dated
NPG.80.270

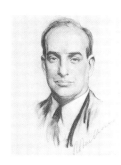

Moses, Robert*, 1888-1981
Public official
Samuel Johnson Woolf, 1880-1948
Charcoal and chalk on paper, 64.8 x
 50.1 cm. (25½ x 19¾ in.), not dated
T/NPG.80.271.91

Mostel, Zero*, 1915-1977
Entertainer
Alfred Bendiner, 1899-1964
Ink on paper, 17.9 x 13.6 cm. (7¹⁄₁₆ x
 5⅜ in.), c. 1945
T/NPG.85.200.87
Gift of Alfred Bendiner Foundation

Motley, John Lothrop, 1814-1877
Historian, diplomat
Thomas Phillips, 1770-1845
Oil on canvas, 76.2 x 63.5 cm. (30 x
 25 in.), c. 1835
NPG.66.8

Motley, John Lothrop, 1814-1877
Historian, diplomat
Silsbee, Case and Company; studio
 active 1858-1863
Photograph, albumen silver print,
 8.7 x 5.4 cm. (3⁷⁄₁₆ x 2⅛ in.), c. 1861
NPG.80.91

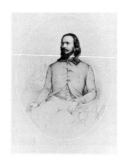

Mount, William Sidney, 1807-1868
Artist
Charles G. Crehen, 1829-?, after
 Charles Loring Elliott
Nagel and Weingaertner lithography
 company
Lithograph, 36.5 x 31 cm. (14⅜ x
 12³⁄₁₆ in.), 1850
NPG.78.73

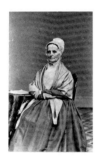

Mott, Lucretia Coffin, 1793-1880
Reformer
Frederick Gutekunst, 1831-1917
Photograph, albumen silver print,
 9.1 x 5.9 cm. (3⁹⁄₁₆ x 2⁵⁄₁₆ in.), 1862
NPG.79.45

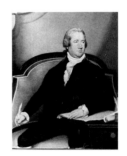

**Muhlenberg, Frederick Augustus
 Conrad,** 1750-1801
Revolutionary statesman
Joseph Wright, 1756-1793
Oil on canvas, 119.3 x 94 cm. (47 x
 37 in.), 1790
NPG.74.1

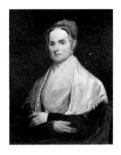

Mott, Lucretia Coffin, 1793-1880
Reformer
Joseph Kyle, 1815-1863
Oil on canvas, 76 x 63.5 cm. (30 x 25
 in.), 1842
NPG.74.72
Gift of Mrs. Alan Valentine

Muir, John, 1838-1914
Naturalist
Edwin Keith Harkness, ?-1934
Bronze, 30.4 cm. (12 in.), 1926
NPG.65.73
*Transfer from the National Gallery
 of Art; gift of Mrs. Ione Bellamy
 Harkness, 1947*

Mott, Lucretia Coffin, 1793-1880
Reformer
Attributed to Frederick A.
 Wenderoth, c. 1814-1884, at the
 Samuel Broadbent studio
Photograph, albumen silver print,
 9.4 x 5.7 cm. (3¹¹⁄₁₆ x 2¼ in.),
 c. 1860
NPG.83.124

Muir, John, 1838-1914
Naturalist
Orlando Rouland, 1871-1945
Oil on canvas, 92.1 x 71.8 cm. (36¼ x
 28¼ in.), not dated
NPG.65.79
*Transfer from the National Museum
 of American Art; gift of Mrs. E. H.
 Harriman to the United States
 National Musuem, 1920*

Moultrie, William, 1730-1805
Revolutionary general
Charles Willson Peale, 1741-1827
Oil on canvas, 67.3 x 57.1 cm. (26½ x
 22½ in.), 1782
NPG.65.57
*Transfer from the National Gallery
 of Art; gift of Andrew W. Mellon,
 1942*

Münch, Charles, 1891-1968
Symphony conductor
Alfred Bendiner, 1899-1964
India ink and pencil on paper, 35 x
 28.5 cm. (13¾ x 11³⁄₁₆ in.), c. 1945
NPG.84.48
Gift of Alfred Bendiner Foundation

Munsel, Patrice*, 1925-
Singer
Alfred Bendiner, 1899-1964
India ink and opaque white on
 paper, 28 x 26 cm. (11 x 10¼ in.),
 c. 1945
T/NPG.85.203
Gift of Alfred Bendiner Foundation

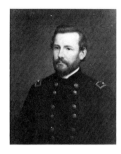

Myer, Albert James, 1829-1880
Union officer
George Peter Alexander Healy,
 1813-1894
Oil on canvas, 76.2 x 62.2 cm. (30 x
 24½ in.), 1876
NPG.70.20
*Transfer from the National Museum
 of American Art; bequest of Miss
 Viola Walden Myer, 1945*

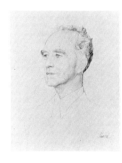

Murphy, Frank, 1890-1949
Statesman, Justice of the United
 States Supreme Court
Oskar Stoessel, 1879-1964
Pencil on paper, 43.3 x 31.4 cm. (17 x
 12⅜ in.), c. 1941
NPG.72.44

Nagel, Charles, 1849-1940
Statesman
Anders Zorn, 1860-1920
Oil on canvas, 61 x 50.8 cm. (24 x 20
 in.), 1901
NPG.69.1
Gift of Charles Nagel, Jr.

Murphy, Frank, 1890-1949
Statesman, Justice of the United
 States Supreme Court
Oskar Stoessel, 1879-1964
Etching, 19.8 x 11.6 cm. (7¾ x 4⅝
 in.), c. 1941
NPG.80.58

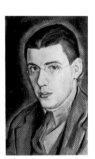

Naiche ("Natchez"), c. 1858-1921
Indian chief
Reed and Wallace studio, ?-?
Photograph, albumen silver print, 14
 x 10.2 cm. (5½ x 4 in.), 1909
NPG.80.245

Murray, Philip, 1886-1952
Labor leader
Abraham Joel Tobias, 1913-
Pencil and india ink on board, 28.3 x
 19.2 cm. (11⅛ x 7⁹⁄₁₆ in.), 1944
NPG.85.36
Gift of Abraham Joel Tobias

Nash, Ogden, 1902-1971
Humorist
Frederick S. Wight, 1902-1986
Oil on canvas, 48.6 x 30.7 cm. (19⅛ x
 12⅛ in.), 1933
NPG.77.235
Gift of the artist

Muybridge, Eadweard, 1830-1904
Photographer
Self-portrait
Collotype, 21.9 x 34.6 cm. (8⅝ x 13⅝
 in.), 1887
NPG.84.134

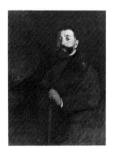

Nast, Thomas, 1840-1902
Cartoonist
John White Alexander, 1856-1915
Oil on canvas, 101.6 x 76.8 cm. (40 x
 30¼ in.), 1887
NPG.66.40

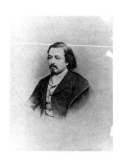

Nast, Thomas, 1840-1902
Cartoonist
Mathew Brady, 1823-1896
Photograph, salt print, 47 x 38.5 cm.
 (18½ x 15⅛ in.), c. 1858
NPG.77.267

Nathan, George Jean, 1882-1958
Drama critic
Soss Melik, 1914-
Charcoal on paper, 56.5 x 44.4 cm.
 (22¼ x 17½ in.), 1956
NPG.68.34

Nast, Thomas, 1840-1902
Cartoonist
Mathew Brady, 1823-1896
Photograph, albumen silver print,
 8.5 x 5 cm. (3⁵⁄₁₆ x 2⅛ in.), 1862
NPG.79.211

Nathan, George Jean, 1882-1958
Drama critic
Doris Ulmann, 1882-1934
Photograph, platinum print, 19.9 x
 15.7 cm. (7¾ x 6⅛ in.), c. 1925
NPG.77.59

Nast, Thomas, 1840-1902
Cartoonist
Self-portrait
Wood engraving, 27.6 x 23.3 cm.
 (10⅞ x 9³⁄₁₆ in.), 1875
Published in *Harper's Weekly*, New
 York, June 19, 1875
NPG.84.104

Nation, Carrie Amelia Moore,
 1846-1911
Reformer
White studio, ?-?
Photograph, gelatin silver print, 14.1
 x 9.8 cm. (5⁹⁄₁₆ x 3⅞ in.), c. 1903
NPG.80.197

Nast, Thomas, 1840-1902
Cartoonist
Self-portrait
Pencil and india ink on paper, 36.1 x
 27 cm. (14³⁄₁₆ x 10⅝ in.), c. 1882
NPG.85.62

Nazimova, Alla, 1879-1945
Actress
Alfred J. Frueh, 1880-1968
Linocut, 25.8 x 6.2 cm. (10⅛ x 2⁷⁄₁₆
 in.), 1922
Published in Alfred J. Frueh's *Stage
 Folk*, New York, 1922
NPG.84.229.s

Nast, Thomas, 1840-1902
Cartoonist
Napoleon Sarony, 1821-1896
Photograph, albumen silver print,
 11.7 x 9 cm. (4⅝ x 3½ in.), c. 1870
NPG.80.73

Neagle, John, 1796-1865
Artist
Unidentified photographer, after
 daguerreotype by Frederick
 DeBourg Richards
Photograph, salt print, 15.5 x 11.9
 cm. (6⅛ x 4¹¹⁄₁₆ in.), c. 1856
NPG.84.149

Neel, Alice*, 1900-1984
Artist
Self-portrait
Oil on canvas, 137.1 x 101.6 cm.
 (54 x 40 in.), 1980
T/NPG.85.19.94

Newcomb, Simon, 1835-1909
Scientist
Harold L. MacDonald, 1861-1923
Oil on canvas, 76.2 x 63.4 cm. (30 x
 24¹⁵/₁₆ in.), 1909
NPG.78.280
Gift of Simon Newcomb Wilson

Newsam, Albert, 1809-1864
Artist
James Queen, 1824-c. 1877, after
 photograph
P. S. Duval and Son lithography
 company
Lithograph, 11.7 x 10.2 cm. (4⅝ x 4
 in.), 1868
Published in Joseph O. Pyatt's
 *Memoir of Albert Newsam (Deaf
 Mute Artist)*, Philadelphia, 1868
NPG.79.128

Niles, John Jacob*, 1892-1980
Musician, folklorist
Doris Ulmann, 1882-1934
Photograph, waxed platinum print,
 20.1 x 15.3 cm. (7¹⁵/₁₆ x 6 in.),
 c. 1931
T/NPG.83.201.90
Gift of Barry Bingham, Sr.

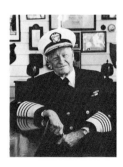

Nimitz, Chester William, 1885-1966
World War II admiral
Philippe Halsman, 1906-1979
Photograph, gelatin silver print, 34.7
 x 27 cm. (13⅝ x 10⅝ in.), 1965
NPG.83.174
Gift of George R. Rinhart

Nimitz, Chester William, 1885-1966
World War II admiral
Albert K. Murray, 1906-
Oil on canvas, 104.1 x 91.4 cm. (41 x
 36 in.) sight, not dated
NPG.65.36
*Transfer from the National Museum
 of American Art; gift of the
 International Business Machines
 Corporation to the Smithsonian
 Institution, 1962*

Nixon, Richard Milhous, 1913-
Thirty-seventh President of the
 United States
William Franklin Draper, 1912-
Oil on canvas, 101.2 x 82.5 cm.
 (39⅞ x 32½ in.), 1980
NPG.81.99
Gift of Jack Drown

Nixon, Richard Milhous, 1913-
Thirty-seventh President of the
 United States
Philippe Halsman, 1906-1979
Photograph, gelatin silver print, 31.5
 x 27.3 cm. (12⁷/₁₆ x 10¾ in.), 1969
NPG.77.279
Gift of George R. Rinhart

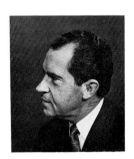

Nixon, Richard Milhous, 1913-
Thirty-seventh President of the
 United States
Philippe Halsman, 1906-1979
Photograph, gelatin silver print, 35 x
 27.3 cm. (13¾ x 10¾ in.), 1969
NPG.77.280
Gift of George R. Rinhart

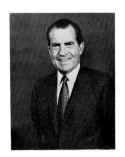

Nixon, Richard Milhous, 1913-
Thirty-seventh President of the
 United States
Philippe Halsman, 1906-1979
Photograph, gelatin silver print, 35 x
 27.3 cm. (13¾ x 10¾ in.), 1969
NPG.77.281
Gift of George R. Rinhart

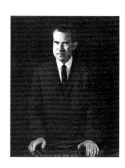

Nixon, Richard Milhous, 1913-
Thirty-seventh President of the
 United States
David Lee Iwerks, 1933-
Photograph, gelatin silver print, 24.1
 x 19 cm. (9½ x 7½ in.), 1960
NPG.78.160

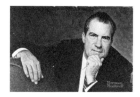

Nixon, Richard Milhous, 1913-
Thirty-seventh President of the
 United States
Norman Rockwell, 1894-1978
Oil on canvas, 46.3 x 66.7 cm. (18¼ x
 26¼ in.), 1968
NPG.72.2
*Donated to the People of the United
 States of America by the Richard
 Nixon Foundation*

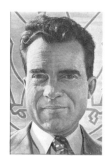

Nixon, Richard Milhous, 1913-
Thirty-seventh President of the
 United States
Guy Rowe ("Giro"), 1894-1969
Grease (?) on artist board, 33 x 27.5
 cm. (13 x 10⅞ in.), 1952
NPG.81.145
Gift of Charles Rowe

Norris, George William, 1861-1944
Statesman
Peggy Bacon, 1895-1987
Crayon on paper, 35.2 x 24.7 cm.
 (13⅞ x 9¾ in.), c. 1935
NPG.74.65

Norris, George William, 1861-1944
Statesman
Jo Davidson, 1883-1952
Terra-cotta, 49.8 cm. (19⅝ in.), 1942
NPG.77.141
*Gift of Mr. and Mrs. James Louis
 Robertson and John P. Robertson*

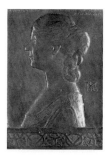

Oakley, Violet, 1874-1961
Artist
Robert Tait McKenzie, 1867-1938
Bronze bas-relief, 37.4 x 27 cm.
 (14¾ x 10⅝ in.), 1925
NPG.83.12
*Gift of the Violet Oakley Memorial
 Foundation*

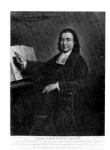

Occom, Samson, 1723-1792
Indian missionary
Jonathan Spilsbury, active 1760-
 1807, after Mason Chamberlin
Mezzotint, 32.1 x 25.3 cm. (12⅝ x
 9¹⁵⁄₁₆ in.), 1768
NPG.71.15

Och-Lochta Micco ("Billy Bowlegs"),
 c. 1818-c. 1864
Indian chief
Julian Vannerson, c. 1827-?
Photograph, salt print, 19 x 13.5 cm.
 (7½ x 5⁵⁄₁₆ in.), 1858
NPG.78.62

Och-Lochta Micco ("Billy Bowlegs"),
 c. 1818-c. 1864
Indian chief
Unidentified artist, after photograph
 by Julian Vannerson
Hand-colored lithograph, 22.1 x 11.9
 cm. (8¹¹⁄₁₆ x 4¹¹⁄₁₆ in.), 1865-1870
Published in Thomas L. McKenney's
 *History of the Indian Tribes of
 North America*, Philadelphia,
 1865-1870
NPG.85.55

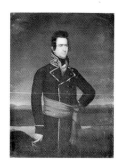

O'Fallon, Benjamin, 1793-1846
Indian agent
Unidentified artist
Oil on canvas, 137.8 x 103.7 cm.
 (54¼ x 40⅞ in.), c. 1833
NPG.81.33
*Gallery purchase and gift of Nancy
 Gesuele Peterson and Edward
 Peterson*

 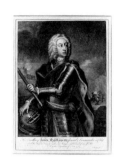

Oglethorpe, James Edward,
1696-1785
Founder of Georgia colony
Thomas Burford, c. 1710-c. 1770,
 after unidentified artist
Mezzotint, 31.7 x 24.9 cm. (12½ x
 9¹³⁄₁₆ in.), before 1757
NPG.77.42

Olin, Stephen, 1797-1851
Clergyman, educator
William Edward West, 1788-1857
Oil on canvas, 91.4 x 71.1 cm. (36 x
 28 in.), not dated
NPG.81.100
Bequest of Olin Downs

O'Keeffe, Georgia*, 1887-1986
Artist
Leonda Finke, ?-
Bronze, 25.4 cm. (10 in.), 1982
T/NPG.83.154.96
Gift of Leonda Finke

Oliver, Andrew, 1706-1774
Colonial statesman
John Singleton Copley, 1738-1815
Oil on copper, 12.1 x 10.2 cm. (4¾ x
 4 in.), c. 1758
NPG.78.218

O'Keeffe, Georgia*, 1887-1986
Artist
Philippe Halsman, 1906-1979
Photograph, gelatin silver print, 28.5
 x 25.7 cm. (11³⁄₁₆ x 10⅛ in.), 1967
T/NPG.83.103.96
Gift of George R. Rinhart

Olmsted, Frederick Law, 1822-1903
Landscape architect
Unidentified artist
Plaster death mask, 27.3 cm. (10¾
 in.), 1903
NPG.67.67
Gift of Olmsted Associates

O'Keeffe, Georgia*, 1887-1986
Artist
Una Hanbury, ?-
Bronze, 29.8 cm. (11¾ in.), 1967
T/NPG.67.37.96

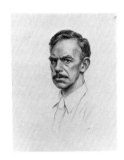

O'Neill, Eugene Gladstone,
1888-1953
Playwright
Soss Melik, 1914-
Charcoal on paper, 59 x 48.2 cm.
 (23¼ x 19 in.), 1936
NPG.68.20

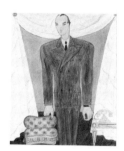 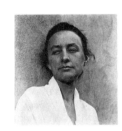

O'Keeffe, Georgia*, 1887-1986
Artist
Paul Strand, 1890-1976
Photograph, platinum print, 19.9 x
 18.9 cm. (7⅞ x 7⁷⁄₁₆ in.), c. 1930
T/NPG.84.159.96

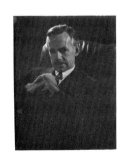

O'Neill, Eugene Gladstone,
1888-1953
Playwright
Edward Steichen, 1879-1973
Photograph, gelatin silver print, 24.6
 x 19.7 cm. (9¹¹⁄₁₆ x 7¾ in.), 1933
NPG.82.89
Bequest of Edward Steichen

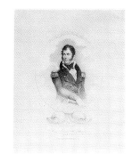

Perkins, Thomas Handasyd,
 1764-1854
Merchant, philanthropist
Hezekiah Wright Smith, 1828-?, after
 Spiridione Gambardella
Engraving, 12.5 x 10.2 cm. (4¹⁵⁄₁₆ x 4
 in.), 1856
Published in *Lives of American
 Merchants*, New York, 1856
NPG.84.107

Perry, Matthew Calbraith, 1794-1858
Naval officer
Sarony lithography company, active
 1853-1857, after daguerreotype by
 Philip Haas
Lithograph with tintstone, 31.5 x
 21.9 cm. (12⁷⁄₁₆ x 8⅝ in.), c.
 1853-1855
NPG.76.50

Perry, Matthew Calbraith, 1794-1858
Naval officer
Unidentified artist
Colored wood-block print, 16.5 x 10.6
 cm. (6½ x 4³⁄₁₆ in.), c. 1854
Published in Miki Kosai's *Ikoku
 Ochiba Kage*, Tokyo, c. 1854
NPG.77.1

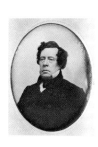

Perry, Matthew Calbraith, 1794-1858
Naval officer
Unidentified photographer
Daguerreotype, 14 x 10.9 cm. (5½ x
 4⁵⁄₁₆ in.), c. 1855
NPG.77.206

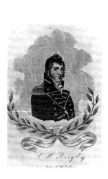

Perry, Oliver Hazard, 1785-1819
War of 1812 naval officer
George Delleker, active c. 1805-1824,
 after Samuel Lovett Waldo
Engraving and etching, 15.9 x 12.2
 cm. (6¼ x 4¹³⁄₁₆ in.), c. 1813
NPG.79.13

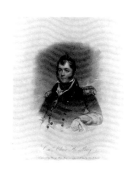

Perry, Oliver Hazard, 1785-1819
War of 1812 naval officer
Thomas Gimbrede, 1781-1832, after
 John Wesley Jarvis
Stipple engraving, 30.8 x 21.7 cm.
 (12⅛ x 8½ in.), 1817-1820
NPG.80.62

Perry, Oliver Hazard, 1785-1819
War of 1812 naval officer
Bernard Francis Hoppner Meyer,
 1811-?, after John Wesley Jarvis
Stipple engraving, 21 x 17.5 cm. (8¼
 x 6⅞ in.), c. 1830-1840
NPG.79.169

Perry, Oliver Hazard, 1785-1819
War of 1812 naval officer
William Strickland, 1788-1854
Aquatint, 13.3 x 13.5 cm. (5¼ x 5⁵⁄₁₆
 in.), c. 1814
NPG.77.93

Pershing, John Joseph, 1860-1948
World War I general
American Lithographic Company,
 active c. 1918
Color lithographic poster, 76.2 x 50.9
 cm. (30 x 20 in.), 1918
NPG.84.79
Gift of PosterAmerica

Pershing, John Joseph, 1860-1948
World War I general
Jo Davidson, 1883-1952
Marble, 57.1 cm. (22½ in.), c. 1918
NPG.77.319
Gift of Dr. Maury Leibovitz

Pershing, John Joseph, 1860-1948
World War I general
Moses Wainer Dykaar, 1884-1933
Marble, 63.8 cm. (25⅛ in.), not dated
NPG.65.80
*Transfer from the United States
National Museum; gift of the
estate of Major General George O.
Squier, 1934*

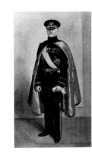

Pershing, John Joseph, 1860-1948
World War I general
Leopold Seyffert, 1887-1956
Oil on canvas, 228.6 x 139.7 cm. (90
x 55 in.), 1938
NPG.65.4
Gift of Mr. and Mrs. Dudley Cooper

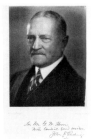

Pershing, John Joseph, 1860-1948
World War I general
Harris and Ewing studio, active
1905-1977
Photograph, gelatin silver print, 24.5
x 19.8 cm. (9⅝ x 7¹³⁄₁₆ in.), c. 1924
NPG.84.253
Gift of Aileen Conkey

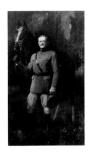

Pershing, John Joseph, 1860-1948
World War I general
Douglas Volk, 1856-1935
Oil on canvas, 242.6 x 150.1 cm. (95½
x 59⅛ in.), 1920-1921
NPG.65.37
*Transfer from the National Museum
of American Art; gift of the city of
Cincinnati through the National
Art Committee, 1923*

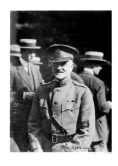

Pershing, John Joseph, 1860-1948
World War I general
Helen Warner Johns Kirtland, ?-?, or
Lucien Swift Kirtland, 1881-1965
Photograph, gelatin silver print, 23.6
x 17.9 cm. (9⁵⁄₁₆ x 7¹⁄₁₆ in.), 1919
NPG.80.285

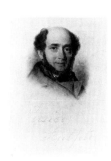

Persico, Luigi, 1791-1860
Artist
Eastman Johnson, 1824-1906
Charcoal and chalk on paper, 54.6 x
38.7 cm. (21½ x 15¼ in.), c. 1850
NPG.71.1

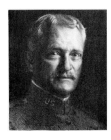

Pershing, John Joseph, 1860-1948
World War I general
Leo Mielziner, 1869-1935
Lithograph, 24.7 x 20.5 cm. (9¾ x
8¹⁄₁₆ in.), 1917
NPG.83.181

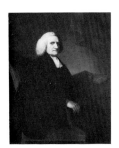

Peters, Richard, 1704 or 1711-1776
Clergyman
Attributed to Mason Chamberlin the
Elder, 1727-1789
Oil on canvas, 127.9 x 102.8 cm.
(50⅜ x 40½ in.), 1764/65
NPG.82.146

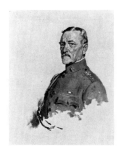

Pershing, John Joseph, 1860-1948
World War I general
Sir William Orpen, 1878-1931
Oil on canvas, 91.4 x 76.8 cm. (36 x
30¼ in.), c. 1919
NPG.68.12
*Gift of the International Business
Machines Corporation*

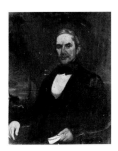

Phelps, Anson, 1781-1853
Businessman
Samuel Lovett Waldo, 1783-1861,
and William Jewett, 1789/90-1874
Oil on canvas, 91.4 x 73.6 cm. (36 x
29 in.), 1854
NPG.71.42
Gift of Phelps Dodge Foundation

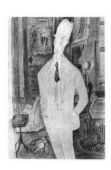

Phillips, Duncan, 1886-1966
Museum director
Aline Fruhauf, 1907-1978
Watercolor and pencil with colored
 pencil and opaque white on paper,
 38.6 x 30.2 cm. (15³⁄₁₆ x 11⅞ in.),
 1949
NPG.83.269
Gift of Erwin Vollmer

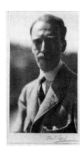

Phillips, Duncan, 1886-1966
Museum director
Clara E. Sipprell, 1885-1975
Photograph, gelatin silver print, 22.7
 x 13.1 cm. (8¹⁵⁄₁₆ x 5³⁄₁₆ in.), c. 1921
NPG.82.200
Bequest of Phyllis Fenner

Phillips, Wendell, 1811-1884
Abolitionist
Leopold Grozelier, 1830-1865, after
 daguerreotype, possibly
 Southworth and Hawes studio
Lithograph with tintstone, 43.9 x
 35.5 cm. (17¼ x 13¹⁵⁄₁₆ in.), c. 1855
NPG.83.183

Phillips, Wendell, 1811-1884
Abolitionist
Martin Milmore, 1844-1883
Bronze, 71.1 cm. (28 in.), 1869
NPG.68.27

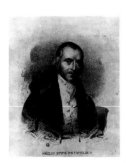

Physick, Philip Syng, 1768-1837
Physician
Albert Newsam, 1809-1864, after
 Henry Inman
Childs and Inman lithography
 company
Lithograph, 19.5 x 15.5 cm. (7¾ x 6⅛
 in.), 1831
NPG.79.97

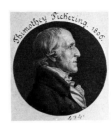

Pickering, Timothy, 1745-1829
Statesman
Charles Balthazar Julien Févret de
 Saint-Mémin, 1770-1852
Engraving, 5.6 cm. (2¼ in.) diameter,
 1806
NPG.74.39.434
Gift of Mr. and Mrs. Paul Mellon

Pickett, Bill, 1870-1932
Rodeo performer
Ritchey Lithographic Corporation,
 active 1920s
Chromolithographic poster, 96.4 x
 61.2 cm. (37¹⁵⁄₁₆ x 24¹⁄₁₆ in.), 1923
NPG.84.113

Pickett, George Edward, 1825-1875
Confederate general
Edward Virginius Valentine,
 1838-1930
Bronze, 69.2 cm. (27¼ in.), 1978 cast
 after 1875 plaster
NPG.78.37

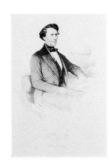

Pierce, Franklin, 1804-1869
Fourteenth President of the United
 States
Marie Alexander Alophe, 1812-1883,
 after photograph
Lithograph, 22.9 x 19.5 cm. (8⅞ x 7¾
 in.), c. 1853
NPG.80.49

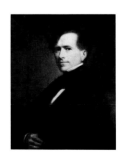

Pierce, Franklin, 1804-1869
Fourteenth President of the United
 States
George Peter Alexander Healy,
 1813-1894
Oil on canvas, 76.2 x 64.1 cm. (30 x
 25¼ in.), 1853
NPG.65.49
*Transfer from the National Gallery
 of Art; gift of Andrew W. Mellon,
 1942*

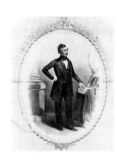

Pierce, Franklin, 1804-1869
Fourteenth President of the United
 States
Abram J. Hoffman, active 1849-1860,
 after daguerreotype by Southworth
 and Hawes
Tappan and Bradford lithography
 company
Lithograph, 46.3 x 35.7 cm. (18¼ x
 14¹/₁₆ in.), c. 1853-1854
NPG.77.5

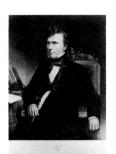

Pierce, Franklin, 1804-1869
Fourteenth President of the United
 States
Alexander Hay Ritchie, 1822-1895,
 after daguerreotype
Mezzotint and line engraving, 46.9
 x 37.5 cm. (18⁷/₁₆ x 14¾ in.), c. 1853
NPG.78.22

Pierce, Franklin, 1804-1869
Fourteenth President of the United
 States
Benjamin W. Thayer lithography
 company, active 1840-1853, after
 unidentified artist
Lithograph with tintstone, 30.2 x
 27.5 cm. (11⅞ x 10¹³/₁₆ in.),
 c. 1847-1852
NPG.77.275

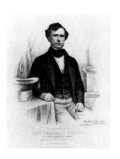

Pierce, Franklin, 1804-1869
Fourteenth President of the United
 States
Morris (Martin?) H. Traubel,
 1820-1897, after daguerreotype by
 Marcus Aurelius Root
Wagner and McGuigan lithography
 company
Lithograph, 35.5 x 32 cm. (14 x 12⅝
 in.), 1852
NPG.77.146

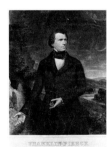

Pierce, Franklin, 1804-1869
Fourteenth President of the United
 States
William E. Tucker, 1801-1857, after
 daguerreotype by Marcus Aurelius
 Root
Mezzotint and line engraving, 43.2
 x 34.4 cm. (17 x 13⁹/₁₆ in.), 1853
NPG.77.94

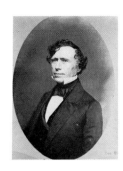

Pierce, Franklin, 1804-1869
Fourteenth President of the United
 States
Unidentified photographer
Photograph, salt print, 18.7 x 13.3
 cm. (7⅜ x 5¼ in.), c. 1858
NPG.77.268

Pike, Zebulon, 1779-1813
Explorer, soldier
Oliver Tarbell Eddy, 1799-1868
Hand-colored etching, 37.3 x 32.7
 cm. (14¹¹/₁₆ x 12⅞ in.), c. 1813
NPG.83.171

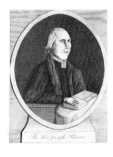

Pilmore, Joseph, 1739-1825
Episcopal clergyman
Attributed to John Norman,
 c. 1748-1817
Engraving, 28 x 21.1 cm. (11 x 8⁵/₁₆
 in.), 1774
NPG.82.74

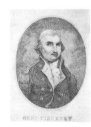

Pinckney, Charles Cotesworth,
 1746-1825
Statesman
Alexander Anderson, 1775-1870,
 after James Earl
Engraving and etching, 9.7 x 7.8 cm.
 (3¹³/₁₆ x 3¹/₁₆ in.), c. 1801
Published in James Hardie's *The*
 New Universal Biographical
 Dictionary and American
 Remembrancer . . . , vol. 3, New
 York, 1801-1802
NPG.80.184.o

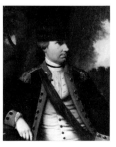

Pinckney, Charles Cotesworth,
 1746-1825
Statesman
Henry Benbridge, 1743-1812
Oil on canvas, 76.2 x 63.5 cm. (30 x
 25 in.), 1774
NPG.67.1

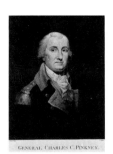

GENERAL CHARLES C. PINCKNEY.

Pinckney, Charles Cotesworth,
1746-1825
Statesman
Cornelius Tiebout, c. 1773-1832,
after Jeremiah Paul, Jr.
Engraving, 29.2 x 23.2 cm. (11½ x
9⅛ in.), c. 1800-1810
NPG.72.63

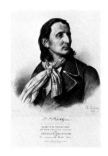

Pitchlynn, Peter Perkins, 1806-1881
Choctaw chief
Charles Fenderich, 1805-1887
P. S. Duval lithography company
Lithograph, 28.2 x 27 cm. (11⅛ x 10⅝
in.), 1842
NPG.72.64

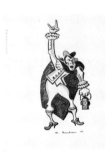

Pinkerton, Allan, 1819-1884
Detective
Alexander Gardner, 1821-1882
Photograph, albumen silver print, 17
x 23 cm. (6¹¹⁄₁₆ x 9⅛ in.), 1862
NPG.78.276

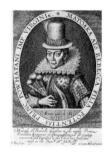

Plumbe, John, Jr., 1809-1857
Photographer
Unidentified artist, after
daguerreotype by John Plumbe, Jr.
Lithograph, 33 x 26 cm. (13 x 10¼
in.), 1846
Contained in *The National
Plumbeotype Gallery,*
Philadelphia, 1847
NPG.78.84.a

Pinza, Ezio, 1892-1957
Singer
Alfred Bendiner, 1899-1964
India ink and pencil on board, 28 x
21.4 cm. (11¹⁄₁₆ x 8⁷⁄₁₆ in.), c. 1945
NPG.84.44
Gift of Alfred Bendiner Foundation

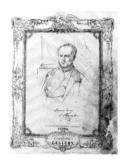

Pocahontas, c. 1595-1617
Daughter of Powhatan chief
Simon van de Passe, 1595-1647
Engraving, 17.5 x 12 cm. (6⅞ x 4¾
in.), 1616
Published in the *Baziliologia,*
London, 1618
NPG.77.43

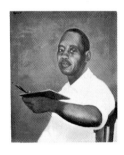

Pippin, Horace, 1888-1946
Artist
Tom Bostelle, 1922-
Oil on canvas board, 61 x 50.8 cm.
(24 x 20 in.), 1939
NPG.80.9
*Gift of the Levi Hood Lodge of the
International Benevolent and
Protective Order of Elks, West
Chester, Pennsylvania*

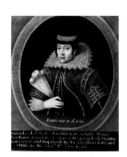

Pocahontas, c. 1595-1617
Daughter of Powhatan chief
Unidentified artist, English school,
after the 1616 engraving by Simon
van de Passe
Oil on canvas, 76.8 x 64.1 cm.
(30¼ x 25¼ in.), after 1616
NPG.65.61
*Transfer from the National Gallery
of Art; gift of Andrew W. Mellon,
1942*

Pippin, Horace, 1888-1946
Artist
Carl Van Vechten, 1880-1964
Photogravure, 22.3 x 15 cm. (8¹³⁄₁₆ x
5⅞ in.), 1983 from 1940 negative
NPG.83.188.36

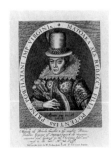

Pocahontas, c. 1595-1617
Daughter of Powhatan chief
Unidentified artist, after Simon van
de Passe
Engraving, 14.7 x 11.4 cm. (5¾ x 4½
in.), 1793
NPG.72.65

Poe, Edgar Allan, 1809-1849
Poet, critic, author
Edouard Manet, 1832-1883, after
 daguerreotype by Hartshorn of
 Masury and Hartshorn, active
 c. 1848
Drypoint, 13.4 x 11.4 cm. (5¼ x 4½
 in.), c. 1875
NPG.82.120
Gift of Edouard Roditi

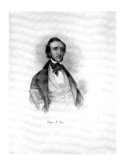

Poe, Edgar Allan, 1809-1849
Poet, critic, author
Welch and Walter engraving
 company, active c. 1846-1848, after
 A. C. Smith
Stipple and line engraving, 15.7 x 12
 cm. (6¼ x 4¾ in.), c. 1846-1848
NPG.79.188

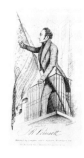

Poinsett, Joel Roberts, 1779-1851
Statesman
William W. Bannerman, ?-c. 1846,
 after Charles Fenderich
Engraving, 19.1 x 10.8 cm. (7½ x 4¼
 in.), 1838
Published in *United States Magazine
 and Democratic Review,* New
 York, 1835
NPG.84.8

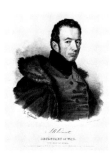

Poinsett, Joel Roberts, 1779-1851
Statesman
Charles Fenderich, 1805-1887
P. S. Duval lithography company
Lithograph, 27.8 x 25 cm. (10¹⁵⁄₁₆ x
 9⅞ in.), 1838
NPG.66.89
*Transfer from the Library of
 Congress, Prints and Photographs
 Division*

Poinsett, Joel Roberts, 1779-1851
Statesman
E. B. and E. C. Kellogg lithography
 company, active c. 1842-1867, after
 William Henry Brown
Lithographed silhouette, 34 x 25.3
 cm. (13⅜ x 10 in.), 1844
Published in William H. Brown's
 *Portrait Gallery of Distinguished
 American Citizens,* Hartford, 1845
NPG.80.276.k
Gift of Wilmarth Sheldon Lewis

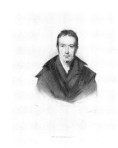

Poinsett, Joel Roberts, 1779-1851
Statesman
Albert Newsam, 1809-1864, after
 William James Hubard
Cephas G. Childs lithography
 company
Lithograph, 12.1 x 10.3 cm. (4¾ x
 4¹⁄₁₆ in.), c. 1830
NPG.84.9

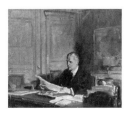

Polk, Frank Lyon, 1871-1943
Statesman
John Christen Johansen, 1876-1964
Oil on canvas, 50.1 x 57.1 cm. (19¾ x
 22½ in.), 1919
NPG.65.87
*Transfer from the National Museum
 of American Art; gift of an
 anonymous donor through Mrs.
 Elizabeth C. Rogerson, 1926*

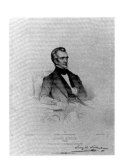

Polk, James Knox, 1795-1849
Eleventh President of the United
 States
Marie Alexandre Alophe, 1812-1883,
 after Savinien Edmé Dubourjal
Cattier lithography company
Lithograph, 22 x 19.7 cm. (8⅝ x 7¾
 in.), 1849
NPG.78.88

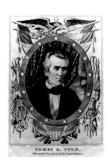

Polk, James Knox, 1795-1849
Eleventh President of the United
 States
Nathaniel Currier, 1813-1888, after
 daguerreotype by John Plumbe, Jr.
Lithograph, 29.2 x 22 cm. (11½ x 8⅝
 in.), 1846
NPG.78.80

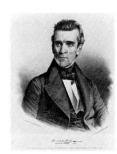

Polk, James Knox, 1795-1849
Eleventh President of the United
 States
Charles Fenderich, 1805-1887
P. S. Duval lithography company
Lithograph, 30.3 x 26.7 cm. (11¹⁵⁄₁₆ x
 10½ in.), 1838
NPG.77.145

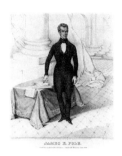

Polk, James Knox, 1795-1849
Eleventh President of the United
 States
Alfred M. Hoffy, active 1835-1864,
 after W. B. Cooper
Lithograph, 43.6 x 35.4 cm. (17⅛ x
 13¹⁵⁄₁₆ in.), 1844
NPG.77.6

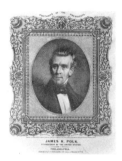

Polk, James Knox, 1795-1849
Eleventh President of the United
 States
Albert Newsam, 1809-1864, after
 Charles Fenderich
P. S. Duval lithography company,
 active 1837-1869
Lithograph, 26 x 22.7 cm. (10¼ x 8⅞
 in.), 1846
NPG.78.119

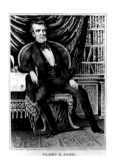

Polk, James Knox, 1795-1849
Eleventh President of the United
 States
Sarony and Major lithography
 company, active 1846-1857, after
 Charles Fenderich
Hand-colored lithograph, 30.3 x 22.1
 cm. (11¹⁵⁄₁₆ x 8¹¹⁄₁₆ in.), 1848
NPG.79.138

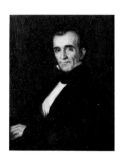

Polk, James Knox, 1795-1849
Eleventh President of the United
 States
Max Westfield, 1882-1971, after oil
 by George Peter Alexander Healy
Oil on canvas, 76.2 x 63.5 cm. (30 x
 25 in.), 1966
NPG.66.5
*Gift of the James Knox Polk
 Memorial Association of Nashville
 and the James K. Polk Memorial
 Auxiliary of Columbia, Tennessee*

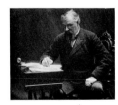

Pond, James Barton, 1838-1903
Lecture manager
Zaida Ben-Yusuf, 1871-?
Photograph, platinum print, 15.8 x
 18.8 cm. (6³⁄₁₆ x 7⅜ in.), c. 1900
NPG.83.202

Porter, Cole, 1892-1964
Composer
Soss Melik, 1914-
Charcoal on paper, 48.2 x 63.5 cm.
 (19 x 25 in.), 1953
NPG.74.32

Porter, David Dixon, 1813-1891
Union admiral
Alexander Gardner, 1821-1882
Photograph, albumen silver print,
 22.3 x 17.5 cm. (8¾ x 6⅞ in.), 1865
NPG.78.155

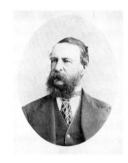

Porter, David Dixon, 1813-1891
Union admiral
Unidentified photographer
Photograph, albumen silver print,
 11.6 x 9 cm. (4⁹⁄₁₆ x 3½ in.), c. 1870
NPG.85.108
Gift of Robert L. Drapkin

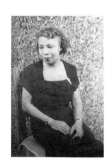

Porter, Dorothy*, 1905-
Librarian
Carl Van Vechten, 1880-1964
Photogravure, 22.3 x 14.9 cm. (8¹³⁄₁₆
 x 5⅞ in.), 1983 from 1951 negative
T/NPG.83.188.37

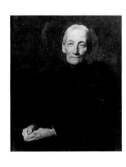

Porter, Sarah, 1813-1900
Educator
Robert Bolling Brandegee, 1848/51-
 1922
Oil on canvas, 76.2 x 63.5 cm. (30 x
 25 in.), 1896
NPG.75.35
*Gift of Mrs. Austin D. Barney, Philip
 C. Barney, and Mrs. Halleck
 Lefferts*

Potter, Clare, ?-?
Designer
Aline Fruhauf, 1907-1978
Watercolor and pencil with crayon,
colored pencil, and opaque white
on paper, 37 x 24.3 cm. (14⁹⁄₁₆ x
9⁹⁄₁₆ in.), 1939
Illustration for *Vogue*, New York,
October 15, 1940
NPG.83.280
Gift of Erwin Vollmer

**Powell, Lewis Thornton ("Lewis
Payne"),** c. 1845-1865
Conspirator in Lincoln assassination
Alexander Gardner, 1821-1882
Photograph, albumen silver print,
8.3 x 5 cm. (3½ x 2 in.), 1865
NPG.80.172
Gift of John Wilmerding

Pound, Ezra Loomis, 1885-1972
Poet
Alvin Langdon Coburn, 1882-1966
Photograph, collotype print, 19.5 x
15.8 cm. (7¹¹⁄₁₆ x 6¼ in.), 1913
NPG.78.14

Powers, Hiram, 1805-1873
Artist
Longworth Powers, ?-1904
Photograph, albumen silver print, 10
x 5.9 cm. (3¹⁵⁄₁₆ x 2⁵⁄₁₆ in.), c. 1865
NPG.78.110

Pound, Ezra Loomis, 1885-1972
Poet
Joan Fitzgerald, 1930-
Bronze, 44.1 cm. (17⅜ in.), 1969
NPG.69.63

Powers, Hiram, 1805-1873
Artist
George Watts, 1817-1904
Pencil on paper, 16.5 x 13.2 cm. (6½
x 5³⁄₁₆ in.), 1846
NPG.80.10

Powell, John Wesley, 1834-1902
Explorer, geologist
Edmund Clarence Messer, 1842-1919
Oil on canvas, 121.9 x 96.5 cm. (48 x
38 in.), 1889
NPG.70.21
*Transfer from the National Museum
of American Art; gift of Mrs. John
Wesley Powell, 1910*

Pownall, Thomas, 1722-1805
Colonial governor
Richard Earlom, 1742/43-1822, after
Francis Cotes
Mezzotint, 36.1 x 27.8 cm. (14¼ x
10¹⁵⁄₁₆ in.), 1777
NPG.77.95

Powell, John Wesley, 1834-1902
Explorer, geologist
Charles Parker, active c. 1887-c. 1913
Photograph, albumen silver print,
14.7 x 10.1 cm. (5¹³⁄₁₆ x 4 in.),
c. 1890
NPG.82.98

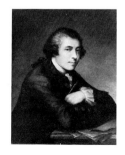

Pratt, Matthew, 1734-1805
Artist
Self-portrait
Oil on canvas, 76.2 x 62.8 cm. (30 x
24¾ in.), 1764
NPG.69.35

Preble, Edward, 1761-1807
Early national naval officer
Edme Quenedey, 1756-1830, after
 John Reich, after George Harrison
Aquatint and etching, 6.2 cm. (2⁷⁄₁₆
 in.) diameter, 1814
NPG.79.153

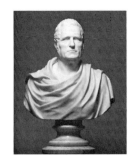

Prime, Nathaniel, 1768-1840
Financier
John Frazee, 1790-1852
Marble, 72.4 cm. (28½ in.), 1832
NPG.84.72
Gift of Sylvester G. Prime

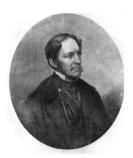

Prescott, William Hickling,
 1796-1859
Historian
Francis D'Avignon, c. 1814-?, after
 daguerreotype by Mathew Brady
Lithograph, 28 x 24.5 cm. (11 x 9⅝
 in.), 1850
Published in Mathew Brady's
 Gallery of Illustrious Americans,
 New York, 1850
NPG.77.96

Pullman, George Mortimer,
 1831-1897
Inventor, industrialist
George K. Warren, c. 1824-1884
Photograph, albumen silver print,
 11.5 x 9.1 cm. (4½ x 3⁹⁄₁₆ in.),
 c. 1870
NPG.80.75

Price, Leontyne*, 1927-
Singer
Carl Van Vechten, 1880-1964
Photogravure, 22.5 x 15 cm. (8⅞ x
 5¹⁵⁄₁₆ in.), 1983 from 1952 negative
T/NPG.83.188.38

Pyle, Ernest Taylor, 1900-1945
Journalist
Jo Davidson, 1883-1952
Bronze, 44.1 cm. (17⅜ in.), c. 1942
NPG.77.317
Gift of Dr. Maury Leibovitz

Priestley, Joseph, 1733-1804
Scientist, educator
Thomas Holloway, 1748-1827, after
 William Artaud
Line engraving, 31.3 x 23.5 cm. (12⁵⁄₁₆
 x 9¼ in.), c. 1794
NPG.77.359

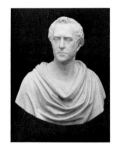

Quincy, Josiah, 1772-1864
Municipal reformer, educator
Horatio Greenough, 1805-1852
Marble, 62.2 cm. (24½ in.), 1827/28
NPG.71.60
Gift of Edmund Quincy

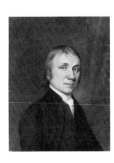

Priestley, Joseph, 1733-1804
Scientist, educator
James Sharples, c. 1751-1811
Pastel on paper, 24.1 x 19 cm. (9½ x
 7½ in.), c. 1797
NPG.77.160

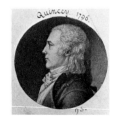

Quincy, Josiah, 1772-1864
Municipal reformer, educator
Charles Balthazar Julien Févret de
 Saint-Mémin, 1770-1852
Engraving, 5.6 cm. (2¼ in.) diameter,
 1796
NPG.74.39.95
Gift of Mr. and Mrs. Paul Mellon

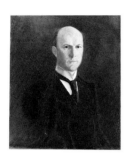

Quinn, John, 1870-1924
Lawyer, patron
George Luks, 1867-1933
Oil on canvas, 76.2 x 63.5 cm. (30 x
 25 in.), 1908
NPG.73.34
Gift of Dr. Thomas F. Conroy

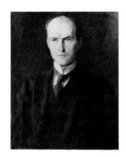

Quinn, John, 1870-1924
Lawyer, patron
John Butler Yeats, 1839-1922
Oil on canvas, 70.8 x 55.5 cm. (27⅞ x
 21⅞ in.), 1908
NPG.75.36
Gift of Dr. Thomas F. Conroy

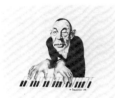

Rachmaninoff, Sergei Vasilievich,
 1873-1943
Composer, musician, symphony
 conductor
Alfred Bendiner, 1899-1964
Lithograph, 19.4 x 22 cm. (7⅝ x 8¹¹⁄₁₆
 in.), 1942
NPG.79.107
Gift of Mrs. Alfred Bendiner

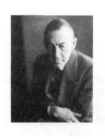

Rachmaninoff, Sergei Vasilievich,
 1873-1943
Composer, musician, symphony
 conductor
Clara E. Sipprell, 1885-1975
Photograph, gelatin silver print, 22.7
 x 17.6 cm. (8¹⁵⁄₁₆ x 6¹⁵⁄₁₆ in.), c. 1925
NPG.82.191
Bequest of Phyllis Fenner

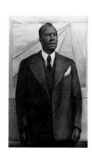

Randolph, Asa Philip*, 1889-1979
Labor leader
Betsy Graves Reyneau, 1888-1964
Oil on canvas, 134.6 x 83.8 cm. (53 x
 33 in.), 1945
T/NPG.67.44.89
Gift of the Harmon Foundation

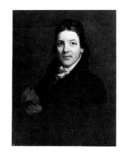

Randolph, John (of Roanoke),
 1773-1833
Statesman
John Wesley Jarvis, 1780-1840
Oil on panel, 76.2 x 63.5 cm. (30 x
 25 in.), 1811
NPG.70.46
Gift of Mrs. Gerard B. Lambert

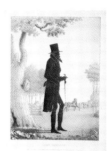

Randolph, John (of Roanoke),
 1773-1833
Statesman
E. B. and E. C. Kellogg lithography
 company, active c. 1842-1867, after
 William Henry Brown
Lithographed silhouette, 34.1 x 25.1
 cm. (13⁷⁄₁₆ x 9⅞ in.), 1844
Published in William H. Brown's
 *Portrait Gallery of Distinguished
 American Citizens,* Hartford, 1845
NPG.80.276.aa
Gift of Wilmarth Sheldon Lewis

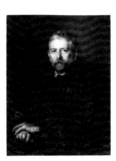

Ranger, Henry Ward, 1858-1916
Artist
Alphonse Jongers, 1872-1945
Oil on canvas, 90.8 x 76.2 cm. (35¾ x
 30 in.), 1906?
NPG.66.67
Gift of James Earle Fraser

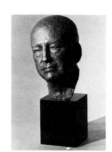

Rayburn, Samuel Taliaferro,
 1882-1961
Statesman
Jimilu Mason, ?-
Bronze, 31.7 cm. (12½ in.), 1970
NPG.72.11
Gift of Mr. and Mrs. Jubal R. Parten

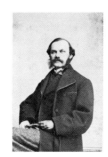

Raymond, Henry Jarvis, 1820-1869
Editor, politician
Mathew Brady, 1823-1896
Photograph, albumen silver print,
 8.3 x 5.4 cm. (3¼ x 2⅛ in.), c. 1863
NPG.80.76

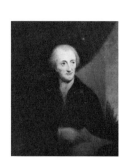

Read, George, 1733-1798
Revolutionary statesman
Robert Edge Pine, c. 1720s-1788
Oil on canvas, 91.4 x 73.6 cm. (36 x
 29 in.), begun 1784
NPG.72.4
Gift of W. B. Shubrick Clymer

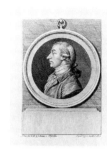

Reed, Joseph, 1741-1785
Revolutionary statesman
Benoit Louis Prevost, 1735-1804, after
 Pierre Eugène Du Simitière
Engraving, 16.2 x 11.7 cm. (6⅜ x 4⅝
 in.), 1780
Published in *Collection des Portraits
 des Généraux, Ministres, et
 Magistrats . . .* , Paris, 1781
NPG.75.57

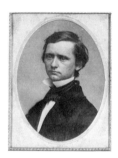

Read, Thomas Buchanan, 1822-1872
Artist
Marcus Aurelius Root, 1808-1888
Daguerreotype, 10.3 x 14.9 cm. (4¹⁄₁₆
 x 5⅞ in.), c. 1850
NPG.65.18
Gift of Miss Eunice Chambers

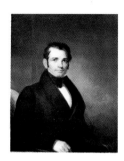

Reed, Luman, 1787-1836
Art patron
Asher Brown Durand, 1796-1886
Oil on canvas, 87 x 69.2 cm. (34¼ x
 27¼ in.), 1835
NPG.81.19

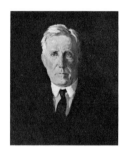

Reed, James Alexander, 1861-1944
Statesman
Ruth Harris Bohan, ?-
Oil on canvas, 61 x 50.8 cm. (24 x 20
 in.), not dated
NPG.70.47
Gift of the artist

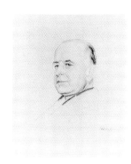

Reed, Stanley Forman*, 1884-1980
Justice of the United States Supreme
 Court
Oskar Stoessel, 1879-1964
Pencil on paper, 35.5 x 25 cm. (14 x
 9⅞ in.), not dated
T/NPG.72.45.90

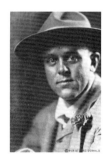

Reed, John, 1887-1920
Journalist
Pirie MacDonald, 1867-1942
Photograph, gelatin silver print, 15.3
 x 22.7 cm. (6 x 8¹⁵⁄₁₆ in.), c. 1916
NPG.78.156

Reed, Thomas Brackett, 1839-1902
Statesman
Thomas Nast, 1840-1902
Ink on paper, 21.9 x 18.6 cm. (8⅝ x
 7⁵⁄₁₆ in.), not dated
NPG.74.67

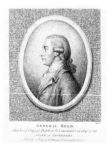

Reed, Joseph, 1741-1785
Revolutionary statesman
B. B. Ellis, ?-?, after Benoit Louis
 Prevost, after Pierre Eugène Du
 Simitière
Stipple engraving, 11.1 x 9.2 cm. (4⅜
 x 3⅝ in.), 1783
Published in *Portraits of the
 Generals, Ministers, Magistrates,*
 London, 1783
NPG.75.76

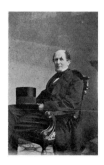

Reed, William Bradford, 1806-1876
Lawyer, diplomat
Mathew Brady, 1823-1896
Photograph, albumen silver print,
 8.8 x 5.4 cm. (3⁷⁄₁₆ x 2⅛ in.), c. 1860
NPG.80.228

Rehan, Ada, 1860-1916
Actress
David Allen and Sons Ltd.
 lithography company, active 1890s
Chromolithographic poster, 68.5 x
 45.6 cm. (26¹⁵⁄₁₆ x 17¹⁵⁄₁₆ in.),
 c. 1895
NPG.84.366
Gift of Mr. and Mrs. Leslie J.
 Schreyer

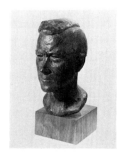

Reuther, Walter Philip, 1907-1970
Labor leader
Oskar Stonorov, 1905-1970
Bronze, 34.8 cm. (13¾ in.), c. 1952
NPG.72.35
Gift of Mrs. Oskar Stonorov

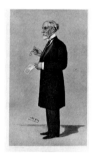

Reid, Whitelaw, 1837-1912
Journalist, diplomat
Vincent Brooks, Day and Son
 lithography company, active
 1867-c. 1905, after Sir Leslie Ward
 ("Spy")
Chromolithograph, 34.4 x 20 cm.
 (13⁹⁄₁₆ x 7⅞ in.), 1902
Published in *Vanity Fair*, London,
 September 25, 1902
NPG.77.334

Revere, Paul, 1735-1818
Silversmith, Revolutionary patriot
Charles Balthazar Julien Févret de
 Saint-Mémin, 1770-1852
Engraving, 5.6 cm. (2¼ in.) diameter,
 1800
NPG.74.39.201
Gift of Mr. and Mrs. Paul Mellon

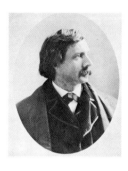

Reid, Whitelaw, 1837-1912
Journalist, diplomat
Napoleon Sarony, 1821-1896
Photograph, albumen silver print,
 11.7 x 9 cm. (4⅝ x 3½ in.), c. 1870
NPG.80.77

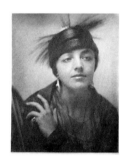

Rhoades, Katharine Nash, 1885-1965
Artist
Alfred Stieglitz, 1864-1946
Photograph, waxed platinum print,
 24.7 x 19.5 cm. (9¾ x 7¹¹⁄₁₆ in.),
 1915
NPG.85.51
Gift of Elizabeth Rhoades Reynolds

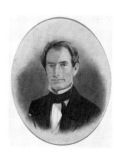

Remington, Eliphalet, 1793-1861
Manufacturer
Unidentified photographer
Photograph, salt print with crayon
 and gouache, 48 x 38 cm. (18⅞ x
 15 in.), c. 1890 after c. 1845
 daguerreotype
NPG.81.142

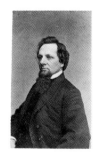

Rice, Dan, 1823-1900
Circus clown
Charles DeForest Fredricks,
 1823-1894
Photograph, albumen silver print,
 9.1 x 5.4 cm. (3⁹⁄₁₆ x 2⅛ in.), c. 1865
NPG.80.215

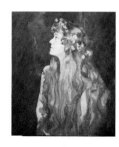

Rethberg, Elisabeth, 1894-1976
Singer
A. Richard Ely, ?-
Oil on canvas, 81.6 x 68.7 cm. (32⅛ x
 27¹⁄₁₆ in.), 1968
NPG.85.77
Gift of A. Richard Ely

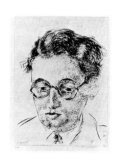

Rice, Elmer Leopold, 1892-1967
Playwright
George Z. Constant, 1892-
Drypoint, 29.9 x 22 cm. (11¾ x 8¹¹⁄₁₆
 in.), 1931
NPG.72.111

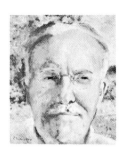

Rice, John Andrew, 1888-1968
Educator
Robert Chambers, 1905-
Oil on masonite, 35.3 x 30.1 cm.
(13¹⁵⁄₁₆ x 11⅞ in.), not dated
NPG.81.5
Gift of Dikka Moen Rice

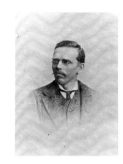

Riis, Jacob August, 1849-1914
Reformer
Davis Garber, ?-?
Photograph, gelatin silver print, 14.3
x 10.3 cm. (5⅞ x 4¹⁄₁₆ in.), c. 1885
NPG.76.89

Rice, Thomas Dartmouth ("Jim Crow"), 1808-1860
Entertainer
Attributed to Max Rosenthal,
1833-1918, after Henry Louis
Stephens
Chromolithograph, 20 x 15.7 cm.
(7⅞ x 6³⁄₁₆ in.), 1851
Published in Henry L. Stephens's
The Comic Natural History,
Philadelphia, 1851
NPG.78.32

Riley, James Whitcomb, 1849-1916
Poet
W. H. Potter, ?-?
Photograph, gelatin silver print, 19.4
x 13.3 cm. (7⅝ x 5¼ in.), c. 1900
NPG.78.251

Richards, William Trost, 1833-1905
Artist
Anna Richards Brewster, 1870-1952
Oil on canvas, 40.6 x 43.2 cm. (16 x
17 in.), 1890
NPG.80.135
Gift of Mrs. James Bryant Conant

Rinehart, Mary Roberts, 1876-1958
Author
Philippe Halsman, 1906-1979
Photograph, gelatin silver print, 34.6
x 27.6 cm. (13⅝ x 10⅞ in.), 1946
NPG.83.105
Gift of George R. Rinhart

Richberg, Donald Randall,
1881-1960
Lawyer, public official
Reuben Nakian, 1897-1987
Plaster, 62.2 cm. (24½ in.), 1933
NPG.83.155
*Gift of Eleanor Richberg Small and
Florence Richberg Campbell*

Ripley, Sidney Dillon*, 1913-
Scientist, secretary of the
Smithsonian Institution
Arnold Newman, 1918-
Color photograph, 25.3 x 20.2 cm.
(9¹⁵⁄₁₆ x 8 in.), 1965
T/NPG.78.184

Rickenbacker, Edward Vernon,
1890-1973
Aviator
H. Ledyard Towle, ?-?
Oil on canvas, 127.3 x 101.2 cm.
(50⅛ x 39⅞ in.), 1919
NPG.71.21
*Transfer from the National Museum
of American History; gift of the
artist in memory of his mother,
Olivia Ledyard Towle, 1924*

Rittenhouse, David, 1732-1796
Scientist
Edward Savage, 1761-1817, after
Charles Willson Peale
Mezzotint, 45.6 x 35.1 cm. (17¹⁵⁄₁₆ x
13¹³⁄₁₆ in.), 1796
NPG.80.149

Roberts, Owen Josephus, 1875-1955
Justice of the United States Supreme
 Court
Oskar Stoessel, 1879-1964
Pencil on paper, 43.2 x 31.7 cm. (17 x
 12½ in.), not dated
NPG.72.46

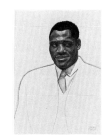

Robeson, Paul Bustill, 1898-1976
Singer, actor, civil rights leader
Winold Reiss, 1886-1953
Pastel on artist board, 76.3 x 54.8 cm.
 (30¹/₁₆ x 21⁹/₁₆ in.), c. 1925
NPG.72.80
*Gift of Lawrence A. Fleischman and
 Howard Garfinkle with a
 matching grant from the National
 Endowment for the Arts*

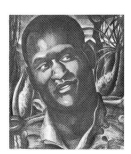

Roberts, Robert Richford, 1779-1845
Clergyman
John Neagle, 1796-1865
Oil on canvas, 76.2 x 63.1 cm. (30 x
 24⅞ in.), c. 1840
NPG.66.10

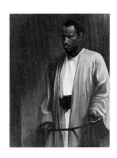

Robeson, Paul Bustill (as Othello),
 1898-1976
Singer, actor, civil rights leader
Betsy Graves Reyneau, 1888-1964
Oil on canvas, 127.6 x 96.5 cm. (50¼
 x 38 in.), 1943-1944
NPG.67.86
Gift of the Harmon Foundation

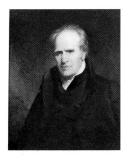

Robeson, Paul Bustill (as Othello),
 1898-1976
Singer, actor, civil rights leader
Alfred Bendiner, 1899-1964
Lithograph, 19.4 x 17.9 cm. (7⅝ x
 7¹/₁₆ in.), c. 1945
NPG.84.45
Gift of Alfred Bendiner Foundation

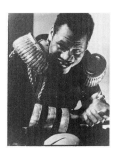

**Robeson, Paul Bustill (as Emperor
 Jones),** 1898-1976
Singer, actor, civil rights leader
Edward Steichen, 1879-1973
Photograph, gelatin silver print, 24.1
 x 19.6 cm. (9½ x 7¾ in.), 1933
NPG.85.17

**Robeson, Paul Bustill (as Emperor
 Jones),** 1898-1976
Singer, actor, civil rights leader
Mabel Dwight, 1876-1955
Lithograph with color, 37.9 x 33.2
 cm. (14⅞ x 13 in.), 1930
NPG.80.63

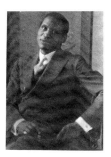

Robeson, Paul Bustill, 1898-1976
Singer, actor, civil rights leader
Doris Ulmann, 1882-1934
Photograph, platinum print, 20.2 x
 15.3 cm. (7¹⁵/₁₆ x 6 in.), c. 1924
NPG.78.2

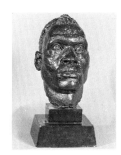

Robeson, Paul Bustill, 1898-1976
Singer, actor, civil rights leader
Jacob Epstein, 1880-1959
Bronze, 34.5 cm. (13½ in.), 1928
NPG.75.18

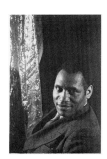

Robeson, Paul Bustill, 1898-1976
Singer, actor, civil rights leader
Carl Van Vechten, 1880-1964
Photogravure, 22.2 x 14.9 cm. (8¾ x
 5⅞ in.), 1983 from 1933 negative
NPG.83.188.39

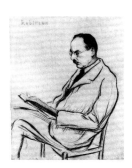

Robinson, Edwin Arlington,
1869-1935
Poet
(Thomas) Richard Hood, 1910-
Drypoint, 18.7 x 16.8 cm. (7⅜ x 6⅝
in.), 1933
NPG.72.66

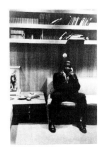

Robinson, Jackie, 1919-1972
Athlete
Garry Winogrand, 1928-1984
Photograph, gelatin silver print, 46.8
x 31.3 cm. (18⁷⁄₁₆ x 12⁵⁄₁₆ in.), 1961
NPG.84.19

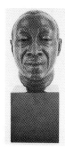

Robinson, James Herman, 1909-1972
Clergyman
Elizabeth Bradford Holbrook, 1913-
Bronze, 30.4 cm. (12 in.), 1968
NPG.81.68
Gift of Mrs. J. A. McCuaig

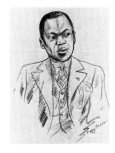

Robinson, Luther (Bill "Bojangles"),
1878-1949
Dancer
Peggy Bacon, 1895-1987
Crayon on paper, 35.5 x 24.4 cm. (14
x 9⅝ in.), c. 1935
NPG.74.68

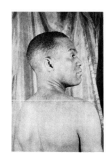

Robinson, Luther (Bill "Bojangles"),
1878-1949
Dancer
Carl Van Vechten, 1880-1964
Photogravure, 22.3 x 14.8 cm. (8¹³⁄₁₆
x 5⅞ in.), 1983 from 1941 negative
NPG.83.188.40

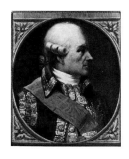

Rochambeau, Jean Baptiste de,
1725-1807
French commander in American
Revolution
Joseph Desiré Court, 1797-1865, after
unidentified artist
Oil on canvas, 65.4 x 54.6 cm. (25¾ x
21½ in.), not dated
NPG.65.47
*Transfer from the National Gallery
of Art; gift of Andrew W. Mellon,
1942*

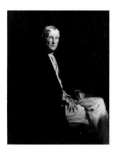

Rockefeller, John Davison, 1839-1937
Industrialist
Timothy Cole, 1852-1931, after John
Singer Sargent
Wood engraving, 21.4 x 27 cm. (8⁷⁄₁₆
x 10⅝ in.), 1921-1924
NPG.77.221

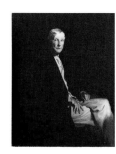

Rockefeller, John Davison, 1839-1937
Industrialist
Jo Davidson, 1883-1952
Bronze, 55.8 cm. (22 in.), 1924
NPG.78.9
*Gift of David, Laurance S., Nelson
A., and John D. Rockefeller III*

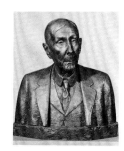

Rockefeller, John Davison, 1839-1937
Industrialist
Adrian Lamb, 1901- , after the 1917
oil by John Singer Sargent
Oil on canvas, 149.2 x 116.2 cm.
(58¾ x 45¾ in.), 1967
NPG.67.17
Gift of John D. Rockefeller III

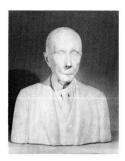

Rockefeller, John Davison, 1839-1937
Industrialist
Paul Manship, 1885-1966
Plaster, 54.3 cm. (21⅜ in.), not dated
NPG.70.32
*Transfer from the National Museum
of American Art; gift of the artist,
1965*

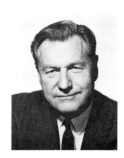

Rockefeller, Nelson Aldrich*,
1908-1979
Statesman, Vice-President of the
 United States
Philippe Halsman, 1906-1979
Photograph, gelatin silver print, 31.5
 x 25.1 cm. (12⁷/₁₆ x 9⁷/₈ in.), 1963
T/NPG.82.173.89
Gift of George R. Rinhart

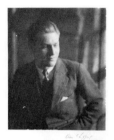

Rockefeller, Nelson Aldrich*,
1908-1979
Statesman, Vice-President of the
 United States
Clara E. Sipprell, 1885-1975
Photograph, gelatin silver print, 23.1
 x 18.8 cm. (9⅛ x 7⁷/₁₆ in.), c. 1930
T/NPG.82.192.89
Bequest of Phyllis Fenner

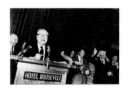

Rockefeller, Nelson Aldrich*,
1908-1979
Statesman, Vice-President of the
 United States
Garry Winogrand, 1928-1984
Photograph, gelatin silver print, 31.4
 x 46.9 cm. (12⅜ x 18⁷/₁₆ in.), 1968
T/NPG.84.21.89

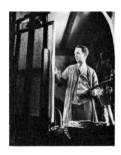

Rockwell, Norman*, 1894-1978
Artist
Harold Haliday Costain, ?-?
Photograph, gelatin silver print, 24.7
 x 19.7 cm. (9¾ x 7¾ in.), 1933
T/NPG.83.252.88

Rockwell, Norman*, 1894-1978
Artist
Peter Rockwell, 1936-
Bronze, 22.5 cm. (8⅞ in.), not dated
T/NPG.74.15.88
Gift of the artist

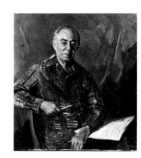

Rodgers, Richard*, 1902-1979
Composer
William Franklin Draper, 1912-
Oil on canvas, 101.6 x 99 cm. (40 x
 39 in.), 1970
T/NPG.70.72.89
Gift of Mr. and Mrs. Richard Rodgers

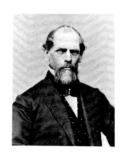

Roebling, John Augustus, 1806-1869
Engineer
Unidentified photographer
Photograph, albumen silver print,
 12.6 x 10 cm. (5 x 3⅞ in.), c. 1869
Bound into *Opening Ceremonies of
 the New York and Brooklyn
 Bridge*, May 24, 1883, Brooklyn,
 1883
NPG.79.222

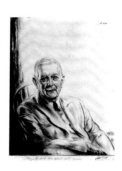

Rogers, Bruce, 1870-1957
Book designer
Walter Tittle, 1883-1968
Drypoint, 25.1 x 20 cm. (9⅞ x 7⅞
 in.), 1940
NPG.79.217

Rogers, Will, 1879-1935
Humorist
Jo Davidson, 1883-1952
Bronze, 48.2 cm. (19 in.), 1935-1938
NPG.67.52

Romberg, Sigmund, 1887-1951
Composer
Alfred Bendiner, 1899-1964
India ink over pencil on paper, 27.2
 x 26.3 cm. (10¹¹/₁₆ x 10⁵/₁₆ in.), 1944
Illustration for *The Evening
 Bulletin*, Philadelphia, July 22,
 1944
NPG.84.55
Gift of Alfred Bendiner Foundation

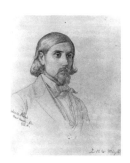

Rood, Ogden Nicholas, 1831-1902
Scientist
Attributed to Peter von Hess,
 1792-1871
Pencil on paper, 19 x 15.4 cm. (7½ x
 6⅛ in.), 1856
NPG.78.279

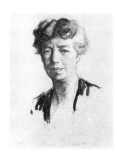

Roosevelt, Anna Eleanor, 1884-1962
First lady, stateswoman
Samuel Johnson Woolf, 1880-1948
Charcoal and white chalk on paper,
 51.3 x 41.3 cm. (20¹/₁₆ x 16⅛ in.),
 1945
NPG.82.135

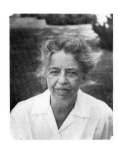

Roosevelt, Anna Eleanor, 1884-1962
First lady, stateswoman
Trude Fleischmann, 1895-
Photograph, gelatin silver print, 31.1
 x 26 cm. (12¼ x 10¼ in.), 1944
NPG.85.42

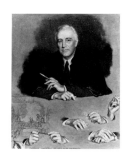

Roosevelt, Franklin Delano,
 1882-1945
Thirty-second President of the
 United States
Douglas Chandor, 1897-1953
Oil on canvas, 136.5 x 116.2 cm.
 (53¾ x 45¾ in.), 1945
NPG.68.49

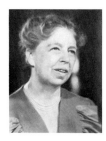

Roosevelt, Anna Eleanor, 1884-1962
First lady, stateswoman
Lotte Jacobi, 1896-
Photograph, Gevalux print, 14.6 x
 11.3 cm. (5¾ x 4⁷/₁₆ in.), 1944
NPG.85.81

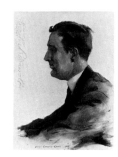

Roosevelt, Franklin Delano,
 1882-1945
Thirty-second President of the
 United States
Joseph Cummings Chase, 1878-1965
Oil on academy board, 62.8 x 47 cm.
 (24¾ x 18½ in.), 1918
NPG.72.122
Gift of Mendel Peterson

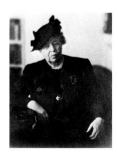

Roosevelt, Anna Eleanor, 1884-1962
First lady, stateswoman
Clara E. Sipprell, 1885-1975
Photograph, gelatin silver print, 25 x
 20.2 cm. (9⅞ x 7¹⁵/₁₆ in.), 1949
NPG.77.140

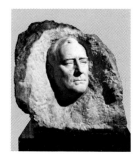

Roosevelt, Franklin Delano,
 1882-1945
Thirty-second President of the
 United States
Jo Davidson, 1883-1952
Stone, 97.1 cm. (38¼ in.), 1951
NPG.72.36
*Gift of the Hon. W. Averell
 Harriman*

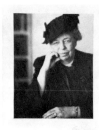

Roosevelt, Anna Eleanor, 1884-1962
First lady, stateswoman
Clara E. Sipprell, 1885-1975
Photograph, gelatin silver print, 22.6
 x 17.6 cm. (8¹⁵/₁₆ x 6¹⁵/₁₆ in.), 1949
NPG.82.158
Bequest of Phyllis Fenner

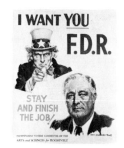

Roosevelt, Franklin Delano,
 1882-1945
Thirty-second President of the
 United States
James Montgomery Flagg, 1877-1960
Color halftone poster, 53.9 x 42.3 cm.
 (21¼ x 16⅝ in.), 1940
NPG.83.10

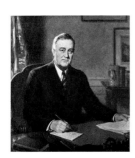

Roosevelt, Franklin Delano,
1882-1945
Thirty-second President of the
United States
Henry Salem Hubbell, 1869-1949
Oil on masonite panel, 121.9 x
116.2 cm. (48 x 45¾ in.), 1935
NPG.66.68
*Transfer from the National Museum
of American Art; gift of Willard
Hubbell, 1964*

Roosevelt, Franklin Delano,
1882-1945
Thirty-second President of the
United States
Keystone View Company, active
1892-1970
Photograph, gelatin silver print, 7.9
x 15.2 cm. (3⅛ x 6 in.), c. 1935
NPG.80.86

Roosevelt, Franklin Delano,
1882-1945
Thirty-second President of the
United States
Violet Oakley, 1874-1961
Graphite and chalk on paper, 33 x 26
cm. (13 x 10¼ in.), 1941
NPG.83.16
*Gift of the Violet Oakley Memorial
Foundation*

Roosevelt, Franklin Delano,
1882-1945
Thirty-second President of the
United States
H. McD. Rundle, ?-?, in the style of
Currier and Ives
Old Print Shop, publisher
Colored lithograph, 29.5 x 23.4 cm.
(11⅝ x 9³⁄₁₆ in.), 1933
NPG.81.52

Roosevelt, Franklin Delano,
1882-1945
Thirty-second President of the
United States
Ben Shahn, 1898-1969
Color lithographic poster, 67.1 x 99.1
cm. (26⁷⁄₁₆ x 39 in.), 1944
NPG.84.112

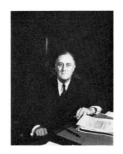

Roosevelt, Franklin Delano,
1882-1945
Thirty-second President of the
United States
Edward Steichen, 1879-1973
Photograph, gelatin silver print, 24.8
x 19.7 cm. (9¾ x 7¾ in.), 1933
NPG.82.85
Bequest of Edward Steichen

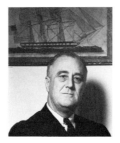

Roosevelt, Franklin Delano,
1882-1945
Thirty-second President of the
United States
Edward Steichen, 1879-1973
Photograph, dye transfer color print,
31.5 x 26.1 cm. (12⅜ x 10¼ in.),
c. 1938
NPG.82.90
Bequest of Edward Steichen

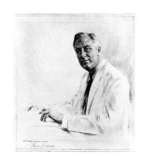

Roosevelt, Franklin Delano,
1882-1945
Thirty-second President of the
United States
Oskar Stoessel, 1879-1964
Etching and drypoint, 41.7 x 37.6 cm.
(16⁷⁄₁₆ x 14¹³⁄₁₆ in.), 1940
NPG.64.14
Gift of David E. Finley

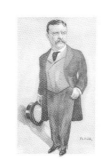

Roosevelt, Theodore, 1858-1919
Twenty-sixth President of the United
States
Vincent Brooks, Day and Son
lithography company, active
1867-c. 1905, after James
Montgomery Flagg
Chromolithograph, 35.7 x 20.7 cm.
(14 x 8⅛ in.), 1902
Published in *Vanity Fair,* London,
September 4, 1902
NPG.81.53

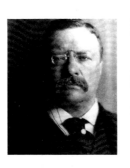

Roosevelt, Theodore, 1858-1919
Twenty-sixth President of the United
States
Alvin Langdon Coburn, 1882-1966
Photogravure, 19.7 x 16.3 cm. (7¾ x
6⁷⁄₁₆ in.), 1907
NPG.77.311

Roosevelt, Theodore, 1858-1919
Twenty-sixth President of the United
 States
Edward Sheriff Curtis, 1868-1952
Photograph, platinum print, 40 x
 30.2 cm. (15¹¹⁄₁₆ x 11⅞ in.), 1904
NPG.79.244

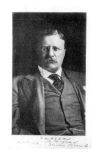

Roosevelt, Theodore, 1858-1919
Twenty-sixth President of the United
 States
Harris and Ewing studio, active
 1905-1977
Photograph, gelatin silver print, 48.5
 x 29.4 cm. (19⅛ x 11⁹⁄₁₆ in.), 1908
NPG.81.170
Gift of Joanna Sturm

Roosevelt, Theodore, 1858-1919
Twenty-sixth President of the United
 States
Sigismund de Ivanowski, 1874-1944
Oil on canvas, 152.4 x 101.6 cm. (60
 x 40 in.), 1910
NPG.72.22
*Gift of Mr. and Mrs. W. B. Dixon
 Stroud*

Roosevelt, Theodore, 1858-1919
Twenty-sixth President of the United
 States
Peter A. Juley, 1862-1937
Photograph, gelatin silver print, 50 x
 37.8 cm. (19¹¹⁄₁₆ x 14⅞ in.), 1903
NPG.81.169
Gift of Joanna Sturm

Roosevelt, Theodore, 1858-1919
Twenty-sixth President of the United
 States
Sally James Farnham, 1876-1943
Bronze relief, 52.8 x 52.8 cm. (20⅝ x
 20⅝ in.), 1906
NPG.74.16

Roosevelt, Theodore, 1858-1919
Twenty-sixth President of the United
 States
Adrian Lamb, 1901- , after the 1908
 oil by Philip Alexius de Lászlo
Oil on canvas, 127 x 101.6 cm. (50 x
 40 in.), 1967
NPG.68.28
*Gift of the Theodore Roosevelt
 Association*

Roosevelt, Theodore, 1858-1919
Twenty-sixth President of the United
 States
James Earle Fraser, 1876-1953
Bronze, 23.5 cm. (9¼ in.), 1920
NPG.77.39

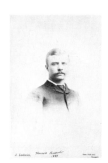

Roosevelt, Theodore, 1858-1919
Twenty-sixth President of the United
 States
J. Ludovici, ?-?
Photograph, albumen silver print, 15
 x 10.6 cm. (5¹⁵⁄₁₆ x 4³⁄₁₆ in.), 1884
NPG.81.125
Gift of Joanna Sturm

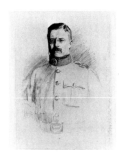

Roosevelt, Theodore, 1858-1919
Twenty-sixth President of the United
 States
Charles Dana Gibson, 1867-1944
Pencil and crayon on paper, 50.8 x
 35.5 cm. (20 x 14 in.), 1898
NPG.73.35

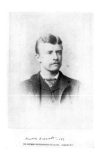

Roosevelt, Theodore, 1858-1919
Twenty-sixth President of the United
 States
Notman Photographic company,
 active 1878-1927
Photograph, albumen silver print,
 14.1 x 10.3 cm. (5⁹⁄₁₆ x 4¹⁄₁₆ in.),
 1883
NPG.81.123
Gift of Joanna Sturm

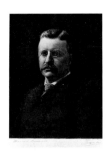

Roosevelt, Theodore, 1858-1919
Twenty-sixth President of the United
 States
Jacques Reich, 1852-1923
Etching, 35.1 x 27.5 cm. (13¹³⁄₁₆ x
 10¹³⁄₁₆ in.), 1900
NPG.67.70
Gift of Oswald D. Reich

Roosevelt, Theodore, 1858-1919
Twenty-sixth President of the United
 States
Unidentified photographer
Photograph, gelatin silver print, 7.7
 x 10 cm. (3 x 3¹⁵⁄₁₆ in.), c. 1907
NPG.78.161

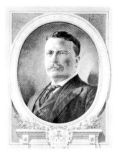

Roosevelt, Theodore, 1858-1919
Twenty-sixth President of the United
 States
Sidney Lawton Smith, 1845-1929,
 after photograph and life drawings
Etching, 56.6 x 43.6 cm. (22¼ x 17⅛
 in.), 1905
NPG.80.57

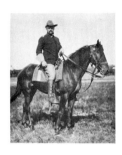

Roosevelt, Theodore, 1858-1919
Twenty-sixth President of the United
 States
Unidentified photographer
Photograph, platinum print, 28.5 x
 23.7 cm. (11³⁄₁₆ x 9⁵⁄₁₆ in.), c. 1898
NPG.81.122
Gift of Joanna Sturm

Roosevelt, Theodore, 1858-1919
Twenty-sixth President of the United
 States
Underwood and Underwood, active
 1882-c. 1950
Photograph, gelatin silver print, 8 x
 15.4 cm. (3³⁄₁₆ x 6¹⁄₁₆ in.), 1902
NPG.80.83

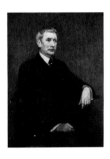

Root, Elihu, 1845-1937
Statesman
Augustus Vincent Tack, 1870-1949
Oil on canvas, 121.9 x 91.7 cm. (48 x
 36⅛ in.), 1922
NPG.67.23
Gift of Mr. Duncan Phillips

Roosevelt, Theodore, 1858-1919
Twenty-sixth President of the United
 States
Underwood and Underwood, active
 1882-c. 1950
Photograph, albumen silver print, 8
 x 15.6 cm. (3⅛ x 6⅛ in.), 1902
NPG.81.82

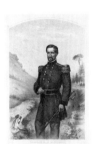

Rosecrans, William Starke,
 1819-1898
Union general
Joseph E. Baker, 1835-1914, after
 photograph by Mathew Brady
J. H. Bufford lithography company
Lithograph with tintstone, 36.6 x
 23.3 cm. (14⅞ x 9⅜ in.), 1861
NPG.82.19

Roosevelt, Theodore, 1858-1919
Twenty-sixth President of the United
 States
Underwood and Underwood, active
 1882-c. 1950
Photograph, gelatin silver print, 25.3
 x 20.3 cm. (10 x 8 in.), 1905
NPG.81.163
Gift of Joanna Sturm

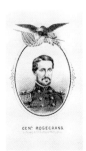

Rosecrans, William Starke,
 1819-1898
Union general
Louis Prang lithography company,
 active 1856-1899, after photograph
Lithograph, 8.3 x 6 cm. (3¼ x 2⅜
 in.), 1862
Contained in D. Dudley's *Officers of
 Our Union Army and Navy. Their
 Lives, Their Portraits,* vol. 1,
 Washington, D.C., and Boston,
 1862
NPG.80.119.x

Rosecrans, William Starke,
 1819-1898
Union general
Samuel Woodson Price, 1828-1918
Oil on canvas, 76.2 x 64.1 cm. (30 x
 25¼ in.), 1868
NPG.71.22
*Transfer from the National Museum
 of American History*

Rosecrans, William Starke,
 1819-1898
Union general
Thomas S. Wagner lithography
 company, active 1840-1865, after
 photograph
Lithograph, 29.9 x 21.2 cm. (11¾ x
 8⅜ in.), 1862-1864
NPG.79.140

Rosenstein, Nettie*, 1893-1980
Designer
Aline Fruhauf, 1907-1978
Watercolor and pencil with colored
 pencil, crayon, and opaque white
 on paper, 40.7 x 33.7 cm. (16 x 13¼
 in.), 1939
Illustration for *Vogue*, New York,
 October 15, 1940
T/NPG.83.281.90
Gift of Erwin Vollmer

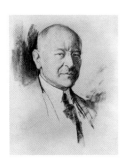

Rosenwald, Julius, 1862-1932
Businessman
Samuel Johnson Woolf, 1880-1948
Charcoal and chalk on paper, 51.5 x
 43 cm. (20¼ x 16⅞ in.), not dated
NPG.80.272

Rubinstein, Helena, 1870-1965
Businesswoman
Miriam Troop, 1917-
Pencil on paper, 27.7 x 35.3 cm.
 (10¹⁵⁄₁₆ x 13¹⁵⁄₁₆ in.), 1948
NPG.72.47

Ruggles, Carl, 1876-1971
Composer
Unidentified photographer
Photograph, gelatin silver print, 15.3
 x 10.1 cm. (6 x 4 in.), c. 1911
NPG.80.38

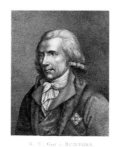

**Rumford, Benjamin Thompson,
 Count,** 1753-1814
Scientist
Franz Xaver Müller, 1756-1837, after
 unidentified artist
Line engraving, 19 x 15.3 cm. (7½ x
 6 in.), after 1792
NPG.77.97

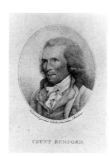

**Rumford, Benjamin Thompson,
 Count,** 1753-1814
Scientist
Joseph Peter Paul Rauschmayr,
 1758-1815, after Georg Dillis
Stipple engraving, 9.6 x 7.9 cm. (3¼
 x 3⅛ in.), after 1792
NPG.77.98

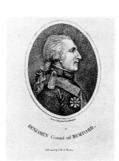

**Rumford, Benjamin Thompson,
 Count,** 1753-1814
Scientist
Edward C. Trenchard, c. 1777-1824,
 after William Ridley, after James
 Tassie
Stipple engraving, 8.6 x 6.7 cm. (3⅜
 x 2⅝ in.), 1798
Published in Rumford's *Essays,
 Political, Economical, and
 Philosophical*, vol. 1, Boston, 1798
NPG.77.212

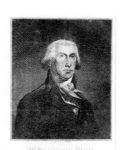

Rush, Benjamin, 1745-1813
Physician
James Akin, c. 1773-1846, after
 Jeremiah Paul, Jr.
Engraving, 18.7 x 15.9 cm. (7⅜ x 6¼
 in.), 1800
NPG.77.253

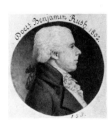

Rush, Benjamin, 1745-1813
Physician
Charles Balthazar Julien Févret de
 Saint-Mémin, 1770-1852
Engraving, 5.6 cm. (2¼ in.) diameter,
 1802
NPG.74.39.153
Gift of Mr. and Mrs. Paul Mellon

Russell, Lillian, 1861-1922
Singer
Alfred J. Frueh, 1880-1968
Linocut, 35.1 x 20.7 cm. (13¹³⁄₁₆ x 8³⁄₁₆
 in.), 1922
Published in Alfred J. Frueh's *Stage
 Folk*, New York, 1922
NPG.84.229.g

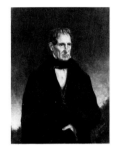

Rush, Richard, 1780-1859
Diplomat
Thomas Waterman Wood, 1823-1903
Oil on canvas, 102.8 x 76.8 cm.
 (40½ x 30¼ in.), 1856
NPG.71.2
*Transfer from the National Museum
 of American Art*

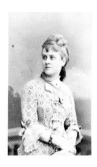

Russell, Lillian, 1861-1922
Singer
José Maria Mora, c. 1847-1926
Photograph, albumen silver print,
 9.2 x 5.7 cm. (3⅝ x 2¼ in.), c. 1880
NPG.80.194

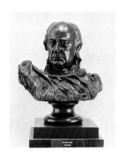

Rush, William, 1756-1833
Artist
Self-portrait
Bronze, 50.8 cm. (20 in.), after the
 c. 1822 original clay
NPG.71.10

Russell, Lillian, 1861-1922
Singer
Adolph (Adolfo) Müller-Ury,
 1862-1947
Pastel on ecru board, 66 x 40.6 cm.
 (26 x 16 in.), not dated
NPG.70.53

Russell, Lillian, 1861-1922
Singer
Benjamin J. Falk, 1853-1925
Photograph, albumen silver print,
 14.5 x 9.8 cm. (5¾ x 3⅞ in.),
 c. 1886
NPG.77.360

Russell, Lillian, 1861-1922
Singer
Napoleon Sarony, 1821-1896
Photograph, albumen silver print, 14
 x 9.8 cm. (5½ x 3⅞ in.), 1895
NPG.80.78

Russell, Lillian, 1861-1922
Singer
Benjamin J. Falk, 1853-1925
Photograph, albumen silver print,
 14.4 x 9.8 cm. (5¹¹⁄₁₆ x 3⅞ in.), 1889
NPG.80.79

Russell, Lillian, 1861-1922
Singer
Strobridge lithography company,
 active 1867-?
Chromolithograph, 78.3 x 61 cm.
 (30¹³⁄₁₆ x 24 in.), c. 1885
NPG.77.329

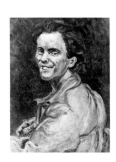

Russell, Morgan, 1886-1953
Artist
Self-portrait
Oil on canvas, 71.7 x 53.3 cm. (28¼ x
 21 in.), c. 1907
NPG.69.57
Gift of Howard Weingrow

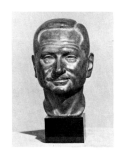

Sabin, Albert Bruce*, 1906-
Scientist
Edmond Romulus Amateis, 1897-
Bronze, 26 cm. (10¼ in.), cast after
 the 1958 terra-cotta
T/NPG.66.46
Gift of the National Foundation

Ruth, George Herman ("Babe"),
 1895-1948
Athlete
Nickolas Muray, 1892-1965
Photograph, gelatin silver print, 24.5
 x 19.5 cm. (9⅝ x 7⅝ in.), 1978 from
 c. 1927 negative
NPG.78.150

**Sa Ga Yeath Qua Pieth Tow ("King
 of the Maquas"),** ?-?
Indian chief
John Simon, 1675-1751/55, after John
 Verelst
Mezzotint, 34.3 x 25.5 cm. (13½ x 10
 in.), third state, c. 1760 from 1710
 plate
NPG.74.22

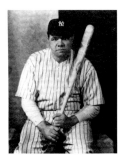

Rutledge, Edward, 1749-1800
Revolutionary statesman
Unidentified artist, after James Earl
John Savage, publisher
Stipple engraving, 29.5 x 23.2 cm.
 (11⅝ x 9⅛ in.), 1802
NPG.78.240

St. Clair, Arthur, 1736-1818
Soldier
Attributed to John Ramage, c. 1748-c.
 1802
Watercolor on ivory, 7 x 5.4 cm. (2¾
 x 2⅛ in.), c. 1787
NPG.83.31
*Gift of Mr. and Mrs. Arthur St. Clair
 Johnson*

Ryder, Albert Pinkham, 1847-1917
Artist
Alice Boughton, 1865/66-1943
Photograph, gelatin silver print, 21.1
 x 16.2 cm. (8⁵⁄₁₆ x 6⅜ in.), 1905
NPG.77.10

St. Denis, Ruth, 1879-1968
Dancer
Nickolas Muray, 1892-1965
Photograph, gelatin silver print, 24.4
 x 19.4 cm. (9⅝ x 7⅝ in.), 1929
NPG.78.15

Ryder, Albert Pinkham, 1847-1917
Artist
Louise Fitzpatrick, ?-1933
Oil on canvas, 57.7 x 48.5 cm. (22¾ x
 19⅛ in.), not dated
NPG.83.1
*Gift of Katherine Caldwell in
 memory of C. E. S. Wood, friend
 and early patron of Ryder*

St. Denis, Ruth, 1879-1968
Dancer
Violet Oakley, 1874-1961
Charcoal and white chalk on paper,
 31.6 x 23.2 cm. (12⅜ x 9⅛ in.), not
 dated
NPG.83.17
*Gift of the Violet Oakley Memorial
 Foundation*

St. Denis, Ruth, 1879-1968
Dancer
Violet Oakley, 1874-1961
Charcoal and white chalk on paper,
 31.5 x 22.7 cm. (12⅜ x 8¹⁵⁄₁₆ in.),
 not dated
NPG.83.18
*Gift of the Violet Oakley Memorial
 Foundation*

St. Denis, Ruth, 1879-1968
Dancer
Violet Oakley, 1874-1961
Charcoal and white chalk on paper,
 31.4 x 23.4 cm. (12⅜ x 9¼ in.), not
 dated
NPG.83.19
*Gift of the Violet Oakley Memorial
 Foundation*

St. Denis, Ruth, 1879-1968
Dancer
Clara E. Sipprell, 1885-1975
Photograph, gelatin silver print, 23.5
 x 18.3 cm. (9¼ x 7³⁄₁₆ in.), 1942
NPG.82.159
Bequest of Phyllis Fenner

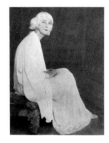

St. Denis, Ruth, 1879-1968
Dancer
Doris Ulmann, 1882-1934
Photograph, platinum print, 20.4 x
 15.3 cm. (8¹⁄₁₆ x 6 in.), c. 1928
NPG.85.91

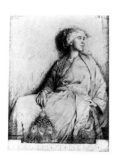

St. Denis, Ruth, 1879-1968
Dancer
Max Wieczorek, 1863-1955
Pastel on paper, 122 x 89.5 cm. (48 x
 35¼ in.), 1920
NPG.72.23

Saint-Gaudens, Augustus, 1848-1907
Artist
George Brewster, 1862-1934
Bronze relief, 36.7 x 30.4 cm. (14½ x
 12 in.), 1904
NPG.69.64

Saint-Gaudens, Augustus, 1848-1907
Artist
John Flanagan, 1865-1952
Bronze, 40.6 cm. (16 in.), 1905-1924
NPG.80.18

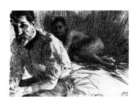

Saint-Gaudens, Augustus, 1848-1907
Artist
Anders Zorn, 1860-1920
Etching, 12.9 x 19.1 cm. (5¼ x 7½
 in.), 1897
NPG.73.37

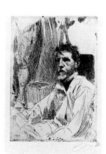

Saint-Gaudens, Augustus, 1848-1907
Artist
Anders Zorn, 1860-1920
Etching, 19.9 x 13.5 cm. (7¹³⁄₁₆ x 5½
 in.), 1897
NPG.73.38

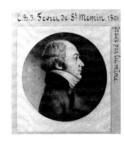

**Saint-Mémin, Charles Balthazar
 Julien Févret de,** 1770-1852
Artist
Self-portrait
Engraving, 5.6 cm. (2¼ in.) diameter,
 1801
NPG.74.39.1
Gift of Mr. and Mrs. Paul Mellon

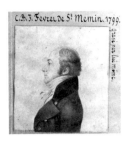

Saint-Mémin, Charles Balthazar Julien Févret de, 1770-1852
Artist
Self-portrait
Engraving, 5.6 x 5.6 cm. (2¼ x 2¼ in.), 1797
NPG.74.39.5
Gift of Mr. and Mrs. Paul Mellon

Salk, Jonas Edward*, 1914-
Scientist
Edmond Romulus Amateis, 1897-
Bronze, 26.3 cm. (10⅜ in.), cast after 1958 plaster
T/NPG.66.29
Gift of the National Foundation

Salk, Jonas Edward*, 1914-
Scientist
Philippe Halsman, 1906-1979
Photograph, gelatin silver print, 34.8 x 27.4 cm. (13¾ x 10¾ in.), 1963
T/NPG.83.108
Gift of George R. Rinhart

Salk, Jonas Edward*, 1914-
Scientist
Peter Strongwater, 1941-
Photograph, gelatin silver print, 36.8 x 36.8 cm. (14½ x 14½ in.), 1982
T/NPG.84.146

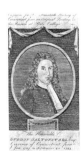

Saltonstall, Gurdon, 1666-1724
Colonial statesman
Amos Doolittle, 1754-1832, after unidentified artist
Etching and engraving, 16.7 x 8.9 cm. (6⁹⁄₁₆ x 3½ in.), 1797
Published in Benjamin Trumbull's *A Complete History of Connecticut,* Hartford, 1797
NPG.76.51

Sampson, Edith Spurlock*, 1901-1979
Jurist
Carl Van Vechten, 1880-1964
Photogravure, 22.3 x 14.9 cm. (8¾ x 5⅞ in.), 1983 from 1949 negative
T/NPG.83.188.41

Sampson, William Thomas, 1840-1902
Naval officer
Kurz and Allison lithography company, active 1880-c. 1899, after photograph
Lithograph, 51.3 x 47 cm. (20⅛ x 18½ in.), c. 1898-1899
NPG.80.111

Sandburg, Carl, 1878-1967
Poet
Emerson C. Burkhart, 1905-1969
Oil on canvas, 76.2 x 64.1 cm. (30 x 25¼ in.), 1951
NPG.73.40

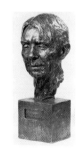

Sandburg, Carl, 1878-1967
Poet
Jo Davidson, 1883-1952
Bronze, 31.7 cm. (12½ in.), 1939
NPG.78.202
Gift of Dr. Maury Leibovitz

Sandburg, Carl, 1878-1967
Poet
Jonathan Leo Fairbanks, 1933-
Pencil on gray paper heightened with chalk, 63.4 x 48.2 cm. (25 x 19 in.), 1957
NPG.83.250
Gift of Theresa L. Fairbanks

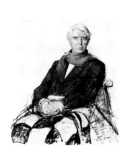

Sandburg, Carl, 1878-1967
Poet
William A. Smith, 1918-
Oil on canvas, 111.3 x 76.2 cm. (40 x
 30 in.), 1961
NPG.80.39
Gift of Kent-Lucas Foundation

Sandburg, Carl, 1878-1967
Poet
Dana Steichen, ?-?
Photograph, gelatin silver print, 24.8
 x 20.1 cm. (9¾ x 7¹⁵⁄₁₆ in.), c. 1926
NPG.77.149

Sandburg, Carl, 1878-1967
Poet
Edward Steichen, 1879-1973
Photographic montage, 33.6 x 26.7
 cm. (13¼ x 10½ in.), 1936
NPG.67.10
Gift of the artist

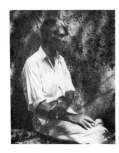

Sandburg, Carl, 1878-1967
Poet
Edward Steichen, 1879-1973
Photograph, gelatin silver print, 23.6
 x 19.2 cm. (9¼ x 7¹¹⁄₁₆ in.), c. 1933
NPG.82.91
Bequest of Edward Steichen

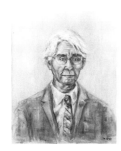

Sandburg, Carl, 1878-1967
Poet
Miriam Svet, 1912-
Oil on canvas, 61 x 50.8 cm. (24 x 20
 in.), 1962
NPG.67.20
Gift of the artist

Sande, Earl, 1898-1968
Athlete
Underwood and Underwood, active
 1882-c. 1950
Photograph, gelatin silver print, 20.3
 x 15.2 cm. (8 x 6 in.), c. 1928
NPG.80.235

Sandos, Mari Susette, 1896-1966
Historian
Philippe Halsman, 1906-1979
Photograph, gelatin silver print, 34.7
 x 27.9 cm. (13¹¹⁄₁₆ x 10¾ in.), 1982
 from 1947 negative
NPG.82.62
Gift of George R. Rinhart

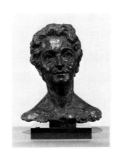

Sanger, Margaret Higgins, 1883-1966
Reformer
Joy Buba, 1904-
Bronze, 46.3 cm. (18¼ in.), cast after
 1964 original
NPG.72.70
Gift of Mrs. Cordelia Scaife May

Sankey, Ira David, 1840-1908
Evangelist
Carlo Pellegrini ("Ape"), 1838-1889
Watercolor over pencil on paper, 29.8
 x 17.9 cm. (11¾ x 7¹⁄₁₆ in.), 1875
NPG.64.5
*Gift of the Trustees, National
 Portrait Gallery, London*

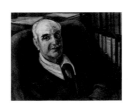

Santayana, George, 1863-1952
Philosopher
Harry Wood, Jr., 1910-
Oil on canvas, 59 x 71.1 cm. (23¼ x
 28 in.), 1950
NPG.73.42

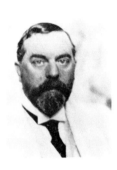

Sargent, John Singer, 1856-1925
Artist
Alvin Langdon Coburn, 1882-1966
Photogravure, 20.1 x 15.7 cm. (7⅞ x
6³⁄₁₆ in.), 1907
NPG.77.312

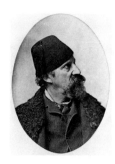

Sarony, Napoleon, 1821-1896
Photographer
Self-portrait
Photogravure, 20.8 x 14.9 cm. (8³⁄₁₆ x
5⅞ in.), c. 1890
NPG.77.313

Sargent, Winthrop, 1753-1820
Revolutionary soldier, statesman
John Trumbull, 1756-1843
Pencil on paper, 11.7 x 7.3 cm. (4⅝ x
2⅞ in.), 1790
NPG.75.1

Sarony, Napoleon, 1821-1896
Photographer
Self-portrait
Photograph, albumen silver print,
14.3 x 10 cm. (5⅝ x 3¹⁵⁄₁₆ in.),
c. 1895
NPG.82.152

Sarnoff, David, 1891-1971
Businessman
Philippe Halsman, 1906-1979
Photograph, gelatin silver print, 34.9
x 27.4 cm. (13¾ x 10¹³⁄₁₆ in.), 1953
NPG.83.109
Gift of George R. Rinhart

Sartain, John, 1808-1897
Artist
Self-portrait, after ambrotype by
Henry Sartain
Engraving and mezzotint, 17.6 x 13
cm. (6⅞ x 5⅛ in.), 1861
Published in *Eclectic Magazine of
Foreign Literature,* New York and
Philadelphia, vol. 53, 1861
NPG.80.55

Sarnoff, David, 1891-1971
Businessman
Samuel Johnson Woolf, 1880-1948
Charcoal and chalk on paper, 57 x
44.5 cm. (22⁷⁄₁₆ x 17½ in.), 1941
NPG.80.273

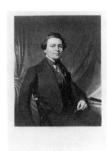

Sartain, John, 1808-1897
Artist
Self-portrait, after daguerreotype by
Marcus Aurelius Root
Mezzotint, 12.7 x 10.2 cm. (5 x 4 in.),
c. 1848
NPG.80.226
Gift of Marvin Sadik

Sarony, Napoleon, 1821-1896
Photographer
Self-portrait
Lithograph, 20.5 x 18.7 cm. (8¹⁄₁₆ x
7⅜ in.), c. 1874
NPG.77.99

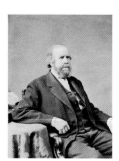

Saxton, Joseph, 1799-1873
Inventor
Mathew Brady, 1823-1896
Photograph, albumen silver print,
14.1 x 10.1 cm. (5½ x 4 in.), 1872
NPG.81.85

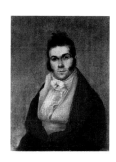

Say, Thomas, 1787-1834
Scientist
Joseph Wood, c. 1778-1830
Oil on panel, 22.8 x 17.1 cm. (9 x 6¾
 in.), c. 1820
NPG.72.112

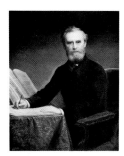

Schurz, Carl, 1829-1906
Statesman
Daniel Huntington, 1816-1906
Oil on canvas, 126.8 x 101.6 cm.
 (49¹⁵⁄₁₆ x 40 in.), 1899
NPG.81.20

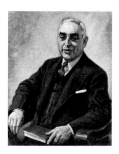

Schick, Bela, 1877-1967
Scientist
Joseph Margulies, 1896-
Oil on canvas, 75.9 x 60.6 cm. (29⅞ x
 23⅞ in.), 1940
NPG.69.58

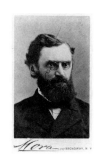

Schurz, Carl, 1829-1906
Statesman
José Maria Mora, c. 1847-1926
Photograph, albumen silver print, 9
 x 5.2 cm. (3⁹⁄₁₆ x 2¹⁄₁₆ in.), c. 1870
NPG.79.53

Schiff, Jacob Henry, 1847-1920
Financier
Hermann Struck, 1876-?
Drypoint, 19 x 25.1 cm. (7½ x 9⅞
 in.), 1913
NPG.76.14
Gift of John M. Schiff

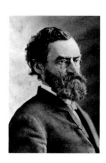

Schurz, Carl, 1829-1906
Statesman
Napoleon Sarony, 1821-1896
Photograph, albumen silver print,
 14.2 x 9.7 cm. (5⁹⁄₁₆ x 3¹³⁄₁₆ in.),
 c. 1876
NPG.78.162

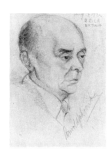

Schley, Winfield Scott, 1839-1911
Naval officer
Harris and Ewing studio, active
 1905-1977
Photograph, waxed brown-toned
 gelatin silver print, 31.9 x 24 cm.
 (12⁹⁄₁₆ x 9½ in.), c. 1905
NPG.84.315
Gift of Aileen Conkey

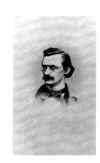

Schurz, Carl, 1829-1906
Statesman
Unidentified photographer
Photograph, albumen silver print,
 9.4 x 5.6 cm. (3¹¹⁄₁₆ x 2³⁄₁₆ in.),
 c. 1860
NPG.78.154

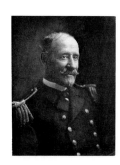

Schoenberg, Arnold, 1874-1951
Composer
Muriel Pargh Turoff, 1904-
Pencil on paper, 14 x 10.2 cm. (5½ x
 4 in.), 1942
NPG.66.41
Gift of the artist

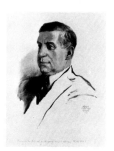

Schwab, Charles Michael, 1862-1939
Businessman
Joseph Cummings Chase, 1878-1965
Oil on academy board, 61.5 x 45.5
 cm. (24¼ x 18 in.), 1918
NPG.72.98
Gift of Mendel Peterson

Scott, Winfield, 1786-1866
Mexican War general
Attributed to Joseph E. Baker,
 1835-1914, after photograph
J. H. Bufford lithography company
Lithograph with tintstone, 33.1 x 23
 cm. (13 x 9¹⁄₁₆ in.), 1861
NPG.83.4

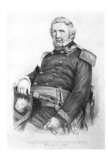

Scott, Winfield, 1786-1866
Mexican War general
Currier and Ives lithography
 company, active 1857-1907, after
 photograph
Lithograph, 30.3 x 22.8 cm. (11¹⁵⁄₁₆ x
 9 in.), 1861
NPG.85.157

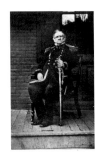

Scott, Winfield, 1786-1866
Mexican War general
Attributed to Mathew Brady,
 1823-1896
Photograph, salt print, 47 x 39.9 cm.
 (18½ x 15¾ in.), c. 1861
NPG.78.245

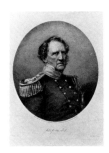

Scott, Winfield, 1786-1866
Mexican War general
Francis D'Avignon, c. 1814-?, after
 daguerreotype by Mathew Brady
Lithograph, 28.2 x 24.5 cm. (11⅛ x
 9⅝ in.), 1850
Published in Mathew Brady's
 Gallery of Illustrious Americans,
 New York, 1850
NPG.72.67

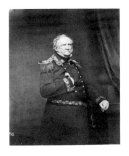

Scott, Winfield, 1786-1866
Mexican War general
Mathew Brady, 1823-1896
Photograph, albumen silver print,
 8.6 x 5.3 cm. (3⅜ x 2¹⁄₁₆ in.), 1861
NPG.79.41

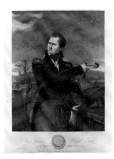

Scott, Winfield, 1786-1866
Mexican War general
Charles DeForest Fredricks,
 1823-1894
Photograph, albumen silver print,
 9.2 x 5.5 cm. (3⅝ x 2⅛ in.), 1862
NPG.80.309
Gift of Dr. Mary W. Juday

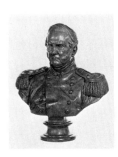

Scott, Winfield, 1786-1866
Mexican War general
Henry Kirke Brown, 1814-1886
Plaster, 73 cm. (28¾ in.), c. 1858
Bronze, 73 cm. (28¾ in.), cast after
 c. 1858 plaster
NPG.65.38 and NPG.65.38.1
 (illustrated)
*Plaster, a transfer from the National
 Museum of American Art; gift of
 Henry Kirke Bush-Brown, 1926*

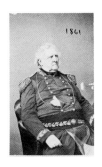

Scott, Winfield, 1786-1866
Mexican War general
Thomas Gimbrede, 1781-1832
Stipple engraving, 37 x 27.2 cm.
 (14⁹⁄₁₆ x 10¹¹⁄₁₆ in.), c. 1820
NPG.77.104

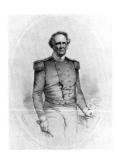

Scott, Winfield, 1786-1866
Mexican War general
Charles G. Crehen, 1829-?, after
 daguerreotype by S. C. McIntyre
Nagel and Weingaertner lithography
 company
Lithograph, 37.2 x 28 cm. (14⅝ x 11
 in.), 1850
NPG.77.103

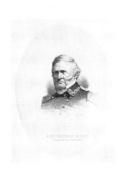

Scott, Winfield, 1786-1866
Mexican War general
Alfred K. Kipps, active 1859-1861,
 after photograph by Mathew Brady
Louis Prang lithography company
Lithograph with tintstone, 22.1 x 16.5
 cm. (8¹¹⁄₁₆ x 6½ in.), c. 1861-1863
NPG.82.23

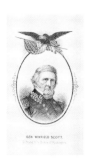

Scott, Winfield, 1786-1866
Mexican War general
Louis Prang lithography company,
 active 1856-1899, after photograph
Lithograph, 8.3 x 6 cm. (3¼ x 2⅜
 in.), 1862
Contained in D. Dudley's *Officers of
 Our Union Army and Navy. Their
 Lives, Their Portraits,* vol. 1,
 Washington, D.C., and Boston,
 1862
NPG.80.119.y

Scott, Winfield, 1786-1866
Mexican War general
Attributed to Thomas S. Wagner
 lithography company, active
 1840-1865, after photograph by
 Brady studio
Lithograph, 31.3 x 26 cm. (12⁵⁄₁₆ x
 10¼ in.), 1861-1864
NPG.79.134

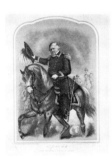

Scott, Winfield, 1786-1866
Mexican War general
William Rush, 1756-1833
Plaster, 43.5 cm. (17⅛ in.), c. 1814
NPG.73.19

Scott, Winfield, 1786-1866
Mexican War general
Unidentified artist
Plaster, 81 cm. (31⅞ in.), c. 1850
NPG.76.8
Gift of Marvin Sadik

Scott, Winfield, 1786-1866
Mexican War general
Henry S. Sadd, active 1832-1850, after
 daguerreotype by Mathew Brady
Engraving, 35.8 x 27.8 cm. (14⅛ x
 10¹⁵⁄₁₆ in.), c. 1840-1850
NPG.77.102

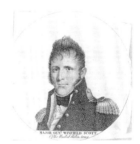

Scott, Winfield, 1786-1866
Mexican War general
Unidentified artist, after Joseph
 Wood
Stipple engraving, 5.8 x 5.2 cm. (2⁵⁄₁₆
 x 2¹⁄₁₆ in.), c. 1820
NPG.79.6

Scott, Winfield, 1786-1866
Mexican War general
Otto Starck, active c. 1861-c. 1865,
 after photograph
Mayer and Stetfield lithography
 company
Lithograph with tintstone, 33.6 x
 23.3 cm. (13¼ x 9¹³⁄₁₆ in.), 1861
NPG.82.8

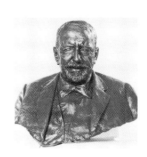

Scripps, Edward Wyllis, 1854-1926
Newspaper publisher, philanthropist
Jo Davidson, 1883-1952
Bronze, 61 cm. (24 in.), 1922-1930
NPG.78.203
Gift of Dr. Maury Leibovitz

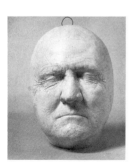

Scott, Winfield, 1786-1866
Mexican War general
Attributed to William J. Stone,
 1798-1865, or his family
Plaster life mask, 24.7 x 16.5 cm. (9¾
 x 6½ in.), 1852
NPG.81.108
Gift of Mrs. Katheryne Simons

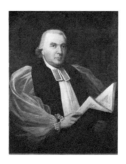

Seabury, Samuel, 1729-1796
Clergyman
Ralph Earl, 1751-1801
Oil on canvas, 91.4 x 71.1 cm. (36 x
 28 in.), 1785
NPG.84.171
*Bequest of Lispenard Seabury
 Crocker*

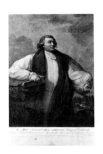

Seabury, Samuel, 1729-1796
Clergyman
William Sharp, 1749-1824, after
 Thomas Spence Duché, Jr.
Engraving, 43.2 x 33 cm. (17 x 13
 in.), 1786
NPG.75.51

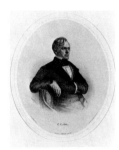

Seaton, William Winston, 1785-1866
Journalist
Leopold Grozelier, 1830-1865, after
 George Peter Alexander Healy
S. W. Chandler and Brother
 lithography company
Lithograph, 27.8 x 24.6 cm. (10¹⁵⁄₁₆ x
 9¾ in.), 1855
Published in Charles H. Brainard's
 *Portrait Gallery of Distinguished
 Americans*, Boston, 1855
NPG.77.100

Seaton, William Winston, 1785-1866
Journalist
Attributed to Joseph Wood,
 c. 1778-1830
Oil on paper, 22.2 x 16.5 cm. (8¾ x
 6½ in.), 1822
NPG.74.8

Sedgwick, Ellery, 1872-1960
Editor
Doris Ulmann, 1882-1934
Photograph, platinum print, 20.3 x
 15.5 cm. (8 x 6½ in.), c. 1925
NPG.85.28

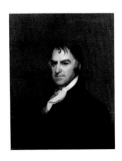

Sedgwick, Theodore, 1746-1813
Statesman, jurist
Attributed to Ezra Ames, 1768-1836,
 after oil by Gilbert Stuart
Oil on canvas, 88.9 x 78.8 cm. (35 x
 31 in.), c. 1810
NPG.70.5
Gift of Lillian Swann Saarinen

Sedgwick, Theodore, 1746-1813
Statesman, jurist
Charles Balthazar Julien Févret de
 Saint-Mémin, 1770-1852
Engraving, 5.6 cm. (2¼ in.) diameter,
 1801
NPG.74.39.449
Gift of Mr. and Mrs. Paul Mellon

Sedgwick, Theodore, 1746-1813
Statesman, jurist
John Rubens Smith, 1775-1849, after
 Henry Williams, after Gilbert
 Stuart
Engraving, 8.8 x 7.8 cm. (3⁷⁄₁₆ x 3¹⁄₁₆
 in.), 1813
Published in *Polyanthos*, vol. 2,
 Boston, May 1813
NPG.84.14

Semmes, Raphael, 1809-1877
Confederate naval officer
Louis Prang lithography company,
 active 1856-1899, after photograph
Lithograph with tintstone, 23.1 x
 17.3 cm. (9¹⁄₁₆ x 6¹³⁄₁₆ in.), c. 1864
NPG.84.368

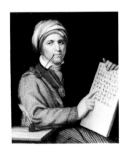

Se-Quo-Yah, 1770?-1843
Indian statesman
Attributed to Henry Inman,
 1801-1846, after Charles Bird King
Oil on canvas, 76.5 x 63.4 cm. (30⅛ x
 25 in.), c. 1830
NPG.79.174

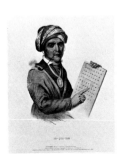

Se-Quo-Yah, 1770?-1843
Indian statesman
Unidentified artist, after Charles
 Bird King
J. T. Bowen lithography company
Hand-colored lithograph, 27.4 x 22.5
 cm. (10⅞ x 8¾ in.), 1837
Published in McKenney and Hall's
 *History of the Indian Tribes of
 North America*, Philadelphia,
 1836-1844
NPG.71.53

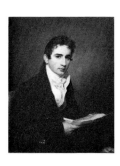

Sergeant, John, 1779-1852
Lawyer
Thomas Sully, 1783-1872
Oil on canvas, 82.5 x 66 cm. (32½ x
 26 in.), 1811
NPG.84.179
Gift of Mrs. Craig Wylie

Serkin, Rudolf*, 1903-
Musician
Alfred Bendiner, 1899-1964
India ink with opaque white on
 paper, 31 x 25.5 cm. (12³⁄₁₆ x 10¹⁄₁₆
 in.), c. 1945
T/NPG.84.40
Gift of Alfred Bendiner Foundation

Serkin, Rudolf*, 1903-
Musician
Alfred Bendiner, 1899-1964
Crayon on paper, 16 x 26 cm. (6⁵⁄₁₆ x
 10¼ in.), c. 1945
T/NPG.84.41
Gift of Alfred Bendiner Foundation

Serkin, Rudolf*, 1903-
Musician
Clara E. Sipprell, 1885-1975
Photograph, gelatin silver print, 23.2
 x 18.9 cm. (9⅛ x 7⁷⁄₁₆ in.), 1960
T/NPG.82.193
Bequest of Phyllis Fenner

Seton, Elizabeth Ann Bayley,
 1774-1821
Humanitarian
Charles Balthazar Julien Févret de
 Saint-Mémin, 1770-1852
Engraving, 5.6 cm. (2¼ in.) diameter,
 1797
NPG.74.39.328
Gift of Mr. and Mrs. Paul Mellon

Seton, Ernest Thompson, 1860-1946
Naturalist
Alexander W. Dreyfoos, 1875/76-1951
Photograph, brown-toned gelatin
 silver print, 23.5 x 18.5 cm. (9¼ x
 7¼ in.), c. 1916
NPG.82.69

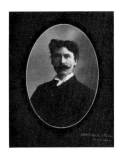

Seton, Ernest Thompson, 1860-1946
Naturalist
H. J. Whitlock and Sons, studio
 active c. 1850-?
Photograph, gelatin silver print, 13 x
 9.3 cm. (5⅛ x 3¹¹⁄₁₆ in.), c. 1894
NPG.82.70

Seward, William Henry, 1801-1872
Statesman
Giovanni Maria Benzoni, 1809-1873
Marble, 58.4 cm. (23 in.), 1872
NPG.65.39
*Transfer from the National Museum
 of American Art; bequest of Sara
 Carr Upton in memory of Olive
 Risley Seward, 1931*

Seward, William Henry, 1801-1872
Statesman
Francis D'Avignon, c. 1814-?, after
 daguerreotype by Jeremiah Gurney
Lithograph, 28 x 24.1 cm. (11 x 9½
 in.), 1853
NPG.72.68

Seward, William Henry, 1801-1872
Statesman
Leopold Grozelier, 1830-1865, after
 daguerreotype by Julian Vannerson
S. W. Chandler and Brother
 lithography company
Lithograph, 26.2 x 24.4 cm. (10⁵⁄₁₆ x
 9⅝ in.), 1855
Published in Charles H. Brainard's
 *Portrait Gallery of Distinguished
 Americans*, Boston, 1855
NPG.77.101

Seward, William Henry, 1801-1872
Statesman
Unidentified photographer
Daguerreotype, 14.1 x 10.7 cm. (5⁹⁄₁₆
x 4¼ in.), c. 1852
NPG.77.269

Shawn, Ted, 1891-1972
Dancer, choreographer
Townsend, ?-?
Photograph, toned solarized gelatin
silver print, 22.8 x 18.6 cm. (9 x
7⁵⁄₁₆ in.), c. 1925
NPG.81.10

Seyffert, Leopold, 1887-1956
Artist
Self-portrait
Charcoal on paper, 50.8 x 40.6 cm.
(20 x 16 in.), c. 1916
NPG.69.80

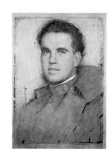

Shawn, Ted, 1891-1972
Dancer, choreographer
Max Wieczorek, 1863-1955
Charcoal on paper heightened with
chalk, 65 x 49 cm. (25¼ x 18¼ in.)
sight, c. 1926
NPG.84.180

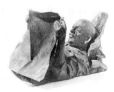

Shahn, Benjamin, 1898-1969
Artist
Jonathan Shahn, 1938-
Copper and bronze, 28.8 cm. (11⅜
in.), 1967
NPG.70.54

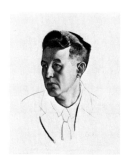

Sheeler, Charles, 1883-1965
Artist
Self-portrait
Pastel on paper, 58.4 x 48.2 cm. (23 x
19 in.), 1924
NPG.73.15

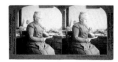

Shaw, Anna Howard, 1849-1919
Reformer
Underwood and Underwood, active
1882-c. 1950
Photograph, gelatin silver print, 7.7
x 15.2 cm. (3⅛ x 6 in.), c. 1910
NPG.81.174

Shepard, Alan Bartlett, Jr.*, 1923-
Astronaut
David Lee Iwerks, 1933-
Photograph, gelatin silver print, 24 x
19 cm. (9⁷⁄₁₆ x 7½ in.), 1966
T/NPG.78.182

Shaw, Anna Howard, 1849-1919
Reformer
Unidentified photographer
Photograph, brown-toned gelatin
silver print, 24.5 x 18 cm. (9¹¹⁄₁₆ x
7¹⁄₁₆ in.), c. 1915
NPG.82.81
*Gift of University Women's Club,
Incorporated*

Shepherd, Alexander Robey,
1835-1909
Public official
Joseph Alexander Bailly, 1825-1883
Marble bas-relief, 55.8 x 40.6 cm. (22
x 16 in.), not dated
NPG.80.26
Gift of Mrs. Katie Louchheim

Sheridan, Philip Henry, 1831-1888
Union general
Currier and Ives lithography
 company, active 1857-1907, after
 photograph
Lithograph, 29.3 x 23.2 cm. (11⁹⁄₁₆ x
 9⅛ in.), c. 1865
NPG.85.152

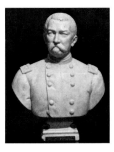

Sheridan, Philip Henry, 1831-1888
Union general
Thomas Buchanan Read, 1822-1872
Marble, 56.2 cm. (22⅛ in.), 1871
NPG.66.73
*Transfer from the National Museum
 of American Art; gift of Mr.
 Benjamin Bell, 1952*

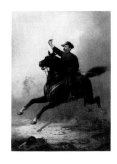

Sheridan, Philip Henry, 1831-1888
Union general
Thomas Buchanan Read, 1822-1872
Oil on canvas, 137.1 x 98.7 cm. (54 x
 38⅞ in.), 1871
NPG.68.51
*Transfer from the National Museum
 of American History; gift of
 Ulysses S. Grant III, 1939*

Sheridan, Philip Henry, 1831-1888
Union general
Unidentified photographer
Photograph, albumen silver print,
 15.4 x 11.6 cm. (6⅜ x 4⁹⁄₁₆ in.), 1864
NPG.78.97

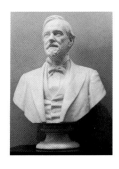

Sherman, John, 1823-1900
Statesman
Daniel Chester French, 1850-1931
Marble, 68.9 cm. (27¼ in.), 1886
NPG.70.33
*Transfer from the National Museum
 of American Art; gift of Lt. John
 Sherman McCallum in memory of
 John T. Sherman, 1920*

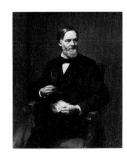

Sherman, John, 1823-1900
Statesman
Henry Ulke, 1821-1910
Oil on canvas, 127 x 101.9 cm. (50 x
 40⅛ in.), 1880
NPG.69.7
Gift of Mrs. Luis A. Bolin

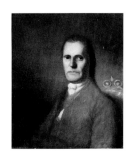

Sherman, Roger, 1721-1793
Statesman
Unidentified artist, after Ralph Earl
Oil on canvas, 67 x 56.3 cm. (26⅜ x
 22³⁄₁₆ in.), after c. 1777
NPG.69.90
Gift of Mr. Bradley B. Gilman

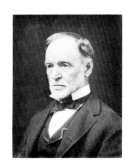

Sherman, William Tecumseh,
 1820-1891
Union general
George C. Cox, 1851-1902
Photograph, albumen silver print,
 23.7 x 18.6 cm. (9⁵⁄₁₆ x 7⁵⁄₁₆ in.),
 c. 1890
NPG.80.177

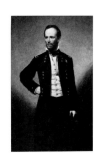

Sherman, William Tecumseh,
 1820-1891
Union general
George Peter Alexander Healy,
 1813-1894
Oil on canvas, 158.7 x 97.1 cm. (62½
 x 38¼ in.), 1866
NPG.65.40
*Transfer from the National Museum
 of American Art; gift of P.
 Tecumseh Sherman, 1935*

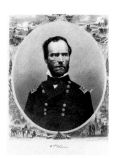

Sherman, William Tecumseh,
 1820-1891
Union general
John C. McRae, active 1850-1880,
 after photograph
Engraving and etching, 33.1 x 26.9
 cm. (12 x 10⁹⁄₁₆ in.), c. 1865
NPG.78.106

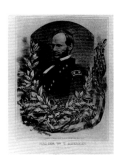

Sherman, William Tecumseh,
 1820-1891
Union general
Max Rosenthal, 1833-1918, after
 photograph
Louis N. Rosenthal, printer
Lithograph with tintstone, 63.2 x
 48.6 cm. (25⅞ x 19⅛ in.), 1865
NPG.79.225

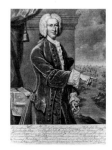

Shirley, William, 1694-1771
Colonial statesman
Peter Pelham, 1697-1751, after John
 Smibert
Mezzotint, 30.1 x 25 cm. (11⅞ x 9⅞
 in.), 1747
NPG.75.80

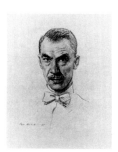

Sherwood, Robert Emmet, 1896-1955
Playwright
Soss Melik, 1914-
Charcoal on paper, 56.5 x 47 cm.
 (22¼ x 18½ in.), 1945
NPG.68.22

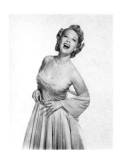

Shore, Frances Rose ("Dinah")*,
 1917-
Singer
Philippe Halsman, 1906-1979
Photograph, gelatin silver print, 34.7
 x 27.1 cm. (13⅝ x 10⅝ in.), 1952
T/NPG.83.110
Gift of George R. Rinhart

Shinburn, Maximillian, 1840-1917
Criminal
Richie studio, ?-?
Photograph, albumen silver print, 14
 x 9.8 cm. (5½ x 3⅞ in.), c. 1894
NPG.82.65
Gift of Pinkerton's, Incorporated

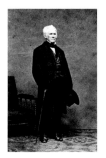

Shreve, Henry Miller, 1785-1851
Steamboat captain
Attributed to George D'Almaine,
 1800-1893
Charcoal and chalk on paper, 31.7
 cm. (12½ in.) diameter, not dated
NPG.69.36

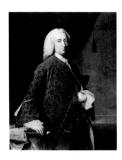

Shinn, Everett, 1876-1953
Artist
Self-portrait
Pastel on board, 33.5 x 25.4 cm. (14 x
 10 in.), 1901
NPG.78.219

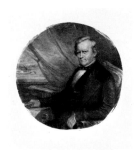

Silliman, Benjamin, 1779-1864
Scientist
Bundy and Williams studio, active
 1863-1869
Photograph, albumen silver print,
 8.9 x 5.6 cm. (3½ x 2¼ in.), c. 1862
NPG.79.55

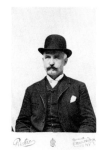

Shirley, William, 1694-1771
Colonial statesman
Thomas Hudson, 1701-1779
Oil on canvas, 127 x 101.6 cm. (50 x
 40 in.), 1750
NPG.80.11

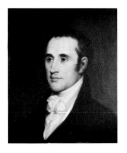

Silliman, Benjamin, 1779-1864
Scientist
John Trumbull, 1756-1843
Oil on panel, 48.8 x 40 cm. (19¼ x
 15¾ in.), 1825
NPG.68.6
Gift of Alice Silliman Hawkes

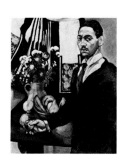

Simonson, Lee, 1888-1967
Scenic designer
Self-portrait
Oil on canvas, 101.9 x 81.6 cm. (40⅛
x 32⅛ in.), c. 1912
NPG.77.239
Gift of Karl and Jody Simonson

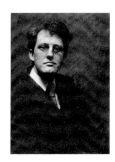

Sloan, John French, 1871-1951
Artist
Gertrude Kasebier, 1852-1934
Photograph, platinum print, 20.5 x
15.3 cm. (8⅛ x 6 in.), c. 1907
NPG.78.246

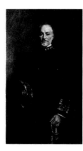

Sims, William Sowden, 1858-1936
World War I admiral
Irving Ramsay Wiles, 1861-1948
Oil on canvas, 141.6 x 85.7 cm. (55¾
x 33¾ in.) sight, 1919
NPG.65.41
*Transfer from the National Museum
of American Art; gift of the
National Art Committee, 1923*

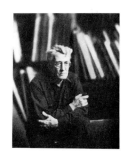

Sloan, John French, 1871-1951
Artist
Clara E. Sipprell, 1885-1975
Photograph, gelatin silver print, 23 x
18.6 cm. (9¹⁄₁₆ x 7⁵⁄₁₆ in.), c. 1949
NPG.82.195
Bequest of Phyllis Fenner

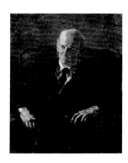

Singer, Isaac Bashevis*, 1904-
Author
Clara Klinghoffer, 1900-1970
Oil on canvas, 91.4 x 77.5 cm. (36 x
30½ in.), 1965
T/NPG.79.154
Gift of the Simon Foundation, Inc.

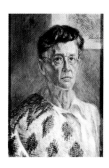

Sloan, John French, 1871-1951
Artist
Self-portrait
Oil and graphite on masonite, 55.8 x
37.4 cm. (22 x 14¾ in.), 1929
NPG.80.176

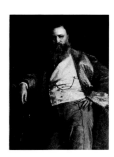

Singer, Isaac Merritt, 1811-1875
Inventor
Edward Harrison May, 1824-1887
Oil on canvas, 130.1 x 97.8 cm. (51¼
x 38½ in.), 1869
NPG.75.37
Gift of the Singer Company

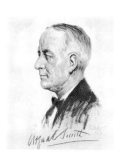

Smith, Alfred Emanuel, 1873-1944
Public official
Samuel Johnson Woolf, 1880-1948
Watercolor and gouache on paper,
43.2 x 33.6 cm. (17 x 13¼ in.), 1928
NPG.80.274

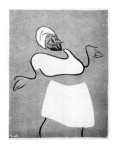

Skinner, Otis, 1858-1942
Actor
Alfred J. Frueh, 1880-1968
Linocut, 31.6 x 24.9 cm. (12⁷⁄₁₆ x 9¹³⁄₁₆
in.), 1922
Published in Alfred J. Frueh's *Stage
Folk*, New York, 1922
NPG.84.229.bb

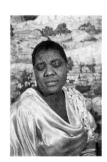

Smith, Bessie, 1894-1937
Singer
Carl Van Vechten, 1880-1964
Photogravure, 22.4 x 14.9 cm. (8¹³⁄₁₆
x 5⅞ in.), 1983 from 1936 negative
NPG.83.188.42

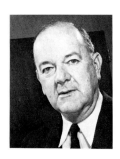

Smith, Cyrus Rowlett*, 1899-
Airline executive
Philippe Halsman, 1906-1979
Photograph, gelatin silver print, 34.7
x 27.3 cm. (13⅝ x 10¾ in.), 1959
T/NPG.83.111
Gift of George R. Rinhart

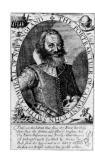

Smith, John, 1579/80-1631
Explorer
Unidentified artist, probably after
Simon van de Passe
Engraving, 15 x 9.2 cm. (5¹⁵⁄₁₆ x 3⅝
in.), c. 1617
NPG.72.113

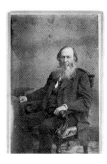

Smith, Gerrit, 1797-1874
Reformer, abolitionist
Mathew Brady, 1823-1896
Photograph, albumen silver print,
8.6 x 5.5 cm. (3⅜ x 2⅛ in.), c. 1862
NPG.80.304
Gift of an anonymous donor

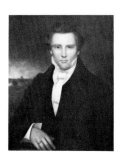

Smith, Joseph, 1805-1844
Founder of the Church of Jesus
Christ of Latter-Day Saints
Adrian Lamb, 1901- , after
unidentified artist
Oil on canvas, 73.6 x 58.4 cm. (29 x
23 in.), 1971
NPG.71.143
*Gift of the Reorganized Church of
Jesus Christ of Latter-Day Saints,
Independence, Missouri*

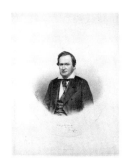

Smith, Gerrit, 1797-1874
Reformer, abolitionist
Leopold Grozelier, 1830-1865, after
daguerreotype by E. G. Weld
S. W. Chandler and Brother
lithography company
Lithograph, 25.4 x 30.4 cm. (10 x
11¹³⁄₁₆ in.), 1854
NPG.83.184

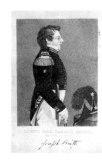

Smith, Joseph, 1805-1844
Founder of the Church of Jesus
Christ of Latter-Day Saints
Oliver Pelton, 1798-1882, after
Sutcliffe Maudsley
Engraving, 11.7 x 9 cm. (4⁹⁄₁₆ x 3½
in.), 1842
Published in John C. Bennett's *The
History of the Saints; or, An
Exposé of Joe Smith and
Mormonism*, Boston, 1842
NPG.82.102

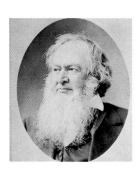

Smith, Gerrit, 1797-1874
Reformer, abolitionist
William Kurz, 1834-1904
Photograph, albumen silver print,
11.5 x 9.1 cm. (4½ x 3⅝ in.),
c. 1870
NPG.80.80

Smith, Lloyd Logan Pearsall,
1865-1946
Author
Edmond Xavier Kapp, 1890-
Lithograph, 18.4 x 21 cm. (7¼ x 8¼
in.), c. 1940
NPG.76.52
Gift of Richard Kenin

Smith, Gerrit, 1797-1874
Reformer, abolitionist
Attributed to E. G. Weld, ?-?
Daguerreotype, 14 x 10.8 cm. (5½ x
4¼ in.), c. 1854
NPG.80.118
Gift of an anonymous donor

Smith, Margaret Chase*, 1897-
Public official
Liz Hart, 1923-
Bronze, 34.2 cm. (13½ in.), 1980
T/NPG.84.160
Gift of Liz Hart

Smith, Samuel, 1752-1839
Statesman
Charles Balthazar Julien Févret de
Saint-Mémin, 1770-1852
Engraving, 5.6 cm. (2¼ in.) diameter,
1798-1800
NPG.74.39.145
Gift of Mr. and Mrs. Paul Mellon

Smith, Samuel, 1752-1839
Statesman
Charles Balthazar Julien Févret de
Saint-Mémin, 1770-1852
Engraving, 5.6 cm. (2¼ in.) diameter,
1798-1800
NPG.74.39.454
Gift of Mr. and Mrs. Paul Mellon

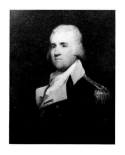

Smith, Samuel, 1752-1839
Statesman
Gilbert Stuart, 1755-1828
Oil on canvas, 73.6 x 61 cm. (29 x 24
in.), c. 1800
NPG.66.50
*Gift of Dr. and Mrs. B. Noland
Carter in memory of the Misses
Mary Coles Carter and Sally
Randolph Carter*

Smithson, James, 1765-1829
Founder of Smithsonian Institution
John Wesley Paradise, 1809-1862,
after unidentified artist
Engraving, 13 x 9.4 cm. (5⅛ x 3¹¹⁄₁₆
in.), 1847
NPG.81.94

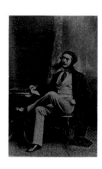

Sothern, Edward Askew, 1826-1881
Actor
George N. Rockwood, 1833-1911
Photograph, albumen silver print,
14.8 x 9.8 cm. (5¹³⁄₁₆ x 3⅞ in.),
c. 1870
NPG.78.99

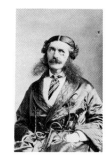

Sothern, Edward Askew, 1826-1881
Actor
Napoleon Sarony, 1821-1896
Photograph, albumen silver print,
9.6 x 6.1 cm. (3¾ x 2⅜ in.), c. 1872
NPG.80.171

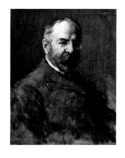

Sousa, John Philip, 1854-1932
Bandmaster, composer
Harry Franklin Waltman, 1871-1951
Oil on canvas, 68.5 x 55.8 cm. (27 x
22 in.), 1909
NPG.69.24
Gift of the Sousa Corporation

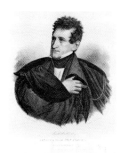

Southard, Samuel Lewis, 1787-1842
Statesman
Charles Fenderich, 1805-1887
Lithograph, 31 x 28.7 cm. (12¼ x 11¼
in.), 1838
NPG.66.90
*Transfer from the Library of
Congress, Prints and Photographs
Division*

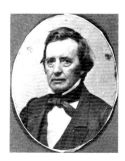

Southworth, Albert Sands, 1811-1894
Photographer
Unidentified photographer
Photograph, salt print, 6.8 x 5.4 cm.
(2¾ x 2⅛ in.), c. 1855
NPG.76.91
Gift of an anonymous donor

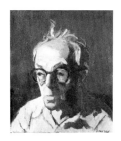

Soyer, Raphael*, 1899-
Artist
Salvatore Del Deo, 1928-
Oil on canvas, 40.6 x 35.5 cm. (16 x
14 in.), 1978
T/NPG.83.122
Gift of Salvatore Del Deo

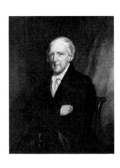

Stevens, John, 1749-1838
Engineer
Unidentified artist
Oil on canvas, 91.4 x 73.6 cm. (36 x
 29 in.), c. 1830
NPG.75.13
Gift of H. H. Walker Lewis in
 memory of his parents, Mr. and
 Mrs. Edwin A. S. Lewis

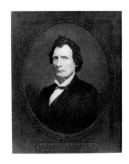

Stevens, Robert Livingston,
 1787-1856
Engineer
Edgar Ludlow Mooney, 1813-1887,
 after Henry Inman
Oil on canvas, 76.2 x 63.5 cm. (30 x
 25 in.), 1852
NPG.75.14
Gift of H. H. Walker Lewis in
 memory of his parents, Mr. and
 Mrs. Edwin A. S. Lewis

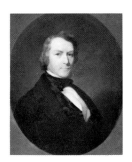

Stevens, Thaddeus, 1792-1868
Statesman
John Sartain, 1808-1897, after
 photograph by C. W. Eberman
Mezzotint, 45.4 x 36.4 cm. (17⅞ x
 14⅝ in.), 1867
NPG.79.24

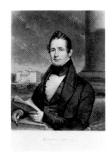

Stevens, Thaddeus, 1792-1868
Statesman
John Sartain, 1808-1897, after Jacob
 Eichholtz
Mezzotint, 23.7 x 19.2 cm. (8⁹⁄₁₆ x
 7⁹⁄₁₆ in.), 1838
NPG.79.74

Stevenson, Adlai Ewing, 1900-1965
Statesman
Philippe Halsman, 1906-1979
Photograph, gelatin silver print, 34.8
 x 27.4 cm. (13¹¹⁄₁₆ x 10¾ in.), 1965
NPG.83.113
Gift of George R. Rinhart

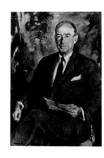

Stevenson, Adlai Ewing, 1900-1965
Statesman
Trafford P. Klots, 1913-1976
Oil on canvas, 114.6 x 76.2 cm. (45⅛
 x 30 in.), 1953
NPG.67.33
Gift of Mrs. Marshall Field and Mrs.
 Elizabeth Ives

Stevenson, Adlai Ewing, 1900-1965
Statesman
Edward Huhner Weiss, 1901-
Acrylic on fiberglass globe, 121.9 cm.
 (48 in.) diameter, 1965
NPG.66.39
Gift of Morris Leibman

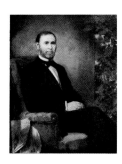

Stewart, Alexander Turney,
 1803-1876
Merchant
Thomas LeClear, 1818-1882
Oil on canvas, 126.8 x 100 cm. (49¹⁵⁄₁₆
 x 39⅜ in.), 1863
NPG.81.21

Stewart, Charles, 1778-1869
War of 1812 naval officer
Washington Lafayette Germon,
 1823-1878
Photograph, albumen silver print,
 20.3 x 15.6 cm. (8¹⁄₁₆ x 6⅛ in.),
 c. 1858
NPG.82.78

Stewart, Charles, 1778-1869
War of 1812 naval officer
Charles Balthazar Julien Févret de
 Saint-Mémin, 1770-1852
Engraving, 5.6 cm. (2¼ in.) diameter,
 1802
NPG.74.39.417
Gift of Mr. and Mrs. Paul Mellon

Stewart, Charles, 1778-1869
War of 1812 naval officer
Thomas Sully, 1783-1872
Pencil on paper, 19.7 x 12.7 cm. (7¾ x 5 in.), c. 1817
NPG.71.17

Stieglitz, Alfred, 1864-1946
Photographer
Aline Fruhauf, 1907-1978
Black ink with opaque white and pencil on paper, 16.1 x 20.6 cm. (6⁵⁄₁₆ x 8¹⁄₁₆ in.), 1960
NPG.83.270
Gift of Erwin Vollmer

Stewart, James*, 1908-
Actor
Alfred Bendiner, 1899-1964
Crayon with opaque white on board, 24.7 x 28.7 cm. (9¾ x 11⁵⁄₁₆ in.), c. 1940
T/NPG.85.205
Gift of Alfred Bendiner Foundation

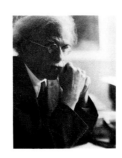

Stieglitz, Alfred, 1864-1946
Photographer
Clara E. Sipprell, 1885-1975
Photograph, gelatin silver print, 22.2 x 17.5 cm. (8¾ x 6⅞ in.), 1932
NPG.82.196
Bequest of Phyllis Fenner

Stewart, Potter*, 1915-1985
Justice of the United States Supreme Court
Oscar Berger, 1901-
Ink over pencil on paper, 49.7 x 36.8 cm. (19⅝ x 14½ in.), c. 1968
T/NPG.69.12.95
Gift of the artist

Stieglitz, Alfred, 1864-1946
Photographer
Paul Strand, 1890-1976
Photograph, gelatin silver print, 12 x 9.3 cm. (4¾ x 3¹¹⁄₁₆ in.), 1929
NPG.82.100

Stewart, Potter*, 1915-1985
Justice of the United States Supreme Court
Philippe Halsman, 1906-1979
Photograph, gelatin silver print, 34.9 x 27.4 cm. (13¾ x 10¹³⁄₁₆ in.), 1964
T/NPG.83.114.95
Gift of George R. Rinhart

Stimson, Henry Lewis, 1867-1950
Statesman
Joy Buba, 1904-
Cast stone, 44.1 cm. (17⅜ in.), 1950
NPG.74.17

Stieglitz, Alfred, 1864-1946
Photographer
Alvin Langdon Coburn, 1882-1966
Photogravure, 16 cm. (6⁵⁄₁₆ in.) diameter, c. 1906
NPG.76.92

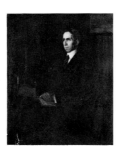

Stokes, Anson Phelps, 1874-1958
Philanthropist
Julius Rolshoven, 1858-1930
Oil on canvas, 161.2 x 135.8 cm. (63½ x 53½ in.), c. 1900
NPG.85.9
Gift of the sitter's grandchildren

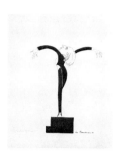

Stokowski, Leopold*, 1882-1977
Symphony conductor
Alfred Bendiner, 1899-1964
India ink and pencil on paper, 35.8 x
28.9 cm. (14¹/₁₆ x 11⅜ in.), c. 1940
T/NPG.84.36.87

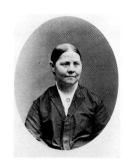

Stone, Lucy, 1818-1893
Reformer
George K. Warren, c. 1824-1884
Photograph, albumen silver print,
11.6 x 9.1 cm. (4⁹/₁₆ x 3⁹/₁₆ in.),
c. 1875
NPG.77.347

Stokowski, Leopold*, 1882-1977
Symphony conductor
Jack Wayne Henderson, 1931-
Prismacolor pencil, raw umber, and
acrylic wash on paper, 60.7 x 45.5
cm. (23⅞ x 17¹⁵/₁₆ in.), 1967
T/NPG.82.126.87
Gift of C. W. Baumgarten

Stone, Lucy, 1818-1893
Reformer
Unidentified photographer
Daguerreotype, 13.9 x 10.7 cm. (5½ x
4¼ in.), c. 1885
NPG.77.271

Stokowski, Leopold*, 1882-1977
Symphony conductor
Leopold Seyffert, 1887-1956
Charcoal on paper, 50.8 x 40.6 cm.
(20 x 16 in.), 1916
T/NPG.69.75.87

Stone, Thomas, 1743-1787
Revolutionary statesman
James Barton Longacre, 1794-1869,
after Robert Edge Pine
Sepia watercolor on artist board, 26.4
x 15.2 cm. (10⅜ x 6 in.), c. 1827
NPG.77.293

Stone, Edward Durrell*, 1902-1978
Architect
Philippe Halsman, 1906-1979
Photograph, gelatin silver print, 34.9
x 27.5 cm. (13¾ x 10¹³/₁₆ in.), 1964
T/NPG.83.115.88
Gift of George R. Rinhart

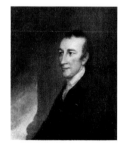

Stone, Thomas, 1743-1787
Revolutionary statesman
Robert Edge Pine, c. 1720s-1788
Oil on canvas, 67.2 x 53.3 cm. (26½ x
21 in.), c. 1785
NPG.71.44
Gift of Mrs. Frank J. Clement

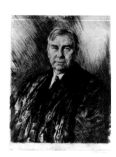

Stone, Harlan Fiske, 1872-1946
Chief Justice of the United States
Oskar Stoessel, 1879-1964
Etching, 37.7 x 29 cm. (14⅞ x 11⁷/₁₆
in.), c. 1941-1943
NPG.64.13
Gift of David E. Finley

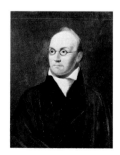

Story, Joseph, 1779-1845
Justice of the United States Supreme
Court
Chester Harding, 1792-1866
Oil on canvas, 76.2 x 63.5 cm. (30 x
25 in.), 1827
NPG.67.28

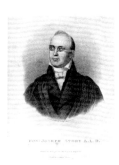

Story, Joseph, 1779-1845
Justice of the United States Supreme
 Court
Pendleton lithography company,
 active 1825-1836, after Chester
 Harding
Lithograph, 11.5 x 10 cm. (4½ x 3¹⁵⁄₁₆
 in.), 1832
Published in *The New-England
 Magazine*, Boston, December 1832
NPG.78.139

Stout, Pola, ?-?
Designer
Aline Fruhauf, 1907-1978
Watercolor and pencil with crayon,
 colored pencil, and opaque white
 on paper, 35.5 x 31.6 cm. (13¹⁵⁄₁₆ x
 12⁷⁄₁₆ in.), 1941
NPG.83.282
Gift of Erwin Vollmer

Stowe, Harriet Elizabeth Beecher,
 1811-1896
Author, reformer
Cartau, ?-?, after daguerreotype
Lithograph, 13.2 x 11.7 cm. (5⅛ x 4½
 in.), c. 1850-1860
NPG.81.63
Gift of Dr. Frank Stanton

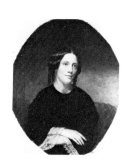

Stowe, Harriet Elizabeth Beecher,
 1811-1896
Author, reformer
Erie lithography company, active
 1890s
Color lithographic poster, 100.6 x
 66.9 cm. (39⅝ x 26⁵⁄₁₆ in.), c. 1890
NPG.84.227
*Gift of Mr. and Mrs. Leslie J.
 Schreyer*

Stowe, Harriet Elizabeth Beecher,
 1811-1896
Author, reformer
Alanson Fisher, 1807-1884
Oil on canvas, 86.4 x 67.9 cm. (34 x
 26¾ in.), 1853
NPG.68.1

Stowe, Harriet Elizabeth Beecher,
 1811-1896
Author, reformer
Charles DeForest Fredricks,
 1823-1894
Photograph, albumen silver print,
 7.9 x 13.1 cm. (3⅛ x 5⅜ in.),
 c. 1862
NPG.83.128
Gift of Clifford Krainik

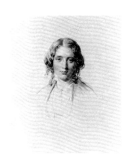

Stowe, Harriet Elizabeth Beecher,
 1811-1896
Author, reformer
Francis Holl, 1815-1884, after George
 Richmond
Stipple engraving, 19 x 15.5 cm. (7½
 x 6⅛ in.), c. 1855
NPG.79.17

Stowe, Harriet Elizabeth Beecher,
 1811-1896
Author, reformer
Dora Wheeler Keith, 1857/58-1940
Pastel on paper, 63.5 x 51 cm. (25 x
 20 in.), c. 1887
NPG.76.15

Stowe, Harriet Elizabeth Beecher,
 1811-1896
Author, reformer
Silsbee, Case and Company, studio
 active 1858-1863
Photograph, albumen silver print,
 8.8 x 5.5 cm. (3⁷⁄₁₆ x 2⅛ in.), c. 1860
NPG.78.252

Stowe, Harriet Elizabeth Beecher,
 1811-1896
Author, reformer
Unidentified photographer
Daguerreotype, 7.4 x 6.7 cm. (2¹⁵⁄₁₆ x
 2⅝ in.), c. 1852
NPG.80.23

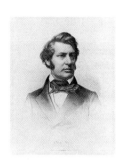

Sumner, Charles, 1811-1874
Statesman
Leopold Grozelier, 1830-1865, after
 daguerreotype by Southworth and
 Hawes
J. H. Bufford lithography company
Lithograph, 28.5 x 22.8 cm. (11¼ x 9
 in.), 1856
Published in Charles H. Brainard's
 *Portrait Gallery of Distinguished
 Americans*, Boston, 1855
NPG.77.106

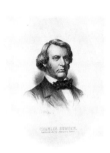

Sumner, Charles, 1811-1874
Statesman
Alfred K. Kipps, active 1859-1861,
 after photograph
Louis Prang lithography company
Lithograph with tintstone, 19.9 x
 14.9 cm. (7¹³⁄₁₆ x 5⅞ in.), c.
 1861-1863
NPG.82.21

Sumner, Charles, 1811-1874
Statesman
John A. Manget lithography
 company, active 1873-1876, after
 Mathew Brady
Lithograph, 27.5 x 24.5 cm. (10¾ x
 9½ in.), c. 1874-1875
NPG.80.50

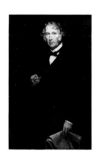

Sumner, Charles, 1811-1874
Statesman
Edgar Parker, 1840-1892
Oil on canvas, 137.1 x 86.4 cm. (54 x
 34 in.), 1874
NPG.69.39

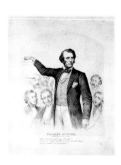

Sumner, Charles, 1811-1874
Statesman
Louis Prang lithography company,
 active 1856-1899, after photograph
Lithograph with tintstone, 27 x 22.1
 cm. (10⅝ x 8¹¹⁄₁₆ in.), c. 1865
NPG.80.150

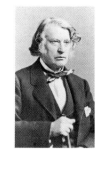

Sumner, Charles, 1811-1874
Statesman
George K. Warren, c. 1824-1884
Photograph, albumen silver print,
 9.5 x 5.5 cm. (3¾ x 2³⁄₁₆ in.), c. 1870
NPG.77.353

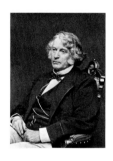

Sumner, Charles, 1811-1874
Statesman
Unidentified photographer
Photograph, albumen silver print,
 14.8 x 10.3 cm. (5¹³⁄₁₆ x 4¹⁄₁₆ in.),
 c. 1870
NPG.77.143

Sumter, Thomas, 1734-1832
Revolutionary general
William G. Armstrong, 1823-1890,
 after Rembrandt Peale
Sepia watercolor on artist board, 27.6
 x 22.8 cm. (10⅞ x 9 in.), c. 1835
NPG.77.287

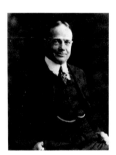

Sunday, William Ashley ("Billy"),
 1862-1935
Evangelist
G. Arthur Fairbanks, ?-?
Photograph, gelatin silver print, 23.5
 x 17.2 cm. (9¼ x 6¾ in.), c. 1915
NPG.78.167

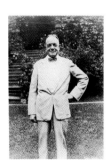

Sunday, William Ashley ("Billy"),
 1862-1935
Evangelist
S. B. McQuown, ?-?
Photograph, gelatin silver print, 16.4
 x 11 cm. (6⁷⁄₁₆ x 4⁵⁄₁₆ in.), c. 1931
NPG.80.299

Sutro, Adolph Heinrich Joseph,
1830-1898
Engineer
Unidentified photographer
Photograph, albumen silver print,
14.7 x 9.7 cm. (5¹³⁄₁₆ x 3¹³⁄₁₆ in.),
c. 1880
NPG.85.102
Gift of Robert L. Drapkin

Swift, Gustavus Franklin, 1839-1903
Businessman
Ralph Elmer Clarkson, 1861-1942
Oil on canvas, 91.4 x 73.6 cm. (36 x
29 in.), 1904
NPG.74.9
Gift of George H. Swift, Jr.

Swanson, Gloria*, 1899-1983
Actress
Nickolas Muray, 1892-1965
Photograph, gelatin silver print, 24.1
x 19.1 cm. (9½ x 7½ in.), 1978 from
c. 1921 negative
T/NPG.78.192.93

Szold, Henrietta, 1860-1945
Zionist leader
Pinchas Litvinovsky, 1894-
Oil (?) on canvas, 48.9 x 39 cm. (19¼
x 15⅜ in.), c. 1940
NPG.81.6
*Gift of Hadassah through the
generosity of Muriel and Philip
Berman*

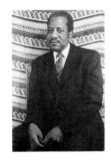

Swanson, Howard*, 1907-1978
Composer
Carl Van Vechten, 1880-1964
Photogravure, 22.3 x 14.9 cm. (8¹³⁄₁₆
x 5⅞ in.), 1983 from 1951 negative
T/NPG.83.188.44

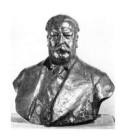

Taft, William Howard, 1857-1930
Twenty-seventh President of the
United States
Robert Ingersoll Aitken, 1878-1949
Bronze, 59.7 cm. (23½ in.), 1909
NPG.82.54

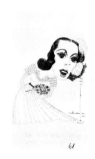

Swarthout, Gladys, 1904-1969
Singer
Alfred Bendiner, 1899-1964
India ink over pencil with opaque
white on paper, 31.1 x 18.3 cm.
(12¼ x 7³⁄₁₆ in.), 1943
Illustration for *The Evening
Bulletin*, Philadelphia, July 9,
1943
NPG.84.50
Gift of Alfred Bendiner Foundation

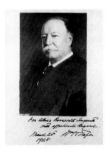

Taft, William Howard, 1857-1930
Twenty-seventh President of the
United States
Harris and Ewing studio, active
1905-1977
Photograph, gelatin silver print, 22.9
x 15.3 cm. (9 x 6¹⁄₁₆ in.), 1928
NPG.81.164
Gift of Joanna Sturm

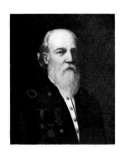

Sweeny, Thomas W., 1820-1892
Soldier
John Randolph Stites, 1836-post 1887
Oil on canvas, 68.5 x 55.8 cm. (27 x
22 in.), not dated
NPG.82.127
Gift of Mrs. Vincent L. Buckley

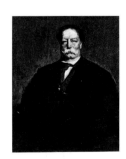

Taft, William Howard, 1857-1930
Twenty-seventh President of the
United States
Robert Lee MacCameron, 1866-1912
Oil on canvas, 100.3 x 81 cm. (39½ x
31⅞ in.), 1909
NPG.65.10
*Gift of Robert F. MacCameron and
his sister, Miss Marguerite
MacCameron*

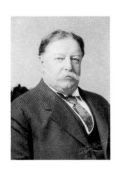

Taft, William Howard, 1857-1930
Twenty-seventh President of the
 United States
Pach Brothers studio, active since
 1867
Photograph, gelatin silver print, 14.3
 x 10.2 cm. (5¹¹⁄₁₆ x 4 in.), 1908
NPG.80.198

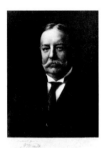

Taft, William Howard, 1857-1930
Twenty-seventh President of the
 United States
Jacques Reich, 1852-1923
Etching, 37.9 x 27.7 cm. (14¹⁵⁄₁₆ x
 10¹⁵⁄₁₆ in.), 1910
NPG.67.69
Gift of Oswald D. Reich

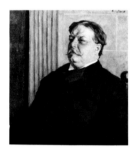

Taft, William Howard, 1857-1930
Twenty-seventh President of the
 United States
William Valentine Schevill,
 1864-1951
Oil on artist board, 85.1 x 74.9 cm.
 (33½ x 29½ in.), c. 1908-1912
NPG.72.25
Gift of William E. Schevill

Taft, William Howard, 1857-1930
Twenty-seventh President of the
 United States
Underwood and Underwood, active
 1882-c. 1950
Photograph, gelatin silver print, 8.1
 x 15.4 cm. (3³⁄₁₆ x 6¹⁄₁₆ in.), c. 1910
NPG.80.84

Taft, William Howard, 1857-1930
Twenty-seventh President of the
 United States
Anders Zorn, 1860-1920
Etching, 22.4 x 19.5 cm. (8¹³⁄₁₆ x 7¹¹⁄₁₆
 in.), 1911
NPG.71.27
*Gift of the Louise Taft Semple
 Foundation*

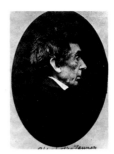

Taney, Roger Brooke, 1777-1864
Chief Justice of the United States
Attributed to Mathew Brady,
 1823-1896
Photograph, salt print, 18.7 x 13.2
 cm. (7³⁄₈ x 5³⁄₁₆ in.), c. 1859
NPG.77.272

Taney, Roger Brooke, 1777-1864
Chief Justice of the United States
Horatio Stone, 1808-1875
Bronze, 73 cm. (28¾ in.), cast after
 1853 original
NPG.77.13

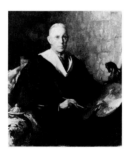

Tarbell, Edmund Charles, 1862-1938
Artist
Self-portrait
Oil on canvas, 114.6 x 97.1 cm. (45⅛
 x 38¼ in.), 1937
NPG.70.22
*Transfer from the National Museum
 of American Art; gift of Mrs.
 Josephine Tarbell Ferrell and Mary
 Tarbell Shaffer to the Smithsonian
 Institution, 1962*

Tarbell, Ida Minerva, 1857-1944
Journalist
Clara E. Sipprell, 1885-1975
Photograph, gelatin silver print, 22.5
 x 18.8 cm. (8⅞ x 7⁷⁄₁₆ in.), c. 1940
NPG.82.201
Bequest of Phyllis Fenner

Tarkington, Newton Booth,
 1869-1946
Author
John White Alexander, 1856-1915
Oil on canvas, 71.1 x 56.2 cm. (28 x
 22⅛ in.), 1906/7
NPG.83.137

Tarkington, Newton Booth,
 1869-1946
Author
Walker Hancock, 1901-
Bronze, 35.2 cm. (13⅞ in.), cast after
 1934 plaster
NPG.69.40
Gift of the artist

Tarkington, Newton Booth,
 1869-1946
Author
Soss Melik, 1914-
Charcoal on paper, 62.2 x 41.9 cm.
 (24½ x 16½ in.), 1939
NPG.74.33

Tarkington, Newton Booth,
 1869-1946
Author
Sebastian Simonet, 1898-1948
Charcoal on board, 57.6 x 49.3 cm.
 (22¹¹⁄₁₆ x 19⅜ in.), c. 1930
NPG.85.65

Tatanka Yotanka ("Sitting Bull"),
 1831?-1890
Indian chief
Römmler and Jonas lithography
 company, active c. 1885, after
 Rudolf Cronau
Colored collotype, 25.6 x 20.7 cm.
 (10¹⁄₁₆ x 8⅛ in.), 1885
NPG.77.277

Tate, Allen (John Orley)*, 1899-1979
Author
Carol Hoorn Fraser, 1930-
Bronze, 43.2 cm. (17 in.), 1957
T/NPG.80.27.89

Tate, Allen (John Orley)*, 1899-1979
Author
Carol Hoorn Fraser, 1930-
Pencil on paper, 59.9 x 48.5 cm.
 (23⁹⁄₁₆ x 19¹⁄₁₆ in.), 1957
T/NPG.80.28.89

Tate, Allen (John Orley)*, 1899-1979
Author
Carol Hoorn Fraser, 1930-
Etching, aquatint, and drypoint, 32.2
 x 25.9 cm. (12¹¹⁄₁₆ x 10³⁄₁₆ in.), 1958
T/NPG.80.29.89

Tate, Allen (John Orley)*, 1899-1979
Author
Carol Hoorn Fraser, 1930-
Woodcut, 35 x 28.6 cm. (13¾ x 11¼
 in.), 1959
T/NPG.80.30.89

Taylor, Bayard, 1825-1878
Author
Mathew Brady, 1823-1896
Photograph, albumen silver print,
 8.2 x 5.4 cm. (3½ x 2³⁄₁₆ in.), c. 1865
NPG.80.95

Taylor, Bayard, 1825-1878
Author
Thomas Hicks, 1823-1890
Oil on canvas, 62.2 x 75.5 cm. (24½ x
 29¾ in.), 1855
NPG.76.6

Taylor, Bayard, 1825-1878
Author
Attributed to Napoleon Sarony,
 1821-1896
Photograph, albumen silver print, 9
 x 6 cm. (3⁹⁄₁₆ x 2⅜ in.), c. 1870
NPG.77.147

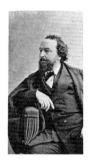

Taylor, Bayard, 1825-1878
Author
Napoleon Sarony, 1821-1896
Photograph, albumen silver print, 14
 x 9.8 cm. (5½ x 3⅞ in.), c. 1870
NPG.78.174

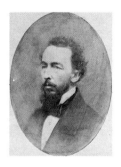

Taylor, Bayard, 1825-1878
Author
Upton, ?-?
Photograph, varnished salt print,
 29.9 x 14.8 cm. (7⅞ x 5⅞ in.),
 c. 1858
NPG.81.70

Taylor, Deems, 1885-1966
Composer
Aline Fruhauf, 1907-1978
Pencil with red and blue chalk on
 paper, 33.3 x 22.2 cm. (13¹⁄₁₆ x 8¹¹⁄₁₆
 in.), c. 1960
NPG.83.43
Gift of Erwin Vollmer

Taylor, Deems, 1885-1966
Composer
Aline Fruhauf, 1907-1978
Woodcut with opaque white, 16.3 x
 10.7 cm. (6⁷⁄₁₆ x 4³⁄₁₆ in.), 1960
NPG.83.131
Gift of Erwin Vollmer

Taylor, Frank Walter, 1874-1921
Artist
Unidentified photographer
Photograph, platinum print, 16.2 x
 12.4 cm. (6⅜ x 4⅞ in.), c. 1900
NPG.78.177

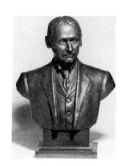

Taylor, Frederick Winslow,
 1856-1915
Engineer
Samuel Murray, 1870-?
Bronze, 69.5 cm. (27⅜ in.), 1916
NPG.68.52
*Gift of Stevens Institute of
 Technology*

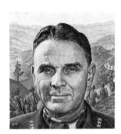

Taylor, Maxwell D.*, 1901-1987
General
Guy Rowe ("Giro"), 1894-1969
Watercolor and crayon on acetate,
 24.1 x 24.5 cm. (9½ x 9⅝ in.), 1953
T/NPG.82.128
Gift of Charles Rowe

Taylor, Zachary, 1784-1850
Twelfth President of the United
 States
Marie Alexandre Alophe, 1812-1883,
 after daguerreotype
Cattier lithography company
Lithograph with tintstone, 29.1 x
 23.2 cm. (11⁷⁄₁₆ x 9⅛ in.), c. 1849
NPG.83.176

Taylor, Zachary, 1784-1850
Twelfth President of the United
 States
Joseph Andrews, c. 1805-1873, after
 daguerreotype by Pettee and
 Cathan
Engraving, 36.4 x 26.9 cm. (14⁹⁄₁₆ x
 10⁹⁄₁₆ in.), 1848
NPG.80.41

Taylor, Zachary, 1784-1850
Twelfth President of the United
 States
H. Bucholzer, active, 1843-1847, after
 daguerreotype
Hand-colored lithograph, 29.1 x 21.2
 cm. (11⁷⁄₁₆ x 8⅜ in.), 1848
NPG.79.189

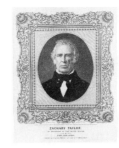

Taylor, Zachary, 1784-1850
Twelfth President of the United
 States
Albert Newsam, 1809-1864, after
 daguerreotype by James Maguire
P. S. Duval lithography company
Hand-colored lithograph, 25.7 x 23
 cm. (10⅛ x 9¹⁄₁₆ in.), 1849
NPG.85.53

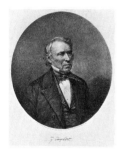

Taylor, Zachary, 1784-1850
Twelfth President of the United
 States
Francis D'Avignon, c. 1814-?, after
 daguerreotype by Mathew Brady
Lithograph, 28.3 x 24.9 cm. (11⅛ x
 9¹³⁄₁₆ in.), 1849
Published in Mathew Brady's
 Gallery of Illustrious Americans,
 New York, 1850
NPG.77.7
Gift of an anonymous donor

Taylor, Zachary, 1784-1850
Twelfth President of the United
 States
Charles Risso, active c. 1832-1850
Benjamin F. Butler lithography
 company
Lithograph with tintstone, 39.3 x
 32.1 cm. (15½ x 12⅝ in.), 1848
NPG.80.126

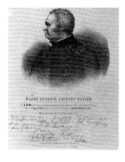

Taylor, Zachary, 1784-1850
Twelfth President of the United
 States
Alfred M. Hoffy, active 1835-1864,
 after Joseph H. Eaton
Lithograph, 22.7 x 24.8 cm. (8¹⁵⁄₁₆ x
 9¾ in.), 1847
NPG.78.70

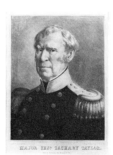

Taylor, Zachary, 1784-1850
Twelfth President of the United
 States
Sarony and Major lithography
 company, active 1846-1857
Hand-colored lithograph, 45 x 35.2
 cm. (17¾ x 13⅞ in.), 1848
NPG.85.163

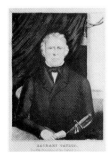

Taylor, Zachary, 1784-1850
Twelfth President of the United
 States
Kelloggs and Comstock lithography
 company, active 1848-1850, after
 daguerreotype by James Maguire
Hand-colored lithograph, 28.9 x 21.3
 cm. (11⅜ x 8⅜ in.), c. 1848
NPG.81.48
Gift of Dr. Frank Stanton

Taylor, Zachary, 1784-1850
Twelfth President of the United
 States
Charles Cushing Wright, 1796-1854,
 after Salathiel Ellis
Bronze medal, 9.5 cm. (3¾ in.)
 diameter, 1848
NPG.77.247
Gift of Marvin Sadik

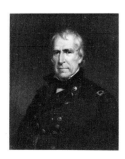

Taylor, Zachary, 1784-1850
Twelfth President of the United
 States
Attributed to James Reid Lambdin,
 1807-1889
Oil on canvas, 76.8 x 62.8 cm. (30¼ x
 24¾ in.), 1848
NPG.76.7
Gift of Barry Bingham, Sr.

Tecumseh, 1768-1813
Indian chief
Unidentified artist, after James
 Trenchard, after William Bartram
Relief cut, 11 x 8.9 cm. (4⁵⁄₁₆ x 3½
 in.), 1817
Published in *Der Gemeinntizige
 Landwirtschafts-Calender . . .
 1818,* Lancaster, 1817
NPG.79.124

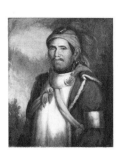

Tenskwatawa ("The Prophet"), c.
 1775-1837
Indian chief
Henry Inman, 1801-1846, after
 Charles Bird King
Oil on canvas, 77.1 x 64.1 (30⅜ x
 25¼ in.), c. 1830-1833
NPG.82.71

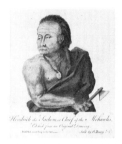

Terrell, Mary Church, 1863-1954
Educator, reformer
J. Richard Thompson, ?-?
Oil over photographic emulsion on
 canvas, 100.3 x 74.9 cm. (39½ x
 29½ in.), 1907
NPG.72.115
Gift of Mrs. Phyllis Langston

**Te Yee Neen Ho Ga Prow
 ("Hendrick"),** c. 1680-1755
Indian leader
Unidentified artist
Hand-colored engraving, 15.5 x 13.8
 cm. (6⅛ x 5⁷/₁₆ in.), c. 1756
NPG.83.175

Thacher, James, 1745-1844
Physician
Pendleton lithography company,
 active 1825-1836, after
 unidentified artist
Lithograph, 9.5 x 7.5 cm. (3¾ x 2⅝
 in.), 1828
Published in James Thacher's
 American Medical Biography,
 Boston, 1828
NPG.78.135

Thayer, Abbott Handerson,
 1849-1921
Artist
Self-portrait
Oil on plywood, 73.5 x 55.8 cm.
 (28¹⁵/₁₆ x 22 in.), 1920
NPG.81.22

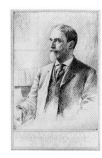

Thayer, James Bradley, 1831-1902
Lawyer, educator
Sidney Lawton Smith, 1845-1929
Etching, 23.5 x 15.2 cm. (9¼ x 6 in.),
 1904
NPG.81.66

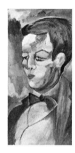

Thayer, Scofield*, 1889-1982
Editor
Edward Estlin Cummings, 1894-1962
Oil on artist board, 44.5 x 21.5 cm.
 (17½ x 8½ in.), 1921
T/NPG.73.36.92

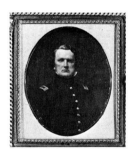

Thomas, George Henry, 1816-1870
Union general
Mathew Brady, 1823-1896, or his
 studio
Daguerreotype, 8.3 x 7.1 cm. (3¼ x
 2¾ in.), c. 1855
NPG.77.61

Thomas, George Henry, 1816-1870
Union general
William Sartain, 1843-1924, after
 photograph
Mezzotint, 28.3 x 24 cm. (11⅛ x 9⁷/₁₆
 in.), c. 1866
NPG.85.170

Thomas, Norman Mattoon,
 1884-1968
Reformer
Joy Buba, 1904-
Cast stone, 42.2 cm. (16⅝ in.), 1951
NPG.71.56

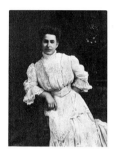

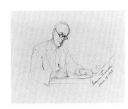

Thomas, Norman Mattoon,
 1884-1968
Reformer
Miriam Troop, 1917-
Pencil on paper, 27.9 x 35.7 cm. (11 x
 14 1/16 in.), 1948
NPG.72.48

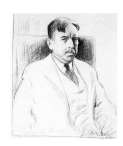

Thorndike, Edward L., 1874-1949
Psychologist
Samuel Johnson Woolf, 1880-1948
Charcoal and chalk on paper, 62.9 x
 48.2 cm. (24¾ x 19 in.), 1931
NPG.80.275

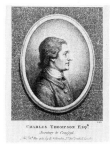

Thomson, Charles, 1729-1824
Revolutionary statesman
B. B. Ellis, ?-?, after Benoit Louis
 Prevost, after Pierre Eugène Du
 Simitière
Stipple engraving, 11.1 x 9.2 cm. (4⅜
 x 3⅝ in.), 1783
Published in *Portraits of the
 Generals, Ministers, Magistrates,*
 London, 1783
NPG.75.74

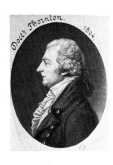

Thornton, William, 1759-1828
Architect, inventor
Charles Balthazar Julien Févret de
 Saint-Mémin, 1770-1852
Engraving, 5.6 cm. (2¼ in.) diameter,
 c. 1804
NPG.74.39.17
Gift of Mr. and Mrs. Paul Mellon

Thomson, Charles, 1729-1824
Revolutionary statesman
Burnet Reading, active 1780-1820,
 after Benoit Louis Prevost, after
 Pierre Eugène Du Simitière
Stipple engraving, 7.3 x 6.1 cm. (2⅞
 x 2⅜ in.), 1783
Published in *American Legislators,
 Patriots, Soldiers,* London, 1783
NPG.78.40

Thorpe, James Francis ("Jim"),
 1887-1953
Athlete
Underwood and Underwood, active
 1882-c. 1950
Photograph, gelatin silver print, 18.3
 x 24.2 cm. (7 3/16 x 9½ in.), c. 1913
NPG.80.327

Thomson, Virgil*, 1896-
Composer, music critic
Alice Neel, 1900-1984
Oil on canvas, 121.9 x 96.5 cm. (48 x
 38 in.), 1971
T/NPG.84.70

Thurber, James Grover, 1894-1961
Humorist
Philippe Halsman, 1906-1979
Photograph, gelatin silver print, 34.5
 x 27 cm. (13 9/16 x 10⅝ in.), 1953
NPG.83.116
Gift of George R. Rinhart

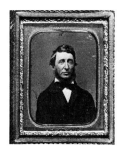

Thoreau, Henry David, 1817-1862
Author
Benjamin D. Maxham, active
 1854-1859
Daguerreotype, 6.3 x 4.7 cm. (2½ x
 1⅞ in.), 1856
NPG.72.119
Gift of an anonymous donor

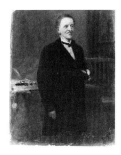

Tilden, Samuel Jones, 1814-1886
Statesman
Thomas Hicks, 1823-1890
Oil on artist board, 38.1 x 29.8 cm.
 (15 x 11¾ in.), c. 1870
NPG.75.38
*Transfer from the Archives of
 American Art*

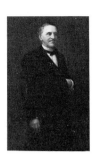

Tilden, Samuel Jones, 1814-1886
Statesman
Thomas Hicks, 1823-1890
Oil on canvas, 134.6 x 83.1 cm. (53 x
 32¾ in.), c. 1870
NPG.76.1

Toklas, Alice B., 1877-1967
Companion of Gertrude Stein
Pavel Tchelitchew, 1898-1957
Gouache on paper, 50 x 32.5 cm.
 (19¹¹⁄₁₆ x 12¹³⁄₁₆ in.), not dated
NPG.80.13

Tilden, Samuel Jones, 1814-1886
Statesman
José Maria Mora, c. 1847-1926
Photograph, albumen silver print,
 14.5 x 10.1 cm. (5¹¹⁄₁₆ x 3¹⁵⁄₁₆ in.),
 c. 1870
NPG.78.170

Toombs, Robert Augustus, 1810-1885
Statesman
Leopold Grozelier, 1830-1865, after
 unidentified artist
Lithograph with tintstone, 41.3 x
 33.6 cm. (16¼ x 13³⁄₁₆ in.), 1855
Published in Charles H. Brainard's
 *Portrait Gallery of Distinguished
 Americans*, Boston, 1855
NPG.82.75.b

**Tilden, William Tatem, Jr. ("Big
 Bill"),** 1893-1953
Athlete
Underwood and Underwood, active
 1882-c. 1950
Photograph, gelatin silver print, 20.6
 x 15.6 cm. (8⅛ x 6⅛ in.), c. 1930
NPG.80.233

Toomer, Jean, 1894-1967
Author
Winold Reiss, 1886-1953
Pastel on artist board, 75.9 x 55.2 cm.
 (29⅞ x 21¾ in.), c. 1925
NPG.72.85
*Gift of Lawrence A. Fleischman and
 Howard Garfinkle with a
 matching grant from the National
 Endowment for the Arts*

Tillich, Paul Johannes Oskar,
 1886-1965
Theologian
Alexander Sander, 1884-1961
Charcoal and chalk on paper, 48.2 x
 31.4 cm. (19 x 12⅜ in.), 1940-1941
NPG.69.76

Toscanini, Arturo, 1867-1957
Symphony conductor
Alfred Bendiner, 1899-1964
Lithograph, 22 x 23 cm. (8⅝ x 9¹⁄₁₆
 in.), 1942
NPG.79.106
Gift of Mrs. Alfred Bendiner

Tilton, James, 1745-1822
Physician
Thomas Edwards, active 1822-1856,
 after unidentified artist
Pendleton lithography company
Lithograph, 9.5 x 7.7 cm. (3¾ x 3
 in.), 1828
Published in James Thacher's
 American Medical Biography,
 Boston, 1828
NPG.78.141

Toscanini, Arturo, 1867-1957
Symphony conductor
Aline Fruhauf, 1907-1978
India ink over pencil on paper, 27.9
 x 20.2 cm. (11 x 7¹⁵⁄₁₆ in.), 1928
Published in *Musical America*, New
 York, March 10, 1928
NPG.83.44
Gift of Erwin Vollmer

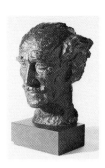

Toscanini, Arturo, 1867-1957
Symphony conductor
Boris Lovet-Lorski, 1891-1973
Bronze, 55.8 cm. (22 in.), 1939
NPG.68.58
Gift of an anonymous donor

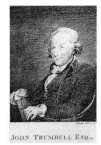

JOHN TRUMBULL ESQ.

Trumbull, John, 1750-1831
Poet
Elkanah Tisdale, 1771-?
Engraving, 11 x 8.4 cm. (4⁵⁄₁₆ x 3⁵⁄₁₆
in.); 1795
Published in John Trumbull's
*M'Fingal: A Modern Epic Poem
. . .* , New York, 1795
NPG.80.1

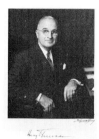

Truman, Harry S, 1884-1972
Thirty-third President of the United
States
Harris and Ewing studio, active
1905-1977
Photograph, gelatin silver print, 23 x
18.4 cm. (9¹⁄₁₆ x 7¼ in.), c. 1945
NPG.84.254
Gift of Aileen Conkey

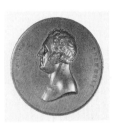

Trumbull, John, 1756-1843
Artist
Robert Ball Hughes, 1806-1868
Bronze, 6.4 cm. (2½ in.) diameter,
1849
NPG.84.78
Gift of Colonel Merl M. Moore

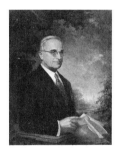

Truman, Harry S, 1884-1972
Thirty-third President of the United
States
Greta Kempton, 1903-
Oil on canvas, 99 x 76.2 cm. (39 x
30 in.), 1948 and 1970
NPG.70.11
*Gift of Dean Acheson, Thomas C.
Clark, John W. Snyder, Robert A.
Lovett, Clinton P. Anderson,
Charles F. Brannan, Charles
Sawyer, W. Averell Harriman,
David K. E. Bruce, Edward H.
Foley, Stuart Symington, William
McChesney Martin, Clark
Clifford, Charles S. Murphy, Ward
M. Canaday, and Joseph Stack*

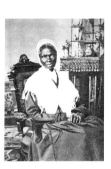

Truth, Sojourner, c. 1797-1883
Abolitionist
Randall studio, ?-?
Photograph, albumen silver print,
15.4 x 10.3 cm. (5¹¹⁄₁₆ x 4¹⁄₁₆ in.),
c. 1870
NPG.79.220

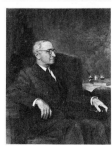

Truman, Harry S, 1884-1972
Thirty-third President of the United
States
Guy Rowe ("Giro"), 1894-1969
Oil on acetate, 30.2 x 26.6 cm. (11⁵⁄₁₆
x 10½ in.), not dated
NPG.84.64
Gift of James J. Miller

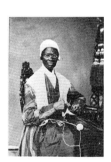

Truth, Sojourner, c. 1797-1883
Abolitionist
Unidentified photographer
Photograph, gelatin silver print, 8.2
x 5.8 cm. (3¼ x 2⁵⁄₁₆ in.), 1864
NPG.78.207

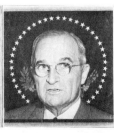

Truman, Harry S, 1884-1972
Thirty-third President of the United
States
Augustus Vincent Tack, 1870-1949
Oil on canvas, 149.2 x 119.3 cm.
(58¾ x 47 in.), 1947-1948
NPG.65.69
*Transfer from the National Gallery
of Art; gift of Mrs. Augustus
Vincent Tack, 1952*

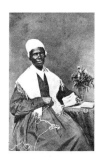

Truth, Sojourner, c. 1797-1883
Abolitionist
Unidentified photographer
Photograph, albumen silver print,
8.7 x 5.6 cm. (3⁷⁄₁₆ x 2³⁄₁₆ in.), 1864
NPG.79.209

Tubman, Harriet, c. 1820-1913
Abolitionist
Robert Savon Pious, 1908-1983
Oil on canvas, 31 x 24.7 cm. (12¼ x
9¾ in.) sight, 1951
NPG.67.41
Gift of the Harmon Foundation

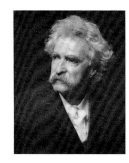

**Twain, Mark (Samuel Langhorne
Clemens),** 1835-1910
Author
Ernest Walter Histed, 1860-1947
Photograph, platinum print, 28.2 x
23.9 cm. (11½ x 9¼ in.), c. 1907
NPG.78.301
Gift of Mr. Terence Pepper

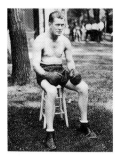

Tunney, James Joseph ("Gene")*,
1898-1978
Athlete
Underwood and Underwood, active
1882-c. 1950
Photograph, gelatin silver print, 24 x
19 cm. (9¹⁵⁄₁₆ x 7½ in.), c. 1926
T/NPG.80.234.88

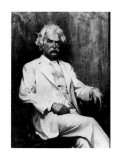

**Twain, Mark (Samuel Langhorne
Clemens),** 1835-1910
Author
Frank Edwin Larson, 1895-
Oil on canvas, 121.9 x 91.4 cm. (48 x
36 in.), 1935
NPG.72.1
Gift of the artist

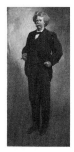

**Twain, Mark (Samuel Langhorne
Clemens),** 1835-1910
Author
John White Alexander, 1856-1915
Oil on canvas, 191.7 x 91.4 cm. (75½
x 36 in.), c. 1902
NPG.81.116

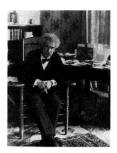

**Twain, Mark (Samuel Langhorne
Clemens),** 1835-1910
Author
Attributed to Alfred J. Meyer, ?-?
Photograph, gelatin silver print, 20.1
x 15 cm. (7¹⁵⁄₁₆ x 5⅞ in.), c. 1903
NPG.76.71
Gift of Mrs. Katie Louchheim

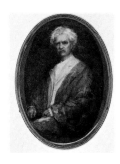

**Twain, Mark (Samuel Langhorne
Clemens),** 1835-1910
Author
Eulabee Dix, 1878-1961
Watercolor on ivory, 11.5 x 8.3 cm.
(4½ x 3¼ in.) oval, 1908
NPG.66.7

**Twain, Mark (Samuel Langhorne
Clemens),** 1835-1910
Author
Albert Bigelow Paine, 1861-1937
Photographic negative, 17.3 x 12.4
cm. (6¾ x 4⅞ in.), 1906
NPG.79.162

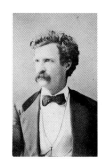

**Twain, Mark (Samuel Langhorne
Clemens),** 1835-1910
Author
Jeremiah Gurney, active 1840-c. 1890
Photograph, albumen silver print,
9.4 x 5.7 cm. (3¹¹⁄₁₆ x 2⅛ in.),
c. 1873
NPG.80.283

**Twain, Mark (Samuel Langhorne
Clemens),** 1835-1910
Author
Albert Bigelow Paine, 1861-1937
Photographic negative, 17.3 x 12.2
cm. (6¹³⁄₁₆ x 4½ in.), 1906
NPG.79.232
Gift of John Seelye

Twain, Mark (Samuel Langhorne Clemens), 1835-1910
Author
Albert Bigelow Paine, 1861-1937
Photographic negative, 17.2 x 12.4 cm. (6¾ x 4¹³/₁₆ in.), 1906
NPG.79.233
Gift of John Seelye

Twain, Mark (Samuel Langhorne Clemens), 1835-1910
Author
James Affleck Shepherd, 1867-1931
Watercolor on paper, 34.1 x 28.5 cm. (13⁷/₁₆ x 11¼ in.), 1907
NPG.83.206

Twain, Mark (Samuel Langhorne Clemens), 1835-1910
Author
Albert Bigelow Paine, 1861-1937
Photographic negative, 17.2 x 12.4 cm. (6¾ x 4¹³/₁₆ in.), 1906
NPG.79.234
Gift of John Seelye

Twain, Mark (Samuel Langhorne Clemens), 1835-1910
Author
William Ireland Starr, ?-?
Photograph, gelatin dry-plate positive transparency, 4.4 x 10.6 cm. (1¾ x 4³/₁₆ in.), 1908
NPG.80.324
Gift of John Seelye

Twain, Mark (Samuel Langhorne Clemens), 1835-1910
Author
Edward Penfield, 1866-1925
Chromolithographic poster, 39.8 x 31.6 cm. (15⅝ x 12⁷/₁₆ in.), 1898
NPG.83.167

Twain, Mark (Samuel Langhorne Clemens), 1835-1910
Author
Theodore Wust, active c. 1860-c. 1901
Wood engraving, 37.1 x 21.1 cm. (14⅝ x 8⅓ in.), 1874
Published in the *Daily Graphic*, October 26, 1874
NPG.78.255

Twain, Mark (Samuel Langhorne Clemens), 1835-1910
Author
Napoleon Sarony, 1821-1896
Photograph, albumen silver print, 11.7 x 8.9 cm. (4⅝ x 3½ in.), c. 1896
NPG.85.3
Gift of Robert L. McNeil, Jr.

Tweed, William Marcy ("Boss"), 1823-1878
Political boss
Jeremiah Gurney, active 1840-c. 1890
Photograph, albumen silver print, 12.9 x 9.3 cm. (5¹/₁₆ x 3¹¹/₁₆ in.), c. 1870
NPG.77.314

Twain, Mark (Samuel Langhorne Clemens), 1835-1910
Author
Otto J. Schneider, 1875-1946
Etching, 50.8 x 31.5 cm. (20 x 12⁷/₁₆ in.), 1906
NPG.69.67

Tweed, William Marcy ("Boss"), 1823-1878
Political boss
Major and Knapp lithography company, active 1864-c. 1871, after photograph
Lithograph with tintstone, 31.1 x 21.2 cm. (12¼ x 8⅜ in.), 1870
Music sheet title page: "Solid Men to the Front Quickstep"
NPG.80.36

Tweed, William Marcy ("Boss"),
1823-1878
Political boss
Napoleon Sarony, 1821-1896
Photograph, albumen silver print,
13.6 x 9.7 cm. (5⅜ x 3¹³⁄₁₆ in.),
c. 1870
NPG.77.154

Tyler, John, 1790-1862
Tenth President of the United States
John Sartain, 1808-1897
Mezzotint, 52.3 x 36.9 cm. (20⁹⁄₁₆ x
14½ in.), 1842
NPG.83.165

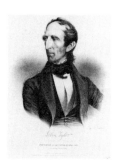

Tyler, John, 1790-1862
Tenth President of the United States
Charles Fenderich, 1805-1887
P. S. Duval lithography company
Lithograph, 28.7 x 27 cm. (11⁵⁄₁₆ x
10⅝ in.), 1841
NPG.66.92
Transfer from the Library of
Congress, Prints and Photographs
Division

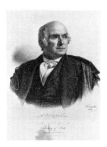

Upshur, Abel Parker, 1791-1844
Statesman
Charles Fenderich, 1805-1887
Edward D. Weber lithography
company
Lithograph, 24.7 x 25.7 cm. (9¾ x
10⅛ in.), 1844
NPG.66.93
Transfer from the Library of
Congress, Prints and Photographs
Division

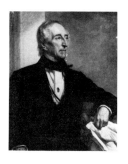

Tyler, John, 1790-1862
Tenth President of the United States
George Peter Alexander Healy,
1813-1894
Oil on canvas, 91.2 x 74 cm. (36⅛ x
29⅛ in.), 1859
NPG.70.23
Transfer from the National Museum
of American Art; gift of Friends of
the National Institute, 1859

Vail, Theodore Newton, 1845-1920
Businessman
Pirie MacDonald, 1867-1942
Photograph, gelatin silver print, 33 x
11.6 cm. (13 x 4⁹⁄₁₆ in.), 1908
NPG.77.315

Tyler, John, 1790-1862
Tenth President of the United States
E. B. and E. C. Kellogg lithography
company, active c. 1842-1867, after
William Henry Brown
Lithographed silhouette, 34 x 25.2
cm. (13⅜ x 9¹⁵⁄₁₆ in.), 1844
Published in William H. Brown's
Portrait Gallery of Distinguished
American Citizens, Hartford, 1845
NPG.80.276.r
Gift of Wilmarth Sheldon Lewis

Valentino, Rudolph, 1895-1926
Actor
Russell Ball, ?-?
Photograph, gelatin silver print, 33.6
x 26.4 cm. (13³⁄₁₆ x 10⁷⁄₁₆ in.),
c. 1925
NPG.78.4

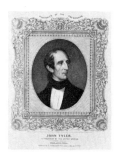

Tyler, John, 1790-1862
Tenth President of the United States
Albert Newsam, 1809-1864, probably
after Charles Fenderich
P. S. Duval lithography company
Hand-colored lithograph, 25.9 x 22.5
cm. (10³⁄₁₆ x 8⅞ in.), 1846
NPG.77.107

Van Buren, Martin, 1782-1862
Eighth President of the United States
Mathew Brady, 1823-1896
Daguerreotype, 14 x 11 cm. (5½ x
4⁵⁄₁₆ in.), c. 1856
NPG.76.104

Van Buren, Martin, 1782-1862
Eighth President of the United States
Nathaniel Currier, 1813-1888, after
 Henry Inman
Lithograph, 30.6 x 25.7 cm. (12$\frac{1}{16}$ x
 10$\frac{1}{8}$ in.), 1840
Published in *The Eight Presidents of
 the United States of America*,
 Hartford, 1840
NPG.84.221.h

Van Buren, Martin, 1782-1862
Eighth President of the United States
James Barton Longacre, 1794-1869
Stipple engraving, 17.3 x 15.4 cm.
 (6$\frac{13}{16}$ x 6$\frac{1}{8}$ in.), 1830
NPG.79.243

Van Buren, Martin, 1782-1862
Eighth President of the United States
Charles Fenderich, 1805-1887
P. S. Duval lithography company
Lithograph, 26.6 x 27 cm. (10$\frac{1}{2}$ x 10$\frac{5}{8}$
 in.), 1839
NPG.66.94
*Transfer from the Library of
 Congress, Prints and Photographs
 Division*

Van Buren, Martin, 1782-1862
Eighth President of the United States
Albert Newsam, 1809-1864, after
 Henry Inman
P. S. Duval lithography company
Hand-colored lithograph, 26 x 22.9
 cm. (10$\frac{1}{4}$ x 9 in.), 1846
NPG.84.2

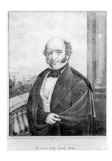

Van Buren, Martin, 1782-1862
Eighth President of the United States
E. B. and E. C. Kellogg lithography
 company, active c. 1842-1867, after
 William Henry Brown
Lithographed silhouette, 34.2 x 25
 cm. (13$\frac{1}{2}$ x 9$\frac{7}{8}$ in.), 1844
Published in William H. Brown's
 *Portrait Gallery of Distinguished
 American Citizens*, Hartford, 1845
NPG.75.46

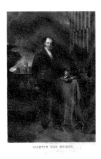

Van Buren, Martin, 1782-1862
Eighth President of the United States
John Sartain, 1808-1897, after Henry
 Inman
Mezzotint (see Abraham Lincoln,
 NPG.79.73), 51.3 x 35.6 cm. (20$\frac{3}{16}$
 x 14 in.), 1837-1841
NPG.79.75

Van Buren, Martin, 1782-1862
Eighth President of the United States
Klauprech and Menzel lithography
 company, active 1840-1859, after
 Charles Fenderich
Lithograph, 44.5 x 36 cm. (17$\frac{1}{2}$ x 14$\frac{1}{8}$
 in.), c. 1840
NPG.80.179

Van Buren, Martin, 1782-1862
Eighth President of the United States
Unidentified artist, after
 daguerreotype by John Plumbe, Jr.
Hand-colored lithograph, 33 x 26 cm.
 (13 x 10$\frac{1}{4}$ in.), 1846
Contained in *The National
 Plumbeotype Gallery*,
 Philadelphia, 1847
NPG.78.84.e

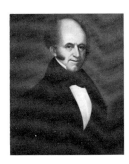

Van Buren, Martin, 1782-1862
Eighth President of the United
 States
John Langendoerffer, active
 1830-1838
Pastel and unidentified medium on
 linen, 66.7 x 56.1 cm. (26$\frac{1}{4}$ x 22$\frac{1}{8}$
 in.), 1838
NPG.79.218
*Gift of the Honorable and Mrs. Blair
 Lee*

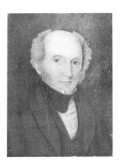

Van Buren, Martin, 1782-1862
Eighth President of the United States
Unidentified artist
Watercolor on ivory, 9.2 x 7 cm. (3$\frac{5}{8}$
 x 2$\frac{3}{4}$ in.), 1845-1850
NPG.80.14
Gift of Mrs. Robert Timpson

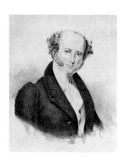

Van Buren, Martin, 1782-1862
Eighth President of the United States
Unidentified artist, after Henry
 Inman
Lithograph, 23.3 x 23 cm. (9⅛ x 9
 in.), c. 1830-1840
NPG.80.151

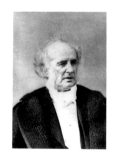

Vanderbilt, Cornelius, 1794-1877
Financier
Nathaniel Jocelyn, 1796-1881
Oil on canvas, 76 x 63.4 cm. (29¹⁵⁄₁₆ x
 25 in.), 1846
NPG.78.281

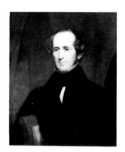

Vanderbilt, Cornelius, 1794-1877
Financier
Napoleon Sarony, 1821-1896
Photograph, albumen silver print,
 14.1 x 9.9 cm. (5⁹⁄₁₆ x 3⅞ in.),
 c. 1870
NPG.77.153

Vanderbilt, William Henry,
 1821-1885
Financier
Frederick Burr Opper, 1857-1937
Chromolithograph, 29.7 x 22 cm.
 (11¹¹⁄₁₆ x 8⅝ in.), 1882
Published in *Puck,* New York,
 October 18, 1882
NPG.84.106

Vanderlip, Frank Arthur, 1864-1937
Businessman
Rudulph Evans, 1878-1960
Bronze, 50.8 cm. (20 in.), 1920
NPG.81.109
Gift of Frank A. Vanderlip, Jr.

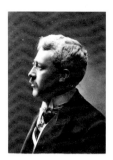

Vanderlip, Frank Arthur, 1864-1937
Businessman
Unidentified photographer
Photograph, platinum print, 12.2 x
 11.9 cm. (6¾ x 4¹¹⁄₁₆ in.), c. 1910
NPG.78.176

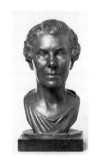

Vanderlip, Narcissa Cox, 1879-1966
Philanthropist
Rudulph Evans, 1878-1960
Bronze, 38.1 cm. (15 in.), 1940
NPG.81.110
Gift of Frank A. Vanderlip, Jr.

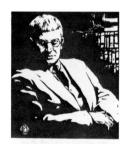

Van Doren, Carl Clinton, 1884-1950
Author, biographer
Bertrand Zadig, 1904-1956
Relief cut, 25.5 x 22.5 cm. (10¹⁄₁₆ x
 8⅞ in.), 1925
NPG.81.88

Van Doren, Mark, 1894-1972
Author
Frederick S. Wight, 1902-1986
Oil on canvas, 61.5 x 50.8 cm. (24¼ x
 20 in.), 1933
NPG.77.240
Gift of the artist

Van Vechten, Carl, 1880-1964
Author
Self-portrait
Photograph, gelatin silver print, 17.7
 x 12.6 cm. (7 x 5 in.), 1945
NPG.77.316

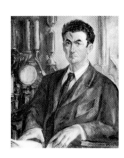

Varèse, Edgard, 1883-1965
Composer
John Sloan, 1871-1951
Oil on canvas, 76.2 x 63.5 cm. (30 x
 25 in.), 1924
NPG.80.15
Gift of Helen Farr Sloan

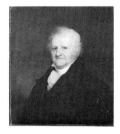

Varnum, Joseph Bradley, 1750/51-
 1821
Public official
Attributed to Ezra Ames 1768-1836
Oil on canvas mounted on board,
 69.2 x 61 cm. (27¼ x 24 in.), c.
 1819
NPG.83.211

Veblen, Thorstein Bunde, 1857-1929
Economist
Bonnie Veblen Chancellor, ?-
Bronze, 55.8 cm. (22 in.), 1982
NPG.83.157
*Gift of the Veblen Preservation
 Project*

Vedder, Elihu, 1836-1923
Artist
Francis Hopkinson Smith, 1836-1915
Pencil on paper, 22.2 x 15.8 cm. (8¾
 x 6¼ in.), not dated
NPG.77.31

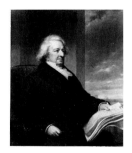

Verplanck, Gulian Crommelin,
 1786-1870
Author
Daniel Huntington, 1816-1906
Oil on canvas, 116.8 x 99 cm. (46 x
 39 in.), 1857
NPG.70.48

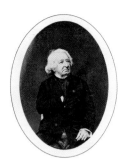

Verplanck, Gulian Crommelin,
 1786-1870
Author
Unidentified photographer, after
 daguerreotype
Photograph, albumen silver print,
 18.2 x 13.4 cm. (7³⁄₁₆ x 5¼ in.),
 c. 1860
NPG.77.118

Victor, Sally*, 1905-1977
Fashion designer
Aline Fruhauf, 1907-1978
Watercolor, india ink, and pencil
 with colored pencil, crayon, and
 opaque white on paper, 45.6 x 33.5
 cm. (17¹⁵⁄₁₆ x 13³⁄₁₆ in.), 1942
T/NPG.83.271.87
Gift of Erwin Vollmer

Villard, Helen Frances Garrison,
 1844-1928
Reformer
Unidentified photographer
Photograph, gelatin silver print, 21.5
 x 16.4 cm. (8½ x 6⁷⁄₁₆ in.), c. 1910
NPG.77.144
Gift of Henry Villard, descendant

Vinson, Fred M., 1890-1953
Chief Justice of the United States
Guy Rowe ("Giro"), 1894-1969
Grease on clear paper, 35 x 30.5 cm.
 (13¾ x 12 in.), 1951
NPG.81.147
Gift of Charles Rowe

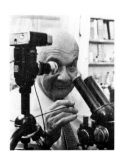

Vishniac, Roman*, 1897-
Scientist
Philippe Halsman, 1906-1979
Photograph, gelatin silver print, 35.1
 x 27.5 cm. (13¹³⁄₁₆ x 10¹³⁄₁₆ in.), 1967
T/NPG.83.117
Gift of George R. Rinhart

Volck, Adalbert John ("V. Blada"),
1828-1912
Caricaturist
Self-portrait
Tin relief, 21.2 cm. (8⅜ in.) diameter,
c. 1900
NPG.72.100
Gift of Bryden B. Hyde

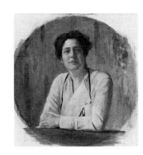

Wald, Lillian D., 1867-1940
Social worker
William Valentine Schevill,
1864-1951
Oil on cardboard, 71.7 x 71.7 cm.
(28¼ x 28¼ in.) feigned circle, 1919
NPG.76.37
*Gift of the Visiting Nurse Service of
New York*

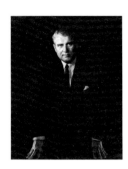

Von Braun, Wernher*, 1912-1977
Scientist
David Lee Iwerks, 1933-
Photograph, gelatin silver print, 24 x
18.9 cm. (9⁷⁄₁₆ x 7⁷⁄₁₆ in.), 1966
T/NPG.78.183.87

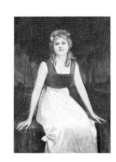

Walker, Lillian, 1887-1974
Actress
? Wissner, ?-?
Oil on canvas, 111.7 x 80 cm. (44 x
31½ in.), 1916
NPG.83.158
Gift of Mrs. Carroll A. McGowan

Wainwright, Jonathan Mayhew,
1883-1953
Military officer
Saboru Miyamoto, 1905-1974
Charcoal, sanguine crayon, and
chalk on paper, 49.8 x 32.5 cm.
(19⅝ x 12³⁄₁₆ in.), 1943
NPG.80.227

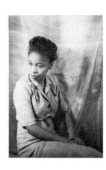

Walker, Margaret*, 1915-
Author
Carl Van Vechten, 1880-1964
Photogravure, 22.5 x 15 cm. (8⅞ x
5¹⁵⁄₁₆ in.), 1983 from 1942 negative
T/NPG.83.188.46

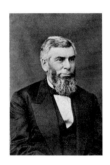

Waite, Morrison Remick, 1816-1888
Chief Justice of the United States
Samuel Fassett, active 1855-1875
Photograph, albumen silver print,
14.7 x 9.9 cm. (5¹³⁄₁₆ x 3⅞ in.),
c. 1876
NPG.78.168

Walkowitz, Abraham, 1878-1965
Artist
Harry Sternberg, 1904-
Serigraph, 60.3 x 33.3 cm. (23¾ x 13
in.), c. 1943-1944
NPG.80.237

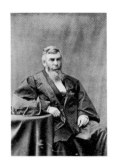

Waite, Morrison Remick, 1816-1888
Chief Justice of the United States
Unidentified photographer
Photograph, albumen silver print,
14.9 x 10.4 cm. (5¹³⁄₁₆ x 4⅛ in.),
c. 1874
NPG.80.200

Wallace, Henry Agard, 1888-1965
Statesman
Jo Davidson, 1883-1952
Bronze, 33 cm. (13 in.), 1942
NPG.75.44
*Gift of Mrs. Jean Douglas, Robert
Wallace, and Henry B. Wallace*

Wallace, Henry Agard, 1888-1965
Statesman
Philippe Halsman, 1906-1979
Photograph, gelatin silver print, 34.5
 x 27 cm. (13⁹/₁₆ x 10⅝ in.), 1945
NPG.82.175
Gift of George R. Rinhart

Walter, Bruno, 1876-1962
Symphony conductor
Aline Fruhauf, 1907-1978
India ink over pencil on paper, 27.3
 x 18.5 cm. (10¾ x 7¼ in.), 1935
Published in *Musical America*, New
 York, January 19, 1935
NPG.83.45
Gift of Erwin Vollmer

Wallenberg, Raoul*, 1912-
Humanitarian
James Rosenquist, 1933-
Lithograph with silkscreen, 73.7 x
 53.1 cm. (29 x 20¹⁵/₁₆ in.), 1984
T/NPG.85.37
*Gift of the Thomas More Society of
 America*

Walter, Thomas Ustick, 1804-1887
Architect
Albert Newsam, 1809-1864, after
 John Neagle
Lehman and Duval lithography
 company
Lithograph, 15.5 x 13.4 cm. (6⅛ x 5¼
 in.), not dated
NPG.77.109

Waller, Thomas Wright ("Fats"),
 1904-1943
Musician
Alfred Bendiner, 1899-1964
Pencil on paper, 21.5 x 28 cm. (8⁷/₁₆ x
 11¹/₁₆ in.), c. 1941
NPG.84.37

Walters, Henry, 1848-1931
Collector
Hans Schuler, 1874-1951
Bronze, 39.3 cm. (15½ in.), 1930
NPG.81.23

Walter, Bruno, 1876-1962
Symphony conductor
Alfred Bendiner, 1899-1964
Lithograph, 20.5 x 19 cm. (8¹/₁₆ x 7½
 in.), c. 1952
NPG.79.101
Gift of Mrs. Alfred Bendiner

Ward, Eben Brock, 1811-1875
Industrialist
Robert T. Bishop, active c. 1871-1872,
 after John Mix Stanley
Calvert lithography company
Lithograph with tintstones, 41.7 x
 33.9 cm. (16⁷/₁₆ x 13⁵/₁₆ in.), c. 1872
NPG.82.72
Gift of Mrs. Katie Louchheim

Walter, Bruno, 1876-1962
Symphony conductor
Alfred Bendiner, 1899-1964
India ink with opaque white on
 paper, 33.8 x 26.5 cm. (13¼ x 10⁷/₁₆
 in.), c. 1945
NPG.84.49
Gift of Alfred Bendiner Foundation

Ward, John Quincy Adams,
 1830-1910
Artist
Charles Henry Niehaus, 1855-1935
Bronze, 87 cm. (34¼ in.), cast after
 original plaster
NPG.70.34
*Transfer from the National Museum
 of American Art; gift of the
 National Sculpture Society, 1957*

Warfield, David, 1866-1951
Actor
Jonathan Scott Hartley, 1845-1912
Bronze, 63.4 cm. (25 in.), 1906
NPG.83.138

Warren, Earl, 1891-1974
Chief Justice of the United States
Miriam Troop, 1917-
Pencil on paper, 27.7 x 35.2 cm.
 (10^{15}/$_{16}$ x 13^{7}/$_{8}$ in.), 1955
NPG.72.49

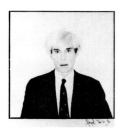

Warhol, Andy*, c. 1930-1987
Artist
Peter Strongwater, 1941-
Photograph, gelatin silver print, 35.4
 x 35.4 cm. (13^{15}/$_{16}$ x 13^{15}/$_{16}$ in.), 1982
T/NPG.84.147
Gift of Christopher Murray

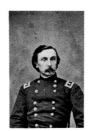

Warren, Gouverneur Kemble,
 1830-1882
Union general
Mathew Brady, 1823-1896
Photograph, albumen silver print,
 8.5 x 5.4 cm. (3^{3}/$_{8}$ x 2^{1}/$_{8}$ in.), c. 1862
NPG.80.291

Warhol, Andy*, c. 1930-1987
Artist
Garry Winogrand, 1928-1984
Photograph, gelatin silver print, 31.4
 x 47 cm. (12^{3}/$_{8}$ x 18^{1}/$_{2}$ in.), 1973
T/NPG.84.23

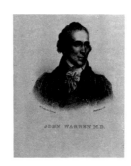

Warren, John, 1753-1815
Physician
Rembrandt Peale, 1778-1860
Pendleton lithography company
Lithograph, 10.5 x 10 cm. (4^{1}/$_{8}$ x 3^{15}/$_{16}$
 in.), 1828
Published in James Thacher's
 American Medical Biography,
 Boston, 1828
NPG.78.133

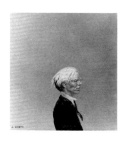

Warhol, Andy*, c. 1930-1987
Artist
James Browning Wyeth, 1946-
Gouache and pencil on paper, 40.6 x
 40 cm. (16 x 15^{3}/$_{4}$ in.), 1975
T/NPG.77.32
Gift of Coe-Kerr Gallery

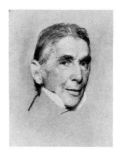

Warren, John Collins, 1778-1856
Physician
Francis Alexander, 1800-1880
Pastel on paper, 55.8 x 47.6 cm. (22 x
 18^{3}/$_{4}$ in.) oval, c. 1845-1850
NPG.69.41

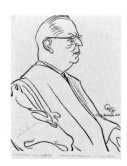

Warren, Earl, 1891-1974
Chief Justice of the United States
Oscar Berger, 1901-
Ink over pencil on paper, 40.6 x 33.6
 cm. (16 x 13^{1}/$_{4}$ in.), c. 1968
NPG.69.9
Gift of the artist

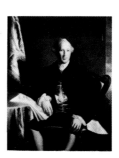

Warren, Joseph, 1741-1775
Revolutionary patriot
Unidentified artist, after John
 Singleton Copley
Oil on canvas, 125.7 x 100.3 cm.
 (49^{1}/$_{2}$ x 39^{1}/$_{2}$ in.), not dated
NPG.77.33

Warren, Robert Penn*, 1905-
Author
Conrad A. Albrizio, 1894-
Oil on canvas, 81.3 x 76.2 cm. (32 x
30 in.), 1935
T/NPG.75.39
Gift of Robert Penn Warren

Washington, Booker Taliaferro,
1856-1915
Educator
Kurz and Allison lithography
company, active 1880-c. 1899, after
Elmer Chickering
Lithograph, 43.9 x 41.5 cm. (17¼ x
16⅜ in.), c. 1895
NPG.80.35

Warren, Robert Penn*, 1905-
Author
Kelly Wise, 1932-
Photograph, gelatin silver print, 31 x
26.1 cm. (12³⁄₁₆ x 10¼ in.), 1984
T/NPG.84.148
Gift of Robert Stoller

Washington, George, 1732-1799
First President of the United States
Giuseppe Ceracchi, 1751-1801/2
Marble, 69.2 cm. (27¼ in.), c. 1816
after the 1792 original
NPG.70.4

Washington, Booker Taliaferro,
1856-1915
Educator
Richmond Barthé, 1901-
Bronze, 79.1 cm. (31⅛ in.), 1946
NPG.73.22

Washington, George, 1732-1799
First President of the United States
Thomas Cheesman, 1760-c. 1820,
after John Trumbull
Engraving, 65.6 x 45.3 cm. (25³⁄₁₆ x
7¹³⁄₁₆ in.), 1796
NPG.82.36

Washington, Booker Taliaferro,
1856-1915
Educator
Arthur P. Bedou, 1882-1966
Photograph, gelatin silver print, 18.6
x 23.8 cm. (7⁵⁄₁₆ x 9⅜ in.), 1915
NPG.78.165

Washington, George, 1732-1799
First President of the United States
Justus Chevillet, 1729-1790, after
Michel Honoré Bonnieu, after
Charles Willson Peale
Engraving, 34.2 x 25.5 cm. (13½ x
10¹⁄₁₆ in.), c. 1775-1802
NPG.77.222

Washington, Booker Taliaferro,
1856-1915
Educator
Elmer Chickering, ?-1915
Photograph, gelatin silver print, 14 x
9.7 cm. (5½ x 3¹³⁄₁₆ in.), c. 1895
NPG.79.208

Washington, George, 1732-1799
First President of the United States
Amos Doolittle, 1754-1832, after
Joseph Wright
Engraving, 2.6 cm. (1¹⁄₁₆ in.)
diameter, 1800
NPG.82.101

Washington, George, 1732-1799
First President of the United States
David Edwin, 1776-1841, after
 Rembrandt Peale
Stipple engraving, 53.1 x 37.5 cm.
 (20⅞ x 14¾ in.), c. 1800
NPG.77.108

Washington, George, 1732-1799
First President of the United States
John Galland, active c. 1796-1817,
 after F. Bartoli and Gilbert Stuart
Stipple engraving, 28.9 x 22.7 cm.
 (11⅜ x 9¹⁵⁄₁₆ in.), c. 1810
NPG.79.205

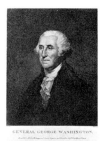

Washington, George, 1732-1799
First President of the United States
David Edwin, 1776-1841, after
 Rembrandt Peale
Stipple engraving, 28.7 x 23 cm.
 (11⁵⁄₁₆ x 9¹⁄₁₆ in.), 1800
NPG.77.227
Gift of Marvin Sadik

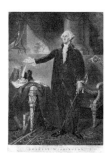

Washington, George, 1732-1799
First President of the United States
Attributed to George Graham, active
 c.1796-c. 1813, after Gilbert Stuart
Mezzotint, 58.3 x 42.2 cm. (22¹⁵⁄₁₆ x
 16⅝ in.), 1801
NPG.85.142

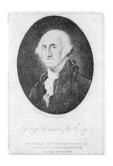

Washington, George, 1732-1799
First President of the United States
David Edwin, 1776-1841, after
 Gilbert Stuart
Stipple engraving, 14.9 x 12 cm. (5⅞
 x 4¾ in.), 1798
NPG.81.58

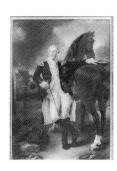

Washington, George, 1732-1799
First President of the United States
Valentine Green, 1739-1813, after
 Charles Willson Peale
Mezzotint, 49.6 x 35.3 cm. (19½ x
 13⅞ in.), 1785
NPG.67.25

Washington, George, 1732-1799
First President of the United States
B. B. Ellis, ?-?, after Benoit Louis
 Prevost, after Pierre Eugène Du
 Simitière
Stipple engraving, 11.1 x 9.2 cm. (4⅜
 x 3⅝ in.), 1783
Published in *Portraits of the
 Generals, Ministers, Magistrates,*
 London, 1783
NPG.75.72

Washington, George, 1732-1799
First President of the United States
Valentine Green, 1739-1813, after
 John Trumbull
Mezzotint, 58.1 x 40.5 cm. (22⅞ x
 15¹⁵⁄₁₆ in.), 1781
NPG.76.54

Washington, George, 1732-1799
First President of the United States
Robert Field, c. 1769-1819, after John
 James Barralet, after Walter
 Robertson
Stipple engraving, 27.9 x 22.9 cm.
 (11 x 9 in.), 1795
NPG.77.198

Washington, George, 1732-1799
First President of the United States
Valentine Green, 1739-1813, after
 John Trumbull
Mezzotint, 32.2 x 25.3 cm. (12¹¹⁄₁₆ x
 10 in.), 1783
NPG.77.197
Gift of Mrs. Katie Louchheim

Washington, George, 1732-1799
First President of the United States
James Heath, 1757-1834, after Gilbert
 Stuart
Engraving, 50.6 x 33.3 cm. (19⅞ x
 13¹⁄₁₆ in.), 1800
NPG.81.55

Washington, George, 1732-1799
First President of the United States
Noël Le Mire, 1724-1801, after Jean
 Baptiste ("Louis") Le Paon, after
 Charles Willson Peale
Engraving, 42.2 x 32.2 cm. (16⅝ x
 12¹¹⁄₁₆ in.), 1780
NPG.77.225

Washington, George, 1732-1799
First President of the United States
Thomas Holloway, 1748-1827, after
 Gilbert Stuart
Line engraving, 23 x 19.7 cm. (9¹⁄₁₆ x
 7¾ in.), 1796
Published in Johann C. Lavater's
 Essays on Physiognomy, vol. 3,
 part 2, London, 1789-1798
NPG.79.139

Washington, George, 1732-1799
First President of the United States
Attributed to Augustus Lenci, active
 c. 1840, after the 1785 original by
 Jean-Antoine Houdon
Plaster life mask, 31 cm. (12¼ in.),
 1843?
NPG.72.37
Gift of Mrs. William D. Chandler

Washington, George, 1732-1799
First President of the United States
Jean-Antoine Houdon, 1741-1828
Plaster, 53.3 cm. (21 in.), c. 1786
NPG.78.1
*Gift of Joe L. and Barbara B.
 Albritton, Robert H. and Clarice
 Smith, and Gallery purchase*

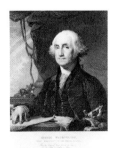

Washington, George, 1732-1799
First President of the United States
Attributed to Nicolas Eustache
 Maurin, 1799-1850, after Gilbert
 Stuart
Lithograph, 29.6 x 24.7 cm. (11⅝ x
 9¾ in.), c. 1825-1828
NPG.79.83

Washington, George, 1732-1799
First President of the United States
H. H. Houston, active 1796-1798,
 after Joseph Wright
Stipple engraving, 9.7 x 7.8 cm. (3¹³⁄₁₆
 x 3¹⁄₁₆ in.), 1797
Published in *The American
 Universal Magazine*,
 Philadelphia, February 6, 1797
NPG.81.57

Washington, George, 1732-1799
First President of the United States
Peter Maverick, 1780-1831, after
 Gilbert Stuart
Stipple and line engraving, 9.8 x 8.2
 cm. (3⅞ x 3¼ in.), 1817
NPG.78.144
*Transfer from the Archives of
 American Art*

Washington, George, 1732-1799
First President of the United States
E. B. and E. C. Kellogg lithography
 company, active c. 1842-1867, after
 William Henry Brown
Lithographed silhouette, 36.3 x 27.4
 cm. (14⁵⁄₁₆ x 10¹³⁄₁₆ in.), 1844
Published in William H. Brown's
 *Portrait Gallery of Distinguished
 American Citizens*, Hartford, 1845
NPG.80.276.a
Gift of Wilmarth Sheldon Lewis

Washington, George, 1732-1799
First President of the United States
Charles Willson Peale, 1741-1827
Mezzotint, 25.1 x 30.2 cm. (9⅞ x 11⅞
 in.), 1780
NPG.76.16
Gift of The Barra Foundation

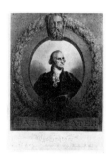

Washington, George, 1732-1799
First President of the United States
Rembrandt Peale, 1778-1860
Oil on canvas, 75.6 x 64.1 cm. (29¾ x
25¼ in.), 1795
NPG.65.59
*Transfer from the National Gallery
of Art; gift of Andrew W. Mellon,
1942*

Washington, George, 1732-1799
First President of the United States
Benoit Louis Prevost, 1735-1804, after
Pierre Eugène Du Simitière
Engraving, 16.2 x 11.7 cm. (6⅜ x 4⅝
in.), 1780
Published in *Collection des Portraits
des Généraux, Ministres, et
Magistrats . . .* , Paris, 1781
NPG.75.55

Washington, George, 1732-1799
First President of the United States
Rembrandt Peale, 1778-1860
Pendleton lithography company
Lithograph, 48.5 x 39 cm. (19⅛ x 15⅜
in.), 1827
NPG.70.56
Gift of Stuart P. Feld

Washington, George, 1732-1799
First President of the United States
Charles Balthazar Julien Févret de
Saint-Mémin, 1770-1852
Engraving, 1.6 x 1.2 cm. (⅝ x ½ in.)
oval, 1800
NPG.74.39.13
Gift of Mr. and Mrs. Paul Mellon

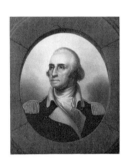

Washington, George, 1732-1799
First President of the United States
Rembrandt Peale, 1778-1860
Oil on canvas, 91.4 x 73.6 cm. (36 x
29 in.) porthole, probably 1853
NPG.75.4
Gift of an anonymous donor

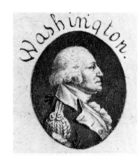

Washington, George, 1732-1799
First President of the United States
Charles Balthazar Julien Févret de
Saint-Mémin, 1770-1852
Engraving, 1.6 x 1.3 cm. (⅝ x ¹⁷⁄₃₂
in.) oval, 1800
NPG.74.39.14
Gift of Mr. and Mrs. Paul Mellon

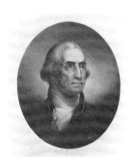

Washington, George, 1732-1799
First President of the United States
Rembrandt Peale, 1778-1860
P. S. Duval lithography company
Lithograph with tintstone, 58.2 x
48.4 cm. (22¹⁵⁄₁₆ x 19¹⁄₁₆ in.), 1856
NPG.77.44

Washington, George, 1732-1799
First President of the United States
Charles Balthazar Julien Févret de
Saint-Mémin, 1770-1852
Copper plate, 7.3 x 6.8 cm. (2⅞ x
2¹¹⁄₁₆ in.), 1798
NPG.77.254

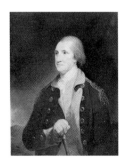

Washington, George, 1732-1799
First President of the United States
Robert Edge Pine, c. 1720s-1788
Oil on canvas, 90.8 x 71.8 cm. (35¾ x
28¼ in.), 1785
NPG.80.16

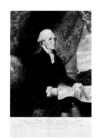

Washington, George, 1732-1799
First President of the United States
Edward Savage, 1761-1817
Mezzotint, 45.6 x 35.2 cm. (17¹⁵⁄₁₆ x
13⅞ in.), 1793
NPG.70.10

Washington, George, 1732-1799
First President of the United States
Edward Savage, 1761-1817
Stipple engraving, 13.7 x 11.2 cm.
(5⅜ x 4⅜ in.), 1792
NPG.81.56

Washington, George, 1732-1799
First President of the United States
Unidentified artist
Marble, 57.8 cm. (22¾ in.),
c. 1800-1810
NPG.75.20

Washington, George, 1732-1799
First President of the United States
James Sharples, c. 1751-1811
Pastel on paper, 23.8 x 18.7 cm. (9⅜
x 7⅜ in.), not dated
NPG.76.17

Washington, George, 1732-1799
First President of the United States
Unidentified artist, after Paul
Revere, after John Norman, after
Charles Willson Peale
Relief cut, 7.2 x 6.3 cm. (2¹³⁄₁₆ x 2½
in.), 1791
Published in *The Federal Almanack*
for 1792, Boston, 1791
NPG.79.80

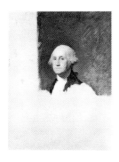

Washington, George, 1732-1799
First President of the United States
Gilbert Stuart, 1755-1828
Oil on canvas, 121.9 x 94 cm. (48 x
37 in.), 1796
NPG.80.115
*Owned jointly with Museum of Fine
Arts, Boston*

Washington, George, 1732-1799
First President of the United States
Unidentified artist
Relief cut, 2.2 x 1.5 cm. (⅞ x ⅝ in.),
1778
Published in *Der Gantz Neue
Verbesserte Nord-Americanische
Calender auf 1779...*, Lancaster,
1778
NPG.79.123

Washington, George, 1732-1799
First President of the United States
James Trenchard, 1747-?, after
unidentified artist
Engraving, 15.4 x 9.3 cm. (6¹⁄₁₆ x 3¹¹⁄₁₆
in.), 1787
Published in *The Columbian
Magazine or Monthly Miscellany,*
Philadelphia, January 1787
NPG.77.213

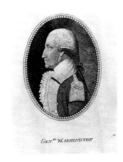

Washington, George, 1732-1799
First President of the United States
Unidentified artist, after Joseph
Wright
Etching, 10.5 x 7.8 cm. (4⅛ x 3¹⁄₁₆
in.), c. 1810
NPG.79.126

Washington, George, 1732-1799
First President of the United States
Attributed to Samuel Wetherbee,
active c. 1811-1825, after Joseph
Wright and John Coles, Sr.
Engraving and etching, 10.6 x 9.6
cm. (4³⁄₁₆ x 3¾ in.), c. 1811
Music sheet title page: "The Battle of
Prague"
NPG.79.147

Washington, George, 1732-1799
First President of the United States
Unidentified artist, after Charles
Willson Peale
Engraving, 19.8 x 14 cm. (7¹³⁄₁₆ x 5½
in.), c. 1783-1786
NPG.79.145

Washington, George, 1732-1799
First President of the United States
Unidentified artist, after Charles
　　Willson Peale
Line engraving, 19.7 x 14.1 cm. (7¹³⁄₁₆
　　x 5⁹⁄₁₆ in.), 1794
Published in Johann C. Lavater's
　　Essays on Physiognomy, vol. 3,
　　part 2, London, 1789-1798
NPG.79.146

Washington, George, 1732-1799
First President of the United States
Unidentified artist, after Gilbert
　　Stuart
Stipple engraving, 3.6 cm. (1⁷⁄₁₆ in.)
　　diameter, c. 1799-1800
Music sheet title page: "Dead March
　　and Monody"
NPG.80.34

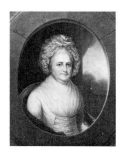

**Washington, Martha Dandridge
　　Custis,** 1731-1802
First lady
Rembrandt Peale, 1778-1860
Oil on canvas, 91.4 x 73.6 cm. (36 x
　　29 in.) porthole, probably 1853
NPG.75.3
Gift of an anonymous donor

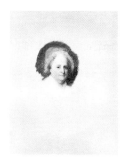

**Washington, Martha Dandridge
　　Custis,** 1731-1802
First lady
Gilbert Stuart, 1755-1828
Oil on canvas, 121.9 x 94 cm. (48 x
　　37 in.), 1796
NPG.80.116
*Owned jointly with Museum of Fine
　　Arts, Boston*

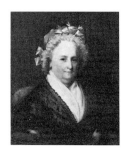

**Washington, Martha Dandridge
　　Custis,** 1731-1802
First lady
Unidentified artist, after the 1796
　　portrait by Gilbert Stuart and the
　　1795 portrait by Charles Willson
　　Peale
Oil on canvas, 76.2 x 64.1 cm. (30 x
　　25¼ in.), first quarter nineteenth
　　century
NPG.70.3

Waters, Ethel*, 1896-1977
Singer, actress
Alfred Bendiner, 1899-1964
Pencil and india ink with opaque
　　white and ben day cutout on
　　board, 15.1 x 15.6 cm. (5¹¹⁄₁₆ x 6³⁄₁₆
　　in.), 1940
T/NPG.85.194.87
Gift of Alfred Bendiner Foundation

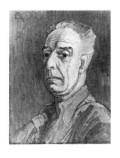

Waters, Ethel*, 1896-1977
Singer, actress
Carl Van Vechten, 1880-1964
Photogravure, 22.5 x 15 cm. (8⅞ x
　　5¹⁵⁄₁₆ in.), 1983 from 1932 negative
T/NPG.83.188.48

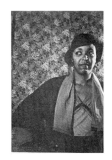

Watkins, Franklin, 1894-1972
Artist
Self-portrait
Oil on canvas, 50.5 x 40.6 cm. (19⅞ x
　　16 in.), 1955
NPG.74.49
*Gift of Mrs. John Steinman and The
　　Barra Foundation*

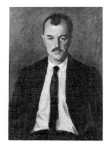

Watson, Forbes, 1879-1960
Art critic
Agnes Watson, 1876-1966
Oil on canvas, 76.2 x 55.8 cm. (30 x
　　22 in.), not dated
NPG.67.21
Gift of John H. Paterson

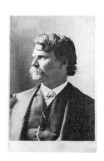

Watterson, Henry, 1840-1921
Journalist
Unidentified photographer
Photograph, albumen silver print, 15
　　x 10.4 cm. (5⅞ x 4¹⁄₁₆ in.), c. 1880
NPG.85.101
Gift of Robert L. Drapkin

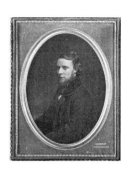

Waud, Alfred Rudolph, 1828-1891
Artist
Jeremiah Gurney, active 1840-1880
Daguerreotype, 14 x 10.8 cm. (5½ x
 4¼ in.), c. 1852
NPG.83.139

Weber, Max, 1881-1961
Artist
Clara E. Sipprell, 1885-1975
Photograph, gelatin silver print, 18.7
 x 23.8 cm. (7⅜ x 9⅜ in.), c. 1923
NPG.82.202
Bequest of Phyllis Fenner

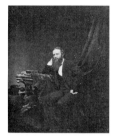

Waud, Alfred Rudolph, 1828-1891
Artist
Unidentified photographer
Photograph, albumen silver print,
 25.1 x 20.1 cm. (9⅞ x 7¹⁵/₁₆ in.),
 c. 1866
NPG.83.140

Webster, Daniel, 1782-1852
Statesman
J. H. Bufford lithography company,
 active 1835-1890, after
 daguerreotype by John W.
 Whipple
Lithograph, 15.1 x 13 cm. (5¹⁵/₁₆ x 5⅛
 in.), c. 1852
Music sheet title page: "Funeral
 March to . . . Daniel Webster"
NPG.78.116

Waud, Alfred Rudolph, 1828-1891
Artist
Unidentified photographer
Photograph, albumen silver print, 10
 x 7.1 cm. (3¹⁵/₁₆ x 2¹³/₁₆ in.), c. 1890
NPG.83.141

Webster, Daniel, 1782-1852
Statesman
Charles G. Crehen, 1829-?, after
 daguerreotype by John Adams
 Whipple
Nagel and Weingaertner lithography
 company
Lithograph, 35 x 29 cm. (13¾ x 11⅜
 in.), after 1848
NPG.77.14

Wayne, Anthony, 1745-1796
Revolutionary general
George Graham, active c. 1796-
 c. 1813, after Jean Pierre Henri
 Elouis
Mezzotint, 45.4 x 35.5 cm. (17⅞ x
 13¹⁵/₁₆ in.), 1796
NPG.79.206

Webster, Daniel, 1782-1852
Statesman
Francis D'Avignon, c. 1814-?, after
 daguerreotype by Mathew Brady
Lithograph, 28.3 x 24.7 cm. (11⅛ x
 9¾ in.), 1850
Published in Mathew Brady's
 Gallery of Illustrious Americans,
 New York, 1850
NPG.77.326

Wayne, Anthony, 1745-1796
Revolutionary general
Benjamin Tanner, 1775-1848, after
 John Trumbull
Stipple engraving, 9.2 x 7.1 cm. (3⅝
 x 2¹³/₁₆ in.), 1797
Published in *New York Magazine or
 Literary Repository,* vol. 2, New
 York, March 1797
NPG.77.214

Webster, Daniel, 1782-1852
Statesman
Charles Fenderich, 1805-1887
P. S. Duval lithography company
Lithograph, 26.4 x 25 cm. (10⅜ x 9⅞
 in.), 1843
NPG.66.95
*Transfer from the Library of
 Congress, Prints and Photographs
 Division*

Webster, Daniel, 1782-1852
Statesman
Chester Harding, 1792-1866
Oil on canvas, 92 x 71.7 cm. (36¼ x
 28¼ in.), c. 1828
NPG.67.59
Gift of Mrs. Gerard B. Lambert

Webster, Daniel, 1782-1852
Statesman
James Barton Longacre, 1794-1869
Sepia watercolor on artist board, 22.5
 x 16.2 cm. (8⅞ x 6⅜ in.), 1830
NPG.76.63

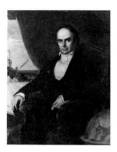

Webster, Daniel, 1782-1852
Statesman
George Peter Alexander Healy,
 1813-1894
Oil on canvas, 128.8 x 102.2 cm.
 (50¾ x 40¼ in.), 1846
NPG.65.51
*Transfer from the National Gallery
 of Art; gift of Andrew W. Mellon,
 1942*

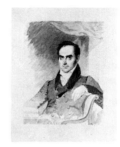

Webster, Daniel, 1782-1852
Statesman
James Barton Longacre, 1794-1869,
 after Gilbert Stuart
Sepia watercolor and pencil on artist
 board, 22.9 x 18.3 cm. (9 x 7¼ in.),
 1830
NPG.77.286

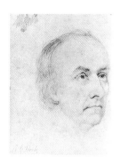

Webster, Daniel, 1782-1852
Statesman
Albert Gallatin Hoit, 1809-1856
Pencil on paper, 14 x 10.8 cm. (5½ x
 4¼ in.), not dated
NPG.71.18

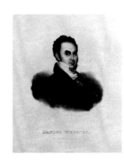

Webster, Daniel, 1782-1852
Statesman
Pendleton lithography company,
 active 1825-1836, after James
 Frothingham
Lithograph, 20.4 x 20 cm. (8 x 7⅞
 in.), c. 1835
NPG.78.92

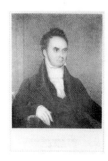

Webster, Daniel, 1782-1852
Statesman
David Claypoole Johnston,
 1799-1865, after Chester Harding
Pendleton lithography company
Lithograph, 22.4 x 18 cm. (8¹³⁄₁₆ x 7⅛
 in.), 1831
NPG.80.109

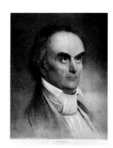

Webster, Daniel, 1782-1852
Statesman
William Sharp, 1802-?, after
 Eastman Johnson
Lithograph with tintstone, 54.3 x
 43.1 cm. (9⅜ x 4¹⁵⁄₁₆ in.), 1848
NPG.82.29

Webster, Daniel, 1782-1852
Statesman
E. B. and E. C. Kellogg lithography
 company, active c. 1842-1867, after
 William Henry Brown
Lithographed silhouette, 34.1 x 24.2
 cm. (13⁷⁄₁₆ x 9¹⁵⁄₁₆ in.), 1844
Published in William H. Brown's
 *Portrait Gallery of Distinguished
 American Citizens*, Hartford, 1845
NPG.79.180

Webster, Daniel, 1782-1852
Statesman
Albert Sands Southworth, 1811-1894,
 and Josiah Johnson Hawes,
 1808-1901; studio active 1844-1861
Daguerreotype, 21.5 x 16.5 cm. (8½ x
 6½ in.), c. 1846
NPG.76.93

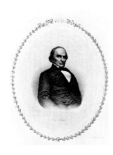

Webster, Daniel, 1782-1852
Statesman
Tappan and Bradford lithography
 company, active 1848-1854, after
 daguerreotype by John Adams
 Whipple
Lithograph with printed gold border,
 26.4 x 71.2 cm. (10⅜ x 28 in.),
 c. 1852-1853
NPG.77.327

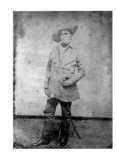

Webster, Daniel, 1782-1852
Statesman
Unidentified photographer, after
 c. 1850 daguerreotype
Photograph, albumen silver print,
 20.1 x 15.1 cm. (7¹⁵⁄₁₆ x 6¹⁵⁄₁₆ in.),
 c. 1860
NPG.79.229

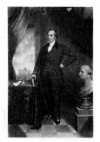

Webster, Daniel, 1782-1852
Statesman
Charles Edward Wagstaff, 1808-?,
 and Joseph Andrews, c. 1805-1873,
 after Thomas Bayley Lawson
Mezzotint and line engraving, 67.5
 x 45.6 cm. (26⁹⁄₁₆ x 17¹⁵⁄₁₆ in.), 1852
NPG.85.171

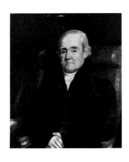

Webster, Noah, 1758-1843
Lexicographer
James Herring, 1794-1867
Oil on panel, 81.3 x 69.8 cm. (32 x
 27½ in.), 1833
NPG.67.31
Gift of Mrs. William A. Ellis

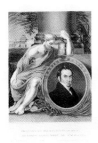

Webster, Daniel, 1782-1852
Statesman
Woodcock and Harvey engraving
 company, active c. 1838-1845, after
 James Frothingham
Engraving and stipple engraving,
 39.4 x 30.5 cm. (15½ x 12 in.), 1838
NPG.79.161

Webster, Noah, 1758-1843
Lexicographer
Unidentified artist
Relief cut, 12.6 x 7.5 cm. (4¹⁵⁄₁₆ x 2¹⁵⁄₁₆
 in.), 1789
Published in Noah Webster's *The
 American Spelling Book*, Boston,
 1789
NPG.78.90

Webster, Daniel, 1782-1852
Statesman
Charles Cushing Wright, 1796-1854
Bronze medal, 7.6 cm. (3 in.)
 diameter, after 1852
NPG.77.248
Gift of Marvin Sadik

Weill, Kurt, 1900-1950
Composer
B. F. Dolbin, 1883-1974
Pencil on paper, 31.1 x 24 cm. (12¼ x
 9½ in.), 1928
NPG.78.263

Webster, Daniel, 1782-1852
Statesman
Unidentified artist
Marble bas-relief, 26 x 20.9 x 5.4 cm.
 (10¼ x 8¼ x 2⅛ in.), not dated
NPG.78.220

Weir, John Ferguson, 1841-1926
Artist
Julian Alden Weir, 1852-1919
Drypoint, 17.5 x 14.5 cm. (16⅞ x 5¹¹⁄₁₆
 in.), 1890
NPG.78.56

Weir, Julian Alden, 1852-1919
Artist
Olin Levi Warner, 1844-1896
Plaster, 58.4 cm. (23 in.), 1880
NPG.75.21

West, Benjamin, 1738-1820
Artist
Attributed to James Smith, 1749-c.
1794
Oil on canvas, 53.9 x 47 cm. (21¼ x
18½ in.), 1770
NPG.80.136
Gift of the Margaret Hall Foundation

Welles, Gideon, 1802-1878
Journalist, statesman
Unidentified photographer
Photograph, albumen silver print,
22.2 x 17.5 cm. (8¾ x 6⅞ in.),
c. 1869
NPG.85.111
Gift of Robert L. Drapkin

West, Benjamin, 1738-1820
Artist
Jonathan Spilsbury, active 1760-
1807, after unidentified artist
Mezzotint and line engraving, 15.4
x 12.7 cm. (6¹/₁₆ x 5 in.), not dated
NPG.71.49

West, Benjamin, 1738-1820
Artist
William Behnes, 1794-1864
Marble, 49.5 cm. (19½ in.), 1820
NPG.76.109

West, Benjamin, 1738-1820
Artist
Caroline Watson, c. 1760-1814, after
Gilbert Stuart
Stipple engraving, 16.3 x 12.9 cm.
(6⅜ x 5¹/₁₆ in.), 1786
NPG.77.223

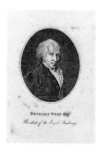

West, Benjamin, 1738-1820
Artist
Attributed to Samuel Hill, active
1789-1803, after Christian Josi,
after Benjamin West
Etching, 10.1 x 8.4 cm. (4 x 3⁵/₁₆ in.),
1795
Published in *The Massachusetts
Magazine*, Boston, December 1795
NPG.77.215

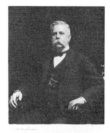

Westinghouse, George, 1846-1914
Inventor, manufacturer
Joseph Gaylord Gessford, 1864/65-
1942
Photograph, platinum-toned gelatin
silver print, 41.1 x 34.7 cm. (16³/₁₆
x 13⅝ in.), 1906
NPG.85.18
*Gift of Westinghouse Electric
Corporation*

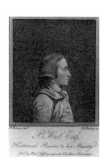

West, Benjamin, 1738-1820
Artist
Burnet Reading, active 1780-1820,
after Pierre Etienne Falconet
Stipple engraving, 13.1 x 10.9 cm.
(5⅛ x 4¼ in.), 1792
NPG.78.41

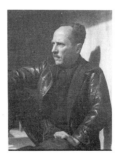

Weston, Edward, 1886-1958
Photographer
Imogen Cunningham, 1883-1976
Photograph, gelatin silver print, 11.3
x 9 cm. (4⅝ x 3⁹/₁₆ in.), 1932
NPG.85.43

Weston, Edward, 1886-1958
Photographer
Peter Krasnow, 1890-1979
Oil on canvas, 127 x 96.5 cm. (50 x
 38 in.), 1925
NPG.77.35
Gift of the artist

Weston, Edward, 1886-1958
Photographer
Neil Weston, ?-
Photograph, gelatin silver print, 24.7
 x 19.6 cm. (9¾ x 7¾ in.), 1977 from
 1945 negative
NPG.77.138

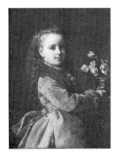

Wharton, Edith, 1862-1937
Author
Edward Harrison May, 1824-1887
Oil on canvas, 72.4 x 54.6 cm. (28½ x
 21½ in.), 1870
NPG.82.136

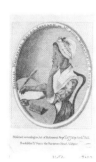

Wheatley, Phillis, c. 1753-1784
Poet
Unidentified artist, after Scipio
 Moorhead
Engraving, 12.8 x 10.1 cm. (5¹/₁₆ x 4
 in.), 1773
Published in Phillis Wheatley's
 *Poems on Various Subjects,
 Religious and Moral,* London,
 1773
NPG.77.2

Wheeler, Burton Kendall, 1882-1975
Statesman
Clifford Kennedy Berryman,
 1869-1949
India ink over pencil on paper, 34.3
 x 36.3 cm. (13½ x 14¼ in.), 1939
Illustration for *The Washington Star,*
 Washington, D.C., June 30, 1939
NPG.84.326
Gift of John L. Wheeler

Wheeler, George Montague,
 1842-1905
Topographical engineer
Henry W. Bradley, 1814-1891, and
 William Herman Rulofson,
 1826-1878; studio active 1863-1878
Photograph, albumen silver print,
 9.3 x 6.2 cm. (3⅝ x 2⁷/₁₆ in.), c. 1872
NPG.78.166

Whipple, John Adams, 1822-1891
Daguerreotypist
Francis D'Avignon, c. 1814-?,
 probably after daguerreotype by
 John Adams Whipple
Lithograph, 14.1 x 11.4 cm. (5⁹/₁₆ x
 4½ in.), 1851
Published in *Photographic Art
 Journal,* New York, August 1851
NPG.79.40

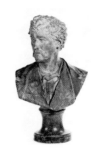

Whistler, James Abbott McNeill,
 1834-1903
Artist
Joseph Edgar Boehm, 1834-1890
Terra-cotta, 67.9 cm. (26¾ in.), 1872
NPG.65.74
*Transfer from the National Gallery
 of Art; bequest of Albert E.
 Gallatin, 1952*

Whistler, James Abbott McNeill,
 1834-1903
Artist
Giovanni Boldini, 1845-1931
Drypoint, 18.4 x 23 cm. (7¼ x 9¹/₁₆
 in.), 1897
NPG.70.74

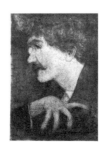

Whistler, James Abbott McNeill,
 1834-1903
Artist
Frederick Francis Foottet, 1850-1935
Etching, 32.8 x 23.5 cm. (12⅞ x 9¼
 in.), c. 1880-1890
NPG.85.232
Gift of Lionel C. Epstein

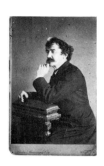

Whistler, James Abbott McNeill,
1834-1903
Artist
London Stereoscopic Company,
 active 1854-c. 1902
Photograph, albumen silver print,
 14.9 x 10.1 cm. (5⅞ x 4 in.), c. 1875
NPG.83.8
Gift of Jem Hom

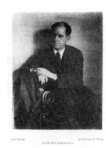

White, Clarence Hudson, 1871-1925
Photographer
Self-portrait
Collotype, 23.8 x 18.8 cm. (9⅜ x 7⅜
 in.), c. 1925
NPG.82.153

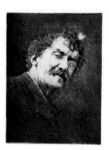

Whistler, James Abbott McNeill,
1834-1903
Artist
Mortimer Menpes, 1855-1938
Etching and drypoint on tinted
 paper, 20 x 15.1 cm. (7⅞ x 5¹⁵⁄₁₆
 in.), c. 1900
NPG.80.178

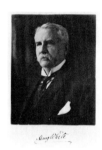

White, Henry, 1850-1927
Diplomat
Harris and Ewing studio, active
 1905-1977
Photograph, gelatin silver print, 23.2
 x 18.2 cm. (9⅛ x 7³⁄₁₆ in.), c. 1918
NPG.84.255
Gift of Aileen Conkey

Whistler, James Abbott McNeill,
1834-1903
Artist
Thomas Robert Way, 1861-1913
Lithograph, 5.7 x 6.2 cm. (2¼ x 2⁷⁄₁₆
 in.), c. 1900
NPG.83.169
Gift of Mrs. J. M. Kaplan

White, Henry, 1850-1927
Diplomat
John Christen Johansen, 1876-1964
Oil on canvas, 76.2 x 76.2 cm. (30 x
 30 in.), 1919
NPG.65.85
*Transfer from the National Museum
 of American Art; gift of an
 anonymous donor through Mrs.
 Elizabeth C. Rogerson*

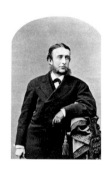

White, Andrew Dickson, 1832-1918
Educator
Napoleon Sarony, 1821-1896
Photograph, albumen silver print,
 13.1 x 9.1 cm. (5⅛ x 3⁹⁄₁₆ in.),
 c. 1875
NPG.78.173

White, Henry, 1850-1927
Diplomat
John Christen Johansen, 1876-1964
Oil on canvas, 76.2 x 76.2 cm. (30 x
 30 in.), 1919
NPG.65.86
*Transfer from the National Museum
 of American Art; gift of an
 anonymous donor through Mrs.
 Elizabeth C. Rogerson*

White, Byron Raymond*, 1917-
Justice of the United States Supreme
 Court
Oscar Berger, 1901-
Ink over pencil on paper, 42.4 x 35.4
 cm. (16¹¹⁄₁₆ x 13¹⁵⁄₁₆ in.), c. 1968
T/NPG.69.14
Gift of the artist

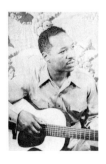

White, Josh, 1908-1969
Singer
Carl Van Vechten, 1880-1964
Photogravure, 22.4 x 14.9 cm. (8¹³⁄₁₆
 x 5¾ in.), 1983 from 1946 negative
NPG.83.188.49

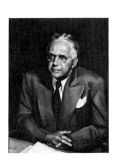

White, Walter Francis, 1893-1955
Civil rights statesman
Betsy Graves Reyneau, 1888-1964
Oil on canvas, 91.4 x 71.1 cm. (36 x
28 in.), 1945
NPG.67.46
Gift of the Harmon Foundation

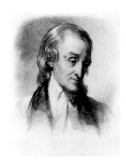

White, William, 1748-1836
Clergyman
John Sartain, 1808-1897, after
Thomas Sully
Mezzotint, 28.4 x 24.4 cm. (11³⁄₁₆ x
9¾ in.), c. 1830
NPG.79.129

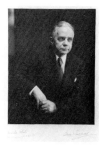

White, Walter Francis, 1893-1955
Civil rights statesman
Clara E. Sipprell, 1885-1875
Photograph, gelatin silver print, 22.6
x 17.5 cm. (8¹⁵⁄₁₆ x 6¹⁵⁄₁₆ in.), c. 1950
NPG.82.197
Bequest of Phyllis Fenner

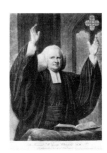

Whitefield, George, 1714-1770
Evangelist
John Greenwood, 1727-1792, after
Nathaniel Hone
Mezzotint, 32.4 x 24.7 cm. (12¾ x 9¾
in.), 1769
NPG.75.77

White, William, 1748-1836
Clergyman
William Russell Birch, 1755-1834
Enamel on copper, 3.5 x 2.8 cm. (1⅜
x 1⅛ in.), not dated
NPG.74.10
Gift of the Reverend DeWolf Perry

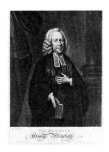

Whitefield, George, 1714-1770
Evangelist
James Moore, ?-?, after Andrew
Miller, after M. Jenkin
Mezzotint, 31 x 25.1 cm. (12³⁄₁₆ x 9⅞
in.), after 1751
NPG.69.77

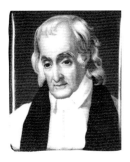

White, William, 1748-1836
Clergyman
E. B. and E. C. Kellogg lithography
company, active c. 1842-1867, after
William Henry Brown
Lithographed silhouette, 34.1 x 25.3
cm. (13⁷⁄₁₆ x 9¹⁵⁄₁₆ in.), 1844
Published in William H. Brown's
*Portrait Gallery of Distinguished
American Citizens,* Hartford, 1845
NPG.79.190

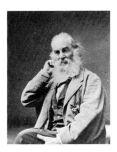

Whitman, Walt, 1819-1892
Poet
Mathew Brady, 1823-1896
Photograph, albumen silver print,
23.9 x 18.7 cm. (9⁷⁄₁₆ x 7⅜ in.),
c. 1867
NPG.76.96
*Gift of Mr. and Mrs. Charles
Feinberg*

White, William, 1748-1836
Clergyman
James Barton Longacre, 1794-1869
Sepia watercolor on artist board, 26.2
x 21.7 cm. (10⁵⁄₁₆ x 8⁹⁄₁₆ in.), 1833
NPG.77.284

Whitman, Walt, 1819-1892
Poet
George C. Cox, 1851-1902
Photograph, platinum print, 22.1 x
18.4 cm. (8¹¹⁄₁₆ x 7¼ in.), 1887
NPG.76.98
*Gift of Mr. and Mrs. Charles
Feinberg*

Whitman, Walt, 1819-1892
Poet
Thomas Eakins, 1844-1916
Photograph, platinum print, 9.5 x
12.2 cm. (3¾ x 4¾ in.), 1979 from
1891 negative
NPG.79.64

Whitman, Walt, 1819-1892
Poet
Thomas Eakins, 1844-1916
Photograph, platinum print, 9.4 x 12
cm. (3¹¹⁄₁₆ x 4¾ in.), 1979 from
1891 negative
NPG.79.69

Whitman, Walt, 1819-1892
Poet
Thomas Eakins, 1844-1916
Photograph, platinum print, 10.3 x
12.2 cm. (3¹¹⁄₁₆ x 4¾ in.), 1979 from
1891 negative
NPG.79.65

Whitman, Walt, 1819-1892
Poet
Thomas Eakins, 1844-1916
Photograph, platinum print, 9.7 x 12
cm. (3¹³⁄₁₆ x 4¾ in.), 1979 from
1891 negative
NPG.79.70

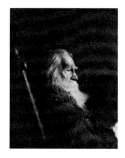

Whitman, Walt, 1819-1892
Poet
Thomas Eakins, 1844-1916
Photograph, platinum print, 12 x 9.8
cm. (4¾ x 3⅞ in.), 1979 from 1891
negative
NPG.79.66

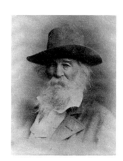

Whitman, Walt, 1819-1892
Poet
Edy Brothers studio, active c. 1880
Photograph, albumen silver print,
14.5 x 9.1 cm. (5¹¹⁄₁₆ x 3⁹⁄₁₆ in.),
1880
NPG.76.97
*Gift of Mr. and Mrs. Charles
Feinberg*

Whitman, Walt, 1819-1892
Poet
Thomas Eakins, 1844-1916
Photograph, platinum print, 12.1 x
9.9 cm. (4¾ x 3⅞ in.), 1979 from
1891 negative
NPG.79.67

Whitman, Walt, 1819-1892
Poet
Frederick Gutekunst, 1831-1917
Photograph, albumen silver print,
13.1 x 10.3 cm. (5⅛ x 4¹⁄₁₆ in.), 1880
NPG.76.94
*Gift of Mr. and Mrs. Charles
Feinberg*

Whitman, Walt, 1819-1892
Poet
Thomas Eakins, 1844-1916
Photograph, platinum print, 9.8 x
12.6 cm. (3⅞ x 4⁷⁄₁₆ in.), 1979 from
1891 negative
NPG.79.68

Whitman, Walt, 1819-1892
Poet
Samuel Hollyer, 1826-1919, after
daguerreotype by Gabriel Harrison
Stipple engraving, 8.1 x 5.7 cm. (3³⁄₁₆
x 2¼ in.), c. 1854-1855
Frontispiece to first edition of *Leaves
of Grass*, Brooklyn, New York,
1855
NPG.82.25

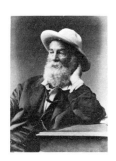

Whitman, Walt, 1819-1892
Poet
G. Frank E. Pearsall, active 1871-1896
Photograph, albumen silver print,
13.8 x 10.2 cm. (5⁷/₁₆ x 4 in.), 1872
NPG.76.95
*Gift of Mr. and Mrs. Charles
Feinberg*

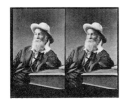

Whitman, Walt, 1819-1892
Poet
G. Frank E. Pearsall, active 1871-1896
Photograph, albumen silver print,
16.1 x 22 cm. (6³/₁₆ x 8⁵/₁₆ in.), 1872
NPG.84.257
Gift of Charles Feinberg

Whitman, Walt, 1819-1892
Poet
Frank Hill Smith, 1841-1904
Blue pencil on paper, 19 x 30.2 cm.
(7½ x 11⅞ in.), 1881
NPG.77.242

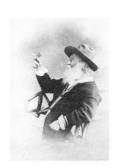

Whitman, Walt, 1819-1892
Poet
Unidentified photographer
Photograph, albumen silver print,
14.3 x 10.1 cm. (5⅝ x 4 in.), c. 1873
NPG.84.258
Gift of Charles Feinberg

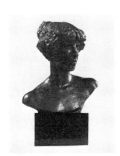

Whitney, Gertrude Vanderbilt,
1875-1942
Artist, patron
Jo Davidson, 1883-1952
Bronze, 42.5 cm. (16¾ in.), 1917
NPG.68.7

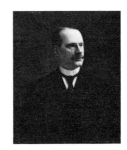

Whitney, William Collins,
1841-1904
Financier
Unidentified artist
Oil on canvas, 76.2 x 63.5 cm. (30 x
25 in.), not dated
NPG.69.42
Gift of Michael Straight

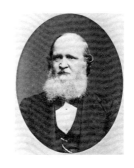

Whitney, William Dwight,
1827-1894
Linguist
Garrett Brothers, ?-?
Photograph, albumen silver print,
11.6 x 9.1 cm. (4⅜ x 3⁹/₁₆ in.),
c. 1868
NPG.78.169

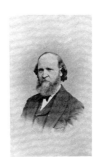

Whitney, William Dwight,
1827-1894
Linguist
George C. Phelps, ?-?
Photograph, albumen silver print,
9.5 x 5.6 cm. (3¾ x 2³/₁₆ in.), c. 1869
NPG.78.172

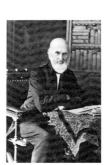

Whittier, John Greenleaf, 1807-1892
Poet
William Notman, 1826-1891
Photograph, gelatin silver print, 14 x
10 cm. (5½ x 3¹⁵/₁₆ in.), 1881
NPG.78.171

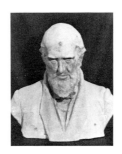

Whittier, John Greenleaf, 1807-1892
Poet
William Ordway Partridge,
1861-1930
Plaster, 64.1 cm. (25¼ in.), 1893
NPG.74.18

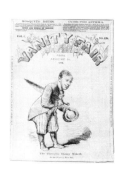

Wikoff, Henry, 1813-1884
Author
Bobbett and Hooper wood-engraving
 company, active 1855-1870, after
 Henry Louis Stephens
Wood engraving, 27.2 x 20.3 cm.
 (10¹¹⁄₁₆ x 8 in.), 1862
Published in *Vanity Fair*, New York,
 August 16, 1862
NPG.85.145

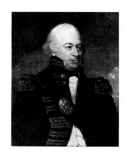

Wilkinson, James, 1757-1825
Early national general
Unidentified artist
Oil on canvas, 77.5 x 64.7 cm. (30½ x
 25½ in.), nineteenth century
NPG.75.15

Wilcox, Cadmus Marcellus,
 1824-1890
Confederate soldier
Unidentified artist
Wood engraving, 25.2 x 24.1 cm.
 (19¹⁵⁄₁₆ x 9⁷⁄₁₆ in.), 1863
Published in *Southern Illustrated
 News*, Richmond, April 25, 1863
NPG.80.281

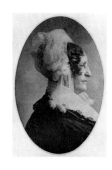

Willard, Emma Hart, 1787-1870
Educator
Unidentified photographer
Photograph, brown-toned platinum
 print, 16.5 x 11.3 cm. (6½ x 4⁷⁄₁₆
 in.), c. 1900 after c. 1850
 daguerreotype
NPG.81.111
Gift of Emma Willard School

Wilder, Thornton Niven, 1897-1975
Author, playwright
Helen Balfour Morrison, ?-
Photograph, gelatin silver print, 26.8
 x 33.4 cm. (10⁹⁄₁₆ x 6⅜ in.), c. 1930
NPG.79.116
*Gift of the estate of Gertrude
 Abercrombie*

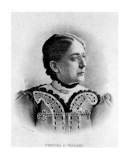

Willard, Frances Elizabeth Caroline,
 1839-1898
Educator, temperance advocate,
 reformer
Kurz and Allison lithography
 company, active 1880-c. 1899, after
 photograph
Lithograph, 53 x 46.7 cm. (21 x 18½
 in.), c. 1897
NPG.80.56

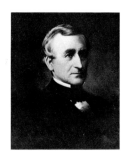

Wilkes, Charles, 1798-1877
Naval officer, explorer
Samuel Bell Waugh, 1814-1885
Oil on canvas, 61 x 51.4 cm. (24 x
 20¼ in.), 1870
NPG.67.63

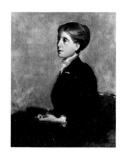

Willard, Frances Elizabeth Caroline,
 1839-1898
Educator, temperance advocate,
 reformer
George Rapp, 1904-
Oil on canvas, 76.2 x 63.5 cm. (30 x
 25 in.), 1871
NPG.71.46
*Gift of the National Women's
 Christian Temperance Union*

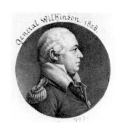

Wilkinson, James, 1757-1825
Early national general
Charles Balthazar Julien Févret de
 Saint-Mémin, 1770-1852
Engraving, 5.6 cm. (2¼ in.) diameter,
 c. 1808
NPG.74.39.394
Gift of Mr. and Mrs. Paul Mellon

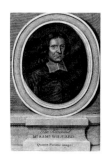

Willard, Samuel, 1639/40-1707
Clergyman
Gerard Van der Gucht, 1696-1776,
 after unidentified artist
Stipple and line engraving, 26.7 x
 17.7 cm. (10½ x 6¾ in.), 1726
Published in Willard's *Complete
 Body of Divinity*, Boston, 1726
NPG.78.45

Williams, Bert, 1876-1922
Entertainer
Alfred J. Frueh, 1880-1968
Linocut, 29.6 x 8.2 cm. (11⅝ x 3³⁄₁₆
 in.), 1922
Published in Alfred J. Frueh's *Stage
 Folk*, New York, 1922
NPG.84.229.n

Willis, Nathaniel Parker, 1806-1867
Journalist
Bobbett and Hooper wood-engraving
 company, active 1855-1870, after
 Henry Louis Stephens
Wood engraving, 15.5 x 13.5 cm. (6⅛
 x 5⁵⁄₁₆ in.), 1862
Published in *Vanity Fair*, New York,
 June 21, 1862
NPG.78.224

Williams, Edward Bennett*, 1920-
Lawyer
Philippe Halsman, 1906-1979
Photograph, gelatin silver print, 35.7
 x 27.5 cm. (13¾ x 10¹³⁄₁₆ in.), 1962
T/NPG.83.118
Gift of George R. Rinhart

Willis, Nathaniel Parker, 1806-1867
Journalist
Mathew Brady, 1823-1896, or his
 studio
Photograph, salt print, 50 x 42.7 cm.
 (19¹¹⁄₁₆ x 16¹³⁄₁₆ in.), c. 1860
NPG.77.150
Gift of The Old Print Shop, Inc.

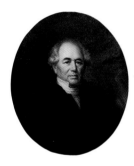

Williams, Eleazar, c. 1789-1858
Indian missionary
Attributed to Giuseppe Fagnani,
 1819-1873
Oil on canvas, 75.6 x 62.8 cm. (29¾ x
 24¾ in.) oval, 1853
NPG.75.40
Gift of Mrs. Lawrence M. C. Smith

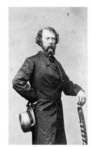

Willis, Nathaniel Parker, 1806-1867
Journalist
Charles DeForest Fredricks,
 1823-1894
Photograph, albumen silver print,
 9.1 x 5.4 cm. (3⁹⁄₁₆ x 2⅛ in.), c. 1863
NPG.80.211

Williams, Talcott, 1849-1928
Journalist
Thomas Eakins, 1844-1916
Oil on canvas, 61.6 x 50.8 cm. (24½ x
 20 in.), not dated
NPG.85.50
*Gift of the Kate and Laurens Seelye
 Family and the Smithson Society,
 and Gallery purchase*

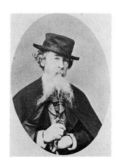

Willis, Nathaniel Parker, 1806-1867
Journalist
George N. Rockwood, 1833-1911
Photograph, albumen silver print,
 7.2 x 5.2 cm. (2⅞ x 2¹⁄₁₆ in.), c. 1867
NPG.80.96

**Williams, Thomas Lanier
 ("Tennessee")*,** 1911-1983
Playwright
Irving Penn, 1917-
Photograph, platinum-palladium
 print, 38.8 x 38.8 cm. (15⁵⁄₁₆ x 15¼
 in.), c. 1977 from 1951 negative
T/NPG.85.40.93

Willkie, Wendell Lewis, 1892-1944
Statesman
Harris and Ewing studio, active
 1905-1977
Photograph, gelatin silver print, 33 x
 23.2 cm. (13 x 9⅛ in.), 1934
NPG.77.351

Willkie, Wendell Lewis, 1892-1944
Statesman
Samuel Johnson Woolf, 1880-1948
Charcoal on paper, 53.3 x 43.1 cm.
(21 x 17 in.), not dated
NPG.74.70

Wills, Helen Newington*, 1905-
Athlete
Frederick Childe Hassam, 1859-1935
Etching, 17.4 x 12.4 cm. (6¹³⁄₁₆ x 4⅞
in.), 1928
T/NPG.77.256

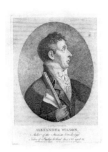

Wilson, Alexander, 1766-1813
Scientist
John James Barralet, c. 1747-1815
Stipple and line engraving, 12.5 x
9.9 cm. (4⅞ x 3⅞ in.), 1814
NPG.85.35

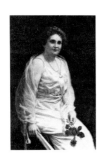

Wilson, Edith Bolling Galt,
1872-1961
First lady
Emile Alexay, 1891-1949
Oil on canvas, 117.1 x 76.8 cm. (46⅛
x 30¼ in.), 1924
NPG.69.43
Gift of Dr. Alan Urdang

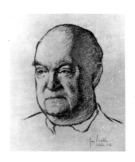

Wilson, Edmund, 1895-1972
Author
George M. Biddle, 1885-1973
Silverpoint drawing on paper, 36.7 x
29.2 cm. (14⁷⁄₁₆ x 11½ in.), 1956
NPG.79.155

Wilson, Henry, 1812-1875
Statesman
Mathew Brady, 1823-1896
Photograph, albumen silver print,
11.8 x 9.1 cm. (4⅝ x 3⁹⁄₁₆ in.),
c. 1872
NPG.79.43

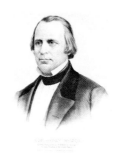

Wilson, Henry, 1812-1875
Statesman
Currier and Ives lithography
company, active 1857-1907, after
photograph by Mathew Brady
Lithograph, 28.3 x 23.7 cm. (11⅛ x
9⅜ in.), c. 1872
NPG.81.54

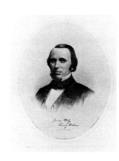

Wilson, Henry, 1812-1875
Statesman
Leopold Grozelier, 1830-1865, after
daguerreotype by John Adams
Whipple
S. W. Chandler and Brother
lithography company
Lithograph, 25 x 23.6 cm. (9⅞ x 9⁵⁄₁₆
in.), 1855
Published in Charles H. Brainard's
*Portrait Gallery of Distinguished
Americans*, Boston, 1855
NPG.77.111

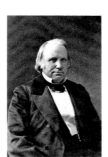

Wilson, Henry, 1812-1875
Statesman
Unidentified photographer
Photograph, platinum print, 14 x 9.5
cm. (5½ x 3¾ in.), c. 1873
NPG.78.175

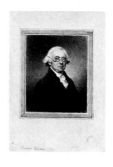

Wilson, James, 1742-1798
Revolutionary statesman, Justice of
the United States Supreme Court
James Barton Longacre, 1794-1869,
after Jean Pierre Henri Elouis
Sepia watercolor on artist board, 18.2
x 14 cm. (7⅜ x 5½ in.), c. 1825
NPG.77.299

Wilson, Thomas Woodrow,
1856-1924
Twenty-eighth President of the
United States
Bryant Baker, 1881-1970
Bronze, 55.8 cm. (22 in.), 1917
NPG.66.34
Gift of the artist

Wilson, Thomas Woodrow,
1856-1924
Twenty-eighth President of the
United States
Keystone View Company, active
1892-1970
Photograph, gelatin silver print, 7.9
x 15.2 cm. (3⅛ x 6 in.), c. 1913
NPG.80.85

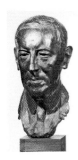

Wilson, Thomas Woodrow,
1856-1924
Twenty-eighth President of the
United States
Timothy Cole, 1852-1931, after
Stephen Seymour Thomas
Wood engraving, 25.6 x 18.5 cm.
(10¹⁄₁₆ x 7¼ in.), 1915
NPG.81.114

Wilson, Thomas Woodrow,
1856-1924
Twenty-eighth President of the
United States
Helen Warner Johns Kirtland, ?-?, or
Lucien Swift Kirtland, 1881-1965
Photograph, gelatin silver print, 12.1
x 9.5 cm. (4¾ x 3¾ in.), 1919
NPG.80.289

Wilson, Thomas Woodrow,
1856-1924
Twenty-eighth President of the
United States
Jo Davidson, 1883-1952
Bronze, 38.1 cm. (15 in.), c. 1918
NPG.77.323
Gift of Dr. Maury Leibovitz

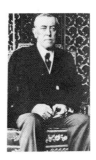

Wilson, Thomas Woodrow,
1856-1924
Twenty-eighth President of the
United States
Helen Warner Johns Kirtland, ?-?, or
Lucien Swift Kirtland, 1881-1965
Photograph, gelatin silver print, 8.1
x 5 cm. (3³⁄₁₆ x 2 in.), 1919
NPG.80.290

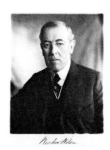

Wilson, Thomas Woodrow,
1856-1924
Twenty-eighth President of the
United States
Harris and Ewing studio, active
1905-1977
Photograph, gelatin silver print, 23.5
x 18.5 cm. (9⁵⁄₁₆ x 7⁵⁄₁₆ in.), c. 1912
NPG.84.256
Gift of Aileen Conkey

Wilson, Thomas Woodrow,
1856-1924
Twenty-eighth President of the
United States
Leo Mielziner, 1869-1935
Lithograph, 31 x 23.7 cm. (12³⁄₁₆ x
19⁵⁄₁₆ in.), c. 1918
NPG.84.4

Wilson, Thomas Woodrow,
1856-1924
Twenty-eighth President of the
United States
John Christen Johansen, 1876-1964
Oil on canvas, 76.5 x 63.2 cm. (30⅛ x
24⅞ in.), c. 1919
NPG.65.84
*Transfer from the National Museum
of American Art; gift of an
anonymous donor through Mrs.
Elizabeth C. Rogerson, 1926*

Wilson, Thomas Woodrow,
1856-1924
Twenty-eighth President of the
United States
Leo Mielziner, 1869-1935
The U.S. Printing and Lithography
Company
Lithographic poster, 70 x 50.9 cm.
(27 x 20 in.), 1918
NPG.84.226
*Gift of Mr. and Mrs. Leslie J.
Schreyer*

Wilson, Thomas Woodrow,
1856-1924
Twenty-eighth President of the
United States
Harriet Anderson Stubbs Murphy,
1852-1935
Oil on linen, 137.1 x 71.7 cm. (54 x
28¼ in.), 1919
NPG.76.110
Gift of Mrs. Harriet Murphy Ross

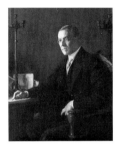

Wilson, Thomas Woodrow,
1856-1924
Twenty-eighth President of the
United States
Edmund Charles Tarbell, 1862-1938
Oil on canvas, 116.8 x 92.1 cm. (46 x
36¼ in.), 1921
NPG.65.42
*Transfer from the National Museum
of American Art; gift of the city of
New York through the National
Art Committee, 1923*

Wilson, Thomas Woodrow,
1856-1924
Twenty-eighth President of the
United States
Unidentified artist, after photograph
Halftone poster, 38.9 x 29.5 cm.
(15⁵⁄₁₆ x 11⅝ in.), 1910
NPG.77.110

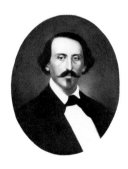

Wimar, Carl, 1828-1862
Artist
Self-portrait
Oil on canvas, 50.8 x 40.6 cm. (20 x
16 in.), not dated
NPG.67.61
Gift of Mr. and Mrs. Martin Kodner

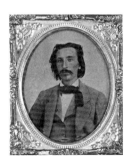

Wimar, Carl, 1828-1862
Artist
Unidentified photographer
Ambrotype, 8.6 x 6.7 cm. (3⅜ x 2⅝
in.), c. 1860
NPG.74.74
Gift of an anonymous donor

Winant, John Gilbert, 1889-1947
Diplomat
Sir James Gunn, 1893-1964
Oil on canvas, 142.2 x 111.7 cm.
(56 x 44 in.), 1947
NPG.72.27

Winnemucca, Sarah, c. 1844-1891
Indian leader
Norval H. Busey, 1845-?
Photograph, albumen silver print,
17.6 x 10.1 cm. (6¹⁵⁄₁₆ x 4 in.),
c. 1882
NPG.82.137

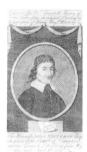

Winthrop, John, 1605/6-1676
Colonial statesman
Amos Doolittle, 1754-1832, after
unidentified artist
Etching and engraving, 16.6 x 9.2
cm. (6⁹⁄₁₆ x 3⅝ in.), 1797
Published in Benjamin Trumbull's *A
Complete History of Connecticut,*
Hartford, 1797
NPG.76.56

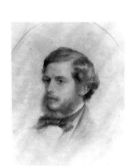

Winthrop, Theodore, 1828-1861
Author, Union soldier
Samuel Worcester Rowse, 1822-1901
Charcoal on paper, 62.2 x 48.9 cm.
(24½ x 19¼ in.), c. 1860
NPG.68.17
Gift of Winslow Ames

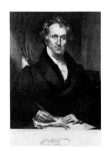

Wirt, William, 1772-1834
Lawyer
John H. Bufford, 1810-1870, after
Henry Inman
Pendleton lithography company
Lithograph, 29.1 x 23.3 cm. (11½ x
9³⁄₁₆ in.), c. 1831
NPG.77.112

Wirt, William, 1772-1834
Lawyer
James Barton Longacre, 1794-1869
Sepia watercolor on artist board, 27.6
 x 21.2 cm. (10⅞ x 8⅜ in.), 1833
NPG.77.282

Wirt, William, 1772-1834
Lawyer
Albert Newsam, 1809-1864, after
 Anson Dickinson
Childs and Inman lithography
 company
Lithograph, 19.5 x 16.5 cm. (7¾ x 6½
 in.), c. 1831-1833
NPG.79.202

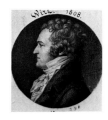

Wirt, William, 1772-1834
Lawyer
Charles Balthazar Julien Févret de
 Saint-Mémin, 1770-1852
Engraving, 5.6 cm. (2¼ in.) diameter,
 1807
NPG.74.39.581
Gift of Mr. and Mrs. Paul Mellon

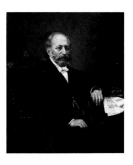

Wise, Isaac Mayer, 1819-1900
Clergyman
Morris Goldstein, 1840-1906
Oil on canvas, 107.3 x 92.1 cm.
 (42¼ x 36¼ in.), 1881
NPG.77.243
Gift of the Hebrew Union College

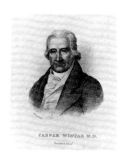

Wistar, Caspar, 1761-1818
Physician
Pendleton lithography company,
 active 1825-1836, after Bass Otis
Lithograph, 10.5 x 8.8 cm. (4⅛ x 3⁷⁄₁₆
 in.), 1828
Published in James Thacher's
 American Medical Biography,
 Boston, 1828
NPG.78.134

Witherspoon, John, 1723-1794
Clergyman, Revolutionary statesman
James Barton Longacre, 1794-1869,
 after Charles Willson Peale
Ink on paper, 21.9 x 16 cm. (8⅝ x
 6⁵⁄₁₆ in.), c. 1825
NPG.77.295

Wolfe, Thomas Clayton, 1900-1938
Author
Soss Melik, 1914-
Charcoal on paper, 63.5 x 48.2 cm.
 (25 x 19 in.), 1938
NPG.74.34

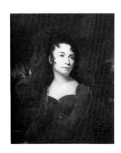

Wood, Juliana Westray, 1778-1838
Actress
Rembrandt Peale, 1778-1860
Oil on canvas, 76.2 x 63.5 cm. (30 x
 25 in.), 1810
NPG.81.120

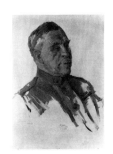

Wood, Leonard, 1860-1927
World War I general
Joseph Cummings Chase, 1878-1965
Oil on academy board, 62.2 x 47 cm.
 (24½ x 18½ in.), c. 1918
NPG.72.102
Gift of Mendel Peterson

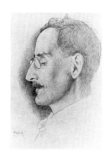

Wood, Leonard, 1860-1927
World War I general
Ernest Haskell, 1876-1925
Silverpoint on paper, 17.3 x 12.5 cm.
 (6¹³⁄₁₆ x 4¹⁵⁄₁₆ in.), 1915
NPG.73.16
Gift of Ernest Haskell, Jr.

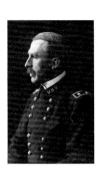

Wood, Leonard, 1860-1927
World War I general
Frances Benjamin Johnston,
 1864-1952
Photograph, gelatin silver print, 21.5
 x 13.6 cm. (8⁷/₁₆ x 5⅜ in.), 1899
NPG.77.348

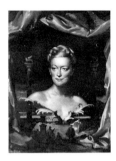

Wood, Peggy*, 1892-1978
Actress
Richard Kitchin, 1913-
Oil on canvas, 101.6 x 76.2 cm. (40 x
 30 in.), c. 1940
T/NPG.79.22.88
Bequest of Margaret Wood Walling

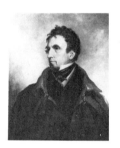

Wood, William Burke, 1779-1861
Actor
Unidentified artist
Oil on canvas, 76.2 x 63.5 cm. (30 x
 25 in.), not dated
NPG.82.109

Woodbury, Charles Herbert,
 1864-1940
Artist
John Singer Sargent, 1856-1925
Oil on canvas, 71.4 x 41.8 cm. (28⅛ x
 16½ in.), 1921
NPG.77.244
*Gift of Mr. and Mrs. David O.
 Woodbury*

Woodbury, Levi, 1789-1851
Justice of the United States Supreme
 Court, statesman
Charles Fenderich, 1805-1887
Lehman and Duval lithography
 company
Lithograph, 28 x 28.2 cm. (11 x 11⅛
 in.), 1837
NPG.66.96
*Transfer from the Library of
 Congress, Prints and Photographs
 Division*

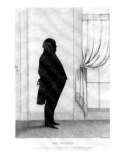

Woodbury, Levi, 1789-1851
Justice of the United States Supreme
 Court, statesman
E. B. and E. C. Kellogg lithography
 company, active c. 1842-1867, after
 William Henry Brown
Lithographed silhouette, 34.2 x 25.4
 cm. (13⁷/₁₆ x 10 in.), 1844
Published in William H. Brown's
 *Portrait Gallery of Distinguished
 American Citizens*, Hartford, 1845
NPG.79.191

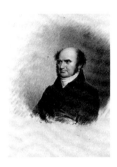

Woodbury, Levi, 1789-1851
Justice of the United States Supreme
 Court, statesman
James Barton Longacre, 1794-1869
Sepia watercolor on artist board, 26.2
 x 20.5 cm. (10⁵/₁₆ x 8¹/₁₆ in.), 1833
NPG.77.283

Woodbury, Levi, 1789-1851
Justice of the United States Supreme
 Court, statesman
Unidentified artist
Plaster, 54.9 cm. (21⅝ in.), not dated
NPG.70.35
*Transfer from the National Museum
 of American Art; gift of the
 National Institute, 1862*

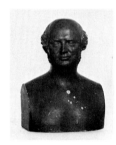

Woodbury, Levi, 1789-1851
Justice of the United States Supreme
 Court, statesman
Unidentified artist, after
 daguerreotype by John Plumbe, Jr.
Hand-colored lithograph, 33 x 26 cm.
 (13 x 10¼ in.), 1846
Contained in *The National
 Plumbeotype Gallery,*
 Philadelphia, 1847
NPG.78.84.k

Woodhouse, Samuel Washington,
 1821-1904
Naturalist
Edward Bowers, 1822-1870
Oil on canvas, 61 x 50.8 cm. (24 x 20
 in.), 1857
NPG.72.28

Woodhull, Victoria Claflin,
 1838-1927
Reformer
Thomas Nast, 1840-1902
Wood engraving, 34.6 x 23.2 cm.
 (13⅝ x 9⅛ in.), 1872
Published in *Harper's Weekly*, New
 York, February 17, 1872
NPG.78.93

Wool, John Ellis, 1784-1869
General
Alonzo Chappel, 1828-1887
Oil on canvas, 59 x 44.4 cm. (23¼ x
 17½ in.), c. 1858
NPG.83.159

Wool, John Ellis, 1784-1869
General
Charles DeForest Fredricks,
 1823-1894
Photograph, albumen silver print,
 9.1 x 5.4 cm. (3⁹⁄₁₆ x 2⅛ in.), c. 1862
NPG.80.329

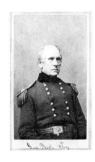

Woollcott, Alexander Humphreys,
 1887-1943
Author, critic
Alfred Bendiner, 1899-1964
Pencil and opaque white on board,
 34.6 x 25.9 cm. (13⅝ x 10³⁄₁₆ in.),
 1941
Illustration for *The Evening
 Bulletin*, Philadelphia, March 11,
 1941
NPG.85.191

Woollcott, Alexander Humphreys,
 1887-1943
Author, critic
Soss Melik, 1914-
Charcoal on paper, 49.5 x 45.7 cm.
 (19½ x 18 in.), 1938
NPG.68.21

Woollcott, Alexander Humphreys,
 1887-1943
Author, critic
Soss Melik, 1914-
Oil on canvas, 86.9 x 61 cm. (34¼ x
 24 in.), 1938
NPG.68.35

Woollcott, Alexander Humphreys,
 1887-1943
Author, critic
Unidentified photographer
Photograph, gelatin silver print, 33.5
 x 26.1 cm. (13³⁄₁₆ x 10¼ in.), c. 1940
NPG.83.203

Worden, John Lorimer, 1818-1897
Union naval officer
Mathew Brady, 1823-1896
Photograph, albumen silver print, 8
 x 15 cm. (3⅛ x 5⅞ in.), c. 1890
 from c. 1864 negative
NPG.77.205

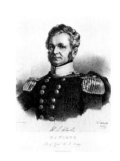

Worth, William Jenkins, 1794-1849
Mexican-American War general
Charles Fenderich, 1805-1887
Edward D. Weber lithography
 company
Lithograph, 25.2 x 26.3 cm. (9¹⁵⁄₁₆ x
 10⅜ in.), 1844
NPG.66.99
*Transfer from the Library of
 Congress, Prints and Photographs
 Division*

Wright, Frances, 1795-1852
Reformer
Nagel and Weingaertner lithography
 company, active 1849-1857, after
 Johan Görbitz
Lithograph, 40 x 34.1 cm. (15¾ x
 13⁷⁄₁₆ in.), c. 1852
NPG.77.217

Wright, Frank Lloyd, 1869-1959
Architect
Berenice Abbott, 1898-
Photograph, gelatin silver print, 24.3
 x 19.4 cm. (9⁹⁄₁₆ x 7⅝ in.), c. 1950
NPG.76.99

Wright, Patience, 1725-1786
Artist
Unidentified artist
Engraving, 12.6 x 9.3 cm. (4¹⁵⁄₁₆ x 3⅝
 in.), 1775
Published in *The London Magazine*,
 December 1, 1775
NPG.78.261

Wright, Frank Lloyd, 1869-1959
Architect
Alfred Bendiner, 1899-1964
Crayon on paper, 38.5 x 25.7 cm.
 (15³⁄₁₆ x 10⅛ in.), 1958
Illustration for *Harper's Magazine*,
 New York, May 1958
NPG.85.192

Wright, Richard, 1908-1960
Author
Miriam Troop, 1917-
Pencil on paper, 27.6 x 35.2 cm. (10⅞
 x 13⅞ in.), 1949
NPG.72.50

Wright, Frank Lloyd, 1869-1959
Architect
Edward Steichen, 1879-1973
Photograph, gelatin silver print, 24.1
 x 19.3 cm. (9½ x 7⅝ in.), c. 1935
NPG.82.92
Bequest of Edward Steichen

Wright, Richard, 1908-1960
Author
Carl Van Vechten, 1880-1964
Photogravure, 22.4 x 15 cm. (8¹³⁄₁₆ x
 5¹⁵⁄₁₆ in.), 1983 from 1939 negative
NPG.83.188.50

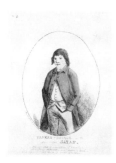

Wright, Joseph, 1756-1793
Artist
Self-portrait
Colored etching, 12.3 x 9.4 cm. (4¹³⁄₁₆
 x 3¹¹⁄₁₆ in.), c. 1780
NPG.82.121

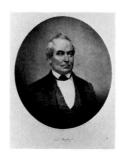

Wright, Silas, 1795-1847
Statesman
Francis D'Avignon, c. 1814-?, after
 daguerreotype by Mathew Brady
Lithograph, 33.9 x 25.2 cm. (13⅜ x
 10⁵⁄₁₆ in.), 1850
Published in Mathew Brady's
 Gallery of Illustrious Americans,
 New York, 1850
NPG.72.71

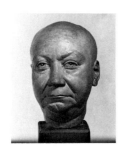

Wright, Louis Tompkins, 1891-1952
Physician
William Ellisworth Artis, 1914-1977?
Terra-cotta, 25.4 cm. (10 in.), 1946
NPG.67.13
Gift of the Harmon Foundation

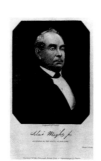

Wright, Silas, 1795-1847
Statesman
Thomas Doney, active 1844-1852,
 after daguerreotype by John
 Plumbe, Jr.
Mezzotint, 12.1 x 9.3 cm. (4¾ x 3⅝
 in.), 1846
Published in *United States
 Magazine and Democratic
 Review*, Washington, D.C., 1846
NPG.78.140

Wright, Silas, 1795-1847
Statesman
E. B. and E. C. Kellogg lithography
 company, active c. 1842-1867, after
 William Henry Brown
Lithographed silhouette, 34.1 x 25
 cm. (13⁷/₁₆ x 9⅞ in.), 1844
Published in William H. Brown's
 *Portrait Gallery of Distinguished
 American Citizens,* Hartford, 1845
NPG.70.2
Gift of Mrs. Dean Acheson

Wright, Wilbur, 1867-1912
Pioneer aviator
Leo Mielziner, 1869-1935
Lithograph, 18.4 x 12.3 cm. (7¼ x
 4¹³/₁₆ in.), 1932 after 1908 drawing
NPG.82.37

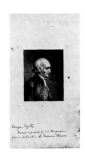

Wythe, George, 1726-1806
Revolutionary statesman
James Barton Longacre, 1794-1869,
 after unidentified artist
Ink on paper, 25.2 x 13.8 cm. (9¹⁵/₁₆ x
 5⁷/₁₆ in.), c. 1825
NPG.77.294

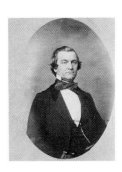

Yancey, William Lowndes, 1814-1863
Statesman
Unidentified photographer
Photograph, salt print, 18.4 x 13.3
 cm. (7¼ x 5¼ in.), c. 1858
NPG.80.165

Yeager, Charles Elwood ("Chuck")*,
 1923-
Pilot
Peter Strongwater, 1941-
Photograph, gelatin silver print, 34.9
 x 34.9 cm. (13¾ x 13¾ in.), 1982
T/NPG.84.170
Gift of Christopher Murray

Yerkes, Charles Tyson, 1837-1905
Financier
Jan Van Beers, 1852-1927
Oil on panel, 24.7 x 29.8 cm. (9¾ x
 11¾ in.), not dated
NPG.76.28
Gift of Mrs. Jay Besson Rudolphy

Young, Brigham, 1801-1877
Religious leader
Hartwig Bornemann, ?-?
Britton and Rey lithography
 company
Lithograph, 58.5 x 50.5 cm. (23 x 19⅞
 in.), c. 1870
NPG.67.57
*Gift of the Church of Jesus Christ of
 Latter-Day Saints*

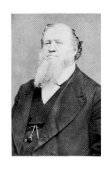

Young, Brigham, 1801-1877
Religious leader
Charles William Carter, 1832-1918
Photograph, albumen silver print,
 15.6 x 10.3 cm. (6⅛ x 4¹/₁₆ in.),
 c. 1865
NPG.80.284

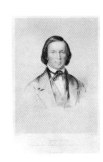

Young, Brigham, 1801-1877
Religious leader
W. H. Gibbs, ?-?, after Frederick
 Hawkins Piercy
Engraving, 22.4 x 16.5 cm. (8¹³/₁₆ x
 6½ in.), 1855
Published in Frederick H. Piercy's
 *Route from Liverpool to Great Salt
 Lake Valley,* Liverpool, 1855
NPG.80.279

Young, Brigham, 1801-1877
Religious leader
Augustin Fraǹcois Lemaître,
 1797-1870, after daguerreotype
Engraving, 15.5 x 8.2 cm. (6⅛ x 3¼
 in.), c. 1855
NPG.78.47

Young, Brigham, 1801-1877
Religious leader
Charles R. Savage, 1832-1909
Photograph, albumen silver print,
 15.8 x 10.4 cm. (6¼ x 4⅛ in.),
 c. 1875
NPG.76.100

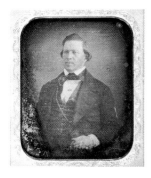

Young, Brigham, 1801-1877
Religious leader
Unidentified photographer, after
 c. 1850 daguerreotype attributed to
 Marsena Cannon
Daguerreotype, 7.7 x 6.9 cm. (3¹⁄₁₆ x
 2¹¹⁄₁₆ in.), c. 1850
NPG.81.75
Gift of the J. Willard Marriott, Jr.,
 Charitable Annuity Trust

Young, Lester, 1909-1959
Entertainer
Alfred Bendiner, 1899-1964
Crayon on paper, 23.1 x 32 cm. (9⅛ x
 12⅝ in.), c. 1945
NPG.85.199
Gift of Alfred Bendiner Foundation

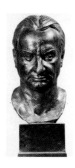

Ziegfeld, Florenz, 1869-1932
Theatrical producer
Cesare Stea, 1893-1959
Bronze, 38.3 cm. (15⅛ in.), not dated
NPG.66.44
Gift of Mrs. A. Sandor Ince

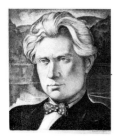

Zigrosser, Carl, 1891-1975
Curator
Mabel Dwight, 1876-1955
Lithograph, 33.5 x 28.9 cm. (13³⁄₁₆ x
 11⅜ in.), 1930
NPG.85.133

Zimbalist, Efrem*, 1889-1985
Musician
Alfred Bendiner, 1899-1964
India ink over pencil on paper, 33.5
 x 25.6 cm. (13³⁄₁₆ x 10¹⁄₁₆ in.), 1944
Illustration for *The Evening*
 Bulletin, Philadelphia, March 11,
 1944
T/NPG.84.53.95
Gift of Alfred Bendiner Foundation

Zimbalist, Efrem*, 1889-1985
Musician
Aline Fruhauf, 1907-1978
Black ink over red chalk on pale blue
 paper, 33.1 x 20.2 cm. (13 x 7¹⁵⁄₁₆
 in.), 1932
Published in *Musical America*, New
 York, April 25, 1932
T/NPG.83.46.95
Gift of Erwin Vollmer

Zorach, William, 1887-1966
Artist
Robert Disraeli, 1905-
Photograph, gelatin silver print, 21.5
 x 17.4 cm. (8⁷⁄₁₆ x 6¹³⁄₁₆ in.), c. 1936
NPG.83.125

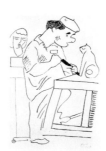

Zorach, William, 1887-1966
Artist
Aline Fruhauf, 1907-1978
India ink over pencil with opaque
 white and touches of pink on
 paper, 31.8 x 25 cm. (12½ x 9¹³⁄₁₆
 in.), c. 1936
NPG.83.47
Gift of Erwin Vollmer

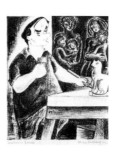

Zorach, William, 1887-1966
Artist
Aline Fruhauf, 1907-1978
Lithograph, 21.6 x 18 cm. (8½ x 7¹⁄₁₆
 in.), 1936
NPG.83.48
Gift of Erwin Vollmer

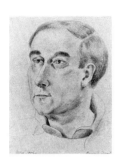

Zorach, William, 1887-1966
Artist
Marguerite Zorach, 1888-1968
Pencil on rice paper, 41.3 x 31.7 cm.
 (16¼ x 12½ in.), 1966
NPG.75.29
Gift of the Halpert Foundation in
 memory of Edith Gregor Halpert

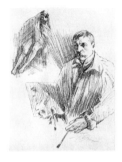

Zorn, Anders Leonard, 1860-1920
Artist
Self-portrait
Pencil on paper, 27.6 x 21.8 cm. (10⅞
 x 8⁹⁄₁₆ in.), c. 1896
NPG.84.174

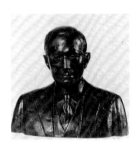

Zukor, Adolph, 1873-1976
Producer
Jo Davidson, 1883-1952
Bronze, 43.2 cm. (17 in.), 1925
NPG.78.197
Gift of Dr. Maury Leibovitz

PORTRAITS OF GROUPS

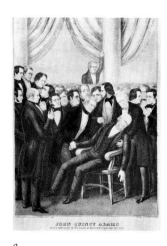

a

b

c

d

e

a **John Quincy Adams Seized with a
 Fit in the House of Representatives
 Feb 21st 1848**
 Adams, John Quincy, 1767-1848
 (seated, center right)
 Kelloggs and Comstock lithography
 company, active 1848-1850
 Hand-colored lithograph, 30.2 x 21.8
 cm. (11⅞ x 8⁹⁄₁₆ in.), c. 1848
 NPG.81.41

b **Muhammad Ali-Oscar Bonavena
 Press Conference***
 Ali, Muhammad (Cassius
 Marcellus Clay, Jr.), 1942-
 (left)
 Garry Winogrand, 1928-1984
 Photograph, gelatin silver print, 31.4
 x 47 cm. (12⅜ x 18½ in.), 1970
 T/NPG.84.27

c **Muhammad Ali and Joe Frazier***
 Ali, Muhammad (Cassius
 Marcellus Clay, Jr.), 1942-
 (top)
 Frazier, Joe, 1944- (bottom)
 LeRoy Neiman, 1926-
 Color halftone, 55.9 x 35.6 cm. (22 x
 14 in.), 1975
 T/NPG.83.34

d **The American Delegation to the
 Paris Peace Conference**
 (seated, left to right)
 House, Edward Mandell,
 1858-1938
 Lansing, Robert, 1864-1928
 Wilson, Thomas Woodrow,
 1856-1924
 White, Henry, 1850-1927
 Bliss, Tasker Howard, 1853-1930
 Helen Warner Johns Kirtland, ?-?, or
 Lucien Swift Kirtland, 1881-1965

Photograph, gelatin silver print, 9.5
 x 12.2 cm. (3¾ x 4¹³⁄₁₆ in.), 1919
NPG.80.288

e **American Prohibitionists**
 (clockwise from top)
 Dow, Neal, 1804-1897
 Cocke, John Hartwell, 1780-1886
 McHenry, M. D., ?-?
 Cary, Samuel Fenton, 1814-1900
 Tilley, Samuel Leonard, 1818-?
 O'Neall, John Belton, 1793-1863
 Delavan, Edward Cornelius,
 1793-1871 (center)
 Leopold Grozelier, 1830-1865, after
 photographs
 J. H. Bufford lithography company
 Lithograph with tintstone, 42.8 x
 36.7 cm. (16¹³⁄₁₆ x 13¹⁵⁄₁₆ in.), 1858
 NPG.80.280

f

g

h

i

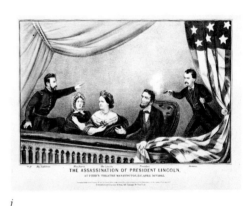

j

f **American Royalty in the House of
 Commons**
Longworth, Nicholas, 1869-1931
 (left)
Reid, Whitelaw, 1837-1912 (right)
Edward Tennyson Reed, ?-?
Pencil on paper, 14 x 16.5 cm. (5½ x
 6½ in.), not dated
NPG.84.7

g **Apache Chiefs**
(left to right)
Chihuahua, ?-1901
Naiche ("Natchez"), c. 1858-1921
Loco, ?-1905
Nana, c. 1810-1896
Goyathlay ("Geronimo"),
 1829-1909
G. B. Johnson, ?-?
Photograph, albumen silver print,
 11.8 x 19 cm. (4⅝ x 7½ in.), 1893
NPG.80.244

h **Apollo 11 Crew***
Armstrong, Neil Alden, 1930-
 (top)
Collins, Michael, 1930- (left)
Aldrin, Edwin ("Buzz"), 1930-
 (right)
Ronald B. Anderson, 1929-
Oil on prepared board, 101.6 x 81.3
 cm. (40 x 32 in.), 1969
T/NPG.70.36
*Gift of Mr. and Mrs. William D.
 Blakemore, Midland, Texas; Mr.
 and Mrs. Omar Harvey, Dallas,
 Texas; Mr. and Mrs. R. K. Keitz,
 Dallas, Texas; Col. and Mrs.
 Thomas A. P. Krock, Dallas,
 Texas; Mr. and Mrs. W. R. Lloyd,
 Jr., Houston, Texas; Dr. and Mrs.
 J. R. Maxfield, Dallas, Texas; Mr.
 and Mrs. Wesley Nagorny, Jr.,
 Houston, Texas; Dr. and Mrs. H.
 B. Renfrow, Dallas, Texas; Mr.
 and Mrs. J. W. Taylor, Dallas,
 Texas; Dr. and Mrs. J. Robert
 Terry, Miami, Florida; Mr. and*

*Mrs. Thomas B. Young, Dallas,
Texas; anonymous donor*

i **Assassination of President Lincoln**
Booth, John Wilkes, 1838-1865
 (left)
Lincoln, Abraham, 1809-1865
 (right)
Joseph Edward Baker, 1835-1914
Hand-colored lithograph, 24.6 x 35.7
 cm. (9¹¹⁄₁₆ x 12¹⁄₁₆ in.), c. 1865
NPG.83.232

j **The Assassination of President
 Lincoln**
Lincoln, Abraham, 1809-1865
 (seated, right)
Booth, John Wilkes, 1838-1865
 (standing, right)
Currier and Ives lithography
 company, active 1857-1907
Hand-colored lithograph, 20.1 x 30.9
 cm. (7¹⁵⁄₁₆ x 12⅛ in.), 1865
NPG.82.50

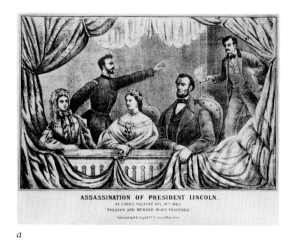

a

b

c

a **Assassination of President Lincoln**
 (seated, left to right)
 Harris, Clara, ?-?
 Lincoln, Mary Todd, 1818-1882
 Lincoln, Abraham, 1809-1865
 (standing, left to right)
 Rathbone, Henry Reed, 1837-1911
 Booth, John Wilkes, 1838-1865
Unidentified artist
Lithograph, 20 x 31 cm. (7⅞ x 12³⁄₁₆
 in.), c. 1865
NPG.83.231

b **Authors' Group**
 (seated, left to right)
 Whittier, John Greenleaf,
 1807-1892
 Emerson, Ralph Waldo, 1803-1882
 Motley, John Lothrop, 1814-1877
 Hawthorne, Nathaniel, 1804-1864
 Longfellow, Henry Wadsworth,
 1807-1882
 (standing, left to right)
 Holmes, Oliver Wendell,
 1809-1894
 Alcott, Amos Bronson, 1799-1888
 Lowell, James Russell, 1819-1891
 Agassiz, Jean Louis Rodolphe,
 1807-1873
Eugene L'Africain, 1859-1892, after
 photographs by Notman
 Photographic Company
Collotype, 55.2 x 43.9 cm. (21¹¹⁄₁₆ x
 17¼ in.), 1883
NPG.85.162

c **Authors of the United States**
 (seated, left to right)
 Longfellow, Henry Wadsworth,
 1807-1882
 Bryant, William Cullen,
 1794-1878
 Irving, Washington, 1783-1859
 Channing, William Ellery,
 1780-1842
 Stowe, Harriet Elizabeth Beecher,
 1811-1896
 Whittier, John Greenleaf,
 1807-1892
 (standing, left to right)
 Kennedy, John Pendleton,
 1795-1870
 Holmes, Oliver Wendell,
 1809-1894
 Poe, Edgar Allan, 1809-1849
 Hawthorne, Nathaniel, 1804-1864
 Cooper, James Fenimore,
 1789-1851

d

e

f

g

Prescott, William Hickling,
 1796-1859
Bancroft, George, 1800-1891
Motley, John Lothrop, 1814-1877
Beecher, Henry Ward, 1813-1887
Curtis, George William, 1824-1892
Emerson, Ralph Waldo, 1803-1882
Lowell, James Russell, 1819-1891
Taylor, Bayard, 1825-1878
Alexander Hay Ritchie, 1822-1895,
 after Thomas Hicks
Engraving, 49.2 x 86.9 cm. (19⅜ x
 34³⁄₁₆ in.), 1866
NPG.76.90

d **Phineas Taylor Barnum and James
 Anthony Bailey**
 Barnum, Phineas Taylor,
 1810-1891 (top)
 Bailey, James Anthony, 1847-1906
 (bottom)
 Strobridge lithography company,
 active 1867-1960, after unidentified
 artist
 Chromolithographic poster,
 Barnum: 24.5 x 19 cm. (9⅝ x 7½
 in.); Bailey: 25 x 18.2 cm. (9⅞ x
 7³⁄₁₆ in.), c. 1881-1891
 NPG.77.115

e **Phineas Taylor Barnum and Family**
 Barnum, Phineas Taylor,
 1810-1891 (seated, center)
 Unidentified photographer
 Photograph, albumen silver print,
 40.5 x 100.1 cm. (15¹⁵⁄₁₆ x 39⅜ in.),
 c. 1865
 NPG.76.67

f **P. T. Barnum and Commodore Nutt**
 Barnum, Phineas Taylor,
 1810-1891 (left)
 Nutt, George Washington
 Morrison ("Commodore"),
 1844-1881 (right)
 A. A. Turner, ?-?
 Photograph, albumen silver print,
 8.2 x 5.6 cm. (3⅜ x 2³⁄₁₆ in.), 1862
 NPG.80.160

g **The Battle at Bunker's Hill, near
 Boston**
 Warren, Joseph, 1741-1775 (left of
 center)
 Johann Gotthard Von Müller,
 1747-1830, after John Trumbull
 Engraving, 50.9 x 76.2 cm. (20 x 30
 in.), 1788-1797
 NPG.82.35

a

b

d

c

e

a **The Battle of Bunker's Hill, or the**
 Death of General Warren
 Warren, Joseph, 1741-1775 (center
 left)
 John Norman, c. 1748-1817, after
 John Trumbull
 Engraving, 49 x 74.1 cm. (19¼ x 29³⁄₁₆
 in.), c. 1833
 NPG.82.32

b **Battle of New Orleans**
 Jackson, Andrew, 1767-1845
 (bottom center)
 Joseph Yeager, c. 1792-1859, after
 Benjamin West
 Engraving, 38.9 x 49.6 cm. (13¼ x
 19⁹⁄₁₆ in.), 1817
 NPG.82.28

c **Jessie Tarbox Beals and Her**
 Assistant, "Pumpkin"
 Beals, Jessie Tarbox, 1870-1942
 Self-portrait
 Photograph, gelatin silver print, 19.2
 x 14.5 cm. (7⁹⁄₁₆ x 5¾ in.), 1904
 NPG.81.137
 Gift of Joanna Sturm

d **August Belmont and Isabel Perry**
 Belmont, August, 1816-1890
 Wouterus Verschuur, 1812-1874
 Oil on canvas, 90.8 x 123.4 cm.
 (35¾ x 48⅝ in.), 1854
 NPG.80.138
 Gift of Paul Mellon

e **Bishops of the Methodist Episcopal**
 Church
 Simpson, Matthew, 1811-1884
 (top center)
 Alexander Hay Ritchie, 1822-1895,
 after photographs
 Engraving, 38.4 x 30 cm. (15⅛ x
 11¹³⁄₁₆ in.), 1873
 NPG.83.130
 Gift of John O'Brien

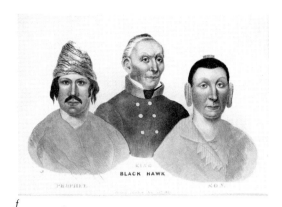

f

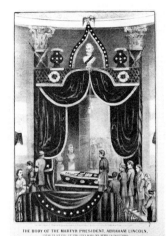

g

h

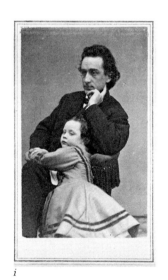

i

j

f **Black Hawk, Prophet, and Son**
 (left to right)
 Wabokieshiek ("White Cloud"
 and "The Prophet"), c. 1794-c.
 1841
 Makataimeshekiakiak ("Black
 Hawk"), 1767-1838
 Nasheakusk ("Whirling
 Thunder"), c. 1800-?
Unidentified artist
Hand-colored lithograph, 25.9 x 41.3
 cm. (10³⁄₁₆ x 16¼ in.), 1833
NPG.81.148

g **The Body of the Martyr President,
 Abraham Lincoln**
 Lincoln, Abraham, 1809-1865
Currier and Ives lithography
 company, active 1857-1907
Lithograph, 30.7 x 21.1 cm. (12¹⁄₁₆ x
 8⁵⁄₁₆ in.), 1865
NPG.83.234

h **The Booth Brothers in "Julius
 Caesar"**
 (left to right)
 Booth, John Wilkes, 1838-1865
 Booth, Edwin Thomas, 1833-1893
 Booth, Junius Brutus, Jr.,
 1821-1883
Jeremiah Gurney, active 1840-c. 1890
Photograph, albumen silver print,
 19.9 x 14.3 cm. (7¹³⁄₁₆ x 5⅝ in.),
 1864
NPG.80.163

i **Edwin Booth and His Daughter,
 Edwina**
 Booth, Edwin Thomas, 1833-1893
Mathew Brady, 1823-1896
Photograph, albumen silver print,
 8.7 x 5.3 cm. (3⅜ x 2⅛ in.), 1866
NPG.80.158

j **Mathew Brady with Juliette Handy
 Brady and Mrs. Haggerty**
 Brady, Mathew, 1823-1896
Mathew Brady studio, active
 1844-1883
Daguerreotype, 10.7 x 8.3 cm. (4¼ x
 3¼ in.), c. 1850
NPG.85.78

a

b

c

d

e

a **Laura Dewey Bridgman Hand Alphabet Broadside**
Bridgman, Laura Dewey, 1829-1889 (right)
Unidentified artist
Wood engraving, 38.5 x 50 cm. (15⅛ x 19¹¹⁄₁₆ in.), c. 1857
NPG.82.42

b **John Brown Brought Out for Execution**
Brown, John, 1800-1859
A. Berghaus, ?-?
Pencil on paper, 24.1 x 35.2 cm. (9½ x 13⅞ in.), 1859
NPG.73.2

c **William Cullen Bryant and Peter Cooper**
Bryant, William Cullen, 1794-1878 (left)
Cooper, Peter, 1791-1883 (right)
Attributed to Napoleon Sarony, 1821-1896
Photograph, albumen silver print, 10 x 14 cm. (3¹⁵⁄₁₆ x 5½ in.), c. 1875
NPG.80.162

d **Florence and Remo Bufano with Walter Damrosch #7**
Bufano, Remo, 1894-1948 (left)
Bufano, Florence, 1897/98-1954 (right)
Prentiss Taylor, 1907-
Photograph, gelatin silver print, 15.7 x 11.1 cm. (6³⁄₁₆ x 4⅜ in.), 1932
NPG.84.235
Gift of the artist

e **Ambrose Burnside and the First Rhode Island Militia at Camp Sprague**
Burnside, Ambrose Everett, 1824-1881 (standing, center)
Unidentified photographer
Photograph, albumen silver print, 27.8 x 37 cm. (10¹⁵⁄₁₆ x 14⁹⁄₁₆ in.), 1861
NPG.78.63

f

g

h

i

j

f **John Burroughs with Grandchildren**
　Burroughs, John, 1837-1921
　Alice Boughton, 1865/66-1943
　Photograph, platinum print, 16.3 x
　　21.3 cm. (6⅜ x 8⅜ in.), c. 1910
　NPG.77.47

g **The Busy Life of a President**
　Garfield, James Abram, 1831-1881
　Unidentified artist
　Wood engraving, 35.2 x 53.4 cm.
　　(13¹³⁄₁₆ x 21 in.), 1880
　Published in *Frank Leslie's
　　Illustrated Newspaper*, New York,
　　December 18, 1880
　NPG.85.160

h **Benjamin Franklin Butler: Battle at
　Great Bethel**
　Butler, Benjamin Franklin,
　　1818-1893
　Adalbert John Volck ("V. Blada"),
　　1828-1912
　Etching, 8.1 x 11.8 cm. (3⅜ x 4⅝ in.),
　　1868
　Published in Pasquino's [J. Fairfax
　　McLaughlin] *The American
　　Cyclops*, Baltimore, 1868
　NPG.80.128.e

i **Benjamin Franklin Butler: Gen. B.
　Capturing Big Bethel**
　Butler, Benjamin Franklin,
　　1818-1893
　Adalbert John Volck ("V. Blada"),
　　1828-1912
　Lithograph, 13.6 x 19 cm. (5⅜ x 7⁷⁄₁₆
　　in.), c. 1862

Published in portfolio entitled *Life
　and Adventures of B. F. B. . . .* ,
　Baltimore, 1862
NPG.79.60

j **Benjamin Franklin Butler:
　Bombastes captures Fort Fisher by
　means of a Patent Volcano**
　Butler, Benjamin Franklin,
　　1818-1893
　Adalbert John Volck ("V. Blada"),
　　1828-1912
　Etching, 7.4 x 10.8 cm. (2⅞ x 4¼ in.),
　　1868
　Published in Pasquino's [J. Fairfax
　　McLaughlin] *The American
　　Cyclops*, Baltimore, 1868
　NPG.80.128.k

a

b

c

d

a **Benjamin Franklin Butler: Bombastes, conqueror of New Orleans**
Butler, Benjamin Franklin, 1818-1893
Adalbert John Volck ("V. Blada"), 1828-1912
Etching, 6.6 x 11 cm. (2⅝ x 4⁵⁄₁₆ in.), 1868
Published in Pasquino's [J. Fairfax McLaughlin] *The American Cyclops*, Baltimore, 1868
NPG.80.128.i

b **Benjamin Franklin Butler: Bombastes encountering ye bricklayer**
Butler, Benjamin Franklin, 1818-1893
Adalbert John Volck ("V. Blada"), 1828-1912

Etching, 10.2 x 7 cm. (4 x 2¾ in.), 1868
Published in Pasquino's [J. Fairfax McLaughlin] *The American Cyclops*, Baltimore, 1868
NPG.80.128.j

c **Benjamin Franklin Butler: Bombastes at the Mass: military Academy**
Butler, Benjamin Franklin, 1818-1893
Adalbert John Volck ("V. Blada"), 1828-1912
Etching, 11.5 x 8.2 cm. (4½ x 3¼ in.), 1868
Published in Pasquino's [J. Fairfax McLaughlin] *The American Cyclops*, Baltimore, 1868
NPG.80.128.a

d **Benjamin Franklin Butler: Bombastes preparing for his crusade to New Orleans**
Butler, Benjamin Franklin, 1818-1893
Adalbert John Volck ("V. Blada"), 1828-1912
Etching, 10.2 x 6.5 cm. (4¹⁄₁₆ x 2⁹⁄₁₆ in.), 1868
Published in Pasquino's [J. Fairfax McLaughlin] *The American Cyclops*, Baltimore, 1868
NPG.80.128.b

e

f

" Leaves gallant Winthrop to his mournful fate,
But takes the field when hapiy 'tis too late."

g

h

"He blew a warlike trump,
And marched to conquest—conquest of a pump."

i

e **Benjamin Franklin Butler:
Bombastes reformeth ye churches**
Butler, Benjamin Franklin,
1818-1893
Adalbert John Volck ("V. Blada"),
1828-1912
Etching, 11.9 x 7.7 cm. (4¹¹⁄₁₆ x 3¹⁄₁₆
in.), 1868
Published in Pasquino's [J. Fairfax
McLaughlin] *The American
Cyclops*, Baltimore, 1868
NPG.80.128.h

f **Benjamin Franklin Butler: General
Bombastes as Ubiquitous after
Battle of Great Bethel**
Butler, Benjamin Franklin,
1818-1893
Adalbert John Volck ("V. Blada"),
1828-1912

Lithograph, 15.5 x 24.2 cm. (6⅛ x 9½
in.), c. 1862
Published in portfolio entitled *Life
and Adventures of B. F. B. . . .* ,
Baltimore, 1862
NPG.79.59

g **Benjamin Franklin Butler:
Bombastes is ubiquitus**
Butler, Benjamin Franklin,
1818-1893
Adalbert John Volck ("V. Blada"),
1828-1912
Etching, 7 x 10.8 cm. (2½ x 4¼ in.),
1868
Published in Pasquino's [J. Fairfax
McLaughlin] *The American
Cyclops*, Baltimore, 1868
NPG.80.128.f

h **Benjamin Franklin Butler: Ye
Conquest of Ye Pump**
Butler, Benjamin Franklin,
1818-1893

Adalbert John Volck ("V. Blada"),
1828-1912
Lithograph, 12 x 22 cm. (4¾ x 8⅝
in.), c. 1862
Published in portfolio entitled *Life
and Adventures of B. F. B. . . .* ,
Baltimore, 1862
NPG.79.63

i **Benjamin Franklin Butler: Conquest
of ye Pump**
Butler, Benjamin Franklin,
1818-1893
Adalbert John Volck ("V. Blada"),
1828-1912
Etching, 7.6 x 12 cm. (3 x 4¾ in.),
1868
Published in Pasquino's [J. Fairfax
McLaughlin] *The American
Cyclops*, Baltimore, 1868
NPG.80.128.d

a

b

c

e

d

a **Benjamin Franklin Butler: Home**
Butler, Benjamin Franklin,
1818-1893
Adalbert John Volck ("V. Blada"),
1828-1912
Etching, 11.3 x 7.3 cm. (4⁷⁄₁₆ x 2⅞
in.), 1868
Published in Pasquino's [J. Fairfax
McLaughlin] *The American
Cyclops*, Baltimore, 1868
NPG.80.128.1

b **Benjamin Franklin Butler: Ye Mass.
Military academy**
Butler, Benjamin Franklin,
1818-1893
Adalbert John Volck ("V. Blada"),
1828-1912
Lithograph, 13 x 18 cm. (5⅛ x 7 in.),
c. 1862

Published in portfolio entitled *Life
and Adventures of B. F. B. . . .* ,
Baltimore, 1862
NPG.79.62

c **Benjamin Franklin Butler:
Occupation of Ye Wicked City of
Baltimore**
Butler, Benjamin Franklin,
1818-1893
Adalbert John Volck ("V. Blada"),
1828-1912
Lithograph, 13.5 x 22 cm. (5⁵⁄₁₆ x 8⅝
in.), c. 1862
Published in portfolio entitled *Life
and Adventures of B. F. B. . . .* ,
Baltimore, 1862
NPG.79.58

d **Benjamin Franklin Butler:
Occupation of ye wicked city of
Baltimore**
Butler, Benjamin Franklin,
1818-1893

Adalbert John Volck ("V. Blada"),
1828-1912
Etching, 7.9 x 11.4 cm. (3⅛ x 4½ in.),
1868
Published in Pasquino's [J. Fairfax
McLaughlin] *The American
Cyclops*, Baltimore, 1868
NPG.80.128.c

e **Benjamin Franklin Butler: Ye Vow**
Butler, Benjamin Franklin,
1818-1893
Adalbert John Volck ("V. Blada"),
1828-1912
Lithograph, 13.5 x 23 cm. (5⁵⁄₁₆ x 9¹⁄₁₆
in.), c. 1862
Published in portfolio entitled *Life
and Adventures of B. F. B. . . .* ,
Baltimore, 1862
NPG.79.61

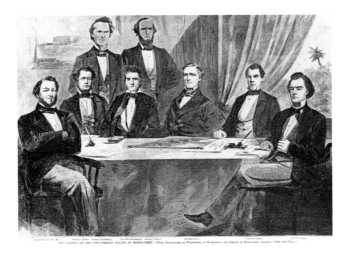

f

g

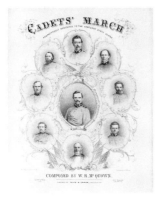

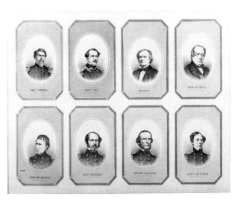

h

i

f **Benjamin Franklin Butler: Ye Vow**
Butler, Benjamin Franklin,
1818-1893
Adalbert John Volck ("V. Blada"),
1828-1912
Etching, 10.9 x 7.6 cm. (4⁵⁄₁₆ x 3 in.),
1868
Published in Pasquino's [J. Fairfax
McLaughlin] *The American
Cyclops*, Baltimore, 1868
NPG.80.128.g

g **The Cabinet of the Confederate
States at Montgomery**
(seated, left to right)
Benjamin, Judah Philip, 1811-1884
Mallory, Stephen Russell, c.
1813-1873
Stephens, Alexander Hamilton,
1812-1883
Davis, Jefferson, 1808-1889
Reagan, John Henninger,
1818-1905

Toombs, Robert Augustus,
1810-1885
(standing, left to right)
Memminger, Christopher
Gustavus, 1803-1888
Walker, LeRoy Pope, 1817-1884
Unidentified artist, after Jesse H.
Whitehurst and Hinton
Wood engraving, 23.3 x 35.2 cm. (9⅛
x 23¹³⁄₁₆ in.), 1861
Published in *Harper's Weekly*, New
York, June 1, 1861
NPG.79.84

h **Cadets' March**
Buckner, Simon Bolivar,
1823-1914 (center)
Hart and Mapother lithography
company, active 1860s, after
photographs by G. H. Nickerson
Lithograph with tintstone, 26.9 x

23.7 cm. (10⁹⁄₁₆ x 9⁵⁄₁₆ in.), 1860
Music sheet title page: "Cadets'
March"
NPG.84.360

i **Card Portraits of Prominent
Characters: Louis Prang's Cartes
de Visite Sample Book**
Anderson, Robert, 1805-1871
Beauregard, Pierre Gustave
Toutant, 1818-1893
Blair, Francis Preston, 1821-1875
Brown, John, 1800-1859
Burnside, Ambrose Everett,
1824-1881
Butler, Benjamin Franklin,
1813-1893
Craven, Tunis Augustus
MacDonough, 1813-1864

a

b

Davis, Jefferson, 1808-1889
Dix, John Adams, 1798-1879
Douglas, Stephen Arnold,
 1813-1861
DuPont, Samuel Francis,
 1803-1865
Ericsson, John, 1803-1889
Foote, Andrew Hull, 1806-1863
Frémont, John Charles, 1813-1890
Grant, Ulysses S., 1822-1885
Holt, Joseph, 1807-1894
Hooker, Joseph, 1814-1879
Jackson, Thomas Jonathan
 ("Stonewall"), 1824-1863
Johnston, Albert Sidney, 1803-1862
Lee, Robert Edward, 1807-1870
Lincoln, Abraham, 1809-1865
Lyon, Nathaniel, 1818-1861
Mason, James Murray, 1798-1871
McClellan, George Brinton,
 1826-1885

McDuffie, George, 1790-1851
Paulding, Hiram, 1797-1878
Phillips, Wendell, 1811-1864
Scott, Winfield, 1796-1866
Seward, William Henry, 1801-1872
Stephens, Alexander Hamilton,
 1812-1883
Wilson, Henry, 1812-1875
Winthrop, Theodore, 1828-1861
Wool, John Ellis, 1784-1869
Louis Prang lithography company,
 active 1856-1899
Forty-eight lithographic and
 photographic cartes de visite, c.
 1861-1862
NPG.83.7.a-vv (detail of page
 illustrated)

a **Jimmy Carter and Rosalynn Smith
 Carter**
 Carter, Jimmy (James Earl, Jr.),
 1924-
 Ansel Adams, 1902-1984
 Photograph, polacolor print, 11.4 x
 8.8 cm. (4½ x 3⁷⁄₁₆ in.), 1980
 NPG.80.306
 *Gift of Mr. and Mrs. James Earl
 Carter, Jr.*

b **Jimmy Carter at the Democratic
 National Convention**
 Carter, Jimmy (James Earl, Jr.),
 1924- (center left)
 Rosalind Solomon, 1930-
 Photograph, gelatin silver print, 22.1
 x 32.6 cm. (8¹¹⁄₁₆ x 12⅞ in.), 1976
 NPG.84.136

c

d

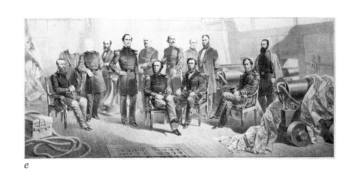

e

c **Celebrated Authors**
 (left to right, top to bottom)
 Schiller, Friedrich von, 1759-1805
 Byron, George Gordon, Lord,
 1788-1824
 Moore, Thomas, 1779-1852
 Scott, Sir Walter, 1771-1832
 Goethe, Johann Wolfgang von,
 1749-1832
 Irving, Washington, 1783-1859
 Alfiéri, Conte Vittorio, 1749-1803
 Cooper, James Fenimore,
 1789-1851
 Jacques Llanta, 1807-1864
 Lemercier lithography company
 Lithograph, 30.5 x 29.2 cm. (12 x 11½
 in.), 1833
 NPG.84.65

d **The Champions of the Union**
 Wilkes, Charles, 1798-1877
 Rosecrans, William Starke,
 1819-1898

McClellan, George Brinton,
 1826-1885
Burnside, Ambrose Everett,
 1824-1881
Sherman, William Tecumseh,
 1820-1891
Butler, Benjamin Franklin,
 1818-1893
Scott, Winfield, 1786-1866
Frémont, John Charles, 1813-1890
DuPont, Samuel Francis,
 1803-1865
Currier and Ives lithography
 company, active c. 1857-1907, after
 photographs
Lithograph with tintstone, 34.9 x
 50.9 cm. (14⅛ x 20¹/₁₆ in.), 1861
NPG.79.179

e **Civil War Naval Officers**
 (left to right)
 Worden, John Lorimer, 1818-1897
 Harwood, Andrew Allen,
 1802-1884

Farragut, David Glasgow,
 1801-1870
Bailey, Theodorus, 1805-1877
DuPont, Samuel Francis,
 1803-1865
Davis, Charles Henry, 1807-1877
Foote, Andrew Hull, 1806-1863
Stringham, Silas Horton,
 1797-1876
Goldsborough, Louis Malesherbes,
 1805-1877
Wilkes, Charles, 1798-1877
Porter, David Dixon, 1813-1891
Unidentified artist, after
 photographs
Lithograph, 30 x 68.5 cm. (11¾ x
 26¹⁵/₁₆ in.), c. 1862
NPG.81.38

a

b

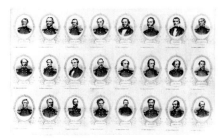

c

d

e

a **Class Work in the Art Student's
League Etching Class**
(left to right)
Sloan, John French, 1871-1951
Henri, Robert, 1865-1929
Gag, Wanda, 1893-1946
Freeman, Marion D., ?-?
Marion D. Freeman, ?-?
Etching and soft ground, 20.1 x 25.1
cm. (7⅞ x 9¹³⁄₁₆ in.), c. 1917-1923
NPG.81.79

b **Stephen Grover Cleveland, Fishing**
Cleveland, Stephen Grover,
1837-1908 (right)
W. Kelly, ?-?
Oil on canvas, 63.4 x 101.6 cm. (25 x
40 in.), 1897
NPG.71.37

c **Confederate Political Leaders and
Generals**
Benjamin, Judah Philip, 1811-1884
Jackson, Thomas Jonathan
("Stonewall"), 1824-1863
Stephens, Alexander Hamilton,
1812-1883
Johnston, Joseph Eggleston,
1807-1891
Lee, Robert Edward, 1807-1870
Davis, Jefferson, 1808-1889
Beauregard, Pierre Gustave
Toutant, 1818-1893
Breckinridge, John Cabell,
1821-1875
Maury, Matthew Fontaine,
1806-1873
Bragg, Braxton, 1817-1876
Charles Magnus, active c. 1854-
c. 1877, after photographs
Lithograph, 48.2 x 28.9 cm. (19 x 11⅜
in.), c. 1861-1865
NPG.79.25

d **Congress Voting Independence**
Edward Savage, 1761-1817
Stipple and line engraving, 47.9 x
65.5 cm. (19 x 25¾ in.), from
unfinished plate, c. 1796-1817
NPG.74.59

e **President Coolidge and His New
Cabinet**
(seated, left to right)
New, Harry Stewart, 1858-1937
Weeks, John Wingate, 1860-1926
Hughes, Charles Evans, 1862-1948
Coolidge, Calvin, 1872-1933
Mellon, Andrew William,
1855-1937
Stone, Harlan Fiske, 1872-1946
Wilbur, Curtis Dwight, 1867-1954
(standing, left to right)
Davis, James John, 1873-1947
Wallace, Henry Cantwell,
1866-1924
Hoover, Herbert Clark, 1874-1964
Work, Hubert, 1860-1942

f

g

h

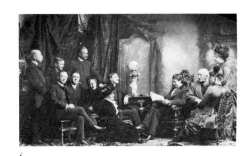

i

Keystone View company, active
 1892-c. 1970
Photograph, gelatin silver print, 7.8
 x 15.2 cm. (3¹/₁₆ x 6 in.), 1924
NPG.81.81

f **A Correct View of the Battle Near
 the City of New Orleans . . .**
 Jackson, Andrew, 1767-1845
 (center)
Francisco Scacki, active 1815
Etching, engraving, aquatint, and
 soft ground, 40.6 x 60.5 cm. (16 x
 23¹³/₁₆ in.), c. 1815
NPG.80.144

g **The Council of War**
 (left to right)
 Lincoln, Abraham, 1809-1865
 Porter, David Dixon, 1813-1891
 Farragut, David Glasgow,
 1801-1870
 Sherman, William Tecumseh,
 1820-1891

 Thomas, George Henry, 1816-1870
 Grant, Ulysses S., 1822-1885
 Sheridan, Philip Henry, 1831-1888
Peter Kraemer, 1823-1907, after
 photographs and Brady studio
Lithograph, 36.5 x 50 cm. (14½ x 19¾
 in.), 1865
NPG.79.185

h **Gustav Cramer and George William
 Harris**
 Cramer, Gustav, 1838-1914 (left)
 Harris, George William, 1872-1964
 (right)
Harris and Ewing studio, active
 1905-1977, and Clifford Kennedy
 Berryman, 1869-1949
Photograph, brown-toned gelatin
 silver print with india ink
 caricature drawing, 16 x 10.9 cm.
 (6⁵/₁₆ x 4⁵/₁₆ in.), c. 1908
NPG.84.312
Gift of Aileen Conkey

i **Augustin Daly's Stock Company**
 (seated, left to right)
 Lewis, James, 1837-1896
 Parker, George, ?-?
 Gilbert, Anne Hartley, 1821-1904
 Rehan, Ada, 1860-1916
 Drew, John, 1853-1927
 Daly, John Augustin, 1838-1899
 Fisher, Charles, 1816-1891
 Drehet, Virginia, ?-?
 (standing, left to right)
 Gilbert, William, ?-?
 Moore, John, ?-?
 LeMoyne, William J., 1831-1905
 Fielding, May, ?-?
Napoleon Sarony, 1821-1896
Photograph, albumen silver print,
 9.3 x 16.2 cm. (3⅝ x 6⅜ in.), 1884
NPG.80.67

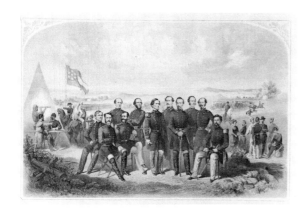

a

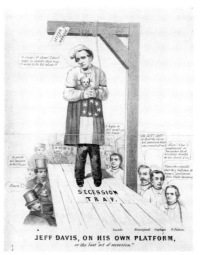

b

c

d

a **Jefferson Davis and His Generals**
(left to right)
Polk, Leonidas, 1806-1864
Magruder, John Bankhead,
 1810-1871
Simmons, Thomas Jefferson,
 1837-1905
Hollins, George Nichols, 1799-1878
McCulloch, Benjamin, 1811-1862
Davis, Jefferson, 1808-1889
Lee, Robert Edward, 1807-1870
Beauregard, Pierre Gustave
 Toutant, 1818-1893
Price, Sterling, 1809-1867
Johnston, Joseph Eggleston,
 1807-1891
Hardee, William Joseph, 1815-1873
Goupil lithography company, active
 in America 1840s-1860s, after
 photographs
Hand-colored lithograph with
 tintstone, 44.8 x 70.2 cm. (17⅝ x
 27⅝ in.), c. 1861
NPG.84.361

b **Jeff Davis, on His Own Platform**
(left to right)
Davis, Jefferson, 1808-1889
Toombs, Robert Augustus,
 1810-1885
Beauregard, Pierre Gustave
 Toutant, 1818-1893
Stephens, Alexander Hamilton,
 1812-1883
Pickens, Francis Wilkinson,
 1805-1869
Currier and Ives lithography
 company, active 1857-1907
Lithograph, 30.5 x 28.1 cm. (12 x
 11¹¹⁄₁₆ in.), c. 1861
NPG.84.200

c **Death of Harrison**
(left to right)
Ewing, Thomas, 1789-1871
Webster, Daniel, 1782-1852
Hawley, Reverend Dr., ?-?
Harrison, William Henry,
 1773-1841

Granger, Francis, 1792-1868
Nathaniel Currier, 1813-1888
Hand-colored lithograph, 21.4 x 32.8
 cm. (8⁷⁄₁₆ x 12⅞ in.), 1841
NPG.81.49
Gift of Dr. Frank Stanton

d **Death of Harrison**
(left to right)
Crittenden, John Jordan, 1787-1863
Harrison, Pike, ?-?
Bell, John, 1797-1869
Harrison, Henry, ?-?
Worthington, N. W., ?-?
Granger, Francis, 1792-1868
Ewing, Thomas, 1789-1871
Webster, Daniel, 1782-1852
Harrison, Mrs., ?-?
Harrison, William Henry,
 1773-1841
Tallmadge, Nathaniel Pitcher,
 1795-1864
Taylor, Anne Tuthill Harrison,
 1813-?

DEATH OF GENERAL ROBERT E. LEE,

e

f

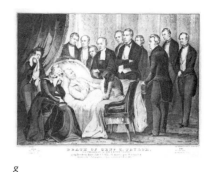

g

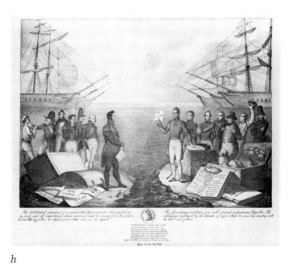

h

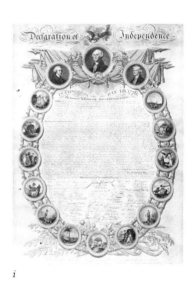

i

Henry R. Robinson, active c. 1831-
c. 1841
Hand-colored lithograph, 22.9 x 33.5
(9 x 13³⁄₁₆ in.), 1841
NPG.84.183

e **Death of General Robert E. Lee**
Lee, Robert Edward, 1807-1870
Currier and Ives lithography
company, active 1857-1907
Lithograph, 19.7 x 31.2 cm. (7¾ x
12¼ in.), 1870
NPG.84.84

f **Death of General Montgomery**
Montgomery, Richard, 1738-1775
(right of center)
Johan Frederik Clemens, 1749-1831,
after John Trumbull
Engraving, 51 x 77.3 cm. (20¹⁄₁₆ x
30⁷⁄₁₆ in.), 1798
NPG.77.226

g **Death of Genl. Z. Taylor**
(left to right)
Taylor, Zachary, 1784-1850
Meredith, William Morris,
1799-1873
Bliss, William Wallace Smith,
1815-1853
Pyne, Reverend Smith, ?-1875
Collamer, Jacob, 1791-1865
Fillmore, Millard, 1800-1874
Preston, William Ballard,
1805-1862
Clayton, John Middleton,
1796-1856
Johnson, Reverdy, 1796-1876
Crawford, George Walker,
1798-1872
Nathaniel Currier, 1813-1888
Hand-colored lithograph, 21 x 30.6
cm. (8¼ x 12¹⁄₁₆ in.), 1850
NPG.82.15

h **The Debilitated Situation of a
Monarchal Government . . .**
Jackson, Andrew, 1767-1845
(standing, center right)
Unidentified artist
Lithograph, 30.1 x 42.1 cm. (11⅞ x
16⁹⁄₁₆ in.), c. 1836
NPG.82.26

i **Declaration of Independence**
(left to right)
Hancock, John, 1736-1793
Washington, George, 1732-1799
Jefferson, Thomas, 1743-1826
James Barton Longacre, 1794-1869,
after Bass Otis, Gilbert Stuart, and
John Singleton Copley
Engraving, stipple engraving, and
etching, 84.4 x 61 cm. (33½ x 24
in.), 1818
NPG.80.129

a

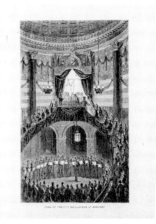

b

c

d

e

a **Dempsey-Willard Fight***
 Willard, Jess, 1883-1968 (left)
 Dempsey, William Harrison
 ("Jack"), 1895-1983 (right)
 James Montgomery Flagg, 1877-1960
 Oil on canvas, 183 x 550 cm. (72 x
 216 in.), 1944
 T/NPG.74.43.93
 Gift of Mr. and Mrs. Jack Dempsey

b **Dome of the City Hall—Scene At
 Midnight**
 Lincoln, Abraham, 1809-1865
 Unidentified artist, after William
 Waud
 Wood engraving with one tint, 17.8
 x 10.7 cm. (7 x 4³⁄₁₆ in.), 1866
 Published in *Obsequies of Abraham
 Lincoln in the City of New York,
 Under the Auspices of the
 Common Council*, New York,
 1866
 NPG.83.235

c **Isadora Duncan and Paris Singer**
 Duncan, Isadora, 1878-1927
 Singer, Paris, 1867-1942
 Arnold Genthe, 1869-1932
 Photograph, gelatin silver print, 24.8
 x 19.4 cm. (9¾ x 7⅝ in.), c. 1920
 NPG.78.258

d **Thomas Eakins and His Sister,
 Frances**
 Eakins, Thomas, 1844-1916
 Unidentified photographer
 Daguerreotype, 10.9 x 8.2 cm. (4¼ x
 3¼ in.), c. 1852
 NPG.80.248

e **Thomas Edison with Elisha E.
 Hudson**
 Hudson, Elisha E., ?-? (left)
 Edison, Thomas Alva, 1847-1931
 (right)
 Unidentified photographer
 Photograph, gelatin silver print, 22 x
 16.7 cm. (8⅝ x 6⁹⁄₁₆ in.), 1916
 NPG.80.295

f

g

h

i

f **Editors at Condé Nast**
 Crowninshield, Francis Welch,
 1872-1947 (seated, left)
 Campbell, Heyworth, 1886-?
 (standing, center)
 White, Clarence H., 1871-1925
 (standing, right)
 Clarence H. White, 1871-1925
 Photograph, brown-toned platinum
 print, 15.8 x 22.7 cm. (6½ x 8¹⁵⁄₁₆
 in.), 1918
 NPG.85.97

g **Dwight D. Eisenhower with His
 Brothers**
 Eisenhower, Dwight David,
 1890-1969 (center)
 Philippe Halsman, 1906-1979
 Photograph, gelatin silver print, 34.2
 x 26.8 cm. (13½ x 10⁹⁄₁₆ in.), 1948
 NPG.83.78
 Gift of George R. Rinhart

h **Eminent Women**
 (left to right)
 Livermore, Mary Ashton Rice,
 1820-1905
 Jewett, Sarah Orne, 1849-1909
 Oliver, Grace Atkinson, 1844-1899
 Jackson, Helen Maria Fiske Hunt,
 1830-1885
 Perry, Nora, 1831-1896
 Larcom, Lucy, 1824-1893
 Burnett, Frances Eliza Hodgson,
 1849-1924
 Ward, Elizabeth Stuart Phelps,
 1844-1911
 Moulton, Ellen Louise Chandler,
 1835-1908
 Alcott, Louisa May, 1832-1888
 Howe, Julia Ward, 1819-1910
 Stowe, Harriet Elizabeth Beecher,
 1811-1896
 Eugene L'Africain, 1859-1892, after
 photographs

Notman Photographic company
Collotype, 53.8 x 42.5 cm. (21³⁄₁₆ x
 16¾ in.), 1884
NPG.81.51
Gift of Dr. Frank Stanton

i **Exercise of Troops in Temple
 Grounds S[h]imoda Japan**
 Perry, Matthew Calbraith,
 1794-1858
 Eliphalet M. Brown, Jr., 1816-1886,
 after Peter Bernard William Heine
 Boell and Michelin lithography
 company
 Lithograph with printed and hand-
 tinted color, 52.2 x 82.6 cm. (20⁹⁄₁₆
 x 32½ in.), 1856
 NPG.82.114
 Gift of August Belmont IV

a

b

c

d

e

a **Douglas Fairbanks and Mary
 Pickford***
 Fairbanks, Douglas, 1883-1939
 Pickford, Mary, 1893-1979
 Nickolas Muray, 1892-1965
 Photograph, gelatin silver print, 24.1
 x 19 cm. (9½ x 7½ in.), 1978 from
 1929 negative
 T/NPG.78.147.89

b **Fall of the Alamo—Death of Crockett**
 Crockett, David, 1786-1836
 Unidentified artist
 Woodcut, 9.4 x 17.2 cm. (3¹¹⁄₁₆ x 6¾
 in.), 1837
 Published in *Davy Crockett's
 Almanack for 1837*, Nashville,
 1837
 NPG.85.139.b

c **Fancied Security, or the Rats on a
 Bender**
 (left to right)
 Fillmore, Millard, 1800-1874
 Toombs, Robert Augustus,
 1810-1885
 Buchanan, James, 1791-1868
 Greeley, Horace, 1811-1872
 Frémont, John Charles, 1813-1890
 Dayton, William Lewis, 1807-1864
 Cobb, Howell, 1815-1868
 Brooks, Preston Smith, 1819-1857
 Louis Maurer, 1832-1932, after
 photographs
 Currier and Ives lithography
 company
 Lithograph, 25.2 x 35.8 cm. (9¹⁵⁄₁₆ x
 14¹⁄₁₆ in.), 1856
 NPG.85.146

d **Al G. Field Minstrels**
 Field, Al G., 1852-1921
 Otis lithography company, active c.
 1900-1935
 Color lithographic poster, 195.4 x
 99.5 cm. (76¹⁵⁄₁₆ x 39³⁄₁₆ in.),
 c. 1900-1910
 NPG.84.115

e **The Fight Between the "Alabama"
 and the "Kearsarge" off Cherbourg,
 June 19, 1864**
 Semmes, Raphael, 1809-1877 (left)
 Gustav W. Seitz , 1826-?
 Hand-colored lithograph with
 tintstone, 27.1 x 40.9 cm. (10¹¹⁄₁₆ x
 16¹⁄₁₆ in.), c. 1864
 NPG.84.369

f

g

h

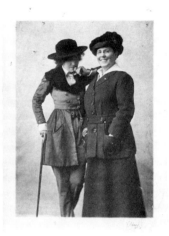

i

f **The First Colored Senator and Representatives**
(seated, left to right)
Revels, Hiram Rhoades, 1822-1901
Turner, Benjamin Sterling, 1825-1894
Walls, Josiah T., 1842-1905
Rainey, Joseph Harvey, 1832-1887
Elliot, R. Brown, 1842-1884
(standing, left to right)
De Large, Robert Carlos, 1842-1874
Long, Jefferson Franklin, 1836-1900
Currier and Ives lithography company, active 1857-1907, after photographs
Lithograph, 22 x 32 cm. (8⅝ x 12½ in.), 1872
NPG.80.195

g **First Landing of Americans in Japan . . . at Gore-Hama . . .**
Perry, Matthew Calbraith, 1794-1858
Eliphalet M. Brown, Jr., 1816-1886, after Peter Bernard William Heine
Sarony lithography company
Lithograph printed in color and finished by hand, 52.2 x 82.5 cm. (20⁹⁄₁₆ x 32½ in.), 1855
NPG.82.115
Gift of August Belmont IV

h **First Reading of the Emancipation Proclamation**
(seated, left to right)
Stanton, Edwin McMasters, 1814-1869
Lincoln, Abraham, 1809-1865
Welles, Gideon, 1802-1878
Seward, William Henry, 1801-1872
Bates, Edward, 1793-1869
(standing, left to right)

Chase, Salmon Portland, 1808-1873
Smith, Caleb Blood, 1808-1864
Blair, Montgomery, 1813-1883
Alexander Hay Ritchie, 1822-1895, after Francis Bicknell Carpenter
Engraving, 53 x 82.2 cm. (20⅞ x 32⅜ in.), 1866
NPG.78.109
Gift of Mrs. Chester E. King

i **Minnie Maddern Fiske with Unidentified Woman**
Fiske, Minnie Maddern, 1865-1932 (left)
Unidentified photographer
Photograph, gelatin silver print, 21.5 x 15.4 cm. (8½ x 6¹⁄₁₆ in.), 1917
NPG.81.77

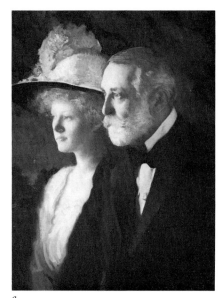

a

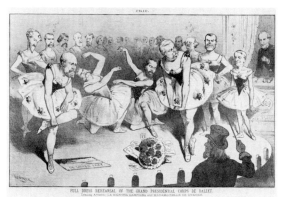

b

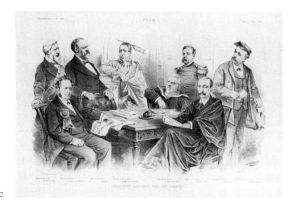

c

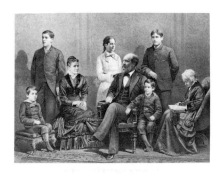

d

a **Henry Clay Frick and Daughter
 Helen**
 Frick, Henry Clay, 1849-1914
 Edmund C. Tarbell, 1862-1938
 Oil on canvas, 78.8 x 59 cm. (31 x
 23¼ in.), c. 1910
 NPG.81.121

b **Full Dress Rehearsal of the Grand
 Presidential Corps de Ballet**
 (left to right)
 Garfield, James Abram, 1831-1881
 Conkling, Roscoe, 1829-1888
 James, Thomas Lemuel, 1831-1916
 Logan, John Alexander, 1826-1886
 Blaine, James Gillespie, 1830-1893
 Schurz, Carl, 1829-1906
 Arthur, Chester Alan, 1830-1886
 Lincoln, Robert Todd, 1843-1926
 Hancock, Winfield Scott,
 1824-1886
 Butler, Benjamin Franklin,
 1818-1893

Dorsey, Stephen Wallace,
 1842-1916
Tilden, Samuel Jones, 1814-1886
Sherman, William Tecumseh,
 1820-1891
Charles Kendrick, active 1880-1902
Color lithograph, 29.6 x 47.5 cm.
 (11⅝ x 18¹¹⁄₁₆ in.), 1880
Published in *Chic*, New York,
 September 1880
NPG.84.194

c **President Garfield and His Cabinet**
 (left to right)
 Blaine, James Gillespie, 1830-1893
 Windom, William, 1827-1891
 Garfield, James Abram, 1831-1881
 Kirkwood, Samuel Jordan,
 1813-1894
 Hunt, William Henry, 1823-1884
 Lincoln, Robert Todd, 1843-1926
 MacVeagh, Isaac Wayne,
 1833-1917

James, Thomas Lemuel, 1831-1916
Joseph Keppler, 1838-1894, after
 photographs
Chromolithograph, 27.4 x 47.1 cm.
 (10¾ x 18⁹⁄₁₆ in.), 1881
Published in *Puck*, New York, March
 16, 1881
NPG.84.198

d **James A. Garfield and Family**
 Garfield, James Abram, 1831-1881
 (seated, center)
 Samuel S. Frizzell, 1843-1895
 J. H. Bufford lithography company
 Lithograph, 35.4 x 48.3 cm. (13⅞ x
 19 in.), 1881
 NPG.77.82

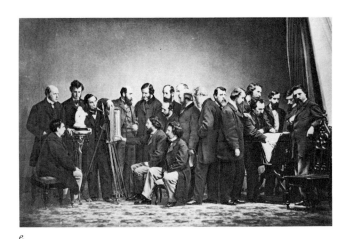

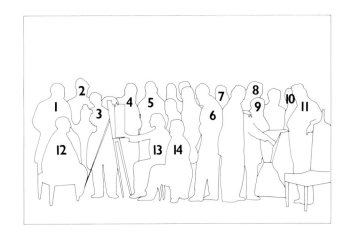

e

f

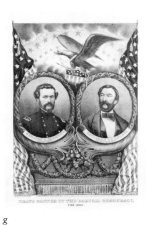

g

e **Gentlemen's Committee on the Fine Arts for the Metropolitan Fair in Aid of the U.S. Sanitary Commission**
Key
1. Cozzens, Abraham M., ?-?
2. Choate, Joseph Hodges, 1832-1917
3. Anthony, Edward, 1818-1888
4. Whitridge, Thomas Worthington, 1820-1910
5. Blodgett, William T., ?-1875
6. Cranch, Christopher Pearse, 1813-1892
7. Leutze, Emanuel Gottlieb, 1816-1868
8. Huntington, Daniel, 1816-1906
9. Johnson, Eastman, 1824-1906
10. Thompson, Launt, 1833-1894
11. Hicks, Thomas, 1823-1890
12. Hunt, Richard Morris, 1827-1895

13. Kensett, John Frederick, 1816-1872
14. Brady, Mathew, 1823-1896
Mathew Brady, 1823-1896
Photograph, albumen silver print, 14.7 x 22.8 cm. (5¾ x 9 in.), 1864
Published in an album entitled *Recollections of the Art Exhibition, Metropolitan Fair, New York, April 1864*
NPG.77.126

f **John Glenn and Walter Cronkite at the State Dinner for the Apollo 11 Astronauts***
Glenn, John Herschel, Jr., 1921- (center left)
Cronkite, Walter, 1916- (center right)
Garry Winogrand, 1928-1984
Photograph, gelatin silver print, 31.2 x 46.5 cm. (12⁵⁄₁₆ x 18⁵⁄₁₆ in.), 1969
T/NPG.84.30

g **Grand Banner of the Radical Democracy, For 1864**
Frémont, John Charles, 1813-1890 (left)
Cochrane, John, 1813-1898 (right)
Currier and Ives lithography company, active 1857-1907
Hand-colored lithograph, 31 x 22.8 cm. (12³⁄₁₆ x 9 in.), 1864
NPG.85.155

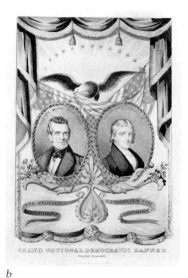

a

b

c

a **Grand Masquerade Ball**
(clockwise from upper left)
Bancroft, George, 1800-1891
Bateman, Kate Josephine,
1843-1917
Stanton, Edwin McMasters,
1814-1869
Kellogg, Clara Louise, 1842-1916
Bellini, ?-?
Barnum, Phineas Taylor,
1810-1891
Booth, Edwin Thomas, 1833-1893
Train, George Francis, 1829-1904
Grant, Ulysses S., 1822-1885
Bryant, William Cullen,
1794-1878
Fowler, Joseph Smith, 1820-1902
Beecher, Henry Ward, 1813-1887
Nast, Thomas, 1840-1902
Maretzek, Max, 1821-1897
Hoffman, John Thompson,
1828-1888

Phillips, Wendell, 1811-1884
Greeley, Horace, 1811-1872
Johnson, Andrew, 1808-1875
Thomas Nast, 1840-1902, after
photographs
Wood engraving, 34.4 x 52.2 (13¼ x
8⁹⁄₁₆ in.), 1866
Published in *Harper's Weekly*, New
York, April 14, 1866
NPG.83.186

b **Grand National Democratic Banner**
Polk, James Knox, 1795-1849 (left)
Dallas, George Mifflin, 1792-1864
(right)
Nathaniel Currier, 1813-1888
Hand-colored lithograph, 29.9 x 21.2
cm. (11¾ x 8⅜ in.), 1844
NPG.85.154

c **Grand National Whig Banner**
Clay, Henry, 1777-1852 (left)
Frelinghuysen, Theodore, 1787-
1862 (right)
Nathaniel Currier, 1813-1888
Hand-colored lithograph, 30 x 21 cm.
(11¹³⁄₁₆ x 8¼ in.), 1844
NPG.82.10

d **Grand Reception of the Notabilities
of the Nation**
(eminent figures, left to right)
Fessenden, William Pitt, 1806-1869
Sherman, William Tecumseh,
1820-1891
Stephens, Ann Sophia, 1813-1886
Schurz, Carl, 1829-1906
Sumner, Charles, 1811-1874
Kilpatrick, Hugh Judson,
1836-1881
Leslie, Miriam Florence Folline,
1836-1914

d

e

Sheridan, Philip Henry, 1831-1888
Hancock, Winfield Scott,
 1824-1886
Farragut, David Glasgow,
 1801-1870
Logan, John Alexander, 1826-1886
Hooker, Joseph, 1814-1879
Greeley, Horace, 1811-1872
Grant, Ulysses S., 1822-1885
Butler, Benjamin Franklin,
 1818-1893
Raymond, Henry Jarvis, 1820-1869
Porter, David Dixon, 1813-1891
Johnson, Andrew, 1808-1875
Howard, Oliver Otis, 1830-1909
Lincoln, Abraham, 1809-1865
Dix, John Adams, 1798-1879
Chase, Salmon Portland,
 1808-1873
Stanton, Edwin McMasters,
 1814-1869
Clay, Cassius Marcellus,
 1810-1903

Sprague, Kate Chase, 1840-1899
Slocum, Henry Warner, 1827-1894
Seward, William Henry, 1801-1872
Colfax, Schuyler, 1823-1885
Welles, Gideon, 1802-1878
Bennett, James Gordon, 1841-1918
Major and Knapp lithography
 company, active 1864-c. 1871, after
 photographs
Lithograph, 38.4 x 51.9 cm. (15 1/16 x
 20 7/16 in.), 1865
NPG.82.30

e **Grand Reception at the White
 House, January 1862**
 (left to right)
 Hay, John Milton, 1838-1905
 Nicolay, John George, 1832-1901
 McDowell, Irvin, 1818-1885
 Lamon, Ward Hill, 1828-1893
 Lincoln, Abraham, 1809-1865
 Cullum, George Washington,
 1809-1892

Chase, Salmon Portland,
 1808-1873
Chase, Kate, 1840-1899
Cameron, Miss, ?-?
Casey, Silas, 1807-1882
Mercier, Charles Alfred, 1816-1894
Peck, John James, 1821-1878
Wise, Henry Augustus, 1819-1869
Franklin, William Buel, 1823-1903
Heintzelman, Samuel Peter,
 1805-1880
McCall, George Archibald,
 1802-1868
Unidentified artist, after Alfred R.
 Waud
Wood engraving, 33.8 x 51.6 cm.
 (13 5/16 x 20 5/16 in.), 1862
Published in *Harper's Weekly*, New
 York, January 25, 1862
NPG.83.241

a

b

c

d

a **Ulysses S. Grant and Family**
 Grant, Ulysses S., 1822-1885
 (seated, left)
 Pach Brothers studio, active since
 1867
 Photograph, albumen silver print,
 25.1 x 33 cm. (9⅞ x 13 in.), c. 1870
 NPG.77.133

b **Ulysses S. Grant and Family**
 Grant, Ulysses S., 1822-1855
 (seated, center)
 Pach Brothers studio, active since
 1867
 Photograph, albumen silver print, 18
 x 23.7 cm. (7¹/₁₆ x 9⁵/₁₆ in.), c. 1883
 NPG.77.134

c **General Grant and His Family**
 Grant, Ulysses S., 1822-1885 (right)
 John Sartain, 1808-1897, after
 William F. Cogswell
 Engraving, 62 x 47.8 cm. (24⅜ x
 18¹³/₁₆ in.), 1868
 NPG.85.46
 *Gift of Gouldsboro Historical Society
 and Dorcas Library of Prospect
 Harbor, Maine*

d **Grant and His Family**
 Grant, Ulysses S., 1822-1885
 William Sartain, 1843-1924
 Engraving, 45.3 x 63.4 cm. (17¹³/₁₆ x
 24¹⁵/₁₆ in.), 1867
 NPG.84.195

e **General Grant and His Family**
 Grant, Ulysses S., 1822-1885
 A. L. Weise and Company
 lithography company, active
 c. 1865-c. 1912
 Hand-colored lithograph, 46.4 x 62.9
 cm. (18¼ x 24¾ in.), 1866
 NPG.82.34

f **Grant and His Generals**
 (left to right)
 Devin, Thomas Casimir,
 1822-1878
 Custer, George Armstrong,
 1839-1876
 Kilpatrick, Hugh Judson,
 1836-1881
 Emory, William Hemsley,
 1811-1887
 Sheridan, Philip Henry, 1831-1888
 McPherson, James Birdseye,
 1828-1864

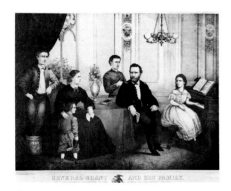

e

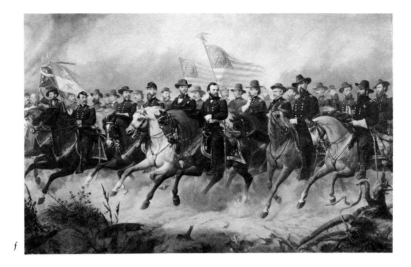

f

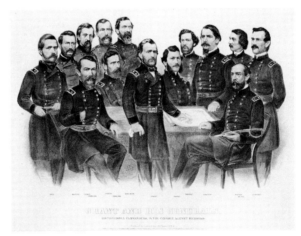

g

Crook, George, 1829-1890
Merritt, Wesley, 1834-1910
Thomas, George Henry, 1816-1870
Warren, Gouverneur Kemble,
 1830-1882
Meade, George Gordon, 1815-1872
Parke, John Grubb, 1827-1900
Sherman, William Tecumseh,
 1820-1891
Logan, John Alexander, 1826-1886
Grant, Ulysses S., 1822-1885
Burnside, Ambrose Everett,
 1824-1881
Hooker, Joseph, 1814-1879
Hancock, Winfield Scott,
 1824-1886
Rawlins, John Aaron, 1831-1869
Ord, Edward Otho Cresap,
 1818-1883
Blair, Francis Preston, 1821-1875
Terry, Alfred Howe, 1827-1890
Slocum, Henry Warner, 1827-1894
Davis, Jefferson Columbus,
 1828-1879

Howard, Oliver Otis, 1830-1909
Schofield, John McAllister,
 1831-1906
Mower, Joseph Anthony,
 1827-1870
Ole Peter Hansen Balling, 1823-1906
Oil on canvas, 304.8 x 486.6 cm.
 (120 x 192 in.), 1865
NPG.66.37
*Gift of Mrs. Harry Newton Blue in
 memory of her husband, Harry
 Newton Blue, 1893-1925, who
 served as an officer of the regular
 U.S. Army, 1917-1925*

g **Grant and His Generals**
 Grant, Ulysses S., 1822-1885
 (standing, center)
 (seated, left to right)
 Sheridan, Philip Henry, 1831-1888
 Rawlins, John Aaron, 1831-1869
 Parke, John Grubb, 1827-1900
 Meade, George Gordon, 1815-1872
 (standing, left to right)

Ord, Edward Otho Cresap,
 1818-1883
Weitzel, Godfrey, 1835-1884
Terry, Alfred Howe, 1827-1890
Crook, George, 1829-1890
Sedgwick, John, 1813-1864
Wright, Horatio Gouverneur,
 1820-1899
Hancock, Winfield Scott,
 1824-1886
Warren, Gouverneur Kemble,
 1830-1882
Humphreys, Andrew Atkinson,
 1810-1883
Currier and Ives lithography
 company, active 1857-1907, after
 photographs
Hand-colored lithograph, 27 x 45 cm.
 (10⅝ x 17⅝ in.), 1865
NPG.81.37

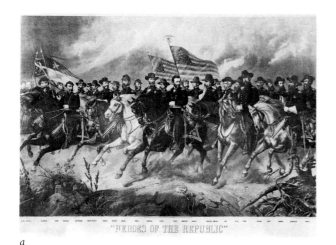

"HEROES OF THE REPUBLIC"

a

b

c

d

a **Grant and His Generals—Heroes of the Republic**
Ferdinand Mayer and Sons lithography company, active 1854-c. 1877, after Ole Peter Hansen Balling
Lithograph with tintstones, 56.5 x 88.3 cm. (22¼ x 34¾ in.), 1867
NPG.82.33

b **Ulysses S. Grant and Mrs. Grant with the Japanese Emperor**
Grant, Ulysses S., 1822-1885
Hiroshige III, 1843-1894
Multicolored woodblock print, 35.6 x 24.1 cm. (14 x 9½ in.), c. 1879
NPG.76.57

c **Grant and His Staff**
(seated, left to right)
Leet, George Keller, ?-1881
Parker, Ely Samuel, 1828-1895
Morgan, Michael Ryan, 1833-?
Williams, Seth, 1822-1866
Rawlins, John Aaron, 1831-1869
Comstock, Cyrus Ballou, 1831-1910
Badeau, Adam, 1831-1882
(standing, left to right)
Webster, Amos, ?-1898
Breneman, Edward De Welden, ?-1870
Babcock, Orville Elias, c. 1840-1884
Grant, Ulysses S., 1822-1885
Bowers, Theodore S., 1835-1866
Porter, Horace, 1837-1921
Alexander Gardner, 1821-1882
Photograph, albumen silver print, 30.5 x 43.2 cm. (12 x 17 in.), 1865
NPG.80.167

d **Great Cry and Little Wool**
(left to right)
Scott, Winfield, 1786-1866
Smith, Caleb Blood, 1808-1864
Seward, William Henry, 1801-1872
Lincoln, Abraham, 1809-1865
Cameron, Simon, 1799-1889
Welles, Gideon, 1802-1878
Blair, Montgomery, 1813-1883
Chase, Salmon Portland, 1808-1873
Unidentified artist
Lithograph, 9 x 15.5 cm. (3½ x 6 in.), 1861
Broadside: Barnstable's *Great Cry and Little Wool*, Baltimore, 1861
NPG.81.69
Gift of Dr. Frank Stanton

e

f

GREETINGS·FROM·THE·HOUSE·OF·WEYHE - 1928

g

h

i

e **Horace Greeley and Family**
 Greeley, Horace, 1811-1872 (left)
Otto Knirsch, active 1853-1860s, after
 photographs
Lithograph, 43.3 x 58.8 cm. (17¹/₁₆ x
 11⅛ in.), 1872
NPG.77.84

f **Greenback-Labor Advocates of 1880**
 Phillips, Wendell, 1811-1884
 Weaver, James Baird, 1833-1912
Unidentified artist, after
 photographs
Lithograph, 54.4 x 36.9 cm. (21⅜ x
 14½ in.), 1881
NPG.79.192

g **Greetings from the House of
 Weyhe***
 (left to right)
Bacon, Peggy, 1895-1987
Weyhe, Erhard, 1882-1972
McBride, Henry, 1867-1962
Gag, Wanda, 1893-1946
Zigrosser, Carl, 1891-1975
Mabel Dwight, 1876-1955
Lithograph, 18 x 21.6 cm. (7¹/₁₆ x 8½
 in.), 1928
Published as Christmas card for
 Weyhe Gallery, 1928
T/NPG.84.228
Gift of Gertrude W. Dennis

h **Dr. and Mrs. Gilbert H. Grosvenor**
 Grosvenor, Gilbert Hovey,
 1875-1966
Irving Penn, 1917-
Photograph, platinum-palladium
 print, 36.3 x 51 cm. (12⁵/₁₆ x 20¹/₁₆
 in.), 1977 from 1951 negative
NPG.85.29

i **Ground Hog Day**
 (left to right)
 Wheeler, Burton Kendall,
 1882-1975
 McNutt, Paul Vories, 1891-1955
 Farley, James Aloysius, 1888-1976
 Garner, John Nance, 1868-1967
Clifford Kennedy Berryman,
 1869-1949
India ink over pencil with opaque
 white on paper, 34.4 x 35.9 cm.
 (13½ x 14⅛ in.), 1940
Illustration for *The Washington Star*,
 Washington, D.C., February 2,
 1940
NPG.84.325
Gift of John L. Wheeler

a

b

c

d *e*

a **John Gunther with Dwight Eisenhower**
Gunther, John, 1901-1972 (left)
Eisenhower, Dwight David, 1890-1969 (right)
Philippe Halsman, 1906-1979
Photograph, gelatin silver print, 34.1 x 27.3 cm. (13⁷⁄₁₆ x 10¾ in.), 1948
NPG.83.79
Gift of George R. Rinhart

b **Winfield Scott Hancock, David Bell Birney, and Their Staffs**
Hancock, Winfield Scott, 1824-1886 (center left)
Birney, David Bell, 1825-1864 (center right)
Unidentified photographer
Photograph, albumen silver print, 12.7 x 20.1 cm. (5 x 7⅞ in.), 1862
NPG.78.96

c **Warren G. Harding with Robert Todd Lincoln and Joseph G. Cannon**
(left to right)
Harding, Warren Gamaliel, 1865-1923
Lincoln, Robert Todd, 1843-1926
Cannon, Joseph Gurney, 1836-1926
Harris and Ewing studio, active 1905-1977
Photograph, gelatin silver print, 14.8 x 23.6 cm. (5⅞ x 9⁵⁄₁₆ in.), c. 1921
NPG.84.247
Gift of Aileen Conkey

d **Jean Harlow and Clark Gable**
Harlow, Jean, 1911-1937
Gable, Clark, 1901-1960
Clarence Sinclair Bull, 1895-1979
Photograph, gelatin silver print, 39.9 x 26.3 cm. (13⅜ x 11⅜ in.), 1937
NPG.81.13

e **Josiah Johnson Hawes, Albert Hawes, and Charles Hawes**
(left to right)
Hawes, Josiah Johnson, 1808-1901
Hawes, Albert, ?-?
Hawes, Charles, ?-?
Albert Sands Southworth, 1811-1894, and/or Josiah Johnson Hawes, 1808-1901, or a Hawes brother; studio active 1844-1861
Daguerreotype, 10.9 x 8.3 cm. (4¼ x 3¼ in.), c. 1848
NPG.80.182

f

g

h

i

j

f **Hugh Hefner and Jesse Jackson at Operation PUSH Fundraiser***
 Hefner, Hugh Marston, 1926-
 (center)
 Jackson, Jesse Louis, 1941-
 (right)
 Garry Winogrand, 1928-1984
 Photograph, gelatin silver print, 31.6
 x 47 cm. (12⁷/₁₆ x 18⁹/₁₆ in.), 1972
 T/NPG.84.26

g **Anna Held and Florenz Ziegfeld**
 Held, Anna, 1865-1918
 Ziegfeld, Florenz, 1869-1932
 Unidentified photographer
 Photograph, gelatin silver print, 19.6
 x 24.4 cm. (7¾ x 9⅝ in.), c. 1900
 NPG.80.102

h **Anna Held and Florenz Ziegfeld**
 Ziegfeld, Florenz, 1869-1932
 Held, Anna, 1865-1918
 Unidentified photographer
 Photograph, gelatin silver print, 24.6
 x 19.8 cm. (9¹¹/₁₆ x 7¹³/₁₆ in.), c. 1900
 NPG.80.103

i **Ernest Hemingway and His Son, John**
 Hemingway, Ernest Miller,
 1899-1961
 Man Ray, 1890-1976
 Photograph, gelatin silver print, 22.9
 x 17.2 cm. (9 x 6¾ in.), c. 1926
 NPG.81.141

j **Robert and Marjorie Henri**
 Henri, Robert, 1865-1929
 Unidentified photographer
 Photograph, gelatin silver print, 20.3
 x 15.2 cm. (8 x 6 in.), c. 1920
 NPG.77.182

a

b

c

d

a **The Hercules of the Union**
 Scott, Winfield, 1786-1866 (left)
 (Hydra, top to bottom)
 Toombs, Robert Augustus,
 1810-1885
 Stephens, Alexander Hamilton,
 1812-1883
 Davis, Jefferson, 1808-1889
 Beauregard, Pierre Gustave
 Toutant, 1818-1893
 Twiggs, David Emanuel, 1790-
 1862
 Pickens, Francis Wilkinson,
 1805-1869
 Floyd, John Buchanan, 1806-1863
 Unidentified artist, after
 photographs
 Lithograph, 30.6 x 22.1 cm. (12$\frac{1}{16}$ x
 8$\frac{11}{16}$ in.), 1861
 NPG.84.102

b **"Wild Bill" Hickok and Mr. Moyer**
 Hickok, James Butler ("Wild
 Bill"), 1837-1876 (seated, right)
 Unidentified photographer
 Tintype, 21.3 x 16.5 cm. (8$\frac{3}{8}$ x 6$\frac{1}{2}$
 in.), c. 1876
 NPG.85.12

c **Thomas Wentworth Higginson with
 Members of His Family**
 Higginson, Thomas Wentworth,
 1823-1911 (seated, right)
 Unidentified photographer
 Daguerreotype, 13.7 x 10.8 cm. (5$\frac{3}{8}$ x
 4$\frac{1}{4}$ in.), c. 1853
 NPG.84.265
 Gift of Mrs. Katie Louchheim

d **Winslow Homer with E. L. Henry,
 A. C. Howland, and Unidentified
 Subjects**
 Homer, Winslow, 1836-1910 (far
 right)
 Unidentified photographer
 Photograph, salt print, 16.5 x 21.5
 cm. (6$\frac{1}{2}$ x 8$\frac{1}{2}$ in.), c. 1865
 NPG.76.77
 Gift of Dr. and Mrs. Jacob Terner

e

f

g

h

e **Honorary Degree**
(left to right)
Seashore, Carl Emil, 1866-1949
Wood, Grant, 1892-1941
Foerster, Norman, 1887-1972
Grant Wood, 1892-1941
Lithograph, 30.2 x 17.7 cm. (11⅞ x 7
in.), 1939
NPG.77.250

f **William Dean Howells with
Daughter, Mildred**
Howells, William Dean, 1837-1920
Augustus Saint-Gaudens, 1848-1907
Bronze relief, 21 x 33.5 cm. (8¼ x
13¼ in.), 1898
NPG.65.65
*Transfer from the National Gallery
of Art; gift of Miss Mildred
Howells, 1949*

g **A. A. Humphreys and Staff**
(left to right)
Christiancy, Henry C., ?-?
Humphreys, Henry Hollingsworth,
?-?
Humphreys, Andrew Atkinson,
1810-1883
McClellan, Carswell, 1835-1892
Cavada, ?-?
James Gardner, ?-?
Photograph, albumen silver print,
17.3 x 22.4 cm. (6¾ x 8¾ in.), 1863
Published in Alexander Gardner's
series *Incidents of the War*,
Washington, D.C., 1863
NPG.79.230

h John Huston, *Annie* Set, Burbank,
1981*
Huston, John, 1906-1987 (center)
Garry Winogrand, 1928-1984
Photograph, gelatin silver print, 31.6
x 47.1 cm. (12⁷⁄₁₆ x 18⁹⁄₁₆ in.), 1981
T/NPG.84.25

a

a **The Inauguration of Franklin Delano Roosevelt**

Key

1. Curtis, Charles E., 1860-1936
2. Hoover, Herbert Clark, 1874-1944
3. Garner, John Nance, 1868-1967
4. Roosevelt, Anna Eleanor, 1884-1962
5. Roosevelt, Franklin Delano, 1882-1945
6. Hughes, Charles Evans, 1862-1948
7. Sullivan, Mark, 1874-1952
8. Lippman, Walter, 1889-1974
9. Smith, Alfred Emanuel, 1873-1944
10. Moley, Raymond Charles, 1886-1975
11. Farley, James Aloysius, 1888-1976
12. Howe, Louis McHenry, 1871-1936

13. Pershing, John Joseph, 1860-1948
14. Baruch, Bernard Mannes, 1870-1965
15. Lehman, Herbert Henry, 1878-1963
16. Young, Owen D., 1874-1962
17. McAdoo, William Gibbs, 1863-1941
18. Walsh, Thomas James, 1849-1933
19. Davis, John William, 1873-1955
20. Baker, Newton Diehl, 1871-1937
21. Glass, Carter, 1858-1946
22. Stimson, Henry Lewis, 1867-1950
23. Davis, Norman Hezekiah, 1878-1944

24. Mellon, Andrew William, 1855-1937
25. Morgan, John Pierpont, Jr., 1867-1943

Miguel Covarrubias, 1902-1957
Color halftone, 34.2 x 48.3 cm. (13⁷⁄₁₆ x 19 in.), 1933
Published in *Vanity Fair*, New York, March 1933
NPG.82.43

b

c

d

e

b **In Memory of the Confederate Dead**
(clockwise from top)
Johnston, Albert Sidney, 1803-1862
Polk, Leonidas, 1806-1864
Rains, James Edward, 1833-1862
Hill, Ambrose Powell, 1825-1865
Stuart, James Ewell Brown ("Jeb"),
1833-1864
Morgan, John Hunt, 1825-1864
(center)
Jackson, Thomas Jonathan
("Stonewall"), 1824-1863
Bennett, Donaldson, and Elmes
lithography company, active 1866,
after photographs
Lithograph with tintstone, 33.8 x
24.8 cm. (13⅝6 x 9¾ in.), c. 1866
Music sheet title page: "In Memory
of the Confederate Dead"
NPG.84.363

c **The International Contest Between
Heenan and Sayers at
Farnsborough, on the 17th of
April 1860**
Heenan, John Carmel, 1835-1873
W. L. Walton, active 1834-1860, after
photographs
Hand-colored lithograph with
tintstone, 66.3 x 99.2 cm. (26⅛6 x
39 in.), 1860
NPG.85.172

d **Introducing John L. Sullivan**
Sullivan, John Lawrence, 1858-
1918 (seated, right)
George Bellows, 1882-1925
Lithograph, 52.6 x 52.7 cm. (20¹¹⁄16 x
20¾ in.), 1916
NPG.75.26

e **Washington Irving and His Literary
Friends at Sunnyside**
(seated, left to right)
Simms, William Gilmore,
1806-1870
Halleck, Fitz-Greene, 1790-1867
Prescott, William Hickling,
1796-1859
Irving, Washington, 1783-1859
Emerson, Ralph Waldo, 1803-1882
Cooper, James Fenimore, 1789-
1851
Bancroft, George, 1800-1891
(standing, left to right)
Tuckerman, Henry Theodore,
1813-1871
Holmes, Oliver Wendell, 1809-
1894
Hawthorne, Nathaniel, 1804-1864
Longfellow, Henry Wadsworth,
1807-1882
Willis, Nathaniel Parker, 1806-
1867

a

b

c

Paulding, James Kirke, 1778-1860
Bryant, William Cullen, 1794-
 1878
Kennedy, John Pendleton,
 1795-1870
Thomas Oldham Barlow, 1824-1889,
 after Christian Schussele, after
 Felix Octavius Carr Darley
Engraving and stipple engraving,
 51.8 x 78.5 cm. (20⅜ x 30⅞ in.),
 1864
NPG.67.89

a **Washington Irving and His Literary
 Friends at Sunnyside**
 (seated, left to right)
 Simms, William Gilmore,
 1806-1870
 Halleck, Fitz-Greene, 1790-1867
 Prescott, William Hickling,
 1796-1859
 Irving, Washington, 1783-1859
 Emerson, Ralph Waldo, 1803-1882

Cooper, James Fenimore, 1789-
 1851
Bancroft, George, 1800-1891
(standing, left to right)
Tuckerman, Henry Theodore,
 1813-1871
Holmes, Oliver Wendell, 1809-
 1894
Hawthorne, Nathaniel, 1804-1864
Longfellow, Henry Wadsworth,
 1807-1882
Willis, Nathaniel Parker, 1806-
 1867
Paulding, James Kirke, 1778-1860
Bryant, William Cullen, 1794-
 1878
Kennedy, John Pendleton,
 1795-1870
Christian Schussele, 1824-1879
Oil on canvas, 132.1 x 198.1 cm. (52
 x 78 in.), 1864
NPG.82.147

b **Charles Ives with Mandeville
 Mullally**
 Ives, Charles Edward, 1874-1954
 (left)
 Raymond Moreau Crosby, 1874-1945
 Ink over pencil on paper, 55.9 x 45.7
 cm. (22 x 18 in.), 1890
 NPG.72.94
 Gift of George G. Tyler

c **Liet. Gen. Thomas J. Jackson and His
 Family**
 Jackson, Thomas Jonathan
 ("Stonewall"), 1824-1863 (right)
 William Sartain, 1843-1924, after
 photographs
 Engraving, 35.4 x 49 cm. (13¹⁵⁄₁₆ x
 19¼ in.), 1866
 NPG.84.350

d

e

f

g

d **Lyndon Johnson, Cape Kennedy, Florida**
Johnson, Lyndon Baines, 1908-1973 (center)
Garry Winogrand, 1928-1984
Photograph, gelatin silver print, 31.2 x 47 cm. (12¼ x 18½ in.), 1969
NPG.84.22

e **Johnson-Willard Fight**
Johnson, John Arthur ("Jack"), 1878-1946 (left)
Willard, Jess, 1883-1968 (right)
Unidentified photographer
Photograph, gelatin silver print, 8.7 x 13.7 cm. (3⁷⁄₁₆ x 5⁷⁄₁₆ in.), 1915
NPG.83.9
Gift of Charles F. Flynn

f **Kings of Wall Street**
(left to right)
Field, Cyrus West, 1819-1892
Sage, Russell, 1816-1906
Hatch, Rufus, 1832-1893
Gould, Jay, 1836-1892
Dillon, Sidney, 1812-1892
Mills, Darius Ogden, 1825-1910
Vanderbilt, William Henry, 1821-1885
Belmont, August, 1816-1890
Ballou, George William, 1848-1929
Keene, James Robert, 1838-1913
Buek and Lindner lithography company, active 1880s, after photographs
Root and Tinker, publishers
Chromolithograph, 45.8 x 60.8 cm. (18 x 24 in.), 1882
NPG.73.14

g **Florence Kirk and Ezio Pinza in *Don Giovanni***
Pinza, Ezio, 1892-1957
Alfred Bendiner, 1899-1964
India ink over pencil with opaque white on paper, 28.5 x 33.6 cm. (11³⁄₁₆ x 13³⁄₁₆ in.), c. 1945
NPG.84.60
Gift of Alfred Bendiner Foundation

a

b

c

d

a **Landing of Commodore Perry . . . at
 Shimoda, Japan . . .**
 Perry, Matthew Calbraith,
 1794-1858
 Eliphalet M. Brown, Jr., 1816-1886,
 after Peter Bernard William Heine
 Sarony lithography company
 Lithograph with printed and hand-
 tinted color, 52.2 x 82.5 cm. (20%₁₆
 x 32½ in.), 1855
 NPG.82.110
 Gift of August Belmont IV

b **Landing of Commodore Perry . . . at
 Yoku-Hama, Japan . . .**
 Perry, Matthew Calbraith,
 1794-1858
 Eliphalet M. Brown, Jr., 1816-1886,
 after Peter Bernard William Heine
 Sarony lithography company

Lithograph with printed and hand-
 tinted color, 52.2 x 82.1 cm. (20½ x
 32⅝ in.), 1855
NPG.82.112
Gift of August Belmont IV

c **The Last Ditch of the Chivalry, or a
 President in Petticoats**
 Davis, Varina Howell, 1826-1906
 Davis, Jefferson, 1808-1889
 Currier and Ives lithography
 company, active 1857-1907
 Lithograph, 22.6 x 36.9 cm. (8⅞ x
 14½ in.), 1865
 NPG.85.147

d **Last Moments of President Lincoln**
 (left to right)
 Welles, Gideon, 1802-1878
 Chase, Salmon Portland, 1808-
 1873
 Lincoln, Abraham, 1809-1865
 Sumner, Charles, 1811-1874
 Lincoln, Robert Todd, 1843-1926
 Halleck, Henry Wager, 1815-1872
 Stanton, Edwin McMasters,
 1814-1869
 J. H. Bufford lithography company,
 active 1835-1890
 Lithograph, 23.2 x 33.1 cm. (9⅛ x 13
 in.), 1865
 NPG.83.233

e

f

g

h

i

e **Gypsy Rose Lee and Her Entourage**
Lee, Gypsy Rose, 1914-1970 (right)
Ralph Steiner, 1899-1986
Photograph, gelatin silver print, 26 x
33.4 cm. (10¼ x 13³⁄₁₆ in.), 1944
NPG.84.267

f **Robert E. Lee and His Generals**
(left to right)
Hampton, Wade, 1818-1902
Stuart, James Ewell Brown ("Jeb"),
1833-1864
Early, Jubal Anderson, 1816-1894
Johnston, Joseph Eggleston,
1807-1891
Hood, John Bell, 1831-1879
Lee, Robert Edward, 1807-1870
Hill, Ambrose Powell, 1825-1865
Jackson, Thomas Jonathan
("Stonewall"), 1824-1863
Longstreet, James, 1821-1904

Beauregard, Pierre Gustave
Toutant, 1818-1893
Morgan, John Hunt, 1825-1864
Goupil lithography company, active
in America 1840s-1860s, after
photographs
Lithograph with tintstone, 43.1 x
68.3 cm. (17 x 38⅞ in.), c. 1865
NPG.84.272

g **Robert E. Lee and Joseph E. Johnston**
Johnston, Joseph Eggleston,
1807-1891 (left)
Lee, Robert Edward, 1807-1870
(right)
D. J. Ryan, ?-?
Photograph, albumen silver print,
13.4 x 9.9 cm. (5¼ x 3¹⁵⁄₁₆ in.), 1870
NPG.78.273

h **Le Général Lafayette**
Lafayette, Marie Joseph Paul Yves
Roch Gilbert du Motier,
Marquis de, 1757-1834 (seated,
center)
Achille Moreau, active 1825-1842,
after Jean Auguste Dubouloz
Aquatint and etching, 41.7 x 54.8
cm. (16⅜ x 21⁹⁄₁₆ in.), 1825
NPG.80.147

i **Jonathan Letterman and
Unidentified Staff**
Letterman, Jonathan, 1824-1872
(front row, second from left)
Alexander Gardner, 1821-1882
Photograph, albumen silver print,
17.1 x 22.9 cm. (6¾ x 9 in.), 1862
NPG.78.98

a

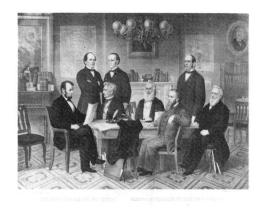

b

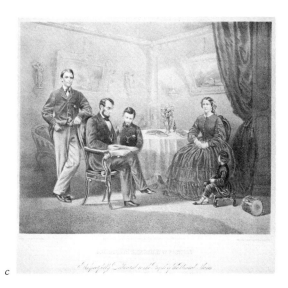

c

a **President Lincoln on the Battlefield of Antietam, October, 1862**
(left to right)
Sacket, Delos Bennet, 1822-1885
Montieth, George, ?-?
Sweitzer, Nelson Bowman, ?-1898
Morell, George Webb, 1815-1883
Webb, Alexander Stewart, 1835-1911
McClellan, George Brinton, 1826-1885
Adams, Scout, ?-?
Letterman, Jonathan, 1824-1872
Loeb, H., ?-?
Lincoln, Abraham, 1809-1865
Hunt, Henry Jackson, 1819-1889
Porter, Fitz John, 1822-1901
Locke, Frederick Thomas, 1826-1893
Humphreys, Andrew Atkinson, 1810-1883

Custer, George Armstrong, 1839-1876
Alexander Gardner, 1821-1882
Photograph, albumen silver print, 17.7 x 22.5 cm. (6¹⁵⁄₁₆ x 8⅞ in.), 1862
NPG.80.106

b **President Lincoln and His Cabinet**
(seated, left to right)
Lincoln, Abraham, 1809-1865
Seward, William Henry, 1801-1872
Welles, Gideon, 1802-1878
Stanton, Edwin McMasters, 1814-1869
Bates, Edward, 1793-1869
(standing, left to right)
Chase, Salmon Portland, 1808-1873
Blair, Montgomery, 1813-1883
Smith, Caleb Blood, 1808-1864

Edward Herline lithography company, active c. 1840-1870, after Francis Bicknell Carpenter and unidentified artist
Hand-tinted lithograph, 44.6 x 61.6 cm. (17⁹⁄₁₆ x 24¼ in.), 1866
NPG.79.223

c **Abraham Lincoln and Family**
(left to right)
Lincoln, Robert Todd, 1843-1926
Lincoln, Abraham, 1809-1865
Lincoln, Thomas, 1853-1871
Lincoln, Mary Todd, 1818-1882
Unidentified child
Henry Atwell Thomas, 1834-1904, after photograph by Anthony Berger
Lithograph, 33.4 x 41.8 cm. (13⅛ x 16⁷⁄₁₆ in.), 1865
NPG.83.225

d

e

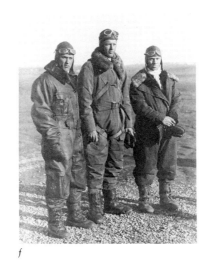

f

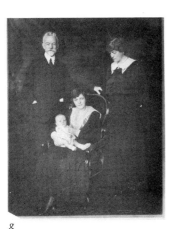

g

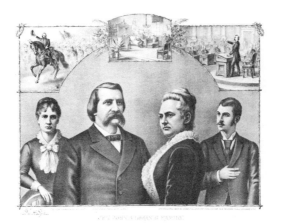

h

i

d **President Lincoln's Funeral**
 Lincoln, Abraham, 1809-1865
 Unidentified artist
 Wood engraving, 35 x 23.3 cm. (13¾
 x 9⅛ in.), 1865
 Published in *Harper's Weekly*, New
 York, May 6, 1865
 NPG.83.242

e **Abraham Lincoln with Mary Todd
 Lincoln**
 Lincoln, Abraham, 1809-1865
 Pierre Morand, 1820-?
 Ink heightened with white on paper,
 20.3 x 12.8 cm. (8 x 5 1/16 in.),
 c. 1864
 NPG.75.28

f **Charles Lindbergh with Thomas
 Nelson and Philip Love**
 (left to right)
 Nelson, Thomas P., 1905-1929
 Lindbergh, Charles Augustus,
 1902-1974
 Love, Philip R., ?-1943
 Unidentified photographer
 Photograph, gelatin silver print, 34.4
 x 27.3 cm. (13 9/16 x 10¾ in.), 1928
 NPG.78.3

g **Henry Cabot Lodge with Members of
 His Family**
 Lodge, Henry Cabot, 1850-1924
 (standing, left)
 Curtis Bell, active c. 1903-?
 Photograph, brown-toned platinum
 print, 24.5 x 19.3 cm. (9⅝ x 7⅝
 in.), c. 1917
 NPG.81.165
 Gift of Joanna Sturm

h **General John A. Logan and Family**
 Logan, John Alexander, 1826-1886
 (center left)
 Kurz and Allison lithography
 company, active 1880-c. 1889, after
 photographs
 Lithograph, 45.5 x 60.5 cm. (17⅞ x
 23 13/16 in.), 1887
 NPG.85.143

i **Log Cabin Anecdotes**
 Harrison, William Henry,
 1773-1841
 Unidentified artist
 Wood-engraved broadside printed in
 red and black, 63.5 x 49 cm. (25 x
 18 5/16 in.), 1840
 NPG.82.12

a

b

c

d

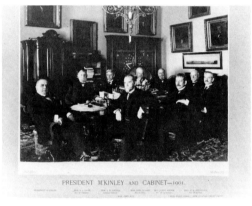

e

a **Alice and Nicholas Longworth***
Longworth, Alice Roosevelt,
1884-1980
Longworth, Nicholas, 1869-1931
Edward Sheriff Curtis, 1868-1952
Photograph, brown-toned platinum
print, 23 x 17.2 cm. (9¹/₁₆ x 6¾ in.),
1906
T/NPG.81.128.90
Gift of Joanna Sturm

b **Alfred Lunt and Lynn Fontanne***
Fontanne, Lynn, c. 1887-1983
Lunt, Alfred, 1893-1977
Nickolas Muray, 1892-1965
Photograph, gelatin silver print, 24.7
x 19.7 cm. (9⅝ x 7¾ in.), 1925
T/NPG.85.21.93

c **McClellan and Family**
McClellan, George Brinton,
1826-1885 (seated, right)
Tholey lithography company, active
c. 1851-c. 1898, after photographs
Hand-colored lithograph with
tintstone, 50.6 x 60.7 cm. (19¹⁵/₁₆ x
23⅞ in.), 1867
NPG.82.31

d **Jeanette MacDonald and Andre
Kostelanetz***
MacDonald, Jeanette, 1901-1965
Kostelanetz, Andre, 1901-1980
Alfred Bendiner, 1899-1964
India ink over pencil on paper, 28.7
x 36.6 cm. (11⁵/₁₆ x 14⅜ in.), c. 1945
T/NPG.84.63.90
Gift of Alfred Bendiner Foundation

e **William McKinley and His Cabinet**
(left to right)
McKinley, William, 1843-1901
Gage, Lyman Judson, 1836-1927
Griggs, John William, 1849-1927
Long, John Davis, 1838-1915
Hay, John Milton, 1838-1905
Wilson, James, 1836-1920
Root, Elihu, 1845-1937
Hitchcock, Ethan Allen, 1835-1909
Smith, Charles Emory, 1842-1908
Pach Brothers studio, active since
1867
Photograph, albumen silver print,
24.7 x 34.3 cm. (9¾ x 12½ in.),
1901
NPG.78.158

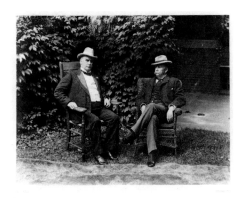

f

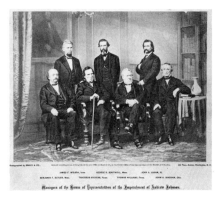

g

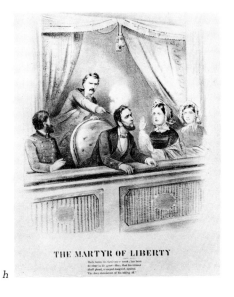

h

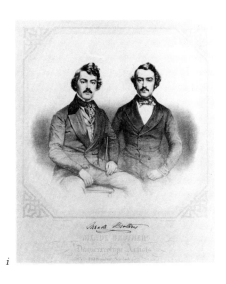

i

f **William McKinley and Garret Hobart**
McKinley, William, 1843-1901 (left)
Hobart, Garret Augustus, 1844-1899 (right)
Pach Brothers Studio, active since 1867
Photograph, gelatin silver print, 25 x 32.9 cm. (9⅞ x 12¹⁵⁄₁₆ in.), c. 1899
NPG.77.357

g **Managers of the House of Representatives of the Impeachment of Andrew Johnson**
(left to right)
Butler, Benjamin Franklin, 1818-1893
Wilson, James Falconer, 1828-1895
Stevens, Thaddeus, 1792-1868
Boutwell, George Sewall, 1818-1905
Williams, Thomas, ?-?
Logan, John Alexander, 1826-1886
Bingham, John A., 1815-1900
Mathew Brady, 1823-1896, or his studio
Photograph, albumen silver print, 17.1 x 22.9 cm. (6¾ x 9 in.), 1868
NPG.77.127

h **The Martyr of Liberty**
(seated, left to right)
Rathbone, Henry Reed, 1837-1911
Lincoln, Abraham, 1809-1865
Lincoln, Mary Todd, 1818-1882
Harris, Clara, ?-?
(standing)
Booth, John Wilkes, 1838-1865
Unidentified artist
Lithograph, 25.4 x 21.6 cm. (10 x 8½ in.), c. 1865
NPG.83.230

i **Charles Meade and Henry Meade**
Meade, Henry William Matthew, 1823-1865 (left)
Meade, Charles Richard, 1827-1858 (right)
Francis D'Avignon, c. 1814-?, after Meade Brothers
Lithograph, 36.3 x 36.3 cm. (14¼ x 14¼ in.), c. 1852
NPG.78.239

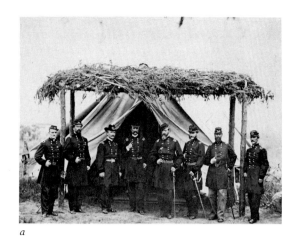

a

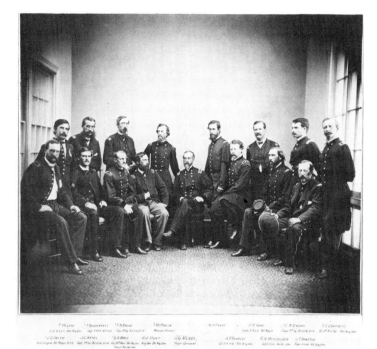

b

a **Meade and His Generals**
(left to right)
Macy, George Nelson, 1836-1875
Webb, Alexander Stewart,
 1835-1911
Ord, Edward Otho Cresap,
 1818-1883
Griffin, Charles, 1825-1867
Meade, George Gordon, 1815-1872
Parke, John Grubb, 1827-1900
Hunt, Henry Jackson, 1819-1889
Humphreys, Andrew Atkinson,
 1810-1883
Timothy O'Sullivan, 1840-1882
Photograph, albumen silver print,
 17.2 x 22.4 cm. (6¾ x 8¹³⁄₁₆ in.),
 c. 1865
NPG.81.28

b **Meade and His Staff**
(seated, left to right)
Smith, J. S., ?-?
Bates, John Coalter, 1842-1919
Macy, George Nelson, 1836-1875
Hunt, Henry Jackson, 1819-1889
Meade, George Gordon, 1815-1872
Ruggles, George David, 1833-1904
Batchelder, Richard Napoleon,
 1832-1901
Barstow, Simon Forrester, 1818-
 1882
(standing, left to right)
Wilson, Thomas, ?-1901
Rosencrantz, Frederick, ?-1879
Bache, Francis Markoe, ?-?
McParlin, Thomas Andrew, ?-1897
Payne, W. H., ?-?
Coxe, John Redman, ?-?
Emory, Campbell Dallas, ?-1878
Campbell, Edward Livingston, ?-?

Alexander Gardner, 1821-1882
Photograph, albumen silver print,
 38.2 x 45.6 cm. (15 x 18 in.), 1865
NPG.81.16

c

d

e

c **Henry Meade and His Daughter,
Sarah**
Meade, Henry William Matthew,
1823-1865
Charles Richard Meade, 1827-1858,
and Henry William Matthew
Meade, 1823-1865, at the Meade
Brothers studio, active 1842-1870
Tintype, 10.2 x 7.6 cm. (4 x 3 in.),
c. 1865
NPG.85.184
*Gift of Mr. and Mrs. Dudley
Emerson Lyons*

d **Henry Meade and His Daughter,
Sarah**
Meade, Henry William Matthew,
1823-1865
Charles Richard Meade, 1827-1858,
and Henry William Matthew
Meade, 1823-1865, at the Meade
Brothers studio, active 1842-1870
Photograph, albumen silver print, 8
x 5.3 cm. (3⅛ x 2⅛ in.), c. 1860
NPG.85.189
*Gift of Mr. and Mrs. Dudley
Emerson Lyons*

e **Henry Meade and Sarah Meserole**
Meade, Henry William Matthew,
1823-1865
Charles Richard Meade, 1827-1858,
and Henry William Matthew
Meade, 1823-1865, at the Meade
Brothers studio, active 1842-1870
Daguerreotype, 7.9 x 7.1 cm. (3⅛ x
2¹³⁄₁₆ in.), c. 1858
NPG.85.181
*Gift of Mr. and Mrs. Dudley
Emerson Lyons*

a

b

c

a **Henry Meade with Unidentified
 Woman**
 Meade, Henry William Matthew,
 1823-1865
 Charles Richard Meade, 1827-1858,
 and Henry William Matthew
 Meade, 1823-1865, at the Meade
 Brothers studio, active 1842-1870
 Daguerreotype, 7.6 x 6.3 cm. (3 x 2½
 in.), c. 1858
 NPG.85.188
 *Gift of Mr. and Mrs. Dudley
 Emerson Lyons*

b **Memory**
 (left to right)
 Henri, Robert, 1865-1929
 Henri, Linda, ?-1905
 Sloan, Dolly, ?-1943
 Sloan, John, 1871-1951
 John Sloan, 1871-1951
 Etching, 17.6 x 21.6 cm. (6¹⁵⁄₁₆ x 8½
 in.), 1906
 NPG.69.37

c **Men of Progress**
 (left to right)
 Morton, William Thomas Green,
 1819-1868
 Bogardus, James, 1800-1874
 Colt, Samuel, 1814-1862
 McCormick, Cyrus Hall, 1809-
 1884
 Saxton, Joseph, 1799-1873
 Goodyear, Charles, 1800-1860
 Cooper, Peter, 1791-1883
 Mott, Jordan Lawrence, 1799-1866
 Henry, Joseph, 1797-1878
 Nott, Eliphalet, 1773-1866
 Ericsson, John, 1803-1889
 Sickles, Frederick, 1819-1895
 Morse, Samuel Finley Breese,
 1791-1872
 Burden, Henry, 1791-1871
 Hoe, Richard March, 1812-1886
 Bigelow, Erastus, 1814-1879
 Jennings, Isaiah, 1792-1862

 Blanchard, Thomas, 1788-1864
 Howe, Elias, 1819-1867
 Christian Schussele, 1824-1879
 Oil on canvas, 130.4 x 194.9 cm.
 (51⅜ x 76¾ in.), 1862
 NPG.65.60
 *Transfer from the National Gallery
 of Art; gift of Andrew W. Mellon,
 1942*

d

f

e

d **Men of Progress—American Inventors**
John Sartain, 1808-1897, after
 Christian Schussele
Mezzotint and engraving, 55.4 x 90.9
 cm. (21¹³⁄₁₆ x 35¾ in.), 1863
NPG.67.88

e **Wesley Merritt and His Staff**
 Merritt, Wesley, 1834-1910 (seated,
 center)
Mathew Brady, 1823-1896
Photograph, albumen silver print,
 11.5 x 14.4 cm. (4½ x 5¹¹⁄₁₆ in.),
 1864
NPG.81.29

f **Millionaires of the United States**
 (top row, left to right)
 Tilden, Samuel Jones, 1814-1886
 Stanford, Leland, 1824-1893
 Mills, Darius Ogden, 1825-1910
 Gould, Jay, 1836-1892
 MacKay, John William, 1831-1902
 (second row)
 Sage, Russell, 1816-1906
 Astor, William Waldorf, 1848-
 1919
 Vanderbilt, Cornelius, 1794-1877
 Belmont, August, 1816-1890
 Flood, James Clair, 1825-1888
 (third row)
 Seney, George Ingraham, 1826-
 1893
 Corcoran, William Wilson,
 1798-1888

 Dillon, Sidney, 1812-1892
 Field, Cyrus West, 1819-1892
Franklin Square lithography
 company, active 1880s, after
 photographs
Lithograph with tintstone, 50.4 x
 66.1 cm. (19¹³⁄₁₆ x 26 in.), 1884
NPG.85.54

a

b

c

d

a **Robert Mills and His Wife**
Mills, Robert, 1781-1855
Jesse H. Whitehurst, c. 1820-1875
Daguerreotype, 13.9 x 10.7 cm. (5½ x
4³⁄₁₆ in.), c. 1851
NPG.79.71
Gift of Richard Evans

b **Mirabeau Arrive aux Champs
Élisées**
Franklin, Benjamin, 1706-1790
(center left)
Louis Joseph Masquelier, 1741-1811,
after Jean Michel Moreau le Jeune
Engraving, 23.3 x 33.1 cm. (9³⁄₁₆ x 13
in.), 1792
NPG.77.349

c **Mosby and His Rangers**
Mosby, John Singleton, 1833-1916
(standing, center)
Daniel Bendann, 1835-1914, and
David Bendann, 1841-1915
Photograph, albumen silver print,
23.2 x 31.5 cm. (9⅛ x 12⅜ in.),
1865
NPG.83.213

d **Patrice Munsel and Raoul Jobin***
Munsel, Patrice, 1925-
Jobin, Raoul, 1906-1974
Alfred Bendiner, 1899-1964
India ink over pencil on paper, 24.1
x 29.2 cm. (9½ x 11⁷⁄₁₆ in.), 1945
Illustration for *The Evening
Bulletin*, Philadelphia, December
12, 1945
T/NPG.84.61
Gift of Alfred Bendiner Foundation

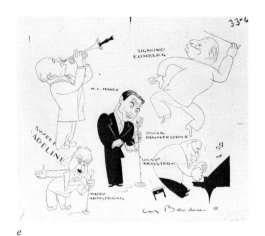

e

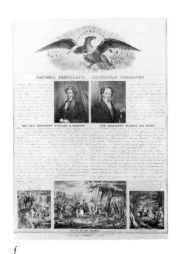

f

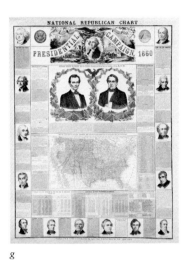

g

h

i

e **Music at the Dell**
Handy, William Christopher,
1873-1958 (top left)
Romberg, Sigmund, 1887-1951
(top right)
Hammerstein, Oscar, II, 1895-1960
(center)
Alfred Bendiner, 1899-1964
India ink over pencil with opaque
white on paper, 27.9 x 34 cm. (11 x
13⅜ in.), c. 1945
NPG.84.62
Gift of Alfred Bendiner Foundation

f **National Democratic Republican
Nomination**
Johnson, Richard Mentor,
1780-1850 (left)
Van Buren, Martin, 1782-1862
(right)
Endicott lithography company,
active 1828-1896

Lithograph, 52.5 x 38.7 cm. (20¹¹⁄₁₆ x
15¼ in.), 1840
NPG.85.45

g **National Republican Chart**
Lincoln, Abraham, 1809-1865
(left)
Hamlin, Hannibal, 1809-1891
(right)
Unidentified artist, after
photographs by Mathew Brady
Hand-colored lithograph, 88 x 65.7
cm. (34⅝ x 25¹³⁄₁₆ in.), 1860
NPG.83.5

h **Richard Nixon with the Apollo 11
Astronauts**
Nixon, Richard Milhous, 1913-
(center left)
Collins, Michael, 1930- (center)
Aldrin, Edwin ("Buzz"), 1930-
(center right)

Garry Winogrand, 1928-1984
Photograph, gelatin silver print, 31.5
x 47 cm. (12⅜ x 18½ in.), 1969
NPG.84.20

i **Richard M. Nixon and Pat Nixon
Campaigning in Westchester, 1960**
Nixon, Richard Milhous, 1913-
Henri Dauman, 1933-
Photograph, gelatin silver print, 23.3
x 35.1 cm. (9³⁄₁₆ x 3¹³⁄₁₆ in.), 1960
NPG.85.89

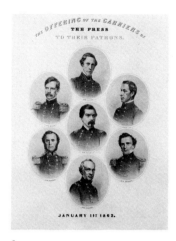

a

b

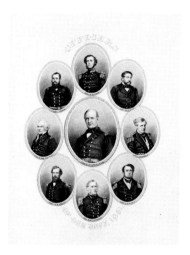

c

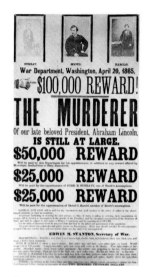

d

a **The Offering of the Carriers of the Press to their Patrons**
(clockwise from top)
Wilkes, Charles, 1798-1877
McCall, George Archibald, 1802-1868
Sherman, Thomas West, 1813-1879
Halleck, Henry Wager, 1815-1872
DuPont, Samuel Francis, 1803-1865
Banks, Nathaniel Prentiss, 1816-1894
(center)
McClellan, George Brinton, 1826-1885
Unidentified artist, after photographs
Lithograph with tintstone, 27.8 x 21.5 cm. (11⅞ x 8⁷⁄₁₆ in.), 1862
NPG.80.278

b **Officers of the American Federation of Labor**
(left to right)
Gompers, Samuel, 1850-1924
Duncan, James, 1857-1928
Morrison, Frank, 1859-1949
Keystone View company, active 1892-1970
Photograph, gelatin silver print, 7.9 x 15.3 cm. (3⅛ x 6 in.), c. 1910
NPG.80.87

c **Officers of Our Navy**
(clockwise from top)
DuPont, Samuel Francis, 1803-1865
Ward, William H., ?-?
Ringgold, Cadwalader, 1802-1867
Foote, Andrew Hull, 1806-1863
Breese, Samuel Livingston, 1794-1870

Craven, Tunis Augustus MacDonough, 1813-1864
Paulding, Hiram, 1797-1878
Braine, Daniel Laurence, 1829-1898
Stringham, Silas Horton, 1797-1876 (center)
John Chester Buttre, 1821-1893, after photographs
Engraving, 18.1 x 13 cm. (7⅛ x 5⅛ in.), 1861
NPG.82.47

d **$100,000 Reward!**
(left to right)
Surratt, John H., 1844-1916
Booth, John Wilkes, 1838-1865
Herold, David E., 1845/46-1865
Unidentified artist
Photographs, albumen silver prints, mounted on printed broadside, 61.4 x 31.9 cm. (24³⁄₁₆ x 12⁹⁄₁₆ in.), 1865
NPG.85.32

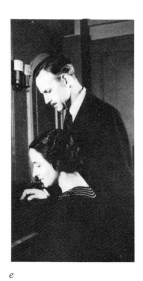

e

f

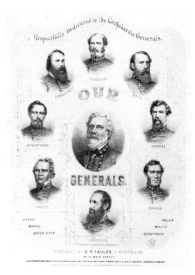

h

g

e **Eugene and Carlotta O'Neill**
 O'Neill, Carlotta, 1888-1964
 O'Neill, Eugene, 1888-1953
Carl Van Vechten, 1880-1964
Photograph, gelatin silver print, 13.1
 x 6.9 cm. (5³⁄₁₆ x 2¹¹⁄₁₆ in.), 1932
NPG.84.142
Gift of Prentiss Taylor

f **Eugene Ormandy and Joseph Szigeti***
 Szigeti, Joseph, 1892-1973 (left)
 Ormandy, Eugene, 1899-1985
 (right)
Alfred Bendiner, 1899-1964
Lithograph, 21 x 22.7 cm. (8¼ x 8¹⁵⁄₁₆
 in.), 1942
T/NPG.79.108.95
Gift of Mrs. Alfred Bendiner

g **Oscars, 1940**
 (left to right)
 Donat, Robert, 1905-1958
 Leigh, Vivien, 1913-1967
 McDaniel, Hattie, 1898-1952
 Mitchell, Thomas, 1895-1962
Alfred Bendiner, 1899-1964
Pencil and crayon with opaque white
 on board, 16 x 35.9 cm. (6⁵⁄₁₆ x 14⅛
 in.), 1940
NPG.85.198
Gift of Alfred Bendiner Foundation

h **Our Generals**
 (clockwise from top)
 Johnston, Joseph Eggleston,
 1807-1891
 Hill, Ambrose Powell, 1825-1865
 Hardee, William Joseph, 1815-
 1873
 Bragg, Braxton, 1817-1876

Jackson, Thomas Jonathan
 ("Stonewall"), 1824-1863
Price, Sterling, 1809-1867
Beauregard, Pierre Gustave
 Toutant, 1818-1893
Longstreet, James, 1821-1904
(center)
Lee, Robert Edward, 1807-1870
Major and Knapp lithography
 company, active 1864-c. 1871, after
 photographs
Lithograph with tintstone, 29.1 x
 22.1 cm. (11⁷⁄₁₆ x 8¹¹⁄₁₆ in.), 1866
Music sheet title page: "Our
 Generals"
NPG.84.364

a

b

a **Prominent Candidates for the
 Democratic Nomination at
 Charleston, South Carolina**
 (left to right, top)
 Lane, James Henry, 1814-1866
 Hunter, Robert Mercer Taliaferro,
 1809-1887
 Breckinridge, John Cabell,
 1821-1875
 Douglas, Stephen Arnold,
 1813-1861
 Houston, Samuel, 1793-1863
 (bottom)
 Stephens, Alexander Hamilton,
 1812-1883
 Orr, James Lawrence, 1822-1873
 Davis, Jefferson, 1808-1889
 Washington, George, 1732-1799
 Guthrie, James, 1792-1869
 Slidell, John, 1793-1871
 Pierce, Franklin, 1804-1869

Unidentified artist, after Gilbert
 Stuart and photographs by
 Mathew Brady
Wood engraving, 35 x 51.3 cm. (13¾
 x 20³⁄₁₆ in.), 1860
Published in *Harper's Weekly*, New
 York, April 21, 1860
NPG.82.14

b **Prominent Candidates for the
 Republican Presidential
 Nomination at Chicago**
 (left to right, top to bottom)
 Bates, Edward, 1793-1869
 Banks, Nathaniel Prentiss,
 1816-1894
 Pennington, William, 1796-1862
 Chase, Salmon Portland, 1808-
 1873
 Seward, William Henry, 1801-1872
 McLean, John, 1785-1861
 Cameron, Simon, 1799-1889

Frémont, John Charles, 1813-1890
Lincoln, Abraham, 1809-1865
Bell, John, 1797-1869
Clay, Cassius Marcellus, 1810-
 1903
A. E. C., ?-?, after photographs
Wood engraving, 35 x 51.8 cm. (13¾
 x 20¼ in.), 1860
NPG.81.80
Gift of Marvin Sadik

c

d

THE RAIL CANDIDATE.

e

f

c **Protection to American Industries**
 Harrison, Benjamin, 1833-1901
 (left)
 Morton, Levi Parsons, 1824-1920
 (right)
 Unidentified artist, after photograph
 by Charles M. Bell (Harrison) and
 unidentified photograph (Morton)
 Lithograph on cloth (handkerchief),
 36.3 x 33.3 cm. (14¼ x 13⅛ in.),
 c. 1888
 NPG.82.16

d **Paul Pry and Col. Hardy**
 Finn, Henry J., 1785-1840 (left)
 Kilner, Thomas, 1777-1862 (right)
 David Claypoole Johnston, 1799-
 1865
 Lithograph, 14.2 x 10.7 cm. (5⁹⁄₁₆ x
 4³⁄₁₆ in.), 1826
 NPG.83.173

e **The Rail Candidate**
 Lincoln, Abraham, 1809-1865
 (center)
 Greeley, Horace, 1811-1872 (right)
 Louis Maurer, 1832-1932, after
 photographs
 Currier and Ives lithography
 company
 Lithograph, 25 x 37.8 cm. (9¹³⁄₁₆ x
 14⅞ in), 1860
 NPG.85.148

f **Rendezvous of Mosby's Men in the
 Pass of the Blue Ridge,
 Shenandoah Valley**
 Mosby, John Singleton, 1833-1916
 (right)
 Mason Jackson, 1819-1903
 Wood engraving, 23.9 x 34.3 cm.
 (9⁷⁄₁₆ x 13½ in.), 1865
 Published in *Illustrated London
 News*, January 21, 1865
 NPG.84.338

a

b

<table>
<tr><td>

a **Representative Journals and
 Journalists of America**
 (left to right, top)
 Hawley, Joseph Roswell, 1826-1905
 Ottendorfer, Oswald, 1826-1900
 Reid, Whitelaw, 1837-1912
 Dana, Charles Anderson, 1819-
 1897
 Childs, George William, 1829-
 1894
 (center)
 Pulsifer, A. M., ?-?
 Weed, Thurlow, 1797-1882
 Haskell, Edwin Bradbury,
 1837-1907
 (bottom)
 Halstead, Murat, 1829-1908
 Medill, Joseph, 1823-1899
 Bennett, James Gordon, 1841-1918
 Watterson, Henry, 1840-1921
 Lawson, Victor Freemont,
 1850-1925

</td><td>

Buek and Lindner lithography
 company, active 1880s, after
 photographs
Root and Tinker, publishers
Lithograph with two tintstones, 40.6
 x 53.3 cm. (16 x 21 in.), 1882
NPG.76.55
Gift of Barry Bingham, Sr.

</td><td>

b **Representative Women**
 (clockwise from top)
 Mott, Lucretia Coffin, 1793-1880
 Stanton, Elizabeth Cady, 1815-
 1902
 Livermore, Mary Ashton Rice,
 1820-1905
 Child, Lydia Maria Francis,
 1802-1880
 Anthony, Susan Brownell,
 1820-1906
 Lippincott, Sara Jane Clarke
 ("Grace Greenwood"), 1823-1904
 (center)
 Dickinson, Anna Elizabeth,
 1842-1932
 L. Schamer, ?-?, after photographs
 Louis Prang lithography company
 Lithograph, 40.5 x 31.1 cm. (15¹⁵/₁₆ x
 12¼ in.), 1870
 NPG.77.196

</td></tr>
</table>

c

d

e

f

g

c **Representative Women of Deseret**
 Smith, Eliza Roxey Snow,
 1804-1887 (center top)
 Augusta Joyce Crocheron, 1844-1915
 Lithograph poster with albumen
 prints, 71.2 x 66 cm. (28 x 24 in.),
 1883
 NPG.78.236

d **The Republican Banner for 1860**
 Lincoln, Abraham, 1809-1865
 (left)
 Hamlin, Hannibal, 1809-1891
 (right)
 Currier and Ives lithography
 company, active 1857-1907, after
 photographs
 Hand-colored lithograph, 30.6 x 23.6
 cm. (12 x 9¼ in.), 1860
 NPG.81.39

e **Return of Commodore Perry . . . from
 . . . Shui . . .**
 Perry, Matthew Calbraith,
 1794-1858
 Eliphalet M. Brown, Jr., 1816-1886,
 after Peter Bernard William Heine
 Boell and Lewis lithography
 company
 Lithograph with printed and hand-
 tinted color, 52.2 x 82 cm. (20⁹⁄₁₆ x
 32¼ in.), 1855
 NPG.82.113
 Gift of August Belmont IV

f **Bill Robinson and Prentiss Taylor***
 Taylor, Prentiss, 1907- (left)
 Robinson, Luther (Bill
 "Bojangles"), 1878-1949 (right)
 Carl Van Vechten, 1880-1964
 Photograph, gelatin silver print, 21.3
 x 14.3 cm. (8⅜ x 5⅝ in.), 1932
 T/NPG.84.145
 Gift of Prentiss Taylor

g **Bill Robinson with Carl Van
 Vechten**
 Robinson, Luther (Bill
 "Bojangles"), 1878-1949 (left)
 Van Vechten, Carl, 1880-1964
 (right)
 Carl Van Vechten, 1880-1964
 Photograph, gelatin silver print, 8.7
 x 13.7 cm. (3⅞ x 5⅞ in.), 1941
 NPG.83.149

a

b

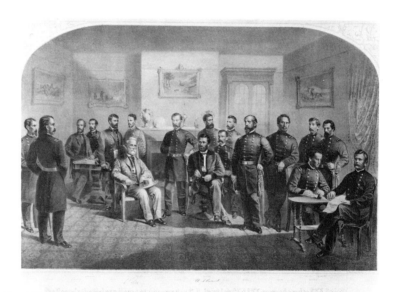

c

a **The Rockefeller Brothers***
(seated, left to right)
Rockefeller, Winthrop, 1912-1973
Rockefeller, John Davison, III,
1906-1978
Rockefeller, Nelson Aldrich,
1908-1979
(standing, left to right)
Rockefeller, Laurance Spelman,
1910-
Rockefeller, David, 1915-
Philippe Halsman, 1906-1979
Photograph, gelatin silver print, 33.5
x 27.3 cm. (13³⁄₁₆ x 10¾ in.), 1949
T/NPG.83.106
Gift of George R. Rinhart

b **The Rockefeller Brothers***
(left to right)
Rockefeller, John Davison, III,
1906-1978
Rockefeller, Nelson Aldrich,
1908-1979
Rockefeller, Laurance Spelman,
1910-
Rockefeller, Winthrop, 1912-1973
Rockefeller, David, 1915-
Philippe Halsman, 1906-1979
Photograph, gelatin silver print, 20.5
x 34.6 cm. (8¹⁄₁₆ x 13⅝ in.), 1958
T/NPG.83.107
Gift of George R. Rinhart

c **The Room in the McLean House, at
Appomattox, C.H.**
(left to right)
Custer, George Armstrong,
1839-1876
Lee, Robert Edward, 1807-1870
Sheridan, Philip Henry, 1831-1888
Grant, Ulysses S., 1822-1885
Meade, George Gordon, 1815-1872
Ord, Edward Otho Cresap,
1818-1883
Major and Knapp lithography
company, active 1864-c. 1871, after
photographs
Lithograph with tintstone, 48.7 x
73.8 cm. (19⅛ x 29 in.), 1867
NPG.80.114

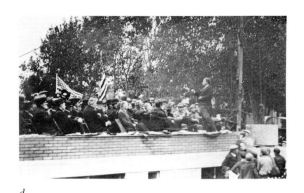

d

e

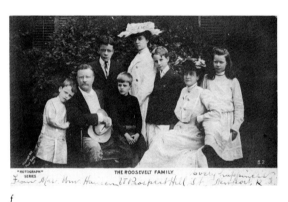

f

g

d **Theodore Roosevelt Addressing the
G.A.R. at Fargo College**
Roosevelt, Theodore, 1858-1919
Unidentified photographer
Photograph, gelatin silver print, 7.8
x 13.4 cm. (3¹/₁₆ x 5¼ in.), 1910
NPG.81.173
Gift of Joanna Sturm

e **Theodore Roosevelt Addressing a
Gathering**
Roosevelt, Theodore, 1858-1919
Underwood and Underwood, active
1882-c. 1950
Photograph, gelatin silver print, 25.3
x 20.2 cm. (9¹⁵/₁₆ x 8 in.), 1905
NPG.81.124
Gift of Joanna Sturm

f **The Roosevelt Family***
Roosevelt, Theodore, 1858-1919
(seated, left)
Longworth, Alice Roosevelt,
1884-1980 (standing, center)
Pach Brothers studio, active since
1867
Photograph, gelatin silver print, 12.6
x 8.5 cm. (14¹⁵/₁₆ x 3⁵/₁₆ in.), 1903
T/NPG.81.157.90
Gift of Joanna Sturm

g **The Theodore Roosevelt Family at
the White House***
Roosevelt, Theodore, 1858-1919
(back row, third from right)
Longworth, Alice Roosevelt,
1884-1980 (back row, second
from right)
Longworth, Nicholas, 1869-1931
(back row, right)
Harris and Ewing studio, active
1905-1977
Photograph, brown-toned gelatin
silver print, 25.1 x 32.5 cm. (9¹⁵/₁₆
x 12¹³/₁₆ in.), 1908
T/NPG.81.126.90
Gift of Joanna Sturm

a

b

c

d

e

a **Theodore Roosevelt with Group at the White House**
Roosevelt, Theodore, 1858-1919 (seated, center)
Barnet M. Clinedinst, Jr., 1874-?
Photograph, gelatin silver print, 40.1 x 50.6 cm. (15¹³⁄₁₆ x 19¹⁵⁄₁₆ in.), 1909
NPG.81.171
Gift of Joanna Sturm

b **Theodore Roosevelt's Last Trip Through North Dakota**
Roosevelt, Theodore, 1858-1919
Edith W. Hughes, ?-?
Photograph, gelatin silver print, 20.7 x 28.8 cm. (8⅛ x 11⁵⁄₁₆ in.), 1918
NPG.81.153
Gift of Joanna Sturm

c **Theodore Roosevelt Leaving the Fisheries Building at the Louisiana Purchase Exposition**
Roosevelt, Theodore, 1858-1919 (right)
Jessie Tarbox Beals, 1870-1942
Photograph, gelatin silver print, 14.5 x 18.9 cm. (5¹¹⁄₁₆ x 7⁷⁄₁₆ in.), 1904
NPG.81.131
Gift of Joanna Sturm

d **Theodore Roosevelt Leaving the West Pavilion at the Louisiana Purchase Exposition**
Roosevelt, Theodore, 1858-1919 (standing, center)
Jessie Tarbox Beals, 1870-1942
Photograph, gelatin silver print, 18.2 x 23.1 cm. (7³⁄₁₆ x 9⅛ in.), 1904
NPG.81.130
Gift of Joanna Sturm

e **President Roosevelt and His Distinguished Party**
Roosevelt, Theodore, 1858-1919 (center)
Underwood and Underwood, active 1882-c. 1950
Photograph, gelatin silver print, 8.5 x 15.6 cm. (3³⁄₁₆ x 6⅛ in.), 1903
NPG.80.82

f

g

h

i

j

f **Theodore Roosevelt and His Party at the Panama Canal**
Roosevelt, Theodore, 1858-1919 (center)
Underwood and Underwood, active 1882-c. 1950
Photograph, brown-toned gelatin silver print, 25.4 x 20.4 cm. (10 x 8 in.), 1906
NPG.81.127
Gift of Joanna Sturm

g **Theodore Roosevelt and His Party on the Reviewing Stand**
Roosevelt, Theodore, 1858-1919 (left)
Jessie Tarbox Beals, 1870-1942
Photograph, gelatin silver print, 7.8 x 13 cm. (3¹⁄₁₆ x 5⁵⁄₁₆ in.), 1904
NPG.81.135
Gift of Joanna Sturm

h **Theodore Roosevelt and His Party on the Reviewing Stand**
Roosevelt, Theodore, 1858-1919 (left)
Jessie Tarbox Beals, 1870-1942
Photograph, gelatin silver print, 18.4 x 19 cm. (7¼ x 7½ in.), 1904
NPG.81.172
Gift of Joanna Sturm

i **Theodore Roosevelt on the Reviewing Stand with Unidentified Officer**
Roosevelt, Theodore, 1858-1919 (right)
Jessie Tarbox Beals, 1870-1942
Photograph, gelatin silver print, 13.1 x 7.5 cm. (5³⁄₁₆ x 2¹⁵⁄₁₆ in.), 1904
NPG.81.133
Gift of Joanna Sturm

j **Theodore Roosevelt on the Reviewing Stand with Unidentified Officer**
Roosevelt, Theodore, 1870-1942
Jessie Tarbox Beals, 1858-1919
Photograph, gelatin silver print, 13.6 x 8.1 cm. (5³⁄₈ x 3³⁄₁₆ in.), 1904
NPG.81.134
Gift of Joanna Sturm

a

b

c

d

e

a **Theodore Roosevelt and Edith Carow Roosevelt on the Reviewing Stand**
Roosevelt, Theodore, 1858-1919
Jessie Tarbox Beals, 1870-1942
Photograph, gelatin silver print, 13.6 x 8.1 cm. (5⅜ x 3³⁄₁₆ in.), 1904
NPG.81.132
Gift of Joanna Sturm

b **Theodore Roosevelt with Unidentified Roughrider**
Roosevelt, Theodore, 1858-1919 (left)
Pach Brothers studio, active since 1867
Photograph, albumen silver print, 25 x 33.7 cm. (9⅞ x 13¼ in.), c. 1898
NPG.81.168
Gift of Joanna Sturm

c **Arthur Rubinstein and Dimitri Mitropoulos***
Rubinstein, Arthur, 1887-1982 (left)
Mitropoulos, Dimitri, 1896-1960 (right)
Alfred Bendiner, 1899-1964
India ink over pencil on paper, 25.1 x 29.7 cm. (9⅞ x 11¹¹⁄₁₆ in.), 1944
Illustration for *The Evening Bulletin*, Philadelphia, June 20, 1944
T/NPG.84.35.92

d **Sacco and Vanzetti**
Vanzetti, Bartolomeo, 1888-1927 (left)
Sacco, Nicola, 1891-1927 (right)
Unidentified photographer
Photograph, gelatin silver print, 13.4 x 24.1 cm. (5¼ x 9½ in.), c. 1921
NPG.80.293

e **The Sad Parting Between Two Old Friends**
(left to right)
Calhoun, John Caldwell, 1782-1850
Foote, Henry Stuart, 1804-1880
Benton, Thomas Hart, 1782-1858
David Claypoole Johnston, 1799-1865
Lithograph, 16.3 x 22.6 cm. (6⁷⁄₁₆ x 8⅞ in.), c. 1850
NPG.84.225

f

g

h

i

f **Self-Portrait with Rita**
 Benton, Thomas Hart, 1889-1975
 Self-portrait
 Oil on canvas, 125.7 x 101.6 cm.
 (49½ x 40 in.), 1922
 NPG.75.30
 Gift of Mr. and Mrs. Jack H. Mooney

g **Daniel Shays and Job Shattuck**
 Shays, Daniel, c. 1747-1825 (left)
 Shattuck, Job, 1736-1814 (right)
 Unidentified artist
 Relief cut, 8.7 x 13 cm. (3½ x 5⅛ in.),
 1787
 Published in *Bickerstaff's Boston
 Almanack for 1787*, third edition,
 Boston, c. 1787
 NPG.75.25

h **General Sheridan and His Division
 Commanders**
 (seated, left to right)
 Gregg, David McMurtrie,
 1833-1916
 Merritt, Wesley, 1834-1910
 Wilson, James Harrison, 1837-1925
 (standing, left to right)
 Davies, Henry Eugene, 1836-1894
 Sheridan, Philip Henry, 1831-1888
 Torbert, Alfred Thomas
 Archimedes, 1833-1880
 Unidentified photographer
 Photograph, albumen silver print,
 15.7 x 20.6 cm. (6³⁄₁₆ x 8⅛ in.), 1864
 NPG.83.214

i **Philip Henry Sheridan and His Staff**
 (left to right)
 Merritt, Wesley, 1834-1910
 Sheridan, Philip Henry, 1831-1888
 Crook, George, 1829-1890
 Forsyth, George Alexander,
 1837-1915
 Custer, George Armstrong,
 1839-1876
 Alexander Gardner, 1821-1882
 Photograph, albumen silver print,
 32.7 x 27.8 cm. (12⅞ x 10¹⁵⁄₁₆ in.),
 c. 1865
 NPG.78.16

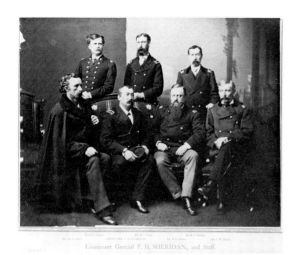

a

b

c

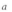

a **Philip Henry Sheridan and His Staff**
(seated, left to right)
Custer, George Armstrong,
1839-1876
Sheridan, Philip Henry, 1831-1888
Sweitzer, Nelson B., ?-1898
Forsyth, James W., 1836-1906
(standing, left to right)
Forsyth, George Alexander,
1837-1915
Asch, Morris Joseph, 1833-1902
Sheridan, Michael Vincent,
1840-1918
J. Lee Knight, ?-?
Photograph, albumen silver print,
22.2 x 29.1 cm. (8¾ x 11½ in.),
1872
NPG.78.17

b **Sherman and His Staff**
(seated, center)
Sherman, William Tecumseh,
1820-1891
Alexander Gardner, 1821-1882
Photograph, albumen silver print,
43.3 x 34.3 cm. (17 x 13½ in.), 1865
NPG.80.166

c **Siege of Vicksburg — General Grant
Meeting the Rebel General
Pemberton**
Pemberton, John Clifford,
1814-1881 (left)
Grant, Ulysses S., 1822-1885 (right)
Francis H. Schell, 1834-1909
Wood engraving, 20 x 23.6 cm. (7⅞ x
9¼ in.), 1863
Published in *Frank Leslie's
Illustrated Newspaper*, August 8,
1863
NPG.84.339

d

f

e

d **Signing of the Treaty of Versailles**
John Christen Johansen, 1876-1964
Oil on canvas, 248.9 x 224.8 cm.
(98 x 88½ in.), 1919
NPG.65.82
*Transfer from the National Museum
of American Art; gift of the city of
New York through the National
Committee, 1923*

e **Signing of the Treaty of Versailles**
Key
1. Pershing, John Joseph,
1860-1948
2. Paderewski, Ignace Jan,
1860-1941
3. Bliss, Tasker Howard, 1853-1930
4. House, Edward Mandell,
1858-1938
5. White, Henry, 1850-1927
6. Lansing, Robert, 1864-1928

7. Wilson, Thomas Woodrow,
1856-1924
John Christen Johansen, 1876-
1964
Oil on canvas, 176.5 x 162.5 cm.
(69½ x 64 in.), 1919
NPG.65.83
*Transfer from the National Museum
of American Art; gift of an
anonymous donor through Mrs.
Elizabeth Rogerson, 1926*

f **William Sowden Sims and William
Mitchell**
Sims, William Sowden, 1858-1936
(left)
Mitchell, William, 1879-1936
(right)
Harris and Ewing studio, active
1905-1977
Photograph, gelatin silver print, 17.6
x 12.8 cm. (6¹⁵⁄₁₆ x 4¹⁵⁄₁₆ in.), c. 1968
from c. 1921 negative
NPG.81.11

a

b

c

d

e

f

Sketches from the Civil War in North America
Adalbert John Volck ("V. Blada"), 1828-1912
Ten etchings, twenty-four transfer lithographs, and lithographed title page (as originally issued), paper size approximately 23 x 30 cm. (9¹⁄₁₆ x 11¹³⁄₁₆ in.), 1863-1864
NPG.79.95.a-dd

a **Butler's Victims of Fort St. Philip**
Butler, Benjamin Franklin, 1818-1893
Transfer lithograph, 1864
NPG.79.95.u

b **The Emancipation Proclamation**
Lincoln, Abraham, 1809-1865
Transfer lithograph, 1864
NPG.79.95.v

c **Free Negroes in the North**
Beecher, Henry Ward, 1813-1887
Transfer lithograph, 1864
NPG.79.95.w

d **Passage Through Baltimore**
Lincoln, Abraham, 1809-1865
Etching, 1863
NPG.79.95.b

e **Scene in Stonewall Jackson's Camp**
Jackson, Thomas Jonathan ("Stonewall"), 1824-1863
Etching, 1863
NPG.79.95.j

f **Worship of the North**
Sumner, Charles, 1811-1874
Beecher, Henry Ward, 1813-1887
Lincoln, Abraham, 1809-1865
Frémont, John Charles, 1813-1890
Scott, Winfield, 1786-1866
Etching, 1863
NPG.79.95.a

g

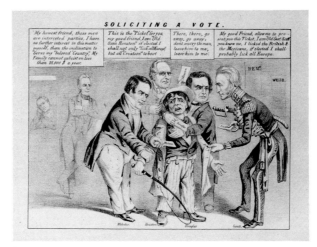

h

i

g **Joseph and Hyrum Smith**
 Smith, Hyrum, 1800-1844 (left)
 Smith, Joseph, 1805-1844 (right)
Unidentified artist
Lithograph, 27 x 20 cm. (10½ x 8
 in.), 1847
NPG.79.159

h **Soliciting a Vote**
 (left to right)
 Clay, Henry, 1777-1852
 Webster, Daniel, 1782-1852
 Houston, Samuel, 1793-1863
 Douglas, Stephen Arnold,
 1813-1861
 Scott, Winfield, 1786-1866
David Claypoole Johnston, 1799-
 1865
Lithograph, 16.4 x 22.4 cm. (6⁷⁄₁₆ x
 8¹³⁄₁₆ in.), c. 1852
NPG.84.224

i **Something for the Boys***
 Merman, Ethel, 1909-1984 (center)
Alfred Bendiner, 1899-1964
India ink over pencil on paper, 29.1
 x 28.7 cm. (11½ x 11⁵⁄₁₆ in.), 1944
Illustration for *The Evening
 Bulletin*, Philadelphia, January 11,
 1944
T/NPG.85.208.94
Gift of Alfred Bendiner Foundation

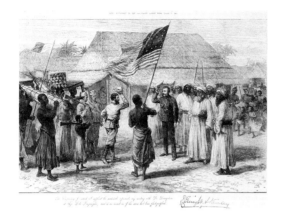

a

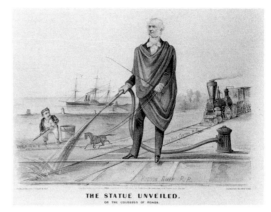

b

General Tom Thumb and Wife.

c

d

a **Henry Stanley Meeting Dr. Livingstone**
Stanley, Henry Morton, 1841-1904 (left of center)
H. H., ?-?
Wood engraving, 32.5 x 49.1 cm. (13¾ x 19⁵⁄₁₆ in.), 1872
Published in *Illustrated London News*, August 10, 1872
NPG.78.262

b **The Statue Unveiled**
Fisk, James, 1834-1872 (left)
Vanderbilt, Cornelius, 1794-1877 (right)
Currier and Ives lithography company, active 1857-1907, after photographs
Lithograph, 22.5 x 34.2 cm. (8⅞ x 13⁷⁄₁₆ in.), 1869
NPG.85.150

c **Charles Sherwood Stratton with Lavinia Warren Stratton**
Stratton, Charles Sherwood, ("Tom Thumb") 1838-1883
Mathew Brady, 1823-1896
Photograph, albumen silver print, 8.5 x 5.4 cm. (3⅜ x 2⅛ in.), 1875
NPG.78.163

d **Charles Sherwood Stratton with Lavinia Warren Stratton**
Stratton, Charles Sherwood, ("Tom Thumb") 1838-1883
Mathew Brady, 1823-1896
Photograph, albumen silver print, 8.5 x 5.3 cm. (3⅜ x 2⅛ in.), 1863
NPG.82.96
Gift of Forrest H. Kennedy

e

f

g

h

e **General Stuart with His Cavalry**
Stuart, James Ewell Brown ("Jeb"),
1833-1864 (right)
Frank Vizetelly, 1830-1883?
Wood engraving, 23.9 x 34.8 cm. (9⅜
x 13¹¹⁄₁₆ in.), 1862
Published in *Illustrated London
News*, London, October 4, 1862
NPG.84.341

f **Billy Sunday**
Sunday, William Ashley ("Billy"),
1862-1935
George Bellows, 1882-1925
Lithograph, 22.9 x 41.3 cm. (9 x 16¼
in.), 1923
NPG.74.69

g **The Supreme Moment. Chief Justice
Fuller Administering the Oath of
Office to President William
McKinley, March 4, 1901**
McKinley, William, 1843-1901
(center)
Roosevelt, Theodore, 1858-1919
(second from right)
Underwood and Underwood, active
1882-c. 1950
Photograph, albumen silver print, 8
x 15.5 cm. (3³⁄₁₆ x 6⅛ in.), 1901
NPG.80.181

h **The Surrender of Genl. Joe Johnston
near Greensboro, N.C. April 26th.
1865**
Sherman, William Tecumseh,
1820-1891 (left)
Johnston, Joseph Eggleston,
1807-1891 (right)
Currier and Ives lithography
company, active 1857-1907
Hand-colored lithograph, 20.8 x 31.9
cm. (8³⁄₁₆ x 12⁹⁄₁₆ in.), 1865
NPG.84.336

a

b SURRENDER OF GEN! LEE, AT APPOMATTOX C.H. Va APRIL 9th 1865.

c

d

a **The Surrender of General Lee**
Lee, Robert Edward, 1807-1870
(left)
Grant, Ulysses S., 1822-1885 (right)
P. S. Duval lithography company,
active 1837-1869
Lithograph with tintstone, 44.1 x
62.1 cm. (17⅜ x 24⁷⁄₁₆ in.), 1866
NPG.84.89

b **Surrender of Genl. Lee, at
Appomattox C.H. Va. April 9th
1865**
Grant, Ulysses S., 1822-1885 (left)
Lee, Robert Edward, 1807-1870
(right)
Currier and Ives lithography
company, active 1857-1907, after
photographs
Hand-colored lithograph, 30.3 x 22.6
cm. (11¹⁵⁄₁₆ x 8⅞ in.), 1865
NPG.84.87

c **Secretary Taft and His Party on the
Deck of the S.S. Manchuria***
Longworth, Alice Roosevelt,
1884-1980 (front row, center)
Longworth, Nicholas, 1869-1931
(front row, right)
Taft, William Howard, 1857-1930
(second row, center)
Unidentified photographer
Photograph, platinum print, 18.9 x
23.5 cm. (7⁷⁄₁₆ x 9¼ in.), 1905
T/NPG.81.158.90
Gift of Joanna Sturm

d **Secretary Taft and His Party Leaving
Ship at Yokohama**
Taft, William Howard, 1857-1930
(center)
William Dinwiddie, 1867-1934
Photograph, platinum print, 6.7 x 10
cm. (2⅝ x 3¹⁵⁄₁₆ in.), 1905
NPG.81.160
Gift of Joanna Sturm

e

f

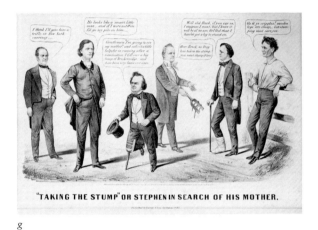

"TAKING THE STUMP" OR STEPHEN IN SEARCH OF HIS MOTHER.

g

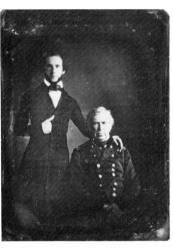

h

e **Secretary Taft and His Staff at Shiba Detached Palace**
Taft, William Howard, 1857-1930 (left)
William Dinwiddie, 1867-1934
Photograph, platinum print, 8.9 x 13 cm. (3½ x 5⅛ in.), 1905
NPG.81.162
Gift of Joanna Sturm

f **Secretary Taft and Miss Alice Roosevelt Leaving Ship at Yokohama***
Taft, William Howard, 1857-1930 (center)
Longworth, Alice Roosevelt, 1884-1980 (right)
William Dinwiddie, 1867-1934
Photograph, platinum print, 6.8 x 15.4 cm. (2¹¹⁄₁₆ x 6¹⁄₁₆ in.), 1905
T/NPG.81.161.90
Gift of Joanna Sturm

g **"Taking the Stump" or Stephen in Search of His Mother**
(left to right)
Bell, John, 1797-1869
Beecher, Henry Ward, 1813-1887
Douglas, Stephen Arnold, 1813-1861
Buchanan, James, 1791-1868
Breckinridge, John Cabell, 1821-1875
Lincoln, Abraham, 1809-1865
Currier and Ives lithography company, active 1857-1907, after photographs
Lithograph, 23.5 x 40.5 cm. (9¼ x 15¹⁵⁄₁₆ in.), 1860
NPG.83.240

h **Zachary Taylor and William S. Bliss**
Bliss, William Wallace Smith, 1815-1853 (left)
Taylor, Zachary, 1784-1850 (right)
Unidentified photographer
Daguerreotype, 10.8 x 8.2 cm. (4¼ x 3¼ in.), c. 1847
NPG.77.142

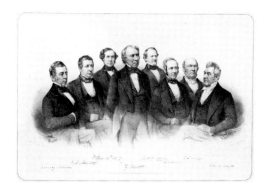

a

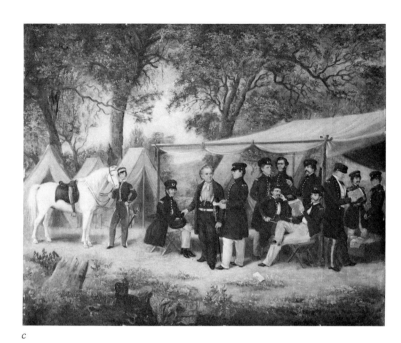

c

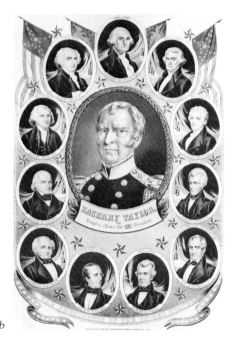

b

a **Zachary Taylor and His Cabinet**
 (left to right)
 Johnson, Reverdy, 1796-1876
 Meredith, William Morris,
 1799-1873
 Preston, William Ballard,
 1805-1862
 Taylor, Zachary, 1784-1850
 Crawford, George Walker,
 1798-1872
 Collamer, Jacob, 1791-1865
 Ewing, Thomas, 1789-1871
 Clayton, John Middleton,
 1796-1856
Francis D'Avignon, c. 1814-?, and
 Abram J. Hoffman, active
 1849-1860, after daguerreotype by
 Mathew Brady
Nagel and Weingaertner lithography
 company
Lithograph, 43.5 x 64.1 cm. (17⅛ x
 25¼ in.), 1849
NPG.76.53
Gift of Barry Bingham, Sr.

b **Zachary Taylor, the People's Choice
 for 12th. President**
 (clockwise from top)
 Washington, George, 1732-1799
 Jefferson, Thomas, 1743-1826
 Monroe, James, 1758-1831
 Jackson, Andrew, 1767-1845
 Harrison, William Henry,
 1773-1841
 Polk, James Knox, 1795-1849
 Tyler, John, 1790-1862
 Van Buren, Martin, 1782-1862
 Adams, John Quincy, 1767-1848
 Madison, James, 1751-1836
 Adams, John, 1735-1826
 (center)
 Taylor, Zachary, 1784-1850
Nathaniel Currier, 1813-1888
Hand-colored lithograph, 33 x 22.7
 cm. (13 x 8¹⁵⁄₁₆ in.), 1848
NPG.84.3

c **Zachary Taylor at Walnut Springs**
 Taylor, Zachary, 1784-1850 (third
 from left)
 Bliss, William Wallace Smith,
 1815-1853 (fourth from left)
 Bragg, Braxton, 1817-1876
 (standing, sixth from left)
William Garl Brown, Jr., 1823-1894
Oil on canvas, 76.2 x 91.4 cm. (30 x
 36 in.), 1847
NPG.71.57

d

e

f

g

d **Three Curtains***
 (left to right)
 Kennedy, Harold J., ?-1971
 Lederer, Francis, 1906-
 Swanson, Gloria, 1899-1983
 Alfred Bendiner, 1899-1964
 Crayon with opaque white on board,
 25.6 x 31 cm. (10¹⁄₁₆ x 12³⁄₁₆ in.),
 1942
 Illustration for *The Evening*
 Bulletin, Philadelphia, December
 8, 1942
 T/NPG.85.206.93
 Gift of Alfred Bendiner Foundation

e **Three Possibilities for 1908**
 (left to right)
 Herrick, Myron Timothy, 1854-
 1929
 Taft, William Howard, 1857-1930
 Francis, David Rowland, 1850-
 1927
 Jessie Tarbox Beals, 1870-1942
 Photograph, gelatin silver print, 18.3
 x 22 cm. (7³⁄₁₆ x 8¹¹⁄₁₆ in.), 1904
 NPG.81.136
 Gift of Joanna Sturm

f **The Trollope Family**
 Trollope, Frances, 1780-1863
 (seated, left)
 Childs and Inman lithography
 company, active 1831-1833
 Lithograph, 22.1 x 26.8 cm. (8¹¹⁄₁₆ x
 10⁹⁄₁₆ in.), 1832
 NPG.85.173

g **Harry S Truman and Thomas E.**
 Dewey
 Truman, Harry S, 1884-1972 (left)
 Dewey, Thomas E., 1902-1971
 (right)
 Ben Shahn, 1898-1969
 Color lithograph, 108 x 69.9 cm. (43
 x 27½ in.), 1948
 NPG.72.69

a

b

c

d

a **Truman and His Military Advisers**
 (left to right)
 Leahy, William Daniel, 1875-1959
 Arnold, Henry Harley, 1886-1950
 Truman, Harry S, 1884-1972
 Marshall, George Catlett, 1880-
 1959
 King, Ernest Joseph, 1878-1956
 Augustus Vincent Tack, 1870-1949
 Oil on canvas, 242.5 x 245.9 cm.
 (95½ x 97 in.), 1949
 NPG.67.68
 Gift of the Phillips Collection

b **Mark Twain and Helen Keller**
 Keller, Helen Adams, 1880-1968
 Twain, Mark (Samuel Langhorne
 Clemens), 1835-1910
 Isabel V. Lyon, 1868-1958
 Photographic negative, 8.8 x 8.8 cm.
 (3½ x 3½ in.), c. 1908
 NPG.79.163

c **Mark Twain and Helen Keller**
 Keller, Helen Adams, 1880-1968
 Twain, Mark (Samuel Langhorne
 Clemens), 1835-1910
 Isabel V. Lyon, 1868-1958
 Photographic negative, 8.7 x 8.8 cm.
 (3½ x 3½ in.), c. 1908
 NPG.79.164

d **Mark Twain and Helen Keller**
 Keller, Helen Adams, 1880-1968
 Twain, Mark (Samuel Langhorne
 Clemens), 1835-1910
 Isabel V. Lyon, 1868-1958
 Photographic negative, 8.6 x 8.6 cm.
 (3⁷/₁₆ x 3⁷/₁₆ in.), c. 1908
 NPG.79.165

e

f

g

h

e **Mark Twain and Helen Keller**
 Keller, Helen Adams, 1880-1968
 Twain, Mark (Samuel Langhorne
 Clemens), 1835-1910
 Isabel V. Lyon, 1868-1958
 Photographic negative, 8.8 x 8.8 cm.
 (3½ x 3½ in.), c. 1908
 NPG.79.166

f **Mark Twain and Helen Keller**
 Keller, Helen Adams, 1880-1968
 Twain, Mark (Samuel Langhorne
 Clemens), 1835-1910
 Isabel V. Lyon, 1868-1958
 Photographic negative, 8.7 x 8.8 cm.
 (3½ x 3½ in.), c. 1908
 NPG.79.167

g **Mark Twain and Helen Keller**
 Keller, Helen Adams, 1880-1968
 Twain, Mark (Samuel Langhorne
 Clemens), 1835-1910
 Isabel V. Lyon, 1868-1958
 Photographic negative, 8.7 x 8.8 cm.
 (3½ x 3½ in.), c. 1908
 NPG.79.168

h **Mark Twain and Literary Friends**
 (seated, left to right)
 Howells, William Dean, 1837-1920
 Twain, Mark (Samuel Langhorne
 Clemens), 1835-1910
 Alden, Henry Mills, 1836-1919
 Hazeltine, Mayo Williamson,
 1841-1909
 (standing, left to right)
 Harvey, George Brinton
 McClellan, 1864-1928
 Munro, David Alexander,
 c. 1845-1910
 Pach Brothers studio, active since
 1867
 Photograph, platinum print, 16.8 x
 22 cm. (6⅝ x 8¹¹⁄₁₆ in.), 1907
 NPG.81.74

a *b*

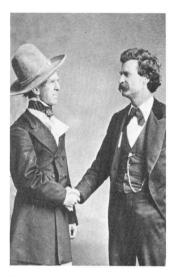

"UNCLE SAM" MAKING NEW ARRANGEMENTS.

c *d*

a **Mark Twain and Isabel V. Lyon**
Twain, Mark (Samuel Langhorne
Clemens), 1835-1910
Lyon, Isabel V., 1868-1958
William Ireland Starr, ?-?
Photograph, gelatin dry-plate
positive transparency, 4.4 x 10.6
cm. (1¾ x 4³⁄₁₆ in.), 1908
NPG.80.322
Gift of John Seelye

b **Mark Twain with Isabel V. Lyon and
Ralph Ashcroft**
(left to right)
Ashcroft, Ralph, ?-?
Twain, Mark (Samuel Langhorne
Clemens), 1835-1910
Lyon, Isabel V., 1868-1958
William Ireland Starr, ?-?
Photograph, gelatin dry-plate
positive transparency, 4.4 x 10.6
cm. (1¾ x 4³⁄₁₆ in.), 1908
NPG.80.323
Gift of John Seelye

c **Mark Twain and John T. Raymond**
Raymond, John T. ("John
O'Brien"), 1836-1887 (left)
Twain, Mark (Samuel Langhorne
Clemens), 1835-1910 (right)
Unidentified photographer
Photograph, albumen silver print,
9 x 5.8 cm. (3½ x 2¼ in.), c. 1875
NPG.80.90

d **"Uncle Sam" Making New
Arrangements**
(left to right)
Bell, John, 1797-1869
Breckinridge, John Cabell,
1821-1875
Douglas, Stephen Arnold,
1813-1861
"Uncle Sam"
Lincoln, Abraham, 1809-1865
Buchanan, James, 1791-1868
Currier and Ives lithography
company, active 1857-1907, after
photographs
Lithograph, 24.5 x 37.9 cm. (9⅝ x
14¹⁵⁄₁₆ in.), 1860
NPG.83.238

e

f

g

e **Union Generals**
(left to right)
Gorman, Willis Arnold, 1816-1876
Franklin, William Buel, 1823-1903
Heintzelman, Samuel Peter,
1805-1880
Porter, Andrew, 1820-1872
McDowell, Irvin, 1818-1885
McClellan, George Brinton,
1826-1885
McCall, George Archibald,
1802-1868
Buell, Don Carlos, 1818-1898
Blerker, Louis (Ludwig), 1812-1863
Casey, Silas, 1807-1882
Porter, Fitz John, 1822-1901
Attributed to Mathew Brady,
1823-1896
Photograph, albumen silver print,
22.4 x 39.5 cm. (8¹³⁄₁₆ x 15⁹⁄₁₆ in.),
1861
NPG.81.27

f **The United States Senate A.D. 1850**
Clay, Henry, 1777-1852 (standing,
center)
Robert Whitechurch, 1814-c. 1880,
after Peter Frederick Rothermel,
after daguerreotypes
Engraving, 68.5 x 86.8 cm. (27 x 34³⁄₁₆
in.), 1855
NPG.77.11
Gift of Mrs. Richard K. Doud

g **United States Senate Chamber**
Thomas Doney, active 1844-1870s,
after James A. Whitehorne, after
daguerreotypes by Victor Piard at
Anthony, Clark and Company
Mezzotint and etching, 68.2 x 91.4
cm. (26⅞ x 36 in.), 1846
NPG.75.79

a

b

c

a **U.S.O. Tour***
 (clockwise from top left)
 Marx, Groucho, 1890-1977
 Brown, Joe E., 1892-1973
 Gable, Clark, 1901-1960
 Menjou, Adolph, 1890-1963
 Alfred Bendiner, 1899-1964
 Crayon with opaque white on board,
 30.6 x 29 cm. (12 1/16 x 11 7/16 in.),
 c. 1943
 T/NPG.85.196.87
 Gift of Alfred Bendiner Foundation

b **Henry Villard and Group of
 Unidentified Men**
 Villard, Henry, 1835-1900 (seated,
 with cane and hat)
 F. Jay Haynes, 1853-1921
 Photograph, albumen silver print,
 12.4 x 20.9 cm. (4 7/8 x 8 1/4 in.), 1883
 NPG.77.62
 Gift of Henry Villard

c **The Vinson Court***
 (left to right)
 Clark, Tom Campbell, 1899-1977
 Jackson, Robert H., 1892-1954
 Frankfurter, Felix, 1882-1965
 Black, Hugo LaFayette, 1886-1971
 Vinson, Fred M., 1890-1953
 Reed, Stanley Forman, 1884-1980
 Douglas, William Orville,
 1898-1980
 Burton, Harold H., 1888-1964
 Minton, Sherman, 1890-1965
 Felix Topolsky, 1907-
 Pencil and ink on paper, three sheets,
 25 x 106 cm. (9 7/8 x 41 3/4 in.)
 overall; 25 x 35.6 cm. (9 7/8 x 14 in.)
 each sheet, 1950
 T/NPG.75.43.90
 Gift of Alexander Lieberman

d

e

f

g

d **George Wallace, Cotton Bowl,
Dallas, 1964***
Wallace, George Corley, 1919-
(center)
Garry Winogrand, 1928-1984
Photograph, gelatin silver print, 31.5
x 47 cm. (12⁷⁄₁₆ x 18⁹⁄₁₆ in.), 1964
T/NPG.84.28

e **David Warfield and Marie Bates**
Warfield, David, 1866-1951
Alfred J. Frueh, 1880-1968
Linocut, 33.1 x 25 cm. (13 x 9¹³⁄₁₆
in.), 1922
Published in Alfred J. Frueh's *Stage
Folk*, New York, 1922
NPG.84.229.hh

f **Booker T. Washington and
Distinguished Guests at Tuskegee
Institute**
Washington, Booker Taliaferro,
1856-1915 (front row, center)
Underwood and Underwood, active
1882-c. 1950
Photograph, gelatin silver print, 8.2
x 15.9 cm. (3¼ x 6¹⁄₁₆ in.), c. 1906
NPG.80.88

g **The Washington Family**
(left to right)
Custis, George Washington Parke,
1781-1857
Washington, George, 1732-1799
Custis, Eleanor Parke, 1779-1852
Washington, Martha Dandridge
Custis, 1731-1802
Lee, William, c. 1768-c. 1804
Edward Savage, 1761-1817, and
David Edwin, 1776-1841, after
Edward Savage
Stipple engraving, 46.8 x 62.3 cm.
(24½ x 18⁷⁄₁₆ in.), 1798
NPG.79.112

a

b

c

d

a **George Washington and Benjamin Franklin**
 Washington, George, 1732-1799 (left)
 Franklin, Benjamin, 1706-1790 (right)
 Unidentified artist, after Johann Caspar Lavater
 Etching and engraving, 10.1 x 15.9 cm. (4 x 6¼ in.), 1788
 Published in *The Columbian Magazine or Monthly Miscellany*, Philadelphia, March 1788
 NPG.77.78

b **George Washington and Horatio Gates**
 Washington, George, 1732-1799 (left)
 Gates, Horatio, 1728/29-1806 (right)
 Unidentified artist
 Relief cut, 7 x 9.7 cm. (2¾ x 3⅞ in.), 1777
 Published in *Bickerstaff's Boston Almanack for 1778*, Danvers, 1777
 NPG.79.78

c **G. Washington in His Last Illness**
 Washington, Martha Dandridge Custis, 1731-1802 (left)
 Washington, George, 1732-1799 (right)
 Unidentified artist
 Hand-colored etching, 25 x 24 cm. (9⅞ x 9⅜ in.), 1800
 NPG.85.137

d **Joseph Weber and Lewis Fields**
 Weber, Joseph, 1867-1942 (left)
 Fields, Lewis, 1867-1941 (right)
 Alfred J. Frueh, 1880-1968
 Linocut, 27.1 x 21.8 cm. (10⅝ x 8⁹⁄₁₆ in.), 1922
 Published in Alfred J. Frueh's *Stage Folk*, New York, 1922
 NPG.84.229.ii

e

f

g

h

i

e **Max Weber and Friends**
 Weber, Max, 1881-1961 (standing, center)
 Clara E. Sipprell, 1885-1975
 Photograph, gelatin silver print, 18.7 x 23.5 cm. (7⅜ x 9¼ in.), c. 1920
 NPG.82.194
 Bequest of Phyllis Fenner

f **Daniel Webster Addressing the United States Senate**
 Webster, Daniel, 1782-1852 (standing, right)
 Eliphalet Brown, Jr., 1816-1886, after photographs
 Lithograph, 55.3 x 75.6 cm. (21¾ x 29¾ in.), 1860
 NPG.80.226

g **Benjamin West and Family**
 West, Benjamin, 1738-1820
 George S. Facius and Johann G. Facius, active 1776-1802, after Benjamin West
 Hand-colored mezzotint, 50.3 x 64.2 cm. (19¾ x 25¼ in.), 1779
 NPG.78.85

h **Benjamin West and Family**
 West, Benjamin, 1738-1820
 D. P. Pariset, 1740-?
 Stipple and line engraving, 17.7 x 23 cm. (6¹⁵⁄₁₆ x 9¹⁄₁₆ in.), 1781
 NPG.78.42

i **Benjamin West and Family**
 West, Benjamin, 1738-1820
 Self-portrait
 Oil on canvas, 33 x 40.6 cm. (13 x 16 in.), c. 1795
 NPG.77.34

b

c

a

a **Benjamin West with Frank W.**
 Wilkin and Henry Wilkin
 (left to right)
 West, Benjamin, 1738-1820
 Wilkin, Henry T. C., 1801-1852
 Wilkin, Frank William, 1790/91-
 1842
 Frank William Wilkin, 1790/91-1842
 Oil on canvas, 177.7 x 142.2 cm.
 (70 x 56 in.), c. 1820
 NPG.66.71
 Transfer from the National Museum
 of American Art; gift of Mrs.
 Mabel Wiles, 1948

b **Senator Burton K. Wheeler and the**
 Court Fight
 (left to right)
 Cummings, Homer Stille,
 1870-1956
 Roosevelt, Franklin Delano,
 1882-1945
 Hughes, Charles Evans, 1862-1948
 Wheeler, Burton Kendall,
 1882-1975
 Clifford Kennedy Berryman,
 1869-1949
 India ink over pencil on paper, 31.8
 x 36.1 cm. (12½ x 14 3/16 in.), 1937
 NPG.84.162
 Gift of John L. Wheeler

c **Where's My Thunder?**
 (left to right)
 Webster, Daniel, 1782-1852
 Clay, Henry, 1777-1852
 Cass, Lewis, 1782-1866
 Foote, Henry Stuart, 1804-1880
 David Claypoole Johnston, 1799-1865
 Lithograph, 17.3 x 22.2 cm. (6 13/16 x
 8¾ in.), c. 1850
 NPG.84.223

d

e

d **The Wild Bunch**
 (seated, left to right)
 Longbaugh, Harry ("The Sundance
 Kid"), c. 1862-1909
 Kilpatrick, Ben ("The Tall
 Texan"), ?-1912
 Parker, Robert LeRoy ("Butch
 Cassidy"), c. 1865-1909
 (standing, left to right)
 Carver, William Todd ("Bill"),
 ?-1901
 Logan, Harvey ("Kid Curry"),
 c. 1865-1903
John Swartz, ?-?
Photograph, gelatin silver print, 16.6
 x 31.6 cm. (6⁹⁄₁₆ x 8½ in.), 1900
NPG.82.66
Gift of Pinkerton's, Incorporated

e **Loretta Young and Her Sisters***
 (left to right)
 Young, Loretta, 1913-
 Blane, Sally, 1910-
 Young, Polly Ann, 1908-
Nickolas Muray, 1892-1965
Photograph, gelatin silver print, 24.4
 x 19.5 cm. (9⅝ x 7¹¹⁄₁₆ in.), 1978
 from 1930 negative
T/NPG.78.151

TIME COLLECTION

As a celebration of *TIME* magazine's fortieth anniversary in 1963, Lyndon B. Johnson quipped that he and many of the 283 other notables present who had appeared on that weekly's cover owed *TIME*'s founding editor, Henry Luce, a debt of thanks for his policy of selecting cover subjects on "a basis other than beauty." Today, the National Portrait Gallery acknowledges its gratitude to Luce and his magazine on this same count and on several others as well. Not only did *TIME* make portraits of the newsworthy the primary focus of its covers over the years; it also had the foresight to save much of the original artwork on which they had been based. By 1978, although the magazine's cover archive did not by any means include all of these drawn, painted, sculpted, and photographic images, it did possess more than eight hundred of them, and in that year Time, Inc. presented this extraordinary pictorial record of our near past to the Gallery. The gift has enriched the museum's holdings of twentieth-century portraiture immeasurably, but the generosity did not stop there. Since then, Time, Inc. has given the Gallery 297 other pieces of original cover artwork.

The portraits in the *TIME* Collection are richly diverse. Among them are a good many images that were based on life sittings with the subject. In style they range from the journalistically real to the semi-abstract. In addition to works by some of the more distinguished periodical illustrators of the past six decades, the collection also contains works by such artists as Peter Hurd, Pietro Annigoni, Robert Vickrey, Roy Lichtenstein, and Marisol Escobar. In other words, the portraits in the Gallery's *TIME* Collection hold our interest not only because of the significant historic personalities they portray, but in many cases also because of who made them.

The likenesses reproduced in the following pages are only a portion of the portraits in the *TIME* Collection and do not include any of the many images of foreign personalities found in it. It is hoped that in the not-too-distant future a comprehensive checklist of all of these pieces will be published. It should also be noted that the criteria—cited in this volume's preface—for determining whether the likeness of a given individual can be admitted to the Gallery's collection do not apply to this body of work. Here, only one factor is decisive: regardless of the subject, the portrait must have been done for a *TIME* cover.

Frederick S. Voss

Adams, Ansel, 1902-1984
Photographer, conservationist
David Hume Kennerly, 1947-
Color photograph, 35.6 x 28 cm. (13⅞
 x 11 in.), 1979
TIME cover: September 3, 1979
NPG.82.TC58
Gift of Time, Inc.

Allen, Heywood ("Woody"), 1935-
Film director, writer, actor
Richard Sparks, 1944-
Oil on canvas, 69.5 x 51.4 cm. (27⅜ x
 21 in.), 1979
TIME cover: April 30, 1979
NPG.82.TC59
Gift of Time, Inc.

Agnew, Spiro Theodore, 1918-
Vice-President of the United States
Louis Glanzman, 1922-
Bricks, board, paper, and tempera,
 55.9 x 33.6 x 45.2 cm. (22 x 13¼ x
 17¹³⁄₁₆ in.), 1968
TIME cover: September 20, 1968
NPG.78.TC194
Gift of Time, Inc.

**Anderson, Jackson Northman
 ("Jack"),** 1922-
Journalist
Harvey Simpson, 1916-1973
Tempera on board, 55.2 x 44.5 cm.
 (21¾ x 17½ in.), 1972
TIME cover: April 3, 1972
NPG.78.TC204
Gift of Time, Inc.

Albert, Carl Bert, 1908-
Statesman
Robert Peak, 1928-
Watercolor and ink on cut paper on
 board, 72.3 x 54.6 cm. (28½ x 21½
 in.), 1971
TIME cover: February 1, 1971
NPG.78.TC197
Gift of Time, Inc.

Anderson, Maxwell, 1888-1959
Playwright
The Vandamm Studio, active 1930s
Photograph, gelatin silver print, 25.3
 x 20.3 cm. (9¹⁵⁄₁₆ x 8 in.), 1934
TIME cover: December 10, 1934
NPG.82.TC60
Gift of Time, Inc.

**Ali, Muhammad (Cassius Marcellus
 Clay, Jr.),** 1942-
Athlete
Boris Chaliapin, 1904-1979
Pencil and tempera on board, 48.2 x
 38.1 cm. (19 x 15 in.), 1963
TIME cover: March 22, 1963
NPG.78.TC307
Gift of Time, Inc.

Andrews, Julie, 1935-
Actress
John Koch, 1909-
Oil on canvas, 51.4 x 41.2 cm. (19⅞ x
 16¼ in.), 1966
TIME cover: December 23, 1966
NPG.78.TC206
Gift of Time, Inc.

Allen, Heywood ("Woody"), 1935-
Film director, writer, actor
Frank Cowan, ?-?
Color photograph, 34 x 23.2 cm. (13⅜
 x 9⅛ in.), 1972
TIME cover: July 3, 1972
NPG.78.TC200
Gift of Time, Inc.

Arden, Elizabeth, 1884-1966
Businesswoman
Boris Chaliapin, 1904-1979
Tempera on board, 33 x 30.5 cm. (13
 x 12 in.), 1946
TIME cover: May 6, 1946
NPG.78.TC210
Gift of Time, Inc.

Armstrong, Neil Alden, 1930-
Astronaut
Louis Glanzman, 1922-
Acrylic and casein on masonite, 81.3
x 61 cm. (32 x 24 in.), 1969
TIME cover: July 25, 1969
NPG.78.TC844
Gift of Time, Inc.

Baldwin, James, 1924-
Author
Boris Chaliapin, 1904-1979
Watercolor and pencil on board, 35.3
x 25.2 cm. (13⅞ x 9⅞ in.), c. 1963
TIME cover: May 17, 1963
NPG.78.TC221
Gift of Time, Inc.

Bacall, Lauren, 1924-
Actress
Boris Chaliapin, 1904-1979
Tempera and pencil on board, 48.2 x
38.1 cm. (19 x 15 in.), 1966
TIME cover: July 29, 1966
NPG.78.TC213
Gift of Time, Inc.

Bancroft, Anne, 1931-
Actress
Aaron Bohrod, 1907-
Tempera on masonite, 39.7 x 28.2
cm. (15⅝ x 11⅛ in.), 1959
TIME cover: December 21, 1959
NPG.78.TC223
Gift of Time, Inc.

Baez, Joan, 1941-
Singer, reformer
Russell Hoban, 1925-
Casein on board, 74.6 x 50.8 cm.
(29⅜ x 21 in.), 1962
TIME cover: November 28, 1962
NPG.78.TC215
Gift of Time, Inc.

Barkley, Alben William, 1877-1956
Vice-President of the United States
Samuel Johnson Woolf, 1880-1948
Charcoal on paper, 30.5 x 27.7 cm.
(14 x 10⅞ in.), 1937
TIME cover: August 23, 1937
NPG.78.TC224
Gift of Time, Inc.

Bailey, F. Lee, 1933-
Lawyer
Barron Storey, 1945-
Acrylic and ink on board, 71.7 x 51.1
cm. (28¼ x 20⅛ in.), 1976
TIME cover: February 16, 1976
NPG.78.TC218
Gift of Time, Inc.

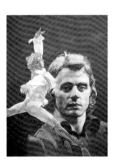

Baryshnikov, Mikhail Nikolayevich,
1948-
Dancer
Barron Storey, 1945-
Acrylic and ink on board, 86.3 x 62.8
cm. (34 x 24¾ in.), 1975
TIME cover: May 19, 1975
NPG.78.TC860
Gift of Time, Inc.

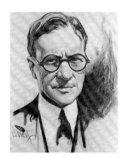

Baker, Newton Diehl, 1871-1937
Statesman
Samuel Johnson Woolf, 1880-1948
Charcoal on paper, 34.3 x 26.4 cm.
(13½ x 10¼ in.), 1932
TIME cover: May 23, 1932
NPG.78.TC220
Gift of Time, Inc.

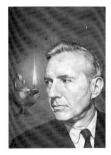

Barzun, Jacques Martin, 1907-
Historian
Boris Chaliapin, 1904-1979
Tempera, pencil, and pastel on
paper, 51.4 x 38.1 cm. (20¼ x 15
in.), 1956
TIME cover: June 14, 1956
NPG.78.TC228
Gift of Time, Inc.

Beck, David Daniel, 1894-
Labor leader
Boris Chaliapin, 1904-1979
Tempera and ink on board, 49.5 x
 38.1 cm. (19¾ x 15 in.), 1957
TIME cover: April 8, 1957
NPG.78.TC232
Gift of Time, Inc.

Benson, Ezra Taft, 1899-
Statesman
Aaron Bohrod, 1907-
Tempera on masonite, 38.7 x 28.2
 cm. (15¼ x 11⅛ in.), 1956
TIME cover: May 7, 1956
NPG.78.TC238
Gift of Time, Inc.

Bing, Sir Rudolph, 1902-
Opera manager
Henry Koerner, 1915-
Oil on canvas, 46 x 32.8 cm. (18⅛ x
 12⅞ in.), 1966
TIME cover: September 23, 1966
NPG.78.TC243
Gift of Time, Inc.

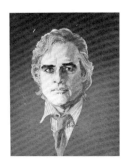

Black, Hugo LaFayette, 1886-1971
Justice of the United States Supreme
 Court
Robert Vickrey, 1926-
Tempera and ink on board, 52.7 x 40
 cm. (20¾ x 15¾ in.), 1964
TIME cover: October 9, 1964
NPG.78.TC244
Gift of Time, Inc.

Brando, Marlon, 1924-
Actor
Robert Peak, 1928-
Charcoal on colored paper, 61 x 48.2
 cm. (24 x 19 in.), 1973
TIME cover: January 22, 1973
NPG.78.TC248
Gift of Time, Inc.

Brooke, Edward William, 1919-
Statesman
Henry Koerner, 1915-
Oil on canvas, 32.4 x 45.7 cm. (12¾ x
 18 in.), 1967
TIME cover: February 17, 1967
NPG.78.TC258
Gift of Time, Inc.

Brown, James Nathaniel ("Jimmy"),
 1936-
Athlete
Henry Koerner, 1915-
Oil on canvas, 46.3 x 33 cm. (18¼ x
 13 in.), 1965
TIME cover: November 26, 1965
NPG.78.TC261
Gift of Time, Inc.

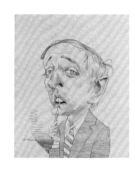

Buckley, William Frank, Jr., 1925-
Editor, author
David Levine, 1926-
Ink on paper, 34.6 x 27.9 cm. (13⅝ x
 11 in.), 1967
TIME cover: November 3, 1967
NPG.78.TC264
Gift of Time, Inc.

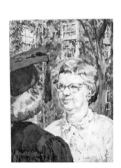

Bunting, Mary, 1910-
Educator
Henry Koerner, 1915-
Oil on canvas, 55.9 x 40.6 cm. (22⅛ x
 16 in.), 1961
TIME cover: November 3, 1961
NPG.78.TC266
Gift of Time, Inc.

Burns, Arthur Frank, 1904- 1987
Economist
Boris Chaliapin, 1904-1979
Watercolor, pencil, and paper collage
 on board, 48.2 x 38.1 cm. (19 x 15
 in.), 1970
TIME cover: June 1, 1970
NPG.78.TC267
Gift of Time, Inc.

Byrd, Richard Evelyn, 1888-1957
Explorer
Samuel Johnson Woolf, 1880-1948
Charcoal on paper, 33.6 x 28.5 cm.
(13¼ x 11¼ in.), 1928
TIME cover: August 20, 1928
NPG.78.TC269
Gift of Time, Inc.

Callas, Maria, 1923-1977
Singer
Henry Koerner, 1915-
Oil on canvas, 55.9 x 71.1 cm. (22 x
28 in.), 1956
TIME cover: October 29, 1956
NPG.78.TC271
Gift of Time, Inc.

Caplin, Alfred Gerald ("Al Capp"),
1909-1979
Cartoonist
Boris Chaliapin, 1904-1979
Tempera and ink on board, 33.3 x
30.2 cm. (13⅛ x 11⅞ in.), 1970
TIME cover: November 6, 1970
NPG.78.TC274
Gift of Time, Inc.

Carson, Johnny, 1925-
Entertainer
Robert Berks, 1922-
Bronze, 53.3 cm. (21 in.), 1967
TIME cover: May 19, 1967
NPG.78.TC281
Gift of Time, Inc.

Carter, Jimmy (James Earl, Jr.), 1924-
Thirty-ninth President of the United
States
Jack H. Breslow, 1927-
Tempera on board, 33.6 x 24.8 cm.
(13¼ x 9¾ in.), 1971
TIME cover: May 31, 1971
NPG.78.TC284
Gift of Time, Inc.

Carter, Jimmy (James Earl, Jr.), 1924-
Thirty-ninth President of the United
States
Alan Reingold, 1954-
Grease pencil and ink on board, 56.5
x 40 cm. (22¼ x 15¾ in.), 1976
TIME cover: May 10, 1976
NPG.78.TC286
Gift of Time, Inc.

Carter, Jimmy (James Earl, Jr.), 1924-
Thirty-ninth President of the United
States
James Sharpe, 1936-
Acrylic and ink on board, 66 x 47.8
cm. (26 x 18¹³⁄₁₆ in.), 1978
TIME cover: October 2, 1978
NPG.82.TC88
Gift of Time, Inc.

Carter, Jimmy (James Earl, Jr.), 1924-
Thirty-ninth President of the United
States
Edward Sorel, 1929-
Ink and watercolor on board, 50.6 x
41.3 cm. (19¹⁵⁄₁₆ x 6¼ in.), 1980
TIME cover: April 28, 1980
NPG.82.TC84
Gift of Time, Inc.

Carter, Jimmy (James Earl, Jr.), 1924-
Thirty-ninth President of the United
States
Barron Storey, 1945-
Acrylic, ink, and airbrush on board,
80.5 x 60.7 cm. (31¹¹⁄₁₆ x 23⅞ in.),
1980
TIME cover: February 4, 1980
NPG.82.TC86
Gift of Time, Inc.

Carter, Jimmy (James Earl, Jr.), 1924-
Thirty-ninth President of the United
States
James Browning Wyeth, 1946-
Watercolor on paper, 34.6 x 27.3 cm.
(13½ x 10¾ in.), 1976
TIME cover: January 3, 1977
NPG.78.TC288
Gift of Time, Inc.

Carter, William Alton, III ("Billy"),
 1937-
Businessman
David Levine, 1926-
Ink and watercolor on paper, 34.6 x
 27.9 cm. (13⅝ x 11 in.), 1980
TIME cover: August 4, 1980
NPG.82.TC80
Gift of Time, Inc.

Chessman, Caryl Whittier,
 1921-1960
Criminal
Bernard Safran, 1924-
Acrylic on masonite, 61 x 43.8 cm.
 (24 x 17¼ in.), 1960
TIME cover: March 21, 1960
NPG.78.TC301
Gift of Time, Inc.

Cavett, Dick, 1936-
Entertainer
Dugald Stermer, 1936-
Acrylic on canvas, 45.7 x 35.6 cm.
 (18 x 14 in.), 1971
TIME cover: June 7, 1971
NPG.78.TC292
Gift of Time, Inc.

Child, Julia, 1912-
Chef, author
Boris Chaliapin, 1904-1979
Tempera on board, 52.7 x 40 cm.
 (20¾ x 15¾ in.), 1966
TIME cover: November 25, 1966
NPG.78.TC303
Gift of Time, Inc.

Cerf, Bennett, 1898-1971
Publisher
Pietro Annigoni, 1910-
Watercolor on paper, 80 x 60.3 cm.
 (31½ x 23¾ in.), 1966
TIME cover: December 16, 1966
NPG.78.TC294
Gift of Time, Inc.

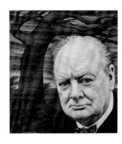

Churchill, Sir Winston Spencer,
 1874-1965
British statesman, honorary United
 States citizen
Ernest Hamlin Baker, 1889-1975
Watercolor on board, 29.8 x 26.7 cm.
 (11¾ x 10½ in.), 1949
TIME cover: January 2, 1950
NPG.78.TC305
Gift of Time, Inc.

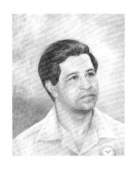

Chavez, Cesar Estrada, 1927-
Labor leader
Manuel Acosta, 1921-
Oil on canvas, 59.7 x 49.5 cm. (23½ x
 19½ in.), 1969
TIME cover: July 4, 1969
NPG.78.TC298
Gift of Time, Inc.

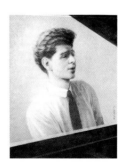

Cliburn, Harvey Lavan ("Van"), Jr.,
 1934-
Musician
Robert Vickrey, 1926-
Tempera on board, 43.8 x 33 cm.
 (17½ x 13 in.), 1958
TIME cover: May 19, 1958
NPG.78.TC308
Gift of Time, Inc.

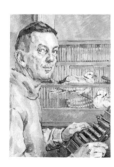

Cheever, John, 1912-1982
Author
Henry Koerner, 1915-
Oil on canvas, 45.7 x 33 cm. (18 x 13
 in.), 1964
TIME cover: March 27, 1964
NPG.78.TC299
Gift of Time, Inc.

Cohan, George Michael, 1878-1942
Composer, actor, producer
Samuel Johnson Woolf, 1880-1948
Charcoal on paper, 33 x 25.2 cm. (13
 x 9⅞ in.), 1933
TIME cover: October 9, 1933
NPG.78.TC309
Gift of Time, Inc.

Coles, Robert, 1929-
Psychiatrist, author
Dennis Wheeler, 1935-
Color photograph with watercolor
 and grease pencil, 29.8 x 22.2 cm.
 (11¾ x 8¾ in.), 1972
TIME cover: February 14, 1972
NPG.78.TC311
Gift of Time, Inc.

Cronkite, Walter Leland, Jr., 1916-
Journalist
Robert Vickrey, 1926-
Tempera on board, 66.7 x 49.8 cm.
 (26¼ x 19⅝ in.), 1966
TIME cover: October 14, 1966
NPG.78.TC319
Gift of Time, Inc.

Commoner, Barry, 1917-
Scientist
Mathias Klarwein, 1932-
Acrylic on board, 28.5 x 20.9 cm.
 (11¼ x 8¼ in.), 1970
TIME cover: February 2, 1970
NPG.78.TC312
Gift of Time, Inc.

Curtis, Charles E., 1860-1936
Vice-President of the United States
Samuel Johnson Woolf, 1880-1948
Charcoal on paper, 34 x 24.8 cm.
 (13⅜ x 9¾ in.), 1928
TIME cover: June 18, 1928
NPG.78.TC320
Gift of Time, Inc.

Conant, James Bryant, 1893-1978
Educator
James Chapin, 1887-1975
Oil on board, 46.3 x 33.6 cm. (18¼ x
 13¼ in.), 1959
TIME cover: September 14, 1959
NPG.78.TC313
Gift of Time, Inc.

Cushing, Richard, 1895-1970
Clergyman
Robert Vickrey, 1926-
Tempera on board, 50.5 x 39.4 cm.
 (19⅞ x 15½ in.), 1964
TIME cover: August 21, 1964
NPG.78.TC321
Gift of Time, Inc.

Connally, John, 1917-
Statesman
Don Ivan Punchatz, 1936-
Tempera on board, 46 x 36 cm. (18⅛
 x 14⅛ in.), 1979
TIME cover: September 10, 1979
NPG.82.TC91
Gift of Time, Inc.

Daley, Richard Joseph, 1902-1976
Mayor of Chicago
Art Shay, ?-?, and Arthur Siegel, ?-?
Color photograph, 30.8 x 40 cm. (20⅛
 x 15¾ in.), c. 1963
TIME cover: March 15, 1963
NPG.78.TC323
Gift of Time, Inc.

Connors, James Scott ("Jimmy"),
 1952-
Athlete
Barron Storey, 1945-
Acrylic on canvas, 67.1 x 50.8 cm.
 (26⁷⁄₁₆ x 20 in.), 1975
TIME cover: April 28, 1975
NPG.78.TC856
Gift of Time, Inc.

Dean, John Wesley, III, 1938-
Lawyer
Stanislaw Zagorski, 1933-
Acrylic and cloth on board, 55.9 x
 41.3 cm. (22 x 16¼ in.), 1973
TIME cover: July 2, 1973
NPG.78.TC332
Gift of Time, Inc.

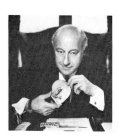

De Mille, Cecil B., 1881-1959
Movie director
Wide World Photos
Photograph, gelatin silver print, 25.3
x 20.3 cm. (9⁵⁄₁₆ x 8 in.), 1934
TIME cover: August 27, 1934
NPG.82.TC95
Gift of Time, Inc.

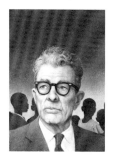

Dirksen, Everett McKinley,
1896-1969
Statesman
Robert Vickrey, 1926-
Tempera and ink on board, 50.1 x
36.9 cm. (19¾ x 14½ in.), 1964
TIME cover: June 19, 1964
NPG.78.TC336
Gift of Time, Inc.

Eaton, Cyrus Stephen, 1883-1979
Financier
Samuel Johnson Woolf, 1880-1948
Charcoal on paper, 35.6 x 26.7 cm.
(14¹⁄₁₆ x 10½ in.), 1930
TIME cover: February 24, 1930
NPG.78.TC343
Gift of Time, Inc.

Einstein, Albert, 1879-1955
Scientist
Ernest Hamlin Baker, 1889-1975
Tempera and ink on board, 32.8 x
29.2 cm. (13 x 11½ in.), 1946
TIME cover: July 1, 1946
NPG.78.TC345
Gift of Time, Inc.

Eisenhower, Dwight David,
1890-1969
Thirty-fourth President of the United
States
Ernest Hamlin Baker, 1889-1975
Watercolor and pencil on board, 30.8
x 22.2 cm. (12¹⁄₁₆ x 8¹³⁄₁₆ in.), 1955
TIME cover: July 4, 1955
NPG.78.TC348
Gift of Time, Inc.

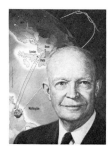

Eisenhower, Dwight David,
1890-1969
Thirty-fourth President of the United
States
Bernard Safran, 1924-
Oil on masonite, 61 x 44.5 cm. (24 x
17½ in.), 1959
TIME cover: January 4, 1960
NPG.78.TC349
Gift of Time, Inc.

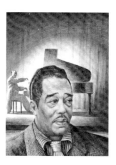

Ellington, Edward Kennedy
("Duke"), 1899-1974
Musician, composer
Peter Hurd, 1904-1984
Tempera on board, 49.5 x 35.6 cm.
(19½ x 14 in.), 1956
TIME cover: August 20, 1956
NPG.78.TC353
Gift of Time, Inc.

Faulkner, William Cuthbert,
1897-1962
Author
Robert Vickrey, 1926-
Pen and ink on paper, 57.8 x 50.1
cm. (22¾ x 19¾ in.), 1964
TIME cover: July 17, 1964
NPG.78.TC364
Gift of Time, Inc.

Ford, Gerald Rudolph, Jr., 1913-
Thirty-eighth President of the United
States
James Sharpe, 1936-
Airbrush and acrylic on board, 68 x
47 cm. (26¾ x 18½ in.), 1976
TIME cover: October 18, 1976
NPG.78.TC378
Gift of Time, Inc.

Ford, Henry, II, 1917-1987
Businessman
Jack Gregory, 1930-
Polyester resin, 48.2 cm. (19 in.), 1970
TIME cover: July 20, 1970
NPG.78.TC382
Gift of Time, Inc.

Fortas, Abe, 1910-1982
Justice of the United States Supreme
 Court
Louis Glanzman, 1922-
Tempera, paper, and photo collage
 on board, 31.1 x 23.2 cm. (12¼ x
 9⅛ in.), 1968
TIME cover: July 5, 1968
NPG.78.TC383
Gift of Time, Inc.

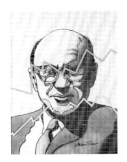

Friedman, Milton, 1912-
Economist
Milton Glaser, 1929-
Acetate, ink, and watercolor on
 newsprint, 50.8 x 38.1 cm. (20 x 15
 in.), 1969
TIME cover: December 19, 1969
NPG.78.TC389
Gift of Time, Inc.

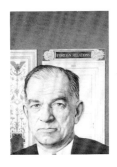

Fulbright, James William, 1905-
Statesman
Robert Vickrey, 1926-
Tempera on board, 44.5 x 31.8 cm.
 (17½ x 12½ in.), 1965
TIME cover: January 22, 1965
NPG.78.TC393
Gift of Time, Inc.

Fuller, Richard Buckminster, Jr.,
 1895-1983
Inventor, philosopher
Boris Artzybasheff, 1899-1965
Tempera on board, 54.6 x 43.2 cm.
 (21½ x 17 in.), c. 1964
TIME cover: January 10, 1964
NPG.78.TC394
Gift of Time, Inc.

Gibson, Althea, 1927-
Athlete
Boris Chaliapin, 1904-1979
Watercolor and pencil on board, 62.3
 x 46.3 cm. (24½ x 18⁵⁄₁₆ in.), 1957
TIME cover: August 26, 1957
NPG.78.TC406
Gift of Time, Inc.

Gleason, Herbert John ("Jackie"),
 1916- 1987
Entertainer
Russell Hoban, 1925-
Casein on masonite, 50.8 x 48.2 cm.
 (20 x 19 in.), 1961
TIME cover: December 29, 1961
NPG.78.TC408
Gift of Time, Inc.

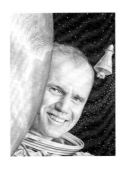

Glenn, John Herschel, Jr., 1921-
Astronaut, statesman
Boris Artzybasheff, 1899-1965
Tempera, ink, pencil, and pastel on
 masonite, 48.2 x 38.1 cm. (19 x 15
 in.), 1962
TIME cover: March 2, 1962
NPG.78.TC409
Gift of Time, Inc.

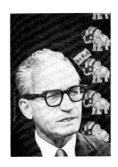

Goldwater, Barry Morris, 1909-
Statesman
Bernard Safran, 1924-
Acrylic on board, 60.7 x 45.5 cm.
 (23⅞ x 17⅞ in.), 1964
TIME cover: June 12, 1964
NPG.78.TC410
Gift of Time, Inc.

Goldwater, Barry Morris, 1909-
Statesman
Robert Vickrey, 1926-
Tempera and ink on board, 56.5 x
 43.5 cm. (22¼ x 17⅛ in.), 1963
TIME cover: July 14, 1963
NPG.78.TC411
Gift of Time, Inc.

**Guest, Lucy Douglas Cochrane
 ("Ceezee"),** 1920-
Socialite
Philippe Halsman, 1906-1979
Photograph, gelatin silver print, 35.2
 x 28.1 cm. (13⅞ x 11¹⁄₁₆ in.), 1962
TIME cover: July 7, 1962
NPG.82.TC105
Gift of Time, Inc.

Harriman, William Averell,
1891-1986
Statesman
Boris Chaliapin, 1904-1979
Tempera and pencil on board, 51.4 x
38.1 cm. (20¼ x 15 in.), 1963
TIME cover: August 2, 1963
NPG.78.TC432
Gift of Time, Inc.

Hoover, John Edgar, 1895-1972
Director of Federal Bureau of
Investigation
Samuel Johnson Woolf, 1880-1948
Charcoal on paper, 35.6 x 25.7 cm.
(14 x 10½ in.), 1935
TIME cover: August 5, 1935
NPG.78.TC451
Gift of Time, Inc.

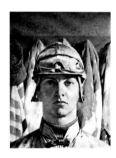

Harris, Julie, 1925-
Actress
Henry Koerner, 1915-
Oil on canvas, 71.1 x 56.5 cm. (28 x
22¼ in.), 1955
TIME cover: November 28, 1955
NPG.78.TC433
Gift of Time, Inc.

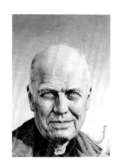

Hope, Leslie Townes ("Bob"), 1903-
Entertainer
Marisol Escobar, 1930-
Polychromed wood, 48.2 cm. (19 in.),
1967
TIME cover: December 22, 1967
NPG.78.TC452
Gift of Time, Inc.

Hartack, William John ("Willie"),
1932-
Athlete
James Chapin, 1887-1975
Oil on canvas, 51.1 x 35.9 cm. (20⅛ x
14⅛ in.), 1958
TIME cover: February 10, 1958
NPG.78.TC435
Gift of Time, Inc.

Hopper, Edward, 1882-1967
Artist
James Chapin, 1887-1975
Acrylic on masonite, 44.4 x 33 cm.
(17½ x 13 in.), 1956
TIME cover: December 24, 1956
NPG.78.TC453
Gift of Time, Inc.

Hefner, Hugh Marston, 1926-
Publisher
Marisol Escobar, 1930-
Polychromed wood, 185.4 cm. (73
in.), 1967
TIME cover: March 3, 1967
NPG.78.TC440
Gift of Time, Inc.

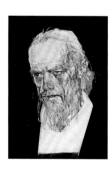

Hughes, Howard Robard, 1905-1976
Industrialist
Barron Storey, 1945-
Ink on board, 55.9 x 40.6 cm. (22 x 16
in.), 1976
TIME cover: April 19, 1976
NPG.78.TC457
Gift of Time, Inc.

Hoffa, James Riddle, 1913-1975?
Labor leader
Boris Chaliapin, 1904-1979
Watercolor and pencil on board, 44.5
x 31.1 cm. (17½ x 12¼ in.), 1959
TIME cover: August 31, 1959
NPG.78.TC447
Gift of Time, Inc.

Hull, Robert Marvin, Jr., 1939-
Athlete
LeRoy Neiman, 1926-
Acrylic on masonite, 121.2 x 86.9 cm.
(47¾ x 34½ in.), 1968
TIME cover: March 1, 1968
NPG.78.TC459
Gift of Time, Inc.

Humphrey, Hubert Horatio,
 1911-1978
Statesman
Louis Glanzman, 1922-
Tempera on wood, 24.8 x 17.8 cm.
 (9¾ x 7 in.), 1968
TIME cover: May 3, 1968
NPG.78.TC460
Gift of Time, Inc.

Johnson, Lyndon Baines, 1908-1973
Thirty-sixth President of the United
 States
Pietro Annigoni, 1910-
Pastel on paper, 48.5 x 38.1 cm. (19 x
 15 in.), 1966
TIME cover: April 12, 1968
NPG.78.TC473
Gift of Time, Inc.

Jackson, Jesse Louis, 1941-
Civil rights leader
Jacob Lawrence, 1917-
Tempera on board, 60.3 x 45.7 cm.
 (23¾ x 18 in.), 1970
TIME cover: April 6, 1970
NPG.78.TC466
Gift of Time, Inc.

Johnson, Lyndon Baines, 1908-1973
Thirty-sixth President of the United
 States
Boris Artzybasheff, 1899-1965
Tempera on board, 47.9 x 38.2 cm.
 (18¹³⁄₁₆ x 15¹⁄₁₆ in.), 1960
TIME cover: April 25, 1960
NPG.82.TC115
Gift of Time, Inc.

Jackson, Reginald Martinez
 ("Reggie"), 1946-
Athlete
Howard Rogers, 1932-
Airbrush and tempera on board, 66.1
 x 48.2 cm. (26 x 19 in.), 1974
TIME cover: June 3, 1974
NPG.78.TC467
Gift of Time, Inc.

Johnson, Lyndon Baines, 1908-1973
Thirty-sixth President of the United
 States
Peter Hurd, 1904-1984, and Henriette
 Wyeth Hurd, 1907-
Tempera on paper, 55.2 x 37.5 cm.
 (21¾ x 14¾ in.), 1964
TIME cover: January 1, 1965
NPG.78.TC477
Gift of Time, Inc.

Jeffers, Robinson, 1887-1962
Poet
Edward Weston, 1886-1958
Photograph, gelatin silver print
 made from halftone, 25.3 x 20.3
 cm. (9⁵⁄₁₆ x 8 in.), c. 1932
TIME cover: April 4, 1932
NPG.82.TC111
Gift of Time, Inc.

Johnson, Lyndon Baines, 1908-1973
Thirty-sixth President of the United
 States
Peter Hurd, 1904-1984
Ink on paper, 20.3 x 12.7 cm. (8 x 5
 in.), 1964
NPG.78.TC478
Gift of Time, Inc.

Johnson, Claudia Taylor ("Lady
 Bird"), 1912-
First lady
Boris Artzybasheff, 1899-1965
Watercolor, polymer, crayon, and
 ink on board, 55.6 x 40.4 cm. (21⅞
 x 15⅞ in.), 1964
TIME cover: August 28, 1964
NPG.78.TC472
Gift of Time, Inc.

Johnson, Lyndon Baines, 1908-1973
Thirty-sixth President of the United
 States
Peter Hurd, 1904-1984
Ink on paper, 20.3 x 12.7 cm. (8 x 5
 in.), 1964
NPG.78.TC479
Gift of Time, Inc.

Johnson, Lyndon Baines, 1908-1973
Thirty-sixth President of the United
 States
Peter Hurd, 1904-1984
Ink on paper, 20.3 x 12.7 cm. (8 x 5
 in.), 1964
NPG.78.TC480
Gift of Time, Inc.

Johnson, Lyndon Baines, 1908-1973
Thirty-sixth President of the United
 States
Peter Hurd, 1904-1984
Ink on paper, 20.3 x 12.7 cm. (8 x 5
 in.), 1964
NPG.78.TC481
Gift of Time, Inc.

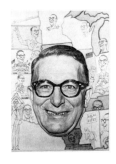

Kefauver, Carey Estes, 1903-1963
Statesman
Boris Chaliapin, 1904-1979
Tempera and ink on board, 33 x 31.8
 cm. (13 x 12⁹⁄₁₆ in.), 1952
TIME cover: March 24, 1952
NPG.78.TC489
Gift of Time, Inc.

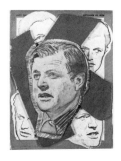

Kennedy, Edward Moore, 1932-
Statesman
Larry Rivers, 1923-
Pencil, cut paper, and wood collage,
 29.2 x 21.6 cm. (11½ x 8½ in.),
 1971
TIME cover: November 29, 1971
NPG.78.TC493
Gift of Time, Inc.

Kennedy, John Fitzgerald, 1917-1963
Thirty-fifth President of the United
 States
Pietro Annigoni, 1910-
Watercolor on paper, 78.5 x 58.7 cm.
 (30⅞ x 23⅛ in.), 1961
TIME cover: January 5, 1962
NPG.78.TC501
Gift of Time, Inc.

Kennedy, John Fitzgerald, 1917-1963
Thirty-fifth President of the United
 States
René Bouché, 1905-1963
Oil on canvas, 101 x 76.2 cm. (40 x
 30 in.), c. 1961
TIME cover: June 9, 1961
NPG.78.TC502
Gift of Time, Inc.

Kennedy, John Fitzgerald, 1917-1963
Thirty-fifth President of the United
 States
Boris Chaliapin, 1904-1979
Watercolor on board, 71.1 x 56.5 cm.
 (28 x 22¼ in.), 1960
TIME cover: November 7, 1960
NPG.78.TC500
Gift of Time, Inc.

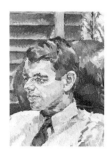

Kennedy, Robert Francis, 1925-1968
Statesman
Louis Glanzman, 1922-
Tempera and ink on paper, 49.5 x
 35.6 cm. (19½ x 14 in.), 1968
TIME cover: June 14, 1968
NPG.78.TC503
Gift of Time, Inc.

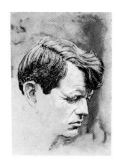

Kennedy, Robert Francis, 1925-1968
Statesman
Henry Koerner, 1915-
Oil on canvas, 45.7 x 32.4 cm. (18 x
 12¹³⁄₁₆ in.), 1962
TIME cover: February 16, 1962
NPG.78.TC504
Gift of Time, Inc.

Kennedy, Robert Francis, 1925-1968
Statesman
Roy Lichtenstein, 1923-
Silkscreen on plexiglas, 58.4 x 41.9
 cm. (23 x 16½ in.), 1968
TIME cover: May 24, 1968
NPG.78.TC491
Gift of Time, Inc.

Kerr, Jean, 1924-
Author
René Bouché, 1905-1963
Oil on canvas, 101.6 x 55.9 cm. (40 x 22 in.), 1961
TIME cover: April 14, 1961
NPG.78.TC509
Gift of Time, Inc.

Land, Edwin Herbert, 1909-
Inventor
Alfred Eisenstaedt, 1898-
Color photograph, 49.5 x 33 cm. (19½ x 13 in.), 1972
TIME cover: June 26, 1972
NPG.78.TC535
Gift of Time, Inc.

King, Martin Luther, Jr., 1929-1968
Civil rights statesman
Boris Chaliapin, 1904-1979
Watercolor and pencil on board, 42.2 x 31.1 cm. (16¹¹⁄₁₆ x 12¼ in.), 1957
TIME cover: February 18, 1957
NPG.78.TC516
Gift of Time, Inc.

Landon, Alfred Mossman, 1887-1987
Businessman, statesman
William Vandivert, ?-
Photograph, gelatin silver print, 25.3 x 20.4 cm. (9¹⁵⁄₁₆ x 8 in.), 1936
TIME cover: May 18, 1936
NPG.82.TC121
Gift of Time, Inc.

King, Martin Luther, Jr., 1929-1968
Civil rights statesman
Robert Vickrey, 1926-
Tempera on paper, 37.5 x 28.5 cm. (14¾ x 11¼ in.), 1963
TIME cover: January 3, 1964
NPG.78.TC517
Gift of Time, Inc.

Lewis, John Llewellyn, 1880-1969
Labor leader
Samuel Johnson Woolf, 1880-1948
Charcoal on paper, 32.8 x 27 cm. (12⅞ x 10⅝ in.), 1933
TIME cover: October 2, 1933
NPG.78.TC545
Gift of Time, Inc.

Kissinger, Henry Alfred, 1923-
Statesman
Louis Glanzman, 1922-
Casein and collage on board, 30.5 x 21.6 cm. (12 x 8½ in.), 1969
TIME cover: February 14, 1969
NPG.78.TC522
Gift of Time, Inc.

Lindsay, John, 1921-
Mayor of New York City
Romare Bearden, 1914-
Photo collage, 35.6 x 25.4 cm. (14 x 10 in.), 1968
TIME cover: November 1, 1968
NPG.82.TC126
Gift of Time, Inc.

Kissinger, Henry Alfred, 1923-
Statesman
Philip Pearlstein, 1924-
Oil on canvas, 91.3 x 66 cm. (35¹⁵⁄₁₆ x 26 in.), 1979
TIME cover: October 1, 1979
NPG.82.TC120
Gift of Time, Inc.

Lodge, Henry Cabot, Jr., 1902-1985
Statesman
Robert Vickrey, 1926-
Tempera on board, 38.1 x 25.4 cm. (15 x 10 in.), 1964
TIME cover: May 15, 1964
NPG.78.TC551
Gift of Time, Inc.

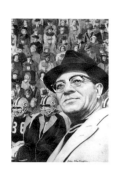

Lombardi, Vincent Thomas,
 1913-1970
Football coach
Boris Chaliapin, 1904-1979
Watercolor and pencil on board, 45.5
 x 30.8 cm. (17⅞ x 12¼ in.), c. 1962
TIME cover: December 21, 1962
NPG.78.TC552
Gift of Time, Inc.

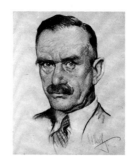

Mann, Thomas, 1875-1955
Author
Samuel Johnson Woolf, 1880-1948
Charcoal on paper, 60 x 48.5 cm.
 (23½ x 19⅞ in.), 1934
TIME cover: June 11, 1934
NPG.78.TC557
Gift of Time, Inc.

Lowell, Robert Traill Spence, Jr.,
 1917-1977
Poet
Sidney Nolan, 1917-
Watercolor on paper, 30.5 x 25.4 cm.
 (12 x 10 in.), 1967
TIME cover: June 2, 1967
NPG.78.TC553
Gift of Time, Inc.

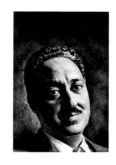

Marshall, Thurgood, 1908-
Justice of the United States Supreme
 Court
James Chapin, 1887-1975
Oil on board, 43.2 x 30.5 cm. (17 x 12
 in.), 1955
TIME cover: September 19, 1955
NPG.78.TC564
Gift of Time, Inc.

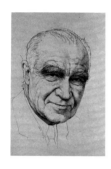

Luce, Henry Robinson, 1898-1967
Publisher
Robert Vickrey, 1926-
Ink on paper, 39.4 x 25.6 cm. (15½ x
 10¼ in.), 1967
TIME cover: March 10, 1967
NPG.78.TC554
Gift of Time, Inc.

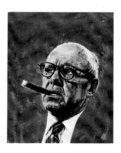

Meany, George, 1894-1980
Labor leader
Paul Calle, 1928-
Mixed media on board, 53.9 x 45.1
 cm. (21¼ x 17¾ in.), 1971
TIME cover: September 6, 1971
NPG.78.TC580
Gift of Time, Inc.

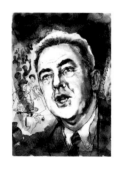

McCarthy, Eugene Joseph, 1916-
Statesman
David Stone Martin, 1913-
Watercolor and ink on board, 36.9 x
 26.4 cm. (14⁹⁄₁₆ x 10⁷⁄₁₆ in.), 1968
TIME cover: March 22, 1968
NPG.78.TC570
Gift of Time, Inc.

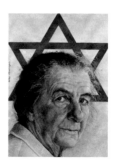

Meir, Golda, 1898-1978
Israeli prime minister
Boris Chaliapin, 1904-1979
Tempera on board, 35.3 x 25.2 cm.
 (13⅞ x 9⅞ in.), 1969
TIME cover: September 9, 1969
NPG.78.TC581
Gift of Time, Inc.

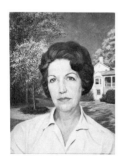

McGinley, Phyllis, 1905-1978
Poet
Boris Chaliapin, 1904-1979
Oil on canvas, 51.1 x 38.4 cm. (20⅛ x
 15⅛ in.), 1965
TIME cover: June 18, 1965
NPG.78.TC574
Gift of Time, Inc.

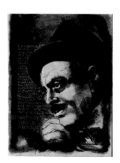

Merrick, David, 1912-
Theatrical producer
David Stone Martin, 1913-
Watercolor and tempera on board,
 48.2 x 36.3 cm. (19 x 14½ in.), 1966
TIME cover: March 25, 1966
NPG.78.TC583
Gift of Time, Inc.

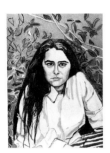

Millet, Katherine Murray ("Kate"),
1934-
Feminist, author
Alice Neel, 1900-1984
Acrylic on canvas, 102.2 x 74.2 cm.
(40¼ x 29¼ in.), 1970
TIME cover: August 31, 1970
NPG.78.TC588
Gift of Time, Inc.

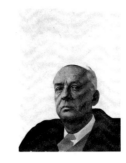

Nabokov, Vladimir Vladimirovich,
1899-1977
Author
Gerard De Rose, 1921-
Oil on canvas, 61 x 58.8 cm. (24 x 20
in.), 1969
TIME cover: May 23, 1969
NPG.78.TC608
Gift of Time, Inc.

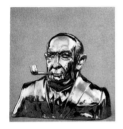

Mitchell, John Newton, 1913-
Statesman, lawyer
Stanley Glaubach, 1925-1973, and
Peter Yanchusk, ?-
Nickel-coated plaster, 43.1 cm. (17
in.), 1973
TIME cover: May 21, 1973
NPG.78.TC591
Gift of Time, Inc.

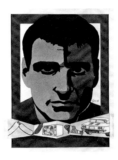

Nader, Ralph, 1934-
Reformer
George Giusti, 1908-
Airbrush and ink on board, 29.2 x
22.9 cm. (11½ x 9 in.), 1969
TIME cover: December 12, 1969
NPG.78.TC609
Gift of Time, Inc.

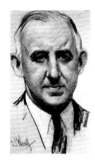

Moley, Raymond Charles, 1886-1975
Author, political adviser
Samuel Johnson Woolf, 1880-1948
Charcoal on paper, 34.6 x 19.7 cm.
(13⅝ x 7¾ in.), 1933
TIME cover: May 8, 1933
NPG.78.TC594
Gift of Time, Inc.

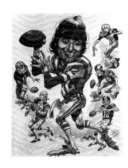

Namath, Joseph William, 1943-
Athlete
Jack Davis, 1923-
Watercolor on board, 59 x 50.1 cm.
(23¼ x 19¾ in.), 1972
TIME cover: October 16, 1972
NPG.78.TC610
Gift of Time, Inc.

Monk, Thelonius Sphere, 1918-1982
Composer, musician
Boris Chaliapin, 1904-1979
Oil on canvas, 53.6 x 38.1 cm. (21⅛ x
15 in.), 1964
TIME cover: February 28, 1964
NPG.78.TC596
Gift of Time, Inc.

Nicklaus, Jack William, 1940-
Athlete
Russell Hoban, 1925-
Casein on masonite, 52.4 x 40.6 cm.
(20⅝ x 16 in.), c. 1962
TIME cover: June 29, 1962
NPG.78.TC623
Gift of Time, Inc.

Moses, Robert, 1888-1981
Public official
Boris Chaliapin, 1904-1979
Tempera and pencil on board, 48.2 x
38.4 cm. (19 x 15⅛ in.), 1964
TIME cover: June 5, 1964
NPG.78.TC94
Gift of Time, Inc.

Niebuhr, Reinhold, 1892-1971
Theologian
Ernest Hamlin Baker, 1889-1975
Tempera on board, 50.8 x 45.1 cm.
(20 x 17¾ in.), 1949
TIME cover: March 8, 1949
NPG.78.TC618
Gift of Time, Inc.

Nixon, Richard Milhous, 1913-
Thirty-seventh President of the
 United States
Stanley Glaubach, 1925-1973
Papier-mâché, 50.8 cm. (20 in.), 1971
TIME cover: January 3, 1972
NPG.78.TC635
Gift of Time, Inc.

O'Connor, Sandra Day, 1930-
Justice of the United States Supreme
 Court
Eraldo Carugati, 1921-
Gouache and pastel on board, 30.9 x
 20.9 cm. (12 x 8¼ in.), 1981
TIME cover: July 20, 1981
NPG.82.TC133
Gift of Time, Inc.

Nixon, Richard Milhous, 1913-
Thirty-seventh President of the
 United States
Bernard Safran, 1924-
Oil on masonite, 61 x 44.5 cm. (24 x
 17½ in.), 1960
TIME cover: October 31, 1960
NPG.78.TC642
Gift of Time, Inc.

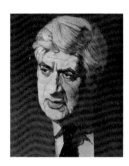

**Onassis, Jacqueline Lee Bouvier
 Kennedy,** 1929-
First lady
Boris Chaliapin, 1904-1979
Gouache and pencil on board, 44.5 x
 31.1 cm. (17½ x 12¼ in.), 1961
TIME cover: January 20, 1961
NPG.78.TC498
Gift of Time, Inc.

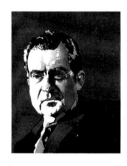

Nixon, Richard Milhous, 1913-
Thirty-seventh President of the
 United States
Barron Storey, 1945-
Oil on board, 50.8 x 40.6 cm. (20 x 16
 in.), 1974
TIME cover: September 16, 1974
NPG.78.TC638
Gift of Time, Inc.

O'Neill, Thomas Philip, Jr. ("Tip"),
 1912-
Statesman
Robert Peak, 1928-
Acrylic and pencil on board, 63.5 x
 49.8 cm. (25 x 19⅝ in.), 1974
TIME cover: February 4, 1974
NPG.78.TC654
Gift of Time, Inc.

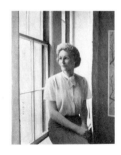

**Nixon, Thelma Catherine Ryan
 ("Pat"),** 1912-
First lady
Robert Vickrey, 1926-
Tempera on masonite, 48.2 x 35.6
 cm. (19 x 14 in.), 1960
TIME cover: February 29, 1960
NPG.78.TC630
Gift of Time, Inc.

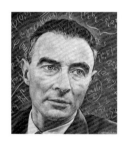

Oppenheimer, Julius Robert,
 1904-1967
Scientist
Ernest Hamlin Baker, 1889-1975
Tempera and ink on board, 30.8 x
 28.2 cm. (12⅛ x 11⅛ in.), 1948
TIME cover: November 8, 1948
NPG.78.TC655
Gift of Time, Inc.

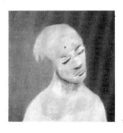

Nureyev, Rudolf Hametovich, 1938-
Dancer
Sidney Nolan, 1917-
Acrylic on board, 124.4 x 124.4 cm.
 (49 x 49 in.), 1965
TIME cover: April 16, 1965
NPG.78.TC651
Gift of Time, Inc.

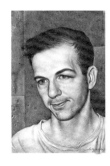

Oswald, Lee Harvey, 1939-1963
Assassin
Boris Artzybasheff, 1899-1965
Tempera on board, 36.6 x 25.7 cm.
 (14⅜ x 10⅛ in.), 1964
TIME cover: October 2, 1964
NPG.78.TC656
Gift of Time, Inc.

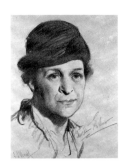

Perkins, Frances, 1882-1965
Stateswoman
Samuel Johnson Woolf, 1880-1948
Charcoal on paper, 34.3 x 26.4 cm.
 (13½ x 10¼ in.), 1933
TIME cover: August 14, 1933
NPG.78.TC668
Gift of Time, Inc.

Rockefeller, Nelson Aldrich,
 1908-1979
Statesman, Vice-President of the
 United States
Marisol Escobar, 1930-
Gray slate, 156.5 cm. (61⅝ in.),
 c. 1974
TIME cover: September 2, 1974
NPG.78.TC707
Gift of Time, Inc.

Rauschenberg, Robert, 1925-
Artist
Self-portrait
Photo collage on board, 46.7 x 39.7
 cm. (18⅜ x 15⅝ in.), 1976
TIME cover: November 29, 1976
NPG.78.TC686
Gift of Time, Inc.

Rockefeller, Nelson Aldrich,
 1908-1979
Statesman, Vice-President of the
 United States
Henry Koerner, 1915-
Oil on canvas, 45.7 x 32.4 cm. (18 x
 12¾ in.), 1962
TIME cover: June 15, 1962
NPG.78.TC706
Gift of Time, Inc.

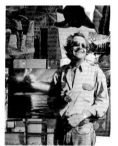

Reagan, Ronald Wilson, 1911-
Fortieth President of the United
 States
Aaron Shikler, 1922-
Essence of oil on paper, 66 x 45.5 cm.
 (26 x 17⅞ in.), 1980
TIME cover: January 5, 1981
NPG.84.TC140
Gift of Time, Inc.

Rockefeller, Nelson Aldrich,
 1908-1979
Statesman, Vice-President of the
 United States
Robert Vickrey, 1926-
Tempera on masonite, 40.6 x 30.5
 cm. (16 x 12 in.), 1958
TIME cover: October 6, 1958
NPG.78.TC708
Gift of Time, Inc.

Richberg, Donald Randall,
 1881-1960
Lawyer, public official
Samuel Johnson Woolf, 1880-1948
Charcoal on paper, 35.6 x 26.4 cm.
 (14¹⁄₁₆ x 10⅜ in.), 1934
TIME cover: September 10, 1934
NPG.78.TC695
Gift of Time, Inc.

Roosevelt, Sara Delano, 1855-1941
Mother of Franklin Delano Roosevelt
Jerry Farnsworth, 1895-
Oil on paper, 29.8 x 23.9 cm. (11¾ x
 9⁷⁄₁₆ in.), 1933
TIME cover: March 6, 1933
NPG.78.TC710
Gift of Time, Inc.

Robertson, Oscar Palmer, 1938-
Athlete
Russell Hoban, 1925-
Casein on masonite, 97.1 x 69.9 cm.
 (38¼ x 27½ in.), 1961
TIME cover: February 17, 1961
NPG.78.TC700
Gift of Time, Inc.

**Rostropovich, Mstislav
 Leopoldovich,** 1927-
Symphony conductor
Richard Sparks, 1944-
Oil on masonite, 57.8 x 38.1 cm.
 (22¾ x 15 in.), 1977
TIME cover: October 24, 1977
NPG.78.TC713
Gift of Time, Inc.

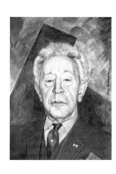

Rubenstein, Arthur, 1887-1982
Musician
Boris Chaliapin, 1904-1979
Oil on canvas, 58.9 x 40.6 cm. (21¼ x
 16 in.), c. 1966
TIME cover: February 25, 1966
NPG.78.TC716
Gift of Time, Inc.

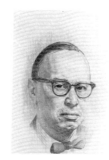

Schlesinger, Arthur Meier, Jr., 1917-
Historian
Boris Chaliapin, 1904-1979
Colored pencil on board, 31.8 x 22.2
 cm. (12⁹⁄₁₆ x 8¾ in.), 1965
TIME cover: December 17, 1965
NPG.78.TC728
Gift of Time, Inc.

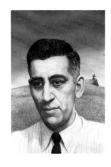

Rusk, Dean, 1909-
Statesman
Louis Glanzman, 1922-
Colored pencil on board, 27.9 x 19.7
 cm. (11 x 7¾ in.), 1966
TIME cover: February 4, 1966
NPG.78.TC717
Gift of Time, Inc.

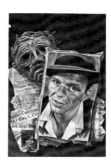

Shepard, Alan Bartlett, Jr., 1923-
Astronaut
Boris Chaliapin, 1904-1979
Tempera on board, 51.8 x 38.1 cm.
 (20⅜ x 15 in.), 1961
TIME cover: May 12, 1961
NPG.78.TC742
Gift of Time, Inc.

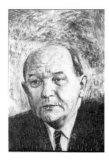

Russell, Rosalind, 1912-1976
Actress
Boris Chaliapin, 1904-1979
Tempera on board, 44.5 x 34.3 cm.
 (17½ x 13⁹⁄₁₆ in.), 1953
TIME cover: March 3, 1953
NPG.78.TC712
Gift of Time, Inc.

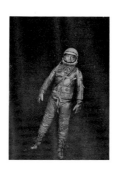

Sills, Beverly, 1929-
Singer
Eric Meola, 1946-
Color photograph, 55.9 x 47 cm. (22
 x 18½ in.), 1971
TIME cover: November 22, 1971
NPG.78.TC748
Gift of Time, Inc.

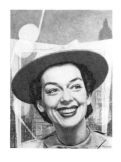

Salinger, Jerome David, 1919-
Author
Robert Vickrey, 1926-
Tempera on board, 43.8 x 29.2 cm.
 (17¼ x 11½ in.), 1961
TIME cover: September 15, 1961
NPG.78.TC723
Gift of Time, Inc.

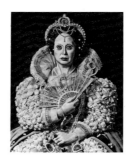

Sinatra, Francis Albert ("Frank"),
 1917-
Singer
Aaron Bohrod, 1907-
Tempera on board, 40 x 20.5 cm.
 (15¾ x 11¼ in.), 1955
TIME cover: August 29, 1955
NPG.78.TC752
Gift of Time, Inc.

Sarnoff, David, 1891-1971
Businessman
Samuel Johnson Woolf, 1880-1948
Charcoal on paper, 47 x 35.9 cm.
 (18½ x 14⅛ in.), 1929
TIME cover: July 15, 1929
NPG.78.TC724
Gift of Time, Inc.

Sirica, John Joseph, 1904-
Jurist
Stanislaw Zagorski, 1933-
Cloth, acrylic, and enamel paint on
 board, 48.2 x 38.1 cm. (19 x 15 in.),
 1973
TIME cover: January 7, 1974
NPG.78.TC753
Gift of Time, Inc.

Skinner, Burrhus Frederic, 1904-
Psychologist
Don Ivan Punchatz, 1936-
Acrylic on board, 38.7 x 28.5 cm.
(15¼ x 11¼ in.), 1971
TIME cover: September 20, 1971
NPG.78.TC754
Gift of Time, Inc.

Stevenson, Adlai Ewing, 1900-1965
Statesman
James Chapin, 1887-1975
Tempera on masonite, 43.2 x 31.5
cm. (17 x 13⅜ in.), 1955
TIME cover: July 16, 1956
NPG.78.TC767
Gift of Time, Inc.

Solti, George, 1912-
Symphony conductor
Bernard Pfriem, 1914-
Pastel and pencil on board, 64.1 x
48.2 cm. (25¼ x 19 in.), 1973
TIME cover: May 7, 1973
NPG.78.TC757
Gift of Time, Inc.

Stokowski, Leopold, 1882-1977
Symphony conductor
Unidentified photographer
Photograph, gelatin silver print, 20.3
x 25.3 cm. (8 x 9¹⁵⁄₁₆ in.), 1940
TIME cover: November 18, 1940
NPG.82.TC141
Gift of Time, Inc.

Solzhenitsyn, Alexander Isayevich,
1918-
Author
James Gill, 1934-
Oil on canvas, 55.8 x 40.6 cm. (22 x
16 in.), 1968
TIME cover: September 27, 1968
NPG.78.TC759
Gift of Time, Inc.

Streisand, Barbra, 1942-
Singer
Henry Koerner, 1915-
Oil on canvas, 45.7 x 33 cm. (18 x 13
in.), 1964
TIME cover: April 10, 1964
NPG.78.TC769
Gift of Time, Inc.

Spitz, Mark Andrew, 1950-
Athlete
Rich Clarkson, 1932-
Color photograph, 23.5 x 18.4 cm.
(9¼ x 7¼ in.), 1972
TIME cover: September 11, 1972
NPG.78.TC762
Gift of Time, Inc.

Tebaldi, Renata, 1922-
Opera singer
Boris Chaliapin, 1904-1979
Tempera, pencil, and ink on board,
51.4 x 38.1 cm. (20¼ x 15 in.), 1958
TIME cover: November 3, 1958
NPG.78.TC777
Gift of Time, Inc.

Stein, Gertrude, 1874-1946
Author, art collector
George Platt Lynes, 1907-1955
Photograph, gelatin silver print, 35.3
x 28.1 cm. (13⅞ x 11¹⁄₁₆ in.), 1933
TIME cover: September 11, 1933
NPG.82.TC139
Gift of Time, Inc.

Tillich, Paul Johannes Oskar,
1886-1965
Theologian
Henry Koerner, 1915-
Acrylic on canvas, 55.9 x 40.6 cm.
(22 x 16 in.), 1959
TIME cover: March 16, 1959
NPG.78.TC785
Gift of Time, Inc.

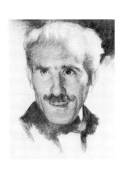

Toscanini, Arturo, 1867-1957
Symphony conductor
Samuel Johnson Woolf, 1880-1948
Charcoal on paper, 30.5 x 26.5 cm.
 (12 x 10⅜ in.), 1934
TIME cover: April 2, 1934
NPG.78.TC788
Gift of Time, Inc.

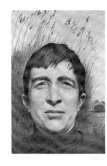

Updike, John Hoyer, 1932-
Author
Robert Vickrey, 1926-
Tempera on paper, 44.5 x 33.6 cm.
 (17½ x 13¼ in.), 1968
TIME cover: April 26, 1968
NPG.78.TC798
Gift of Time, Inc.

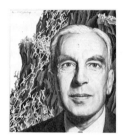

Toynbee, Arnold Joseph, 1889-1975
Historian
Boris Artzybasheff, 1899-1965
Tempera, pencil, and ink on paper,
 45.7 x 35.6 cm. (18 x 14 in.), 1947
TIME cover: March 17, 1947
NPG.78.TC790
Gift of Time, Inc.

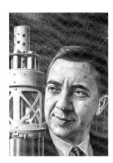

Van Allen, James Alfred, 1914-
Scientist
Boris Artzybasheff, 1899-1965
Tempera, ink, and pencil on
 masonite, 47.6 x 38.1 cm. (18¹³⁄₁₆ x
 15 in.), 1959
TIME cover: May 4, 1959
NPG.78.TC199
Gift of Time, Inc.

Truman, Harry S, 1884-1972
Thirty-third President of the United
 States
Boris Chaliapin, 1904-1979
Mixed media on board, 51.4 x 38.4
 cm. (20¼ x 15¹⁄₁₆ in.), 1956
TIME cover: August 13, 1956
NPG.78.TC793
Gift of Time, Inc.

Wallace, George Corley, 1919-
Statesman
Boris Chaliapin, 1904-1979
Tempera on board, 52.7 x 38.4 cm.
 (20¾ x 15⅞ in.), 1963
TIME cover: September 27, 1963
NPG.78.TC806
Gift of Time, Inc.

Tugwell, Rexford Guy, 1891-1979
Economist
Samuel Johnson Woolf, 1880-1948
Charcoal on paper, 35.3 x 24.2 cm.
 (13⅞ x 9½ in.), c. 1934
TIME cover: June 25, 1934
NPG.78.TC795
Gift of Time, Inc.

Wayne, John, 1907-1979
Actor
Boris Chaliapin, 1904-1979
Tempera, pencil, and ink on board,
 33.6 x 34.3 cm. (13⁵⁄₁₆ x 13½ in.),
 1952
TIME cover: March 31, 1952
NPG.78.TC807
Gift of Time, Inc.

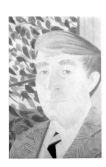

Updike, John Hoyer, 1932-
Author
Alex Katz, 1927-
Oil on canvas, 122.5 x 86.7 cm. (48½
 x 34⅛ in.), 1982
TIME cover: October 18, 1982
NPG.84.TC156
Gift of Time, Inc.

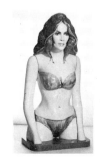

Welch, Raquel, 1940-
Actress
Frank Gallo, 1933-
Epoxy resin, 106 cm. (41¾ in.), 1969
TIME cover: November 28, 1969
NPG.78.TC808
Gift of Time, Inc.

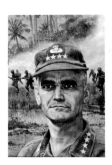

Westmoreland, William Childs,
 1914-
Vietnam War general
Boris Chaliapin, 1904-1979
Tempera and pencil on board, 52.7 x
 40 cm. (20¾ x 15¾ in.), 1965
TIME cover: February 19, 1965
NPG.78.TC859
Gift of Time, Inc.

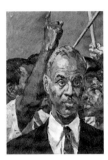

Wilkins, Roy, 1901-1981
Civil rights statesman
Henry Koerner, 1915-
Oil on canvas, 45.7 x 32.4 cm. (18 x
 12¾ in.), 1963
TIME cover: August 30, 1963
NPG.78.TC812
Gift of Time, Inc.

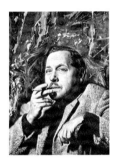

**Williams, Thomas Lanier
 ("Tennessee"),** 1911-1983
Playwright
Bernard Safran, 1924-
Oil on masonite, 61.6 x 44.5 cm.
 (24¼ x 17½ in.), 1962
TIME cover: March 9, 1962
NPG.78.TC814
Gift of Time, Inc.

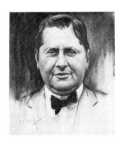

Wrigley, William, Jr., 1861-1932
Businessman
Samuel Johnson Woolf, 1880-1948
Charcoal on paper, 35.9 x 30.8 cm.
 (14¼ x 12⅛ in.), 1929
TIME cover: October 14, 1929
NPG.78.TC822
Gift of Time, Inc.

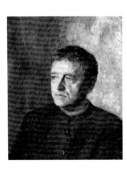

Wyeth, Andrew Newell, 1917-
Artist
Henriette Wyeth, 1907-
Acrylic on canvas, 64.1 x 53.9 cm.
 (25¼ x 21¼ in.), 1963
TIME cover: December 27, 1963
NPG.78.TC823
Gift of Time, Inc.

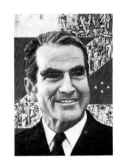

Zumwalt, Elmo Russell, Jr., 1920-
Naval officer
Don Stivers, 1926-
Acrylic on board, 50.8 x 34.9 cm. (20
 x 13¾ in.), 1970
TIME cover: December 21, 1970
NPG.78.TC831
Gift of Time, Inc.

Portraits of Groups

Astronauts
 (left to right)
 Anders, William Alison, 1933-
 Borman, Frank, 1928-
 Lovell, James A., Jr., 1928-
Hector Garrido, 1927-
Acrylic and tempera on masonite,
 53.9 x 40 cm. (21¼ x 15¾ in.), 1968
TIME cover: January 3, 1969
NPG.78.TC203
Gift of Time, Inc.

Berrigan Brothers
 Berrigan, Patrick, 1923- (left)
 Berrigan, Daniel, 1921- (right)
James Sharpe, 1936-
Oil on board, 46 x 31.3 cm. (18³⁄₁₆ x
 13⁷⁄₁₆ in.), 1971
TIME cover: January 25, 1971
NPG.78.TC242
Gift of Time, Inc.

Jimmy Carter and His Opponents
 (left to right)
 Carter, Jimmy (James Earl, Jr.),
 1924-
 Udall, Morris King, 1922-
 Jackson, Henry M., 1912-1983
 Wallace, George Corley, 1919-
 Shriver, Sargent, 1915-
Jack Davis, 1923-
Watercolor and ink on board, 76.2 x
 50.8 cm. (30 x 20 in.), 1976
TIME cover: March 8, 1976
NPG.78.TC283
Gift of Time, Inc.

Gerald Ford and Henry Kissinger
 Ford, Gerald Rudolph, Jr., 1913-
 (left)
 Kissinger, Henry Alfred, 1923-
 (right)
Jack Davis, 1923-
Watercolor on board, 58.4 x 49.2 cm.
 (23 x 19⅜ in.), 1975
TIME cover: June 2, 1975
 (international issue)
NPG.78.TC371
Gift of Time, Inc.

Hollywood's Honchos
 Reynolds, Burt, 1931?- (left)
 Eastwood, Clint, 1936- (right)
Neil Leifer, 1943-
Color photograph, 35.7 x 28 cm.
 (14 x 11 in.), 1978
TIME cover: January 9, 1978
NPG.82.TC99
Gift of Time, Inc.

Jimmy in the Lions' Den
 (clockwise from top)
 Carter, Jimmy (James Earl, Jr.),
 1924-
 Brezhnev, Leonid Ilyich,
 1906-1982
 Begin, Menachem, 1913-
 Sadat, Anwar, 1918-1981
 Hua Kuo Feng, 1920-
 Schmidt, Helmut H. W., 1918-
Edward Sorel, 1929-
Watercolor and ink on paper, 50.8 x
 38.1 cm. (20 x 15 in.), 1977
TIME cover: August 8, 1977
NPG.78.TC468
Gift of Time, Inc.

Lerner and Loewe
 Lerner, Alan Jay, 1918-1986 (left)
 Loewe, Frederick, 1904- (right)
Boris Chaliapin, 1904-1979
Tempera on board, 62.3 x 46 cm.
 (24⁹⁄₁₆ in. x 18⅛ in.), 1960
TIME cover: November 14, 1960
NPG.78.TC544
Gift of Time, Inc.

New U.S. Ambassadors
 (left to right)
 Reischauer, Edwin Oldfather,
 1910-
 Kennan, George Frost, 1904-
 Galbraith, John Kenneth, 1908-
Boris Chaliapin, 1904-1979
Tempera on board, 51.4 x 38.1 cm.
 (20¼ x 15 in.), 1961
Time cover: January 12, 1962
NPG.78.TC92
Gift of TIME, Inc.

Nixon Rides the Waves
 Key
 1. Laird, Melvin, 1922-
 2. Nixon, Richard Milhous, 1913-
 3. Thieu, Nguyen van, 1923-
 4. Ceausescu, Nicolae, 1918-
 5. Brezhnev, Leonid Ilyich,
 1906-1982
 6. Thurmond, Strom, 1902-
Pat Oliphant, 1936-
Ink and watercolor on board, 69.2 x
 53.3 cm. (27¼ x 21 in.), 1969
TIME cover: August 15, 1969
NPG.78.TC643
Gift of Time, Inc.

FREDERICK HILL MESERVE COLLECTION

Frederick Hill Meserve (1866-1962), an amateur historian and a noted authority on Abraham Lincoln, built the most important archive of historical American photographs in private hands. Of its extensive holdings, the greatest treasures of Meserve's collection were the sole vintage print of the last photograph of Abraham Lincoln, taken by Alexander Gardner just days before Lincoln's assassination and known as the "cracked-plate" portrait because it was printed from the broken negative, and a group of more than 5,400 collodion glass-plate negatives, most taken in Mathew Brady's studios, comprising a remarkably comprehensive pictorial index of the prominent personalities of the Civil War era.

In 1981, with the assistance of the United States Congress, the National Portrait Gallery purchased the original "cracked-plate" portrait of Abraham Lincoln and the Brady negatives, which include six of Lincoln, from the descendants of Frederick Hill Meserve. With this acquisition the National Portrait Gallery became not only one of the most important repositories of original Abraham Lincoln photographs, but also—after the Library of Congress and the National Archives—the third major guardian of original Brady negatives.

This addendum to the checklist of the Permanent Collection is a sample of images in the National Portrait Gallery's holdings from the Frederick Hill Meserve Collection. Further information can be obtained from the Curator of Photographs at the National Portrait Gallery.

William F. Stapp

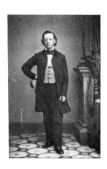

Beecher, Henry Ward, 1813-1887
Clergyman
Mathew Brady studio, active
 1844-1883
Collodion glass-plate negative, 8.8 x
 5.9 cm. (3½ x 2⅜ in.), c. 1861
NPG.81.M17

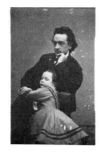

Booth, Edwin Thomas, 1833-1893,
 and his daughter Edwina, 1861-?
Actor
Mathew Brady studio, active
 1844-1883
Collodion glass-plate negative, 9.5 x
 6 cm. (3¾ x 2⅜ in.), 1866
NPG.81.M30

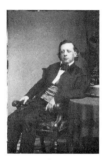

Beecher, Henry Ward, 1813-1887
Clergyman
Mathew Brady studio, active
 1844-1883
Collodion glass-plate negative, 8.6 x
 5.8 cm. (3⅜ x 2⁵⁄₁₆ in.), c. 1861
NPG.81.M18

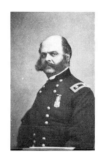

Burnside, Ambrose Everett,
 1824-1881
Union general
Mathew Brady studio, active
 1844-1883
Collodion glass-plate negative, 8.9 x
 5.9 cm. (3½ x 2⅜ in.), c. 1865
NPG.81.M44

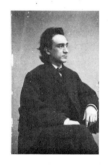

Booth, Edwin Thomas, 1833-1893
Actor
Mathew Brady studio, active
 1844-1883
Collodion glass-plate negative, 8.9 x
 5.9 cm. (3½ x 2⅜ in.), 1864
NPG.81.M28

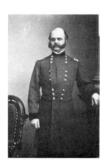

Burnside, Ambrose Everett,
 1824-1881
Union general
Mathew Brady studio, active
 1844-1883
Collodion glass-plate negative, 9.1 x
 6.2 cm. (3⅝ x 2⁷⁄₁₆ in.), c. 1862
NPG.81.M49

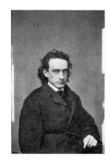

Booth, Edwin Thomas, 1833-1893
Actor
Mathew Brady studio, active
 1844-1883
Collodion glass-plate negative, 8.9 x
 5.8 cm. (3½ x 2⁵⁄₁₆ in.), 1866
NPG.81.M29

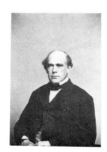

Chase, Salmon Portland, 1808-1873
Statesman, Chief Justice of the
 United States
Mathew Brady studio, active
 1844-1883
Collodion glass-plate negative, 8.9 x
 6.3 cm. (3½ x 2½ in.), c. 1864
NPG.81.M57

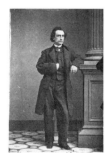

Booth, Edwin Thomas, 1833-1893
Actor
Mathew Brady studio, active
 1844-1883
Collodion glass-plate negative, 8.9 x
 5.9 cm. (3½ x 2⅜ in.), c. 1861
NPG.81.M33

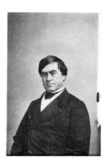

Clay, Cassius Marcellus, 1810-1903
Abolitionist
Mathew Brady studio, active
 1844-1883
Collodion glass-plate negative, 8.9 x
 5.9 cm. (3½ x 2⅜ in.), c. 1863
NPG.81.M59

Colfax, Schuyler, 1823-1885
Statesman
Mathew Brady studio, active
1844-1883
Collodion glass-plate negative, 8.7 x
5.8 cm. (3⁷⁄₁₆ x 2⁵⁄₁₆ in.), c. 1866
NPG.81.M70

Farragut, David Glasgow, 1801-1870
Union admiral
Mathew Brady studio, active
1844-1883
Collodion glass-plate negative, 9 x
5.8 cm. (3⁹⁄₁₆ x 2⁵⁄₁₆ in.), 1863
NPG.81.M84

Cooper, Peter, 1791-1883
Manufacturer, inventor,
philanthropist
Mathew Brady studio, active
1844-1883
Collodion glass-plate negative, 8.7 x
5.8 cm. (3⁷⁄₁₆ x 2⁵⁄₁₆ in.), c. 1862
NPG.81.M75

Fillmore, Millard, 1800-1874
Thirteenth President of the United
States
Mathew Brady studio, active
1844-1883
Collodion glass-plate negative, 8.8 x
5.8 cm. (3½ x 2⁵⁄₁₆ in.), c. 1861
NPG.81.M13

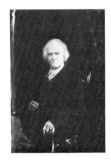

Dallas, George Mifflin, 1792-1864
Statesman
Mathew Brady studio, active
1844-1883
Collodion glass-plate negative, 8.8 x
5.9 cm. (3½ x 2⅜ in.), c. 1861
NPG.81.M78

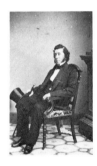

Fish, Hamilton, 1808-1893
Statesman
Mathew Brady studio, active
1844-1883
Collodion glass-plate negative, 8.7 x
5.9 cm. (3⁷⁄₁₆ x 2⅜ in.), c. 1861
NPG.81.M16

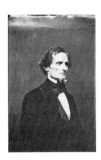

Davis, Jefferson, 1808-1889
President, Confederate States of
America
Mathew Brady studio, active
1844-1883
Collodion glass-plate negative, 9.3 x
6.2 cm. (3¹¹⁄₁₆ x 2⁵⁄₁₆ in.), c. 1860
NPG.81.M82

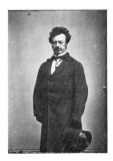

Forrest, Edwin, 1806-1872
Actor
Mathew Brady studio, active
1844-1883
Collodion glass-plate negative, 9 x
6.4 cm. (3⁹⁄₁₆ x 2⁹⁄₁₆ in.), c. 1861
NPG.81.M91

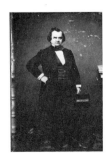

Douglas, Stephen Arnold, 1813-1861
Statesman
Mathew Brady studio, active
1844-1883
Collodion glass-plate negative, 8.6 x
5.9 cm. (3⅜ x 2⅜ in.), c. 1860
NPG.81.M9

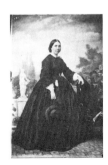

Frémont, Jessie Benton, 1824-1902
Author
Unidentified studio
Collodion glass-plate negative, 9 x
6.1 cm. (3⁹⁄₁₆ x 2⅜ in.), c. 1863
NPG.81.M95

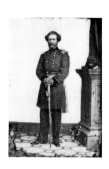

Frémont, John Charles, 1813-1890
Explorer
Mathew Brady studio, active
 1844-1883
Collodion glass-plate negative, 8.8 x
 5.9 cm. (3½ x 2⅜ in.), c. 1862
NPG.81.M93

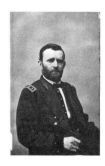

Grant, Ulysses S., 1822-1885
Eighteenth President of the United
 States
Mathew Brady studio, active
 1844-1883
Collodion glass-plate negative, 9.3 x
 5.8 cm. (3¹¹⁄₁₆ x 2⁵⁄₁₆ in.), c. 1864
NPG.81.M108

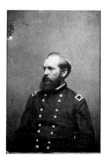

Garfield, James Abram, 1831-1881
Twentieth President of the United
 States
Mathew Brady studio, active
 1844-1883
Collodion glass-plate negative, 9.2 x
 6.3 cm. (3⅝ x 2½ in.), 1862
NPG.81.M96

Hawthorne, Nathaniel, 1804-1864
Author
Mathew Brady studio, active
 1844-1883
Collodion glass-plate negative, 8.9 x
 6.2 cm. (3½ x 2⁷⁄₁₆ in.), c. 1862
NPG.81.M113

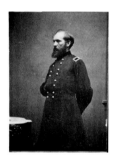

Garfield, James Abram, 1831-1881
Twentieth President of the United
 States
Mathew Brady studio, active
 1844-1883
Collodion glass-plate negative, 9.2 x
 6.3 cm. (3⅝ x 2½ in.), 1862
NPG.81.M97

Henry, Joseph, 1797-1878
Scientist, first secretary of the
 Smithsonian Institution
Mathew Brady studio, active
 1844-1883
Collodion glass-plate negative, 9.2 x
 12.7 cm. (3⅝ x 5 in.), c. 1862
NPG.81.M115

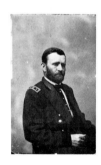

Grant, Ulysses S., 1822-1885
Eighteenth President of the United
 States
Mathew Brady studio, active
 1844-1883
Collodion glass-plate negative, 9.4 x
 5.8 cm. (3¾ x 2⁵⁄₁₆ in.), c. 1864
NPG.81.M99

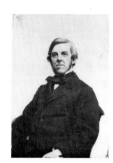

Holmes, Oliver Wendell, 1809-1894
Author
Mathew Brady studio, active
 1844-1883
Collodion glass-plate negative, 8.7 x
 5.9 cm. (3⁷⁄₁₆ x 2⅜ in.), c. 1864
NPG.81.M118

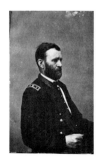

Grant, Ulysses S., 1822-1885
Eighteenth President of the United
 States
Mathew Brady studio, active
 1844-1883
Collodion glass-plate negative, 9.3 x
 5.8 cm. (3¹¹⁄₁₆ x 2⁵⁄₁₆ in.), c. 1864
NPG.81.M100

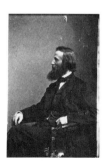

Huntington, Daniel, 1816-1906
Artist
Mathew Brady studio, active
 1844-1883
Collodion glass-plate negative, 8.9 x
 5.8 cm. (3½ x 2⁵⁄₁₆ in.), c. 1862
NPG.81.M127

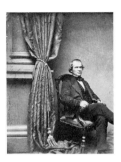

Johnson, Andrew, 1808-1875
Seventeenth President of the United
 States
Mathew Brady studio, active
 1844-1883
Collodion glass-plate negative, 10 x
 8 cm. (3¹⁵⁄₁₆ x 3³⁄₁₆ in.), c. 1866
NPG.81.M10

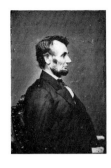

Lincoln, Abraham, 1809-1865
Sixteenth President of the United
 States
Anthony Berger, ?-?, at the Mathew
 Brady studio
Collodion glass-plate negative, 8.9 x
 6 cm. (3½ x 2⅜ in.), 1864
NPG.81.M3

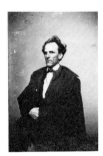

Keene, Laura, 1826-1873
Actress
Mathew Brady studio, active
 1844-1883
Collodion glass-plate negative, 8.8 x
 6.5 cm. (3½ x 2⁹⁄₁₆ in.), c. 1864
NPG.81.M128

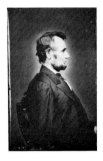

Lincoln, Abraham, 1809-1865
Sixteenth President of the United
 States
Anthony Berger, ?-?, at the Mathew
 Brady studio
Collodion glass-plate negative, 8.9 x
 5.8 cm. (3½ x 2⁵⁄₁₆ in.), 1864
NPG.81.M5

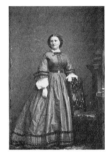

Lane, Harriet, 1830-1903
Socialite
Mathew Brady studio, active
 1844-1883
Collodion glass-plate negative, 8.8 x
 5.7 cm. (3½ x 2¼ in.), c. 1861
NPG.81.M130

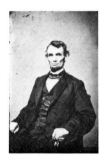

Lincoln, Abraham, 1809-1865
Sixteenth President of the United
 States
Anthony Berger, ?-?, at the Mathew
 Brady studio
Collodion glass-plate negative, 8.9 x
 5.8 cm. (3½ x 2⁵⁄₁₆ in.), 1864
NPG.81.M6

Lane, James Henry, 1814-1866
Abolitionist, Union general
Mathew Brady studio, active
 1844-1883
Collodion glass-plate negative, 9.1 x
 18.9 cm. (3⅝ x 7½ in.), c. 1861
NPG.81.M132

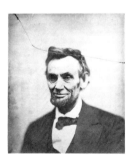

Lincoln, Abraham, 1809-1865
Sixteenth President of the United
 States
Alexander Gardner, 1821-1882
Photograph, albumen silver print, 45
 x 38.6 cm. (17 x 15³⁄₁₆ in.), 1865
NPG.81.M1

Lincoln, Abraham, 1809-1865
Sixteenth President of the United
 States
Anthony Berger, ?-?, at the Mathew
 Brady studio
Collodion glass-plate negative, 8.8 x
 6.1 cm. (3½ x 2⅜ in.), 1864
NPG.81.M2

Lincoln, Abraham, 1809-1865
Sixteenth President of the United
 States
Alexander Gardner, 1821-1882, at the
 Mathew Brady studio
Collodion glass-plate negative, 8.9 x
 5.8 cm. (3½ x 2⁵⁄₁₆ in.), 1861
NPG.81.M7

Lincoln, Abraham, 1809-1865
Sixteenth President of the United
 States
Alexander Gardner, 1821-1882, at the
 Mathew Brady studio
Collodion glass-plate negative, 8.9 x
 5.8 cm. (3½ x 2⁵⁄₁₆ in.), 1861
NPG.81.M8

McClellan, George Brinton,
 1826-1885
Union general
Mathew Brady studio, active
 1844-1883
Collodion glass-plate negative, 8.9 x
 5.9 cm. (3½ x 2⅜ in.), 1863
NPG.81.M147

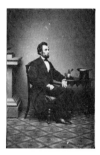

Lincoln, Abraham, 1809-1865
Sixteenth President of the United
 States
Thomas Le Mere, ?-?, at the Mathew
 Brady studio
Collodion glass-plate negative, 8.2 x
 5.9 cm. (3¼ x 2⅜ in.), 1863
NPG.81.M4

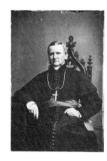

McCloskey, John, 1810-1885
Clergyman
Mathew Brady studio, active
 1844-1883
Collodion glass-plate negative, 8.9 x
 5.7 cm. (3½ x 2¼ in.), c. 1864
NPG.81.M161

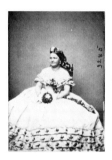

Lincoln, Mary Todd, 1818-1882
First lady
Mathew Brady studio, active
 1844-1883
Collodion glass-plate negative, 9.1 x
 6.4 cm. (3⅝ x 2⁹⁄₁₆ in.), 1861
NPG.81.M139

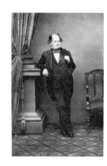

Maury, Matthew Fontaine,
 1806-1873
Naval officer, oceanographer
Mathew Brady studio, active
 1844-1883
Collodion glass-plate negative, 8.8 x
 5.7 cm. (3½ x 2¼ in.), c. 1861
NPG.81.M162

Lincoln, Mary Todd, 1818-1882
First lady
Mathew Brady studio, active
 1844-1883
Collodion glass-plate negative, 8.8 x
 6.8 cm. (3½ x 2¾ in.), c. 1863
NPG.81.M144

Morse, Samuel Finley Breese,
 1791-1872
Artist, inventor
Mathew Brady studio, active
 1844-1883
Collodion glass-plate negative, 8.9 x
 5.8 cm. (3½ x 2⁵⁄₁₆ in.), 1862
NPG.81.M167

Longfellow, Henry Wadsworth,
 1807-1882
Poet
Mathew Brady studio, active
 1844-1883
Collodion glass-plate negative, 8.7 x
 5.8 cm. (3⁷⁄₁₆ x 2⁵⁄₁₆ in.), c. 1863
NPG.81.M146

Schurz, Carl, 1829-1906
Statesman
Mathew Brady studio, active
 1844-1883
Collodion glass-plate negative, 8.8 x
 5.8 cm. (3½ x 2⁵⁄₁₆ in.), c. 1862
NPG.81.M168

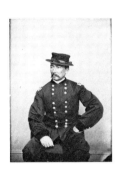

Sheridan, Philip Henry, 1831-1888
Union general
Mathew Brady studio, active
 1844-1883
Collodion glass-plate negative, 9.2 x
 7.4 cm. (3⅝ x 2¹⁵⁄₁₆ in.), 1864
NPG.81.M171

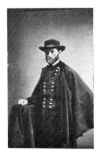

Sherman, William Tecumseh,
 1820-1891
Union general
Mathew Brady studio, active
 1844-1883
Collodion glass-plate negative, 9.3 x
 5.8 cm. (3¹¹⁄₁₆ x 2⁵⁄₁₆ in.), c. 1865
NPG.81.M176

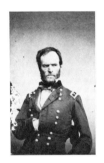

Sherman, William Tecumseh,
 1820-1891
Union general
Mathew Brady studio, active
 1844-1883
Collodion glass-plate negative, 9.2 x
 5.7 cm. (3⅝ x 2¼ in.), c. 1865
NPG.81.M177

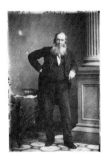

Smith, Gerrit, 1797-1874
Reformer, abolitionist
Mathew Brady studio, active
 1844-1883
Collodion glass-plate negative, 8.8 x
 5.7 cm. (3½ x 2¼ in.), c. 1863
NPG.81.M181

Smith, Gerrit, 1797-1874
Reformer, abolitionist
Mathew Brady studio, active
 1844-1883
Collodion glass-plate negative, 8.8 x
 5.7 cm. (3½ x 2¼ in.), c. 1862
NPG.81.M190

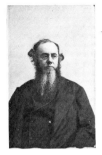

Stanton, Edwin McMasters,
 1814-1869
Statesman
Mathew Brady studio, active
 1844-1883
Collodion glass-plate negative, 9.3 x
 5.8 cm. (3¹¹⁄₁₆ x 2⁵⁄₁₆ in.), c. 1864
NPG.81.M192

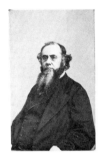

Stanton, Edwin McMasters,
 1814-1869
Statesman
Mathew Brady studio, active
 1844-1883
Collodion glass-plate negative, 9.3 x
 5.7 cm. (3¹¹⁄₁₆ x 2¼ in.), c. 1864
NPG.81.M198

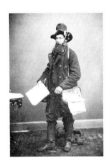

Waud, Alfred Rudolph, 1828-1891
Artist
Mathew Brady studio, active
 1844-1883
Collodion glass-plate negative, 12.4
 x 8.7 cm. (4¾ x 3⁷⁄₁₆ in.), c. 1862
NPG.81.M202

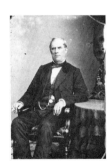

Weed, Thurlow, 1797-1882
Editor
Mathew Brady studio, active
 1844-1883
Collodion glass-plate negative, 8.8 x
 6 cm. (3½ x 2⅜ in.), c. 1862
NPG.81.M203

Wilkes, Charles, 1798-1877
Naval officer, explorer
Mathew Brady studio, active
 1844-1883
Collodion glass-plate negative, 8.7 x
 5.7 cm. (3⁷⁄₁₆ x 2¼ in.), c. 1863
NPG.81.M204

INDEX OF SITTERS

INDEX OF ARTISTS